VENUS AND THE ARTS OF LOVE IN RENAISSANCE FLORENCE

In this volume, Rebekah Compton offers the first survey of Venus in the art, culture, and governance of Florence from 1300 to 1600. Organized chronologically, each of the six chapters investigates one of the goddess's alluring attributes – her golden splendor, rosy-hued complexion, enchanting fashions, green gardens, erotic anatomy, and gifts from the sea. By examining these attributes in the context of the visual arts, Compton uncovers an array of materials and techniques employed by artists, patrons, rulers, and lovers to manifest Venusian virtues. Her book explores technical art history in the context of love's protean iconography, showing how different discourses and disciplines can interact in the creation and reception of art. *Venus and the Arts of Love* offers new insights on sight, seduction, and desire, as well as concepts of gender, sexuality, and viewership from both male and female perspectives in the early modern era.

Rebekah Compton is Associate Professor of Renaissance and Baroque Art History at the College of Charleston, South Carolina. She is a recipient of a Mellon Postdoctoral Fellowship at Columbia University and a fellow of I Tatti, the Harvard University Center for Italian Renaissance Studies.

VENUS AND THE ARTS OF LOVE IN RENAISSANCE FLORENCE

REBEKAH COMPTON

College of Charleston

CAMBRIDGE
UNIVERSITY PRESS

CAMBRIDGE
UNIVERSITY PRESS

University Printing House, Cambridge CB2 8BS, United Kingdom

One Liberty Plaza, 20th Floor, New York, NY 10006, USA

477 Williamstown Road, Port Melbourne, VIC 3207, Australia

314–321, 3rd Floor, Plot 3, Splendor Forum, Jasola District Centre, New Delhi – 110025, India

79 Anson Road, #06–04/06, Singapore 079906

Cambridge University Press is part of the University of Cambridge.

It furthers the University's mission by disseminating knowledge in the pursuit of
education, learning, and research at the highest international levels of excellence.

www.cambridge.org
Information on this title: www.cambridge.org/9781108842914
DOI: 10.1017/9781108913393

First published 2021

Printed in the United Kingdom by TJ Books Limited, Padstow Cornwall

A catalogue record for this publication is available from the British Library.

ISBN 978-1-108-84291-4 Hardback

To West and Grace

"When humbly we look into the depth of God's infinity, our love burns warmly and eagerly and so does our joy."

—Marsilio Ficino

CONTENTS

FIGURES

ACKNOWLEDGMENTS

My long relationship with Venus began with my doctoral dissertation at the University of California, Berkeley. I am especially grateful to Loren Partridge for his initial suggestion to expand my research on Michelangelo and Pontormo's *Venus and Cupid* into a study of the goddess in sixteenth-century Florence. Loren's steadfast support, diligent reading, and nurturing kindness helped to birth this project. I also owe a debt of gratitude to Chris Hallett, who shared with me the ancient art of Venus, and to Albert Russell Ascoli, who introduced me to the pleasures of Boccaccio. While at the University of California, Berkeley, my research was funded by the Dean's Normative Time Grant, the IIE Fulbright Fellowship for Dissertation Research, the Samuel H. Kress Travel Fellowship for Dissertation Research, and the Doreen B. Townsend Center for the Humanities Dissertation Fellowship.

The present book, with its expanded time frame and investigation of materials and techniques, developed in New York City during a two-year Andrew W. Mellon Postdoctoral Fellowship at Columbia University. Michael Cole, in particular, asked me a number of penetrating questions, which prompted me to rethink Venus' relationship to art. I am grateful for conversations shared about the project with David Rosand, James Saslow, Shira Brisman, Frédérique Baumgartner, and Aimee Ng. I would like to thank Paul Barolsky for reviewing early versions of the new material and for his suggestion to read the Goncourt brothers. I would also like to express my sincere gratitude to William E. Wallace, who has supported my studies of Michelangelo since my master's degree at Washington University and who continues to give my writing his careful attention.

I am very appreciative to the Yale University Art Gallery for allowing me to study the Uccello *cassone* when it was brought into conservation. I would like to thank Ian McClure and Irma Passeri for opening the chest and allowing me to examine the interior and exterior paintings under ultraviolet light and stereo microscope. I remain extremely grateful to the Summer Teachers Institute in Technical Art History (STITAH), a collaborative program between the Conservation Center at the Institute of Fine Arts, the Yale University Art Gallery, the Yale Center for British Art, and the Kress Foundation. This program taught me many new things about the science of art. I would like to

thank Sarah Barack, Ian McClure, Irma Passeri, Ashok Roy, Laurence Kanter, and Anikó Bezur for graciously answering all of my questions. I am also grateful for the College of Charleston's Faculty Research & Development Grant, which allowed me to visit the Hamilton Kerr Institute in Cambridge and the Scientific Department of the National Gallery in London, where Marika Spring kindly met with me to discuss red lakes in early modern art.

In conjunction with my research into technical art history, I developed a course dedicated to the materials and techniques of Renaissance art. I would like to thank the students who took this course and shared with me both the joys and sorrows of water gilding with gold leaf, tempera painting with malachite, and glazing with verdigris. I appreciate the Art and Architectural History Department and the Innovative Teaching and Learning in the Liberal Arts Small Grant from the College of Charleston for funding this course. Their generous support has resulted in a wonderful collection of Renaissance materials, which have been a pleasure to study. My thanks are due to Kip Bulwinkle at Karson Photography for his meticulous patience in photographing pigments from the collection for this publication.

The manuscript of *Venus and the Arts of Love* owes much to the monthly meetings of the College of Charleston's Art and Architectural History writing group. Marian Mazzone solidly critiqued multiple versions of each chapter, and Jessica Streit offered astute advice on writing style, organization, and argument phrasing. Nathaniel Walker read the manuscript from beginning to end and provided insightful suggestions throughout. In addition to this group, I would like to thank Sarah Owens for assistance with the book's prospectus and Richard Bodek for his inspiring course on *The Good Life*. I would also like to express my appreciation to the following people for reading and commenting on various chapters: Barry Stiefel, Charles Rosenberg, Patricia Rubin, Jonathan K. Nelson, Sara F. Matthews-Grieco, Nicole Blackwood, Francesco Freddolini, Cinzia Maria Sicca, Karen Hope Goodchild, Leila Sinclaire, and Valery Rees.

Several curators and conservators have shared art objects or archival records that are not easily accessible. I express my appreciation to Nick Humphrey at the Victoria and Albert Museum, Joachim Homann at the Bowdoin College Museum of Art, Adriano Giachi at the Villa Petraia, Maddalena Taglioli at the Scuola Normale Superiore, Troels Filtenborg at the Statens Museum for Kunst, and Andrea Di Lorenzo at the Museo Poldi Pezzoli. With regard to image rights, I would like to thank Patrizia Piergiovanni of the Galleria Colonna, Ferdinand Vaandrager of the Religious and Profane Medieval Badges Foundation, and Muriel Prandato of Fratelli Alinari. I am indebted as well to the staff of the Archivio Restauri e Fotografico dell'Opificio delle Pietre Dure, Gabinetto Fotografico delle Gallerie degli Uffizi, Museo

Archeologico Nazionale di Firenze, Bibliothèque nationale de France, Patrimonio Nacional, Harvard Art Museums, and Yale University Art Gallery.

I am extremely grateful to my editor Beatrice Rehl, who guided me – like a bright star – through the publication of this book. Her clarity and patience will not be forgotten. Thanks are due as well to Katherine Barbaro, Eric Christianson, and Divya Arjunan for their assistance during the book's production. The illustration program would not have been possible without the generous support of Thomas and Sabine Haythe. I owe them a debt of gratitude for establishing the Haythe Faculty Research Grant for Renaissance and Baroque Art History, which funded the the book's color illustrations. I am privileged to have received the following grants to subsidize the costs of image rights: the RSA – Samuel H. Kress Publication Subvention for Art Historians, Dean's Excellence Award in the School of the Arts, College of Charleston's Faculty Research & Development Grant, and the Art and Architectural History Department's Antique Symposium Fund. I would like to express my sincerest gratitude to Diane Miller and Mary Beth Heston for their unwavering support of the illustration program. In addition, I would like to thank Katherine Pocock, Leah Bancheri, María Carrillo-Marquina, Paige Miller, and Emily McDaniel for their assistance with illustration titles and bibliographic references.

Finally, I would like to say thank you to my family and friends, who have offered prayers, advice, and reassurance throughout this project. I extend my gratitude to Allen, Courtney, Nick, Brian, Suzanne, and Ben for watching the children at key periods during the book's writing and production. A special thank you goes out to my sister, Wimberly, and my parents, Billy and Elizabeth, who have listened with care to the discoveries, frustrations, and journeys of book writing. I am blessed to have friends who are both encouraging and understanding. Of particular note are Ann-Whitney Chanslor, Kelly Corwin, Morgan Ziegler, Lisa Vickers, Anne LeClercq, Jessica and Todd Garrett, Deas Manning, Nicole Klem, Moira Duggan, Anne Svetlik Derbyshire, and Jessica Porter. Finally, I thank my children, West and Grace, for their precious love. With a full heart, I dedicate this book to them.

INTRODUCTION

Sweet Persuasions

Love, I find, mythologizes life.[1]
 —Ovid (43 BCE–17/18 CE), *Amores*

Between 1300 and 1600, Venus and her arts of love charmed the citizens of
Florence. Among the soft violets, pinks, and blues of dusk and dawn, her bright
star twinkled above the city. Her presence graced festive celebrations, when silk
dresses hand-stitched with gold and pearls rustled in corridors and fragrant
perfumes infused with citrus, jasmine, and sea-spun ambergris delighted the
sense of smell. At such events, Venus attended to laughter, dancing, and sweet
songs; she inspired paintings and sculptures, garlands and wreaths. She also
frequented the bedchamber, where bodies clung together on feather-stuffed
mattresses, when the sight of incandescent skin, dainty fingers, curving hips, and
yielding chests ignited desire. In the dark of night, her passions also broke
hearts, enraged minds, and diseased bodies. For, the goddess of love also
lingered in the cloying scent of betrayal and the violent penetration of rape.[2]
As this book illustrates, Venus and her charms were both celebrated and
censured for pleasuring *Fiorenza*, the city of flowers, where beauty and fertility
were heavenly, but lust and deceit could be dangerous and sometimes deadly.

This book examines Venus and the history of her arts in the society, culture,
and governance of Florence between 1300 and 1600. It begins with Andrea
Pisano's relief of the planet *Venus* (Fig. 1) on the city's Campanile and concludes
with the goddess's sculpted and painted presence in Medicean Ducal

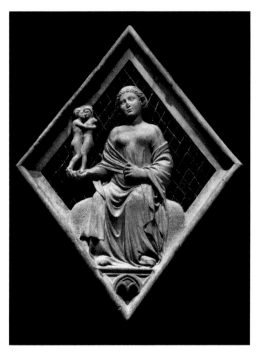

1 Attributed to Nino Pisano, *Venus*, ca. 1337–41, relief for the Campanile at the Cathedral of Santa Maria del Fiore, now at the Museo dell'Opera del Duomo, Florence, Italy. Photo: Peter Horree / Alamy Stock Photo

commissions, including the Sala degli Elementi (Fig. 2) and Francesco I's *studiolo* inside the Palazzo Ducale (Palazzo Vecchio). Organized chronologically, each of the six chapters investigates one of the goddess's alluring attributes – her golden splendor, rosy-hued complexion, enchanting fashions, green gardens, erotic anatomy, and gifts from the sea. Venus works well as a case study here because her attributes (her starlight, skin, raiment, jewelry, shells, etc.) drive her powers of seduction, and the visual arts can be said to operate in a similar manner, attracting attention and arousing desire through the calculated manipulation of specific materials. *Venus and the Arts of Love* examines technical art history in relation to love's iconography, offering new perspectives on early modern understandings of sight, seduction, and desire.

In this way, *Venus and the Arts of Love* engages with Jacques Lacan's notion of a desiring viewer, who can be captivated by a work of art.[3] Lacan posits that the painter "gives something for the eye to feed on" and invites the viewer "to lay down his gaze there as one lays down one's weapons." Lacan goes on to describe this effect as "pacifying" and "Apollonian."[4] Here, it is the Venusian rather than the Apollonian effects of art that are taken up. Of relevance to this approach are (1) the optical poetics of love, in which the eyes are the messengers of the heart and (2) Marsilio Ficino's theory that "Love, therefore beginning from Beauty, ends in Pleasure."[5] It should be remembered that during the period under investigation, one of the three purposes of art within the Catholic faith was to arouse the viewer and excite the heart. Indeed, during a sermon given inside of the city's Duomo in 1493, Girolamo Savonarola declared, "Love is like a painter. The works of a good painter so charm men that, in contemplating them, they remain suspended, and sometimes to such an extent that it seems they have been put in an ecstasy and taken outside of themselves."[6] This book examines the power of Venus and her pictorial tradition to encourage such ecstatic states. Even in a devout Christian city, Venus was more than a mere symbol; she was a goddess, or something very near to one, with countless temples great and small, made not of marble but of gold, malachite, coral, rubies, and pearls, and raised throughout the city, in the most intimate and powerful of places.

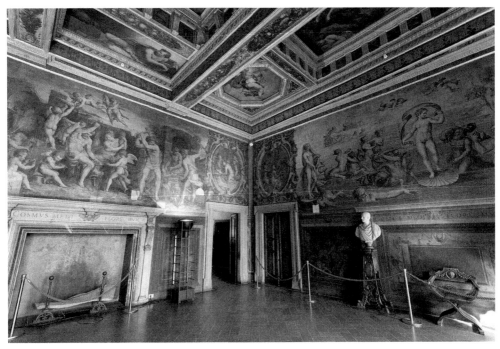

2 Giorgio Vasari and workshop, *Birth of Venus* and *Forge of Vulcan*, Sala degli Elementi, 1555–57, Palazzo Vecchio, UNESCO World Heritage Site, Florence, Italy. Photo: John Kellerman / Alamy Stock Photo

FRAMING VENUS

The chronology of *Venus and the Arts of Love in Renaissance Florence* spans across three hundred years, roughly from 1300 to 1600. These historical parameters are generous and somewhat artificial; however, they extend from Venus' public appearance on the Republican city's Campanile (1337) to her semi-public presence in the Palazzo Ducale (Palazzo Vecchio) as an embodiment of the Medici Ducal State (1575). Between these two points in time, Venus' reputation burgeons and blossoms, ebbs and flows. The book concludes at the end of the sixteenth century, when the Medici Ducal Dynasty was firmly secured in Florence. At this point in time, Venus' affairs and iconography were widely known, having been disseminated through popular mythographic compendiums, treatises on love, and erotic prints. In the seventeenth and eighteenth centuries, the goddess continued to appear in Florence; however, her beauty materialized in different forms, including theatrical performances, large-scale fresco cycles, and small bronzes.

Traditionally, the story of Venus in Renaissance Florence has focused on Sandro Botticelli's *Primavera* and Agnolo Bronzino's *Allegory with Venus and Cupid*. Art historians, such as Aby Warburg and E. H. Gombrich, drew

scholarly attention to Botticelli's Venuses, documenting the goddess's presence in the literary and artistic heritage of antiquity and in the philosophies of Neoplatonic love.[7] This iconographic scholarship was continued by Charles Dempsey, who explored her poetic and carnivalesque valences in the vernacular culture of Lorenzo de' Medici.[8] In the 1980s and 1990s, art historians interested in mannerist art unveiled the complex allegories and burlesque sexuality of Bronzino's *Allegory with Venus and Cupid*.[9] Other Florentine representations of Venus have received scholarly attention as well. Jacqueline Marie Musacchio and Adrian W. B. Randolph, for example, have explored the complexity of Venus and her imagery within the material culture of marriage in fifteenth-century Florence.[10] The *Venus and Cupid* designed by Michelangelo Buonarroti and painted by Jacopo Pontormo in 1532 was the subject of a 2002 exhibition organized by Franca Falletti and Jonathan Katz Nelson.[11] Moreover, the sculptural fountain dedicated to *Fiorenza* as *Venus Anadyomene* has been the subject of studies by Cristina Acidini Luchinat and Claudia Lazzaro, whose archival work unearthed the chronology of this ambitious ducal project.[12] *Venus and the Arts of Love* builds upon this scholarship and presents a chronological survey of the goddess's portrayal in paintings, sculptures, and the decorative arts, created in Florence between 1300 and 1600.

During this three-hundred-year period, Venus enjoyed popularity in places other than Florence. As evidenced by Stephen J. Campbell, Renaissance artists traveled widely and created works of art outside of the "centers" of Florence, Venice, and Rome.[13] With her multivalent personality and charming beauty, Venus serves as a nexus point for examining this exchange of ideas and forms. Florentine poets and artists, for example, were influenced by the French tradition of chivalric love, the nudes and painting techniques of Flemish artists, and the astrological studies undertaken in Padua and Ferrara. They were fascinated with Venus' portrayal in sixteenth-century Rome and Venice. Rome, in particular, enhanced the goddess's erotic reputation. The discovery and collection of ancient statues, as James Grantham Turner has pointed out, prompted artists to experiment with the depiction of multiple views of the female body as well as multiple forms of love.[14] Venetian artists similarly sensualized Venus, modeling her form on the bodies of courtesans and capturing her tangible beauty through the use of *colorito*, as discussed by Rona Goffen, Mary Pardo, and Jill Burke.[15] Venus also enjoyed popularity in the German art of Lucas Cranach, the French tradition at Fontainebleau, and the mythological art of late sixteenth-century Netherlandish artists.[16] While this study focuses on Florence, it is hoped that the iconographical and technical information provided in it will foster the examination of Venus in other geographical locations and other time periods.

The rise of Venus' star in Florence was prompted, in part, by the dissemination of new knowledge. The city's diplomatic and economic connections

with Naples, Sicily, Spain, France, Flanders, and England provided scholars, such as Dante Alighieri and Giovanni Boccaccio, with access to a wide range of Latin, Greek, and Arabic manuscripts. Those privy to this new learning were mostly of the elite, educated class; however, the ideas garnered from these texts soon influenced broader social networks.[17] This book examines Venus within this burgeoning scholarly tradition, and her prevalence within it may come as a surprise to some. Not only is she central to the long-studied traditions of Neoplatonic philosophy and amorous poetry, but she also plays a role in Arabic medicine and magic, gynecology and women's health, cosmetics and cosmeceuticals, fashion and perfumery, as well as the natural sciences of botany and minerology. By examining her position within these various disciplines, this book reveals how Venus served as a site of discursive negotiation, prompting individuals to think in new ways about complex issues, such as desire, fertility, sight, magic, creativity, and power.

Venus also offered an avenue for individuals to discuss gender and sexuality. As Mary Garrard illustrates in *Brunelleschi's Egg*, patrons and artists took advantage of Venus' multiple identities to reinforce the female archetypes of mother, bride, wife, and whore.[18] The goddess often overstepped the prescribed boundaries of feminine modesty and chastity, while also overturning normative ideals of masculinity. Moreover, Venus governed a spectrum of sexual inclinations and orientations, including marital, homoerotic, bisexual, polyamorous, and incestuous desires. In discussing viewer responses to representations of Venus, I address these contradictory and, at times, problematic aspects of gender and sexuality. While these perspectives range from well-grounded conclusions to adventurous hypotheses, I try to honor Venus' fluidity in the categories of gender and sexuality within the historical context of the period under investigation.

In the course of deconstructing Venus' trajectory in Florence, this book pays special attention to the physical materials and artistic techniques that evolved over time to fulfill and even enhance the goddess's particular iconographic demands. Taking into consideration restoration and conservation reports, scientific analyses, records of the Arte di medici e speziali and Arte della seta, recipe books, color treatises, inventories, and Medici archival documents (along with practical experimentation), this book analyzes the pigments, grounds, binders, metals, stones, and other materials that artists and artisans wielded to capture Venus' beauty. In recent years, the field of art history has begun to explore materials, a methodological approach introduced in the writings of Henri Focillon and Michael Baxandall.[19] Art historians, such as Michael Cole, Rebecca Zorach, Jodi Cranston, and Ann-Sophie Lehmann, have opened new doors for the exploration of materials in relation to the generation and appreciation of early modern art.[20] The study of materials and techniques depends, in part, on the technical research conducted in the conservation and scientific departments of

museums and universities, such as the Yale University Art Galleries, the National Gallery in London, the Hamilton Kerr Institute, and the Opificio delle Pietre Dure in Florence. Using high-tech microscopic, chromatographic, and spectro-photometric instruments, scientists, conservators, and restorers produce detailed technical reports of objects that can then be united with the scholarship of curators and art historians to uncover many of art's secrets.[21]

During the Renaissance, patrons and artists chose materials for their aesthetic properties (their opacity, transparency, sheen, or sparkle), their cost, their availability, and their ability to remain colorfast. What is not so well known is that pigments, supports, binders, and metals were also adopted for their symbolic, therapeutic, and even talismanic powers. Believed to possess active powers, materials could attract, channel, emanate, reflect, stimulate, and soothe; they could be hot or cold, moist or dry. These natural elements originated in distant lands and a variety of political, economic, and social factors affected their procurement and importation. Malachite was found in the Black Forest of Germany, musk in the Himalayan mountains of India, and coral along the coast of Tabarka, Africa. While seemingly mythical, Venus' island of Cyprus was a major trading post, standing as the easternmost stronghold of Christianity in the Mediterranean. Ships laden with incense, brazilwood, indigo, soap, honey, silk, rose water, copper, pomegranate seeds, and crimson lac arrived at the port of Livorno from Cyprus and provided Florentines with an array of Venusian treasures.[22] *Venus and the Arts of Love* examines these materials and their manipulation by Renaissance artists into attractive and delightful objects that aroused desire – desire which often threatened to cross the line from appreciation and enthusiasm to something less chaste.

VENUS IN FOURTEENTH-CENTURY FLORENCE

Venus makes her public debut in Florence on a relief lozenge (Fig. 1) ornamenting the Campanile in the sacred heart of the city. Andrea Pisano and his workshop sculpted two tiers of reliefs for this bell tower between 1337 and 1342.[23] Venus appears in the series of the seven planets, which sits above reliefs of humankind's achievements and alongside reliefs of the seven virtues, seven liberal arts, and seven sacraments. In his foundational study of the Campanile, Marvin Trachtenberg writes that the seven planets "not only are among the earliest manifestations in monumental art of their genre but undoubtedly, as [Jean] Seznec suggests, the most exalted."[24] The prestige of the reliefs lies in their prominent position on the bell tower's west or main façade, where they assert sovereignty in high relief against backgrounds of tiny blue-glazed tiles suggestive of the celestial spheres.

In other fourteenth-century astrological cycles, the planets govern similar civic spaces. Venus (Fig. 3) is gracefully woven into the acanthus leaf

decoration of an exterior capital of the Palazzo Ducale in Venice. The planetary deity (Fig. 4) perches above Ambrogio Lorenzetti's frescos of *Good and Bad Government* in the Palazzo Pubblico of Siena.[25] She also appears in the monumental astrological cycle, painted by Giotto di Bondone for the Palazzo della Ragione in Padua. In the series of frescos dedicated to Libra (Fig. 5), Venus is depicted as a partially nude female – her thighs and pubis covered with white drapery – standing in front of a gold eight-pointed star. She holds a mirror in one hand and a gold necklace in the other. The surrounding scenes, which include Cupid, female devotees, and a woman seated at her toilette, emphasize the planet's astrological powers over love, fertility, and beauty.[26]

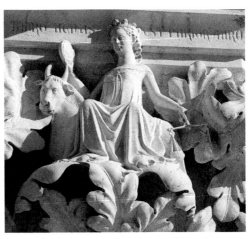

3 Detail of a statue of a woman (Venus) over a bull in a column in Saint Mark's Square near the Ducal Palace, July 14, 2016. Photo: FC_Italy / Alamy Stock Photo

During the fourteenth century, astrology was also synthesized into sacred contexts, especially those inspired by the writings of Thomas Aquinas. In the Spanish Chapel of Florence's Santa Maria Novella, Andrea di Bonaiuto includes Venus in his *Triumph of St. Thomas and Allegory of the Sciences* (Fig. 6), frescoed between 1365 and 1367. The planetary deity is painted in a small roundel or *tondo*, sculpted into the pediment of the Gothic throne occupied by

4 Ambrogio Lorenzetti, *Venus*, detail of decorative band, 1338–40, Palazzo Pubblico, the Hall of the Government of the Nine or Hall of Peace, Siena, Italy. Photo: Archivi Alinari, Firenze

Rhetoric, the second to last figure on the viewer's right.[27] Venus admires her beauty in a looking glass above Rhetoric and above Cicero, the ancient Roman writer and orator who wooed his audience with ornament, adornment, charm, and grace.[28] In the *Convivio* (1304–1307), Dante Alighieri assigns Rhetoric to Venus, declaring that the planet is comparable to this liberal art "in terms of two properties. The first is the radiance of its aspect, which is the most delightful to see of all the stars. The second is that it appears in both the morning and the evening."[29] Standing with arm akimbo and a faint smile playing at the corners of her lips, Bonaiuto's Venus embodies the eloquence and persuasion of sweet rhetorical speech.

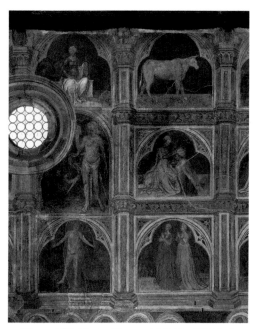

5 Giotto di Bondone, Giovanni Miretto, and Stefano da Ferrara, detail of panels related to the zodiac sign of Libra, including the figure of Venus, fourteenth to fifteenth century, Salone of Palazzo della Ragione, Padua, Italy. Photo: Archivi Alinari, Firenze

On the Florentine Campanile, *Venus* (Fig. 1) asserts sovereignty as a young, well-dressed lady. She wears a fashionably cut, formal dress that drapes into soft curves between her knees, and she pulls a stately mantle around her shoulders. Like other planetary deities in the series, she personifies a contemporary social type, an iconography that correlates with Michael Scot's description of the planets in his popular scientific handbook *Liber introductorius*, composed between 1220 and 1236 at the Sicilian court of Emperor Frederick II. In Scot's text, Mars wages war against the infidel as a crusading knight, while Apollo asserts divine authority in the guise of a king. Scot describes Venus as a beautiful lady, dressed in fashionable clothing and clutching a bouquet of flowers.[30] On the Campanile, she holds two naked lovers, rather than a bouquet, and gazes upon their embrace rather than into a mirror.

This miniature couple signifies Venus' governance over amorous, procreative, and concupiscent desire; however, the pair may likewise symbolize the power of art to arouse these same passions. The truncated torso of the tiny female suggests this reading. While her missing left arm could be the result of damage, it could also be a purposeful exclusion by Pisano or his workshop to suggest that the figure is a sculpture. Close examination reveals that the female's torso is separated from her lover's arm and hand. The illusion is furthered by a contrast between the male and female's response to each other. With his leg bent in a pseudo-*contrapposto* stance, the male presses his body and his genitalia against the female, touching his lips and nose to her cheeks. She does not return his gaze or kiss, offering a stone-cold response to his sexual advances. Is this a portrayal of a man embracing a nude female statue, a meta-sculpture within the artist's relief? If so, Pisano and his workshop may be referencing a well-known tale of art's fascinating powers of seduction.

The story of Pygmalion and Galatea is recounted in Book 10 of Ovid's *Metamorphoses* and features prominently in *The Romance of the Rose*, written by Guillaume de Lorris and Jean de Meun between 1230 and 1280. A master in the art of sculpture, Pygmalion carved "in snow-white ivory, with wondrous art, / a female figure more exquisite than / a woman who was born could ever

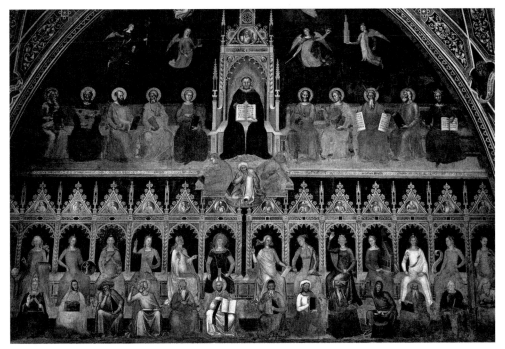

6 Andrea di Bonaiuto, *Triumph of St. Thomas and Allegory of the Sciences*, 1365–67, Spanish Chapel, Basilica of Santa Maria Novella, Florence, Italy. Photo: Peter Horree / Alamy Stock Photo

match."[31] Taken by both beauty and vanity, Pygmalion falls in love with his own creation. In *The Romance of the Rose*, he bemoans his unnatural state of desire, declaring that, "when I want to ease myself, to embrace and to kiss, I find my love as rigid as a post and so very cold that my mouth is chilled when I touch her to kiss her."[32] A French illuminated manuscript of *The Romance of the Rose* from ca. 1405 includes an illustration of Pygmalion (Fig. 7) embracing a stiff and pale statue dressed in an elegant red gown. The text explains, "nor did she appear less beautiful without clothes than when she was dressed."[33] The sensual allure of Galatea's nude body may be referenced in the meta-sculpture on the Florentine Campanile. According to Ovid, the sculptor's agonizing desire does not last forever. Venus finally rescues her devotee and transforms his ivory statue into living flesh, which warms, softens, and blushes under his touch.[34] Is a similar metamorphosis occurring on the Campanile relief under the goddess's direct gaze?

The myth of Pygmalion celebrates the power of art. Nonetheless, it also explores objectophilia or object sexuality in that inordinate desire is directed towards an inanimate object. In his first-century patristic writings, Clement of Alexandria condemns this type of love, linking it to both the deception of art and the practice of idolatry.[35] He compares the story of Pygmalion and Galatea

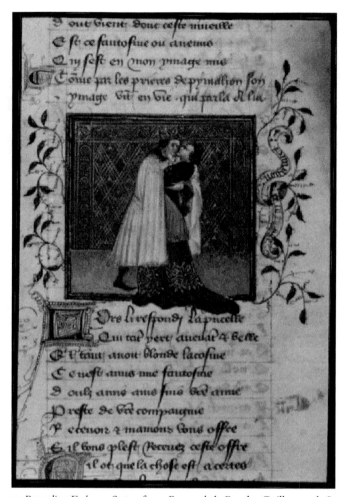

7 *Pygmalion Embraces Statue*, from *Roman de la Rose* by Guillaume de Lorris and Jean de Meun, ca. 1405, FR245, fol. 152r, Pierpont Morgan Library, New York, USA. Photo: The Picture Art Collection / Alamy Stock Photo

with another tale of objectophilia recounted by Pliny the Elder in Book 36 of the *Natural History* and by Lucian of Samosata in his *Affairs of the Heart*. On the island of Knidos, where Praxiteles' nude *Aphrodite* stood in an open-air shrine, "a man once fell in love with it and hiding by night embraced it," leaving a stain upon the sculpture that "betrays this lustful act."[36] On the Campanile, the ardent, pressing passion of the male against the inert body of the female is reminiscent of this ejaculatory experience, which symbolizes how Venus and her arts exert emotional and physical power over viewers.

In the fourteenth century, Venus was associated with both illicit sexual desire and the worship of idols.[37] Indeed, the intertwining of these two vices may have halted a plan to install statuettes of the seven planets inside the

Florentine Baptistery. A document in the Opera del Duomo from ca. 1334 describes a project to position less than life-sized statues of the planets alongside Jesus on the corners of an octagonal screen surrounding the central baptismal area.[38] Gert Kreytenberg suggests that Andrea Pisano's unusual statuette of *Santa Reparata* (Fig. 8), now in the Museo dell'Opera del Duomo, was originally conceived as the planet Venus. This cosmological decorative program for the baptistery was never completed, most likely because sculpted, three-dimensional statues of the planetary deities could have been interpreted as idols, demanding veneration in a sacred space.

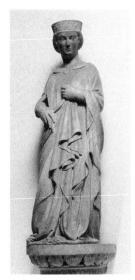

8 Andrea Pisano, *Santa Reparata*, ca. 1336, marble statue, Museo dell'Opera di Santa Maria del Fiore (Museo dell'Opera del Duomo), Florence, Italy. Photo: akg-images / De Agostini Picture Lib. / A. Dagli Orti

Anxieties surrounding idol worship were prevalent during the fourteenth century. On November 7, 1357, the Sienese government removed an ancient statue of Venus from a fountain in the city center because of its associations with both idolatry and lust. Lorenzo Ghiberti recounts the story in his *Commentaries*. During an excavation, the Sienese unearthed an ancient statue of a nude female standing beside a dolphin. The name of Lysippos (390–300 BCE) was found on its base. The citizens of Siena, especially the artists, celebrated the find and then installed this "marvelous" and "incredible" work of art in a public space within the city.[39] Before long, however, questions were raised as to whether this statue – a pagan idol – was to blame for the city's political and economic misfortunes. According to Ghiberti, the city "was suffering many reverses in their war with Florence," which led to one citizen speaking before the city council and declaring, "considering that things have gone ill with us ever since we found this statue and considering that idolatry is forbidden by our faith, we must believe that God has visited us, for our errors, with all these adversities." The citizen advised "taking it [the statue] down and smashing it to pieces, sending the fragments to be buried in Florentine soil."[40] The November 7 proclamation of the Sienese government, found in the records of the *concistoro*, argues that the statue should be removed because it is *inhonestum*, or dishonest, a statement that draws attention to the illicit sexual desire known to be provoked by nude Venuses.[41] In Ghiberti's account, the disgruntled Sienese citizen's plan was executed and the shattered sculpture was buried in Florentine territory. Though intended as a curse or form of detrimental magic towards an enemy, the placement of the statue beneath Florentine soil functioned instead as a magical charm that assured Venus' reign within the city for years to come. The story of her powerful presence within Florence for the next two centuries is the subject of *Venus and the Arts of Love*.

BOOK ORGANIZATION

After the Moon, Venus is the brightest heavenly body in the night sky. Her light inflames lovers and illuminates the amorous tales of Dante Alighieri and Giovanni Boccaccio. Chapter 1 takes as its subject epiphanic paintings of Venus on three early fifteenth-century objects presented to couples on the occasion of a betrothal, wedding, or birth. Created by unknown artists, these paintings are some of the first to portray Venus outside of encyclopedic depictions of the seven planets. This chapter examines the use of light-catching materials to illustrate Venus' splendor (gilding, liquid gold, and yellow pigments) as well as the geometry of the mandorla, an aureole of light that transported viewers into visionary experiences. By appropriating the iconographic conventions of sacred epiphanies, fifteenth-century artists characterized Venus as a potent, liminal force capable of penetrating the Earth's sphere and charming individuals in transitional moments of the life cycle. The young women and men under her influence exemplify love's joys and sorrows, while simultaneously paying homage to the social structure of the family.

Chapter 2 examines early representations of the female nude by Paolo Ucello and his workshop, Lo Scheggia (Giovanni di ser Giovanni Giudi), Paolo Schiavo, Antonio Pollaiuolo, and Sandro Botticelli. Working between 1425 and 1485, these artists privileged tangible flesh and anatomy over celestial splendor and symbolism. This chapter investigates medieval and early Renaissance understandings of skin, outlines the characteristics of a healthy complexion, and discusses the role of flesh in both marriage negotiations and reproductive physiology. To cultivate desirable complexions, noble women and their handmaidens practiced Venus' secret arts, the materials of which consisted of ewers, basins, tubs, soaps, depilatories, creams, ointments, perfumes, dyes, and paints. In fourteenth- and fifteenth-century medical treatises, women were likened to artists: first, in their ability to generate new persons, and second, in their manipulation of specific materials to transform their own visages and cultivate rosy-hued complexions. For artists, social success also depended on picturing desirable flesh. This challenge prompted innovations in modeling anatomy, mixing colors, working with binders, and fashioning glazes. Crafted during a period when humanists began to question the church's views of sin and shame, these painted female nudes represent a conceptual shift that placed the body and its reproductive abilities – if only for a short time – at the very center of Florence's future social and political prosperity.

Chapter 3 examines the magical virtues of Venus' clothing in Sandro Botticelli's *Primavera*, *Venus and Mars*, and *Venus and the Three Graces*. In his *Three Books on Life*, written between 1480 and 1489, Marsilio Ficino lays out a set of medical-magical theories based on the writings of Thomas Aquinas and the *Picatrix*, which acknowledge the influence of the planets and the

constellations on matter and material bodies. Ficino explains that heavenly bodies wield both beneficial and malignant forces, which can be encouraged or counteracted through the manipulation of specific materials prone to their influence. He speaks, for instance, of "catching Venus' breath" in the construction and wearing of garments in order to imbue the body and the spirit with a beneficial quality. Ficino's theories have perceptible relationships with Botticelli's famous paintings of Venus. The goddess's clothing correlates with descriptions of her celestial likeness, while her white dress, gold embroidery, and red mantle may have possessed secret virtues that could be channeled by viewers privy to her celestial cult. This chapter explores Botticelli's personal ties to the silk industry and investigates his techniques for rendering the material and spiritual power of Venus' enchanting fashions into paint. By folding and pleating fabric with light and shadow, simulating colorful dyes with rich pigments, and weaving complicated patterns into his textiles, Botticelli captured the magical allure of Venus and the Florentine silk industry. A spirited garment, as all readers of Ficino understood, could animate both body and soul.

Venus' lush green gardens, shady evergreen groves, and fragrant floral bowers are the subject of Chapter 4. These verdant landscapes provided a place for the enjoyment of romance and other delights; however, they also offered curative properties to nourish and heal the mind, body, and spirit. In his *Three Books on Life*, Marsilio Ficino dedicates the color green and gardens to Venus. He explains how verdure things abound with a certain salubrious humor that flows to humans through the odor, sight, use, and habitation of and in them. Green things restore and stimulate vision, while also increasing fertility and the likelihood for success in conception and childbirth. This chapter explores these concepts in relation to the mediums and materials that artists used to create green places within the domestic interior. It pays particular attention to green pigments and Botticelli's use of them in his *Primavera*, *Venus and Mars*, *Venus and the Three Graces*, and *Birth of Venus*. In the cosmological chain of correspondences, Venus governs copper, and derivatives of the metal, such as malachite and verdigris, were believed to emanate her celestial virtues. Manipulated carefully in different mediums, these pigments materialized the green geography of the goddess's earthly paradise.

Venus did not flourish in Florentine art between 1494 and 1530, when puritanical preaching, factious war, and economic decline overpowered affairs of the heart. In his fiery sermons, Girolamo Savonarola condemned lascivious images within the bedroom and denounced the contemporary cult of feminine beauty as a form of idolatry. In 1497, all things Venusian, including gaming tables, playing cards, musical instruments, silk fabric, hair ornaments, cosmetics, perfumes, disgraceful art, and books of magic were incinerated in the bonfire of vanities.[42] The new Republic that followed Savonarola's execution in 1498 foregrounded masculine valor over feminine grace. David was called

upon to embody strength and courage in the face of outside adversity. As Zeus declared to Aphrodite in the *Iliad*, "Not to you, my child, are given works of war; but attend to the lovely works of marriage."[43]

Chapter 5 examines the return of Venus to Florence in drawings and paintings by Michelangelo Buonarroti, Jacopo Pontormo, Agnolo Bronzino, Giorgio Vasari, and Michele Tosini. Designed between 1532 and 1565, these erotic representations of the goddess replace formal heraldry and floral fecundity with leering satyrs, wanton caresses, and breathless kisses. In this art, anatomy both expresses and stimulates desire, an effect achieved through the study of live studio models and sensuous sculptural fragments. Transforming bodies from drawings to paintings, Florentine artists privileged artifice (art from art) over materials. At the same time, they questioned *both* artifice and love by illustrating the dangers of venereal excess. Responding to an already clichéd representation of the female nude found inside *cassoni* or on panels hidden beneath thick drapery, Florentine artists repositioned and reproduced the bodies of Venus and Cupid to titillate their viewers and brandish their *ingegno*, or genius, within the competitive artistic climate of sixteenth-century Italy.

Chapter 6 investigates Venus' aquatic origins and her opulent gifts from the sea. As Duke of Florence from 1537 to 1574, Cosimo I de' Medici ambitiously pursued maritime projects that expanded the reach of Florence beyond the Arno valley. Allusions to his new domain appear at the Villa Castello and Palazzo Ducale (Palazzo Vecchio) in the figure of *Venus Anadyomene*, who rises nude from the salty womb of the sea to receive aquatic treasures – ambergris, coral, and pearls – from Nereids and Tritons. This chapter examines marine materials associated with Venus and their role within the court of Duke Cosimo I and his wife, the Duchess Eleonora de Toledo. The ducal perfumer Ciano, who commissioned a *Venus Anadyomene* for his own palazzo courtyard, fashioned sultry fragrances from ambergris, while Duke Cosimo pursued coral fishing in the Mediterranean Sea. Arriving from Venice, Peru, and Cadiz, iridescent pearls were another oceanic treasure that Cosimo purchased and then bestowed in the form of diplomatic gifts to secure political and marital alliances. This chapter analyzes the early modern natural history of these maritime treasures, which encouraged both love and peace – Venusian virtues needed to secure the Medici's Ducal Dynasty.

In standard accounts of art history, Venus dwells in Venice, flaunting her charms in the voluptuous nudes of Titian, while David resides in Florence, asserting his masculine *virtù* in the stoic sculpture of Michelangelo. Venus, however, proclaimed her power within Florence, not only in Botticelli's *Primavera* and Bronzino's *Allegory of Venus and Cupid* but also on betrothal boxes, wedding chests, birth trays, frescoed walls, and fountain sculptures. Conceived from the severed testicles of Uranus falling into the womb of the

sea, Venus is a liminal deity, betwixt and between heaven and earth, form and matter, culture and nature, day and night. Her beauty, however, supersedes these fluctuating, mutable dualities to exert a direct, inexorable power to attract, seduce, and delight, sometimes deceptively. Taking heed of this warning, let us follow her through the bedrooms, galleries, halls, and gardens, where her devotees manifested their devotion by practicing the arts of love, for each other and for Florence.

NOTES

1 Ovid, *Amores*, trans. Guy Lee (London: John Murray, 1968), 67.

2 Giovanni Boccaccio's description of Venus, as he notes, is based on the astrological writings of Abu Ma'shar (Latinized as Albumasar, 787–886) and Andalò di Negro (1260–1334). He writes, "They want Venus to be a woman of phlegmatic complexion and nocturnal, humble with friends and affable, keen in thought for the composition of verses, laughing at perjury, deceitful, credulous, courteous, patient and very easygoing but of honest character and mien, cheerful, delightful, and extremely charming, and a woman who despises corporeal strength and weakness of the mind. In addition, Venus signifies the beauty of the face, attractiveness of the body, and an adornment for everything, and so the use of precious unguents, fragrant aromatics, games of dice and calculation, or of bandits, and also drunkenness and feasts, wines, honeys, and whatever seems to pertain to sweetness and warmth, equally fornication of every kind and wantonness and a multitude of coition, the guardianship of statues and pictures, the composition of wreaths and wearing of garments, weavings with gold and silver, the greatest amusement in song and laughter, dancing, music by stringed instruments and pipes, weddings, and many other things." Giovanni Boccaccio, *Genealogy of the Pagan Gods, Volume I: Books I–V*, trans. Jon Solomon, I Tatti Renaissance Library 46 (Cambridge, MA: Harvard University Press, 2011), vol. 1, Book 3, 382–85. In her *Epistle of Othea*, Christine de Pizan explains the dangers of this goddess: "Do not make Venus your goddess, / do not set store in her promise. / The pursuit of her is painful, / not honorable, and perilous." Pizan glosses the text, writing, "Venus gives influence of love and of idleness; and she was a lady so named who was the queen of Cyprus. And because she exceeded all in excellent beauty and voluptuousness, and was very amorous and not constant in one love but abandoned to many, they called her the goddess of love. And for this reason, that she gave influence of lechery, Othea says to the good knight that he not make her his goddess. This is to understand that, in this life which promotes vices, he should not abandon his body nor his intent. And Hermes says: 'The vice of lechery taints all virtues'." Christine de Pizan, *Christine de Pizan's Letter of Othea to Hector*, trans. Jane Chance (Cambridge: D. S. Brewer, 1997), 45–46.

3 "At the scopic level, we are no longer at the level of demand, but of desire, of the desire of the Other . . . Generally speaking, the relation between the gaze and what one wishes to see involves a lure." When speaking of scopic desire and painting, Lacan asks, "How could this *showing* satisfy something, if there is not some appetite of the eye on the part of the person looking? This appetite of the eye that must be fed produces the hypnotic value of painting." Jacques Lacan, *The Four Fundamental Concepts of Psychoanalysis*, ed. Jacques-Alain Miller and trans. Alan Sheridan (London: Kainac, 2004), 104, 115. Lacan's theories on art are discussed by Hubert Damisch, *The Judgment of Paris*, trans. John Goodman (Chicago: University of Chicago Press, 1996), 28–36. Alfred Gell also discusses the agency of the object in relation to its recipient, see Alfred Gell, *Art and Agency: An Anthropological Theory* (Oxford: Oxford University Press, 1998), 12–27.

4 Lacan, *The Four Fundamental Concepts of Psychoanalysis*, 101.

5 "And when the eyes live in delight, they are so taught and instructed that they cannot be joyful alone, but want the heart to enjoy itself too. The eyes alleviate the heart's woes, for, like true messengers, they send the heart immediate reports of what they see; and then the heart for joy must forget the sorrows and darkness in which it had dwelt. In just the same way as the light drives darkness before it, so Sweet Looks effaces the shadows where the heart lies night and day, languishing of love; for the heart suffers no pain when the eyes see what it wishes." Guillaume de Lorris and Jean de Meun, *The Romance of the Rose*, trans. Charles Dahlberg (Princeton, NJ: Princeton University Press, 1971), 69. For Ficino's statement, see Marsilio Ficino, *Commentary on Plato's Symposium on Love*, trans. Sears Reynolds Jayne (Dallas: Spring Publications, 2000), 46.

6 "L'amore è come un dipintore. Un buono dipintore, se e' dipigne bene, tanto delettano gli uomini le sue dipinture, che nel contemplarle rimangon sospesi, e qualche volta in tal modo che e' pare che e' sieno posti in estasi e fuora di loro, e pare che e' si dimentichino di loro medesimi." Girolamo Savonarola, *Sermoni e prediche di F. Girolamo Savonarola* (Prato: R. Guasti, 1846), 434–35; for English translation, see Alexander Nagel, "Gifts for Michelangelo and Vittoria Colonna," *Art Bulletin* 79 (1997): 653.

7 Aby Warburg, "Sandro Botticelli's *Birth of Venus* and *Spring*: An Examination of Concepts of Antiquity in the Italian Early Renaissance (1893)," in *The Renewal of Pagan Antiquity: Contributions to the Cultural History of the European Renaissance*, trans. David Britt (Los Angeles: Getty Research Institute, 1999), 88–111; E. H. Gombrich, "Botticelli's Mythologies: A Study in the Neoplatonic Symbolism of His Circle," *Journal of the Warburg and Courtauld Institutes* 8 (1945): 43–60.

8 Charles Dempsey, "Mercurius Ver: The Sources of Botticelli's *Primavera*," *Journal of the Warburg and Courtauld Institutes* 31 (1968): 251–73; Charles Dempsey, *The Portrayal of Love: Botticelli's Primavera and Humanist Culture at the Time of Lorenzo the Magnificent* (Princeton, NJ: Princeton University Press, 1992).

9 Scholarship on the *Allegory* is vast and includes Erwin Panofsky, *Studies in Iconology: Humanistic Themes in the Art of the Renaissance* (New York: Harper & Row, 1962), 86–91; Michael Levey, "Sacred and Profane Significance in Two Paintings by Bronzino," in *Studies in Renaissance and Baroque Art Presented to Anthony Blunt on His 60th Birthday* (New York: Phaidon 1967), 30–33; Graham Smith, "Bronzino's Use of Prints: Some Suggestions," *Print Collectors* 9 (1978): 110–13; Graham Smith, "Jealousy, Pleasure, and Pain in Agnolo Bronzino's 'Allegory of Venus and Cupid'," *Pantheon* 39 (1981): 250–59; Charles Hope, "Bronzino's *Allegory* in the National Gallery," *Journal of the Warburg and Courtauld Institutes* 45 (1982): 239–43; J. F. Conway, "Syphilis and Bronzino's London Allegory," *Journal of the Warburg and Courtauld Institutes* 49 (1986): 250–55; Iris Cheney, "Bronzino's London *Allegory*: Venus, Cupid, Virtue, and Time," *Source* 6 (1987): 12–18; Lynette Bosch, "Bronzino's London *Allegory*: Love versus Time," *Source* 9 (1990): 30–35; Paul Barolsky and Andrew Ladis, "The 'Pleasurable Deceits' of Bronzino's So-Called London *Allegory*," *Source* 10 (1991): 32–36; Robert Gaston, "Love's Sweet Poison: A New Reading of Bronzino's London *Allegory*," *I Tatti Studies* 4 (1991): 249–88; Leatrice Mendelsohn, "Saturnian Allusions in Bronzino's London *Allegory*," in *Saturn from Antiquity to the Renaissance*, ed. Massimo Ciavolella and Amilcare Iannucci (Toronto: Dovehouse, 1992), 101–50; John F. Moffitt, "A Hidden Sphinx by Agnolo Bronzino, 'Ex Tabula Cebetis Thebani'," *Renaissance Quarterly* 46 (1993): 277–307; Jaynie Anderson, "A 'Most Improper Picture': Transformations of Bronzino's Erotic Allegory," *Apollo* 139 (1994): 19–28; John F. Moffitt, "An Exemplary Humanist Hybrid: Vasari's 'Fraud' with Reference to Bronzino's 'Sphinx'," *Renaissance Quarterly* 49 (1996): 303–33; Margaret Healy, "Bronzino's London *Allegory* and the Art of Syphilis," *Oxford Art Journal* 20 (1997): 3–11; Deborah Parker, *Bronzino: Renaissance Painter as Poet* (Cambridge: Cambridge University Press, 2000), 130–67; Simona Cohen, "The Ambivalent Scorpio in Bronzino's London *Allegory*," *Gazette des Beaux-Arts* 135 (2000): 171–88; Maurice Brock, *Bronzino*, trans. David Poole Radzinowicz and Christine Schultz-Touge (Paris:

Flammarion, 2002), 214–31; Will Fisher, "Peaches and Figs: Bisexual Eroticism in the Paintings and Burlesque Poetry of Bronzino," in *Sex Acts in Early Modern Italy*, ed. Alison Levy (Burlington: Ashgate, 2010), 151–64; Patricia Lee Rubin, *Seen from Behind: Perspectives on the Male Body and Renaissance Art* (New Haven, CT: Yale University Press, 2018), 82–84.

10 For studies addressing the social interaction with art in the Florentine domestic interior, see Jacqueline Marie Musacchio, *Art, Marriage, and Family in the Florentine Renaissance Palace* (New Haven, CT: Yale University Press, 2008); Adrian W. B. Randolph, *Touching Objects: Intimate Experiences of Italian Fifteenth-Century Art* (New Haven, CT: Yale University Press, 2014).

11 Franca Falletti and Jonathan Katz Nelson, eds., *Venus and Love: Michelangelo and the New Ideal of Beauty* (Florence: Giunti, 2002).

12 Claudia Conforti, "Il giardino di Castello come immagine del territorio," in *La città effimera e l'universo artificiale del giardino: la Firenze dei Medici e l'Italia del'500*, ed. Marcello Fagiolo (Rome: Officina, 1980), 152–61; Claudia Conforti, "L'invenzione delle allegorie territoriali e dinastiche del giardino di Castello a Firenze," in *Il giardino come labirinto della storia* (Palermo: Centro studi di storia e arte dei giardini, 1984), 190–97; Cristina Acidini Luchinat, ed., *Fiorenza in Villa* (Florence: Alinari, 1987); Claudia Conforti, "Acque, condotti, fontane e fronde: le provisioni per la delizia nella villa medicea di Castello," in *Teatro delle acque*, ed. Attilio Petruccioli and Dalu Jones (Rome: Elefante, 1992), 76–89; Claudia Conforti, "Il Castello verde: il giardino di Castello, gli spazi del manierismo," *FMR* 12 (1993): 59–78; Cristina Acidini Luchinat and Giorgio Galletti, *Le ville e i giardini di Castello e Petraia a Firenze* (Ospedaletto: Pacini, 1992), 41–92.

13 Stephen J. Campbell, *The Endless Periphery: Toward a Geopolitics of Art in Lorenzo Lotto's Italy* (Chicago: University of Chicago Press, 2019), 1–24.

14 James Grantham Turner also argues that Roman portrayals of Venus and Mars's adultery served as a turning point in the explicit visual representation of coitus; see James Grantham Turner, *Eros Visible: Art, Sexuality and Antiquity in Renaissance Italy* (New Haven, CT: Yale University Press, 2017), 223–69.

15 For the ties between *colorito* and the sensual female, see Rona Goffen, *Titian's Women* (New Haven, CT: Yale University Press, 1997), 126–69. For courtesan culture, see Jill Burke, *The Italian Renaissance Nude* (New Haven, CT: Yale University Press, 2018), 147–57; Mary Pardo, "Artifice as Seduction in Titian," in *Sexuality and Gender in Early Modern Europe: Institutions, Texts, Images*, ed. James Grantham Turner (Cambridge: Cambridge University Press, 1993), 55–89.

16 For a discussion of the nude in German prints and the work of Lucas Cranach, see Ariane Mensger, ed., *Weibsbilder: Eros, Macht, Moral und Tod um 1500* (Berlin: Deutscher Kunstverlag, 2017), 30–95. For Fontainebleau, see Dora and Erwin Panofsky, "The Iconography of the Galerie François Ier at Fontainebleau," *Gazette des Beaux-Arts* 1 (1958): 114–90; Kathleen Wilson-Chevalier, "Women on Top at Fontainebleau," *Oxford Art Journal* 16 (1993): 34–48; Janet Cox-Rearick, *The Collection of Francis I: Royal Treasures* (New York: Harry N. Abrams, 1996); Katherine Crawford, *The Sexual Culture of the French Renaissance* (Cambridge: Cambridge University Press, 2010). For Netherlandish mythology, see Marisa Bass, *Jan Gossart and the Invention of Netherlandish Antiquity* (Princeton, NJ: Princeton University Press, 2016). For a survey of Venus' prevalence in Renaissance portrayals of the female nude across Europe, see Thomas Kren with Jill Burke and Stephen J. Campbell, eds., *The Renaissance Nude* (Los Angeles: J. Paul Getty Museum, 2018).

17 Paul Oskar Kristeller, *Renaissance Thought and Its Sources*, ed. Michael Mooney (New York: Columbia University Press, 1979); Charles Trinkaus, *The Poet as Philosopher: Petrarch and the Formation of Renaissance Consciousness* (New Haven, CT: Yale University Press, 1979); Arthur Field, *The Origins of the Platonic Academy of Florence* (Princeton, NJ: Princeton University Press, 1988); Eugenio Garin, *Astrology in the Renaissance: Zodiac of Life*, trans.

Carolyn Jackson, June Allen, and Clare Robertson (London: Arkana, 1990); Peter Godman, *From Poliziano to Machiavelli: Florentine Humanism in the High Renaissance* (Princeton, NJ: Princeton University Press, 1998), Ronald G. Witt, *"In the Footsteps of the Ancients": Origins of Humanism from Lovato to Bruni* (Leiden: Brill, 2000); Charles G. Nauert, *Humanism and the Culture of Renaissance Europe* (Cambridge: Cambridge University Press, 2006).

18 Mary Garrard, *Brunelleschi's Egg: Nature, Art, and Gender in Renaissance Italy* (Berkeley: University of California Press, 2010).

19 Henri Focillon, *The Life of Forms in Art* (New York: Zone Books, 1989); Michael Baxandall, *The Limewood Sculptors of Renaissance Germany* (New Haven, CT: Yale University Press, 1980); Michael Baxandall, *Painting and Experience in Fifteenth-Century Italy* (Oxford: Oxford University Press, 1972).

20 Michael W. Cole, *Cellini and the Principles of Sculpture* (New York: Cambridge University Press, 2002); Rebecca Zorach, *Blood, Milk, Ink, Gold: Abundance and Excess in the French Renaissance* (Chicago: University of Chicago Press, 2006); Jodi Cranston, *The Muddied Mirror: Materiality and Figuration in Titian's Later Paintings* (University Park: Pennsylvania State University Press, 2010); Ann-Sophie Lehman, "How Materials Make Meaning," *Nederlands Kunsthistorisch Jaarboek (NKJ) / Netherlands Yearbook for History of Art* 62 (2012): 6–27; Christy Anderson, Anne Dunlop, and Pamela Smith, eds., *The Matter of Art: Materials, Practices, Cultural Logics, c. 1250–1750* (Manchester: Manchester University Press, 2015).

21 Scholarship in the field of technical art history began to be published in the 1960s by collaborative teams of scientists, restorers, and curators at the National Gallery of Art in Washington, DC and the National Gallery of Art in London. A set of key articles on Renaissance pigments was written from 1966 to 1974; this series was then edited and published; see Ashok Roy, ed., *Artists' Pigments: A Handbook of Their History and Characteristics*, vol. 2 (Oxford: Oxford University Press, 1993). Scholarship on the creation of Italian panel paintings was published in 1989 by Ashok Roy and Jo Kirby (scientists), David Bomford and Jill Dunkerton (conservators), and Dillian Gordan (curator) of the National Gallery in London; see David Bomford, Jill Dunkerton, Dillian Gordon, Ashok Roy, and Jo Kirby, *Art in the Making. Italian Painting before 1400* (London: National Gallery Publications, 1989). Today, this synergetic work continues at these two museums and at many other institutes. Examples of publications in this area include Jo Kirby, Maarten van Bommel, and André Verhecken, eds., *Natural Colorants for Dyeing and Lake Pigments. Practical Recipes and their Historical Sources* (London: Archetype, 2014); David Saunders, Marika Spring, and Andrew Meek, eds., *The Renaissance Workshop* (London: Archetype, 2013). A different and equally stimulating approach to the study of materials and techniques is practiced at the Hamilton Kerr Institute, a branch of the Fitzwilliam Museum in Cambridge, where restoration and conservation are learned, in part, through the practice of recreating period art. For an example of this approach, see Lucy Wrapson, ed., *In Artists' Footsteps: The Reconstruction of Pigments and Paintings. Studies in Honour of Renate Woudhuysen-Keller* (London: Archetype, 2012). Spike Bucklow from the Hamilton Kerr Institute has also published books and articles that link archival and scientific research with the cultural history of materials; see Spike Bucklow, *The Alchemy of Paint: Art, Science, and Secrets from the Middle Ages* (London: Marion Boyars, 2009); Spike Bucklow, *Red: The Art and Science of a Colour* (London: Reaktion Books, 2016). For a review of the early modern technical art history field, see Caroline Fowler, "Technical Art History as Method," *Art Bulletin* 101 (2019): 9–17.

22 Francesco Balducci Pegolotti (1290–1347) describes the exports of Cyprus in his *Libro di divisamenti di paesi e di misuri di mercatanzie e d'altre cose bisognevoli di sapere a mercatanti*, also known as *Pratica della mercatura*. The following materials appear in a list compiling the tariffs Florentine merchants paid on items from Cyprus: *incenso* (incense), *verzino* (brazilwood), *indaco* (indigo), *zucchero* (sugar), *mele d'abeille, mele di Cannameli* (honey), *drappi d'oro* (cloths of gold), *velluti di seta* (velvets), *sapone* (soap), *seta bisanti* (Byzantine silk), *allume* (alum),

drappi di seta (silk cloths), *acqua rosa* (rose water), *orpimento* (orpiment), *rame lavorato* (worked copper), *grana di pome granate* (grains of pomegranates). Another list of items exported from Cyprus includes the following materials: *lacca matura, lacca acerba, polvere di lacca* (mature lac, unripe lac, lac powder), *incenso* (incense), *indaco* (indigo), *allume* (alum), *mandorle* (almonds) *orpimento* (orpiment). For Pegolotti's text, see Giovanni Francesco Pagnini, ed., *Della decima e di varie altre gravezze imposte dal comune di Firenze*, vol. 2 (Lisbon and Lucca, 1765–66; reprint, Bologna: Forni, 1967), Book 3, 72–73, 308–309.

23 This encyclopedic sculptural program begins on the first tier with the creation of Adam and Eve followed by the allegories of human labors, among which are found the seven mechanical arts. The reliefs on the second tier start with the planets on the west façade and continue with the virtues, liberal arts, and sacraments. While Andrea Pisano designed this sculptural program, his workshop completed most of the reliefs. According to Anita Fiderer Moskowitz, a superior sculptor close to Andrea sculpted the figure of Venus. For information on the reliefs, see Anita Fiderer Moskowitz, *The Sculpture of Andrea and Nino Pisano* (Cambridge: Cambridge University Press, 1986), 31–50, 88; Gert Kreytenberg, *Andrea Pisano und die toskanishce Skulptur des 14. Jahrhunderts* (Munich: Bruckmann, 1984), 58–59; Marvin Trachtenberg, *The Campanile of Florence Cathedral: "Giotto's Tower"* (New York: New York University Press, 1971), 85–98.

24 As Trachtenberg points out, earlier cycles of the planets did not hold such a prominent position; see Trachtenberg, *The Campanile of Florence Cathedral*, 96.

25 For a comparison of thirteenth- and fourteenth-century planetary representations, see Diana Norman, "Astrology, Antiquity and Empiricism: Art and Learning," in *Siena, Florence and Padua: Art, Society and Religion 1280–1400*, ed. Diana Norman, vol. 1 (New Haven, CT: Yale University Press, 1995), 217–42.

26 The astrological frescos in the Palazzo della Ragione in Padua were painted by Giotto around 1306–09, destroyed by fire in 1420, and repainted by Nicolò Miretto and Stefano da Ferrara around 1425–50. For a discussion of the Libra series, see Maria Beatrice Rigobello and Francesco Autizi, *Palazzo della Ragione di Padova: Simbologie degli astri e rappresentazioni del governo* (Padua: Il Poligrafo, 2008), 199–200; Dieter Blume, "Michael Scot, Giotto and the Construction of new Images of the Planets," in *The Images of the Gods, Papers of a Conference in Memory of Jean Seznec*, ed. Rembrandt Duits and François Quiviger (London: Warburg Institute Colloquia, 2009), 137.

27 Seznec and Trachtenberg identify the figures in the roundels as the planets; however, they do not analyze their iconography; see Jean Seznec, *The Survival of the Pagan Gods: The Mythological Tradition and Its Place in Renaissance Humanism and Art* (Princeton, NJ: Princeton University Press, 1972), 70; Trachtenberg, *The Campanile*, 96.

28 Venus appears with a mirror in the planetary cycles of Venice, Padua, and Siena. A possible literary source for Venus' portrayal with the looking glass is the *Picatrix*. The passage, which will be discussed further in Chapter 3, reads, "Dress yourself in white clothes, and on your head wear a white headdress, because it is her symbol. The other is an ornament like a woman's veil. Dress yourself in ample, precious, and beautiful silk clothes interwoven with gold. Place a crown on your head adorned with precious pearls and stones. Wear a gold ring on your hand decorated with a stone of pearl and golden bracelets on your arms. Take up a mirror in your right hand, and in the left carry a comb." *Picatrix: A Medieval Treatise on Astral Magic*, trans. Dan Attrell and David Porreca (University Park: Pennsylvania State University Press, 2019), 173.

29 Dante Alighieri, *Convivio. A Dual-Language Critical Edition*, ed. and trans. Andrew Frisardi (Cambridge: Cambridge University Press, 2018), 106–107.

30 Michael Scot describes the planet Venus as follows: "Sic figuratur Venus: habet faciem formosam, nec longam, nec ex toto rotundam, mediocriter pinguem, albam et coloratam, oculos vagos, mammas elevatas, capillos blundos, tricas grandes et cyrros iuxta // tympora, pulchras vestes // et frixatas et gemmatas, habens rosam in manu prope os, et honeste intuens Mercurium." For Latin text, see Silke Ackermann, *Sternstunden am Kaiserhof.*

Michael Scotus und sein Buch von den Bildern und Zeichen des Himmels (Frankfurt am Main: Peter Lang, 2009), 264. For information on Scot's influence on Renaissance images of the planets, see Erwin Panofsky and Fritz Saxl, "Classical Mythology in Mediaeval Art," *Metropolitan Museum Studies* 4 (1933): 242–45; Seznec, *The Survival of the Pagan Gods*, 160–63.

31 Ovid, *The Metamorphoses*, trans. Allen Mandelbaum (New York: Harcourt Brace, 1993), Book 10, 335–36.

32 Lorris and Meun, *The Romance of the Rose*, 341–42.

33 Lorris and Meun, *The Romance of the Rose*, 344.

34 Ovid, *The Metamorphoses*, Book 10, 335–38.

35 "Thus, that Cyprian Pygmalion became enamoured of an image of ivory: the image was Aphrodite, and it was nude. The Cyprian is made a conquest of by the mere shape, and embraces the image. This is related by Philostephanus. A different Aphrodite in Cnidus was of stone, and beautiful. Another person became enamoured of it, and shamefully embraced the stone. Posidippus relates this. The former of these authors, in his book on Cyprus, and the latter in his book on Cnidus. So powerful is art to delude, by seducing amorous men into the pit. Art is powerful, but it cannot deceive reason, nor those who live agreeably to reason. The doves on the picture were represented so to the life by the painter's art, that the pigeons flew to them; and horses have neighed to well-executed pictures of mares. They say that a girl became enamoured of an image, and a comely youth of the statue at Cnidus. But it was the eyes of the spectators that were deceived by art; for no one in his senses ever would have embraced a goddess, or entombed himself with a lifeless paramour, or become enamoured of a demon and a stone. But it is with a different kind of spell that art deludes you, if it leads you not to the indulgence of amorous affections: it leads you to pay religious honour and worship to images and pictures." Clement of Alexandria, "Exhortation to the Heathen," in *Fathers of the Second Century: Hermes, Tatian, Athenagoras, Theophilus, and Clement of Alexandria (Entire)*, ed. Philip Schaff (London: Aeterna Press, 2016), 56–57.

36 The original story in Pliny reads, "The shrine in which it [Praxiteles' *Aphrodite*] stands is entirely open so as to allow the image of the goddess to be viewed from every side, and it is believed to have been made in this way with the blessing of the goddess herself. The statue is equally admirable from every angle. There is a story that a man once fell in love with it and hiding by night embraced it, and that a stain betrays this lustful act." Pliny, *Natural History, Volume X: Books 36–37*, trans. D. E. Eichholz, Loeb Classical Library 419 (Cambridge, MA: Harvard University Press, 1962), Book 36, 16–17. Lucian's version of the story is more elaborate, mentioning how the man fell in love with the goddess and spent his days at her temple. His desire soon turned into "desperation and he found in audacity a procurer for his lusts." One night, he hid within the temple and his "amorous embraces were seen after day came and the goddess had that blemish to prove what she'd suffered." Lucian, *Soloecista. Lucius or The Ass. Amores. Halcyon. Demosthenes. Podagra. Ocypus. Cyniscus. Philopatris. Charidemus. Nero*, trans. M. D. Macleod, Loeb Classical Library 432 (Cambridge, MA: Harvard University Press, 1967), 174–77.

37 In his *Liber introductoris*, Michael Scot describes the type of faith or religious sect that Venus signifies as "the cult of idols" ("Ex sectis fidei, significat cultum ydolorum, ut sacrificia, orationes, experimenta"). For text, see Richard Kay, *Dante's Christian Astrology* (Philadelphia: University of Pennsylvania Press, 1994), 69, 305. The original text is found in the Munich codex, Bayerische Staatsbibliotehk, MS. Clm 10268, fols. 102vb–103ra. The association between Venus and idolatry appears in the *Madkhal* or *Introduction to the Craft of Astrology* by Abu al-Saqr Abd al-Aziz Ibn Uthman Ibn Ali al-Qabisi l-Mawsili al-Hashimi (died 967), generally known as Al-Qabisi or Alcabitius in Latin. In this text, Alcabitius connects Venus to "the worship of idols." Alcabitius wrote his introduction to astrology in 950; his text was translated into Latin by John of Seville in the mid-twelfth century and used as a textbook in universities; see Kay, *Dante's Christian Astrology*, 69, 265–66.

38 A document, probably dating from 1334, by the *offiziali di musaico* (the administrators of the construction works for the Baptistery) describes the project, stating, "anche ordinarono che sul cerchio di mezzo della chiesa di S. Gio. si facciano otto figure scolte di marmo, cioè in ciascuno chanto una come meglio e più bellamente fare si possano. De le quali l'una sia la figura del nostro segnore Ihu. Chro. e le sette siano figure delle VII pianete." For discussion of the project, see Gert Kreytenberg, "Andrea Pisano's Earliest Works in Marble," *Burlington Magazine* 122 (1980): 3–7; Moskowitz, *The Sculpture of Andrea and Nino Pisano*, 56.

39 In a Florentine manuscript of Giovanni Boccaccio's *Decameron* dated to 1370, there is an illustration of a nude *Venus pudica*, with her left arm reaching to cover her pubis, raised on a pedestal above a six-sided fountain. This illustration could refer to the statue installed in Siena and the *inhonestum* nudity of Venus in a public space, though the bunches of grass, suggested by groups of six quick strokes of the pen, may illustrate a garden rather than a public piazza. For the illustration and a discussion of its connections to the Sienese episode, see Bernhard Degenhart and Annegrit Schmitt, *Corpus der italienischen Zeichnungen, 1300–1450* (Berlin: Mann, 1968), 134–37. For the illustration, see the Florentine manuscript of Boccaccio's *Decameron* of ca. 1370 in Paris, Bibliotèque Nationale, Ms. ital. 482 (7260), f. 4v.

40 "Una ancora [statua], simile a queste due, fu trovata nella città di Siena, della quale ne feciono grandissima festa e dagli intendenti fu tenuta maravigliosa opera, e nella base era scritto il nome del maestro, il quale era eccellentissimo maestro, il nome suo fu Lisippo; ed aveva in sulla gamba in sulla quale ella si posava un alfino [=delfino]. Questa non vidi se non disegnata di mano d' un grandissimo pittore della città di Siena, il quale ebbe nome Ambruogio Lorenzetti; la quale teneva con grandissima diligenza un frate antichissimo dell' ordine de' frati di Certosa; il frate fu orefice ed ancora il padre, chiamato per nome frate Jacopo, e fu disegnatore, e forte si dilettava dell'arte della scultura, e cominciommi a narrare come essa statua fu trovata, facendo un fondamento, ove sono le case de' Malavolti; come tutti gli intendenti e dotti dell'arte della scultura ed orefici e pittori corsono a vedere questa statua di tanta maraviglia e di tanta arte. Ciascuno [la] lodava mirabilmente; e grandi pittori che erano in quello tempo in Siena a ciascuno pareva grandissima perfezione fosse in essa. E con molto onore la collocarono in su la loro fonte come cosa molta egregia. Tutti concorsono a porla con grandissima festa ed onore e muroronla magnificamente sopra essa fonte: la quale in detto luogo poco regnò in su essa. Avendo la terra moltissime avversità di guerra con [i] fiorentini e essendo nel consiglio ragunati il fiore de' loro cittadini, si levò un cittadino e parlò sopra questa statua in questo tenore: – Signori cittadini, avendo considerato dapoi [che] noi trovammo questa statua sempre siamo arrivati male, considerato quanto l'idolatria è proibita alla nostra fede, doviamo credere tutte le avversità [che] noi abbiamo, Iddio ce le manda per i nostri errori. E veggiamlo per effetto che da poi noi onoriamo detta statua, sempre siamo iti di male in peggio. Certo mi rendo che, per insino noi la terremo in sul nostro terreno, sempre arriveremo male. Sono uno di quelli [che] consiglierei essa si ponesse e tutta si lacerasse e spezzassesi et mandassesi a seppellire in sul terreno de' Fiorentini. – Tutti d'accordo raffermarono il detto del loro cittadino, e così missono in esecuzione, e fu seppellita in sul nostro terreno." Lorenzo Ghiberti, *I commentari*, ed. Ottavio Morisani (Naples: Ricciardi, 1947), 56. For discussion of the text, see Creighton E. Gilbert, "Ghiberti on the Destruction of Art," *I Tatti Studies* 6 (1995): 139–41; Jane C. Long, "The Survival and Reception of the Classical Nude: Venus in the Middle Ages," in *The Meanings of Nudity in Medieval Art*, ed. Sherry C. M. Lindquist (Farnham: Ashgate, 2012), 56–57.

41 The record dated November 7, 1357 is found in the *concistoro* and reads, "Pro statua fontis Campi. Item quod statua marmorea ad presens in Fonte Campi posita, quam eitius potest tollatur ex inde eum inhonestum videatur; et fiat ex inde et de ea quod Dominis Duodecim (Governatori) videbitur et placebit." Published in "Una statua greca trovata in Siena nel sec. XIV," *Miscellanea storica senese* 5 (1898): 175–76. For text, see Long, "The Survival and

Reception of the Classical Nude," 64. For information on the document, see Gilbert, "Ghiberti on the Destruction of Art," 140.

42 In his *Istorie della città di Firenze*, Jacopo Nardi provides an account of items thrown into the bonfire of vanities during the Carnival of 1497: "an amazing multitude of such disgraceful statues and paintings, and also wigs and women's hair ornaments, bits of silk, cosmetics, orange flower water [for the complexion], musk, perfumes of many sorts, and similar vanities, and then beautiful and expensive gaming tables, chessboards, playing cards and dice, harps and lutes and citterns and similar musical instruments, the works of Boccaccio and Morganti, and books of all sorts, and an amazing quantity of books of magic and superstition." *Selected Writings of Girolamo Savonarola: Religion and Politics, 1490–1498*, ed. Anne Borelli and Maria C. Pastore Passaro (New Haven, CT: Yale University Press, 2005), 254.

43 Homer, *Iliad, Volume I: Books 1–12*, trans. A. T. Murray, rev. William F. Wyatt, Loeb Classical Library 170 (Cambridge, MA: Harvard University Press, 1925), Book 5, 238–39, lines 426–30.

ONE

GOLDEN SPLENDOR

Visions of Venus

> Oh beautiful Venus, oh sacred light,
> oh beneficial splendor, oh blessed star
> beautiful above every beauty,
> that spreads love from the sublime heaven.[1]
> —Leonardo Bruni (1370–1444)

The planet Venus shines in the twilight sky as the evening or the morning star (see Fig. 9). After the Sun and the Moon, she is the brightest light in the heavens. She casts reflections as well as shadows upon the Earth, a radiance that encouraged Renaissance philosophers and poets to describe this planet as the celestial source of love.[2] On several objects from the early fifteenth century, Venus attracts and enflames lovers through her resplendent light. Apparitions of her materialize on a betrothal box, a birth tray, and several wedding chests. Created for the intimate space of the bedchamber, these objects are among the first to represent the goddess outside of encyclopedic, serial depictions of the seven planets or narrative scenes of the Judgment of Paris. Unnoticed by previous scholars, each object presents a vision of Venus, either arrayed in resplendent garments or nude, surrounded by a mandorla of glowing light. These scintillating apparitions enthrall the human figures depicted in the artworks, and it was hoped that they would do the same for their recipients.

Epiphanies of Venus illuminate the verses of Dante Alighieri, Giovanni Boccaccio, and other Tuscan poets, such as the Florentine Chancellor Leonardo Bruni, whose hymn to the goddess opens this chapter. For these

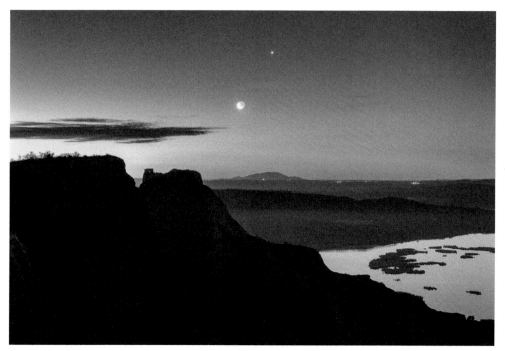

9 Moonrise next to Venus at dawn over a lake from the mountains, March 2019. Photo: Juan Lopez Ruiz /
Alamy Stock Photo

fourteenth- and fifteenth-century writers, the bright light of Venus' star is the
source and motive force of amorous and procreative desire, which descends to
Earth via her shining splendor. Medieval cosmology explains that the planets
transmit celestial virtues to Earth in the form of light rays, a composite theory
derived from Ptolemy's *Tetrabiblos* (90–168 CE) and the writings of Persian
philosophers, such as Abu Ma'shar (Albumasar) (787–886 CE) and Ibn Sina
(Avicenna) (980–1036 CE). In Tuscan literature, this concept of Venus' active
cosmological splendor merges with optical theories that describe light as the
causal agent of sight and the transmitter of images from the eye to the heart.[3]
Light's ability to transverse space and then to strike, illuminate, and burn made
it a fitting metaphor – like the arrow – for love's power to wound, enflame,
and enlighten.[4]

 To represent Venus' energetic light on Earth, fifteenth-century artists appro-
priated the materials and techniques traditionally reserved for sacred epiphanies.
They manipulated gold leaf, liquid gold, yellow ocher, and lead-tin yellow to
materialize celestial brilliance. They worked with circles, concentric arcs, *vesica
piscis*, and rays to symbolize the interaction of heavenly and earthly spheres.
Iconographically, this imagery was sacred, and its appropriation for amorous
portrayals of Venus may appear transgressive at first; however, writers since the
time of Fabius Planciades Fulgentius (fifth–sixth century CE) and Isidore of

Seville (ca. 560–636) had defended astrology with passages from Isaiah 11:2–3 and the apocalyptic writings of the Book of Revelation. Dante, for instance, describes Venus' light as one of the seven gifts of the Holy Spirit.[5] In the visual arts, the merging of sacred and profane imagery may reference this literary syncretism or justify astrological content; however, it also likely stimulated discussion of love's liminal position between the sacred and the profane.

Art historians have argued that the female recipients of these amorous gifts, painted with visions of Venus, may have identified with the goddess as a dominant female or as the "woman-on-top."[6] These interpretations tend to characterize Venus and thereby the receiver of the gift in an assertive, even aggressive light, as a *femme fatale*. In this chapter, I avoid eliding Venus' identity with that of the viewer and argue instead that she should be understood as a cosmological influence on the gifts' recipients. It is important to remember that betrothal boxes, wedding chests, and birth trays were presented to women and/or couples during adolescence, the period of life that the planet Venus governed.[7] In his *Liber Astronomiae* of 1277, Guido Bonatti writes that with regard to human age, "Venus has to signify adolescence," and according to Isidore of Seville, adolescence spans from 14 to 28.[8] Taking this period of young love into consideration, this chapter hopes to shed light on the values and aspirations of Venus' understudies, and through them, the larger society they hoped to join and sustain as lovers, spouses, parents, and leaders.

A GOLDEN MIRAGE

In 1421, a man from the Florentine Bechi family presented a gilt box (Fig. 10) as a betrothal present to his future bride. On the box's lid, Venus materializes in a golden circle of light and encourages a young maiden to open her heart and find happiness in love. The dimensions of this cylindrical box (29 cm diameter and 14 cm tall) are those of a small chest or *forzerino*, typically given by a suitor to his future bride during their engagement.[9] The box's origin has been a subject of debate since the early twentieth century. Millard Meiss argued that it was Sienese; Frank J. Mather declared it to be Umbrian; and John Pope-Hennessy described it as Lombardian.[10] My own research into the box's heraldry, however, suggests that it was commissioned by a Florentine family. The single coat of arms emblazoned twice on the lid's edge is that of the Bechi family, who lived in the quarter of the Black Lion in Santa Croce. The *stemma* is a gold *banda doppiomerlata*, a crenellated band that descends diagonally from the viewer's left to right, against a blue background.[11] Associated with the military and the Guelph party, the *banda doppiomerlata* belongs to a number of Tuscan families; however, different colors and/or subsidiary symbols distinguish each family's coat of arms. For example, the Aldobrandini di Madonna family boasts a diagonal, crenellated band in gold,

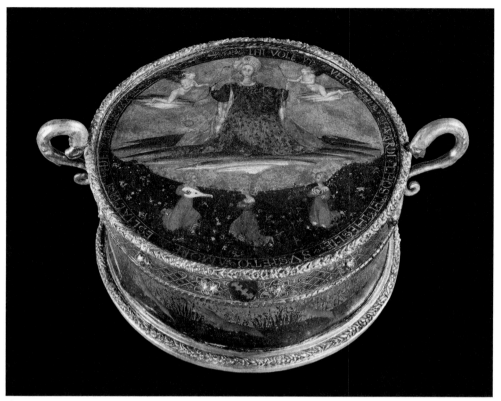

10 Marriage casket decorated with the *Triumph of Venus*, 1421, Musée du Louvre, Paris. Photo: Erich Lessing / Art Resource

but it is flanked on either side by three stars.[12] The Marzi family of Siena, to whom the box was linked before the advent of color printing, claims a silver *banda doppiomerlata* on a red background, rather than the Bechi's gold band on blue.[13]

Like other round betrothal boxes, the *Triumph of Venus* is constructed from thin pieces of shaved wood, cut and molded into circles, then covered with gesso – gypsum mixed with animal glue.[14] After construction, raised *pastiglie* or molded gesso decorations were applied. Scrolling vines, lacertine tracery, and geometric borders adorn the surfaces of several extant betrothal chests, while others are ornamented with even more elaborate moldings, such as portrait busts or miniature animals. Cennino Cennini offers instructions for sculpting *pastiglia* decorations in his early fourteenth-century *Libro dell'arte*, a handbook of recipes for materials and directions for their technical use. Cennini explains that "with this same gesso, or with one with a stronger glue, you can cast some lions' heads or other impressions cast in earth or clay."[15] Twelve lion heads encircle the lid of the Bechi box, perhaps referring to Florence's heraldic Marzocco or the family's residence in Santa Croce's *quartiere* (quarter) of

the Black Lion. The box's other gesso moldings speak to love: triumphant flower garlands wrap its foot and lid, while two dolphins arch to form its handles. The entire surface is gilded with gold leaf, a lavish technique made possible by the object's small size.

In comparison with other extant, round betrothal chests, the lid painting on the Bechi box is one of the most elaborate and the only one to present a vision of Venus. The painting's composition resembles illustrations of the planet *Venus* (Fig. 11) found in illuminated manuscripts of Christine de Pizan's (1364–ca. 1430) *Épitre d'Othéa* or *Epistle of Othea*.[16] In an early manuscript of the text now in the British Library, Venus sits on a bank of clouds surrounded by a series of heavenly circles. Below, courtly lovers offer her bright red hearts. In the text accompanying the illustration, Othea or Prudence warns the knight Hector that he should

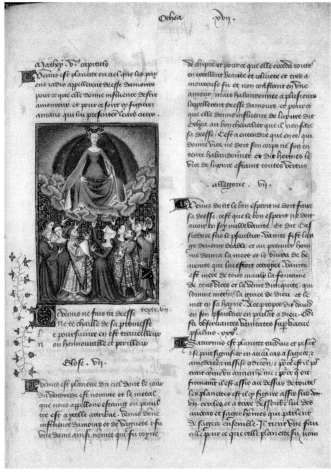

11 Illustrated by Master of the Cité des Dames, author Christine de Pizan, *Venus Presented with Hearts* (whole folio). Venus holds in her lap the hearts of her devotees who, standing below, raise their hearts to her; text beginning with decorated initial "D," from *L'Épitre d'Othéa*, 1410–11. Photo: © British Library Board / Robana / Art Resource, NY

not make Venus his goddess because she lures men to love, idleness, lechery, and vanity.[17] This cautionary advice, expressed by a female poet of the French court, contrasts with the emphatically virile, amorous rhetoric found in Andreas Capellanus' *Art of Courtly Love* and Guillaume de Lorris and Jean de Meun's *The Romance of the Rose*.[18] Though it is uncertain when or if a copy of the *Epistle of Othea* reached Florence, over 40 manuscripts of the text exist from the fifteenth century. According to Millard Meiss, humanists of the French court were in contact with Florentine citizens, such as Coluccio Salutati between 1390 and 1415, and it is through these connections, Meiss argues, that "the box bears witness to the diffusion of French pictorial forms in Italy."[19]

On the Bechi box, Venus sits on a cosmological rainbow of clouds, which also suggests the celestial spheres. Rather than receiving hearts, she bestows the weapons of love – a Turkish bow and a long arrow – to a pair of nude blindfolded cupids. Three flaxen-haired maidens kneel in the flowering meadow below. The female on the viewer's left strums a lute, while the one on the right beats a tambourine, two instruments dedicated to the planet Venus.[20] Both ladies are clad in vermillion gowns. Their companion, in the center, wears a slightly more ornate, crimson dress painted with red lake. Rather than playing an instrument, this damsel folds both of her arms across her chest, tucking her hands beneath her elbows. Her gesture, which contrasts with those of the ardent lovers in the *Epistle of Othea* illustration, seems to suggest refusal rather than obeisance.[21] Looking to her companion rather than to Venus, this female has yet to be touched by the goddess's resplendent power. The inscription encircling the lid is intended for her as well as for Bechi's fiancé: "Whoever wishes to live happily should look on her to whom are subject Love and the other gods 1421" (CHI VOLE VIVERE FELICE GHUARDI CHOSTEI CHEGLIE SUGIETO AMORE EGLIATLTRI IDEI MCCCCXXI).

The lid's inscription correlates with Venus' persuasive speeches to vacillating lovers in several of Giovanni Boccaccio's romantic tales. In *Fiammetta*, the goddess appears in a brilliant aura of light and encourages the young female protagonist – who has fallen for the Florentine merchant Panfilo – to follow her heart, declaring that all are subject to the will and power of love.[22] In another aureate apparition in the *Nymph of Fiesole*, Venus materializes before a lad named Africo in a burst of golden light and proclaims that he should not resist love because no one, not even the gods, has ever defended himself against her.[23] While not directly illustrating either tale, the vision of Venus on the betrothal box asserts a similar message, prompting the central maiden and Bechi's fiancé to surrender to love and to look to Venus for a happy marital union.

The artist of the Bechi box captured the visionary aspects of this amorous epiphany by manipulating geometry and light. The triumphant portrayal of Venus resembles representations of Christ in glory, in particular the prominent, more than life-sized mosaic of *Christ Overseeing the Last Judgment* (Fig. 12),

decorating the vault of the Florentine Baptistery on axis with its altar. Upright and frontal, Jesus sits on a cosmic rainbow inside a mandorla or circle of golden light bound by a blue band. This circular mandorla emphasizes Jesus' glory through light while simultaneously symbolizing heaven. Plato, for example, wrote that "as a Circle revolving in a circle He [God] established one sole and solitary Heaven."[24] Medieval astrological texts also described the celestial realm as circular. For example, the *Ghayat al-Hakim* or *The Goal of the Sage* (an Arabic

12 *Christ Overseeing the Last Judgement*, central ceiling of the Florence Baptistery, ca. 1240–1300. Photo: akg-images / Pictures from History

text on astrology and astral magic composed between the ninth and eleventh centuries and translated into Latin in 1256 with the title of *Picatrix*) explains that "the shape of heaven is spherical, round, and smooth in its surface area and so is everything in it with respect to their qualities and rotations."[25] The text's author declares that this concept cannot be doubted because "what is first and oldest in the world ought to have a perfect shape. The perfect shape and figure is a circle because it is the first of all the shapes and is itself made up of a single line."[26]

In the Baptistery mosaic, the circular mandorla surrounding Jesus symbolizes the highest heaven of the cosmos. The arching striations of the cosmic rainbow refer to the series of heavenly spheres that encase one another and lead from the planets, to the fixed stars, to the angelic realm, and finally up to the Empyrean Heaven. This geometry schematically represents the firmament; it also signifies Jesus' divine splendor, the glory of which could be experienced on Earth through an epiphanic vision.[27] On the Bechi betrothal box (Fig. 10), Venus sits on a similar cosmic rainbow of light-filled celestial spheres. She places her foot on the third sphere, her planetary domain. A mandorla, formed by the circular shape of the box and bound by the blue band containing the gold inscription, surrounds the goddess. The artist suggests the meeting of her heaven with that of Earth in the garden's curved horizon line.

The gold leaf (Fig. 13a) of Venus' mandorla materializes her celestial light, the same light that characterizes visionary experiences in literature. Artists often employed gold in their representations of otherworldly light because of its rarity, expense, and resistance to rust. As a shiny metal, gold also generates light.[28] On the Bechi box, the gilded ground surrounding Venus forms a reflective surface that bounces outside light back towards the viewer, creating an intimate bond between the eye and the object. The raised and depressed surfaces of the *pastiglie* or gesso moldings multiply the intersections and generate different degrees of reflection. The play between represented and reflected light produces a visual

(a) (b) (c)

13 Samples of (a) gold leaf, (b) yellow ocher, and (c) lead-tin yellow. Photo: Kip Bulwinkle / Karson Photography

drama that enchants the viewer, placing her, like the maidens below, under the goddess's illuminating spell of love. In both *Christ in Glory* and *The Triumph of Venus*, a deity appears in an otherworldly apparition and persuades the viewer to make a choice: to believe or not to believe; to love or not to love!

Facing the viewer and gazing outward, Venus is a celestial sovereign. She models rich garments, an iconographic attribute that also dazzles the viewer.[29] In his scientific handbook *Liber introductorius*, composed between 1220 and 1236 at the court of Frederick II, Michael Scot describes Venus as a lady clad in "beautiful garments, embroidered and bejeweled."[30] On the Bechi box, the deity wears a stylish *giornea* – an overgarment with splits down the sides – fashioned from crimson silk and lined with ermine fur, two of the most expensive textiles in fifteenth-century Florence.[31] The artist painted the silk with a glossy red lake pigment, manufactured from either lac resin or clippings of silk thread dyed with the costly kermes insect.[32] When light passes through the transparent layer of red pigment, it reflects off of the gold ground beneath, creating the illusion of a shimmering silk textile. For the mantle's lining, the artist used lead white and gray shadows to imitate the downy softness of white fur. A similar technique is employed for Venus' *balzo*, a round headdress constructed of a wire or willow branch frame, over which a luxurious textile is wrapped. The artist replicated the luster of a pearlescent silk by painting the *balzo* with shades of gray and then placing tiny dots of pure lead white across the textile's surface. In the center of the headdress sits a gold and ruby brooch, encircled by rubies and sapphires.[33]

When Bechi's bride-to-be opened her golden box, she would have found several gifts. It is likely that one of these was an ornate headdress or *balzo* similar to the one worn by Venus and the central maiden. Because of its large, circular shape and vertical depth, Millard Meiss argued that the object may have functioned as a cake box; however, it is more likely that the box was crafted to hold a *balzo*.[34] In fifteenth-century Florence, the *balzo* was a feminine version of the masculine *mazzocchio*; both types of headdresses were fashionable because they allowed men and women to display an additional rich textile on their heads. Such a luxurious gift was intended to charm the

recipient of this golden betrothal box and like a golden arrow, spark a tiny flame of desire within her heart.[35] The nature of that desire, however, is dictated by another inscription found on the inside of the box, which reads, "honest and beautiful lady, a pure love needs faith" (ONESTA NA BELLA DONNA UN PURO AMOR VUOLE FEDE).[36] This message, which appears on other betrothal boxes, originates in an epigram by Boccaccio. It lauds the recipient of the gift as both honest and beautiful; however, it also requires that her love be pure and faithful.[37] It makes a promise that if the virtuous bride, who may have been wary of the proposed union, trusts in the goodness of her groom and willingly submits herself to the commitment of marriage, Venus will fill her heart with love. It implies, perhaps, that the betrothed couple are not sufficiently familiar with each other for that trust to have naturally grown beforehand and that a leap of faith and an honest heart are needed for joy to blossom in marriage.

SCINTILLATING RAYS

While the Bechi betrothal box features an elegantly clothed Venus materializing before three kneeling ladies, the goddess appears in a very different fashion on a 12-sided Florentine birth tray of *Venus and Lovers* (Fig. 14) created in the first half of the fifteenth century.[38] Hovering in the night air, Venus stands completely nude before a group of kneeling knights. A yonic-shaped mandorla surrounds her winged body, from which she emits over 150 rays of light. Long gilt beams stream from her pubis and extend directly to the eyes, lips, noses, and hearts of the six men, who genuflect in the dark but fruitful garden below. Gold inscriptions identify these courtly lovers ordered from the viewer's left to right as Achilles, Tristan, Lancelot, Samson, Paris, and Troilus. Transfixed, these men have fallen to their knees as supplicants to Venus: on the right, Troilus crosses his hands over his chest in submission; in the center, Samson opens his arms in wonder; and on the left, Lancelot and Achilles touch their hearts, moved by love. The diagonal trajectories of gaze, gesture, and rays form an opposing pyramidal construction with Venus at its apex. She is the central source of light and power.

Family members customarily commissioned and presented *deschi da parto* to brides or new mothers in preparation for or in celebration of a child's birth.[39] Draped with white cloths, the salvers were used to carry boiled chicken, savory broth, almond cookies, or rose-sugar candy to postpartum women who, after giving birth, might be confined to their chambers for up to 40 days.[40] This practice of bringing gifts to new mothers can be seen in Domenico Ghirlandaio's *Birth of St. John the Baptist* (Fig. 57), painted ca. 1485. Once unveiled, birth trays revealed sparkling and colorful surfaces illustrated with mythological, historical, or nativity scenes. Within the confinement chamber,

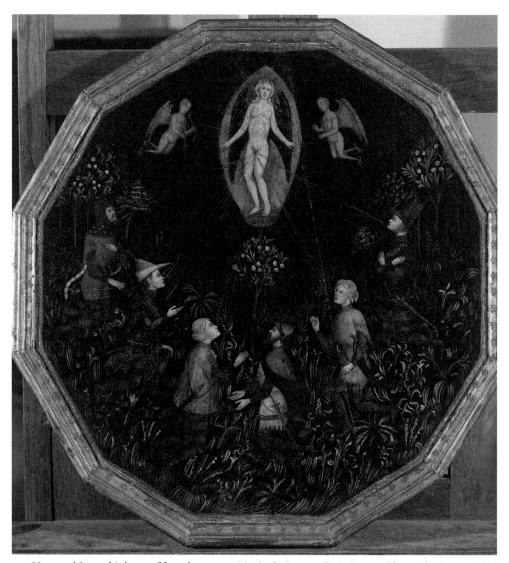

14 *Venus and Lovers*, birth tray, fifteenth century, Musée du Louvre, Paris, France. Photo: akg-images / De Agostini Picture Library

the painted salvers circulated among what Adrian W. B. Randolph has described as a "limited female audience," being "handled and passed from one set of hands to another."[41] However, after this gendered period of viewing, birth trays entered bedroom suites, where they hung alongside devotional paintings, wedding chests, mirrors, and tapestries. Here, the father, family members, and other close friends would have also seen them.[42] The 1492 inventory of the Medici palace, for example, lists "a round birth tray painted with the Triumph of Fame" as hanging in Lorenzo de' Medici's bedroom.[43] This tray, attributed to Lo Scheggia (Giovanni di Ser Giovanni

Guidi), was commissioned for Lorenzo's own birth. His possession and display of it in his chambers until his death suggests that objects, like the *Venus and Lovers* birth tray, were not only intended as presents for the mother but also as gifts for the newborn, eventually becoming part of the child's own estate.

As the celestial source of fertility, Venus would seem a natural choice for birth trays; however, she is limited to only a few scenes of the *Judgment of Paris* or the *Abduction of Helen*.[44] The *Venus and Lovers* salver is the only extant tray to depict the goddess in a cosmological position, a status indicated by the *vesica piscis* mandorla surrounding her body. This yonic-shaped aura of light is formed by the intersection of two circles, which unite to form a vertically pointed oval.[45] Euclid references the shape in Proposition 1 of the *Elements*, when he describes the construction of an equilateral triangle whose vertices sit within the meeting of two circles with the same radius.[46] Artists often used the *vesica piscis* mandorla to represent the intersection of two spheres in their portrayals of Jesus' transfiguration or ascension into heaven.[47] In Andrea di Bonaiuto's *Ascension of Christ* (Fig. 15) in the Spanish Chapel of Santa Maria Novella, Jesus ascends from Earth into Heaven in a *vesica piscis* mandorla. Mary and the Apostles kneel in the garden below as witnesses to this miraculous intersection of the celestial with the terrestrial. On the *Venus and Lovers* birth tray, Venus hovers in a similar *vesica piscis* mandorla, which suggests the convergence of her planetary sphere with that of the Earth.

In addition to astrological phenomena, the *vesica piscis* mandorla surrounding the body of Venus may have also brought to mind glyphic representations of the female genitalia. Several isolated vulvas appear on medieval sexual badges.

15 Andrea di Bonaiuto, vault, pendentive with *Ascension of Christ*, ca. 1346–79, fresco, Spanish Chapel, S. Maria Novella, Florence, Italy. Photo: Scala / Art Resource, NY

16 Secular badge, *Three Phalli Process a Crowned Vulva*, 1375–1425, Family van Beuningen Collection, Bruges, Belgium. Photo: © Family van Beuningen Collection

On one secular badge (Fig. 16), three anthropomorphized phalluses exhibiting features of both knights and lower animals carry a crowned, triumphant vulva; the male devotion and subservience to the female sexual organ is reminiscent of the *Venus and Lovers* birth tray. Standing on a small mound inside of the mandorla, Venus seems to have entered through a door or gateway from the heavenly into the earthly realm.[48] Like the artist of the Bechi box who uses the circle as a compositional form, the painter repeats the pointed V of the *vesica piscis* in the horizon line and placement of the kneeling lovers in the garden. The shape also defines Venus' pubic mound, her *mons veneris*, from which she emits brilliant light rays.

The artist of the birth tray materialized Venus' bright splendor by manipulating different light-catching materials. He painted her luminous, rosy-hued flesh with lead white and vermillion and her blonde hair with lead-tin yellow. He colors the mandorla with a soft shade of yellow ocher (Fig. 13b) and paints her light-diffusive rays with bright liquid gold. The artist's decision to color the mandorla with yellow ocher instead of gold is unusual but visually effective. The matte finish of the ocher contrasts with, but does not overpower, the reflective sheen of the gold. According to Cennini, the process for making liquid gold consists of grinding sheets of gold leaf with albumen (egg white) and then binding this mixture with egg yolk or glue.[49] Enough binder should be added to the powdered gold until it flows and resembles the consistency of ink or paint. When viewed under the sun, a candle, or an oil lamp, this shimmering pigment simulates Venus' scintillating light, flickering and twinkling in the night sky.

Iconographically, the gold striations of Venus' planetary light resemble those found in representations of the Pentecost. In a *Pentecost* illumination (Fig. 17) by the Master of the Dominican Effigies, the Holy Spirit diffuses its virtues to Mary and the Apostles through shimmering golden light. The geometric angle of the rays, which are those ordered by the circle of heaven, indicate the descent of the Holy Spirit's celestial light.[50] In Book 2 of his *Convivio*, Dante Alighieri connects the light of Venus' planet to the Holy Spirit. He begins by explaining that the positions and movements of the heavenly spheres can be

"determined by means of an art called optics, and by arithmetic and geometry, as observed by the senses and reason, and by means of other sense data."[51] He then explains that the circle of Venus is moved by the angelic order of the Thrones, who "receiving their nature from the love of the Holy Spirit, carry out their activity, which is connatural in them, that is, the movement of that heaven, full of love."[52] Dante continues, writing that from the movement of these angels and ultimately from the Holy Spirit,

17 Master of the Dominican Effigies, *Pentecost*, ca. 1340, detached leaf. Photo: Album / Alamy Stock Photo

> the form of that heaven receives a virtuous ardor, through which souls down here are kindled to love, according to their disposition. And because the ancients understood that this heaven was the cause of love on earth, they called Love the son of Venus … In addition, I say that this spirit arrives along the rays of the star, for it should be known that the rays of each heaven are the paths along which their virtue descends upon things here below.[53]

Dante reiterates this idea in the *Divine Comedy* when he enters the third realm of Paradise with Beatrice and proclaims, "The world, when still in peril, thought that wheeling, / in the third epicycle, Cyprian / the fair sent down her rays of frenzied love."[54] In his journey through the third heaven, the poet encounters spirits who brighten, shine, and burn "like sparks among flames," as they manifest love.[55]

On the *Venus and Lovers* birth tray, the gold striations streaming from Venus could have reminded viewers of the Holy Spirit's diffusion of light as well as the astrological belief that the planets transmit their virtues to Earth through light rays, which are particularly powerful at the moment of one's birth. It may be that the *Venus and Lovers* salver was commissioned to celebrate the birth of a male child in Venus' zodiac houses of Libra or Taurus. In an illuminated manuscript of Guido Bonatti's *Liber Astronomiae* (Fig. 18), celestial influences in the form of golden rays descend upon a newborn child from a star. If the *Venus and Lovers* birth tray was created for a child born under the sign of Venus, then it may have been intended to teach the child about the beneficial yet dangerous powers of this planet, which, as Venus' diverse devotees attest, has wielded

18 Historiated initial "C"(um) with a birth scene with a midwife presenting the newborn to the mother, who rests in a bed, at the beginning of the *Tractatus de nativitatibus, Liber Astronomiae* by Guido Bonatti, 1490. Arundel 66, f. 148, British Library, London, England. Photo: Album / Alamy Stock Photo

a potent influence on the lives of many noble individuals. The notion that birth trays contain a specific message for a child or for a mother to teach her child is supported by Giorgio Vasari's description of a drawing created by Francesco Salviati for "one of those *tondi*, in which food is brought to a newly delivered woman." According to Vasari, Francesco's design of the ages of man, the Sun, the Moon, and the goddess Pallas Athena signifies that "on behalf of newborn children one should pray before any other thing for wisdom and goodness."[56] What specific messages might the *Venus and Lovers* birth tray have conveyed to its fifteenth-century viewers?

The six men on the birth tray (Achilles, Tristan, Lancelot, Samson, Paris, and Troilus) are all children of Venus. Each knight's romantic quest, however, is ambiguous.[57] We can take the example of Troilus (the last knight on the viewer's right), whose tumultuous love story is told in Boccaccio's *Filostrato*. The tale takes place during the Trojan War. Troilus, the son of Priam, loses his heart to Criseida after seeing her at a festival in the Palladium. Following several exchanges through their friend Pandaro, the two finally meet, embrace, kiss, and copulate several times. Holding Troilus tightly in her arms one morning, after a night spent together, Criseida describes the tenacious grip of desire, which keeps each lover locked in the other's mind and heart: "My soul, I have already heard it said long ago, if I remember correctly, that love is an avaricious spirit and when he seizes anything he holds it so strongly clasped and pressed with his claws that counsel as to how to free it is given in vain."[58] While a poet like Petrarch refers to these sharp talons as a trap, the early fourteenth-century treatise writer Francesco da Barberino, who endeavored to allegorize Cupid's features in a favorable light, characterizes his "falcons' feet" as emblematic of the "firm hold" of God's love on man.[59] In the hierarchy of angels, red seraphs embody the fiery or burning nature of divine love.[60] On the birth tray, the two red cupids on either side of Venus possess sharp talons, which symbolize how (celestial or terrestrial) seizes, wounds, and clings to individuals.

In *Filostrato*, Troilus is happy to be captured by love. One morning after spending the night with Criseida, he beholds Venus' star in the sky and praises

her "bright and invigorating" rays.[61] He sings of her "glad splendor" and her "eternal light" that calms the fierce anger of Mars and Jupiter, renews and invigorates nature, and brings unity to cities and humans in the form of friendship.[62] The qualities that Troilus praises in Venus are positive and resemble those that are desired in a wife or mother, the recipient of the birth tray. Nevertheless, Boccaccio's tale ends tragically. Soon after their romance begins, Criseida is taken away from Troilus and traded to the Greeks for a Trojan prisoner. She then falls in love with Diomede, a Greek soldier. After learning of her treachery, Troilus seeks vengeance in war, using his passion to kill "more than one thousand" until Achilles finally slays him.[63] The Trojan's actions reveal unrestrained passion and its negative consequences.

Similar stories about the effects wrought by the goddess's "rays of frenzied love" could be told about Achilles, Tristan, Lancelot, Samson, and Paris. In the confinement chamber and later in the more public bedroom suite, the *Venus and Lovers* birth tray encouraged the recitation, reading, and discussion of these fictional dramas, offering pleasurable entertainment and moral instruction. While the nude figure of Venus emitting gilt striations from her pubis honored the generative power of the female, whose body transformed in order to beget and birth a new human being, the knights below reminded her child, who may have been born under this bright star, that love also wielded dark and deadly powers.

BRIGHT VISIONS

The artist of the *Venus and Lovers* birth tray used gold rather sparingly, unlike the creator of the Bechi betrothal box. In general, birth trays were more economical gifts than betrothal or wedding chests. The inventory for Apollonio di Giovanni and Marco del Buono's Florentine shop, which produced both types of objects and kept records from 1446 to 1463, lists a birth tray (*desco da parto*) for 9 florins and pairs of wedding chests (*cassoni*) for 23–60 florins.[64] In Florence, a skilled artisan, such as a weaver or woodworker, made an average salary of 35 florins per year.[65] The price differentiation between these types of objects depended on their size, wood type, moldings, quantity of gold, and number of painted surfaces. *Cassoni* were the largest and most expensive of amorous gifts. Though essentially private, these wedding chests had grand debuts, being carried through the streets of Florence during the marriage procession, from the palazzo of the bride's father to that of her groom.[66] The chests publicly revealed to other Florentines the opulence and wealth of the two families joining together.

In the first half of the fifteenth century, artists ornamented the narrative scenes on *cassone* panels with an abundance of gold, a practice that the humanist architect Leon Battista Alberti complained of in his treatise *On*

19 Attributed to Fra Angelico (formerly attributed to the Master of the Griggs Crucifixion), *Scenes* [
Boccaccio's "Il ninfale fiesolano," ca. 1415–20. Bowdoin College Museum of Art, Brunswick, Maine, U
Photo: Bowdoin College Museum of Art, Brunswick, Maine, Gift of the Samuel H. Kress Foundatio[

Painting of 1435. Alberti uses the example of Dido and specifically bemoans the
practice of gilding her accessories – her quiver, hair, girdle and the reins of
her horse – because gold's reflective surface interrupts the illusion of space
in the narrative scene. He praises instead the painter "who imitates the rays of
gold with colors."[67] The artistic shift to representing light with yellow pig-
ments rather than gold leaf can be seen on a *cassone* panel illustrated with scenes
from Boccaccio's *Nymph of Fiesole* (Fig. 19).[68] The panel, which was likely
painted between 1430 and 1440, has been attributed to Fra Angelico; however,
it was painted more likely by Giovanni Toscanini, who trained in the work-
shop of Lorenzo Ghiberti. Two other *cassone* panels ornamented with scenes
from the *Nymph of Fiesole* exist, and one of these is also attributed to Giovanni
Toscanini. The other panel, which was once part of the Corsi Collection
in Florence, includes the Medici coat of arms. This panel may have been
commissioned for the marriage of Cosimo de' Medici to Contessina de' Bardi
in 1416. The current locations of these two panels are unknown.[69]

In the first vignette of the Bowdoin panel, Diana meets with her nymphs –
virgins and other maidens placed by their parents under her tutelage.[70] They
gather at the foot of Mount Ceceri, the ancient *pietra serena* or sandstone
quarries located northeast of Florence between Fiesole and Settignano. On
the panel, Diana sits upright inside of a stony enclosure and warns her nymphs
of the dangers involved in flirting with men, threatening to kill any nymph who
displays such an indiscretion. The tale's protagonist Africo stumbles upon this
enclave while wandering through the shadowy hills and winding streams
of the Mugello landscape. Peeking over the edge of Diana's cave, Africo sees
and then falls in love with Mensola, one of the goddess's nymphs. Sleeping that
night, he witnesses a vision of Venus "encircled in resplendent light."[71] In the
center of the panel, Toscanini represented this scene by depicting Africo
sleeping on a bed in a hut and Venus appearing before him, as if in a glowing
dream. The aureole of light surrounding the goddess corresponds in shape to a
vesica piscis mandorla and contrasts with the dark stone enclosure protecting
Diana's body. The geometry of the mandorla, however, is not exact and appears
more flame-like than the one represented on the *Venus and Lovers* birth tray.

Toscanini generated Venus' effulgent light with subtle pigment variations rather than with gold leaf or liquid gold. He laid down an initial layer of lead-tin yellow, followed by lead white, then red lake. Lead-tin yellow (Fig. 13c) played a fundamental role in the transition from gold leaf to yellow pigments. Even at the height of gold grounds in Florentine painting, lead-tin yellow was used for clothing and landscape details. Two types of lead-tin yellow were used in Florence during the fifteenth century.[72] The oldest form of the pigment – known as lead-tin yellow, type II – was produced by melting yellow lead glass. A recipe from a Bolognese manuscript, which Mary Merrifield dates to the first half of the fifteenth century, reads, "To make *giallolino* for painting: take 2 lbs. of this calcined lead and tin, that is 2 lbs. of this glass for paternosters, 2 ½ lbs. of minium, and ½ lb. of sand from the Val d'Arno pounded very fine; put it into a furnace and let it fine itself, and the color will be perfect."[73] According to Lara Broecke, the second type of the pigment – known as lead-tin yellow, type I – began to be produced in Florence "in the second quarter of the fifteenth century."[74] This light lemon-yellow pigment consists of lead (lead monoxide), minium (lead dioxide), and tin heated together in a mixture of 3:3:1. We do not know for certain which type of lead-tin yellow (type I or type II) Toscanini used for the *Nymph of Fiesole* panel, as the panel was painted at some point in the first half of the fifteenth century, when both pigments were available.

In his *Libro dell'arte*, Cennini provides a description of *giallolino*, which scholars take to be lead-tin yellow. He writes that it is "very hard and heavy like a stone and difficult to break up." He explains that it must be "crushed" using a "bronze mortar" before mulling, and if crushed and mulled properly, it will produce "a very beautiful yellow."[75] As Hermann Kühn explains in his study of the pigment, the brilliance of lead-tin yellow is due to the "yellow highly refracting particles of vitreous appearance" within the pigment, which has a refractive index "higher than 2.0." Kühn points out that this high refractive index "creates strong relief" in "media with a low refractive index," such as egg tempera.[76] On the *cassone* panel, the use of lead-tin yellow and lead white for the aureole of light encircling Venus directs the viewer's attention to Africo's vision of the goddess. Toscanini's layering of translucent red lake on top of the yellow–white combination produces a fiery glow that alludes to the fire of love, which the vision of Venus kindles in Africo's heart.[77]

In a second vision, Venus persuades Africo to disguise himself as a female nymph, deceive Mensola, and then ravish her until Cupid can strike with an arrow. Toscanini conveys the sexual nature of Venus' command by depicting her nude, surrounded by golden light, in the center of the panel. Venus' floating, diagonal pose and obscured feet resemble those of Eve rising from Adam's side in Lorenzo Ghiberti's *Story of Adam and Eve* panel (Fig. 20), completed between 1430 and 1436 for the north doors of the Florentine

Baptistery. This quotation connects the *Nymph of Fiesole* panel closer to Giovanni Toscanini, who studied with Ghiberti. Like Eve, Venus is anatomically sensual. Toscanini delineated her curves with a brown contour line and turned her chest slightly towards the viewer to display her round breasts. Venus covers her pubis with one hand, a gesture that may read as modesty but one that also directs attention to the female genitalia and her mandate for Africo to "ravish" Mensola.

In a scene located to the right of this vision, Africo's parents warn their son of the dangers involved in pursuing nymphs. Africo ignores his parents' advice, and at the top of the panel, he traverses with Mensola through the rocky landscape. In

20 Lorenzo Ghiberti, *Story of Adam and Eve: Creation of Adam and Eve; Original Sin; Expulsion from Paradise,* panel from the Gate of Paradise, 1425–52, Museo dell'Opera del Duomo, Florence, Italy. Photo: Scala / Art Resource, NY

the final scene, the pair join the other nymphs in a pool of cool water. Right before entering the water, Africo makes a plea: "Now, Venus teach me! Help me now; now give me your precious counsel! The hour has come it seems, when I must take her."[78] Africo then strips off his dress, rushes into the water, and seizes Mensola. Toscanini dramatically depicted the first moments of this sexual assault. Stepping forward naked, Africo grabs one of Mensola's arms, squeezing it at the elbow. He then reaches around and clutches the back of her neck. In her study of medieval rape scenes, Diane Wolfthal notes that "the gesture of the grasped wrist is a shorthand in rape imagery to indicate that force is being used."[79] Toscanini's depiction of Africo grasping Mensola's arm and neck thus emphasizes the force of his sexual assault.

The depicted rape scene falls into the category of the "heroic," as discussed by Susan Brownmiller, in that its sexual violence is "eroticized and sanitized."[80] Specifically, in the case of this panel, the artist omits several unpleasant details of the assault. Boccaccio writes, for example, that "she [Mensola] defended herself with all her strength as long as she was able. As her cheeks streamed with tears, she wrenched violently one way and then another against the arms that clutched her." The sexual act was also "not without great struggle and loud shrieks and not without perhaps some loss of blood."[81] On the panel, Mensola's fight against Africo's assault is not violent. Though she lunges away from him, she also turns back to look at him. Her pose and gestures are not overly distressed. The artist does not depict the loss of blood, and the translucent stream, likely painted with a copper green glaze that has

since browned, only increases the scene's eroticism, encouraging the viewer to look beneath the water at the nymph's bare legs, pubis, and buttocks.

In the far right, the other nymphs stare in fascinated horror as they retreat from the attack, despite the fact that Boccaccio states that "they did not look back once."[82] In Toscanini's scene, only one nymph looks away, and only one nymph expresses concern over the grievous transgression by holding her forehead in her hand. With her back to the viewer and hair streaming over her shoulders, the nymph in the right foreground is highly eroticized. The artist incises a continuous contour line from her left shoulder blade, down her back, and around the curve and crease of her buttocks. The nymph behind her is perhaps even more sensualized with her thighs opened wide beneath the pool of water. A third nymph mischievously peeks out at the edge of the *cassone* panel's frame and catches the viewer's eye. Here, the painted story ends.

The Bowdoin *cassone* panel does not depict the denouement of Boccaccio's *Nymph of Fiesole*. In the closing scenes of the narrative, Mensola finally succumbs to Africo, after he asserts that he (rather than she) is the victim, declaring that he has suffered "many trials" and was "compelled" to rape her by Love.[83] After having sex again with Africo, Mensola leaves and does not return. After a month or so, Africo loses all hope and drives a steel spear into his breast. His suicide results in his metamorphosis into a stream. Soon after, Mensola discovers that she is pregnant and delivers a baby boy; however, Diana learns of her transgression and transforms her into a stream as well.[84] On the *cassone*, the pool of water – where Africo raped Mensola and took his life – flows into a stream that winds its way through the surrounding country-side. Today, the streams of Africo and Mensola join together east of Florence under a bridge, near the Villa I Tatti.

The child from Africo and Mensola's union, however, is saved. An older nymph, who helped Mensola with her delivery, carries the newborn Pruneo to his grandparents. As an adult, Pruneo becomes "seneschal and governor over the land and people" and watches "his family increase to a large clan, each one a citizen of Fiesole, nobler and stronger than his neighbor."[85] Indeed, Boccaccio's *Nymph of Fiesole* is an origin myth that recounts the founding of Fiesole and then Florence. According to Boccaccio, "the Romans founded Florence to see that the survivors of Fiesole should not rebuild the city." Following the war, Africo's descendants move to Florence, join in marriage to the city's families, become citizens, and receive many honors. In turn, Florence increases "in wealth and population," enjoying "peace for many years."[86] Boccaccio's *Nymph of Fiesole* and its appearance on this wedding chest panel honors the origins of families, such as the Medici, who came to Florence from the hills of the Mugello.

Boccaccio's depicted narrative marks the transitional moment of marriage, when a woman metamorphoses from a faithful, clothed virgin of Diana into a

nude, sexually active bride of Venus. The amorous apparition creates a transition in the narrative, marking a before and after response that is intended to arouse desire. Even the ornament of the *cassone*'s frame, which alternates between birds and roses sculpted in gesso and gilded against a blue background, playfully alludes to male and female genitalia joining together in matrimony. With wings lowered and round heads lifted high, the sculpted birds resemble erect phalli. Interestingly, Boccaccio employs avian metaphors in his description of Africo's rape of Mensola, writing that "as they struggled thus, something awoke that, till that time, had slept dejectedly. Lifting its haughty crest, it commenced wildly to knock against the gate and thrust its head so far within that it gained entry."[87] Boccaccio's weaving together of sex and violence in the *Nymph of Fiesole* is erotic; however, the tragic arc of the story also warns against deceit, impatience, rejection of parental advice, and failure to commit fully to one's mate. Female viewers may have also understood Mensola's fate as an allusion to or a reminder of their possible death in childbirth, a hard but inescapable fact of life that new brides had to process once they lost their virginity.

On the fifteenth-century objects discussed in this chapter, Venus' splendor illuminates a number of liminal moments: the first spark of love, the initial sight of the beloved's nude body, and the spiritual and physical union of man and woman for the conception of a new being. Her iconography reveals a complex mixture of Greek and Roman mythology, Arabic astrology, Christian allegory, and Tuscan poetry. In literature, the Christianized aspects, which include moral glosses and the connection of her planetary light to the Holy Spirit, serve as a defense for the study of both mythology and astrology. In art, the synthesized imagery, which consists of representing Venus with the conventions of sacred epiphanies, leads to ambiguity and in the end highlights the enigma of love, which could be both bright and delightful but also violent and deadly. As we will see, Venus becomes iconic within marital art produced during the fifteenth century, appearing as the goddess of love and fertility on an increasing number of objects fashioned to celebrate nuptial union and successful birth.

NOTES

1 "O Venere formosa, o sacro lume, / o salutar fulgore, o alma stella / bella sopra ogni bella, / che dal sublime cielo amor diffondi." *Lirici toscani del Quattrocento*, ed. Antonio Lanza, vol. 1 (Rome: Bulzoni, 1973), 333, lines 1–4.

2 Leon Battista Alberti notes this phenomenon in his *Treatise on Painting* of 1435 when he compares different light sources, including those of the sun, the moon, and "that other beautiful star Venus" ("Seguita di lumi; dico de lumi alcuno essere dalle stelle, come dal sole, da la luna et da quell'altra bella stella Venere. Altri lumi sono da i fuochi ma tra questi si vede molta differentia"). For the Italian text, see Leon Battista Alberti, *Della pittura*, ed.

Luigi Mallè (Florence: G. C. Sansoni, 1950), 64; for English, see *On Painting*, trans. John R. Spencer (New Haven, CT: Yale University Press, 1966), 50.

3 For medieval theories regarding celestial sources of light, see Simon A. Gilson, *Medieval Optics and Theories of Light in the Works of Dante* (Lewiston: E. Mellen Press, 2000), 7–37.

4 In Canto V of *Paradiso*, Beatrice describes her radiance as a "fire of love" ("ti fiammeggio nel caldo d'amore"), declaring to Dante that "once seen, / that light, alone and always, kindles love; / and if a lesser thing allures your love, / it is a vestige of that light which – though / imperfectly – gleams through the lesser thing" ("Come apprende, / così nel bene appreso move il piede. / Io veggio ben sì come già resplende / ne l'intelletto tuo l'etterna luce, / che, vista, sola e sempre amore accende"). Dante Alighieri, *The Divine Comedy: Paradiso*, trans. Allen Mandelbaum, vol. 3 (Berkeley: University of California Press, 1982), Book 5, 38–39, lines 1, 5–9.

5 Robert G. Babcock, "Astrology and Pagan Gods in Carolingian 'Vitae' of St. Lambert," *Traditio* 42 (1986): 95–113. For Dante's discussion of the seven planets and their relationship to the Holy Spirit and the angelic orders, see Dante Alighieri, *Convivio. A Dual-Language Critical Edition*, ed. and trans. Andrew Frisardi (Cambridge: Cambridge University Press, 2018), 76–77.

6 Anne Jacobson-Schutte, "'Trionfo delle donne': Tematiche di rovesciamento dei ruoli nella Firenze rinascimentale," *Quaderni storici* 44 (1980): 481–82; Cecilia de Carli, *I deschi da parto e la pittura del primo Rinascimento toscano* (Turin: Umberto Allemandi, 1997), 23, 74; Adrian W. B. Randolph, *Touching Objects: Intimate Experiences of Italian Fifteenth-Century Art* (New Haven, CT: Yale University Press, 2014), 191–96.

7 Michael Scot, for example, associates Venus with "adolescence, the beginning of youth," while also explaining that the planet governs "all women, youths, and boys, but not an old person." For this text and a discussion of the age of life that Venus rules according to different astrologers, see Richard Kay, *Dante's Christian Astrology* (Philadelphia: University of Pennsylvania Press, 1994), 78–79.

8 "Et habet significare similiter ex aetate hominis adolescentiam et maxime in mera iuventute, quae est a 14. anno usque ad 22." For Guido Bonatti's text, see Kay, *Dante's Christian Astrology*, 308. Isidore of Seville writes, "The third age, adolescence (*adolescentia*), is mature (adultus, ppl. of *adolescere*) enough for procreating and lasts until the twenty-eighth year." Isidore of Seville, *The Etymologies*, trans. and ed. Stephen A. Barney, W. J. Lewis, J. A. Beach, and Oliver Berghof (Cambridge: Cambridge University Press, 2006), 241. For Dante's discussion of ages, see Dante, *Convivio*, 326–31.

9 For the patronage and gifting of betrothal chests in Florence, see Jacqueline Marie Musacchio, *Art, Marriage, and Family in the Florentine Renaissance Palace* (New Haven, CT: Yale University Press, 2008), 127–35; Randolph, *Touching Objects*, 117–37.

10 Paul Schubring originally associated the chest with the Florentine school; see Paul Schubring, *Cassoni: Truhen und Truhenbilder der italienischen Frührenaissance* (Leipzig: K.W. Hiersemann, 1915), 229–30. Millard Meiss attributed it to the Sienese artist Giovanni di Paolo; see Millard Meiss, "The Earliest Work of Giovanni di Paolo," *Art in America* 24 (1936): 137–43. Later, Meiss decided against the Giovanni di Paolo attribution but still argued that the piece was Sienese; see Millard Meiss, *French Painting in the Time of Jean de Berry. The Limbourgs and their Contemporaries* (London: Thames and Hudson, 1974), 26. For the Umbrian attribution, see Frank J. Mather, "A Quattrocento Toilet Box in the Louvre," *Art in America* 11 (1922): 45–51. For the Lombard attribution, see John Pope-Hennessy, *Giovanni di Paolo, 1403–1483* (New York: Oxford University Press, 1938), 23. For other discussions of the object, see Paul F. Watson, *The Garden of Love in Tuscan Art of the Early Renaissance* (Philadelphia: Art Alliance Press, 1979), 85–89; Gwendolyn Trottein, *Les enfants de Vénus: art et astrologie à la renaissance* (Paris: Lagune, 1993), 49–51.

11 For a description of the *banda doppiomerlata* and the families associated with this blazon, see Piero Marchi, ed., *I blasoni delle famiglie toscane conservati nella raccolta Ceramelli-Papiani*, publication of the Archivio di Stato di Firenze (Rome: Athena, 1992), 50, 516–17. In the

manuscript, the Bechi family's blazon is described as "d'azzurro, alla banda doppiomerlata d'oro," ASF, *Raccolta Ceramelli Papiani*, fasc. 497.

12 The Aldobrandini di Madonna *stemma* is described as "d'azzurro, alla banda doppiomerlata d'oro, accostata da sei stelle a otto (o sei) punte dello stesso, ordinate tre per lato." ASF, *Raccolta Ceramelli Papiani*, fasc. 73.

13 For the attribution of the box to the Marzi family, see Giovanni Previtali, ed., *Il Gotico a Siena: miniature, pitture oreficerie, oggetti d'arte* (Florence: Centro Di, 1982), 359–60. The Marzi *stemma* is described as "di rosso, alla banda doppiomerlata d'argento." ASF, *Raccolta Ceramelli Papiani*, fasc. 7013.

14 For a discussion of these circular wooden boxes in relation to workshop practices, see Musacchio, *Art, Marriage, and Family*, 130–31.

15 "Tal giesso o piu forte dicholla puoi buttare alchuna testa / di leone o daltre stanpe stanpate in terra overo in crea ungi." Cennino Cennini, *Il libro dell'arte*, trans. Lara Broecke (London: Archetype, 2015), 161.

16 Meiss and Trottein relate the iconography of the betrothal chest to early illustrations of the *Epistle of Othea*; see Meiss, "The Earliest Work of Giovanni di Paolo," 138; Trottein, *Les enfants de Vénus*, 42. In the French tradition of courtly love, Pizan was a prolific female writer, who carefully oversaw the production of her manuscripts and illustration programs. In a manuscript written ca. 1405, descriptions of the text's illustrations, including those of the seven planets, are given in purple rubrics. One rubric instructs that "where the images are in clouds, it is to be understood that they are the figures of gods or goddesses," and "since they revolve around the circles that are called zodiacs, they sit on circles." For a discussion of Pizan's authorship of the rubrics and direction over the illustrations of the planets, see Meiss, *French Painting in the Time of Jean de Berry*, 24–26; Sandra L. Hindman, *Christine de Pizan's Epistre Othéa: Painting and Politics at the Court of Charles VI*, Studies and Texts 77 (Toronto: Pontifical Institute of Mediaeval Studies, 1986), 75–89; Charlotte E. Cooper, "Learning to Read Christine de Pizan's *Epistre Othea*," *Pecia. Le livre et l'écrit* 17 (2014): 41–63.

17 Christine de Pizan, *Christine de Pizan's Letter of Othea to Hector*, trans. Jane Chance (Cambridge: D. S. Brewer, 1997), 45–46.

18 Andreas Capellanus, *The Art of Courtly Love*, trans. John Jay Parry (New York: Frederick Ungar Publishing, 1959); Guillaume de Lorris and Jean de Meun, *The Romance of the Rose*, trans. Charles Dahlberg (Princeton, NJ: Princeton University Press, 1971). For a discussion of the amorous theories in this tradition, see Jean Markale, *Courtly Love: The Path of Sexual Initiation*, trans. Jon Graham (Rochester, VT: Inner Traditions, 2000), 1–79; Don A. Monson, *Andreas Capellanus, Scholasticism, & the Courtly Tradition* (Washington, DC: The Catholic University of America Press, 2005), 42–166; James A. Schultz, *Courtly Love, the Love of Courtliness, and the History of Sexuality* (Chicago: University of Chicago Press, 2006), 51–98. For the debate surrounding the content of *The Romance of the Rose*, see Christine de Pizan et al., *Debate of the Romance of the Rose*, ed. and trans. David F. Hult (Chicago: University of Chicago Press, 2010), 37–194.

19 Meiss notes that French humanists corresponded with Coluccio Salutati in their quest for works by ancient authors. In 1396, Gontier Col, the secretary of Jean de Berry, visited Florence; see Meiss, *French Painting in the Time of Jean de Berry*, 19–23, 26.

20 For a discussion of instruments in representations of the planet Venus and her children, see Zdravko Blazekovic, "Music in Medieval and Renaissance Astrological Imagery" (PhD diss., City University of New York, 1997), 199–210, 220–31; Trottein, *Les enfants de Vénus*, 15–81. The *Picatrix* states that Venus governs "playing instruments pleasantly, singing, dancing, and producing harmonies with instruments." *Picatrix: A Medieval Treatise on Astral Magic*, trans. Dan Attrell and David Porreca (University Park: Pennsylvania State University Press, 2019), 134. Boccaccio also places under Venus' guardianship "the greatest amusement in song and laughter, dancing, music by stringed instruments and pipes, weddings and many other things" ("delectationem plurimam circa cantum et risum,

saltationes, fidicinas, et fistulas nuptiasque et alia multa"). Giovanni Boccaccio, *Genealogy of the Pagan Gods, Volume I: Books I–V*, trans. Jon Solomon, I Tatti Renaissance Library 46 (Cambridge, MA: Harvard University Press, 2011), Book 3, 384–85.

21 The artist's portrayal of the central maiden with her arms crossed in front of her chest is an unusual iconography that does not appear, for example, in the illustrations of Venus in Christine de Pizan's *Othea*. The gesture is rare in art. One example, however, does appear in an illustration of *Cydippe* in a French manuscript of Ovid's *Heroides* or twenty-one letters of women, copied and illustrated between 1490 and 1510. In the half-length portrait, Cydippe stands with her arms crossed at her chest. In the letter that accompanies the portrait, she writes to Acontius who deceived her with false promises of marriage on the island of Delos. She writes to him from home, where she is ill and unable to follow through with her present nuptials. She speaks of her inability to love and wed her prospective groom, who perceives her displeasure through her "open signs." In relation to the text, Cydippe's crossed-arm gesture in the illustration seems to convey her obstinacy to be wed to her current suitor. The similarity of Cydippe's crossed arms to those of the central maiden on the Bechi box suggest that her gesture also might be read in terms of obstinacy or refusal to submit to a proposed marriage. For Cydippe's letter, see Ovid, *Heroides. Amores*, trans. Grant Showerman, rev. G. P. Goold. Loeb Classical Library 41 (Cambridge, MA: Harvard University Press, 1914), 292–311. For the illustration, see Ovid, *Les XXI epistres des dames illustes traduicttes d'Ovide*, for Reverend Pere en Dieu Monseigneur L'Evesque de Angoulesme, France, 1490–1510, MS. HM 60, fol. 118v, now located at the Huntington Library.

22 Fiammetta describes her vision, writing: "A magnificent lady, surrounded by a light so bright that the sight could hardly bear it, offered herself to my view ... little by little she uncovered more clearly her lovely aspects in that brilliant light." She continues, "in her I experienced beauties impossible to express in words and inconceivable among mortals if not seen" ("Una bellissima donna s'offerse agli occhi miei, circundata da tanta luce che appena la vista la sostenea. Ma pure stando essa ancora tacita nel mio cospetto, quanto potei per lo lume gli occhi aguzzare tanto li pinsi avanti, infino a tanto che alla mia conoscenza pervenne la bella forma, e vidi lei ignuda ... Ella non dicea alcuna cosa, anzi o forse contenta ch'io la riguardassi, ovvero me vedendo di riguardarla contenta, a poco a poco tra la fulvida luce di sé le belle parti m'apriva piú chiare, per che io bellezze in lei da non potere con lingua ridire, né senza vista pensare intra' mortali, conobbi"). Boccaccio, *Elegia di Madonna Fiammetta*, ed. Maria Pia Mussini Sacchi (Milan: Mursia, 1987), 51; for English translation, see *The Elegy of Lady Fiammetta*, ed. and trans. Mariangela Causa-Steindler and Thomas Mauch (Chicago: University of Chicago Press, 1990), 16–17.

23 Giovanni Boccaccio, *The Nymph of Fiesole*, trans. Daniel J. Donno (New York: Columbia University Press, 1960), 15–17. In his footnotes, Paul Watson connects a passage in Boccaccio's *Nymph of Fiesole* to this inscription; see Watson, *The Garden of Love*, 154.

24 Plato writes, "Such, then, was the sum of the reasoning of the ever-existing God concerning the god which was one day to be existent, whereby He made it smooth and even and equal on all sides from the center, a whole and perfect body compounded of perfect bodies. And in the midst thereof He set Soul, which He stretched throughout the whole of it, and therewith He enveloped also the exterior of its body; and as a Circle revolving in a circle He stablished one sole and solitary Heaven, able of itself because of its excellence to company with itself and needing none other besides, sufficing unto itself as acquaintance and friend. And because of all this He generated it to be a blessed God." Plato, *Timaeus. Critias. Cleitophon. Menexenus. Epistles*, trans. R. G. Bury, Loeb Classical Library 234 (Cambridge, MA: Harvard University Press, 1929), 64–65. For the ancient philosophical and artistic tradition of using the circle to represent the heavens, see Dietrich Mahnke, *Unendliche Sphäre und Allmittelpunkt. Beitrage zur Genealogie der mathematischen Mystik* (Halle an der Saale: M. Neimeyer, 1937), 215–44.

25 *Picatrix*, 43.

26 *Picatrix*, 44.

27 For a discussion of rainbows in Byzantine art, see Liz James, *Light and Colour in Byzantine Art* (Oxford: Clarendon Press, 1996), 91–109.

28 For the symbolic meanings of gold, see Dominic Janes, *God and Gold in Late Antiquity* (Cambridge: Cambridge University Press, 1998), 18–93; Hans-Gert Bachmann, *The Lure of Gold: An Artistic and Cultural History*, trans. Steven Lindberg (New York: Abbeville Press, 2006), 199–234. For gold and its reflective powers, see Paul Hills, *The Light of Early Italian Painting* (New Haven, CT: Yale University Press, 1987), 3–16; Moshe Barasch, *Light and Color in the Italian Renaissance Theory of Art* (New York: New York University Press, 1978), 21–24.

29 As Timothy McCall argues in his study of resplendent male adornment, brilliance was "an essential courtly ideal" in fifteenth-century Italy that asserted an individual's "sovereign status." Timothy McCall, "Brilliant Bodies: Material Culture and the Adornment of Men in North Italy's Quattrocento Courts," *I Tatti Studies in the Italian Renaissance* 16 (2013): 445–90.

30 Michael Scot describes the planet Venus as follows: "Sic figuratur Venus: habet faciem formosam, nec longam, nec ex toto rotundam, mediocriter pinguem, albam et coloratam, oculos vagos, mammas elevatas, capillos blundos, tricas grandes et cyrros iuxta // tympora, pulchras vestes // et frixatas et gemmatas, habens rosam in manu prope os, et honeste intuens Mercurium." For Latin text, see Silke Ackermann, *Sternstunden am Kaiserhof. Michael Scotus und sein Buch von den Bildern und Zeichen des Himmels* (Frankfurt am Main: Peter Lang, 2009), 264. For a discussion of Scot's influence on artists, see Dieter Blume, "Michael Scot, Giotto and the Construction of new Images of the Planets," in *The Images of the Gods, Papers of a Conference in Memory of Jean Seznec*, ed. Rembrandt Duits and François Quiviger (London: Warburg Institute Colloquia, 2009), 129–50; Dieter Blume, "Picturing the Stars: Astrological Imagery in the Latin West, 1100–1550," in *A Companion to Astrology in the Renaissance*, ed. Brendan Dooley (Leiden: Brill, 2014), 351–67.

31 For a discussion of textile costs, see Carole Collier Frick, *Dressing Renaissance Florence. Families, Fortunes, & Fine Clothing* (Baltimore: Johns Hopkins University Press, 2002), 91–99.

32 *Lacca* is included in the list of items imported from Cyprus by Francesco Balducci Pegolotti, who conducted business on the island between 1324 and 1327. *Lacca* is also listed on a tariff advisory as coming from Cyprus and is discussed in Filippo di Niccolò Frescobaldi's 1471 advice book on purchasing goods; see Giovanni Francesco Pagnini, ed., *Della decima e di varie altre gravezze imposte dal comune di Firenze*, vol. 2 (Lisbon and Lucca, 1765–1766; reprint, Bologna: Forni, 1967), Book 3, 308, 314–15, 366–67.

33 The bulbous shape of the *balzo* is formed by a wire or willow frame. A luxurious textile was then placed over the frame. If a woman's hair was long enough, it could be braided and then wrapped around the *balzo* with ribbons. These ornamental headdresses were considered "high fashion" in Florence during the early decades of the fifteenth century; see Rosita Levi Pisetzky, *Storia del costume in Italia*, vol. 2 (Milan: Istituto Editoriale Italiano, 1964), 292; Jacqueline Herald, *Renaissance Dress in Italy 1400–1500* (London: Bell & Hyman, 1981), 50; Elisabetta Gnignera, *I soperchi ornamenti: copricapi e acconciature femminili nell'Italia del Quattrocento* (Siena: Protagon, 2010), 15–33.

34 Meiss, *French Painting in the Time of Jean de Berry*, 26.

35 In 1433, Francesco de' Medici gave his wife Costanza Guicciardini a "balzo of crimson silk ornamented with pearls" ("balzo di cremisi ornato di perle"). Egidia Polidori Calamandrei, *Le vesti delle donne fiorentine nel Quattrocento* (Rome: Multigrafica, 1973), 82.

36 For interior inscription, see Schubring, *Cassoni: Truhen und Truhenbilder*, 230.

37 Watson, *Garden of Love*, 88–89.

38 The *Venus and Lovers* birth tray has been attributed to the so-called Master of Charles of Durazzo, who Miklós Boskovits and Everett Fahy identify as Francesco di Michele; see Miklós Boskovits, "Il Maestro di Incisa Scapaccino e alcuni problemi di pittura tardogotica in Italia," *Paragone* 501 (1991): 47; Everett Fahy, "Florence and Naples: A Cassone Panel in

the Metropolitan Museum of Art," in *Hommage à Michel Laclotte. Études sur la peinture du Moyen Âge et de la Renaissance*, ed. Pierre Rosenberg, Cécile Scailliérez, and Dominique Thiébaut (Milan: Electa, 1994), 231–43. The birth tray's iconography is discussed by Eugene B. Cantelupe, "The Anonymous *Triumph of Venus* in the Louvre: An Early Renaissance Example of Mythological Disguise," *Art Bulletin* 44 (1962): 238–42; Watson, *The Garden of Love*, 81–85; Jacobson-Schutte, "'Trionfo delle donne'," 481–82; Carli, *I deschi da parto*, 74–75; Claudia Däubler-Hauschke, *Geburt und Memoria. Zum italienischen Bildtyp der deschi da parto* (Berlin: Deutscher Kunstverlag, 2003), 219–21; Michael Camille, *The Medieval Art of Love: Objects and Subjects of Desire* (London: Abrams, 1998), 32–33; Adrian W. B. Randolph, "Gendering the Period Eye: Deschi da Parto and Renaissance Visual Culture," *Art History* 27 (2004): 553–58; the catalogue entry (no. 66) by Jacqueline Marie Musacchio in *Art and Love in Renaissance Italy*, ed. Andrea Bayer (New York: Metropolitan Museum of Art, 2008), 149–50; David Lang Clark, "The Louvre 'Triumph of Venus' Panel: A Satire of Misogynists," *Aurora* 10 (2009): 1–12; Randolph, *Touching Objects*, 191–95.

39 For birth trays, see Carli, *I deschi da parto*, 15–21; Jacqueline Marie Musacchio, *The Art and Ritual of Childbirth in Renaissance Italy* (New Haven, CT: Yale University Press, 1999), 59–89; Däubler-Hauschke, *Geburt und Memoria*, 17–38; the catalogue entries (nos. 66–75) by Jacqueline Marie Musacchio in Bayer, ed., *Art and Love in Renaissance Italy*, 149–63; Randolph, *Touching Objects*, 169–203.

40 On medicines and foods given to new mothers, see Musacchio, *The Art and Ritual of Childbirth*, 40–42; James Shaw and Evelyn Welch, *Making and Marketing Medicine in Renaissance Florence* (New York: Rodopi, 2011), 207–208.

41 Randolph, "Gendering the Period Eye," 457–58; Randolph, *Touching Objects*, 169–88.

42 Musacchio, *The Art and Ritual of Childbirth in Renaissance Italy*, 61–64.

43 The inventory lists the *Triumph of Fame* birth tray as "uno descho tondo da parto, dipintovi il Trionfo della Fama . . . f.10." Marco Spallanzani and Giovanna Gaeta Bertelà, eds., *Libro d'inventario dei beni di Lorenzo il Magnifico* (Florence: Associazione Amici del Bargello, 1992), 27. For a detailed discussion of this object, see Däubler-Hauschke, *Geburt und Memoria*, 85–124.

44 Three *Abduction of Helen* birth trays depict Paris kidnapping his beloved from the island of Cythera, where she was attending a festival at the temple of Venus, according to the thirteenth-century writer Giovanni delle Colonne. These paintings include a nude statue of the goddess on a pedestal. For examples of these birth trays, see Däubler-Hauschke, *Geburt und Memoria*, 206–92; Carli, *I deschi da parto*, 62–89, 104–15. For information on art and literature related to the life of Paris, including the *Judgment of Paris* and *Abduction of Helen*, see Jerzy Miziolek, "The Awakening of Paris and the Beauty of the Goddesses: Two *Cassoni* from the Lanckoronski Collection," *Mitteilungen des Kunsthistorischen Institutes in Florenz* 51 (2007): 299–336.

45 For the Pythagoreans, the *vesica piscis* symbolized the unification of opposites, in particular the celestial with the terrestrial; see Todorova Georgieva Rostislava, "The Migrating Symbol: *Vesica Piscis* from the Pythagoreans to the Christianity," in *Harmony of Nature and Spirituality in Stone* (Belgrade, Serbia: Stone Studio Association, 2011), 217–28.

46 In Euclid's *Elements* (Book 1, Proposition 1), the *vesica piscis* is a shape formed in the construction of an equilateral triangle. *Greek Mathematical Works, Volume I: Thales to Euclid*, trans. Ivor Thomas, Loeb Classical Library 335 (Cambridge, MA: Harvard University Press, 1939), 452–55.

47 Otto Brendel, "Origin and Meaning of the Mandorla," *Gazette des Beaux-Arts* 25 (1944): 5–24; Aurelie A. Hagstrom, "The Symbol of the Mandorla in Christian Art: Recovery of a Feminine Archetype," *ARTS* 10 (1998): 25–29; Christian Kleinbub, *Vision and the Visionary in Raphael* (University Park: Pennsylvania State University Press, 2011), 12–17; Todorova Georgieva Rostislava, "Visualizing the Divine Mandorla as a Vision of God in Byzantine Iconography," *Ikon* 6 (2013): 287–96.

48 Ann Marie Rasmussen, "Hybrid Creatures: Moving beyond Sexuality in the Medieval Sexual Badges," in *From Beasts to Souls: Gender and Embodiment in Medieval Europe*, ed. Jane E. Burns and Peggy McCracken (Notre Dame, IN: University of Notre Dame Press, 2013), 221–47; Patricia Simons, *The Sex of Men in Premodern Europe: A Cultural History* (New York: Cambridge University Press, 2014), 79–97.

49 Cennini explains how to make liquid gold, writing, "Togli i pezi dell oro fine in quantita secon / do il lavoro che vuoi fare o volessi scrivere con esso cioe dieci / o venti pezi mettili in su n la pietra profereticha e con chiara / duovo bene sbattuta amodo detto tria bene el detto oro et poi il metti in / n un vasellino invetriato mettivi tanta tenpera che chorra / o a ppenna o a ppennello." Cennini, *Il libro dell'arte*, 206. In her discussion of shell gold, Lara Broecke explains the necessity of grinding gold leaf with salt or another abrasive to create gold powder. Cennini, however, omits this step in his recipe. For Broecke's explanation, see Cennini, *Il libro dell'arte*, 207.

50 This idea is expressed in the *Picatrix* in the following terms: "The firmament is, as we have said, a round sphere in all its parts, truly symmetrical in its roundness and contained by the line of a circle, in whose middle is a point from which all the lines that lead to the line of the circumference are of equal length; that point is called the center. They say that those lines symbolize the rays that the stars project onto the Earth, as if into its core. From these rays arise the effects and powers of the images, and this is how they work." *Picatrix*, 44.

51 "Sì che secondo lui, secondo quello che si tiene in astrologia ed in filosofia poi che quelli movimenti furono veduti, sono nove li cieli mobili; lo sito delli quali è manifesto e diterminato, secondo che per un'arte che si chiama perspettiva, e [per] arismetrica e geometria sensibilemente e ragionevolemente è veduto, e per altre esperienze sensibili." Dante, *Convivio*, 64–65. In the twelfth-century writings of Raymond of Marseilles, the Holy Spirit is described as acting through the planets and manifesting itself astrologically. For a discussion of these theories, see Charles W. Clark, "A Christian Defense of Astrology in the Twelfth Century: The 'Liber Cursuum Planetarum' of Raymond of Marseilles," *International Social Science Review* 70 (1995): 96; Babcock, "Astrology and Pagan Gods in Carolingian 'Vitae' of St. Lambert," 95–113. For a discussion of Dante's notions of the angelic circles and the diffusion of God's spirit through light, see Herbert D. Austin, "Dante Notes: III from Matter to Spirit," *Modern Language Notes* 38 (1923): 140–48.

52 "Per che ragionevole è credere che li movitori del cielo della Luna siano dell'ordine delli Angeli, e quelli di Mercurio siano li Arcangeli, e quelli di Venere siano li Troni: li quali, naturati dell'amore del Santo Spirito, fanno la loro operazione, connaturale ad essi, cioè lo movimento di quello cielo, pieno d'amore." Dante, *Convivio*, 76–77.

53 "Li quali, naturati dell'amore del Santo Spirito, fanno la loro operazione, connaturale ad essi, cioè lo movimento di quello cielo, pieno d'amore; dal quale prende la forma del detto cielo uno ardore virtuoso, per lo quale le anime di qua giuso s'accendono ad amore, secondo la loro disposizione. E perché li antichi s'accorsero che quello cielo era qua giù cagione d'amore, dissero Amore essere figlio di Venere, sì come testimonia Virgilio nel primo dello Eneida, ove dice Venere ad Amore: 'Figlio, vertù mia, figlio del sommo padre, che li dardi di Tifeo' (cioè quello gigante) 'non curi'; e Ovidio, nel quinto di Metamorphoseos, quando dice che Venere disse ad Amore: 'Figlio, armi mie, potenzia mia'." Dante, *Convivio*, 76–77. Dante goes on to describe how this love descends to Earth: "Dico anche che questo spirito viene per li raggi della stella: per che sapere si vuole che li raggi di ciascuno cielo sono la via per la quale discende la loro vertute in queste cose di qua giù." Dante, *Convivio*, 80–81.

54 Dante, *The Divine Comedy: Paradiso*, vol. 3, 66–67, canto 8, lines 1–8.

55 In his journey through Venus' sphere, Dante encounters Cunizza da Romano (ca. 1198–ca. 1279), whose amorous passion for many men metamorphosed into an ardent love of God. Upon meeting Dante, Cunizza declares, "I shine here / because this planet's radiance conquered me" ("e qui refulgo / perché mi vines il lume d'esta stella"). Dante also speaks

with Folco of Marseilles, a troubadour poet who later in life became the Bishop of Toulouse. Folco explains that "even as this sphere receives my imprint, so was I impressed with its" ("e questo cielo / di me s'imprenta, com' io fe' di lui"). The French poet then identifies the spirit beside him, who "sparkles so, / as would a ray of sun in limpid water" ("così scintilla / come raggio di sole in acqua mera"), as the Old Testament heroine Rahab. Dante, *The Divine Comedy: Paradiso*, vol. 3, 74–75, canto 9, lines 32–33; 78–79, canto 9, lines 94–96; 78–79, canto 9, lines 112–17.

56 "Avendo Francesco fatto amicizia con Piero di Marcone orefice fiorentino, e divenutogli compare, fece alla comare, e moglie di esso Piero, dopo il parto, un presente d'un bellissimo disegno, per dipignerlo in un di que' tondi nei quali si porta da mangiare alle donne di parto: nel quale disegno era in un partimento riquadrato, ed accomodato sotto e sopra con bellissime figure, la vita dell'uomo, cioè tutte l'età della vita umana, che posavano ciascuna sopra diversi festoni appropriati a quella età secondo il tempo: nel quale bizzarro sparti-mento erano accomodati in due ovati bislunghi la figura del Sole e della Luna, e nel mezzo Isais, città d'Egitto, che dinanzi al tempio della Dea Pallade dimandava sapienza; quasi volendo mostrare che ai nati figliuoli si doverebbe innanzi ad ogni altra cosa pregare sapienza e bontà. Questo disegno tenne poi sempre Piero così caro come fusse stato, anzi come era, una bellissima gioia." Giorgio Vasari, *Le vite de più eccellenti pittori scultori ed architettori scritte*, ed. Gaetano Milanesi, vol. 7 (Florence: G. C. Sansoni, 1881), 20–21; for English text, see Giorgio Vasari, *Lives of the Most Eminent Painters, Sculptors, and Architects*, trans. Gaston du C. de Vere, vol. 8 (London: Macmillan, 1914), 172–73.

57 These romantic tales and their tragic endings have prompted scholars to interpret Venus as a *femme fatale*. Cecilia de Carli, in her monograph on birth trays, writes that "Here Venus, represented 'in mandorla' in the guise of a profane Maestà, emanating light and rays of tragic consequence, is assisted paradoxically by two winged devils." She continues: "the seduction of Venus, the most powerful and natural of passions, is also the most dangerous and idolatrous." Carli, *I deschi da parto*, 23, 74. A similar interpretation can be found in Raimond van Marle, *Iconographie de l'art profane au Moyen-Age et à la Renaissance et la décoration des demeures*, vol. 2 (Hague: Nijhoff, 1932), 464–65.

58 "Anima mia, io udii, ragionando / giá é assai, s'i' mi ricordo bene, / ch'amore é uno spirto avaro, e quando / alcuna cosa prende, sí la tene / serrata forte e stretta con gli artigli, / ch'a liberarla invan si dan consigli." For Italian and English text, see Giovanni Boccaccio, *Filostrato*, ed. Vincenzo Pernicone, trans. Robert P. apRoberts and Anna Bruni Seldis (New York: Garland, 1986), 156–57.

59 Petrarch also employs the motif in a poem to Love, writing, "so many snares and unkept promises / had made me feel the fierceness of your claw" ("tanti lacciuol, tante impromesse false, / tanto provato avea'l tuo fiero artiglio"). For Italian and English text, see Petrarch, *The Canzoniere or Rerum vulgarium fragmenta*, trans. Mark Musa (Bloomington: Indiana University Press, 1996), 106–107, sonnet 69, lines 3–4. In Barberino's poem, the passage on Cupid's feet reads, "I' sì gli ò facti i pie' suoi di falcone, / a intendimento del forte gremire / che fa di lor ch' el sa che'l sosterranno; / e quando à messi quegli in perfectione, / non si parte da .llor, se per morire / prima non si dissolve l'esser ch' ànno." Francesco da Barberino, *I documenti d'amore (Documenta amoris)*, ed. Marco Albertazzi, vol. 2 (Lavis: La Finestra, 2008), 579, lines 37–42. Barberino's text was illustrated with images of Cupid, winged and blindfolded, with prominent, three-taloned claws. For a discussion of this imagery, see Erwin Panofsky, "Blind Cupid," in *Studies in Iconology. Humanistic Themes in the Art of the Renaissance* (New York: Icon Editions, 1972), 117–21.

60 For a discussion of the characteristics of seraphim, see Meredith Gill, *Angels and the Order of Heaven in Medieval and Renaissance Italy* (Cambridge: Cambridge University Press, 2014), 26, 57.

61 "Questo m'induce, dea, tanto a lodarmi / del tuo lucente e virtuoso raggio, / per lo qual benedico ch'alcune armi / non mi difeser dal chiaro visaggio, / nel qual la tua virtú vidi dipinta, / e la potenza lucida e distinta." Boccaccio, *Filostrato*, 174–75.

62 The opening of Troilus's hymn to Venus reads, "O luce eterna, il cui lieto splendore / fa
 bello il terzo ciel dal qual ne piove / piacer, vaghezza, pietate ed amore, / del sole amica, e
 figliuola di Giove, / benigna donna d'ogni gentil core, / certa cagion del valor che mi
 move / a' sospir dolci della mia salute, / sempre lodata sia la tua virtute." The hymn
 continues for 16 stanzas; see Boccaccio, *Filostrato*, 170–79.

63 After describing the romantic drama between Criseida, Troilus, and Diomede, Boccaccio
 concludes the tale, writing, "L'ira di Troiolo in tempi diversi / a' Greci nocque molto sanza
 fallo, / tanto che pochi ne gli uscieno avversi / che non cacciasse morti del cavallo, / sol che
 ei l'attendesser, sí perversi / colpi donava; e dopo lungo stallo, / avendone giá morti piú di
 mille, / miseramente un dí l'uccise Achille." Boccaccio, *Filostrato*, 408–409.

64 For the inventory of Apollonio di Giovanni and Marco del Buono's workshop, see Ellen
 Callmann, *Apollonio di Giovanni* (Oxford: Clarendon Press, 1974), 76–81.

65 Richard A. Goldthwaite, "An Entrepreneurial Silk Weaver in Renaissance Florence,"
 I Tatti Studies in the Italian Renaissance 10 (2005): 85.

66 On wedding chests in marriage rituals, see Brucia Witthoft, "Marriage Rituals and Marriage
 Chests in Quattrocento Florence," *Artibus et Historiae* 3 (1982): 43–59. Gombrich discusses
 the aesthetic effect of *cassone* exteriors; see E. H. Gombrich, "Apollonio di Giovanni:
 A Florentine *Cassone* Workshop Seen through the Eyes of a Humanist Poet," *Journal of
 the Warburg and Courtauld Institutes* 18 (1955): 16–34.

67 Alberti writes, "There are some who use much gold in their *istoria*. They think it gives
 majesty. I do not praise it. Even though one should paint Virgil's Dido whose quiver was of
 gold, her golden hair knotted with gold, and her purple robe girdled with pure gold, the
 reins of the horse and everything gold, I should not wish gold to be used, for there is
 more admiration and praise for the painter who imitates the rays of gold with colours.
 Again we see in a plane panel with a gold ground that some planes shine where they ought
 to be dark and are dark where they ought to be light." ("Truovasi chi adopera molto in sue
 storie oro, che stima porga maëstà; non lo lodo. Et benché dipigniesse quella Didone di
 Vergilio ad cui era la pharetra d'oro; i capelli aurei nodati in oro et la veste purpurea cinta
 pur d'oro, freni al cavallo et ogni cosa d'oro, non però ivi vorrei punto adoperassi oro però
 che, ne i colori imitando i razzi del oro, sta più admiratione et lode al artefice. Et anchora
 veggiamo in una piana tavola alcuna superficie ove sia l'oro, quando deono essere obscure
 risplendere et quando deono essere chiare parere nere.") For Italian, Alberti, *Della pittura*,
 102; for English, *On Painting*, 85.

68 Scholarship on the panel includes Paul Watson, "Boccaccio's *Ninfale Fiesolano* in Early
 Florentine Cassone Painting," *Journal of the Warburg and Courtauld Institutes* 34 (1971):
 331–33; Laurence B. Kanter, Pia Palladino, et al., *Fra Angelico* (New Haven, CT: Yale
 University Press, 2005), 19-21; Katy Kline, ed., *Beauty & Duty: The Art and Business of
 Renaissance Marriage* (Brunswick: Bowdoin College Museum of Art, 2008), 15–22.
 Boccaccio's *Nymph of Fiesole* was a popular text; at least thirty-three manuscripts of the
 poem survive along with numerous early printed editions. For a discussion of the tale's
 popularity, see Santorre Debenedetti, "Per la fortuna della *Teseida* e del *Ninfale Fiesolano* nel
 secolo XIV," *Giornale storico della letteratura italiana* 40 (1912): 259–64.

69 One of the *Nymph of Fiesole* panels was sold by the Honolulu Academy of Arts in the 1990s.
 For the attribution of this panel to Giovanni Toscani and a discussion of his career, see
 Luciano Bellosi, "Il Maestro della Crocifissione Griggs: Giovanni Toscani," *Paragone* 17
 (1966): 44–58. The second panel, which is known only through a photograph in the Frick
 Archives, was once part of the Corsi Collection in Florence. This panel includes the Medici
 coat of arms on its frame. For reference to this object, see Boskovits, "Il Maestro di Incisa
 Scapaccino," 47. Though likely not by the same artist, the Honolulu and Corsi panels
 depict different episodes from Boccaccio's narrative and illustrate how the story could
 be spread across a pair of chests. Further information regarding the attributions of all three
 panels can be found in the *cassone* panel's file (BCMA Accession#: 1961.100.1) at the
 Bowdoin College Museum of Art, Brunswick, Maine.

70 "There also reigned at that time a goddess named Diana, and many ladies held her in devotion. But chiefly those who hated lust and wished to remain virgins chose to dedicate themselves to her. She welcomed them with great rejoicing, and kept them in the woods and in the forests. Many maidens besides were offered to her by fathers and by mothers who had promised them, some for favors and some for gifts received. Diana accepted them all with open arms so long as they were willing to observe chastity, to renounce men and vanity, and to do her service." ("Ancor regnava in que' tempi un'iddea / la qual Diana si facea chiamare, / e molte donne in divozion l'avea; / e maggiormente quelle ch'osservare / volean verginità, e che spiacea / lor la lussuria e a lei si volean dare, / costei le riceveva con gran feste, / tenendole per boschi e per foreste. // Ed ancor molte glien'erano offerte / dalli lor padri e madri, che promesse / l'avean a lei per boti, e chi per certe / grazie o don che ricevuto avesse; / Diana tutte con le braccia aperte / le riceveva, pur ch'elle volesse / servar verginità e l'uom fuggire, / e vanità lasciar e lei servire.") Giovanni Boccaccio, *Tutte le opere. Amorosa vision – Ninfale fiesolano – Trattatello in laude di Dante*, ed. Vittore Branca, vol. 3 (Verona: Mondadori, 1974), 292–93, stanzas 7–8; for English text, see Boccaccio, *Nymph of Fiesole*, 4–5.

71 Boccaccio describes the apparition: "Therefore, sleeping one night, the youth thought he beheld a vision of a woman encircled in resplendent light with a little naked child clinging to her neck who clasped a bow in one hand while he drew forth an arrow from his quiver with the other to shoot at him. But then, 'Wait, my child,' the lady said to him; 'don't be in haste'." ("Per ch'una notte il giovane, dormendo, / veder in visione gli parea / una donna con raggi risplendendo, / ed un piccol garzone in collo avea, / ignudo tutto ed un arco tenendo; / e del turcasso una freccia traea / per saettar, quando la donna: – Aspetta, – / gli disse – figliuol mio: non aver fretta. –") Boccaccio, *Tutte le opere*, vol. 3, 302–303, stanza 43; Boccaccio, *Nymph of Fiesole*, 15–16. After the vision, Africo states, "This lady who appeared to me just now is surely Venus with her child" (E poi dicea: "Questa donna mi pare, / ch'ora m'apparve, Vener col figliuolo"). Boccaccio, *Tutte le opere*, vol. 3, 304, stanza 50; Boccaccio, *Nymph of Fiesole*, 17.

72 For the production of lead-tin yellow and its characteristics, see Hermann Kühn, "Lead-Tin Yellow," in *Artists' Pigments: A Handbook of Their History and Characteristics*, ed. Ashok Roy, vol. 2 (Oxford: Oxford University Press, 1993), 83–93; Lara Broecke's comments on the pigment in Cennini, *Il libro dell'arte*, 72–73; David Coles, *Chromatopia: An Illustrated History of Colour* (New York: Thames & Hudson, 2019), 68–69.

73 "Rp. 273. A fare zallolino per dipengiare. – Havve lb doi de questo stagno et piombo calcinato et doi lb de questo vetrio da patrenostrj et doi lb et ½ di minio et meza lb. de rena de valdarno sotilmente pista et mecti in fornace et fa affinare et sera perfecto." Mary P. Merrifield, *Original Treatises on the Arts of Painting*, vol. 2 (New York: Dover, 1967), 529.

74 For Lara Broecke's notes on lead-tin yellow, see Cennini, *Il libro dell'arte*, 72–73.

75 "Giallo e un colore che ssi chiama giallorino el quale e artificiato e e molto / sodo egrieve come prieta e duro da spezare questo colore s adopera in f / rescho e dura senpre cioe in muro e in tavola con tenpere questo colore vuole / essere macinato si chome gli altri predetti conaqua chiara non molto vuole / essere triata e innanzi che il trii perche e molto malagievole a ridurlo in / polvere convienti per mortaro di bronzo pestarlo si come de fare del lapis amatito / ede quando l ai mettudo inn opera color molto vagho in giallo che di qesto / colore con altre mescholanze come ti dimostro se ne fa di belle verdure / e color derbe e ssi mi do a intendere che questo color sia propia prieta nata / in luogho di grande arsure di montangnie pero ti dico sia colore / artificiato manon darchimia." Cennini, *Il libro dell'arte*, 72.

76 Kühn, "Lead-Tin Yellow," in *Artists' Pigments*, 91–93.

77 After viewing the apparition of Venus, Africo describes his emotions, saying, "I feel as if I were all ablaze within with flames of love. I feel as though my heart and breast were being consumed in every quarter." ("I' mi sento arder dentro tutto quanto / dall' amorose fiamme, e consumare / mi sento 'l petto e 'l core da ogni canto.") Boccaccio, *Tutte le opere*,

vol. 3, 329, stanza 140; Boccacio, *Nymph of Fiesole*, 41. In another lament on his state, he declares, "Oh, my grievous and blighted life, melting away like snow in sunlight under the burden of my sorrow! I burn like tinder, yet see no haven for my deliverance" ("Oh me dolente, la mia vita prava! / ch'ella si va come neve struggendo / al sol, tanto questa doglia la grava, / e come legno al fuoco mi divampo, / né veggio alcun riparo allo mio scampo"). Boccaccio, *Tutte le opere*, vol. 3, 338, stanza 172; Boccaccio, *Nymph of Fiesole*, 51.

78 "Ora m'insegna, Vener, or m'aiuta, / ora mi dona il tuo caro consiglio; / ora mi par che l'ora sia venuta, / nella qual debbo a costei dar di piglio." Boccaccio, *Tutte le opere*, vol. 3, 354, stanza 233; Boccaccio, *Nymph of Fiesole*, 67.

79 Diane Wolfthal, "'A Hue and A Cry': Medieval Rape Imagery and Its Transformation," *Art Bulletin* 75 (1993): 43.

80 Susan Brownmiller, *Against Our Will: Men, Women, and Rape* (Toronto: University of Toronto Press, 1981), 313–42.

81 "Mensola, le parole non intende / ch'Africo le dicea, ma quanto puote / con quella forza ch'ell'ha si difende, / e fortemente in qua e'n là si scuote / dalle braccia di colui che l'offende, / bagnandosi di lagrime le gote; / ma nulla le valea forza o difesa, / ch'Africo la tenea pur forte presa. // [...] // ma con battaglia grande ed urlamento / e forse che di sangue spargimento." Boccaccio, *Tutte le opere*, vol. 3, 357–58, stanzas 243 and 244; Boccaccio, *Nymph of Fiesole*, 70.

82 "E tutte l'altre ninfe molto in fretta / uscir dell'acqua, a' lor vestir correndo; / né però niuna fu che lì sel metta, / ma coperte con essi via fuggendo, / ché punto l'una l'altra non aspetta, / né mai indietro si givan volgendo; / ma chi qua e chi là si dileguoe, / e ciascuna le sue armi lascioe." Boccaccio, *Tutte le opere*, vol. 3, 357, stanza 241; Boccaccio, *Nymph of Fiesole*, 69.

83 The text reads, "Now I've described the many trials I've borne on your account. If, therefore, I've used force against you, I did so only because I was compelled to, not because I chose to hurt you. The cause of it was Love, who kept me in this woe, and his, the blame. Complain of him, for that would be more just." ("Ora t'ho raccontato il gran tormento / ch'i' ho, per te, portato e sostenuto; / però se io ho usato isforzamento, / l'ho fatto sol perché forza m'è suto, / non perch'i' sia di noiarti contento; / ma sol Amor, che m'ha per te tenuto / in queste pene, n'ha colpa e cagione. / Duolti di lui, ché n'aria più ragione!") Boccaccio, *Tutte le opere*, vol. 3, 363, stanza 265; Boccaccio, *Nymph of Fiesole*, 75.

84 For these events, see Boccaccio, *Nymph of Fiesole*, 99–118.

85 "Atalante gli pose tanto amore, / veggendo ch'era sì savio e valente, / che siniscalco il fe', con grande onore, / sopra la terra e sopra la sua gente, / e di tutto'l paese guidatore // [...] // Pruneo rimase in grandissimo stato / con la sua Tironea, della qual ebbe / dieci figliuol, ciascun pro' e costumato / tanto, che maraviglia a dir sarebbe; / e poi ch'egli ebbe a ciascun moglie dato, / in molta gente questa schiatta crebbe, / e sempre furo a Fiesol cittadini, / grandi e possenti sopra lor vicini." Boccaccio, *Tutte le opere*, vol. 3, 414, stanza 447 and 415, stanza 452; Boccaccio, *Nymph of Fiesole*, 126, 129.

86 "Poi fu Firenze posta pe' Romani, / acciò che Fiesol non si rifacesse // [...] // Ma poi ch'uscita fu l'ira di mente, / per ispazio di tempo, e pace fatta / tra li Romani e la scacciata gente, / quasi tutta la gente fu ritratta / ad abitare in Firenze possente: / fra' qual vi venne l'africhea schiatta, / i quai vi fur volentier ricevuti / da' cittadini, e molto car tenuti. // E per levar lor ogni sospeccione, / sed e' l'avesson, d'esser oltraggiati, / e ancor per dare lor maggior cagione / d'amar la terra e d'esser anco amati, / e fatto fosse a ciaschedun ragione, / si furo insieme tutti imparentati, / e fatti cittadin con grande amore, / avendo la lor parte d'ogni onore. // Così multiplicando la cittade / di Firenze in persone e'n gran ricchezza, / gran tempo resse con tranquillitade." Boccaccio, *Tutte le opere*, vol. 3, 416–417, stanzas 455–58; Boccaccio, *Nymph of Fiesole*, 130.

87 "Per la contesa che facean si desta / tal che prima dormia malinconoso, / e, con superbia rizzando la cresta, / cominciò a picchiar l'uscio furioso; / e tanto dentro vi diè della testa, / ch'egli entrò dentro, non già con riposo." Boccaccio, *Tutte le opere*, vol. 3, 357, stanza 244; Boccaccio, *Nymph of Fiesole*, 70.

TWO

CULTIVATING COMPLEXIONS
Cleaning and Coloring the Flesh

.

I begin with self-cultivation ... True beauty's a gift of the gods, few can boast they possess it –
and most of you, my dears, don't. Hard work will improve the picture: neglect your looks, and
they'll go to pot, even though you're a second Venus.[1]
 —Ovid (43 BCE–17/18 CE), *Ars Amatoria*

If the eyes are the gateway to the soul, then the skin is the billboard of the body,
broadcasting a person's age and health, and sometimes race and social class,
almost instantly. Throughout much of European history, women have born the
great responsibility (and burden) of presenting clear skin, rosy cheeks, and pink
lips – for displaying that intoxicating "glow" that poets and painters praise
(Figs. 21 and 22).[2] In fifteenth-century Florence, this vibrant complexion was
not only a sign of beauty but also proof of the body's proper humoral balance
and good blood flow, both of which were considered necessary for reproduct-
ive health. Anyone involved in the anxiety-inducing negotiations surrounding
marriage – including suitors, mothers, fathers, and even nosy aunts and uncles –
judged a prospective bride's complexion closely, taking note of whether her
skin was fair or olive, blemished or clear, and enhanced by cosmetics or not.[3]
The stakes were high since the flesh of the chosen bride entered into the
family's bloodline, and any overlooked blemish or rash might indicate infertility
or worse, introduce a disease, such as small pox, into the marital bedchamber.

 Governed by Venus since antiquity, the toilette provided women with
a set of materials for cleaning, smoothing, scenting, and coloring their flesh.

21 Sandro Botticelli, *Birth of Venus*, detail, ca. 1484–86, Gallerie degli Uffizi, Florence, Italy. Photo: Peter Barritt / Alamy Stock Photo

In Giorgio Vasari's sixteenth-century *Toilet of Venus* (Fig. 23), we see the mirror, sponge, ewers, basins, waters, and flowers needed for cultivating a beautiful complexion. In Baccio Bandinelli's contemporaneous drawing of the same subject, also titled *Toilet of Venus* (Fig. 24), we encounter the team of women responsible for making the toilette a success. Likely a study from life, Bandinelli's figures remind us of the handmaidens and servants who filled tubs, washed skin, and dried hair in the domestic interior of elite households. These women also collected ingredients and prepared ointments. Local apothecaries, similar to the *Medieval Apothecary Shop* (Fig. 25) depicted in a fifteenth-century fresco at Issogne Castle, sold many of the raw materials needed for the toilette: orpiment and quicklime for hair removal, brazilwood shavings for rouge, and rose oil and Cyprus powder for fragrance.[4] Artists also had "skin in the game," so to

22 Piero del Pollaiuolo, *Portrait of a Woman*, ca. 1480, Bequest of Edward S. Harkness, 1940, Metropolitan Museum of Art, New York, USA. Photo: Image copyright © The Metropolitan Museum of Art. Image source: Art Resource, NY

speak. In the closing chapters of his early fifteenth-century *Libro dell'arte*, Cennino Cennini warns the painter that, "In the service of young women, especially of those from Tuscany, you may find yourself demonstrating certain

23 Giorgio Vasari, *Toilet of Venus*, 1558, oil on poplar, Stuttgart, Staatsgalerie, Germany. Photo: akg-images

24 Baccio Bandinelli, *Toilet of Venus with Three Nymphs and a Study of an Arm*, ca. 1530–60, Gabinetto Disegni e Stampe, Gallerie degli Uffizi, Florence, Italy. Photo: Gabinetto Fotografico delle Gallerie degli Uffizi

colors for which they have a fancy. And it is their custom to beautify themselves with certain waters."[5] Cennini's comment highlights a correlation, explored in this chapter, between the materials used by artists to paint flesh and the cosmetics and cosmeceuticals employed by women to cultivate it.

This chapter examines early Florentine portrayals of the nude female on art objects intended for the domestic interior and explores the relationship of these bodies to fourteenth- and fifteenth-century discourses on Venus, skin, fertility, and the feminine toilette. It argues that these paintings of the nude (1) offered instruction to women in the arts of beauty and (2) provided a physical image that could aid in the generation of healthy children. Previous scholars have discussed these bare bodies as ideal embodiments of poetic beauty or as arousing stimuli for marital procreation.[6] While not ignoring the male gaze or sexual intercourse, this chapter focuses on the care and cultivation of the female body, whose flesh – after being approved by a family – joined with the flesh of another in order to produce more flesh. Placed in bedroom suites, these nudes were viewed not only by upper-class women but also by handmaidens and servants. This communal, feminine aspect of beautification is often neglected in the study of these objects.

The chapter begins with a discussion of flesh and reproduction, looking at the physical features indicative of feminine health and fertility as outlined in medical treatises and familial letters. It examines the tools and techniques that women wielded to live up to these standards and

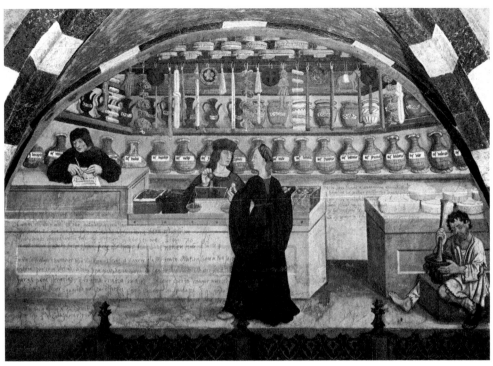

25 *Medieval Apothecary Shop*, fifteenth century, Issogne Castle, Italy. Photo: Science History Images / Alamy Stock Photo

references recipes for cosmeceuticals, cosmetics, and perfumes, found in two medieval and early Renaissance manuscripts.[7] The texts examined in this chapter are (1) Book 3 on "Women's Cosmetics" in the *Trotula* ensemble, a twelfth-century Latin text with Arabic origins and (2) *Amiria*, a short book of cosmetic recipes, written in the Tuscan vernacular and found in a codex under the name of Carlo Alberti, the brother of Leon Battista Alberti.[8] The genre of cosmetic writing, which blossoms in the sixteenth century, has its origins in the writings of Ovid. And while the first-century poet's forays into this field may have prompted the writing of the *Trotula* or the *Amiria*, these two texts include recipes and authorial perspectives that differ from those of Ovid. In *Amiria*, the female speaker defends her art by declaring that "our endeavors are similar to those of painters who use varnish to retain and defend each of their given colors."[9]

The second half of the chapter focuses on fifteenth-century Florentine paintings of the female nude by Paolo Uccello and his workshop, Lo Scheggia (Giovanni di Ser Giovanni Guidi), Paolo Schiavo, Antonio Pollaiuolo, and Sandro Botticelli. Between 1450 and 1500, these artists experimented with materials and techniques in order to present the pearlescent, rosy-hued skin desired by society. This chapter focuses on fair skin as the art of

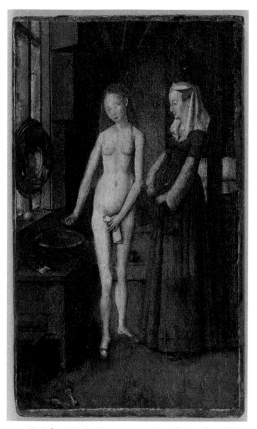

26 (?) After Eyck, Jan van; previously attributed to Unidentified Artist, *Woman at her Toilet*, early sixteenth century. Harvard Art Museums (Cambridge, MA) / Fogg Museum, Francis H. Burr, Louise Haskell Daly, Alpheus Hyatt Purchasing and William M. Prichard Funds. Photo: © President and Fellows of Harvard College

painting other skin colors, including the subtle shades achieved by mixing blues with ochers, would not be practiced until the seventeenth century by artists such as Rembrandt van Rijn and Peter Paul Rubens. The technical achievements of Florentine artists in the fifteenth century, however, were influenced by early fifteenth-century Netherlandish oil paintings. Although Kenneth Clark criticized the nudes within this tradition as being "naked" rather than "nude," these works of art were highly prized in fifteenth-century Italy.[10] A Medici inventory from the Villa Careggi of 1482, for example, describes a Flemish painting depicting "two nude females that bathe with other figures at the window."[11] Interestingly, northern artists often featured the nude in contemporary scenes of bathing and the toilette, as seen in the early sixteenth-century copy of Jan van Eyck's *Woman at her Toilet* (Fig. 26). Florentine artists, in contrast, situated their nudes in mythological contexts. Bare-skinned women with the attributes of Venus appear on the inner lids of *cassone* decorated with stories of mythical romance and in large-scale paintings of the Olympian gods, such as Sandro Botticelli's *Birth of Venus*. Only in the sixteenth century would female bathers, in the guise of Venus, become a popular subject in Florentine art.

GENERATING AND CULTIVATING FLESH

Gynecological treatises written between 1150 and 1450 explain that the female, during pregnancy, generates different layers or types of flesh. The first layer is the placenta, which a follower of the German doctor and philosopher Albertus Magnus (ca. 1200–80) describes as "a certain skin in the womb in which the fetus is enveloped."[12] The second skin is that of the infant, which originates when a man's semen conjoins with a woman's *materia* or matter, which includes both her blood and moisture.[13] Ancient, medieval, and Renaissance

writers often compared the process of a female generating a baby's body to an artist painting or sculpting the human body. The Ferrarese physician Michele Savonarola (1385–1468), for example, describes how the female creates the individual parts of the embryo's body and converts blood into flesh "just as painters first outline and form the members of the figure and then cover them with flesh [*incarnano*]."[14] Saint Hildegard of Bingen (1098–1179), a German Benedictine abbess, philosopher, and writer, explains that in a woman's womb, "a human form is shaped from [the milky coagulation of semen], like a painting."[15]

Because a female needed to transform materials such as semen, blood, and water into the new flesh of a child, grooms as well as their parents paid close attention to the form, color, and cleanliness of her body. Medical treatises and familial letters reference these three factors specifically when discussing a woman's ability to reproduce successfully.[16] The *Trotula*, for instance, discusses the problems that arise in conception if a woman (or a man) is severely under- or overweight, and letters exchanged among kinsmen describe how a young girl's figure might change in form once she becomes a woman and then a matron.[17] Appraisal of a prospective bride's body is evidenced by a request in 1463 from the Sforza family to see the potential bride, Dorotea Gonzaga, naked "in case she had a hunchback." The Gonzaga family denied this request, which ended the marriage negotiations.[18] The petition itself, however, speaks to the close attention paid to the form of the female body as well as to the fear that any deformation or blemish might be symptomatic of a disease or of infertility. According to Hildegard of Bingen, enlarged lymph nodes, red welts, or unusual swellings occurred in women who were not menstruating properly and therefore could not release the "toxic" humors from their bodies.[19]

Cleanliness was another desired characteristic of prospective brides.[20] In a poem dedicated to the "contemplation of a Florentine daughter," Giovanni Martini, writes of the maiden's "clean curls," her "clean ears," her "white throat, immaculate and without any defect," and her "clean arm and hand," all of which are white and sparkling on this "new Venus."[21] Since antiquity, Venus had been associated with the bath. In fifteenth-century Florence, upper-class women bathed at home, often with the help of handmaidens or domestic servants. Most did not frequent public establishments, where those of lesser means cleaned. As Diane Wolfthal and Jill Burke have illustrated, these Venusian places – large pools shared by men and women bathing with or without clothes – were prone to illicit sexuality.[22] The private bath was an elite privilege that required a supply of water, bathing tools, soaps, and towels. Inventories of Florentine palaces list bathing materials, including basins for feet washing, basins for hand washing, copper tubs, pitchers, ewers, and pails along with special towels for drying the hair, body, hands, and face.[23]

In the *Trotula*, the section "On Women's Cosmetics" opens with a set of procedures for making a woman "very soft and smooth and without hairs from her head down."[24] The text instructs the woman to soak first in a steam bath or warm water and wash with French soap. It then directs the lady's handmaiden to apply a depilatory made from quicklime and orpiment (an arsenic sulfide used also as a yellow-orange pigment) in order to "pull out the hairs from the pubic area."[25] In the copy of Jan van Eyck's *Woman at her Toilet* (Fig. 26), the young maiden's gesture of holding a towel to her pubis may signal a recent depilation. In addition to hair removal creams, the *Trotula* and *Amiria* recommend other salves to tighten skin and remove age spots, wrinkles, warts, and bruises. To firm a bosom "infrequently handled," the author recommends a distillation of green pine or a decoction of alum powder and dragon's blood, a pigment also used by painters.[26] If a woman suffers from an "abscessed or freckled complexion," she can try Cleopatra's luxurious formula of pearls liquefied in vinegar or a cheaper cream made with oil of tartar.[27] For smoothing "roughness of the face caused by the sun or the wind," the *Trotula* recommends a "varnish" composed of deer tallow and powdered crystal.[28]

In addition to form and cleanliness, the color of a prospective bride's body was also under scrutiny. In a letter to Piero de' Medici of 1468, Lucrezia Tornabuoni writes that the 16-year-old Clarice Orsini, future bride of their son Lorenzo, "is fairly tall and fair-skinned ... Her face is on the round side, but pleasant enough ... I could not judge her breasts, for the Romans keep theirs covered, but they appeared to be well formed."[29] The fair skin noted by Lucrezia in this appraisal of Clarice Orsini references not only a standard of beauty but also one of health.[30] Luminous skin, which could characterize a complexion of any color, evidenced a woman's moist temperament, while rosy hues pointed to the good flow of blood and the harmonious balance of humors (blood, bile, and phlegm) in her body.[31] As we have seen, both moisture and blood were materials considered necessary for the generation of new flesh in the womb. According to the author of *Amiria*, "very graceful beauty extends to the *candidissime* (very luminous white) and holds on to the cheeks that are vibrant and diffuse as the rose color of the apple. This usually comes from good health and an optimal complexion more often than from some artificial means."[32]

While some women were blessed with a luminous, rosy-hued complexion, those who were not often turned to cosmetics.[33] Women applied white paints, ointments, and powders to their faces, hands, bosom, and teeth to cover scars, hide blemishes, or alter color.[34] Almost all of the recipes for white cosmetics in the *Trotula* and *Amiria* include lead white (Fig. 27a), a toxic pigment also used by painters. Because of the toxicity of lead white, Cennini warns women that if such artificial preparations are used, "your face quickly becomes wizened and

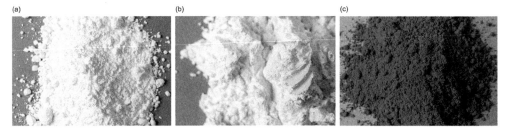

27 Samples of (a) lead white, (b) St. John's white, and (c) vermillion. Photo: Kip Bulwinkle / Karson Photography

your teeth black, and in the end, women grow old before their time. They turn into the most revolting old women there could be."[35] Lead white, however, was rarely used alone, and most recipes suggest mixing it with other naturally bleaching elements, such as tartar, camphor, borax, or alum. To achieve luminescence, glimmering substances were added, including crushed alabaster, coral, marble, or crystal.[36] Women used red and pink cosmetics to enhance the vibrancy of their lips and cheeks, particularly if these areas were pale from "sickness or some other vice," as the *Amiria* notes.[37] In Italy, vermillion (Fig. 27c) was avoided in cosmetics, presumably because of its toxicity. Women were encouraged, instead, to use red lake or brazilwood (Fig. 51b and d). In the *Amiria*, the technique for making a red lake cosmetic is the same as that for manufacturing the pigment.[38] In the *Trotula*, the recipe is simpler: place shavings of brazilwood in an eggshell containing rosewater and a little alum and apply to the cheeks with cotton.[39]

Finally, after cleaning and smoothing their skin, women were encouraged to scent their bodies with aromatic oils, powders, and perfumes infused with roses, myrtle, violets, or orange blossoms. The guild of the Arte dei medici e speziali sold Cypriot and Babylonian powders, two types of soaps, and "unguents of every sort."[40] They offered rose water for 8 *lire* or *soldi* per pound and rose oil for 4 *lire* or *soldi* per pound. They also stocked juniper, chamomile, laurel, violet, and lily oils.[41] In addition to their use as fragrances, these floral and herbal oils functioned medicinally. Roses treated inflammation, and according to the fifth-century physician Theophrastus, were suitable because of their "heat and lightness" to open passages. If a woman was having trouble giving birth, for example, her vagina could be anointed with rose oil.[42] The numerous roses included in paintings of the female nude could reference the cosmetic and medicinal benefits of Venus' favorite flower.

PAINTING FLESH

In the bedroom suite, where skin was judged, cultivated, and generated, Florentine men and women expected to see art that featured luminescent,

rosy-hued bodies. They feared contact with putrid green or pale, peeling flesh. Occasionally, artists depicted diseased skin in representations of St. Lazarus or St. Roch, patron saints associated with the plague; however, these works of art were not intended for the domestic interior. Moreover, they were usually commissioned for chapels outside of Florence and served as votive paintings to ward off the plague and other epidemics.[43] Part of the fear surrounding the viewing of deformed, blemished, or discolored skin, particularly within the domestic interior, originated in the Aristotelian notion of maternal impressions, which posits that images seen by a mother powerfully affect the formation of a baby's features in her womb. Michele Savonarola explains the idea, describing how impressions of external things are stored in the imaginative faculty of a woman's brain and during impregnation, they descend to the womb and impress a certain image "into the material that will generate the fetus."[44] He proves his point with an anecdote, in which he explains how "a white woman gave birth to a very black child, as Aristotle tells us, because during the act of *coitus*, she remembered and reserved in her fantasy the similitude of a moor, in other words, a black person that had been painted in her room."[45] Savonarola goes on to explain that if two lovers are ugly and desire to have beautiful offspring, then they should look upon and place in the mind a lovely figure of a woman and this will be a great help for breeding good-looking children.[46] Leon Battista Alberti includes a similar statement regarding maternal impressions in his architectural treatise *On the Art of Building in Ten Books*.[47] It was therefore advisable for couples to keep images of beautiful people in the bedroom to gaze upon before and after sex.

In the inventory of Paola Gonzaga, who was married in 1477, a "naked Venus" is listed among the possessions kept in her *cassoni*, which also held gold, silver, pearls, precious stones, diamonds, gowns, a wooden chest, an ivory box, ivory combs, gilt jugs, and a water basin.[48] It is likely that Venus' inclusion in this collection relates to her role as a fertility goddess; however, her body could have also been employed for maternal impressions, as an aid in the propagation of handsome children. In the astrological art of melothesia, the planet Venus rules the reproductive organs; she also governs the flesh. Abraham Ibn Ezra states in *The Beginning of Wisdom* of 1148 that "in her [Venus'] share of the human body is the flesh, the milk, the liver, and the semen. All moisture [in the body] belongs to her."[49] In his discussion of fetal development, Michele Savonarola explains that the planet also oversees the "enfleshing" of the embryo in the fifth month of pregnancy.[50] The popularity of Venus' nude body in the bedroom, which would increase steadily throughout the fifteenth century and into the sixteenth century, relates to sex and reproduction, as scholars have shown; however, it also relates to her governance over the skin, the body, and the care of both. The multiplicity of Venus' identity in these realms likely encouraged her presence in Paola Gonzaga's personal collection of objects.

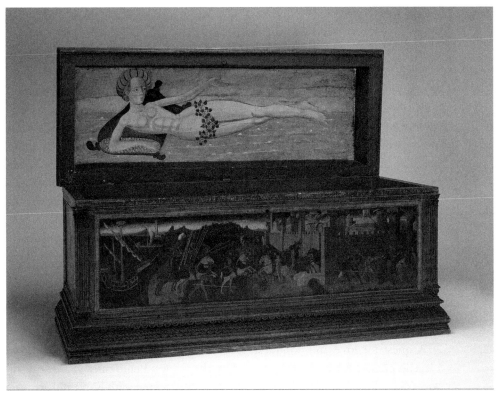

28 Paolo Uccello, *The Battle of the Greeks and Amazons before the Walls of Troy; Allegories of Faith and Justice; and Reclining Nude*, ca. 1460, Yale University Art Gallery, New Haven, CT. Photo: Yale University Art Gallery

Some of the earliest Florentine depictions of the female nude are located on the inner lids of *cassoni* or marriage chests, presented to brides and grooms on the day of their wedding. A chest attributed to Paolo Uccello and his workshop (Fig. 28), dated ca. 1460 and now in the Yale University Art Galleries, is one of only three intact *cassoni* with a reclining female nude on its inner lid. Two panels exist with reclining males, neither of whom are nude.[51] We know from Leon Battista Alberti's treatise *On the Family* that *cassoni* were placed in bedroom suites and were primarily the domain of the wife and her household servants.[52] The husband may at some point peruse the chests' contents in privacy, if we believe Alberti, for "his own pleasure or to check them over."[53] Placed on the ground, the chests were opened to retrieve and return clothing and linen as well as jewelry and toiletry items, then closed and locked in order to protect their contents from harm or theft. The interior of a *cassone* featuring a reclining nude on its inner lid and now in the Victoria and Albert Museum is lined with crimson velvet and includes areas for the storage of bottles and small containers associated with the toilette. On a practical level, the painted nudes inside of these chests provided a model –

almost like a paper doll – of the bride's nude body, which the handmaiden cleaned, smoothed, and colored, then dressed and undressed with clothing from inside of the chest.

In the flickering candlelight of night, the opening of a chest and the sight of a female nude inside would have also been erotic, introducing dynamics of concealment and display (anticipation and pleasure) into the chest's function.[54] In Tuscan poetry, there are several descriptions of the arousing effect of seeing Venus' nude body in a secret, enclosed place. The most famous of these statements appears in Giovanni Boccaccio's *Book of Theseus*, when Palaemon's prayer travels to Venus' inner sanctum and finds her reclining nude upon a bed, a sight that the author proclaims has "marvelous power."[55] A similar description of the titillating nature of the goddess's nude body occurs in a poem by the Florentine Antonio Bonciani, written around 1448 for Astorre II Manfredi, Lord of Faenza. Bonciani writes "with great zeal, one sees beautiful Venus reclining nude in the middle of the bed, which has the power to move anyone who wants to see her."[56] The poet remains, star-struck, in front of this beautiful image until he is taken with the jewel on her head and then continues on with his amorous journey.

A quest for love and conquest decorates the central exterior panel of the Uccello *cassone*. Amazon warriors lead by the fearless Penthesilea charge out of Troy's gates on horseback, wearing dresses and attacking with bows and arrows. They clash with a band of silver-clad Greek soldiers, who advance from their ships wielding long, sharp spears.[57] In Christine de Pizan's *Epistle of Othea*, Penthesilea, the queen of the Amazons, is described as a "brave and virtuous female," who "loved Hector and fought for him in vengeance." According to Pizan, Penthesilea ranks as a chivalric heroine, who upon seeing her beloved's corpse, pledged to "avenge his death."[58] On the chest, the artist depicts Penthesilea in a gold dress, metal armor, and a helmet. She fights bravely for the honor of Hector; however, she is eventually captured and killed by Achilles. In the right corner of the panel, several Amazons try to pull Achilles' spear out of Penthesilea's neck. Three Greek soldiers, however, attack the female warriors with swords and spears. The narrative illustrates both male and female valor; however, it strongly warns women against engaging in masculine endeavors. The chest's depicted violence resembles Boccaccio's *Nymph of Fiesole* (Fig. 19) in that it justifies the man's "taking" of the female body and reminds the bride of her submissive role within the marital union. That role is reiterated on the inner lid of the Uccello *cassone*, where a nude female reclines on the sea. This female could be Penthesilea, Helen, or an allegorical embodiment of Love, similar to the figures of Justice and Faith painted on the chest's exterior side panels. The attributes of water, waves, pillow, *balzo*, and rose garland, however, suggest that the nude female may be Venus, whose beguiling promises at the Judgment of Paris precipitated the Trojan War.[59]

According to Laurence B. Kanter, Curator of Early Modern Art at the Yale University Art Galleries, Uccello's son, Donato di Paolo Uccello, likely painted this nude.[60] The rendering of the female's anatomy (Fig. 29) is rather naïve: circles for breasts, an oval carapace-like form for the torso, a triangle for the pubis, and swooping arcs for shoulders and knees. This type of anatomical stylization was unusual for mid-fifteenth-century Florence; however, Uccello and his workshop also produced mosaics.[61] The artist's geometric forms and faceting rather than blending of colors correlate with mosaic designs. The female's torso resembles thirteenth-century depictions of Christ's body on the cross; however, more emphasis has been placed on her womb, hips, and thighs. The artist delineated an extremely long curve from her mid-waist to her knee. A *pentimento*, visible beneath the skin, reveals that her navel was originally much higher. The woman's belly button, which marks the original attachment of a child to his mother via the umbilical cord, was lowered, likely in an attempt to elongate this fertile area of the body where matters of the flesh ruled.

Donato di Paolo Uccello (or Uccello's workshop) delineated the female's shape and anatomy with a brown pigment, possibly brown umber. This technique strayed from the Giottesque tradition, in which anatomical forms were modeled with *verdaccio* shadows. As described by Cennini, *verdaccio* is a mixture of ocher, black, white, and vermillion that results in a dark greenish-black pigment that Florentine artists, such as Masaccio, used for contour lines and shadows.[62] Lo Scheggia (Giovanni di Ser Giovanni Guidi), the brother of Masaccio, used this pigment for the contour lines and anatomical modeling of a female nude on the inner lid of a *cassone* (Fig. 30), located in the National Gallery of Denmark. Following incision marks in the gesso, Lo Scheggia delineated the female's shape and then suggested the concave and convex forms of her womb, pubis, and hips with *verdaccio* shadows. The technique contributes to the illusion of the figure's three-dimensionality; however, it may have also influenced the dark, shadowy appearance of her skin.

Inside the Uccello *cassone*, the reclining female displays a bright, gleaming complexion due to the avoidance of *verdaccio* shadows as well as to the careful mixing of white and red pigments with egg yolk. In his handbook, Cennini advises that "for the faces of young people with fresh flesh tone," the artist should "temper" his pigments with "egg yolk from city hens because they are whiter yolks than those that country or farm hens produce; these are good, because of their ruddiness, for binding flesh tones of old or brown-skinned people."[63] To paint flesh in tempera, fifteenth-century Florentine artists mixed egg yolk with lead white and vermillion pigments (Fig. 27a and c).[64] Lead white was one of the cheapest pigments and one of the primary ingredients in cosmetics. It was manufactured by burying coils of lead in terracotta vats and exposing them to vinegar, a process that corroded the metal and generated a white encrustation, which could be scraped and used as a pigment.[65] Lead

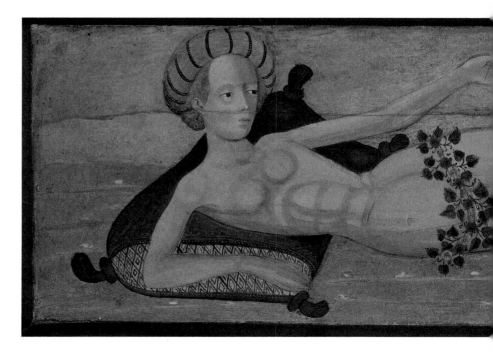

29 Paolo Uccello, *Reclining Nude*, ca. 1460, Yale University Art Gallery, New Haven, CT. Photo: Yale University Art Gallery

white has one of the highest refractive indexes, creates a dense and opaque paint, and does not yellow over time. Its virtues worked well for the depiction of luminous, well-moisturized skin. Human skin, however, could not be depicted with only lead white, unless the painter was representing a corpse. For living flesh, the artist needed to indicate, in some manner, the flow of blood beneath the skin.[66] To suggest this rosy glow, painters employed vermillion, a pigment found naturally in cinnabar or manufactured alchemically through a combination of mercury and sulfur.[67] With its warm orange tones, vermillion tinged flesh better than red lake, a naturally translucent pigment with cold violet tones. In contrast to red lake, vermillion mixed easily with lead white and immediately covered the preparatory ground.

In his *Libro dell'arte*, Cennini recommends mixing three flesh tones from lead white and vermillion: (1) the middle tint for the entire figure, (2) the darkest one for intensifying the shadows, and (3) the lightest one for the highlights.[68] On the inner lid of the Uccello *cassone*, the flesh tones were painted side by side rather than blended together. The individual colors separate into ribbons of pale, soft, and deep pink. The combination of egg yolk, lead white, and vermillion, however, forms a solid, impenetrable layer, which reflects rather than captures light to give body to the figure. Dainty white lines form highlights. A thin one runs down the center of the maiden's nose. The artist

brightened her cheeks with rouge, fashioned into perfect little circles.[69] According to the Greek physician Hippocrates (460–370 BCE), when a woman conceives a male child, her face becomes flush on account of the male heat now within her; if a female, she will become pallid and sluggish.[70]

The female nude inside of the Yale *cassone* possesses a glowing complexion; her flesh appears smooth and clean. Her complexion is not marred by moles, warts, freckles, or pimples, and she is free of hair from her head down to her toes. A tentative peak through the rose garland around her waist reveals a hairless pubis, a feature of the flesh that, as we have seen, required the skillful manipulation of specific materials, including arsenic sulfide. The depiction of water beneath the young woman may allude to bathing, but it may also reference Venus' birth from the foam of the sea, a myth that will be discussed at the end of this chapter. The garland of roses embracing her *mons veneris* evokes a sweet fragrance, which may have once scented this chest in the form of silk sachets filled with powdered rose petals.[71]

A similar nude female, whose appearance with Cupid suggests her identity as Venus, reclines in a Florentine panel (Fig. 31) painted by Paolo Schiavo or one of his assistants between 1440 and 1450, or between 1460 and 1478.[72] The panel's rectangular format and highly finished surface, some of which has been repainted, suggest that it may have been an early *spalliera*, a painting created independently of a *cassone* and hung on the wall of a contemporary bedroom suite.[73] The goddess's lithe, angular body resembles nudes produced by

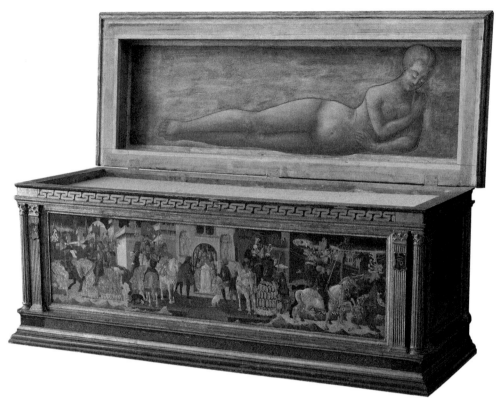

30 Lo Scheggia (Giovanni di Ser Giovanni Guidi), *Cassone* with *Reclining Nude*, ca. 1450–75, National Gallery of Denmark, Copenhagen. Photo: National Gallery of Denmark

Flemish artists, such as Jan van Eyck (Fig. 26) and Roger Van der Weyden. Examples of these paintings were present in Florence, as noted by the listing of a Flemish painting depicting "two nude females that bathe with other figures at the window" in the 1482 inventory of the Medici Villa Careggi.[74] Schiavo's trim figure along with his rejection of heavy *verdaccio* modeling correlates with the style of painting practiced in Florence during the first half of the fifteenth century by artists such as Masolino da Panicale (1383–1447), Pisanello (1395–1455), and Gentile da Fabriano (1370–1427). In his *Lives of the Artists*, Giorgio Vasari claims that Paolo Schiavo was a follower of Masolino, and it is possible that Schiavo adopted the older artist's techniques, which may have included the use of oil instead of egg as a medium for the painting of flesh.[75]

For Venus' fair yet rosy complexion, Schiavo mixes lead white with small amounts of vermillion. He also employs a visual illusion, adopted by many artists of the period, to suggest the goddess's light but also pink skin tone. The illusion consists of two parts: (1) Schiavo placed Venus' nude body against white linen sheets, a contrast that draws attention to her bright but not pure white skin and (2) he included passages of vermillion in the quilting of the pillows, rose garland, and wings of Cupid, which heighten the rosy glow of both the mother and

son's skin, thereby creating the illusion of living flesh. Schiavo painted the skin of Venus and Cupid with short, small strokes, carefully modulating the tones into a smooth, even surface. The terms that Cennini employs in his instructions for blending flesh tones, such as *frescha* (fresh), *gientilmente* (gently), *delicato* (delicate), and *allequidandole e amorbidandole si chome un fummo* (melting them and softening them like a puff of smoke), evoke the desired texture of youthful flesh.[76] In tempera, creating these transitions takes patience and skill as the individual colors dry quickly and do not allow for manipulation or repainting. Schiavo's success at blending colors is evident if we compare the skin of his Venus with that of the nude inside of the Yale *cassone* (Fig. 29), where the individual bands of color stand out sharply from one another. In his panel, Schiavo achieves an almost abstract chromatic and textural unity that suggests the delicate beauty of Venus' and Cupid's identical complexions. His pairing of the two deities evokes the belief that if a pregnant woman were to gaze studiously upon this image, maternal impressions would transfer the luminous skin of this mother and son to her own child.

It is possible that similar theories relate to the portrayal of a nude couple surrounded by ten equally bare, winged-toddlers on a *Mirror Frame in the Form of the Medici Ring* (Fig. 32), now located at the Victoria and Albert Museum in London.[77] This object has been connected to the Pollaiuolo workshop as well as to an artist close to Lorenzo Ghiberti; it is usually dated between 1470 and 1480. During the second half of the fifteenth century, mirrors became popular marital gifts among the elite families of Florence. Marco Parenti (1421–97) purchased one on the occasion of his marriage to Caterina Strozzi, who may have used it in conjunction with the special soaps and waters that she requested from her brother in Naples "to enhance her beauty."[78] Familial records reveal that Parenti also purchased mirrors for his three daughters as part of their dowries.[79] In the fifteenth century, glass mirrors were manufactured in Venice and Flanders, while ones of silver and pewter were produced in Florence.[80] The city's artisans created an array of frames for mirrors, though the most common extant types appear to be constructed of wood, decorated with gesso, then painted. Several of these frames, which feature ideal beauties with luminescent, rosy-hued complexions, are still in existence. The *Mirror Frame in the Form of the Medici Ring* is one such frame that would have originally encased a round mirror of silver, pewter, or blown glass.

Like the basin, ewer, and water, the mirror was a much-desired object of the toilette. Its surface reflected a woman's complexion back to her own gaze. Mirrors also served as tools for artists. Leonardo da Vinci explains that "the mirror ought to be taken as a guide. If you but know well how to compose your picture, it will also seem a natural thing seen in a great mirror."[81] Leonardo's advice applies to artists as well as to women, who composed their own naturalistic pictures in front of the mirror. The *Mirror*

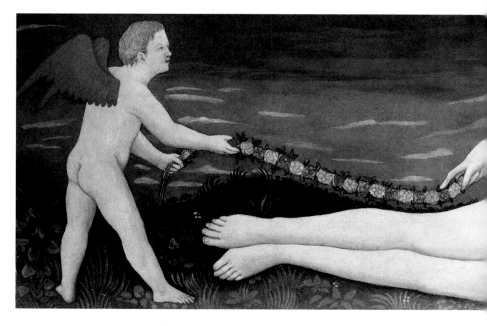

31 Paolo Schiavo, *Venus on Pillows Holding a Garland of Flowers with a Putto*, ca. 1440–50, Galleria Bellini, Florence, Italy. Photo: Christie's Images / Artothek / Alinari Archives

Frame in the form of the Medici Ring presents a family with matching rosy-hued complexions. Pollaiuolo painted the ten *amorini* and the nude couple, who are often identified as Venus and Mars, with the same palette of white and pink flesh tones. The even application of paint and the smooth transitions between colors suggest the use of oil rather than egg yolk as a binder for the pigments. One wonders if the original owners of the mirror believed that the process of conception could be aided by the viewing of this nude couple and their charming *amorini* or if maternal impressions were thought to be magnified by looking into a mirror and seeing one's own flesh. In an ekphrastic description of the *Erotes* in his *Imagines*, Philostratus (ca. 170–247/250) describes nymphs offering mirrors to Venus as gifts in appreciation for making them "mothers of Cupids and therefore blest in their children."[82] The *Mirror Frame in the Form of the Medici Ring* emphasizes procreative fertility while also providing the female with an essential tool in her quest for timeless beauty.[83]

REPRODUCING FLESH

The next Florentine innovation in the genre of the female nude occurs in Sandro Botticelli's *Birth of Venus* (Fig. 33), a monumental wall painting measuring 5.8 × 9.2 feet and likely created for a member of the Medici family between 1484 and 1486.[84] Instead of a single nude figure, Botticelli depicted a

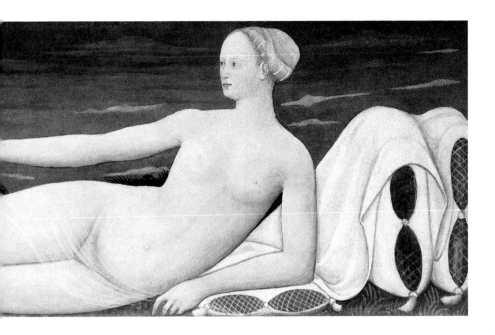

narrative scene of Venus' triumphal arrival to the island of Cyprus. Rather than reclining, the goddess stands in a pose inspired by Praxiteles' famous *Aphrodite of Knidos*, a marble sculpture known in the Renaissance through Roman copies, including small bronze statuettes of *Venus pudica* (Fig. 34). Botticelli's Venus models the anatomical curves of the ancient prototype rather than the thinner, more angular shapes of Uccello and Schiavo's nudes. It is likely that Botticelli saw and drew an ancient sculptural variant of Praxiteles' *Aphrodite of Knidos* when he was in Rome painting frescos for the Sistine Chapel in 1482. He likely knew of the sculpture's erotic power from Pliny the Elder's *Natural History* or Lucian of Samosata's *Affairs of the Heart*.[85] He may have also been familiar with Filarete's *Treatise on Architecture* (written between 1460 and 1464), which stated that the original sculpture was in Rome and "excited to desire any man who saw it."[86]

32 After Antonio Pollaiuolo, *Mirror Frame in the Form of the Medici Ring*, 1470–80, Victoria and Albert Museum, London. Photo: © Victoria and Albert Museum, London

Botticelli painted the *Birth of Venus* on canvas rather than wood, a change of support that he was experimenting with in the 1480s.[87] The restoration report from 1986/1987 indicates that Botticelli applied a thin layer of preparatory ground (*gesso fino*) on linen cloth instead of the standard thick ground (*gesso grosso*) used

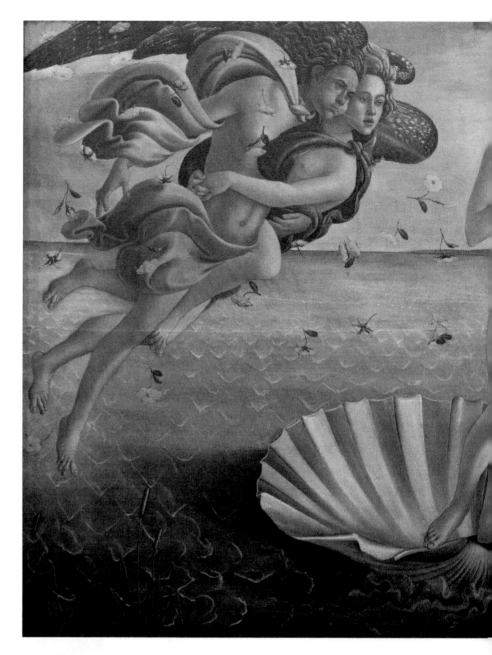

33 Sandro Botticelli, *Birth of Venus*, ca. 1484–86, Gallerie degli Uffizi, Florence, Italy. Photo: Adam Eastland / Alamy Stock Photo

for wood panels. Restorers found that this layer of gesso contains a substantial amount of crystalline gypsum believed to be alabaster, in less than the normal amount of glue. While gypsum and anhydrite (Fig. 35a) are chalky and opaque, alabaster (Fig. 35b) is translucent and luminous; it is the finest grade of gypsum. The term "alabaster skin" derives from the milky white, yet slightly

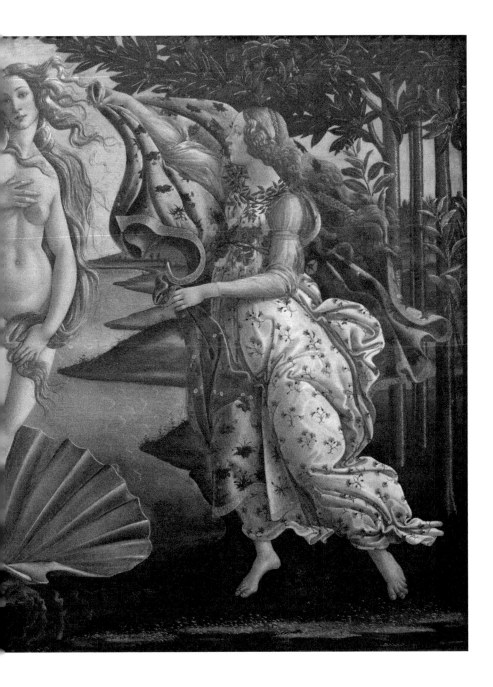

pink color of the stone, which allows for light to shine within it but not through it, an effect that produces a soft rather than a bright illumination. Botticelli's thin alabaster ground captures light and color, which contributes to the incandescent glow of Venus' skin.[88]

On top of this thin preparatory ground, Botticelli transferred his drawing of Venus from a cartoon to the canvas. Reflectographs reveal subtle yet

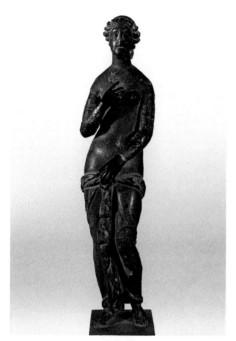

34 Roman statuette of *Venus*, a variation of Praxiteles' *Aphrodite of Knidos*, second century CE, Museo Archeologico Nazionale, Florence, Italy. Photo: by concession of the Museo Archeologico Nazionale di Firenze (Polo Museale della Toscana)

clear contour lines as well as several corrections in the goddess's pose and anatomy.[89] Botticelli modeled Venus' form with shadows painted in verdigris (Fig. 55c), a pigment manufactured by exposing copper plates to vinegar.[90] Naturally translucent, verdigris produces a soft, silky shadow. The subtle turquoise tones resemble the color of veins beneath flesh, an effect that enhances the painted goddess's living presence. Next, Botticelli applied his flesh tones in very thin layers (Fig. 36), making sure that the verdigris was still visible in the primary areas of shadow. He used lead white and vermillion bound in either albumen (egg white) or oil, instead of egg yolk.[91] In one of these fluid mediums, he laid down an initial layer of flesh color and then tinted Venus' skin with pink and yellow glazes, fashioned from a small amount of pigment in a substantial amount of oil. Restorers found that in the *Primavera*, Botticelli applied a thin glaze or veil of red lake (Fig. 51b) to certain areas of Venus' skin to enhance and perfect her rosy glow.[92] In the *Birth of Venus*, he used similar glazes to differentiate colors and surface textures on the goddess's skin. With an ocher glaze, he strengthened but also softened the shadows under her breasts, at her navel, and in the triangular area of her pubis. He painted a pink blushing glaze across Venus' chin, cheeks, nostrils, and around her hazel eyes (Fig. 21). He reserved the purest red, though still mixed with lead white, for her tinted lips.

Botticelli's layering of thin colors, each with its own refractive surface of binder and pigment particle, creates a stunning effect. Light penetrates through the white, pink, ocher, and green down to the alabaster ground so that, visually, Venus' skin glows. The artist's use of thin layers of translucent or semitranslucent paint also creates fluid transitions between the colors, approximating the soft and smooth texture of real flesh. Botticelli's decision to bind his pigments with oil correlates with the contemporaneous experiments of Antonio Pollaiuolo and Leonardo da Vinci, who were painting skin and

(a)

(b)

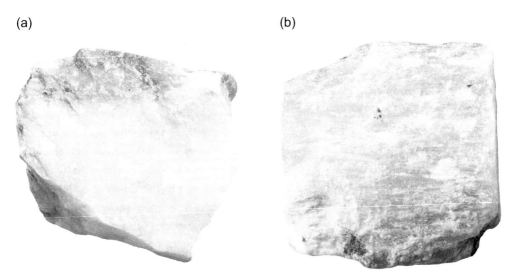

35 (a) Anhydrite stone isolated on white background, September 6, 2016. Photographer: Valery Vvoennyy. Photo: Panther Media GmbH / Alamy Stock Photo. (b) Macro shooting of specimen natural rock-specimen of gypsum (alabaster) mineral stone isolated on white background, December 22, 2015. Photo: Valery Voennyy / Alamy Stock Photo

drapery with similar oil glazes. Another influence on Botticelli's adoption of the technique may have been the Flemish painting of nude bathers listed in the Medici inventory of 1482.

As Aby Warburg has argued, Angelo Poliziano, the learned poet and friend of Lorenzo de' Medici, likely proposed the *concetto* of Botticelli's *Birth of Venus*.[93] In his *Stanze per la giostra* (1478), Poliziano describes a scene of Venus' nativity, sculpted on one of the piers flanking the entrance to her temple on Cyprus. Poliziano's account draws on several ancient sources, including Hesiod's tale of Aphrodite's birth in the *Theogony* (700 BCE) and the second Homeric Hymn (seventh century BCE), which narrates the goddess's arrival to the shores of Cyprus.[94] In his text, Poliziano explains how the goddess emerges from the waves and "presses her hair with her right hand, covering with the other her sweet mound of flesh."[95] He then narrates how the Horae, goddesses of the seasons, welcome Venus and adorn her with a starry robe and jewels of gold. Botticelli's painting differs from Poliziano's poem in the positioning of the goddess's hands and in the portrayal of one Hora instead of three; however, the painting and the poem reflect one another.

In Poliziano's poem, Venus' nativity constitutes a cosmological moment when the goddess of generation is herself generated from the seed of heaven – the severed testicles of Uranus – falling into the earthly womb of the sea. In the *Saturnalia* (ca. 430 CE), the Roman writer Macrobius explains that upon Venus' parturition, "the capacity for engendering living things in an unbroken sequence

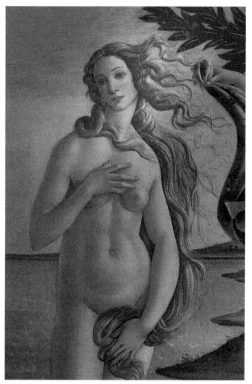

36 Sandro Botticelli, *Birth of Venus*, detail, ca. 1484–86, Gallerie degli Uffizi, Florence, Italy. Photo: Peter Barritt / Alamy Stock Photo

of reproduction was transferred from water to Venus, so that all things would thenceforth come into being through the intercourse of male and female."[96] In his *Genealogy of the Gods*, Giovanni Boccaccio (1313–75) repeats this allegory, explaining how the myth's different elements (a god's severed testicles, the rhythmic movement of the waves, the sea foam, and the womb of the sea) signify the different materials and movements needed to generate a child: blood, sexual thrusting, semen, and moisture. In effect, the genitalia of Uranus (the male contribution to procreation) are thrown into the sea (the female body), and the friction of the waves (similar to the movement of two bodies in coitus) creates foam or *spume*, which then produces offspring in the womb.[97] In Botticelli's composition, the sky and the sea – the goddess's father and mother – press against one another at the painting's horizon line and bisect Venus' navel. In this same area, the collar of the cloak held by the Hora curves in another distinctive undulating shape, which is not unlike a diagrammatic image of a uterus or a placenta, one of the skins generated by the female during pregnancy.

The wind god Zephyr, who is described in the second Homeric Hymn to Aphrodite, also allegorically relates to reproductive physiology. In her twelfth-century gynecological treatise, Hildegard of Bingen explains that intercourse begins with desire, a mental and physiological change brought about by a "virile wind" that stirs up the male's blood into "foamy semen" and erects his phallus for ejaculation.[98] Women also experienced this "wind of pleasure," which "falls" into the uterus and "stirs her blood toward pleasure," spreading out into the wide and open space around the navel.[99] In the *Birth of Venus*, Zephyr's fertilizing breath blows in faint white lines directly to Venus' navel and womb. Pushing the air from his lungs, Zephyr also whips the sea water into *spume*, or foamy semen. This frothy, bubbling substance gathers at the base of the scallop shell, an ancient symbol of the womb.[100]

Allegorically, Botticelli's *Birth of Venus* suggests the complex process of reproduction. The artist visualizes the physical joining of man and wife in coitus with the intertwined bodies of Zephyr and Flora. From their union, roses fall from heaven; the soft pink petals resemble the goddess's rosy-hued

flesh. In a Florentine carnival song, women are encouraged to use the flowers of Venus to excite their husband's love: "Women, who burn with love / take for yourselves things / that are full of the fragrances / of violets, lilies, and roses; / and these are good for the spouses / to make their lovers joyful."[101] With its youthful bodies surrounded by pink roses, salt water, warm breezes, green grass, and flowering trees, Botticelli's painting is aphrodisiacal. Indeed, the birth of Venus was known to have inspired desire in an instant. According to the Homeric Hymn, the immortals, who "welcomed her [Aphrodite] on sight," each prayed "to take her home as his wedded wife."[102] Poliziano similarly explains that upon seeing the newly born goddess, the other gods longed "to share the pleasures of her bed."[103]

With the liminal position of this earth-borne goddess in mind, we should also consider the other, more spiritual implications of her creation, particularly as the painting was created within Marsilio Ficino's Neoplatonic circle. In his commentary on Plato's *Philebus* (1474), Ficino describes Venus' genesis as a cosmogonic mystery that symbolizes the birth of beauty, rather than the birth of sex, within the human soul. Ficino explains how the falling of Uranus' testes into the foaming sea stands for the pouring forth of divinity into the human soul, which is then fertilized to create beauty (Venus) within itself, a beauty that enables upward ascent towards divine or "higher things" as well as downward movement towards sensible or "lower things."[104] By portraying the moment of Venus' birth, Botticelli created a discursive image of beauty that could arouse the viewer to seek the lofty transcendence of Ficino's Neoplatonic philosophies or the sexual fulfillment of Poliziano's sensual verses.

Modeled after Praxiteles' *Aphrodite*, Botticelli's nude Venus enjoyed considerable success in late fifteenth-century Florence. At least four copies of the goddess exist today. One is likely by Botticelli, two appear to be by his workshop, and the fourth is by Lorenzo di Credi. In all four variations, Venus stands in a *contrapposto* pose with her hands in the ancient *pudica* gesture. Isolated from the maritime setting of her birth and from the subsidiary figures in the narrative, she is alone against a solid black background. These pared-down versions, derived either from the original cartoon or from traced copies of the central figure, were likely cheaper than Botticelli's original *Birth of Venus*. They speak, however, to the broadly held desire to possess a nude female in the guise of Venus. Placed within bedroom suites, these works of art not only stimulated passion within the marital bond but also reminded women of the self-cultivation necessary to sustain that passion over decades, or else, as the ancient poet Ovid declared, your complexion might "go to pot, even though you're a second Venus."[105]

The special waters, soaps, colors, oils, and powders used by women in fifteenth-century Florence were intended to aid in the process of cultivating a luminous, rosy-hued complexion, a physical feature that increased their

chances of marriage and motherhood. Many of the paintings of Venus examined in this chapter addressed a female audience of 14- to 28-year-olds, who would have known that much of their social and matrimonial value was attached to beautiful and healthy flesh. Crafted during a period when humanists began to question the church's views of sin and shame, these paintings of nude Venuses represent a conceptual shift that placed the female body and its reproductive abilities at the very center of Florence's future prosperity. That women were willing to transform themselves in imitation of these ideals, even at the risk of poisoning themselves or earning the ire of their elders, speaks to the power of this aesthetic ideal and the sorrows that awaited those who fell short of it. Venus, like love itself, could be cruel.

NOTES

1 Ovid, "The Art of Love," in *The Erotic Poems*, trans. Peter Green (London: Penguin Books, 1982), Book 3, 217.

2 For historical discussions of the poetic and social ideals that encouraged rosy cheeks and pink lips, see Elizabeth Cropper, "On Beautiful Women, Parmigianino, Petrarchismo, and the Vernacular Style," *Art Bulletin* 58 (1976): 374–94; Teresa Riordan, *Inventing Beauty. A History of the Innovations that Have Made Us Beautiful* (New York: Broadway Books, 2004), 33–61; Aileen Ribeiro, *Facing Beauty: Painted Women & Cosmetic Art* (New Haven, CT: Yale University Press, 2011), 68–76.

3 In a letter to her son Filippo in Naples, Alessandra Macinghi Strozzi describes a potential bride's complexion, writing, "As far as her looks go, they tell me what I have in fact seen. She has a good, well-proportioned figure ... Her skin is not very fair, but not dark; rather she has an olive complexion. I saw her without cosmetics and in low-heeled shoes. So, what I saw fits with what I have been told, and I don't think I was wrong about it and about her disposition." ("Della bellezza, mi dicono quello ch' io m' ho veduto, ch' ell' ha una bella persona, e benfatta; el viso è lungo: ma i' no la pote' in viso molto vedere, perché parve ch' ella se n' avvedesse ch' io la guatavo; ... Ella non è di pelo molto bianco, ma non è bruno; è ulivigna. I' la vidi sanza liscio, e con poche pianelle. Sì che di quello ch' i' ho veduto se riscontra col dire di chi i' n' ho domandata; e non me ne pare essere ingannata di questo, e della condizione buona ch' ell' ha.") For Italian text, see Alessandra Macinghi Strozzi, *Tempo di affetti e di mercanti: lettere ai figli esuli* (Milan: Garzanti, 1987), 240; for English translation, see Mary Rogers and Paolo Tinagli, eds., *Women in Italy, 1350–1650. Ideals and Realities* (Manchester: Manchester University Press, 2005), 119.

4 Orpiment, rose oil, and Cyprus powder are among the many materials offered for the toilette by Florentine apothecaries. These materials are included in the *gabelle* of the Arte dei medici e speziali from 1442; see Giovanni Francesco Pagnini, ed., *Della decima e di varie altre gravezze imposte dal comune di Firenze: contenente La pratica della mercatura scritta da Giovanni di Antonio da Uzzano nel 1442*, vol. 2 (Lisbon and Lucca, 1765–66; reprint, Bologna: Forni, 1967), Book 4, 22–23.

5 "Egliacchaderebbe inservigio delle giovani donne spezial / mente di quelle di toschana di dimostrare alchuno colore / del quale anno vagheza e usano di farsi belle dalchune aque." Cennino Cennini, *Il libro dell'arte*, trans. Lara Broecke (London: Archetype, 2015), 249.

6 For discussions of sexual responses to reclining nude figures inside of *cassone* chests, see Patricia Rubin, "The Seductions of Antiquity," in *Manifestations of Venus*, ed. Caroline

Arscott and Katie Scott (Manchester: Manchester University Press, 2001), 24–38; Adrian W. B. Randolph, *Touching Objects: Intimate Experiences of Italian Fifteenth-Century Art* (New Haven, CT: Yale University Press, 2014), 151–67.

7 This genre of writing, often described as *secreti*, or secrets, does not become popular until the sixteenth century. The first of these texts is Girolamo Ruscelli, *De secreti del reverendo donno Alessio Piemontese* (Lyon: Theobaldo Pagano, 1558). For a discussion of this genre of writing, see Jo Wheeler, *Renaissance Secrets: Recipes and Formulas* (London: Victoria and Albert Museum, 2009), 7–13.

8 Including cures for unwanted smells in the mouth and genitalia as well as a recipe for "making a woman seem to be a virgin," Book 3 of the *Trotula* ensemble is a practical guide for preparing a woman's body for intercourse. Anicio Bonucci attributed the Florentine text of *Amiria* to Leon Battista Alberti. The text appears in the Magliabechiana al Codice N. 38, Palch. IV, under the name of Carlo Alberti, the brother of Leon Battista. Bonucci argues that the technical language of *Amiria* appears in other works by Leon Battista, such as *Ecatomfilea* or *Efebia*, another work under the name of Carlo Alberti; see Bonucci's introduction to the text in Leon Battista Alberti, *Amiria* in *Opere volgari*, ed. Anicio Bonucci, vol. 5 (Florence: Galileiana, 1849), 269–70.

9 "In noi simile adopera, quale a' dipintori la vernice ritiene e difende ogni dato colore." *Amiria* in Alberti, *Opere volgari*, vol. 5, 279.

10 Kenneth Clark, *The Nude: A Study in Ideal Form* (New York: Doubleday, 1956), 308–47. For a discussion of Flemish paintings of the female nude and their appearance in Italian collections, see Peter Schabacker and Elizabeth Jones, "Jan van Eyck's 'Woman at Her Toilet': Proposals concerning its Subject and Context," *Annual Report (Fogg Art Museum)* 1974/1976 (1974–76): 59–60; Paula Nuttall, "Reconsidering the Nude: Northern Tradition and Venetian Innovation," in *The Meanings of Nudity in Medieval Art*, ed. Sherry Lindquist (Farnham: Ashgate, 2012), 299–318; Diane Wolfthal, "From Venus to Witches: The Female Nude in Northern Europe," in *The Renaissance Nude*, ed. Thomas Kren with Jill Burke and Stephen J. Campbell (Los Angeles: J. Paul Getty Museum, 2018), 81–91.

11 Bartolomeo Facio (1400–57) described two paintings of nudes: (1) nudes emerging from the bath, owned by Ottaviano della Carda, advisor to Federico da Montefeltro and (2) a woman at bath spied on by young men, belonging to a patron in Genoa. For Facio's text, see Michael Baxandall, "Bartholomaus Facius on Painting: A Fifteenth-Century Manuscript of *De Viris Illustribus*," *Journal of the Warburg and Courtauld Institutes* 27 (1964): 90–107, especially 102–104. The Flemish painting of nudes owned by the Medici was located at the Villa Careggi. The inventory entry reads: "due femine gnude che si bagnono et più altre figure alle finestre." For inventory, see Eugène Müntz, *Les collections des Médicis au XVe siècle* (Paris: Jules Rouam, 1888), 90. For a discussion of this painting, see Paula Nuttall, *From Flanders to Florence: The Impact of Netherlandish Painting, 1400–1500* (New Haven, CT: Yale University Press, 2004), 112.

12 In commentaries to Pseudo-Albertus Magnus' *Women's Secrets*, the placenta is described as "a certain skin in the womb in which the fetus is enveloped ... and it is generated with other skins from the seeds of generation." *Women's Secrets: A Translation of Pseudo-Albertus Magnus's De Secretis Mulierum with Commentaries*, ed. Helen Rodnite Lemay (Albany: State University of New York Press, 1992), 108.

13 Hildegard of Bingen describes conception in the following manner: "Man's blood instills a cold foam into the woman which is coagulated by the warmth of the mother's flesh and developed into a sanguineous form. This foam, staying in that warmth, later on grows from the sweat of the mother's dry nourishment into a firm small human figure until the creator's script, which formed the human, perfuses this entire firm human figure, just as a potter forms his most glorious vessel." Hildegard of Bingen, *On Natural Philosophy and Medicine. Selections from Cause et cure*, trans. Margret Berger (Cambridge: D. S. Brewer, 1999), 44.

14 "Facto che ha tale operatione nei sei primi zuorni o cerca procede a la generatione di le ale del pecto, quello formendo e lineando le altre parte dil corpo, mandando per tute il sangue

necessario a la formatione dil corpo … e da poi converte il sangue sparso in carne, la quale rempie le vacuità che se ritrovano fra membro e membro, come fanno depentori che prima lineano e formano i membri di la figura, da puoi quelli incarnano." Michele Savonarola, *Il trattato ginecologico-pediatrico in volgare*, ed. Luigi Belloni (Milan: Società Italiana di Ostetricia e Ginecologia, 1952), 33–34.

15 Bingen, *On Natural Philosophy and Medicine*, 84, 44–45.

16 As a planet, Venus was believed to bestow a healthy body type to those born under her influence. Ptolemy, for example, describes Venus' children as "more shapely, graceful, womanish, effeminate in figure, plump, and luxurious." The statures of the children of other planetary deities are different: Saturn's children are "robust"; Jupiter's offspring are "tall, and commanding respect"; while Mercury's children are "lean and spare." Ptolemy, *Tetrabiblos*, trans. F. E. Robbins, Loeb Classical Library 435 (Cambridge, MA: Harvard University Press, 1940), Book 3, 308–11.

17 The *Trotula* explains that "there are some women who are useless for conception, either because they are too lean and thin, or because they are too fat and the flesh surrounding the orifice of the womb constricts it and does not permit the seed of the man to enter" ("Quedam mulieres sunt inutiles ad concipiendum, uel quia nimis tenues sunt et macre, uel quia sunt nimis pingues et caro circumuoluta orificio matricis constringit eam, nec permittit semen uiri in eam intrare"). *Trotula*, 94–95. In a letter of April 25/26, 1477, Girolamo Strozzi writes to his kinsman and patron Filippo Strozzi about the appearance of his future wife: "All this has been put together by my poor powers of judgement. My verdict is that she may be a more beautiful young woman and matron than she is a girl, if she doesn't grow fat, which I couldn't be sure about. She has a good, well-made body, but her features are not genteel or delicate, though [they are] dignified, taken all together. About her height, I would not judge her to be taller than I am. I doubt I am mistaken about her height, as she was wearing flat slippers. Her hands are fleshy, or to put it another way, pudgy and not long; her arms are better proportioned." For letter, see ASF, Carte Strozziane, third series, 247, ff. 3233, 34. For translation, see Heather Gregory, "Daughters, Dowries and the Family in Fifteenth Century Florence," *Rinascimento* 27 (1987): 232.

18 Luca Beltrami, "L'annullamento del contratto di matrimonio fra Galeazzo M. Sforza e Dorotea Gonzaga (1463)," *Archivio Storico Lombardo* 6 (1889): 129–31. For discussion of the incident in terms of nudity, see Jill Burke, *The Italian Renaissance Nude* (New Haven, CT: Yale University Press), 53.

19 Hildegard of Bingen explains that in sanguine women who do not menstruate, a "worm" can grow in the flesh, lymph nodes can burst, or leprosy can appear. In a phlegmatic woman, tumors may appear or "they will develop wildly growing flesh on a limb, like a gall." Choleric women may show black tumors or cancers of the breast, while melancholic women end up with gout or "rapid swelling of the body because waste matter and foulness, from which menstruation should have purged their bodies, remain enclosed in them." Bingen, *On Natural Philosophy and Medicine*, 63–65. In *De secretis mulierum*, a follower of Albertus Magnus warns men not to have sex with women during menstruation because the "venom" of their menses can cause leprosy or cancer. According to one commentator, infants conceived at this time might also develop leprosy. This commentator explains that women are so full of venom in the time of their menstruation that they "poison animals by their glance, they infect children in the cradle, they spot the cleanest mirror; and whenever men have sexual intercourse with them they are made leprous and sometimes cancerous." See Commentator A in *Women's Secrets*, 60.

20 Abraham Ibn Ezra and the *Picatrix* both assign cleanliness to Venus; see Avraham Ben Meir Ibn Ezra, *The Beginning of Wisdom (Reshith Hochma)*, trans. Meira B. Eptstein (Las Vegas: ARHAT, 1998), 199; *Picatrix: A Medieval Treatise on Astral Magic*, trans. Dan Attrell and David Porreca (University Park: Pennsylvania State University Press, 2019), 157. In his treatise *On the Family*, Alberti explains the importance of cleanliness in a wife: "Who is stupid enough, not to see clearly that a woman who does not care for neatness and

cleanliness in her appearance, not only in her dress and body but in all her behavior and language, is by no means well mannered?" Leon Battista Alberti, *The Family in Renaissance Florence*, trans. Renée Neu Watkins (Columbia: University of South Carolina Press, 1969), 116.

21 "Il naso ha tanta bella fazïone / che fa innamorar giovani e vecchi, / puliti e par gli orecchi, / [...] / sì che dimostra suo' piccoli denti, / bianchi e rilucenti, / [...] / isvelta gola e bianca, / immaculata sanza alcun difetto! / [...] / distese braccia grosse e la sua mano / bianca, sottile, vezzosa e pulita, / sottili e lunghe dita / colle unghie rilucenti e un poco tenere. // Ogni altra parte d'esta nuova Venere, che tien coperta d'assai belle veste." *Lirici toscani del Quattrocento*, vol. 2, 44, lines 29–31, 38–39, 47–48, 54–58.

22 Diane Wolfthal, *In and Out of the Marital Bed: Seeing Sex in Renaissance Europe* (New Haven, CT: Yale University Press, 2010), 121–53; Burke, *The Italian Renaissance Nude*, 38–41.

23 Items for the bath and toilette appear in the 1492 inventory of the Medici Palace, taken at the death of Lorenzo de' Medici. In the water closet of the chamber of Piero de' Medici, which is located in the same chamber as *cassoni* containing garments, the following items are listed: "a cedar table with a trestle base, a washtub on feet, a barber's bowl, a basin for hand washing, a brass candlestick, two lamps with brass bases, a round bronze bucket with two funnels, and a pewter jug." In the room above the antechamber of Piero de' Medici, we find the following towels listed: "ten hairdressing towels in a set and with a fringe of thread, eight thin towels of 3 ½ br. each, in a set for hairdressing, twenty wide towels of 2 ½ br. each, for the bed-settle, ten face towels, rounded, 3 ½ br. each, twenty-five face towels, thin, of – br. each, with white stripes, three and a half thin towels, for widowed women, six towels without fringe, of thin cloth, 3 br. each, seventeen French linen towels with fringe of thread and wide embroidered plaid pattern, thirty face towels from large to small, twenty-four shaving towels from large to small, eight thin towels without stripes, three towels with decorated fringe and six women's aprons." Richard Stapleford, *Lorenzo de' Medici at Home. The Inventory of the Palazzo Medici in 1492* (University Park: Pennsylvania State University Press, 2013), 151, 160.

24 "Ut mulier suauissima et planissima fiat et sine pilis a capite inferius, inprimis eat ad balnea, et si non consueuerit, fiat ei stupha hoc modo." *Trotula*, 166–67.

25 The bath is described as follows in the *Trotula*: "Ut mulier suauissima et planissima fiat et sine pilis a capite inferius, inprimis eat ad balnea, et si non consueuerit, fiat ei stupha hoc modo. ... Postea etiam ungat se totam hoc psilotro, quod recipit calcem uiuam et bene cribellatam, et pone in uase figuli uncias .iii. et decoque in modum pultis. Post accipe auripigmentum unciam .i. et iterum coque, et proba cum penna si sit satis coctum. ... Cum mulier hoc psilotro se totam inunxerit, sedeat in stupha multum calida, nec fricet se quoniam excoriarentur membra eius. Sed cum parum steterit, tempta pillos euellere a pectine. ... Deinde exeat et tunc accipiat furfur distemperatum cum aqua calida, et postea colet et super se fundat. Illud carnem mundificat et lenit. Deinde lauet se aqua tepida, et stet parum ut cutis aliquantulum desiccetur. Postea accipe alcannam cum albuminibus ouorum, et inungat omnia membra. Hoc carnem lenit, et si qua fuerit ustura ex psilotro, hanc remouet et reddit lucidam et suauem." *Trotula*, 166–69. Orpiment, which was used also as a pigment, is included in the *gabelle* of the Arte dei medici e speziali guild: "orpimento il 100. a peso lir. 3. La libbra den. 7. e un terzo - - - - - - - - - - fior. - -lir. 3 - - - -." Pagnini, ed., *Della decima e di varie altre gravezze imposte dal comune di Firenze*, vol. 2, Book 4, 22.

26 Dragon's blood was a pigment, also sold by the Arte dei medici e speziali: "sangue di dragone la libbra - - - - - fior. - -lir. - -1.4." Pagnini, ed., *Della decima e di varie altre gravezze imposte dal comune di Firenze*, vol. 2, Book 4, 24.

27 "Quelle adunque saranno con ragione quanto vi s' affaccia. Sono macule e segni lintigginosi, e porri, calli simili cose, molto a ténere e dilicate bellezze nimiche e contrarie. Queste si leveranno tutte, se torrete in prima (qual solea usare, quanto dicono, la famosa reina

Cleopatra) perle liquefatte in aceto, e gibetti insieme, e simili odoriferi. Ma troveremo in pronto suco di radice di canna, dicozione di limoni in vino, itios, farina di ceci, amido di fave, borace, olio di mandorle dolci. Ancora radice di cocomeri spolverizzata, bollita in orina, usata più dì, lieva dal viso panni e rughe." *Amiria* in Alberti, *Opere volgari*, vol. 5, 282. A recipe for a facial ointment in the *Trotula* reads, "Primo abluat faciem cum sapone gallico et cum aqua calida optime et cum colatura furfuris abluat se in balneo. Postea accipe oleum de tartaro et inungat faciem suam prius desiccatam. Oleum de tartaro sic fit ... Tali oleo in ampulla collecto, mulier faciem suam inungat per .vii. noctes et totidem dies, et etiam per .xv. si habeat uultum pannosum et lentiginosum." *Trotula*, 176–77.

28 The varnish is described as follows in the *Trotula*: "Ad asperitatem faciei de sole uel uento, uel ad eam dealbandam et clarificandam, sepum ceruinum bulliat in aqua. Deinde in aliam aquam cola, et colatum diu cum manibus moueatur, et tunc habeatur puluis cristalli et uernicis." *Trotula*, 180–81.

29 Paul Strathern, *The Medici: Power, Money, and Ambition in the Italian Renaissance* (London: Pegasus, 2017), 152.

30 It was also believed that the planets contributed to an individual's complexion. According to Ptolemy, Saturn "makes his subjects in appearance dark-skinned," while Mercury "makes his subjects in appearance sallow" or of "olive complexion." Jupiter and Venus make their subjects in appearance "light of skin but in such a way as to have a good color." Ptolemy, *Tetrabiblos*, Book 3, 308–11. A poetic reference to the complexion of Venus' children can be found in a poem by Filippo Scarlatti, describing his beloved Giuletta's beauty. He writes, "Giuletta pellegrina, alta e vezzosa, / angelica, gentile e grazïosa, / candida, rossa, in paradiso nata, / tu siedi in terza spera incoronata, / dove Amor vive e trïonfando posa." *Lirici toscani del Quattrocento*, ed. Antonio Lanza, vol. 2 (Rome: Bulzoni, 1975), 513, poem 32, lines 2–6.

31 According to Hildegard of Bingen, the darker, redder hues of a man's flesh exemplify the heat of his virility in contrast to the woman's pale tones, which indicate the moisture of her fertility; see Bingen, *On Natural Philosophy and Medicine*, 58.

32 "Gratissima bellezza porge sulle candidissime e tenere gote acceso e sparso quasi come rosato colore suso il pome. Questo disidero in voi da buona sanità e ottima complessione più molto che da artifizio alcuno." *Amiria* in Alberti, *Opere volgari*, vol. 5, 278.

33 Queen Elizabeth I, for example, used a cosmetic containing lead white to cover the deep marks left from her battle with small pox; see Eleanor Herman, *The Royal Art of Poison: Filthy Palaces, Fatal Cosmetics, Deadly Medicine, and Murder Most Foul* (New York: St. Martin's Press, 2018), 31–38.

34 For white cosmetic recipes and for the whitening of teeth, see *Trotula*, 178–81, 186–87; *Amiria* in Alberti, *Opere volgari*, vol. 5, 278–79, 280.

35 "Ti che sse usi altro matrial fattura il volto viene / in corto tenpo vizo e denti negri efinalmente le donne invechiano / innanzi il corso del tenpo pervengnion le piu soze vecchie ch / e possa essere." Cennini, *Il libro dell'arte*, 249.

36 Alberti's recipe for "when you want to show off very white flesh" includes: milk, bean starch, crushed marble, crushed glass, white lead decocted in river water, a feather of alum, borax, camphor, oil of tartar, calcined tartar, calcined crystal, calcined egg shells, rock alum, incense, mastic, myrrh, dragon's blood, galbanum, and frankincense, mixed together and strained through a cloth" ("E quando pure godessi mostrarvi candidissime, torrete qualunche sia latte, amido di qualunche legume, marmo trito, vetro pesto, biacca molto dicotta in acqua di fiume, piuma d'allume, borace, canfora, olio di tartaro, tartaro calcinato, calcina di cristallo, calcina di gusci d'uovo, allume di rocca arso, incenso, mastice, mirra, draganti, galbano, olibano, decotti insieme e stillati per feltro"). For this and other white cosmetic recipes, see *Amiria* in Alberti, *Opere volgari*, vol. 5, 278–80. The *Trotula* provides similar recipes. The simplest consists of lead white, ground, then cooked with rainwater, dried, and then cooked with rosewater. For white cosmetics, see *Trotula*, 162–63, 178–81, 186–91.

37 "E piacendovi in quelle biancose parti avere vostri labbri coloritissimi e le gote bene accese, se per infermità o altro vizio fussono smorte e scolorite, arete comune rimedio dicozione di grana o brasile, insieme con allume di rocca in orina di fanciulli, or in un vino vecchio, bianco e possentissimo." *Amiria* in Alberti, *Opere volgari*, vol. 5, 279.

38 Red dye materials, either *grana* (dried kermes or cochineal insects) or shavings of *verzino* (brazilwood or sappanwood), should be combined with alum and an acidic substance, such as white wine or a young boy's urine. The acid then precipitates the red dye from the insects or wood shavings onto the alum. Dried, the combination forms a lump of color that could be ground, then moistened with water for application. The recipe in *Amiria* reads, "E piacendovi in quelle biancose parti avere vostri labbri coloritissimi e le gote bene accese, se per infermità o altro vizio fussono smorte e scolorite, arete comune rimedio dicozione di grana o brasile, insieme con allume di rocca in orina di fanciulli, o in uno vino vecchio, bianco e possentissimo." See *Amiria* in Alberti, *Opere volgari*, vol. 5, 279. There are four types of *grana* listed in the *gabelle* of the Arte dei medici e speziali: "grana di Provenza il 100. a peso - - - fior. 3. lir. - - - - - -"; "grana di Romania il 100. a peso fior. 4. lir. 2. La libbra fol. 4. den. 7 e un quinto - - fior. 4. lir. 2. - - - -"; "grana di Valenza il 100. a peso fior. 2. lir. 2. La libbra fol. 2. - - - - - - - - - fior. 2 lir. 2. - - - -"; and "grana Spagnuola, grana Barberesca il 100. a peso fior. 1. lir. 2. La libbra fol. 1. den. 2. e due quinti - - - - - - - - - fior. 1. lir. 2. - - - -." Brazilwood or *verzino* is listed as "verzino mondo, o schorzuto il cento a peso fiorini 1. lire 1. La libbra soldi 1. - - - fior. 1 lir. 1. - - - - -." Pagnini, ed., *Della decima e di varie altre gravezze imposte dal comune di Firenze*, vol. 2, Book 4, 20, 25.

39 "Recipe rasuram brasilii et ponatur in testa oui parum continentis aque rosacee, et ponatur ibidem parum aluminis, et hoc tali ungat bombacem et imprimat super faciem et reddat eam rubeam." For this recipe and others for reddening the lips, see *Trotula*, 178–79, 184–85.

40 The *gabelle* for the guild of the Arte dei medici e speziali includes "polvere di Cipri il 100. a peso lir. 1. 16. La libbra den. 4. e un terzo - - - fior. - - lir. 1. 16. - -"; "polvere di Banbilonia il 100. a peso lir. 2. 8. La libbra den. 5. e tre quarti - - - fior. - - lir. 2. 8 - -"; "sapone sodo, sapone molle il 100. a peso soldi 15. 7. La libbra den. 1. e sette ottavi - - - - - fior. - - lir. - - 15. 7."; and "unguenti d'ogni ragione la libbra - - - - fior. - - lir. - - - - 5." Pagnini, ed., *Della decima e di varie altre gravezze imposte dal comune di Firenze*, vol. 2, Book 4, 23, 24, 26.

41 Rose water is listed as "acqua rosata la libbra - - - - - - - fior. - - lir. - - 8.- -." Oils are listed as "olio rosato, olio di ginepro, olio di camamilla, olio d' aneti, olio di ruta, olio laurino, olio di volpe, olio d' assenzio, olio violato, olio melato, olio di gigli, olio di mastrice, olio di neufano la libbra - fior. - - lir. - - - - 4." Pagnini, ed., *Della decima e di varie altre gravezze imposte dal comune di Firenze*, vol. 2, Book 4, 18, 22.

42 Theophrastus writes of the rose: "while this perfume is both light as to its scent and also by its heat well adapted to bring the passages to a suitable temperature and to open them Again the fragrance also supplies a stimulus to movement. This perfume is also considered to be good against lassitude, because its heat and its lightness make it suitable, and also because it penetrates to the inner passages." Theophrastus, *Enquiry into Plants, Volume II: Books 6–9. On Odours. Weather Signs*, trans. Arthur F. Hort, Loeb Classical Library 79 (Cambridge, MA: Harvard University Press, 1916), 370–71. For the use of roses in treatments for the menses, for pregnancy, and for labor, see *Trotula*, 84–85, 96–97, 100–101.

43 Two Florentine paintings that include patron saints displaying green skin or red welts that evidence the plague are (1) Piero di Cosimo, *Madonna and Child with Saints Lazarus and Sebastian*, ca. 1480–85, Church of SS Michele Arcangelo e Lorenzo Martire, Montevettolini, Italy and (2) Sandro Botticelli and Assistant, *Madonna and Child Enthroned with Saints Sebastian, Lawrence, John the Evangelist and Roch*, 1499, Montelupo Fiorentino, pieve di San Giovanni Evangelista, Italy. These works were commissioned for churches outside of Florence and appear to have functioned as votive paintings to ward off the plague.

44 "Questo adonca spirito animale, il quale se parte dal cervello nel tempo de la impregnatione, nel quale se fa la impressione di le similitudine di le cosse exteriore, spetialiter nel

primo ventriculo suo dove habita la vertù fantastica, descende al luoco de la generatione cum tal similitudine più in lui impressa, e cussì più potente quella imprime ne la materia di la quale generare se debbe il feto." Savonarola, *Il trattato ginecologico-pediatrico*, 14.

45 "E per somegliante caxuone una dona biancha parturite uno fiolo nigrissimo, come dice Aristotile, havendo lei in tal acto memoria e similitudine reservata ne la fantasia de uno muoro overo negro ne la camera suoa depinto." Savonarola, *Il trattato ginecologico-pediatrico*, 14.

46 "E di questo loco togliere se può la caxuone il perchè le giovene amorose, quando prima se engravidano, parturiscono i fioli alcuna fiata a li amanti simile; apresso, che quelle che suono brute, se desiderano havere bella prole, cussì se debono raramente spechiare e ponere la mente ad alcuna bella figura di dona e di quella spesso spesso aricordarse, specialiter in l'acto di la coniunctione: che certa gie serà grande aiuto a generare bella prole." Savonarola, *Il trattato ginecologico-pediatrico*, 14.

47 Alberti writes, "Wherever man and wife come together, it is advisable only to hang portraits of men of dignity and handsome appearance; for they say that this may have a great influence on the fertility of the mother and the appearance of future offspring." Leon Battista Alberti, *On the Art of Building in Ten Books*, trans. Joseph Rykwert et al. (Cambridge, MA: MIT Press, 1988), 299. For discussions of maternal impressions, see Jacqueline Marie Musacchio, "Imaginative Conceptions in Renaissance Italy," in *Picturing Women in Renaissance and Baroque Italy*, ed. Geraldine A. Johnson and Sara F. Matthews Grieco (Cambridge: Cambridge University Press, 1997), 42–60; Geraldine Johnson, "Beautiful Brides and Model Mothers. The Devotional and Talismanic Functions of Early Modern Marian Reliefs," in *The Material Culture of Sex, Procreation and Marriage in Premodern Europe*, ed. Anne L. McClanan and Karen Rosoff Encarnación (New York: Palgrave, 2002), 135–61; Steven Connor, *The Book of Skin* (Ithaca, NY: Cornell University Press, 2004), 101–18. For a discussion of how the bed, the bedroom, and sex were understood during the early modern period, see Wolfthal, *In and Out of the Marital Bed*, 12–41.

48 For this inventory, see Susan E. Wegner, "Unpacking the Renaissance Marriage Chest: Ideal Images and Actual Lives," in *Beauty & Duty: The Art and Business of Renaissance Marriage*, ed. Katy Kline (Brunswick: Bowdoin College Museum of Art, 2008), 13; Graham Hughes, *Renaissance Cassoni: Masterpieces of Early Italian Art: Painted Marriage Chests 1400–1500* (London: Art Books International, 1997), 66.

49 Ezra, *The Beginning of Wisdom*, 101. Ptolemy also describes the parts of the body that might suffer an injury or a disease and the individual planets that govern each part. To Venus he ascribes "smell, the liver, and the flesh." Ptolemy, *Tetrabiblos*, Book 3, 318–21.

50 Michele Savonarola writes that Venus influences the fifth month and "gives the generation of flesh, which is augmented and formed into a beautiful figure of members" ("Nel quinto influisse Venus, ... apresso giova a la generatione di la carne, quella augumentando e formendo di bella figura i membri"). Savonarola, *Il trattato ginecologico-pediatrico*, 38.

51 For the Uccello *cassone*, see Lisa R. Brody et al., "A 'Cassone' Painted in the Workshop of Paulo Uccello and Possibly Carved in the Workshop of Domenico del Tasso," *Yale University Art Gallery Bulletin* (2010): 114–17. For discussion of the nude and semi-nude figures inside of *cassoni*, see Ellen Callmann, "An Apollonio di Giovanni for an Historic Marriage," *Burlington Magazine* 119 (1977): 174–81; E. H. Gombrich, "Apollonio di Giovanni: A Florentine Cassone Workshop Seen through the Eyes of a Humanist Poet," *Journal of the Warburg and Courtauld Institutes* 18 (1955): 27; Musacchio, "Imaginative Conceptions in Renaissance Italy," 42–60; Randolph, *Touching Objects*, 151–67.

52 One of the first lessons Leon Battista Alberti teaches his new wife, as he boasts of in his treatise *On the Family*, concerns a *cassone*: "Dear wife, if you put into your marriage chest not only our silken gowns and gold and valuable jewelry, but also the flax to be spun and the little pot of oil, too, and finally the little chicks, and then locked the whole thing securely with your key, tell me would you think you had taken good care of

everything because everything was locked up?" The answer to Alberti's question is no, since a pot of oil might ruin the gowns and locking up the flax would preclude spinning it. For a wife should learn not only to guard her possessions but also to put them in their proper place. Alberti's advice suggests that marriage chests were the domain of the wife or the domestic servant to whom she assigned them; see Alberti, *The Family in Renaissance Florence*, 221–22.

53 Alberti, *The Family in Renaissance Florence*, 209.

54 Patricia Simons, "The Visual Dynamics of (Un)veiling in Early Modern Culture," in *Visual Cultures of Secrecy in Early Modern Europe*, ed. Timothy McCall, Sean Roberts, and Giancarlo Fiorenza (Kirksville, MI: Truman State University Press, 2013), 24–53.

55 "When she first approached, she found Opulence guarding the door, at which she marveled greatly. When she was permitted by Opulence to enter, she saw that the place was dark when she first went in. As she remained there, however, she found that there was a little light, and she saw Her reclining naked on a huge bed that was very beautiful to see. She had golden curls, unbraided and bound about her head. Her countenance was such that those who have been most praised have no beauty to compare with hers. Her arms and her bosom and her elevated breasts were completely visible, and the rest of her body was covered by a robe so flimsy that it scarcely concealed anything. The place was scented with a thousand perfumes." In the gloss to the text, Boccaccio discusses the arousing materials in this place of Venus and notes that seeing the goddess nude in secret "has marvelous power." Giovanni Boccaccio, *The Book of Theseus (Teseida delle Nozze d'Emilia)*, trans. Bernadette Marie McCoy (New York: Medieval Text Association, 1974), Book 7, 179; commentary, 200.

56 "Venere bella si vedea giacere / ignuda a mezzo el letto con gran zelo, / che ben potea chi la volea vedere, / bench'ella avessi in sulle carni un velo / sottile e bianco, che meno occupava / el corpo suo che non fa l'aria el cielo. / In questa bella immagin rimirava." *Lirici toscani del Quattrocento*, vol. 1, 299, lines 154–60.

57 When the Uccello *cassone* was brought into conservation in July of 2016, the armor was examined under stereo-microscope. The investigation revealed the presence of silver particles, possibly a powdered silver pigment mixed with egg white. The patron and artist likely knew that the silver pigment would tarnish; however, they still chose it, not for its longevity, but rather for its magnificent gleam during the wedding procession and the beginning of the couple's marriage.

58 "Penthesilea was a maiden, queen of the Amazons, and was very beautiful and of marvelous prowess in arms, and hardy; for the great good which the renown transmitted through all the world of Hector the worthy, this one loved him with very great love, and from the parties of the Orient came to Troy in the time of the great siege to see Hector. But when she found him dead, she became despondent out of moderation; and with a very great host of gentlewomen very chivalrously avenged his death, where she performed deeds of marvelous prowess and many great griefs she created for the Greeks. And because she was virtuous, it is said to the good knight that he ought to love her, and this is understood that each good knight ought to love and prize every virtuous person, and similarly a woman strong in virtue of intelligence and constancy." Christine de Pizan, *Christine de Pizan's Letter of Othea to Hector*, trans. Jane Chance (Cambridge: D. S. Brewer, 1997), 52.

59 The ancient rhetorician Libanius (314–94 CE) described Venus as wearing a rose garland at the Judgment of Paris; see Mirella Levi D'Ancona, *The Garden of the Renaissance: Botanical Symbolism in Italian Painting* (Florence: Leo S. Olschki, 1977), 330.

60 The attribution of the Yale *cassone* to Uccello's son was discussed with Laurence Kanter in July of 2016. For information on the stylistic features of Uccello's studio and his son Donato di Paolo Uccello, see Laurence B. Kanter, "The 'cose piccole' of Paolo Uccello," *Apollo* 52 (2000): 15–17. Paolo Uccello's daughter was also a painter, documented as such upon her death as a nun in the Carmelite Order. No paintings have been attributed to her; see Scott

Nethersole, *Art of Renaissance Florence: A City and Its Legacy* (London: Laurence King Publishing, 2019), 71.

61 Kanter, "The 'cose piccole' of Paolo Uccello," 17.

62 Cennini writes of the underlayer: "ti conviene comin / ciare per questo modo abbi unpocho diverde terra conun poco / dibiaccha ben tenperata ea tistesa danne due volte sopra ilviso / sopra le mani sopra ipie e sopra ingnudi." Cennini, *Il libro dell'arte*, 190. In a section dedicated to painting flesh on panels, Cennini mentions shading first (before the application of flesh tones) with *verdaccio*. His recipe for *verdaccio* appears in the section on painting bodies in fresco. Here, he explains that *verdaccio* is a mixture of "ocria schura," "nero," "biancho san giovanni," and "cinabrese"; see Cennini, *Il libro dell'arte*, 98, 101.

63 "Ma questo cotal letto vuo / le essere a visi di giovani con frescha incarnazione tenperato / illetto e lle incarnazioni co rrossume duovo di ghalline de / lla cipta perche sono piu bianchi rossumi che quelli che fanno / le ghalline dicontado o ville che sono buoni per la loro rosseza / a ttenperare incarnazioni divecchi o bruni." Cennini, *Il libro dell'arte*, 190.

64 For a historical discussion of painting recipes for skin tones found in German, Dutch, and French manuscripts, see Ann-Sophie Lehmann, "Fleshing Out the Body: The 'Colours of the Naked' in Workshop Practice and Art Theory, 1400–1600," *Nederlands Kunsthistorisch Jaarboek* 58 (2007–2008): 89–92.

65 For lead white's production and its characteristics, see Rutherford J. Gettens, Hermann Kühn, and W. T. Chase, "Lead White," in *Artists' Pigments: A Handbook of Their History and Characteristics*, ed. Ashok Roy, vol. 2 (Oxford: Oxford University Press, 1993), 67–81. For a discussion of the unusual characteristics of this pigment, see Spike Bucklow, "Lead White's Mysteries," in *The Matter of Art: Materials, Practices, Cultural Logics, c. 1250–1750*, ed. Christy Anderson, Anne Dunlop, and Pamela H. Smith (Manchester: Manchester University Press, 2015), 141–59; David Coles, *Chromatopia: An Illustrated History of Colour* (New York: Thames & Hudson, 2019), 38–39.

66 In his instructions for painting a dead man, Cennini instructs the artist, "do not apply any pink because a dead person has no color" ("non dare rossetta al / chuna che l morto nonn a nullo colore"). Cennini, *Il libro dell'arte*, 192.

67 For a discussion of vermillion's characteristics and manufacture, see Rutherford J. Gettens, Robert L. Feller, and W. T. Chase, "Vermilion and Cinnabar," in *Artists' Pigments*, vol. 2, 159–82; Coles, *Chromatopia*, 70–71.

68 "Sechondo che llavori et colorisci in muro per quel medesimo modo fatte tre maniere dincar / nazioni piu chiara luna che ll altra mettendo ciaschuna / incarnazion nelsuo luogho degli spazii del viso." Cennini, *Il libro dell'arte*, 190.

69 Cennini explains that for the "reliefs" of the face, such as the "tip of the nose," the artist should use "pure lead white." Cennini, *Il libro dell'arte*, 190. In his discussion of painting faces in fresco, Cennini describes the pinks of the cheeks as *meluze* or apples, noting that "my master used to position these apples nearer to the ears than to the nose because they help to bring the face into relief." Cennini, *Il libro dell'arte*, 99, 102.

70 The change in a woman's skin color resulting from the carrying of a male or a female in the womb is noted in most treatises concerned with female health. Treatises describe the skin color of a woman after the conception of a male child either as red or as "good coloring." The text of *De secretis mulierum* reads, "If a male is conceived, the woman's face is of a reddish color, and her movement is light." *Women's Secrets*, 123. In *Della vita civile*, the Florentine Matteo Palmieri (1406–75) writes of this effect: "In questo tempo se la creatura piglia forma masculina ritiene la gravida colore migliore; la grossezza gli dà meno molestia, e prima comincia ad avere moto vivo. La femina più tardi dà moto vivace, la madre fa pallida: indeboliscele gambe, falla tarda, e dàlle peggiore grossezza." Matteo Palmieri, *Della vita civile* (Milan: Giovanni Silvestri, 1825), 15. This effect is also cited in *Trotula*, 104–105.

71 A recipe for "a sweet and odiferous powder, very excellent to lay in chests and coffers" appears in a 1555 treatise written by Girolamo Ruscelli. Composed of dried and pulverized

rose buds, rosewater, musk, and pounded violets, this powder was placed in "very fine linen bags" and put in chests "where your apparel lieth." Ruscelli, *De secreti del reverendo donno Alessio Piemontese*, 50.

72 For discussion of Paolo Schiavo's *Venus on Pillows*, see Luigi Bellini, *Gallery Bellini. Museo Bellini dal 1756* (Florence: Nerbini, 2009), 38–39; catalogue entry (no. 58b) by Deborah L. Krohn in *Art and Love in Renaissance Italy*, ed. Andrea Bayer (New York: Metropolitan Museum of Art, 2008), 134–36; Randolph, *Touching Objects*, 152–54.

73 For information on *spalliere*, see Anne B. Barriault, *Spalliera Paintings of Renaissance Tuscany. Fables of Poets for Patrician Homes* (University Park: Pennsylvania State University Press, 1994), 1–11; Nathaniel Silver, "'Among the Most Beautiful Works He Made.' Botticelli's *Spalliera* Paintings," in *Botticelli Heroines + Heroes*, ed. Nathaniel Silver (London: Paul Holberton Publishing, 2019), 32–55.

74 For entry, see Müntz, *Les collections des Médicis au XVe siècle*, 90. For a discussion of the entry, see Schabacker and Jones, "Jan van Eyck's 'Woman at Her Toilet': Proposals concerning its Subject and Context," 59–60.

75 In his *Life of Masolino*, Vasari writes, "And Paolo Schiavo – who painted the Madonna and the figures with their feet foreshortened on the cornice on the Canto de' Gori in Florence – strove greatly to follow the manner of Masolino, from whose works, having studied them many times, I find his manner very different from that of those who were before him, seeing that he added majesty to the figures, and gave softness and a beautiful flow of folds to the draperies. The heads of his figures, also, are much better than those made before his day, for he was a little more successful in making the roundness of the eyes, and many other beautiful parts of the body." ("E Paolo Schiavo, che in Fiorenza in sul canto de'Gori fece la Nostra Donna con le figure che scortano i piedi in su la cornice, s'ingegnò molto di seguir la maniera di Masolino, l'opere del quale avendo io molte volte considerato, truovo la maniera sua molto variata da quella di coloro che furono innanzi a lui, avendo egli aggiunto maestà alle figure, e fatto il panneggiare morbido e con belle falde di pieghe. Sono anco le teste delle sue figure molto migliori che l'altre fatte innanzi, avendo egli trovato un poco meglio il girare degli occhi, e nei corpi molte altre belle parti.") For Italian text, see Giorgio Vasari, *Le vite de' più eccellenti pittori, scultori ed architettori*, ed. Gaetano Milanesi, vol. 2 (Florence: G. C. Sansoni, 1878), 266; for English text, see Giorgio Vasari, *Lives of the Most Eminent Painters, Sculptors, and Architects*, trans. Gaston du C. de Vere, vol. 2 (London: Macmillan, 1912), 166–67. Despite Vasari's comment, there is no documentation linking the two artists; however, Schiavo was given the task of completing Masolino's frescos on the choir walls of the Collegiata in Castiglione Olona. For documentation of Schiavo's work at the Collegiata and a discussion of Schiavo as Masolino's pupil, see Paul Joannides, *Masaccio and Masolino: A Complete Catalogue* (London: Harry N. Abrams, 1993), 34, 247. For an analysis of the differences between the styles of Masolino and Schiavo as well as a critique of Schiavo's style, see Ellen Callmann, "Masolino da Panicale and Florentine Cassone Painting," *Apollo* 150 (1999): 42–49, in particular 43–44.

76 For Cennini's instructions for painting flesh, see Cennini, *Il libro dell'arte*, 97–102, 190–91.

77 The diamond ring was a heraldic symbol of both the Medici and Tornabuoni families. Several mirrors are listed in the 1492 inventory of the Medici palace, and one is described as ornamented with a diamond motif. In a bedchamber above the Sala Grande, a "large mirror in low relief" is mentioned. In the chamber of the two beds, the inventory lists "a silver mirror weighing 1 lib., 5 ounces, on one side the infant [Christ], on the other a diamond and coat of arms with branches around." Another mirror is documented alongside a box of musk and a jewelry box in the large bedchamber of Lorenzo de' Medici, while a "round mirror with ivory frame decorated with the seven virtues" appears in the ante-chamber of Piero de' Medici's bedroom; see Stapleford, *Lorenzo de' Medici at Home*, 65, 107, 120, 156.

78 "Dice la Caterina, che tu faccia ch'ell' abbia un poco di quel sapone; e se v'è niuna buon' acqua o altra cosa da far bella, che ti prega gliele mandi presto; e per persona fidata, chè se

ne fa cattività." For Italian and English text, see *Selected Letters of Alessandra Strozzi*, trans. Heather Gregory (Berkeley: University of California Press, 1997), 34–35.

79 For a discussion of mirrors in Florentine inventories of the fifteenth century, see Jacqueline Marie Musacchio, *Art, Marriage, and Family in the Florentine Renaissance Palace* (New Haven, CT: Yale University Press, 2008), 165–68. For the Parenti inventory, which includes the following citations: "specchio grande," "specchio d'avorio a figure bello," and "speccio grande d'osso a figure bello," see Carte strozziane II, 17 bis, 68r, 71v, and 78v.

80 For a discussion of the mirror's relationship to the gaze, art, and beauty, see Sabine Melchior-Bonnet, *The Mirror: A History*, trans. Katharine H. Jewett (New York: Routledge, 2001), 3–8, 14–20; Mark Pendergrast, *Mirror, Mirror: A History of the Human Love Affair with Reflection* (New York: Basic Books, 2003), 137–39.

81 For the Leonardo quote, see Pendergrast, *Mirror, Mirror*, 138.

82 Philostratus the Elder, Philostratus the Younger, Callistratus, *Philostratus the Elder, Imagines. Philostratus the Younger, Imagines. Callistratus, Descriptions*, trans. Arthur Fairbanks, Loeb Classical Library 256 (Cambridge, MA: Harvard University Press, 1931), Book I. 6, 29. In his discussion of Venus' iconography, Vincenzo Cartari notes this ekphrasis, explaining how the nymphs make a statue of Venus and offer her a silver mirror "because she makes them the mothers of such beautiful offspring" ("alcuni altri hanno voluto, che piutosto sia uno specchio, perche scrive Filostrato nella dipintura, ch'ei fa de gli Amori, che le Ninfe possero una statoa à Venere, perch'elle la fecero madre di cosi bella prole, come sono gli Amori, e le dedicarono uno specchio di argento, con alcuni adornamenti de i piedi dorati"). Vincenzo Cartari, *Le imagini de i dei de gli antichi* (Lyon: Stefano Michele, 1581), 458.

83 A veiled warning against the desire for eternal youth may have been included in the iconography of *Mirror Frame in the Form of the Medici Ring*. The pose of the nude male resembles representations of Endymion on Roman sarcophagi. Endymion's quest for eternal youth led to his being condemned "to sleep forever." If such a reference was recognized via the ancient quotation, it would have reminded the viewer of the dangers that accompanied the desire for eternal youth, a desire fostered with the mirror and the judgment of one's constantly aging complexion. For a discussion of this object, see Patricia Lee Rubin and Alison Wright, *Renaissance Florence: The Art of the 1470s* (London: National Gallery Publications Ltd., 1999), 320–21; John Pope-Hennessy, *Catalogue of Italian Sculpture in the Victoria and Albert Museum. Volume I: Text. Eighth to Fifteenth Century* (London: Her Majesty's Stationery Office, 1964), 153, 154; Eric Maclagan and Margaret H. Longhurst, *Catalogue of Italian Sculpture. Text* (London: Victoria and Albert Museum, 1932), 49.

84 For discussions of Botticelli's *Birth of Venus*, see Aby Warburg, "Sandro Botticelli's *Birth of Venus* and *Spring*: An Examination of Concepts of Antiquity in the Italian Early Renaissance (1893)," in *The Renewal of Pagan Antiquity: Contributions to the Cultural History of the European Renaissance*, trans. David Britt (Los Angeles: Getty Research Institute, 1999), 88–111; E. H. Gombrich, "Botticelli's Mythologies: A Study in the Neoplatonic Symbolism of His Circle," *Journal of the Warburg and Courtauld Institutes* 8 (1945): 43–60; Arnaldo D'Addario, *Due quadri del Botticelli eseguiti per nascite in Casa Medici: Nuova interpretazione della "Primavera" e della "Nascita di Venere"* (Florence: Olschki, 1992); Jane C. Long, "Botticelli's 'Birth of Venus' as Wedding Painting," *Aurora: The Journal of the History of Art* 9 (2008): 1–27.

85 Pliny, *Natural History, Volume X: Books 36–37*, trans. D. E. Eichholz, Loeb Classical Library 419 (Cambridge, MA: Harvard University Press, 1962), Book 36, 16–17; Lucian, *Soloecista. Lucius or The Ass. Amores. Halcyon. Demosthenes. Podagra. Ocypus. Cyniscus. Philopatris. Charidemus. Nero*, trans. M. D. Macleod, Loeb Classical Library 432 (Cambridge, MA: Harvard University Press, 1967), 174–77.

86 Filarete, *Filarete's Treatise on Architecture; Being the Treatise by Antonio di Piero Averlino, Known as Filarete*, ed. and trans. John R. Spencer (New Haven, CT: Yale University Press, 1965), 267.

87 Though somewhat new in the 1480s, canvas was being used by other Florentine artists, and Botticelli completed several paintings on this support during this decade, including his *Wymss Madonna* and a *Pallas with a Shield*, which once hung in the bedchamber of Piero de' Medici. The inventory for "the chamber of Piero" includes "a canvas in a gilt frame, about 4 br. high by 2 br. wide, depicting a figure of Pa[llas] with a shield before her and a jousting lance by Sandro di Botticello f. 10." For inventory, see Stapleford, *Lorenzo de' Medici at Home*, 143.

88 Mauro Matteini and Arcangelo Moles, "Indagine sui materiali e le stesure pittoriche del dipinto," *Gli Uffizi Studi e Ricerche: La Nascita di Venere e l'Annunciazione del Botticelli restaurate* 4 (1987): 75–78. The alabaster ground is also described by Cristina Acidini, "For a Prosperous Florence: Botticelli's Allegories," in *Botticelli: Likeness, Myth, Devotion*, ed. Andreas Schumacher (Frankfurt: Städel Museum, 2010), 86.

89 For example, Botticelli drew and then redrew Venus' breasts three times, eventually choosing the middle size; see Alfio Del Serra, "Il restauro della Nascita di Venere," *Gli Uffizi Studi e Ricerche: La Nascita di Venere e l'Annunciazione del Botticelli restaurate* 4 (1987): 53.

90 Botticelli's choice to combine verdigris with lead white was unorthodox, if considered in the context of Cennini's *Il libro dell' arte*. Cennini declares that these two pigments "are absolute mortal enemies" ("Questo cholore ebuono in tavola tenperato / con cholla ghuarti di nonne avicinarlo mai conbiaccha perche in tutto sono ini / mici mortali"). Cennini, *Il libro dell'arte*, 82.

91 Alessandro Cecchi describes Botticelli's technique in the *Birth of Venus* as "una tempera magra su tela, verniciata a chiara d'uovo." Alessandro Cecchi, *Botticelli* (Milan: Federico Motta, 2005), 219. During restoration, only samples of Zephyr and Chloris' flesh were analyzed. The samples revealed lead white and vermillion but did not confirm the binder as egg or oil; see Matteini and Moles, "Indagine sui materiali e le stesure pittoriche del dipinto," 79.

92 Mauro Matteini and Arcangelo Moles, "La Primavera, Tecnica di esecuzione e stato di conservazione," in *Metodo e scienza operatività e ricerca nel restauro (Firenze 23 giugno 1982–6 gennaio 1983)*, ed. Umberto Baldini (Florence: Sansoni, 1983), 228.

93 Warburg, "Sandro Botticelli's *Birth of Venus* and *Spring*," 89–95. For Poliziano's description of Venus' birth, see Angelo Poliziano, *The Stanze*, trans. David Quint (University Park: Pennsylvania State University Press, 1993), 50–53, stanzas 99–103.

94 Hesiod writes, "Then his son reached out from his ambush with his left hand, and with his right hand he grasped the monstrous sickle, long and jagged-toothed, and eagerly he reaped the genitals from his dear father and threw them behind him to be borne away. ... And when at first he had cut off the genitals with the adamant and thrown them from the land into the strongly surging sea, they were borne along the water for a long time, and a white foam rose up around them from the immortal flesh; and inside this grew a maiden. First she approached holy Cythera, and from there she went on to sea-girt Cyprus. She came forth, a reverend, beautiful goddess, and grass grew up around her beneath her slender feet. Gods and men call her (a) 'Aphrodite,' the foam-born goddess and (b) the well-garlanded 'Cytherea,' (a) since she grew in the foam, (b) and also 'Cytherea,' since she arrived at Cythera, (c) and 'Cyprogenes,' since she was born on sea-girt Cyprus, (d) and 'genial,' since she came forth from the genitals." Hesiod, *Theogony. Works and Days. Testimonia*, trans. Glenn W. Most, Loeb Classical Library 57 (Cambridge, MA: Harvard University Press, 2007), 16–19. The second Homeric Hymn to Aphrodite (no. 6) reads, "Of the reverend, gold-crowned, lovely Aphrodite I will sing, who has been assigned the

citadels of all Cyprus that is in the sea. That is where the wet-blowing westerly's force brought her across the swell of the noisy main, in soft foam; and the Horai with headbands of gold received her gladly, and clothed her in divine clothing. . . . When they had put all the finery about her body, they led her to the immortals, who welcomed her on sight and took her hand in greeting; and each of them prayed to take her home as his wedded wife, as they admired the beauty of violet-crowned Cytherea." *Homeric Hymns. Homeric Apocrypha. Lives of Homer*, trans. Martin L. West, Loeb Classical Library 496 (Cambridge, MA: Harvard University Press, 2003), 182–83.

95 "Giurar potresti che dell'onde uscissi / la dea premendo colla destra il crino, / coll'altra il dolce pome ricoprissi." Poliziano, *The Stanze*, 52-53, stanza 101.

96 Macrobius, *Saturnalia, Volume I: Books 1–2*, ed. and trans. Robert A. Kaster, Loeb Classical Library 510 (Cambridge, MA: Harvard University Press, 2011), Book 1, 88–91.

97 Giovanni Boccaccio, *Genealogy of the Pagan Gods, Volume I: Books I–V*, trans. Jon Solomon, I Tatti Renaissance Library 46 (Cambridge, MA: Harvard University Press, 2011), 396–401.

98 According to Hildegard of Bingen, "The blood vessels that are in a male's liver and abdomen converge in his genitals. When the wind of pleasure surges from the male's marrow it falls into his loins and stirs up in his blood a taste for pleasure. . . . The male burns in that site so strongly with pleasure that he forgets himself in his ardor and cannot restrain the ejaculation of foamy semen." She refers to a "virile wind that erects the stem to its full strength. For that reason, the stem cannot become erect and plough woman like soil, because it has lost the wind of its powers that had to strengthen it for the task of producing offspring." Bingen, *On Natural Philosophy and Medicine*, 57, 78.

99 Bingen, *On Natural Philosophy and Medicine*, 62.

100 In his *Li nuptiali* of 1513, Marco Antonio Altieri compares the shell of Venus' birth, where Uranus' sperm gathered, to the place in the female body where "procreation leads to conception." Following a discussion of Venus' birth and her governance of marriage, he writes, "significandose proceder dal continuo et frequentato moto, come del mare facilemente se comprende, et de quel reoscirne copia de spuma, quanto significhi la sperma genitale, concreta in quella conca, voglia significarce el corpo matronale, dove consista el procrearse quel concepto." Marco Antonio Altieri, *Li nuptiali*, ed. Enrico Narducci (Rome: Roma nel Rinascimento, 1995), 81. The Roman playwright Plautus (d. 184 BCE) first described Venus' birth from a scallop; however, the iconography appeared earlier in Hellenistic terracotta sculptures. Plautus, *The Little Carthaginian. Pseudolous. The Rope*, ed. and trans. Wolfgang de Melo, Loeb Classical Library 260 (Cambridge, MA: Harvard University Press, 2012), 474–75. Venus appears in a scallop shell in various terracotta sculptures from the Hellenistic period. For the connection between Plautus' description and these objects, see Eleanor Winsor Leach, "Plautus' Rudens: Venus Born from a Shell," *Texas Studies in Literature and Language* 15 (1974): 915–31.

101 "Donne, chi sente d'Amore, / prenda del vostre cose; / le son tutte pien d'odore, / di viole, gigli, e rose; / e son buone per le spose, / a far lieti i loro amanti." Antonfrancesco Grazzini, *Tutti i trionfi, carri, mascherate, o canti carnascialeschi andati per Firenze dal tempo del Lorenzo de' Medici* (Florence: Lorenzo Torrentino 1559), 66, lines 41–46.

102 *Homeric Hymns. Homeric Apocrypha. Lives of Homer*, 182–83.

103 "Tutti li dei di sua biltà godere, / e del felice letto aver talento." Poliziano, *The Stanze*, 52–53.

104 Ficino writes, "But what Hesiod says of Venus in his *Theogony* (when he says Saturn castrated the Sky and threw the testicles into the sea, and from these and the swirling foam Venus was born) must be understood perhaps as referring to the fertility for creating all things. The fertility lies hidden in the first principle of things; and the divine intelligence at first drinks it down and unfolds it inside itself, then pours it out into the soul and into matter. It is called 'the sea' because of movement and time and the wetness of procreation. When the soul is first abundant with that fertility, it produces intelligible beauty in itself by turning towards higher things. It begets the glory of sensible forms in matter by turning

towards lower things. But from turning like this towards beauty and from the generation of beauty the soul is called Venus. And since pleasure has been mingled into every glance at beauty and into beauty's every generation, and since all generation is from the soul (which is called Venus), the majority have thought Venus is pleasure itself." Marsilio Ficino, *The Philebus Commentary*, trans. Michael Allen (Tempe, AZ: Arizona Center for Medieval and Renaissance Studies, 2000), 138.

105 Ovid, "The Art of Love," in *The Erotic Poems*, Book 3, 217.

THREE

SARTORIAL SEDUCTION
Silk, Embroidery, and Venusian Magic

And since we happen to mention clothing here, will you forbid a person, pious Father, when making a garment or first wearing it, to take care to catch a little of Venus's breath by which the garment, becoming as it were Venereal, may likewise imbue the body and spirit with a beneficial quality?[1]

— Marsilio Ficino (1433–99), *Three Books on Life*

In his *Three Books on Life*, written in Florence during the 1480s, Marsilio Ficino poses several questions to a priest regarding the influence of the planets and the stars. He inquires whether the Moon should be observed "when people scatter seed on the fields and plant vines and olives," and in turn, whether the favor of Venus should be sought for the "planting of man?"[2] With regard to clothing, he describes how people commonly avoid garments that could be contaminated with a "poisonous vapor" – a miasma that could infect the skin with a disease, such as the plague, scabies, or leprosy.[3] He then asks the priest if he would forbid someone to construct or wear a garment at a propitious time in order to receive beneficial influences from Venus. He writes assuredly, with a reference to Saint Thomas Aquinas, that "clothing and other products of art *do* receive a particular quality from a star."[4]

What are the "qualities" of the stars that Ficino and his contemporaries had in mind? How did they imagine celestial influences being invested in earthly, human artifacts, such as textiles or even colors? What role did art play in activating these powers? This chapter examines the celestial ties

between Venus and the sartorial arts in the context of Ficino's *Three Books on Life* and Sandro Botticelli's *Primavera*, *Venus and Mars*, and *Venus and the Three Graces* (Figs. 37–39). In these paintings, Venus wears a long day dress pleated into rivulets of white silk, embroidered with gold thread, bedazzled with pearls and rubies, and accessorized with another rose silk textile woven with enchanting gilt patterns. The goddess appears in similar garments in at least five other *spalliera* paintings (Figs. 40 and 41) by Botticelli's workshop or his close followers. In this chapter, I argue that Botticelli's portrayal of Venus in these garments correlates with her celestial likeness, a representation of the planetary deity employed for image-based magic. This branch of magic is discussed in the *Picatrix*, an Arabic book of occult wisdom, which Ficino referenced in his writing of the *Three Books on Life*. In art historical scholarship on Botticelli's paintings, Venus' raiment is often compared to the ceremonial clothing of Isis or the Virgin Mary.[5] Such correlations make sense, considering that the *Picatrix* and Ficino's *Three Books on Life* are based on an ancient tradition of wisdom that syncretizes Greco-Roman, Judeo-Christian, and Arabic-Islamic beliefs with sacred mythology, astrology, and astral magic. As will be shown, this tradition was also of interest to the patrons of Botticelli's Venuses.

The second half of the chapter investigates the technical, material, and spiritual attributes of Venus' garments. In the macro-microcosmic chain of correspondences – discussed by Ficino and ultimately derived from the *Picatrix* – materials, colors, and patterns are capable of transferring celestial gifts to humans through the five senses. By depicting the sensual aspects of Venus' raiment and adornments, Botticelli attracts the viewer while also gifting them beneficial virtues. His ability to represent the specific visual qualities of textiles and adornments – the diaphanous translucency of silk or the flaming brilliance of a ruby – increases, in turn, the spiritual potency of his paintings. As will be illustrated, these effects were achieved more easily in panel painting than in fresco. Botticelli's success at capturing both the material and spiritual valence of Venus' garments, a skill that can be seen as well in his religious paintings, was likely influenced by his close ties to the silk industry. His enchanting representations of Venus' raiment also assert her position as patron goddess of the sartorial arts. The second-century astrologer, Claudius Ptolemy, for example, classifies Venus as patron of weavers, dyers, vendors of apparel, and garland makers, while the twelfth-century Jewish writer, Abraham Ibn Ezra, writes that the planetary sphere denotes "all embroidery and pretty garments" and of the trades, she benefits "anything that is dyed" and "sewing."[6] According to a fifteenth-century carnival song, her new fashions will "make sweet conquest of noble and beautiful youths and maidens" and "will keep Florence always in song and laughter, / and you will say: Florence is paradise!"[7]

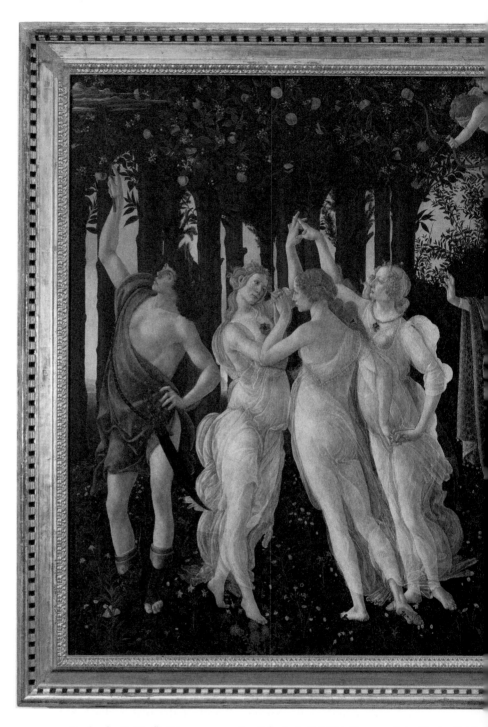

37 Sandro Botticelli, *Primavera*, ca. 1480, Gallerie degli Uffizi, Florence, Italy. Photo: Gabin- Fotografico delle Gallerie degli Uffizi

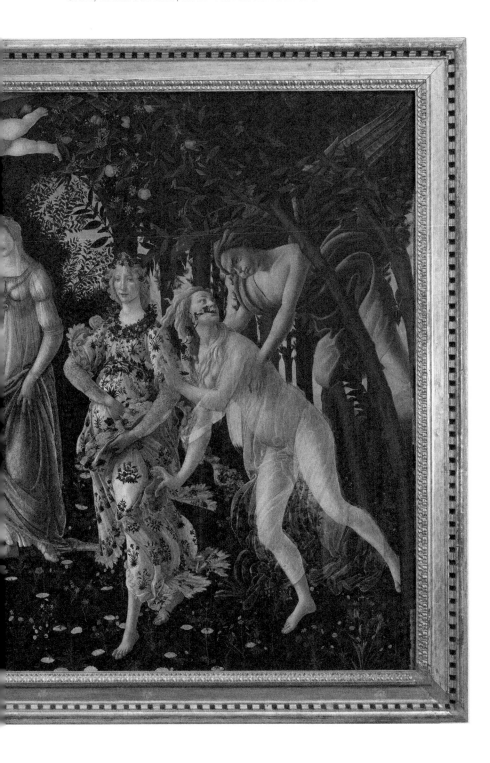

38 Sandro Botticelli, *Venus and Mars*, ca. 1485, National Gallery of Art, London. Photo: Fine Art Images / Alinari Archives, Firenze

39 Sandro Botticelli, *Venus and the Three Graces Presenting Gifts to a Young Woman*, early 1490s, Musée du Louvre, Paris. Photo: SuperStock / Alamy Stock Photo

LOCATION AND PATRONAGE

Inventories suggest that Botticelli's paintings of a clothed Venus were commissioned for the decoration of bedroom suites and occupied places similar to those discussed so far in this book. His paintings, however, are much larger in scale.

The *Primavera* (Fig. 37) for example, measures 6′8″ × 10′4″ (2.03 m × 3.1 m), dimensions that resemble those of Flemish tapestries (Fig. 58) or large-scale altarpieces.[8] Botticelli painted the *Primavera* on eight poplar panels, using rich pigments, tempera glazes, and shell gold.[9] Though the patron and original location of the *Primavera* are unknown, an inventory from 1499 suggests that it was owned, at some point, by the cadet branch of the Medici family, either by Lorenzo or Giuliano di Pierfrancesco, and that it once hung above a *lettuccio* (a

40 Attributed to Sandro Botticelli, *Venus and Three Putti*, early 1490s, Musée du Louvre, Paris. Photograph of temporary exhibitions gallery dedicated to the Renaissance, December 3, 2012. Photo: Hemis / Alamy Stock Photo

daybed-storage chest) in a ground-floor room of their palazzo on the Via Larga.[10] Lillian Zirpolo and Mirella Levi D'Ancona have suggested that the *Primavera* was commissioned for Lorenzo di Pierfrancesco's marriage to Semiramide d'Appiano on July 19, 1482, a wedding that took place on Friday or *venerdì* – the day of Venus.[11]

Botticelli's *Venus and Mars* (Fig. 38), created in the early 1480s, likely served a similar purpose. The oblong rectangular panel resembles other *spalliera* paintings, which were commissioned to decorate pieces of furniture or to hang above a wall's wainscoting in fifteenth-century bedrooms. The patron and original location of the *Venus and Mars* are also unknown, though the painting likely celebrates a Vespucci marriage, as E. H. Gombrich argued in 1945.[12] The *vespucce* (wasps) hovering in the painting's right corner correspond to the Vespucci coat of arms. Moreover, the family had close ties to Botticelli, Ficino, and the Medici.[13] Though Charles Dempsey has suggested that the painting's highly erotic content brings into question its original purpose as a marital gift, the work's format along with the portrayal of Venus in white and gold seems to suggest its original placement within a bedroom suite.[14]

In 1873, Botticelli's fresco of *Venus and the Three Graces* (Fig. 39) was found inside the Tornabuoni Villa Chiasso Macieregli in Careggi. According to a 1498 inventory of the villa, this fresco along with another one depicting *Grammar Presenting Lorenzo to the Liberal Arts* decorated a suite of rooms belonging to Lorenzo, the son of Giovanni Tornabuoni.[15] Patricia Simons has argued convincingly that the frescos celebrate Lorenzo's second marriage to Ginevra di Bongianii Gianfigliazzi in 1491.[16] Lorenzo commemorated his first marriage to Giovanna degli Albizzi with a similar panel painting of *Venus* (Fig. 41), designed for the couple's bedroom suite in the Tornabuoni's city palazzo. Attributed to Bartolomeo di Giovanni, one of Botticelli's assistants, this panel hung alongside a vertical panel of *Apollo* and a series of *spalliera*

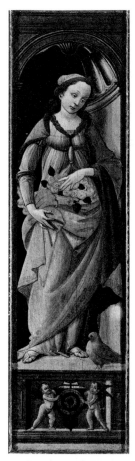

41 Bartolomeo di Giovanni, *Venus*, 1487. Photo: Location of artwork unknown; photo from the Fototeca of the Fondazione Zeri

paintings illustrating *Jason and the Argonauts*. In the *Argonautica*, Medea is a practitioner of magic, who offers her incantations and potions to Jason on the condition that he promise to wed her.[17] Lorenzo's decision to include this narrative alongside two planetary deities in the decoration of his bedroom suite may indicate his interest in occult knowledge and magical arts.

During the fifteenth century, the practice of magic could be dangerous, as the church considered it to be both heretical and idolatrous. The author of the *Picatrix* repeatedly states that the book should only be consulted by a "sage," someone with the "prerequisite knowledge," who studies the discipline "exhaustively." Moreover, this person should consider what is written beneficial "such that everything done through it be done for the good and in the service of God."[18] Ficino too discusses his *Three Books on Life* as a work of divine wisdom, and in his defense of the text, written shortly after its completion, he declares that "from this workshop, the Magi, the first of all, adored the newborn Christ."[19] For Ficino and his circle of friends and students, the Magi provided a fundamental link between Christianity and older forms of "pagan" knowledge.[20] In a sermon, titled *De stella magorum*, Ficino explains that the study of astrology prepared the Magi to discern prophecies and follow the Star of Bethlehem, a comet whose brilliance was set against the backdrop of Jupiter, the Sun, and Venus. He goes on to explain that the Magi's gifts possessed planetary powers proclaiming Jesus' kingship: "incense, belonging to Venus, betokens his divine grace and his priesthood."[21] It may be telling that the circle of patrons who commissioned Botticelli's celestially clothed Venuses also associated themselves with the Magi, including membership in the lay-confraternity of the Compagnia de' Magi and ownership of *Adoration of the Magi* paintings (Fig. 42).[22] Although hypothetical, it is possible that the Medici, Vespucci, and Tornabuoni studied this ancient tradition of magical wisdom and in commissioning Botticelli's paintings of Venus, sought to channel her powerful, efficacious starlight from the heavens.

ASTRAL MAGIC

The theory of natural or astral magic is based on the belief that God emanates powers through the spheres of the planets and the fixed stars, down to earth, and into its matter. In Ficino's *Three Books on Life* and in the *Picatrix*, the word

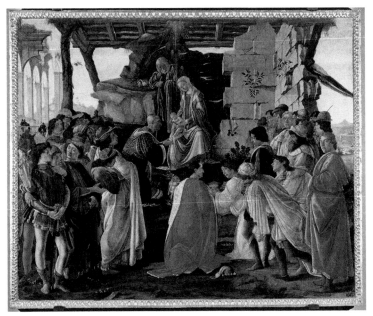

42 Sandro Botticelli, *The Adoration of the Magi*, ca. 1475, Gallerie degli Uffizi, Florence, Italy.
Photo: Scala / Art Resource, NY

virtue – a term derived from the Latin word *vis* or power – is employed to
describe celestial agency invested into terrestrial matter. The *Picatrix* states,
"Know that the thing that is called 'a virtue' is that which is evidenced by
nature and experiment. If an agent acts according to its own power, its
nature will be manifest in its work – especially when such an action exists
with power over those things, not over the manifest nature it has within
them."[23] In his *Three Books on Life*, Ficino designates Venus as a beneficial
planet and her primary virtue as "the natural and procreative force and spirit as
well as whatever increases the latter."[24] He also claims that she is "very
good for a healthy and prosperous life, since she makes a man fruitful
and happy."[25]

When one wishes to practice astral magic, it is essential that the desired
outcome correlate with the petitioned heavenly body's natural powers. Thus,
a request for love or friendship should be directed to Venus, while one for the
destruction of an enemy should be offered to her opposite, the red star of
Mars.[26] It is also wise to reach out to Venus on a day and at an hour when
she is ascendant. This time-sensitive information appears at the bottom of a
Florentine engraving of the *Children of Venus* from ca. 1465 (Fig. 43). The print's
text explains that Venus' zodiacal houses are Taurus and Libra, her day is Friday
or *venerdì*, her night is Tuesday or *martedì*, and her hours are the 1st, 8th, 15th,
and 22nd of the day.[27] The print also illustrates the places (the garden, orchard,
bath, and castle), activities (dancing, playing and listening to music), and

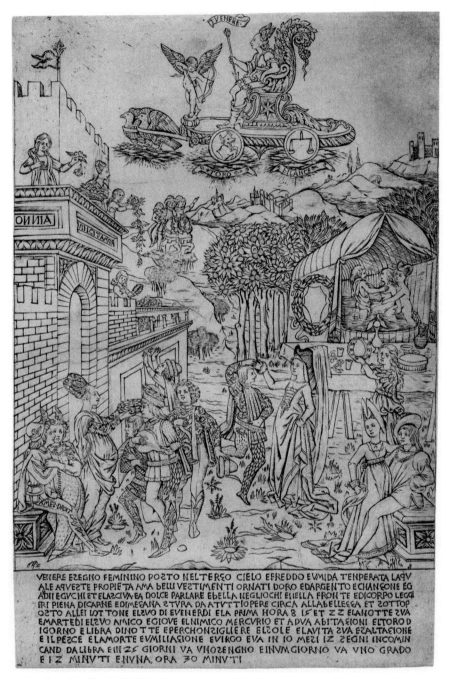

43 Attributed to Baccio Baldini, *Venus*, ca. 1464, British Museum, London. Photo: © Trustees of the British Museum

materials (garments embroidered with gold and silver, garlands, and bouquets of flowers) believed to channel Venus' powers from the heavens.[28] In the *Picatrix* and Ficino's *Three Books on Life*, we find a more complete list of Venusian materials, which can be divided into the following categories: (1) metals

and minerals – bronze, copper, silver, yellow or red brass, magnesium, litharge, coral, malachite, sapphire, beryl, pearls, lapis lazuli, carnelian, chalcedony; (2) flowers and plants – crocus, *arhenda* (orchids), roses, violets, lilies, balsam, julep mint, nutmeg, amber; (3) animals and birds – gazelles, sheep, deer, rabbits, partridges, calandra, larks, turtle-doves, pigeons, white water wag-tails; (4) colors – sky blue, gold, yellow, green, white.[29] If these materials are activated when Venus is ascendant in the heavens or in conjunction with other favorable planets, then wishes directed to her are more likely to come true.

The primary manual on astral magic known during the fifteenth century was the *Picatrix*, an encyclopedic collection of magical theories and astrological practices, titled *Ghāyat al-Ḥakīm* or *The Goal of the Sage*, which was composed in Islamic Iberia in the mid-tenth century (ca. 954–59). The scholar Abū'l-Qāsim Maslama ibn al-Qāsim Ibrāhīm al-Qurtubī al-Zayyāt (henceforth referred to as al-Qurtubī) is the text's likely author. According to Dan Attrell and David Porreca, al-Qurtubī traveled throughout the Islamic world and had access to an extensive collection of books, including the Greek philosophical texts of Plato and Pythagoras as well as astrological and magical texts from Egypt, Mesopotamia, and India.[30] In 1256, the *Ghāyat al-Ḥakīm* was translated into vernacular Spanish at the court of Alfonso X of Castile. Shortly thereafter, it was translated from Spanish into Latin, when it was given the name of *Picatrix*.[31]

Magic in the *Picatrix* revolves around planetary and zodiacal positions, talismanic images, occult inscriptions, ritual garments, and codified prayers. The text, for example, instructs the reader that "when you wish to pray to Venus and request something from the matters pertinent to her":

> Dress yourself in white clothes, and on your head wear a white headdress, because it is her symbol. The other is an ornament like a woman's veil. Dress yourself in ample, precious, and beautiful silk clothes interwoven with gold. Place a crown on your head adorned with precious pearls and stones. Wear a gold ring on your hand decorated with a stone of pearl and golden bracelets on your arms.[32]

The text then includes two prayers to the planet and a suffumigation to be burned in order to draw forth her powers.[33] We know that Ficino read and studied the *Picatrix*. He supposedly borrowed a copy from one "Georgio Medico," as mentioned in a letter written to Filippo Valori, discovered by the literary scholar Daniela Delcorno Branca. In the letter, Ficino states that, "although he could not lend him [Valori] a manuscript of *Picatrix*, nor did he recommend reading it, all its doctrines which were not either frivolous or condemned by the Christian religion" were incorporated into his *Three Books on Life*.[34] Ficino, for example, leaves out the prayers, sacrifices, and suffumigations offered to each planetary deity. He also omits maleficent or destructive magic as well as many of the materials used for its performance, including menstrual blood, dried and powdered human testicles, and the skin of

a woman's vulva.[35] For Ficino, cosmological correspondences should be used for medicinal, therapeutic, and constructive purposes rather than for detrimental curses.

Though Ficino questions whether or not image-based magic is effective, he discusses it within the text. This branch of magic is dependent on the belief that certain figures and symbols, when constructed with the appropriate materials at the correct time, can attract planetary forces from the heavens. According to the *Picatrix*, "the gift of planetary influence is in magical images and the reception of their powers, and also that the forms of similarity and dissimilarity appear evidently enough (since similarity emerges from a kind of union within the images' effects)."[36] Because image-based magic seeks the power of another deity through an image, it verges on idolatry. Cognizant of this fact, Ficino mentions the story of the Hebrews' construction of the golden calf in his discussion of this art. He explains that the Hebrews, "from having been brought up in Egypt, learned how to construct the golden calf, as their own astrologers think, in order to capture the favor of Venus and the Moon against the influence of Scorpio and Mars, which was inimical to the Jews."[37] The outcome of such idolatry, which Ficino does not explicitly cite, was not positive. Those who fashioned and worshiped the golden calf were either murdered by the Levites or struck with the plague.[38] As if to defend himself against this fact, Ficino opens the next paragraph with an argument as to why medicines (powders, unguents, electuaries) are more effective than images in channeling celestial forces.[39] He declares that astrologically constructed images are not intended to contain actual deities. Rather, in their likeness, they *suggest* the planetary deity's spirit and thus confer upon their viewers a "celestial gift."[40] He then reminds his reader "not to think we are speaking here of worshipping the stars, but rather of imitating them and thereby trying to capture them," to obtain a "natural influence."[41]

Although Ficino does not explicitly discuss paintings in the context of image-based magic (and explains that wood is not a particularly good container for celestial virtues), he does describe how celestial forces can be channeled within a space painted with cosmological images and/or symbols.[42] He also writes that "qualities, however, which are less elemental or material, such as lights (that is, colors), similarly also numbers and figures" are very powerful "to obtain celestial gifts (as they think)."[43] Such qualities are potent because they are closer to the things of heaven, where there is no matter. To further his point, Ficino states that the power of celestial images is similar to that of other figural images, which provoke specific emotional, physical, or mental states. He describes – in a manner similar to Leon Battista Alberti in his *On Painting* – how "easily a mourning figure moves pity in many people" and how a "figure of a lovable person instantly affects and moves the eyes, imagination, spirit, and humors; no less living and efficacious is a celestial figure."[44]

Ficino includes a description of Venus' celestial likeness in his discussion of image-based magic. He writes, "For gaiety and strength of body, a young Venus holding apples and flowers in her hand, dressed in yellow and white, made in the hour of Venus, when the first face of Libra, or of Pisces, or of Taurus was ascending with her."[45] In his description of Venus' garments, Ficino uses the Latin word *croceis*, which can mean yellow, saffron, or golden. His source for this celestial figure was most likely a Latin version of the *Picatrix*, which includes similar images. There is one, for example, that describes Venus holding an apple and flowers and wearing white. Instead of standing, she rides a stag with her hair spread about her.[46] Celestial figures resembling these descriptions appear in fifteenth-century art. In the astrological cycle of the Palazzo della Ragione in Padua (a cycle damaged by fire in 1420 and then repainted by Nicolò Miretto and Stefano da Ferrara between 1425 and 1450), Giotto di Bondone depicts a young female (Fig. 44) wearing a white satin dress embroidered with gilt thread and holding flowers. The figure is featured in the series of frescos dedicated to Taurus, the zodiac house of Venus, and scholars concur that the maiden represents the planet as the goddess of April.[47] Venus in the *Month of April* (Fig. 45) models a similar white gown cinched with a golden band in the astrological cycle of Duke Borso d'Este's Palazzo Schifanoia, painted by Francesco del Cossa, Ercole Roberti, and others from 1469 to 1470.[48] Iconographically, this cycle draws inspiration from the *Picatrix*, and we know that Galeotto Marzio, who studied in Ferrara and taught in both Padua and Bologna, owned a copy of the *Picatrix*. Furthermore, Marzio's astrological and magical writings were so controversial that he was accused of heresy. He escaped the Inquisition and its sentence through the support of Lorenzo de' Medici and King Mattia Corvino.[49]

44 Anonymous, *Woman with Flowers. From the Month of April, Sign of Taurus*, fifteenth century, Palazzo della Ragione, Padua, Italy. Photo: Scala / Art Resource, NY

Like Giotto and Cossa, Botticelli represents Venus in white and gold. In the *Primavera*, he connects her celestial figure to the zodiacal house of Taurus and the month of April, when her planet is in the ascendant. It is at this time that astrologers recommended directing petitions to Venus concerning marriages and alliances.[50] Botticelli's representation of the goddess in the Villa Chiasso Macieregli fresco, where she wears a white and gold garment and offers flowers to the Tornabuoni bride, correlates closely with the planetary deity's celestial likeness. The same could be said for her presence in the *Venus and Mars* where her conciliatory virtues overpower the malign forces of her paramour. The iconographic similarities between Botticelli's Venuses, clothed in white and gold, and astrological descriptions of her celestial likeness suggest that his paintings may have been intended to channel beneficial forces, such as "gaiety and strength of body," for those open to receiving celestial gifts.

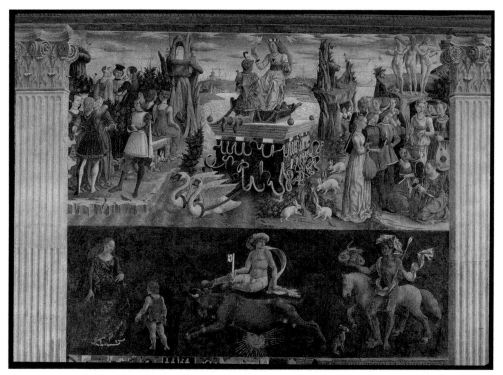

45 Francesco del Cossa, *Month of April: Triumph of Venus and Astrological Symbols*, fresco, 1469–70, Palazzo Schifanoia, Ferrara, Italy. Photo: Scala / Art Resource, NY

A WHITE DRESS: INCANDESCENT TRANSPARENCY

In the context of astral magic, white is a color given to Venus, and silk is a textile associated with her beneficial virtues. Furthermore, luminescent and transparent qualities, which characterize the light day dress or *cotta* that Botticelli's goddess wears, closely resemble the celestial lights. In his *Three Books on Life*, Ficino writes, "Indeed, any colors, if they are fresh or at least pertain to silk, are more stellar; they are potent also in metals and stones and glass because of their resemblance to celestial things."[51] Ficino makes a similar point with his ranking of colors on a scale from one-to-twelve in a letter written with Giovanni Cavalcanti to Lotterio Neroni. Black is on the first and lowest level, white on the ninth level, transparent or shining on the tenth, brilliant on the eleventh, and finally brilliance itself on the twelfth and highest level.[52] The philosopher's categorization of these lights and colors gives us a sense of how viewers may have understood the diaphanous gown of Botticelli's goddess and mythological descriptions of her garments as "splendid," "shimmering," "shining," and "bright."[53]

In fifteenth-century Florence, white silk was manufactured through a specific technical process, which allowed weavers to achieve the visual properties of brightness, luster, and transparency in their textiles. White silk thread

46 Thai silk and cocoon, July 2, 2004, Thailand. Photo: Narongkrit Dalhirunrut / Alamy Stock Photo

was not produced directly from raw silk skeins (Fig. 46) but rather was purified by dyers who boiled the skeins to remove the sericin, or natural yellow gum, left from the silk worm's cocoon. The dyers then refined the color by bleaching the silk, a process that included exposing it to sulfur fumes in a closed room.[54] The end result was a bright white silk thread with pearlescent, reflective qualities. This thin thread was then twisted into various levels of thickness to manufacture translucent veils and *camicie* (chemises), flowing silk *cotte* (day dresses), and luminescent satin *giornee* (gowns).

To capture the shine, luster, and transparency of white silk, Florentine artists worked with several different white pigments. For paintings in tempera and oil, they used lead white (Fig. 27a), an extremely bright and opaque pigment manufactured by exposing coils of lead to vinegar or other acidic substances. As discussed in Chapter 2, lead white has the highest refractive index of all pigments and works well in both tempera and oil. For frescos, artists employed a different pigment: a specific type of slaked lime, known as St. John's white (Fig. 27b). Like white silk thread, this pigment was produced through a process of refinement in which cakes of lime were exposed daily to sunlight in order to create a bright "perfect white."[55] Despite this natural bleaching process, St. John's white is not as opaque or as bright as lead white. In frescos, the subtle visual qualities of luminescence and transparency, which characterize silk textiles, could not be achieved with this pigment.

Whether in tempera or in fresco, Florentine artists painted white textiles differently than colorful ones. For a blue garment, such as Zephyr's cloak (Fig. 37), Botticelli used the purest hue of azurite to create shadows and lighter shades of the pigment mixed with lead white to form highlights. For Venus' white dress (Fig. 47), the process is reversed with Botticelli employing the

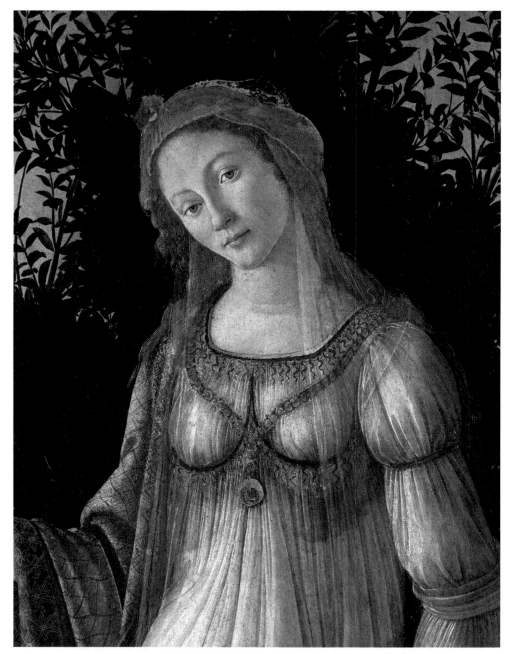

47 Sandro Botticelli, *Primavera*, detail of head of Venus, ca. 1480, Gallerie degli Uffizi, Florence, Italy. Photo: akg-images / Rabatti & Domingie

purest hue of the pigment for the highlights rather than for the shadows, which he painted with a mixture of black, white, brown umber, and/or yellow ocher. In the 1470s and 1480s, Florentine artists began to experiment with new mediums and in turn, to replicate the lustrous reflection of colored light

on white garments. Leonardo da Vinci mentions this optical effect in one of his notebook entries: "If you see a woman dressed in white in the midst of a landscape, that side which is towards the sun is bright in color, so much so that in some portions it will dazzle the eyes like the sun itself." Meanwhile, the other side, "which is towards the atmosphere," will appear "steeped in blue."[56] In the *Primavera*, Botticelli suggests colored light falling on Venus' white dress with layers of thin paint, consisting of colored pigments bound with albumen (egg white), egg yolk mixed with oil, or oil alone.[57] He records the blue reflections from her mantle by placing a long stroke of azurite (Fig. 74a) down the middle of her dress and another one along the edge of her veil, located to the viewer's right. These subtle suggestions of colored light were difficult to create in the fresco medium because the pigments were bound to wet plaster rather than being mixed into translucent glazes.

In addition to being light-reflective, white silk garments were also transparent. To capture this diaphanous visual property, Botticelli used three different techniques, which can be analyzed by studying Venus' silk veil in the *Primavera*. First, he diluted lead white in a medium more translucent than egg yolk, such as albumen (egg white) or linseed oil. Second, he applied this thin, fluid glaze over areas covered by the transparent fabric. Finally, he omitted the glaze in certain places, leaving parts of the goddess's skin, hair, and dress completely exposed, which enhances the illusion of transparency.[58] Similar examples of transparency can be seen in Botticelli's *Venus and Mars*. The outer layer of the goddess's dress, for example, splits above her knee, where another layer of sheer fabric covers but also reveals the shapely contours of her leg. The puff of white silk embracing the goddess's right shoulder is charmingly transparent. In the *Primavera*, Botticelli used these same techniques to paint the provocatively see-through chemises of Chloris and the three Graces.[59] Here, he exploited the more sensual aspects of transparency. In the Villa Chiasso Macieregli fresco, the goddess's light-footed companions wear much heavier garments, fashioned from white, green, and yellow textiles. While there is a literary source for their thick, multi-colored dresses, the change in attire is likely related to the technical limitations of the fresco medium, where gossamer textiles are difficult to depict, as evidenced by Venus' white dress (Fig. 49) in the Tornabuoni fresco.[60]

GOLD EMBROIDERY: THE *CESTUS* AND ITS CHARMS

Part of the beauty and fascination of Venus' white dress derives from the elaborate gold embroidery that outlines its edges and the sensual parts of the goddess's body. Why did Botticelli include this glittering adornment of twisted and braided gilt thread? Astrologically, Venus governs weavings and embroideries of gold and silver. Michael Scot mentions this art in connection

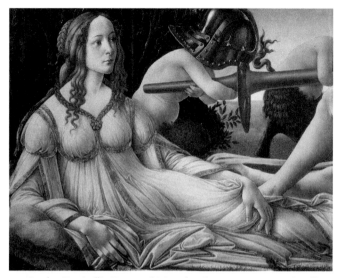

48 Sandro Botticelli, *Venus and Mars*, detail, ca. 1485, National Gallery of Art, London. Photo: Hirarchivum Press / Alamy Stock Photo

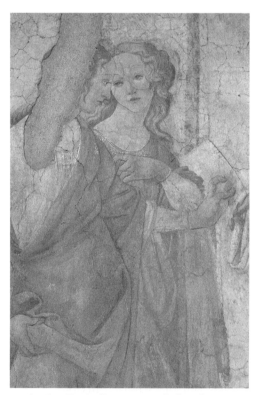

49 Sandro Botticelli, *Venus and the Three Graces Presenting Gifts to a Young Woman*, detail, early 1490s, Musée du Louvre, Paris. Photo: Masterpics / Alamy Stock Photo

with the planet in his *Liber introductorius*, as does Giovanni Boccaccio in his *Genealogy of the Gods* and the inscription included on the Florentine engraving of the *Children of Venus* (Fig. 43).[61] In addition to these astrological associations, Venus' enchanting embroidery also correlates with her mythological *cestus*, a girdle known to possess magical powers of seduction.

Artists before Botticelli, like Giotto and Cossa, represented the *cestus* as an accessory worn at the waist (Figs. 44 and 45). Instead of a belt, Botticelli depicted gold embroidery lining Venus' neck and breasts (Figs. 47–49). This adornment could reveal his or his advisor's knowledge of Book 14 of Homer's *Iliad*, which recounts the tale of Hera asking Aphrodite to help bring a promiscuous Zeus back to her marriage bed. According to Homer, "she [laughter-loving Aphrodite] spoke, and loosed from her bosom the embroidered strap,

inlaid, in which are fashioned all manner of allurements; in it is love, in it desire, in it dalliance – persuasion that steals the senses even of the wise."[62] Aphrodite instructs Hera to place this charming accessory on her breasts. When Zeus sees Hera wearing the *cestus*, he is overwhelmed with desire and wants to have sex with her, as if newlyweds, in their marriage bed.[63] In the fifth-century epic poem *Dionysiaca*, Nonnus of Panopolis writes that the "goading *cestus* whipt him to hotter love. As Zeus looked upon her, his eyes were enslaved."[64]

Botticelli's gold embroidery seems to correlate with Homer's description of a "curiously embroidered girdle" at Venus' bosom. In the *Primavera* (Fig. 47), he illustrated two different types of embroideries: (1) a fringe of flame-shaped spangles outlines Venus' neckline and breasts and (2) a string of glimmering pearls crosses her bosom and ends in a gold pendant in the shape of a crescent moon wrapped around a square ruby. Painted with liquid gold, the tiny flames of Venus' embroidery catch and reflect light, just as the *cestus* ignites the fire of love within the heart. In *Dionysiaca*, Nonnus describes the enchanting powers of rubies and pearls, which ornament the crown that Hera wears with Venus' magical *cestus*. The rubies are "the servants of love; when they move, the Cyprian flame sends out bright sparklings," and the pearls are "the Indian stone of love, offspring itself of the waters and akin to the Foamborn."[65]

Botticelli's decision to fashion Venus' talisman in the shape of a crescent moon correlates with theories of astral magic that speak of these two heavenly bodies working in conjunction with one another. The *Picatrix*, for example, states that "in all works for love and benevolence toward a man or woman, see to it that the Moon be received by Venus in a trine or sextile aspect."[66] In his *Three Books on Life*, Marsilio Ficino similarly explains the benefits of this conjunction: "The Moon, then, and Venus signify the natural and procreative force and spirit as well as whatever increases the latter."[67] Botticelli's design of Venus' brooch as a crescent moon arching above a fiery ruby corresponds with both books' instructions for using earthly materials and talismanic images to channel the favorable influences of these two heavenly bodies.

In Botticelli's *Venus and Mars* (Fig. 48), a star ruby orbited by eight pearls embellishes a braid decorating the neckline of the goddess's dress. This braid is likely a *pannocchia* or rope of false hair woven from a horse's mane or tail.[68] Its rhythmic weave compliments the ribbon of gold embroidery that encircles Venus' breasts and runs down the middle of her gown. Botticelli employed a V pattern [VVVV] for the embroidery lining her upper body and then used a tighter crisscross pattern [XXXX] for the split down the center. The intertwining of the braid and gilt trims symbolically expresses, like the magical *cestus*, Venus' ability to bind, tie, and unite individuals in love. Lorenzo de' Medici, who was described by Niccolò Machiavelli as "marvelously involved in things of Venus," wrote a poem on the subject of Venus and Mars.[69] In the

course of the poem's dialogue, the god of war declares, "Around the heart, your white braid wraps, / durable chain of the ardent lovers / and strong lace that one can never untie."[70]

In his *Liber introductorius*, Michael Scot explains that the elaborate adornment of Venus' dress symbolizes her power to enamor others.[71] Indeed, Botticelli's gilt trim does seduce the viewer, directing attention to the goddess's smooth white neck and full round breasts, which are more mature than in earlier art, where she sports the small, high breasts of a 14- or 15-year-old. Botticelli's shiny embroidery also journeys down Venus' body to the split in her dress and the translucent layer of her gown that offers a glimpse of her lower leg. If we read Mars's limp finger as his lax phallus, then we might see the gold lining running between Venus' thumb and forefinger as the silky folds and deep slit, outlined in gold, of her own genitalia. The play with fabric is titillating in its suggestiveness.

The striking brilliance and exactitude of Botticelli's embroidered pattern in *Venus and Mars* suggests the possibility of mordant gilding, a technique in which gold leaf (Fig. 13a) is applied on top of an adhesive to create strong lines of gold. These distinct highlights reflect light while simultaneously representing reflections of sunlight. Botticelli paid close attention to embroidery in his art, which indicates his familiarity with this subsection of the Arte della seta. In fifteenth-century Florence, artists often worked with embroiderers or *ricamatori* to fabricate standards and banners for religious processions, tournaments, and jousts. In his *Lives of the Artists*, Vasari notes Botticelli's development of a particular type of embroidery or "inlaid work," which Carole Collier Frick identifies as the *commesso* technique, in which designs are stitched into one piece of cloth and then appliqued to another.[72] Several priestly vestments attest to his work in this field, including an extant chasuble and cope hood embroidered with the *Coronation of the Virgin* (Fig. 50) and located today at the Museo Poldi Pezzoli in Milan.[73] The border of the hood, with its twisted and braided thread of gold, resembles the designs ornamenting Venus' white dresses.

50 Designed by Sandro Botticelli, *The Arms of Portugal Held by Angels*, appliqué embroidery on the hood of a cope, ca. 1485–90, Museo Poldi Pezzoli, Milan, Italy. Photo: Museo Poldi Pezzoli

Metallic thread was one of the primary materials used for embroidery. In fourteenth-century Florence, the silk guild imported a high-quality metallic

thread called "Cyprian gold," which was manufactured by wrapping gold leaf around a thin piece of silk and animal ligament.[74] The production of this thread on the goddess's native island of Cyprus indicates a practical tie between Venus and garments woven or adorned with gilt thread. As silk trade increased in the fifteenth century, Florence began to manufacture its own gold and silver filament, with some agencies producing gold leaf for gilding panel paintings and for wrapping silk thread.[75] *Battilori* (gold beaters), however, tended to beat gold for either silk merchants or artists and not both, as illustrated by the career path of Botticelli's older brother Antonio. Guild records reveal that Antonio joined the Arte della seta on May 20, 1462, and then as a *battiloro*, he matriculated to the Compagnia di San Luca (Company of Saint Luke), the painter's confraternity, on October 18, 1472.[76] Antonio's years of work for the Arte della seta and the Company of Saint Luke as a *battiloro* likely influenced the prevalence of both gold leaf and painted gilt thread in Botticelli's art.

ROSE BROCADE: LUXURIOUS LOVE

The final spiritually potent component of Venus' attire is the red or pink textile that accompanies her in Botticelli's paintings and those of his followers. In a section laying out "the colors of the clothes or vestments of the planets," the *Picatrix* notes that "the color of Venus is like pink and is best made of silk."[77] The planetary deity wears a pink dress in Ambrogio Lorenzetti's representation of the planet (Fig. 4) in the Palazzo Pubblico of Siena; she dons a red *giornea* on the lid of the Bechi betrothal box (Fig. 10). Few ancient or Renaissance literary sources, outside of the *Picatrix*, assert that Venus goes clothed in red or pink, but even artists who dressed the goddess in starry white usually accessorized with a red or pink textile.[78] This practice could have been encouraged by the need, as discussed in Chapter 2, to foreground the rosy glow of Venus' luminescent complexion.

Of the many dyes that filled the vats of Florence's *tintori* workshops – a profession, as mentioned previously, governed by the planet Venus – crimson was among the most expensive and highly esteemed.[79] Referred to in documents as *chermes* or *grana*, this dye produced durable scarlet, crimson, and rose hues, variations of which can be seen in the chasuble and cope hood embroidered with Botticelli's design of the *Coronation of the Virgin* (Fig. 50). This dye was manufactured from the pulverized bodies of scale insects (Fig. 51a), including kermes (*Kermes vermilio*), Polish cochineal (*Porphyrophora polonica*), Armenian cochineal (*Porphyrophora hamelii*), and stick lac (*Kerria lacca* and *Kerria chinensis*).[80] According to the Florentine *Trattato della seta* (*Treatise on Silk*), written by the Arte della seta between 1450 and 1460, dyers paid a tariff of 30 *soldi* to dip a pound of silk once in kermes red and 40 *soldi* to dip the same amount twice.[81]

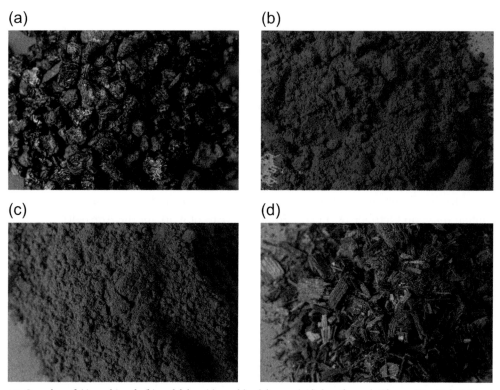

51 Samples of (a) cochineal, (b) red lake, (c) madder lake, and (d) brazilwood. Photo: Kip Bulwinkle / Karson Photography

Other, cheaper red dyes existed, but they were not as colorfast or as durable. These less expensive dyes were derived from plant materials, such as (1) *verzino* or brazilwood (Fig. 51d), a hard red sappanwood grown in the East and imported into Europe and (2) madder roots from the Middle East, eastern Mediterranean, India, and the British Isles, which produced a dye and pigment with a pink to coral hue (Fig. 51c).[82] Silk merchants paid 100 florins for 100 lbs. of kermes (and up to 200 florins for *grana* from Spain), 25 florins for 100 lbs. of brazilwood, and 3 florins for 100 lbs. of madder.[83] While the two plant-based dyes were versatile in the shades of reds they produced, both were certain to fade, and kermes remained a consistently more trustworthy and desirable dye.

Depending on how kermes was manipulated in the dying process, it could produce a deep crimson thread or one that leaned more towards a violet-tinged rose. Bedding, dresses, girdles, and sleeves woven from kermes silk (Figs. 19, 22, 57, and 58) were an expensive luxury. They were often presented to women as betrothal or bridal gifts. In a letter dated August 24, 1447 to her son Filippo in Naples, Alessandra Macinghi Strozzi describes the counter-dowry gifts that Marco Parenti, the owner of a *bottega d'arte di seta*, or silk

shop, promised to her daughter Caterina Strozzi. The account is notable for the number of items dyed crimson or rose: for her engagement, "a gown of crimson velvet for her made of silk and a surcoat of the same fabric, which is the most beautiful cloth in Florence" and for her marriage, "some crimson velvet to be made up into long sleeves lined with marten" and a "rose-colored gown embroidered with pearls."[84]

During the Renaissance, kermes silk was used not only for couture fashions but also for medicine, being a prominent ingredient in heart tonics and other electuaries or syrups.[85] In an allegorical chapter of his *Three Books on Life*, titled "The Conversation of the Old People Traversing the Green Fields under the Leadership of Venus," Ficino mentions the beneficial virtues of silk and places it in a category of materials, along with gold, silver, coral, and precious stones, that are temperate and uplifting for the spirit. He writes, "For since these most beautiful and almost celestial things could not be created under the earth without the greatest gift from the heavens, it is probable that in things of this kind wonderful powers from the heavens inhere." Ficino continues by describing how a medicine compounded from these materials "dilates, illuminates, and collects" the spirit and "delights it inwardly and refreshes it as greenness does externally to the eyes."[86] In his *Three Books on Life*, Ficino — whose brothers were apothecaries — offers several recipes for electuaries, many of which are derived from *On the Powers of the Heart*, written by the Persian physician and astronomer Ibn Sina, known as Avicenna (980–1037). One electuary calls for almonds, pine-nuts, cucumber seeds, hard sugar, rose, lemon or citrus water, cinnamon, sandal, coral, pearls, saffron, raw scarlet silk, gold, silver, jacinth, emerald, sapphire, and carbuncle.[87] The use of raw scarlet silk (dyed *chermes* or *grana*) along with rose, sandal, coral, pearls, emerald, sapphire, and carbuncle in this recipe reveals the valence of Venusian materials in Renaissance pharmacology.

Raw scarlet silk was also used to manufacture red lake pigment (Fig. 51b), the same pigment employed by fifteenth-century artists for the painting of crimson and rose silk textiles. To prepare red lake — according to a recipe in a Bolognese treatise — clippings of silk textiles dyed in kermes are mixed with ley "made from the ashes of bean-stalks." The mixture is strained eight to ten times, then rock alum is added to give body to the lake pigment.[88] Red lake could also be made from stick lac resin, another red dye material. In his *Libro dell'arte*, Cennino Cennini explains that red lakes prepared from kermes silk clippings are "very pleasing to the eye"; however, he warns that they may lose their "color straight away." He argues that a red lake made from stick lac works best.[89] Whether from silk or lac, red lakes produced a naturally transparent pigment, and technical skill was required to create the illusion of a crimson silk textile.[90]

In the *Primavera*, Botticelli painted Venus' crimson silk mantle with a deeply saturated, transparent red lake on top of a white imprimatur, as seen in a

52 Microphotograph of a fragment from Venus' mantle, in cross section illustrating the white imprimatur, a layer of red lake, and varnish, sample taken during restoration of 1978–82. Detail from Sandro Botticelli, *Primavera*, ca. 1480, Gallerie degli Uffizi, Florence, Italy. Photo: Opificio delle Pietre Dure, Florence

microscopic sample of the garment (Fig. 52), analyzed by Mauro Matteini and Arcangelo Moles during the painting's restoration.[91] In the brightest areas of the textile, Botticelli placed thin layers of red lake, allowing the white of the imprimatur to shine through the red. In the shadows of the folds, he layered stronger hues over a darker, possibly blue, pigment. In some of the deepest folds of the fabric, he painted the purest and deepest red lakes. In his *Venus and Mars*, Botticelli used a similar technique for the plush pink pillow that Venus leans against. Because of its transparency and need for a protein binder, red lake is problematic in *buon fresco*. In *Venus and the Three Graces*, Botticelli painted Ginevra's crimson dress with other red pigments, likely sinopia, red ocher, or red lead. Her velvet pile, however, does not convey the more celestial aspects of the textile. Similarly, Venus' mantle lacks the luster of a rich silk garment. The seductive beauty of Venus' mantle in the *Primavera* is achieved through the luster and transparency of Botticelli's red lake pigment, which is "very pleasing to the eye" and fashioned from the same materials as those used to dye silk this same color, silk that Ficino describes as both "dilating" and "illuminating."[92]

Finally, it should be noted that Botticelli ornamented Venus' red and rose textiles with patterns woven in gold thread, another connection to an art governed by the planetary deity. Botticelli's fabrics resemble brocades in which two or more colored silk threads are shuttle-woven together to create a smooth design. In contrast, damasks are fabricated with warp and weft satin threads, which produce a larger pattern with a more variegated surface.[93] Botticelli rarely painted damask textiles. His familiarity with silk brocades could relate to his brother's membership in and career as a *battiloro* for the

Arte della seta. Vasari also mentions in his *Life of Botticelli* that a cloth-weaver "came to live in a house next to Sandro's and erected no less than eight looms, which, when at work, not only deafened poor Sandro with the noise of the treadles and the movement of the frames, but shook his whole house" so that "he could not work or even stay at home."[94] A truce between the two craftsmen was finally achieved through Botticelli's wit and artistry.

Botticelli designed and painted a different pattern for each of Venus' brocades. He wove an abstract rosette, which may have been transferred via a stencil, into the blue lining of Venus' mantle in the *Primavera* and the pink pillow in *Venus and Mars*.[95] Remnants of gold on the Villa Chiasso Macieregli fresco suggest that Venus' cloak was once enlivened with the family's heraldic diamond.[96] Both the rose and the diamond are symbols of love. The most unusual and complex design, however, appears on the red side of Venus' mantle in the *Primavera* (Fig. 47). This pattern consists of square divisions, which can be read also as diamonds. Each square contains a large Greek cross, then a smaller Greek cross, which is divided into five equal square segments, each of which contains another small square. At the meeting of four, square divisions, there is another square divided into four squares with one small square in each segment. The geometric effect is bewildering: diagonal, vertical, and horizontal lines meet in the space of a centimeter or two, which gives the fabric a crystalline geometric quality akin to Byzantine or Arabic patterns.

The complexity of the design suggests that Botticelli may have illustrated a specific textile. The pattern, for example, stretches and distorts as Venus' thigh and knee press through the drapery in her *contrapposto* pose.[97] In his study of gold brocades, Rembrandt Duits argues that a bedcover in the 1499 inventory of Lorenzo and Giuliano Pierfrancesco de' Medici may be the textile used for Venus' mantle. The entry describes "a Levantine bed-cover, with the color of red lake, lined with blue cloth, eight *braccia* long and seven *braccia* wide."[98] In addition to replicating an actual textile, Botticelli's geometric pattern of a Byzantine or Greek cross suggests Venus' compatibility with Christianity.[99] Furthermore, the cross was believed to possess other magical, talismanic powers. Inspired by a passage in the *Picatrix*, Ficino writes that "the cross, therefore, said the ancients, is a figure which is made by the strength of the stars and serves as a receptacle of their strength; it therefore possesses the greatest power among images and receives the forces and spirits of the planets."[100]

In his three paintings of Venus, Botticelli's goddess models a brilliant, shimmering white raiment enlivened by gold embroidery and a rose brocade. Her attire correlates with her celestial likeness as a planetary deity, an image capable of channeling her cosmological gifts in the practice of image-based magic. Like Mars's armor, which protected his body and frightened his enemies, or Mercury's caduceus, which healed ailments and united conflicting parties, Venus' clothing and jewelry attracted attention and aroused desire.

Moreover, the individual elements of her attire were fashioned from a set of luxurious materials also believed to possess celestial virtues, as discussed in Ficino's *Three Books on Life* and the *Picatrix*. It is likely that the patrons of Botticelli's Venus paintings, which included the Medici, Vespucci, and Tornabuoni, were interested in this tradition of Arabic magic and astrology. Botticelli too may have been familiar with it considering that he is portrayed alongside the Medici family and the Magi in his 1475 painting of *The Adoration of the Magi* (Fig. 42). The artist stands in the right corner of the painting and looks out at the viewer. His brown robe, painted with yellow ocher, contrasts with the brightly dyed and intricately tailored garments of his contemporaries, suggesting his status as a craftsman. His presence, however, alongside these elite and well-educated citizens, indicates his familiarity with and perhaps his inclusion within their social network.[101] The self-portrait also reveals his regard for and association with the Magi, the ancient astrologers who used their knowledge of the stars to find Jesus, a human of divine origin, and to present him with gifts imbued with the celestial virtues of Jupiter, the Sun, and Venus.

NOTES

1 "At postquam hic in vestium incidimus mentionem, prohibebisne, pie pater, in veste conficienda, vel primum induenda spiraculum Veneris diligenter aucupari, quo quasi Venerea facta vestis, similiter prospera quadam corpus et spiritum afficiat qualitate?" Marsilio Ficino, *Three Books on Life*, trans. Carol V. Kaske and John R. Clark (Tempe, AZ: Arizona Center for Medieval and Renaissance Studies, 2002), 382–83.

2 "Concessum quoque abs te et insuper approbatum, crescente Luna eademque aucta lumine, nec aliunde infortunata, seminibus agros spargere, vites oleasque serere. Cur non igitur ad plantandum (ut cynice loquar) hominem utamur beneficio Lunae Iovisque et Phoebi? Nam Veneris quidem ad haec officio semper utimur – sed rectius modo dixissem: semper utuntur, nam ipsa mihi Venus est Diana." Ficino, *Three Books on Life*, 380–83.

3 Ficino begins this section by discussing "unfortunate houses" that are infected with "the poisonous vapor of the plague." He then writes of how this vapor "lurks from the epidemic in a garment" and "infects long afterwards the unwary user and kills him." Later in the paragraph, he states, "But that infected clothing infects the user, even the scabies and leprosy testify." ("Ubi contagiosa quaedam calamitas aedificii ferme sic inficit habitantem, ut venenosus pestilentiae vapor etiam ad biennium in pariete servatus, qualis etiam ex epidemia latens in veste, diu postea utentem inficit incautum atque perdit. . . . Infectas vero vestes utentem inficere etiam, testis est scabies atque lepra.") Ficino, *Three Books on Life*, 382–83.

4 "Vestes quidem et cetera artis opera certam a sidere qualitatem accipere, Thomas Aquinas in libro *De fato* confirmat." Ficino, *Three Books on Life*, 382–83. For a discussion of Thomas Aquinas' influence on Ficino, see John Christopoulos, "By 'Your Own Careful Attention and the Care of Doctors and Astrologers': Marsilio Ficino's Medical Astrology and Its Thomist Context," *Bruniana & Campanelliana* 16 (2010): 389–404.

5 For a discussion of Venus' similarity to the Egyptian goddess Isis, see Jean Gillies, "The Central Figure in Botticelli's 'Primavera'," *Woman's Art Journal* 2 (1981): 12–16. For her similarities to the Virgin Mary, see Paul Barolsky, "Botticelli's *Primavera* and the Poetic Imagination of Italian Renaissance Art," *Arion* 8 (2000): 32; Charles Dempsey, "L'amore e la figura della ninfa nell'arte di Botticelli," in *Botticelli e Filippino: l'inquietudine e la grazia nella*

pittura fiorentina del Quattrocento, ed. Daniel Arasse, Pierluigi de Vecchi, and Jonathan Katz Nelson (Milan: Skira, 2004), 32.

6 Ptolemy writes, "If Venus rules action, she makes her subjects persons whose activities lie among the perfumes of flowers or of unguents, in wine, colors, dyes, spices, or adornments, as, for example, sellers of unguents, weavers of chaplets, innkeepers, wine-merchants, druggists, weavers, dealers in spices, painters, dyers, sellers of clothing." Ptolemy, *Tetrabiblos*, trans. F. E. Robbins, Loeb Classical Library 435 (Cambridge, MA: Harvard University Press, 1940), Book 4, 384–85. According to Ibn Ezra, "Of clothing," Venus denotes "all embroidery and pretty garments." "Of the trades [she denotes working with] anything that is dyed, and in sewing." Ibn Ezra (Avraham Ben Meir Ibn Ezra), *The Beginning of Wisdom (Reshith Hochma)*, trans. Meira B. Eptstein (Las Vegas: ARHAT, 1998), 100–01

7 "Ma Vener bella sempre in canti, e'n feste, / in balli, in nozze, e'n mostre, / in varie foggie, e'n nuove sopravveste, / in torniamentì, e'n giostre; / farà dolce conquista / d'alme gentili, e belle, / di giovani, e donzelle; / con amorosa vesta / terrà sempre Fiorenza in canto, e riso, / e dirassi: Fiorenza è 'l Paradiso." Antonfrancesco Grazzini, *Tutti i trionfi, carri, mascherate, o canti carnascialeschi andati per Firenze dal tempo del Lorenzo de' Medici fino all'anno 1559* (Lucca: Pel Benedini, 1750), 559, lines 31–40.

8 For studies of the *Primavera*, see Aby Warburg, "Sandro Botticelli's *Birth of Venus* and *Spring*: An Examination of Concepts of Antiquity in the Italian Early Renaissance (1893)," in *The Renewal of Pagan Antiquity: Contributions to the Cultural History of the European Renaissance* (Los Angeles: Getty Research Institute, 1999), 112–33; E. H. Gombrich, "Botticelli's Mythologies: A Study in the Neoplatonic Symbolism of his Circle," *Journal of the Warburg and Courtauld Institutes* 8 (1945): 8–43; Charles Dempsey, "Mercurius Ver: The Sources of Botticelli's *Primavera*," *Journal of the Warburg and Courtauld Institutes* 31 (1968): 251–73; Charles Dempsey, *The Portrayal of Love: Botticelli's Primavera and Humanist Culture at the Time of Lorenzo the Magnificent* (Princeton, NJ: Princeton University Press, 1992); Mirella Levi D'Ancona, *Botticelli's Primavera: A Botanical Interpretation Including Astrology, Alchemy and the Medici* (Florence: Leo S. Olschki, 1983), 25–67; Lilian Zirpolo, "Botticelli's 'Primavera': A Lesson for the Bride," *Women's Art Journal* 12 (1991): 24–28; Joanne Snow-Smith, *The Primavera of Sandro Botticelli* (New York: Peter Lang, 1993); Claudia La Malfa, "Firenze e l'allegoria dell'eloquenza: una nuova interpretazione della *Primavera* di Botticelli," *Storia dell'Arte* 97 (1999): 249–93; Barolsky, "Botticelli's *Primavera* and the Poetic Imagination of Italian Renaissance Art," 5–35; Giovanni Reale, *Botticelli. La "Primavera" o le "Nozze di Filologia e Mercurio"? Rilettura di carattere filosofico ed ermeneutico del capolavoro di Botticelli con la prima presentazione analitica dei personaggi e di particolari simbolici* (Rimini: Idea Libri, 2001); Rebecca Zorach, "Love, Truth, Orthodoxy, Reticence; or, What Edgar Wind Didn't See in Botticelli's *Primavera*," *Critical Inquiry* 34 (2007): 190–224; Cristina Acidini, "For a Prosperous Florence: Botticelli's Allegories," in *Botticelli: Likeness, Myth, Devotion*, ed. Andreas Schumacher (Frankfurt: Städel Museum, 2010), 74–82; Lew Andrews, "Botticelli's 'Primavera', Angelo Poliziano, and Ovid's 'Fasti'," *Artibus et Historiae* 32 (2011): 73–84; Christopher Poncet, *La scelta di Lorenzo: La Primavera di Botticelli tra poesia e filosofia* (Pisa: Fabrizio Serra, 2012).

9 For the full restoration report of the *Primavera*, see Primavera: anni 1981–83, GR 8720 in the Archivio dell'Opificio delle Pietre Dure. For a discussion of the report in Italian, see Mauro Matteini and Arcangelo Moles, "La Primavera, Tecnica di esecuzione e stato di conservazione," in *Metodo e scienza operatività e ricerca nel restauro (Firenze 23 giugno 1982–6 gennaio 1983)*, ed. Umberto Baldini (Florence: Sansoni, 1983), 226–33. For English, see Umberto Baldini, *Primavera: The Restoration of Botticelli's Masterpiece* (New York: Harry N. Abrams, 1986), 35–83.

10 The entry (no. 38) that may refer to the *Primavera* in the 1499 inventory of Lorenzo and Giovanni di Pierfrancesco de' Medici's palazzo reads, "Uno quadro di lignamo apicato sopra el letucio, nel quale è depinto nove figure de donne ch'omini [B: 1° quadro grande

sopra il lettuccio che v'è viii fiure], estimato – l. 100–." Florence, ASF, *Archivio mediceo avanti il principato*, filza CXXIX, fols. 480–528. For a discussion of the location of Botticelli's painting and the inventory, see John Shearman, "The Collections of the Younger Branch of the Medici," *Burlington Magazine* 117 (1975): 12–27, for inventory entry, 25; Webster Smith, "On the Original Location of the *Primavera*," *Art Bulletin* 57 (1975): 31–39.

11 For scholarship connecting the *Primavera* to Lorenzo di Pierfrancesco's marriage, see Zirpolo, "Botticelli's 'Primavera': A Lesson for the Bride," 24–28; Barolsky, "Botticelli's *Primavera* and the Poetic Imagination of Italian Renaissance Art," 5–35. Lorenzo di Pierfrancesco married Semiramide d'Appiano on Friday, July 19, 1482. This date was chosen after the original wedding date of May 1482 had to be changed due to the death of Lucrezia Tornabuoni, Lorenzo de' Medici's mother. For wedding date, see Levi D'Ancona, *Botticelli's Primavera: A Botanical Interpretation*, 27–28. It is also possible that the *Primavera* was created earlier for Lorenzo de' Medici to decorate chambers within the Medici Palace. Lorenzo was the guardian of Lorenzo and Giovanni di Pierfrancesco, and as Cristina Acidini has argued, he may have given his younger nephews the painting as part of a negotiated settlement, following his loss of a substantial portion of their inheritance. Acidini, "For a Prosperous Florence: Botticelli's Allegories," 76–79.

12 For scholarship that connects Botticelli's *Venus and Mars* to the Vespucci, see Gombrich, "Botticelli's Mythologies," 46–50; Arnolfo B. Ferruolo, "Botticelli's Mythologies, Ficino's *De Amore*, Poliziano's *Stanze per la Giostra*: Their Circle of Love," *Art Bulletin* 37 (1955): 17–25; Liana Cheney, *Botticelli's Neoplatonic Images* (Potomac, MA: Scripta Humanistica, 1993), 56–59, 106–12; Acidini, "For a Prosperous Florence: Botticelli's Allegories," in *Botticelli: Likeness, Myth, Devotion*, 89–91.

13 Louis A. Waldman, "Botticelli and his Patrons: The Arte del Cambio, the Vespucci, and the Compagnia dello Spirito Santo in Montelupo," in *Sandro Botticelli and Herbert Horne: New Research*, ed. Rab Hatfield (Florence: S.E.I. srl, 2009), 105–35.

14 Charles Dempsey, *Inventing the Renaissance Putto* (Chapel Hill: University of North Carolina Press, 2001), 107–46.

15 For scholarship on *Venus and the Three Graces*, see Helen S. Ettlinger, "The Portraits in Botticelli's Villa Lemmi Frescoes," *Mitteilungen des Kunsthistorischen Institutes in Florenz* 20 (1976): 404–407; Gert Jan van der Sman, "Sandro Botticelli at Villa Tornabuoni and a Nuptial Poem by Naldo Naldi," *Mitteilungen des Kunsthistorischen Institutes in Florenz* 51 (2007): 159–86; Patricia Simons, "Giovanna and Ginevra: Portraits for the Tornabuoni Family by Ghirlandaio and Botticelli," *I Tatti Studies in the Italian Renaissance* 14/15 (2011–12): 103–35; Maria DePrano, *Art Patronage, Family, and Gender in Renaissance Florence: The Tornabuoni* (Cambridge: Cambridge University Press, 2018), 167–89.

16 Simons, "Giovanna and Ginevra," 103–35.

17 DePrano, *Art Patronage, Family, and Gender in Renaissance Florence*, 92–96.

18 In the prologue, the author of the *Picatrix* writes, "I therefore pray to the highest creator that this work of ours falls into the hands of no sage lest they be capable of following everything I am about to say herein – and consider it beneficial – such that everything done through it be done for the good and in the service of God." In Book 1, he writes again, "Know, therefore, that the secret we mean to divulge in our book cannot be understood without the prerequisite knowledge. Whoever intends to understand it must focus on knowledge and pursue it exhaustively. The secret will not be revealed except by a sage – one determined to study these disciplines in the right order. This secret is most pure and will be of great advantage to you." *Picatrix: A Medieval Treatise on Astral Magic*, trans. Dan Attrell and David Porreca (University Park: Pennsylvania State University Press, 2019), 38, 40.

19 "Ex hac officina Magi omnium primi Christum statim natum adoraverunt." Ficino, *Three Books on Life*, 396–97.

20 One of the few documented meetings or gatherings at Ficino's farmhouse, which Christopher Poncet argues was the setting of his Platonic Academy, takes place on "this

most happy day in which the nativity of the King of kings is celebrated." The meeting is
described by Benedetto Colucci in his *Declamationes* as occurring in 1473. For a discussion
of this text and the location of Ficino's proposed Platonic Academy, see Christopher
Poncet, "Ficino's Little Academy of Careggi," *Bruniana & Campanelliana* 19 (2013):
67–76, especially 72. For further information about the Academy, see Paul Oskar
Kristeller, "The Platonic Academy of Florence," *Renaissance News* 14 (1961): 147–59.

21 Stephen M. Buhler, "Marsilio Ficino's De stella magorum and Renaissance Views of the
Magi," *Renaissance Quarterly* 43 (1990): 348–71.

22 André Chastel, *Art et humanisme à Florence au temps de Laurent le Magnifique* (Paris: Presses
universitaires de France, 1959), 241–46; Rab Hatfield, "The Compagnia de' Magi," *Journal
of the Warburg and Courtauld Institutes* 33 (1970): 107–61; Rab Hatfield, *Botticelli's Uffizi
"Adoration": A Study in Pictorial Content* (Princeton, NJ: Princeton University Press, 1976),
11–67.

23 *Picatrix*, 89.

24 "Luna ergo Venusque vim et spiritum naturalem atque genitalem et quae hunc augent."
Ficino, *Three Books on Life*, 264–65.

25 "Multum enim ad validam prosperamque vitam adiuvat, siquidem Venus fecundat homi-
nem facitque laetum. Hanc igitur observabis." Ficino, *Three Books on Life*, 266–69.

26 The *Picatrix* gives the following advice: "Use Venus when you wish to seek love and
friendship; then your request will be fulfilled and flourish more easily." It also states, "Do
not seek union from Mars nor separation from Venus. Do not seek to make any planet
deviate from its nature and path." *Picatrix*, 236.

27 The text of the *Children of Venus* print reads, "El suo di e venerdi e la prima hora 8 15 et 22 e
la notte sua e martedi el suo amico e Giove el nimico Mercurio et a dua abitazioni el toro di
giorno e libra di notte."

28 Similar activities are given to Venus in the *Picatrix*: "From cloth types, she governs all those
with decoration. From the crafts, she governs all the skills of painting, illustrating, selling
perfumes, playing instruments pleasantly, singing, dancing, and producing harmonies with
instruments." *Picatrix*, 134.

29 "Out of the metals, Venus governs red bronze and has a part in silver and glass. Out of the
stones, she governs azure, coral, and malachite, and partly over beryl and magnesium."
Picatrix, 104. "Venus governs bronze and copper among the minerals." *Picatrix*, 107. "From
the stones, she governs pearls. From the minerals, she governs lapis lazuli and litharge. From
the plants, she rules all those with a pleasant smell, like the crocus, the *arhenda*, roses, and
all the flowers with a good odor, taste, and beautiful appearance. From the spices, she
governs balsam and good grains of very fragrant julep mint, nutmeg, and amber. From the
animals, she governs women, camels, beautiful things, all the handsome animals, and those
balanced in the bodies, like gazelles, sheep, deer, and rabbits. From the birds, she governs all
the beautiful and famous ones and those with beautiful singing voices, like partridges,
calandra, larks, and similar ones. From the insects, she governs the decorated and beautiful
ones. From the colors, she rules sky blue and gold lightly fading to green." *Picatrix*, 134.
According to Ficino, "One obtains things from Venus through her animals which we have
mentioned and through carnelian, sapphire, lapis lazuli, brass (yellow or red), coral and all
pretty, multicolored or green colors and flowers, musical harmony, and pleasant odors
and tastes" (*Three Books on Life*, 253). "But how the power of Venus may be attracted by
turtle-doves, pigeons, white water wag-tails, and the rest, modesty forbids me to reveal"
(249). "Colors which are very watery, white, green, a bit yellowish, similar to the colors of
violets, roses, and lilies, and also odors of this sort, refer to Venus, the Moon, and Mercury"
(297). "By a similar power from Jupiter and Venus in particular, coral and chalcedony are
good against the delusions of black bile" (301).

30 Dan Attrell and David Porreca write that the origins of the *Picatrix*'s wisdom tradition "can
be traced back to the likes of Plato, Pythagoras, Orpheus, Moses, Hermes Trismegistus,
Enoch, Zoroaster and ultimately, to a pre-lapsarian Adam." *Picatrix*, 2–3.

31 Theories of astral magic gained precedence in Spain and Sicily between 1000 and 1300. Abraham Ibn Ezra wrote a textbook of astrology titled *The Beginning of Wisdom* (*Reshith Hochma*) in 1148, while Michael Scot completed his *Liber introductorius*, a book on the planets, their images, and uses of astrology, at the Sicilian court of Emperor Frederick II between 1225 and 1232.

32 *Picatrix*, 173.

33 "May God preserve you, O Venus, who are mistress and fortune, cold and humid, fair in your effects and complexion, pure, beautiful, pleasant-smelling, pretty and decorated! You are the mistress of gold and silver jewelry; fond of love, joy, decorations, parties, elegance, songs, and instruments that respond with the voice and are sung from the heart, songs sung with a beat and pipe music, games and comforts, rest and love. You have stood firm in your effects. You love wines, rest, joy, and sex with women since all these stand as your natural effects. I myself invoke you by all your names: in Arabic, *Zohara*; in Latin, *Venus*; in Persian, *Anyhyt*; in Roman, *Affludita*; in Greek, *Admenita*; in Indian, *Sacra*. I conjure you by the Lord God, Lord of the high firmament, and by the obedience that you render unto God, and by the power and dominion that He holds above you so that you may heed my prayer, remember my request, and do such-and-such for me (state your request here). I conjure you by BEYTEYL, who is that angel whom God placed with you for bringing about your powers and effects." The text continues with the suffumigation. "While doing this, the suffumigation should be constantly burning in the censer, the composition of which is this: Take equal parts of aloewood, sukk, costus, saffron, labdanum, mastic gum, poppy husks, willow leaves, and lily root. Grind everything up, and mix it in rosewater. Make tablets the size of chickpeas. Throw them in the censer's fire until your ritual is complete." *Picatrix*, 173–74.

34 The letter reads, "Valoris voluntate erga te tum de bonitate doctrinaque tua, permotus, significavit pluribus si quod [*ms.* quid] Picatricis opus quaeris habuisset, id ultro tibi et libentissime missurum. Rogavit itaque, cum ipse per aegritudinem non posset, ut suo nomine ad te litteras darem significaremque huiusmodi Picatricis librum quem iam diu a Georgio Medico sibi commodatum iam riddidisset [*ms.* reddidisse] se quidem diu et multum perlegisse multamque in eo versando operam et acute legendo studium posuisse, sed invenisse plurima nullius fere momenti nugisque simillima; quae vero utilia inerant et lectione digna, ea in libros quos ipse de vita composuit [*ms.* composita] transtulisse, reliqua vero aut frivola et vana aut et christiana religione damnata reliquisse. Dehortatur itaque te Ficinus ipse ab eiusmodi lectione in qua plurimum laboris, utilitatis vero parum invenitur, quum praesertim quae in eo ipso opera alicuius usus (vel) ponderis sunt eadem singula fortasse melius, compendiosius certe lucidiusque, legantur in illo ipso libro quem *De vita* inscripsit quem [*ms.* que] quidem si diligentissime volveris, nihil aut a Picatrice illo aut ab alio scriptore aliquo desiderabis quod ad eam rem quam maxime quaeris facere possit." For transcription of letter, see Daniela Delcorno Branca, "Un discepolo del Poliziano: Michele Acciari," *Lettere italiane* 28 (1976): 470. For further discussion of the influence of the *Picatrix* on Ficino's writings, see Vittoria Perrone Compagni, "La magia ceremoniale del 'Picatrix' nel Rinascimento," *Atti dell'Accademia di Scienze Morali e Politiche* 88 (1977): 279–330.

35 Among the many strange recipes or magical arts given are the following three spells: Spell #89 "A woman's menstrual fluid given to anyone will cause leprosy. If anyone bathes in it, they will die quickly." Spell #100 "The testicles of a man, dried, pulverized, and eaten with incense, mastic gum, cinnamon, and cloves, makes a man truly younger and gives him an exceptionally good color." Spell #111 "Take the vulva of a woman (that is, the skin), and carry it in a yellow cloth with the tongue of a snake bound to it. You will be powerful in making factions and friendships. A woman's pubic hair does the same." For these and other spells, see *Picatrix*, 206, 207, 208.

36 *Picatrix*, 96.

37 "Hebraei quoque in Aegypto nutriti struere vitulum aureum didcerunt, ut eorundem astrologi putant, ad aucupandum Veneris Lunaeque favorem contra Scorpionis atque Martis influxum Iudaeis infestum" Ficino, *Three Books on Life*, 306–307.

38 Exodus 32:35.

39 For Ficino's discussion on why medicines receive celestial influences better than images, see Ficino, *Three Books on Life*, 306–307. He writes at a later point in the discourse, "I think, therefore, that it would be safer to trust oneself to medicines than to images; and that the things we said cause celestial power in images can have their efficacy rather in medicines than in figures." ("Denique tutius fore arbitror medicinis quam imaginibus se committere; rationesque a nobis de potestate coelesti pro imaginibus assignatas in medicinis potius quam in figuris efficaciam habere posse.") Ficino, *Three Books on Life*, 342–43.

40 "Therefore, you should not doubt, they say, that the material for making an image, if it is in other respects entirely consonant with the heavens, once it has received by art a figure similar to the heavens, both conceives in itself the celestial gift and gives it again to someone who is in the vicinity or wearing it." ("Ergo ne dubites, dicent, quin materia quaedam imaginis faciendae, alioquin valde congrua coelo, per figuram coelo similem arte datam coeleste munus tum in se ipsa concipiat, tum reddat in proximum aliquem vel gestantem.") Ficino, *Three Books on Life*, 332–33.

41 "Tres vero potissimum regulas ad hoc afferemus, si prius admonuerimus, ne putes nos impraesentia de stellis adorandis loqui, sed potius imitandis et imitatione captandis." Ficino, *Three Books on Life*, 356–57.

42 "Similarly, images made of wood have little force. For wood is both perhaps too hard to take on celestial influence easily and less tenacious, if it does receive it, in retaining it; and it soon loses almost any vigor of cosmic life at all and is easily transmuted into another quality after it is rooted out of the bowels of its mother earth. But gems and metals, although they seem too hard for accepting a celestial influence, nevertheless retain it longer if they receive it, as Iamblichus confirms." ("Proinde imagines ex ligno confectae vim forte parvam habent. Nam lignum et forsan durius est ad coelestem influxum facile capiendum et minus tenax, si acceperit, retinendum; et omnino postquam ex matris terrae visceribus est evulsum, paulo post ferme totum amittit mundanae vitae vigorem et facile in qualitatem aliam transmutatur.") Ficino, *Three Books on Life*, 308–309. For his discussion of a chamber marked with "figures and colors," see Ficino, *Three Books on Life*, 346–47.

43 "Qualitates autem quae minus elementares materialesve sunt, scilicet lumina, id est colores, numeros quoque similiter et figuras ad talia forsitan minus posse, sed ad coelestia munera (ut putant) valere permultum." Ficino, *Three Books on Life*, 328–29.

44 "Nosti praeterea quam facile multis misericordiam moveat figura lugentis, et quantum oculos imaginationemque et spiritum et humores afficiat statim atque moveat amabilis personae figura. Nec minus viva est et efficax figura coelestis." Ficino, *Three Books on Life*, 330–31. For a discussion of substantial forms v/s figures in the philosophy of Ficino and other writers that influenced him, see Brian P. Copenhaver, "Scholastic Philosophy and Renaissance Magic in the *De vita* of Marsilio Ficino," *Renaissance Quarterly* 37 (1984): 523–54.

45 "Ad laetitiam roburque corporis Veneris imaginem puellarem, poma floresque manu tenentem, croceis et albis indutam, hora Veneris, facie Librae vel Piscium vel Tauri ascendente cum Venere." Ficino, *Three Books on Life*, 336–37. In his *Speculum lapidum* of 1502, Camillo Leonardi claims that a talisman inscribed with a similar image of Venus makes whoever carries it "quick in action and able to carry out everything to its desired end." ("Veneris imagines multae sunt ut ex magicis habetur: tamen hae in lapidibus sculptae inveniuntur: ut mulier cum magna veste ac stola in manuque laurum tenens. Virtus est levitatem in agendis dare: ac omnia ad optatum finem deducere: timorem submersionis aquae aufert: & potestatem accommodat.") Camillo Leonardi, *Speculum lapidum, cui accessit Sympathia septem metallorum ac septem selectorum lapidum ad planetas. Petri Arlensis de Scudalupis* (Paris: Sevestri et Gillius, 1610), 192–93.

46 The image of Venus in the *Picatrix* is described as follows: "The image of Venus, according to the opinion of other sages, is the shape of a woman riding a stag with her hair down, and in her right hand she has an apple, and in her left she has flowers; her clothes are of white colors. This is her shape." *Picatrix*, 107.

47 For a discussion of the paintings under Venus' zodiac house of Taurus, see Maria Beatrice Rigobello and Francesco Autizi, *Palazzo della Ragione di Padova: Simbologie degli astri e rappresentazioni del governo* (Padua: Il Poligrafo, 2008), 175–79; Dieter Blume, "Michael Scot, Giotto, and the Construction of New Images of the Planets," in *Images of the Pagan Gods: Papers of a Conference in Memory of Jean Seznec*, ed. Rembrandt Duits and François Quiviger, Warburg Institute Colloquia 14 (London: Aragno, 2009), 129–50.

48 For discussions of the Schifanoia frescos in relation to the *Picatrix* and talismanic magic, see Marco Bertozzi, "Schifanoia: Il salone dei dipinti perduti. Con una appendice su Aby Warburg: lo 'stile' del paganesimo antico," in *Lo Zodiaco del principe: i decani di Schifanoia di Maurizio Bonora*, ed. Elena Bonatti (Ferrara: Maurizio Tosi, 1992), 23–33; Marina Alfano, "L'armonia di Schifanoia. Allegorie musicali nel Rinascimento," in *Lo Zodiaco del principe*, 71–72; Dieter Blume, "Picturing the Stars: Astrological Imagery in the Latin West, 1100–1500," in *A Companion to Astrology in the Renaissance*, ed. Brendan Dooley (Leiden: Brill, 2014), 335–45.

49 For a discussion of Marzio Galeotto's use of the *Picatrix*, see Compagni, "La magia ceremoniale," 303–10.

50 In his early sixteenth-century treatise on nuptial rituals, Marco Antonio Altieri notes that couples often scheduled weddings in April because Venus, who controls desire and generation, rules this month. Altieri explains that couples should not get married in February or May and then describes April as a good month. He writes, "Con assai diverse et varie rascione el medesmo ne recita de Maio; asserendoce Aprile, sì come Aphrodite intitulasse da Venere, singulare operatrice in qual vogliase misterio de contractarve el generare." Marco Antonio Altieri, *Li nuptiali*, ed. Enrico Narducci (Rome: Roma nel Rinascimento, 1995), 59.

51 "Quilibet vero colores si vivi sint vel saltem sericii magis stellares existunt. In metallis quoque et lapidibus atque vitris propter coelestem similitudinem sunt potentes." Ficino, *Three Books on Life*, 296–97.

52 For letter, see Marsilio Ficino, *Meditations on the Soul: Selected Letters of Marsilio Ficino*, trans. Members of the Language Department of the School of Economic Science, London (Rochester, VT: Inner Traditions International, 1996), 162.

53 In the fifth Homeric Hymn, Aphrodite seduces the Lydian shepherd Anchises, makes love to him, and then conceives Aeneas, father of Rome. As she stands before Anchises, her raiment is described as follows: "her shining garments; for she wore a dress brighter than firelight, and she had twisted bracelets and shining ear buds. Round her tender neck there were beautiful necklaces of gold, most elaborate, and about her tender breasts it shone like the moon, a wonder to behold. Anchises was seized by desire." *Homeric Hymns. Homeric Apocrypha. Lives of Homer*, ed. and trans. Martin L. West, Loeb Classical Library 496 (Cambridge, MA: Harvard University Press, 2003), 162–69, for garments, 166–67. In the *Iliad*, Aphrodite's raiment is referenced when she protects her son Aeneas from a mortal wound. "About her dear son she flung her white arms, and in front of him she spread a fold of her bright garment to be a shelter against missiles, ... then the son of great-hearted Tydeus thrust with his sharp spear and leapt at her, and cut the surface of her delicate hand, and immediately through the ambrosial raiment, which the Graces themselves had toiled over making for her." Homer, *Iliad, Volume I: Books 1–12*, trans. A. T. Murray, rev. William F. Wyatt, Loeb Classical Library 170 (Cambridge, MA: Harvard University Press, 1925), Book 5, 228–31.

54 For the process of manufacturing white silk thread, see Florence Edler de Roover, "Andrea Banchi, Florentine Silk Manufacturer and Merchant in the Fifteenth Century," in *Studies in Medieval and Renaissance History*, ed. William M. Bowsky, vol. 3 (Lincoln: University of Nebraska Press, 1966), 242–43.

55 Cennini describes the process as follows: "biancho e un colore naturale mabene |e| artificiato el / quale si fa per questo modo tolli la calcina sfiorata ben biancha / mettila spolverata inn uno mastello per ispazio di di otto rimutando on / gni di di acqua chiara et rimescholando ben la chalcina e ll acqua / accio che nne butti fuora ongni grasseza poi ne fa

panetti picoli / mettili al sole su per li tetti e quanto piu antichi son questi panetti tanto / piu e migliore biancho | se l vuoi far presto e buono | quando i panetti / son secchi triali p in sulla tua pria con acqua et poi ne fa panecti / errisecchali effa cosi due volte et vedrai come sara perfetto biancho." Cennini, *Il libro dell'arte*, 83.

56 Leonardo writes, "Se vederai una donna vestita in bianco infra una campagna, quela parte di lei che fia veduta dal sole, il suo colore fia chiaro in modo che darà in parte, come il sole, noia alla vista; e quella parte che ffia veduta dall'aria luminosa per li razi del sole tessuti e penetrati infra essa, perché l'aria in sé è azura, la parte della dona vista da dett'aria parrà pendere in azzurro." *Scritti d'arte del Cinquecento. Colore*, ed. Paola Barocchi, vol. 9 (Milan: Riccardo Ricchiardi, 1979), 2131.

57 In their analysis of pigment samples from the *Primavera*, Mauro Matteini and Arcangelo Moles found the protein of egg but also the protein of another substantial fat, likely oil. From these results, they argued that Botticelli painted the *Primavera* in *tempera grassa*. They also found that Botticelli employed transparent glazes of color, such as red lake and verdigris; see Matteini and Moles, "La Primavera, Tecnica di esecuzione e stato di conservazione," 228–30. For the full restoration report of the *Primavera*, see Primavera: anni 1981–83, GR 8720 in the Archivio dell'Opificio delle Pietre Dure. In his English book on the restoration of Botticelli's *Primavera*, Umberto Baldini writes, "Light and shadow, modeling, and diaphanous drapery are created with layer upon layer of thin paint, in colors whose harmonies are so modulated that the effect of *sfumatura* is produced." Restoration of the three Graces' transparent garments, for example, uncovered strokes of pink, gray, and blue with highlights in lead white; see Baldini, *Primavera: The Restoration of Botticelli's Masterpiece*, 48–49, 59, 68.

58 Another technique for depicting a translucent textile was to paint the area covered by the textile, skin for example, with a mixture of lead white and flesh tone to suggest both the translucent covering and the skin beneath it. Botticelli's contemporary Piero di Cosimo often used this technique, as seen his *The Finding of Vulcan on Lemnos*.

59 The three Graces' sheer garments resemble *camicie* or chemises. In the late fifteenth century, chemises were being fashioned from silk rather than from linen and embroidered with gold thread; see Pisetzky, *Storia del costume in Italia*, vol. 2, 285–87. For discussion of the three Graces' chemises, see Dempsey, *The Portrayal of Love*, 67; Herald, *Renaissance Dress in Italy*, 212.

60 In his description of the three Graces and their allegorical meanings, Seneca the Younger mentions their wearing transparent garments, but he also writes, "I could find another poet in whose writings they are girdled and appear in robes of thick texture or of Phryxian wool." Seneca, *Moral Essays, Volume III: De Beneficiis*, trans. John W. Basore, Loeb Classical Library 310 (Cambridge, MA: Harvard University Press, 1935), Book 1, 14–15. Botticelli's choice of green, white, and gold for the three Graces' garments corresponds with contemporary descriptions of the triad in terms of verdure, gladness, and splendor. Pico della Mirandola, for example, writes, "The poets say that this Venus has as her followers, or handmaidens as it were, the three Graces, whose names, in the vernacular, are: Greenness, Joy, and Splendor. The three Graces are merely three properties attendant upon ideal beauty." Giovanni Pico della Mirandola, *Commentary on a canzone of Benivieni*, trans. Sears Reynolds Jayne (New York: Peter Lang, 1984), Book 2, 113. This passage is also discussed in Gombrich, "Botticelli's Mythologies," 33; Charles Dempsey, "Botticelli's Three Graces," *Journal of the Warburg and Courtauld Institutes* 34 (1971): 326–30.

61 Michael Scot labels his description: "Sic figuratur Venus" and writes of her "pulchras vestes // et frixatas et gemmatas." As to their meaning, he writes, "Ornatus et frixatura clamidis signat virtutem, qua naturaliter attrahit alios ad se, ut appetant esse secum." Text contained in Silke Ackermann, *Sternstunden am Kaiserhof. Michael Scotus und sein Buch von den Bildern und Zeichen des Himmels* (Frankfurt am Main: Peter Lang, 1996), 264. Boccaccio writes that Venus signifies "the guardianship of statues and pictures, the composition of wreaths and wearing of garments, weavings with gold and silver" ("magisteria circa statuas

et picturas, sertorum compositiones et vestium indumenta, auro argentoque contexta"). Giovanni Boccaccio, *Genealogy of the Pagan Gods, Volume I: Books I–V*, trans. Jon Solomon, I Tatti Renaissance Library 46 (Cambridge, MA: Harvard University Press, 2011), Book 3, 382–85. The bottom of the *Children of the Planet Venus* print reads, "Venus is a feminine sign located in the third heaven. She is cold and moist, temperate, who has these properties: she loves beautiful vestments adorned with gold and silver." ("Venere e segno feminino posto nel terzo cielo e freddo e umida tenperata. La quale a queste propieta ama belli vestimenti ornati doro e dargeto.")

62 Homer, *Iliad, Volume II: Books 13–24*, trans. A. T. Murray, rev. William F. Wyatt, Loeb Classical Library 171 (Cambridge, MA: Harvard University Press, 1925), Book 14, 82–83.

63 Homer, *Iliad, Volume II: Books 13–24*, Book 14, 82–91.

64 Nonnos, *Dionysiaca, Volume II: Books 16–35*, trans. W. H. D. Rouse, Loeb Classical Library 354 (Cambridge, MA: Harvard University Press, 1940), Book 32, 446–47.

65 Nonnos, *Dionysiaca, Volume II*, Book 32, 444–47.

66 *Picatrix*, 80. The beneficial conjunction of Venus and the Moon are discussed in other places within the *Picatrix*. One spell reads, "When you wish to craft an image for inducing love between two individuals (and to give their love and joy the strength of an oak), make images in both of their likenesses. Make them in the hour of Jupiter or Venus with the head of the Dragon ascending. Let the Moon be with Venus or looking toward her in favorable aspect. Let the lord of the seventh house look upon the lord of the first house in a trine or sextile aspect. Afterward, join the images together in an embrace, and bury them at the home of one of the two people (i.e., at that person's home whom you wish to feel most in love). Whatever you desire shall come about." *Picatrix*, 53. In another place, the text explains that "in all works of magic made for love, friendship, and fellowship or anything similar to these, see to it that the Moon be conjoined to Venus or facing her in the sign of Pisces or that the Moon in Pisces be facing Venus in the sign of Taurus. When we will have observed that set of astrological conditions in such things, we shall obtain our intent wondrously and achieve what we desired." *Picatrix*, 127–28.

67 "Luna ergo Venusque vim et spiritum naturalem atque genitalem et quae hunc augent." Ficino, *Three Books on Life*, 264–65.

68 On *pannocchia*, see Charles Dempsey, *The Early Renaissance and Vernacular Culture* (Cambridge, MA: Harvard University Press, 2012), 97–98.

69 Niccolò Machiavelli, *Florentine Histories*, trans. Laura F. Banfield and Harvey C. Mansfield, Jr. (Princeton, NJ: Princeton University Press, 1988), 362.

70 "Intorno al col suo bianca treccia avvolga, / delli ardenti amator dura catena, / e forte laccio, che giammai si sciolga." Italian text in William Roscoe, *The Life of Lorenzo de' Medici, called the Magnificent*, 8th ed. (London: Henry G. Bohn, 1865), 434.

71 See passage in Ackermann, *Sternstunden am Kaiserhof. Michael Scotus und sein Buch von den Bildern*, 264.

72 Vasari writes that Botticelli "was among the first to discover the method of decorating standards and other sorts of hangings with the so-called inlaid work, to the end that the colors might not fade and might show the tint of the cloth on the other side." He mentions that "by his hand," there is "the baldacchino of Orsanmichele, covered with beautiful and varied figures of Our Lady" and the design for the "embroidered border of the Cross that the Friars of S. Maria Novella carry in processions." ("E fu egli de'primi che trovasse di lavorare gli stendardi ed altre drapperie, come si dice, di commesso, perchè i colori non istinghino o mostrino da ogni banda il colore del drappo. E di sua mano così fatto è il baldacchino d'Orsanmichele, pieno di Nostre Donne, tutte varie e belle: il che dimostra quanto cotal modo di fare meglio conservi il drappo, che non fanno i mordenti che lo ricidono e dannogli poca vita; sebbene, per manca spesa, è più in uso oggi il mordente che altro.") For Italian, see Giorgio Vasari, *Le vite de' più eccellenti pittori, scultori ed architettori*, ed. Gaetano Milanesi, vol. 3 (Florence: G. C. Sansoni, 1878), 323; for English, see Giorgio Vasari, *Lives of the Most Eminent Painters, Sculptors and Architects*, trans. Gaston du C. de Vere,

vol. 3 (London: Macmillan, 1912), 253–54. For a description of this embroidery technique, see Frick, *Dressing Renaissance Florence*, 53. For discussion of Botticelli's work with embroiderers, see Annarosa Garzelli, *Il ricamo nella attività artistica di Pollaiolo, Botticelli, Bartolomeo di Giovanni* (Florence: Edam, 1973), 22–25, 28–38; Alessandro Cecchi, *Botticelli* (Milan: Federico Motta, 2005), 268–76.

73 For a complete technical study of the *cappuccio*, see Maria Teresa Balboni Brizza, ed., *Botticelli e il ricamo del Museo Poldi Pezzoli. Storia di un restauro* (Milan: Museo Poldi Pezzoli, 1990). Andrea Di Lorenzo discusses the original patron and eventual function of the *cappuccio*; see catalogue entry (no. 7.15) in *Money and Beauty: Bankers, Botticelli and the Bonfire of the Vanities,* ed. Ludovica Sebregondi and Tim Parks (Florence: Giunti, 2011), 222–23. Sabine Hoffman argues that the original hood included only the lower design of two angels holding the arms of Portugal and that the upper design of the *Coronation of the Virgin* was added to the garment at a later date; see catalogue entry (no. 136) in *Botticelli Reimagined*, ed. Mark Evans and Stefan Weppelmann (London: V&A Publishing, 2016), 288.

74 As Rembrandt Duits explains, the thread most commonly used to manufacture gold brocades in fourteenth-century Florence was a "gilt membrane thread, or so-called Cyprian gold, which consisted of a silk thread wrapped in a thin strip of gilded animal gut." Rembrandt Duits, *Gold Brocade and Renaissance Painting: A Study in Material Culture* (London: Pindar, 2008), 74. This thread is also mentioned as the highest quality gilt thread in Florence, see Florence Edler de Roover, *L'arte della seta a Firenze nei secoli XIV e XV*, ed. Sergio Tognetti (Florence: Leo S. Olschki, 1999), 88.

75 For a discussion of these agencies, see De Roover, *L'arte della seta*, 87–98.

76 For Antonio's matriculation into the silk guild, see ASF, Arte della Seta o di Por S. Maria 8, matricole dal 1433 al 1474, c. 13. Document (no. 9) included in Herbert P. Horne, *Alessandro Filipepi, commonly called Sandro Botticelli, painter of Florence*, vol. 1 (London: G. Bell & Sons, 1908), 474. For the Company of St. Luke (the painter's guild), see ASF, Accademia del Disegno prima Compagnia dei Pittori 2, cc. 5v.–6r. For document, see Horne, *Alessandro Filipepi, commonly called Sandro Botticelli*, vol. 1, 5. These two citations are discussed in Cecchi, *Botticelli*, 19.

77 *Picatrix*, 139.

78 In one of the oldest portrayals of the planetary deity, found in George Fendulus' *Liber astrologiae* of 1220–30, Venus is clad in all red; however, a number of other deities also wear red, including the Sun, Mars, Mercury, and the Moon; see Dieter Blume, *Regenten des Himmels. Astrologische Bilder in Mittelalter und Renaissance* (Berlin: Akademie Verlag, 2000), tables 1–11. In his astrological cycle at the Church of the Eremitani in Padua, Guariento di Arpo distinguishes the planetary deities with different colors. The Moon, for example, wears white, while the Sun wears yellow and radiates red rays of light. Venus dons a pink dress. Other artists include red textiles as part of Venus' attire. In the House of Taurus in the Palazzo della Ragione, Giotto's Venus models sleeves fashioned from a deep pink textile woven with gold thread, while Francesco del Cossa's goddess in the Palazzo Schifanoia wears a red dress (*gamurra*) under her white *cioppa*.

79 On *chermisi* dye, see Frick, *Dressing Renaissance Florence*, 101–102; John H. Munro, "The Medieval Scarlet and the Economics of Sartorial Splendour," in *Cloth and Clothing in Medieval Europe*, ed. E. M. Carus-Wilson, Kenneth G. Ponting, and N. B. Harte (London: Heinemann, 1983), 14–18; Luca Molà, *The Silk Industry of Renaissance Venice* (Baltimore: Johns Hopkins University Press, 2000), 107–20; Michel Pastoureau, *Red: The History of a Color*, trans. Jody Gladding (Princeton, NJ: Princeton University Press, 2016), 40–43, 90–93; Amy Butler Greenfield, *A Perfect Red: Empire, Espionage, and the Quest for the Color of Desire* (New York: Harper Perennial, 2006), 5–33.

80 Silk merchants purchased four types of insect materials for the making of crimson dye: (1) kermes, a scale insect found on evergreen kermes oaks in Spain, France, North Africa, and the Eastern Mediterranean; (2) St. John's Blood, called Polish cochineal, was cultivated in the grasslands of Poland and Eastern Europe. The insects were harvested around the feast

day of St. John the Baptist on June 24; (3) Armenian red, also known as Ararat cochineal, originates from the shield louse and was harvested in the grasslands at the foot of Mount Ararat. It was imported to Italy from Constantinople; and (4) Indian lac, a resin excreted by female lac insects and collected from trees in South East Asia, including India, Sri Lanka, Burma, and China. For information on these insects and the dyes they produced, see Jo Kirby, Maarten van Bommel, and André Verhecken, eds., *Natural Colorants for Dyeing and Lake Pigments. Practical Recipes and their Historical Sources* (London: Archetype, 2014), 9–13; Molà, *The Silk Industry of Renaissance Venice*, 107–12; Spike Bucklow, *Red: The Art and Science of a Colour* (London: Reaktion Books, 2016), 23–28.

81 For prices, see De Roover, *L'arte della seta*, 46. Florence Edler de Roover explains that threads dyed only once were used for damask and satin and those twice-dyed were used for velvets; see De Roover, "Andrea Banchi, Florentine Silk Manufacturer and Merchant in the Fifteenth Century," 243.

82 Fpr information regarding where sappanwood (*Caesalpinia sappan* L.) and madder (*Rubia tinctorum* L., *Rubia cordifolia* L., and *Rubia peregrine* L.) are found, see Kirby et. al., *Natural Colorants for Dyeing and Lake Pigments*, 13–14.

83 For prices, see De Roover, *L'arte della seta*, 44–45.

84 "E come si maritò, gli tagliò una cotta di zetani vellutato chermisi, e così la roba di quello medesimo: ed è'l più bel drappo che sia in Firenze; che se lo fece'n bottega. . . . E ordina di fare un velluto chermisi, per farlo colle maniche grandi, foderato di martore, quando n'andrà a marito: e fa una cioppa rosata, ricamata di perle." For Italian and English text, see *Selected Letters of Alessandra Strozzi*, trans. Heather Gregory (Berkeley: University of California Press, 1997), 30–31.

85 Popular electuaries often consisted of red roses mixed with honey and syrup, combined with various spices and seeds, to which could be added customized ingredients ranging from ambergris to coral to powdered pearls, depending on the ailment. James Shaw and Evelyn Welch, *Making and Marketing Medicine in Renaissance Florence* (New York: Rodopi, 2011), 248–50. Bucklow also mentions the use of kermes for medicines, in particular for heart tonics; see Bucklow, *Red*, 27.

86 "Cum enim sub terra nequeant speciosissima et quasi coelestia procreari absque summo quodam beneficio coeli, probabile est rebus eiusmodi mirificas coelitus inesse virtutes. Compositio vero eiusmodi, quae dilatando et illuminando spiritum aeque congregat, eta delectat eum intrinsecus atque recreat, sicut foris viriditas oculos, atque ipsum etiam apud senes in naturali quadam viriditate diutissime servat, quasi laurum, olivam, pinum, etiam hieme virentem." Ficino, *Three Books on Life*, 206–207.

87 For Ficino's electuaries, see Ficino, *Three Books on Life*, 154–57.

88 For a discussion of lake pigments and the different materials used to create them, see Kirby et al., *Natural Colorants for Dyeing and Lake Pigments*, 69–75; Daniel V. Thompson, *The Materials and Techniques of Medieval Painting* (New York: Dover Publications, 1956), 108–24. A recipe included in a Bolognese manuscript instructs the reader to take clippings of cloth dyed with *grana* and mix them with ley "made from the ashes of bean-stalks," strain the mixture 8–10 times, then add rock alum to give the lake pigment body. The recipe reads as follows: "Rp. 139. *Affare lacha*. – Recipe panno o veramente cimatura de grana ma el rosato o panno de grana e migilore perche ha piu substantia et mecti in lesciva de cenere de fava et questa liscia vole esser forte et fa cosci octo o dece volte mectendo dentro la cenere et colala che sera fortissima et in la dicta liscia poni el dicto panno el quale se consumera presto et poi el cola et lassa possare la colatura et se tu voli dare a lo dicto collore corpo tollj alume di rocho et mistica cum la dicta lacca et polla a secare et e facta et sappi che la cenere se po fare de cenere de cerro overo de fecia de vino etc." Mary P. Merrifield, *Original Treatises on the Arts of Painting*, vol. 2 (New York: Dover, 1967), 456–57; for other red lake recipes, 432–57. For further discussion of lac and kermes, see Kirby et al., *Natural Colorants for Dyeing and Lake Pigments*, 71–78, 82–84, 101–102; David Coles, *Chromatopia: An Illustrated History of Colour* (New York: Thames & Hudson, 2019), 56–57, 60–61.

89 "Rosso e un cholor che ssi chiama lacha laquale e cholor artifizia / to nonne piu riciette maio tichonsiglio per lo tuo denaro / tolghi i cholor fatti per amor dellepratiche ma ghuardati dichogni / oscier la buona pero che sse ne dipiu ragioni fi fa lacha dicimatu / ra di drappo over dipanno ed e molto bella alocchio di questa / dico che ti ghuarda pero ch ella ritiene senpre in se grassezza per chagion / dell alume e non dura niente ne con tenpere ne sanza tenpe / re e disubito prede suo cholore ghuardatene ben di questa ma tto / lli lacha la qual silavora di ghomma ede asciutta magra grane / llosa che quasi par nera e tien cholor saghuineo questa non p / uo essere altro che buona e perfetta togli questa e triala in sulla / tua pria macinala chon acqua chiara ede buona in tavola e an / che s adopera in muro chontenpera mall aria e ssua nimicha / alchun son che llatriano chonorina mavien dispiacievole perche / subito puza." Cennini, *Il libro dell'arte*, 68–69.

90 In his *Treatise on the Arts of Painting, Sculpture, and Architecture* (1585), Giovanni Paolo Lomazzo recommends red lake for capturing the "luster and liveliness" of silk. He writes of red lake and verdigris, "Ora lavorando ad oglio usansi questi colori per rappresentar, come se veri fossero, tutti i corpi trasparenti chiari, come sono i carbonchi, i rubini e simili; ... I medesimi colori si usano ancora per dar il lustro e la vivacità al raso et all'ormesino alterati de i loro colori naturali sopra le abbozzature. La quale usanza è passata tanto inanzi che, senza risguardo alcuno dei precetti de l'arte, attendendo solamente alla vaghezza, si usa non solamente nei drappi nominati di sopra, ma ancora nei panni di falde contrarie, che non richiedono quella trasparenza o vivacità di seta." *Scritti d'arte del Cinquecento. Colore*, vol. 9, 2242–43.

91 In their report, Matteini and Moles describe the pigment as "lacca carminio" and note that the color is less fluorescent in U.V. than "lacca di garanza" or madder lake. They also note that substantial areas of the pigment have been lost over time; see Matteini and Moles, "La Primavera, Tecnica di esecuzione e stato di conservazione," 229.

92 Ficino, *Three Books on Life*, 206–207.

93 For a discussion of the differences between brocades and damasks in terms of weaving processes and prices, see Richard A. Goldthwaite, "An Entrepreneurial Silk Weaver in Renaissance Florence," *I Tatti Studies in the Italian Renaissance* 10 (2005): 80–87.

94 "Venne una volta ad abitare allato a Sandro un tessitore di drappi, e rizzò ben otto telaia, i quali, quando lavoravano, facevano non solo col romore delle calcole e ribattimento delle casse assordare il povero Sandro, ma tremare tutta la casa, che non era più gagliarda di muraglia che si bisognasse; donde, fra per l'una cosa e per l'altra, non poteva lavorare o stare in casa." Vasari-Milanesi, *Le vite*, vol. 3, 320; Vasari-Du Vere, *Lives*, vol. 3, 252.

95 Levi D'Ancona describes this pattern as fleurons or *fioretti* in Italian and connects the design with Giuliano de' Medici's love affair with a woman named Fioretta; see Levi D'Ancona, *Botticelli's Primavera: A Botanical Interpretation*, 65–66.

96 Cecchi, *Botticelli*, 242.

97 For a discussion of how artists traditionally foreshortened patterns on fabrics, see Duits, *Gold Brocade and Renaissance Painting*, 49–53.

98 The entry (no. 29) in the 1498 inventory reads, "Una coltre da lecto di livante, rossa timta in lacha, fodrata in tela azurra, lunga br. octo e larga br. 7 – l. 120–." This textile is listed in the house in Fiesole. Shearman, "The Collections of the Younger Branch of the Medici," 24. Duits argues that this textile might be the mantle held by Venus and that the estimated price is "about 20 gold florins." Duits, *Gold Brocade and Renaissance Painting*, 208.

99 In her analysis of symbolism in the *Primavera*, Levi D'Ancona argues that the cross pattern may refer to the crucifixion of Jesus, which happened on Friday, the day of Lorenzo di Pierfrancesco de' Medici's wedding to Semiramide d'Appiano; see Levi D'Ancona, *Botticelli's Primavera: A Botanical Interpretation*, 28.

100 "Crucem ergo veteres figuram esse dicebant tum stellarum fortitudine factam, tum earundem fortitudinis susceptaculum; ideoque habere summam in imaginibus potestatem, ac vires et spiritus suscipere planetarum." Ficino, *Three Books on Life*, 334–35. Ficino declares that he read this in a "certain Arabic miscellany." The *Picatrix* states, "Since we could never

fully comprehend the forms of the planetary spirits, the ancient sages of this art chose the cross as a universal figure. This is because all bodies have a surface, and the surface of an image has a longitude and latitude (and the cross is the appropriate image for longitude and latitude). Therefore, we have said that this image is the universal tool in these rituals and the receptacle of the planetary spirits' powers because they work well with other images. This is one of the secrets of this art." *Picatrix*, 148–49.

101 For a discussion of portraits in the *Adoration of the Magi*, see Hatfield, *Botticelli's Uffizi "Adoration": A Study in Pictorial Content*, 68–100.

FOUR

GREEN GARDENS

Venus' Verdant Virtues

> Leave your beloved isle, you Cyprian queen;
> Leave your enchanted realm so delicate,
> Goddess of love! Come where the rivulet
> Bathes the short turf and blades of tenderest green!
> Come to these shades, these airs that stir the screen
> Of whispering branches and their murmurs set
> To the love bird's enamored canzonet:
> Choose this for your own land, your loved domain!
> And if you come by these clear rills to reign,
> Bring your dear son, your darling progeny;
> For there be none that knows his empire here.[1]
> —Lorenzo de' Medici (1449–1442), *Poesie volgari nuovamente*

Venus is a goddess of nature, who resides in landscapes responsive to her powers over spring and generation. She thrives in gardens (Fig. 53) carpeted with thick green grass, surrounded by aromatic myrtle bushes, sweet orange trees, and soft pink roses. Rising from the waves and wringing salty foam from her blonde tresses, Venus also rules over the peaceful seas and verdant shores of her Mediterranean islands (Fig. 54). Other mythological deities inhabit different landscapes: Diana and her nymphs guard the deep recesses of the moss-covered forests with their rocky outcroppings and cool streams (Fig. 19). Vulcan sweats in the glowing heat of his fiery forge, carved into the side of a volcanic mountain (Fig. 2). Each deity's powers correspond to his or her settings: Diana's sylvan spaces embody her virginity and passion for the hunt,

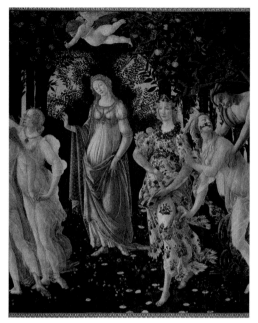

53 Sandro Botticelli, *Primavera*, detail of Venus, ca. 1480, Gallerie degli Uffizi, Florence, Italy. Photo: Scala / Art Resource, NY

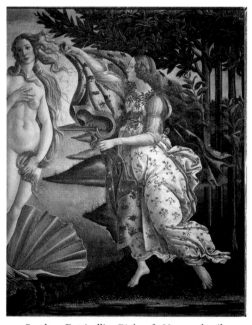

54 Sandro Botticelli, *Birth of Venus*, detail, ca. 1484–86, Gallerie degli Uffizi, Florence, Italy. Photo: Scala / Art Resource, NY

while Venus' cultivated gardens express her dominion over love, fertility, and pleasure.

Of all Venus' habitats, the island of Cyprus is the most famous, followed by the island of Cytherea, and Mount Cithaeron. Poets since the fifth century have celebrated the temperate weather, grassy meadows, evergreen groves, and fragrant flowers characteristic of these landscapes. Artists have painted their verdant geography, using a set of difficult but beautiful pigments, including green earth (celadonite and glauconite), verdigris, and malachite (Fig. 55a–d). In both poetry and art, Venus' landscapes correspond to the literary topos of the *locus amoenus*, a delightful place dedicated to amorous pursuits. Traditionally, art historians discuss Venus' landscapes in the context of this motif, drawing attention to their alluring and, at times, bewitching effects.[2] While taking note of their romantic character, this chapter argues that Venus' natural habitats also possessed salubrious and curative powers associated with both vision and fertility.

The chapter begins with a brief geographical overview of Cyprus and Mount Cythaeron in Tuscan poetry and argues that these charming literary descriptions inspired the fruitful and be-flowered landscapes of Florentine artists. After this iconographic discussion, the chapter turns to the psychological and physiological benefits of the color green and the different mediums and materials that artists employed to generate verdant places within the domestic interior. It pays close attention to greenery within the bedchamber, birthing chamber, and other places dedicated to familial celebrations,

55 Samples of (a) green earth (celadonite), (b) green earth (glauconite), (c) verdigris, and (d) malachite. Photo: Kip Bulwinkle / Karson Photography

where the invigorating and salutary virtues of the color and of Venus were in high demand. The chapter concludes with an analysis of Botticelli's gardens in the *Primavera, Venus and Mars, Venus and the Three Graces,* and *Birth of Venus.* Similar to mid-fifteenth-century devotional paintings, where the settings surrounding Mary and Jesus shift from gold to green, Venus' verdant landscapes reveal new developments in naturalism and new techniques for working with green pigments. The chapter demonstrates that, in addition to naturalism, the pharmacological and sensorial merits of green contributed to the popularity of Venus' viridescent gardens.

VISUAL POETICS

One of the earliest descriptions of Cyprus is found in the *Epithalamium of Honorius and Maria* by the fifth-century poet Claudian, who details the island's geography when Cupid flies from Italy across Cyprus to find his mother and invite her to attend and bless the nuptials of Honorius, the Western Roman Emperor. Over the course of thirty-six lines, Claudian pictures a colorful and sweet-smelling landscape consecrated "to pleasure and to Venus." He describes

meadows "bright with flowers," shady groves filled with bird songs, fountains bubbling with amorous elixirs, and "a courtyard rich with fragrant turf that yields a harvest of perfume." A "green gleam" rises from an evergreen grove that encircles Venus' palace, which features emerald beams, aquamarine walls, and jasper doors.[3] Claudian's odoriferous, green landscape established the standard for literary descriptions of the goddess's garden, and his verdant imagery reappears in the writings of fourteenth- and fifteenth-century Tuscan poets, such as Giovanni Boccaccio, Francesco Petrarca, Antonio di Meglio, Lorenzo de' Medici, and Angelo Poliziano. Claudian's popularity among these poets may relate to a thirteenth-century legend that claimed him to be a Florentine citizen. Filippo Villani (1325–1407) begins his *Lives of Famous Men* with a biography dedicated to Claudian, and the ancient poet's portrait appeared in the fresco cycle of *uomini illustri* (famous men), painted inside of the Palazzo Pubblico (Palazzo Vecchio) at the end of the fifteenth century.[4]

Florentine descriptions of Venus' landscapes were also influenced by the allegorical gardens of love found in twelfth- and thirteenth-century French literature. In *The Romance of the Rose*, the walled garden – where the delicate red rose awaits her eager lover – is the domain of Diversion, who with his followers "enjoys and comforts himself, for he could find no better place or spot to indulge in pleasure."[5] This garden contains "flowers of various colors and the sweetest perfumes," trees of every sort, whose "long and high" branches "keep the place from heat" and protect the "tender" grass from the sun's harm.[6] Upon the "thick, short grass," "one could couch his mistress as though on a feather bed, for the earth was sweet and moist on account of the fountains, since as much grass as possible grew there."[7] This comparison of the grassy earth to a soft couch reserved for one's mistress resembles Paolo Schiavo's *Venus on Pillows* (Fig. 31) and Sandro Botticelli's *Venus and Mars* (Fig. 38), which depict the goddess reclining in a bed of verdure.

Giovanni Boccaccio's familiarity with both Claudian's verses and the French *locus amoenus* is evident in his descriptions of Venus' green gardens in the romantic tales of *The Amorous Vision* (*Amorosa visione*), *The Book of Theseus* (*Teseida*), *Filocolo*, and *The Florentine Nymph* (*Ninfe fiorentina*).[8] Boccaccio locates the goddess's enchanting garden in *The Book of Theseus* on Mount Cithaeron instead of on Cyprus. The setting is "shaded among very tall pines" with "a leafy and beautiful garden full of very green plants, of fresh grasses, and of every new flower." As the lover Palaemon's prayer makes its way to Venus, she sees "clear fountains springing there, and it seemed to her that among the other shrubs the myrtle flourished most."[9] While Boccaccio and his characters delight in this land of love, Petrarch bemoans it as a vile and dangerous place that seduces and then imprisons the soul. In his *Triumph of Love* (composed ca. 1338–43), Petrarch describes

the landscape through which Cupid parades his pris-
oners as a "delicate and soft little island, which is
bathed by the sea and not burned by the sun," and
takes away all "manly thoughts." Its shady spots,
alluring fragrances, and gentle waters do not arouse
virtues, but rather the vices of falsehood, avarice, and
lust.[10] This verdant island perched on the edge of
the sea appears in an illustration of the *Triumph of
Love* (Fig. 56) included in a Florentine illuminated
manuscript of Petrarch's *Triumphs*, painted by
Francesco D'Antonio del Chierico in 1456. Standing
atop a triumphal chariot, Cupid leads his band
through the fertile landscape. In the foreground,
Chierico depicts Delilah cutting Samson's hair as well
as Phyllis riding Aristotle with bit and whip in order
to illustrate love's power over both the strongest and
the wisest of men. In his verses, Petrarch does not
name Aristotle and Phyllis specifically; however, the
couple often appeared in illustrations of the *Triumph
of Love*.[11] Petrarch's description of Cupid's amorous
landscape, which is both enchanting and critical, also

56 Francesco d'Antonio del
Chierico, *Triumph of Love*, from a
Florentine manuscript with the
Triumphs of Francesco Petrarca (Ms.
italien 545, fol. 11v), 1456,
Bibliothèque Nationale, Collection
Magnard, Paris. Photo: akg-images

brings to mind the *Venus and Lovers* birth tray (Fig. 14), in which six courtly
lovers kneel in a grassy be-flowered meadow, enclosed by fruit trees. The
vermillion *amorini* with their sharp claws foretell of the snares that can trap
and wound the lover in this beguiling place. The consequences, which could
be both emasculating and deadly, often appear in illustrations of Petrarch's
Triumph of Love; however, they are absent, though possibly implied, on the
Venus and Lovers birth tray.

One of the longest and most vibrant portraits of Venus' Cyprian paradise
appears in Angelo Poliziano's *Stanze*, written between 1475 and 1478 for
the joust of Giuliano de' Medici. In these verses, Poliziano tells of a green
hill, a sunny and happy meadow full of trembling grass, and a countryside
clothed with roses, violets, lilies, and other flowers.[12] He mentions a grove
above this hill filled with evergreen trees: fir, holm-oak, laurel, cypress,
plane tree, turkey-oak, beech, cornel berry, willow, elm, ash, pine, maple,
palm, ivy, box tree, and myrtle.[13] Of these, he singles out "the myrtle that
forever yearns for its goddess," who adorns its "green tresses with white
flowers."[14] Arriving in Cyprus from Florence, Cupid finds his mother in a
fragrant, rose-filled bower, entertaining Mars and soothing his passions with
her sweet kisses.[15] It is this verdant, perfumed, and pleasurable place that
Botticelli painted in his *Primavera*, *Venus and Mars*, *Venus and the Three Graces*,
and *Birth of Venus*.

SENSORIAL MEDICINE

In Tuscan poetry and art, Venus' landscapes are characterized as verdant places; her grassy meadows and evergreen groves symbolize spring, youth, and hope, particularly in the context of the *locus amoenus*. In pharmacological literature, green is also described as a salubrious color, benefiting both vision and fertility. According to several ancient authors, this pleasant color soothes and refreshes the eyes. Aristotle (384–22 BCE), for instance, writes that the green stone malachite (Fig. 55d) "fetches a price comparable to gold; for it is a drug used for the eyes."[16] In his *Natural History*, Pliny the Elder (23–79 CE) explains that verdigris (Fig. 55c) works in the form of a salve or pill to counteract "glaucoma and cataract, and also against films on the eyes or roughness and white ulcerations in the eye and affections of the eyelids."[17] Emeralds could also improve eyesight. Pliny, for example, recounts how gem-engravers, after straining their eyes with tedious work, replenished their sense of sight by gazing upon emeralds.[18] Verdant places were believed to possess similar curative powers. In her twelfth-century medical treatise, Hildegard von Bingen (1098–1179) instructs the reader, who suffers from weak eyes, "to go to a green meadow and look at it long enough until the eyes become moist as from weeping, because the greenness of this meadow removes what is turbid in the eyes and makes them bright and clear."[19]

Discussion of green's virtues continues into the fifteenth century. Marsilio Ficino writes about the color in his *Three Books on Life*. He begins by claiming that Venus favors the color green and thrives in gardens and meadows. He explains that verdant things abound with a "very salubrious humor and a lively spirit" and that a "youthful spirit flows to humans through the odor, sight, use, and habitation of and in them."[20] According to Ficino, green affects vision most directly, and through the eyes, it replenishes the spirit itself. Why does green have this salutary effect? First of all, Ficino explains, green is a temperate color. While bright colors, such as white and gold, dilate the eyes and delight them too much, dark colors, including black and purple, contract the eyes and offer them no pleasure. By taking part in both black and white, green "equally delights and conserves sight."[21] Second, Ficino writes that green things are soft and tender, a texture that calms the eyes' rays rather than "destroying" and "breaking" them, as hard and rough surfaces do.[22] Third, green is a moist color aligned with the element of water.[23] It therefore aids bodily functions dependent on moisture, including vision, fertility, and childbirth. Ficino claims that green, under the governance of Venus and the Moon, is "quite proper for newborns, accommodated also to mothers."[24] In conclusion then, green's temperate, tender, and moist virtues could benefit the mind and the body through the sense of sight.

Renaissance associations between the color green and fertility were also dependent upon the belief that humans possessed their own viridity. In her

medical treatise, Hildegard of Bingen speaks of a man's "virile greenness" that "erects the stem to its full strength."[25] She then describes that of a woman: "As a tree, from its greenness brings forth blossoms and leaves and bears fruit, so too woman, from the greenness of the rivulets of menstrual blood, brings forth blossoms and leaves in the fruit of her womb."[26] Signifying both fertility and growth, this viridity within humans could be enhanced and nourished by interaction with green things. Venus' evergreen myrtle was one such material. In antiquity and in the Renaissance, this medicinal plant was employed to arouse sexual desire and to foster reproductive health. In his *Genealogy of the Gods*, Boccaccio explains that "from its berries a certain substance can be made to excite passion and then strengthen it."[27] In his medicinal herbal of 1554 (based on Dioscorides' first-century *De materia medica*), Pier Andrea Mattioli includes recipes for myrtle wine and oil, noting that the plant encourages moistness in the uterus, cures heavy menstrual cycles, and decreases inflammation in the testicles.[28] He also claims that myrtle baths could inflame one to "such cupidity, that he or she would want to embrace everything."[29] By planting the myrtle bush in the very center of the *Primavera* (Fig. 37), Botticelli reminds his viewers of its fecund virtues.

GREEN PLACES

In fifteenth-century Florence, citizens sought the salutary effects of green by traveling beyond the city walls to the grassy meadows and moss-covered forests of Tuscany. Wealthy families, such as the Medici and Tornabuoni, owned villas in the Florentine *contado*. These country houses provided refuge from the heat, stress, and epidemics of the urban environment. They also encouraged amorous delight and restorative peace, two of Venus' virtues. The benefits of the color, however, were not limited to the villa but were also sought in the city, where open-air gardens in townhouses, convents, and monasteries served as natural green places. Many Florentines also desired greenery inside of their homes and commissioned artists to design verdant works of art for them. Several different mediums with paired materials fulfilled this demand. This section examines three of them: frescoes painted with green earth (*terra verde*), textiles made of yarns dyed in mixtures of vegetal matter, and garlands woven with evergreen plants.

Wall frescos painted with green earth or *verde terra* offered an affordable option for introducing verdancy into interiors. The pigment green earth (Fig. 55a and b) was quarried in Verona and Cyprus. It derives from the minerals celadonite (a) and glauconite (b) and displays hues ranging from a pastel seafoam green to a darker olive hue. In 1471, a pound (*libbra*) of *verde terra* cost 4 *soldi*.[30] Because of this low price, the pigment could be purchased in bulk and used to fresco entire rooms. In his *Libro dell'arte*, Cennino Cennini

offers directions for painting frescos in green earth on already-plastered walls. Working *a secco* or without fresh plaster, the artist should cover the walls with two or three layers of green earth and then draw designs in charcoal, ink, or black paint. Next, he should dab the fresco with a sponge dipped in water and honey, a technique that added texture and variety to the green base, making it appear more naturalistic. Finally, the artist should apply shadows with black wash and add figures in lead white.[31] Due to the low cost of green earth and the fresco's creation *a secco* (a faster method than *buon fresco*), the technique described by Cennini offered patrons a relatively quick and affordable option for creating a green place within their homes. Green earth's flat hues, however, were not suitable for the glimmering, emerald gardens that many patrons desired in their bedrooms after the mid-fifteenth century.

Before the widespread depiction of landscapes in panel paintings, wealthy citizens purchased and hung verdure textiles inside their homes, either solid green silks woven in Florence or tapestries of wool and silk imported from Northern European cities, such as Antwerp or Bruges.[32] In the inventory of the Palazzo Medici taken at the death of Lorenzo de' Medici in 1492, these items included "two bench-back tapestries of foliage and landscape lined in green cloth" and "a set of tapestry bed curtains adorned with foliage."[33] The family also owned a painted green bedcover, a green velvet duvet embroidered in gold, and a dog's bed covered with green taffeta.[34] Domenico Ghirlandaio's fresco of the *Birth of John the Baptist* (Fig. 57), painted around 1485 for the

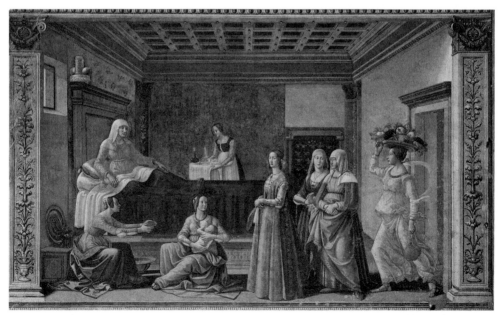

57 Domenico Ghirlandaio, *Birth of St. John the Baptist*, 1485, fresco, Capella Tornabuoni, Santa Maria Novella, Florence, Italy. Photo: Rabatti - Domingie / akg-images

Tornabuoni chapel in Santa Maria Novella, depicts a well-appointed bed-chamber, similar to one that may have existed in the Palazzo Medici. The room is decorated with two types of verdant textiles: a sizable, solid green cloth hangs on the wall, while a smaller, floral tapestry drapes across the doorway. The deployment of green within the space of this birthing chamber suggests that the color may have offered benefits to the mother and her newborn child at a precarious moment in their lives.

Verdant textiles were expensive, in part because of the cost and labor involved in dyeing silk or wool thread green. Although scholarship tends to focus on the history of kermes red, the most expensive dye in fifteenth-century Florence, price comparisons reveal that green dyes cost as much, or almost as much, as crimson.[35] According to the Florentine *Trattato della seta* (*Treatise on Silk*), composed during the 1450s by the Arte della seta (silk weavers guild), dyers paid a tariff of 30 *soldi* to dip a pound of silk once in kermes red and 40 *soldi* to dip the same amount twice. They paid 20 *soldi* to tint a pound of silk thread green and 40 *soldi* to dye it green-brown (*verde bruno*).[36] While kermes dye could be manufactured from a single animal body (the kermes or cochineal insect), green had to be carefully mixed from different blue and yellow materials, such as woad, indigo, sumac, and weld, also known as *guadarella* or "dyer's rocket."[37] Green's high price tag depended on a dyer's ability to mix a consistent, colorfast dye from this variety of organic materials. Weaving several shades of green threads into foliate patterns also cost money, which increased the price of verdure tapestries. In the Medici inventory of 1492, the bench-back tapestries woven with foliage designs and lined in green cloth are valued at 70 florins, while a gilt bronze panel of the *Madonna and Child* by Donatello is appraised at only 25 florins.[38] In the inventory of Lorenzo and Giuliano di Pierfrancesco's city palazzo, the painting that scholars identify as Botticelli's *Primavera* (Fig. 37) is valued at 100 silver *lire* or *soldi* (16–17 florins), while two tapestries "*a verdura*" command the prices of 360 *lire* (60 florins) and 120 *lire* (20 florins), respectively.[39]

In addition to adorning bedrooms and birthing chambers, green textiles decorated the rooms and courtyards where banquets and feasts were celebrated. As with clothing, the virtues of Venus could be petitioned on propitious occasions with the use of green textiles and plants. In Netherlandish paintings, verdure tapestries hang on the walls behind brides at wedding feasts, as seen in Gerard David's *Marriage of Cana* (Fig. 58) from 1503. Similar textiles drape behind the wedding party in Botticelli's *Marriage Feast of Nastagio degli Onesti* (Fig. 59), painted in 1482. Long garlands of myrtle tied with ribbons crown these bench-back tapestries. The tradition of using myrtle for wedding decor-ations and nuptial rituals dates back to antiquity. In Claudian's *Epithalamium for Honorius and Maria*, Venus directs her "winged band" to "entwine the gleaming door-posts with my sacred myrtle."[40] Marco Antonio Altieri, who wrote a

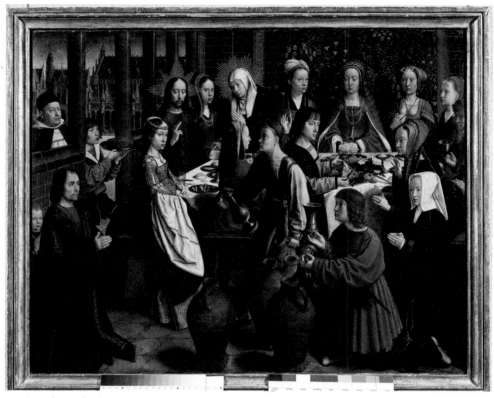

58 Gerard David, *The Marriage at Cana*, ca. 1500, Musée du Louvre, Paris. Photo: Scala / Art Resource, NY

treatise on nuptial rituals in 1503, describes the propitious powers of the plant, declaring that "from myrtle, inimical to every violence, accompanied by flowers, fragrances, and other stimulants, come good auspices in the couple's future, including joy, desire, and the ability to copulate for the acquisition of healthy and amiable children."[41] As a decoration for nuptial celebrations, myrtle promised to channel Venus' beneficial virtues for newly married couples, while also delighting wedding guests with the sweet fragrance of its evergreen leaves.

GREEN GEOGRAPHY

In fifteenth-century Florence, verdure tapestries and verdant frescos provided an all-encompassing form of decoration that allowed individuals to receive and enjoy the salubrious benefits of Venus' greenery. Large-scale textiles draped from ceiling to floor inside of bedrooms, and frescos – painted from the upper moldings to the wainscoting and even across ceilings – covered entire rooms with grasses, trees, and a variety of evergreen plants. When the interests of artists and patrons shifted from small wedding chest panels to large-scale *spalliere*

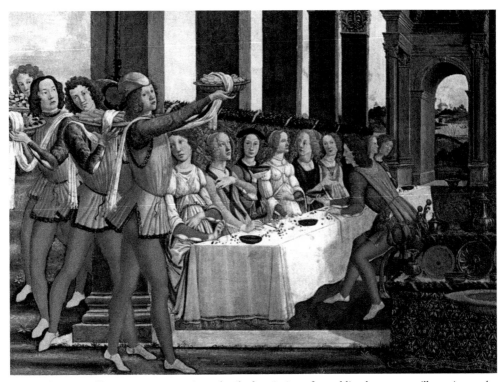

59 Sandro Botticelli, *Banquet*, representing a detail of a painting of a wedding banquet, an illustration to the novel of the *Decameron* of Giovanni Boccaccio, "Nastagio of the Honest Ones," 1483. Photo: akg-images / Fototeca Storica Nazionale Ando Gilardi

paintings, green landscapes merged with secular narratives to form a new type of verdant interior art. Rather than immersive green places, these paintings created Albertian windows for the viewer to look into green worlds peopled with chivalric knights and Olympian deities.[42] Early paintings of this type, such as Paolo Uccello's *Battle of San Romano* and Botticelli's *Primavera* (Fig. 37), include a landscape that fills the entire pictorial field. In the later works of these artists, one-point and atmospheric perspective generate horizon lines and distant views. As the demand for green gardens increased, Florentine artists refined their skills for working with a set of difficult though beautiful green pigments.

For verdant landscapes in tempera, most Florentine artists working after 1450 used either malachite (*verdazzurro*) or verdigris (*verderame*) or a combination of the two. Both pigments derive from copper and produce elegant greens. In the cosmological chain of correspondences, Venus governs copper and this metal, like myrtle or the rose, is closely associated with her planet. In his sixteenth-century treatise on mining, Vannoccio Biringuccio (1480–1539) explains how copper, "nourished by the influence of Venus," is unearthed where there are stones that contain "shiny specks, like talc" that have a "greenish cast," making a "bed of a certain thick viscous and green

60 Antonio Pollaiuolo, *Apollo and Daphne*, ca. 1470–80, National Gallery of Art, London. Photo: Heritage Images / Fine Art Images / akg-images

putrefaction."[43] Biringuccio may be referring to malachite or verdigris which naturally forms on or alongside Venus' copper. Nourished by her influence, these green pigments were cosmologically capable of emanating Venus' celestial virtues.[44] It is appropriate at this point to consider the procurement, cost, technical manipulation, and efficacy of these two pigments.

Verdigris (Fig. 55c) is a copper acetate, manufactured by exposing copper plates to vinegar, urine, or wine.[45] The colored rust that forms on the copper is blue-green in hue, similar to our modern teal. In the 1471 inventory of the Florentine apothecary Tommaso di Giovanni, a pound of verdigris cost between 18 and 20 *soldi*, which is four-to-five times as much as a pound of green earth.[46] In contrast to the opacity and loaminess of green earth, verdigris is translucent and brilliant; however, it is also volatile and fleeting. Cennini writes that "if you want to make an absolutely perfect green for grass, it [verdigris] is lovely to the eye but does not last."[47] As a pigment, verdigris poses difficulties in the fresco and tempera mediums. It is hostile to lead white, and when improperly bound and exposed to sunlight or moisture, it darkens to a chestnut brown or even a deep black.[48] Between 1450 and 1470, a number of Florentine artists experimented with verdigris bound in egg, resin, and/or oil; however, the lush green places that they skillfully painted are now dull brown landscapes. In Antonio Pollaiuolo's *Apollo and Daphne* (Fig. 60), for example, the landscape behind the ill-fated lovers looks more like a muddy swamp in the Maremma rather than a verdant valley near the Arno.

Of all the green pigments available to fifteenth-century Florentine artists, malachite (Fig. 55d) was the most expensive and probably the most popular. It was also the green closest to the color of fresh grass and new leaves. The *Picatrix* lists it as one of Venus' minerals. Pliny also explains that this stone "protects children, and has a natural property that is a prophylactic against danger."[49] Found alongside azurite in copper mines, malachite is a bright green, opaque stone with blue tones. When ground, it forms a coarse pigment of individual particles, similar to fine sand. Cennini instructs the painter to "mull it just a little with a light hand for the sake of the blue because if you ground it too much it would turn a dull color and ashen."[50] Although malachite works best in tempera, it does not dissolve in egg *or* oil. Because of its sand-like consistency, artists often suspended the tiny particles in lead white or lead-tin yellow and then applied this mixture over a black or yellow imprimatur.[51] In Florence, malachite was cheaper than gold or ultramarine; however, it was

significantly more expensive than green earth or verdigris, costing about the same as red lake (manufactured from silk dyed with the kermes insect) and azurite blue (malachite's natural twin). The 1471 inventories of the Florentine artists Neri di Bicci (1419–92) and Alessio Baldovinetti list malachite (*verdazzuro*) as 144–68 *soldi* per pound, which is nine times more expensive than verdigris and forty-two times more costly than green earth.[52]

While Bicci and Baldovinetti's inventories provide a price range for malachite, there are several questions surrounding how the mineral was sold. In the inventories of *speziali*, *verdazzurro* is rarely, if ever, mentioned. For example, in the Arte di medici e speziali section of the *gabelle* of 1442 (a list of all the goods sold by the Florentine guilds), there is an entry each for green earth, verdigris, and two for azurite; however, *verdazzurro* is not listed.[53] Similarly, the pigment is absent from the 1471 inventory of the Florentine apothecary Tomasso di Giovanni.[54] In Venice too, *verdazzurro* does not appear in the records of the *vendecolori* or color sellers, including one inventory from 1534 that lists 102 materials. In contrast, *verdazzurro* does appear in the Venetian artist Lorenzo Lotto's (1480–1557) inventory of his own painting supplies, just as it had in the inventories of Bicci and Baldovinetti.[55]

Malachite's conjunction with azurite, its natural twin, likely explains this conflicting evidence.[56] In his treatise on mining, Biringuccio explains that *verdazzurro* "is more or less green or blue according to the quantity of the mixture . . . It is gathered with care from the colored stones and is cleansed and made fine by washing and grinding."[57] Biringuccio's entry suggests that *verdazzurro* was both green and blue and that the greener parts could be separated out from the bluer ones.[58] Following this line of argument, it would seem that the *speziali*, who sold the raw materials, classified malachite under the general category of azurite, from which it was derived, while artists like Bicci, Baldovinetti, and Lotto separated the *verdazzurro* (green) and *azzuro grosso* (blue) pigments in their inventories.

BOTTICELLI'S VERDANT TECHNIQUES

Botticelli painted the landscapes of the *Primavera*, *Venus and Mars*, and *Venus and the Three Graces* using malachite and occasionally a verdigris glaze. For the beflowered meadow of the *Primavera* (Fig. 61), he employed the traditional Florentine technique for painting greenery on panels. According to Cennini's *Libro dell'arte*, an artist should begin with a black imprimatur, then lay in foliage with thick strokes of *verdazzurro* (malachite), add highlights with green mixed with *giallolino* (yellow) or with *giallolino* alone, and finally "throw" fruit, flowers, and birds onto the greenery.[59] In adherence to this method and proven by scientific analysis, Botticelli laid down a black imprimatur for the vegetation of the *Primavera*, which he then painted with

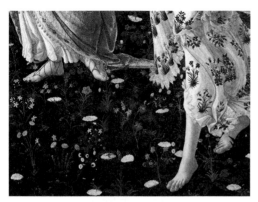

61 Sandro Botticelli, *Primavera*, detail, ca. 1480, Gallerie degli Uffizi, Florence, Italy. Photo: Erich Lessing / Art Resource, NY

verdazzurro (malachite).[60] On top of the dark ground, he delineated a variety of naturalistic foliage, including knife-, lancet-, and heart-shaped leaves in fanning clusters. To differentiate between the plants, Botticelli painted highlights in lead-tin yellow, yellow ocher, and lead white. The foliage of the *Primavera* may have once glimmered with even lighter and brighter shades of green. When the painting was restored, conservators found that Botticelli applied a series of transparent verdigris glazes (verdigris mixed with resin) on top of the malachite vegetation.[61] This technique would have added saturation and depth to the painting's dense greenery. The fragility of the pigment in conjunction with the dark imprimatur, however, may have contributed to an overall darkening of the landscape.

In the *Primavera* (Fig. 37), Botticelli's thickly forested garden boasts ripe oranges and an array of springtime flowers. According to studies of the painting completed during its restoration, Botticelli illustrated 500 individual plants: 60–70 tufts of grass, 240 nonflowering plants (such as leaf rosettes and ferns), and 190 flowering plants. Among these plants, scholars have identified 42 different species. Some of the plants were drawn from life, while others appear to have been copied from illuminated herbals.[62] Botticelli's blossoming meadow runs across roughly a third of the painting and includes irises, carnations, daisies, strawberries, hyacinths, cornflowers, roses, and other bright blooms. The floral space is complemented at the top with white citrus blossoms and voluptuous orange fruit hanging within an arbor of trees. Botticelli interwove the branches of these trees to create a pergola above Venus; behind the goddess, a flourishing bush of myrtle fans out like a nimbus. The overall effect of this detailed garden, which reaches from the bottom to the top of the panel, resembles the verdure found in Flemish tapestries, such as the one depicted in Gerard David's *Marriage at Cana* (Fig. 58).

For the green landscape in his *Venus and Mars* (Fig. 38), Botticelli employed a similar technique to that used in the *Primavera*; however, he achieved a more convincingly enclosed bower that recedes into an open meadow by varying his application of malachite. In the foreground, Botticelli painted the turf with a thick, almost dry mixture of malachite and tempera on top of a dark imprimatur. Thin diagonal strokes alternate with clusters of vertical ones to create the illusion of a thick carpet of fresh grass, which seems moist with dew. Individual blades caress the soles and toes of Venus' left foot, and wispy tufts reach up to

touch the edges of her white raiment. Beyond the trees, a meadow extends. Here, Botticelli introduced atmospheric perspective by painting the distant landscape with fluid, horizontal strokes of malachite on top of a yellow rather than a black imprimatur. The smooth turf optically replicates the receding terrain's diminishing textures. The green fades in color, becoming more yellow as it reaches the horizon line, which creates the illusion of distance. Through this technique, Botticelli established a contrast between the shady enclosure of the evergreen grove and the open space of the vast *prato*.

In Botticelli's *Venus and Mars*, the gods of love and war rest in a thicket of evergreen myrtle or laurel, bushes which emit soft perfumes in the spring. The verdant landscape provides a temperate and tender resting place for the paramours, a space that correlates with that described by Giovanni Boccaccio as conducive to intercourse. In his commentary to *The Book of Theseus*, Boccaccio writes that the shade provided by the groves in Venus' garden offers "opportune refreshment" against the heat and therefore creates the temperate environment needed for coitus.[63] He explains that temperance is required for venereal acts because a man who is too cold or too hot will not be able to perform the act properly.[64] Second, Boccaccio describes a shady grove as "the kind of location which the powers of Venus require, for they want comfort and darkness."[65]

In Botticelli's painting, the temperate and cool shade of Venus' garden has charmed Mars, who appears to have fulfilled his virile desires, through union with her. The phallic lance and vulvic shell allude to the couple's recent sexual activity.[66] Falling between his legs, Mars's slack right hand and forefinger metaphorically reference his fatigued member and exhausted state following coitus. With his head tilted back, eyes closed, mouth open, and body relaxed, Mars sleeps. In his analysis of this painting, Charles Dempsey argued that the god of war experiences a "nightmare of sexual obsession and domination of the soul possessed and tormented not just by erotic fantasies but by the demons of Mars's own moral confusion, his preoccupation with luxuriousness and venery."[67] Dempsey's interpretation points to a perspective, based on Petrarchan writings, that classified Venus' gardens as places of idleness and lechery rather than as spaces of peace and conciliation. The ambiguous nature of the goddess's landscapes, however, contributed to their allure. Hanging above a bed or in the vicinity of one that may have been draped in green fabrics, Botticelli's *Venus and Mars* provided a temperate, soft, and shaded landscape conducive to sex, whether procreative or otherwise.

Botticelli included a similar, though less detailed, green place in his fresco of *Venus and the Three Graces* (Fig. 39) at the Tornabuoni Villa Chiasso Macieregli in Careggi, located 7–9 km from Florence. The goddess and her entourage greet Lorenzo's second wife, Ginevra di Bongianni Gianfigliazzi, in a garden – possibly resembling one at the villa – that was once defined by a flowering field,

a grove of trees, and a decorative fountain.[68] Photographs of the fresco taken between 1873 and 1882 show multiple tree trunks in the background and a few scattered flowers.[69] Today, the figures stand on the dark ground of the imprimatur, which was originally covered with green grass and colorful flowers. In this fertile bower, Venus presents Ginevra with a bouquet of flowers. She likely brings roses; however, only faintly colored stems remain (Fig. 49). The loss of green pigment across this landscape may be a result of Botticelli's application of malachite *a secco* rather than in *buon fresco*. According to documents outlining the requirements for painting the Sistine Chapel frescos, Botticelli and other Florentine artists were obligated to paint their landscapes with malachite, applied *a secco*.[70] This choice was likely technical and related to the material properties of malachite, which does not bind well with wet plaster. If this technique was standard for fresco painting, it may explain the loss of malachite from the Villa Chiasso Macieregli fresco and from other Florentine frescoed gardens, such as Masolino da Panicale's *Temptation of Adam and Eve* of 1425–27, where the nude couple stand against a solid black ground rather than a lush and verdant Garden of Eden.

In his *Birth of Venus* (Fig. 54), Botticelli employed a variety of techniques to paint the grassy shoreline and evergreen grove surrounding the goddess's island of Cyprus. Pigment samples taken during restoration of the painting reveal that the vegetation alternates between (1) areas painted with coarsely ground malachite bound in a tempera mixture of both the white or albumen and the yellow or yolk of an egg and (2) areas painted with pure verdigris. Botticelli covered his vegetation with a transparent verdigris glaze, which Mauro Matteini and Arcangelo Moles describe as saturating "the interstices between the large granules of malachite and verdigris to intensify the green tones."[71] Botticelli painted the dark leaves framing the top edge of the painting with malachite mixed with carbon black. For the brighter leaves illuminated by sunlight, he mixed malachite with a lead-based yellow pigment, either lead-tin yellow or lead antimonite. Matteini and Moles note that the "very fine nature" of the yellow pigment "penetrates into the inner granules of the green," as seen in a pigment sample from the painting (Fig. 62).[72] Botticelli then used mordant gilding, gold leaf applied with an adhesive, on the leaves of his foliage. The restorers found that this gold was added after the canvas was framed. This discovery suggests that Botticelli or another artist attempted to use the gold to distinguish the individual leaves of the foliage, a feature lost in the *Primavera*. The use of gold may also relate to a practice, noted by Cennini, of using gold to "work up some trees so that they look like some of the trees in Paradise."[73] Cennini mentions this technique in his discussion of ground or shell gold. In the *Birth of Venus*, Botticelli employed powdered gold bound with albumen (egg white) and egg yolk to fashion highlights for Venus' hair and for the shell.[74] The mordant gilding on the trees creates stronger and thicker lines than

62 Microphotograph of a fragment from the foliage, in cross-section, from Sandro Botticelli's *Birth of Venus*, 1484–86, restoration report of 1987–88, Opificio delle Pietre Dure e Laboratori di Restauro, Florence, Italy. Photo: Opificio delle Pietre Dure e Laboratori di Restauro, Florence

the dainty strokes of shell gold and suggests the fall of sunlight on the leaves and trunks of these paradisiacal trees. It also enriches and balances the darker areas of the painting.

In his four paintings of Venus, Botticelli applied malachite and verdigris in different combinations to materialize the green geography of the goddess's landscapes. Examining the evolution of his landscape painting techniques is relevant in the context of Leonardo da Vinci's comment that Botticelli did not "appreciate" landscapes and painted them "very poorly." This statement appears in a codex of Leonardo's *Libro di pittura* in the Apostolic Vatican Library. The passage reads,

> He who does not love equally all things in painting is not universal; as with one who does not appreciate landscape and thinks it is a thing of brief, simple investigation for example; Botticelli said, such a study is futile, because by just throwing a sponge full of different colors at the wall, you leave a stain, in which you can see a beautiful landscape. It is very true that in such a stain you can see whatever you want to find there, that is; human heads, different animals, battle-scenes, rocks, seas, clouds or woods, and similar things; and use them as "outlines," in which you can see whatever appears to you. But whilst these stains suggest inventions, they do not teach you to finish any detail. And this is why that artist made very sad landscapes.[75]

Leonardo's account of Botticelli's claim that landscapes can be made by "throwing a sponge full of different colors at the wall" reminds us of Cennini's directions for creating green places in fresco, specifically his advice that the painter should "dab the fresco with a sponge dipped in water and

honey."[76] While Leonardo's comment addresses the Renaissance notion that illusory images appear in stains or in the accidents of nature, it does not account for the fact that Botticelli may have been making a joke that referenced this earlier painting technique. Botticelli had a penchant for satire, jests, and jokes. His landscapes are certainly more complex than the frescos fashioned according to Cennini's cost-efficient technique, though they are not as advanced as Leonardo's atmospheric vistas. Botticelli's detailed renderings of individual plants, however, were novel. In the *Primavera*, he illustrated forty different plant species, including the correct petal arrangements for three different types of roses. A simplicity, however, does pervade his land forms and atmospheric perspectives.

Despite these shortcomings, Botticelli's landscapes correlate closely with the poetic portraits of Cyprus found in Tuscan poetry. The soft green meadows, bright flowers, and shady evergreen groves are characteristic of the *locus amoenus*, a delightful place dedicated to amorous pursuits. In the context of Ficino's medical-magical theories, these gardens – generated from copper green pigments infused with Venus' planetary virtues – possessed curative powers, being able to restore vision and encourage fertility. They were also conducive to procreative intercourse. Furthermore, Botticelli's verdant landscapes in the *Primavera*, *Venus and Mars*, *Venus and the Three Graces*, and *Birth of Venus* reveal new developments in naturalism and new techniques for using green pigments in Florence during the second half of the fifteenth century.

SAVONAROLA'S WINTER

Painted with copper greens, the lush landscapes that surround the celestial likenesses of Venus in Botticelli's paintings may have been intended as talismans to encourage the reception of the planet's beneficial influences from the heavens. It would not be long, however, before these types of astrological theories and magical remedies would be questioned. Ficino himself seemed to anticipate the coming controversy when he appended two apologetic letters to his *Three Books on Life*, before its publication on December 3, 1489. A few months later in May of 1490, the philosopher was accused of heresy and magic before Pope Innocent VIII (Giovanni Battista Cybo, 1432–92). Through influential friends and letters, his name was cleared, but the scandal indicated a tightening of church control.[77] The stage was set for the rise of the Dominican friar Girolamo Savonarola (1452–98). Following Lorenzo de' Medici's death in 1492 and the exile of the Medici family in 1494, Savonarola established a position of political power in Florence, urging the city towards moral reform through castigating sermons, preached publicly in the Duomo.

In his sermons, Savonarola condemned both the practice of astrology and the making of talismanic images. He also critiqued lascivious images in the bedroom and the vanity of feminine adornment.[78] During a sermon in 1496, he declared, with a reference to Aristotle, that "you shouldn't have dishonest figures painted near children, because seeing them, they become lustful." In addition to condemning artists for creating lascivious figures, he criticized patrons, insisting that "those of you who own them should have those images in your houses plastered over and destroyed."[79] In another sermon preached during Lent in 1497, Savonarola contrasted the gardens offered by Jesus to the soul with the vain desires of men and women to gaze upon their lovers. He asserted that "you have had as much pleasure through your eyes as you've wanted, you've had painted mirrors in chambers and a thousand images to excite you to pleasure. I have let you do everything; your eye has fed in this meadow."[80]

To Savonarola, the contemporary cult of feminine beauty was a form of idolatry. He chastised Florentine citizens for their love of ornament and adornment, sins of *luxuria* that endangered the soul. In 1494, Savonarola proclaimed, "And you, mother, who adorn your daughters with so many vanities and luxurious ornaments and wigs, bring them all here to us to send them up in flames, so that, when the wrath of God shall descend, these things will not be found in your homes."[81] On February 8, 1497, Savonarola staged a bonfire of the vanities in the Piazza della Signoria, and many of the items consigned to the fire were associated with Venus. Jacopo Nardi's list of objects thrown onto the pyre included "a marvelous multitude of shameful sculptures and paintings, as well as dead hair and ornamental headdresses for women, Middle Eastern articles, cosmetics, orange blossom water, musk, perfumes of various kinds and similar vanities," musical instruments, "the works of Boccaccio and the *Morganti*, as well as an extraordinary number of books on enchantments, magic and superstitions."[82] Licked by the flames, not of magical desire but rather of scorching repression, Venus – like Marsilio Ficino and many others – fled Florence. Despite the vengeful burning of Savonarola in the middle of the Piazza della Signoria, it would be some time before Venus returned to the city of flowers.

NOTES

1 "Lascia l'isola tua tanto diletta, / lascia il tuo regno delicato, & bello, / Ciprigna dea, e vien sopra il ruscello, / che bagna la minuta & verde herbetta: // vieni à quest'ombra, & alla dolce auretta, / che fa mormoreggiar ogni arbuscello, / à canti dolci d'amorosi uccelli. / Questa da te per patria sia eletta. // Et se tu vien tra queste chiare linse, / sia teco il tuo amato, & caro figlio, / che qui non si conosce il suo valore." Lorenzo de' Medici, *Poesie volgari nuovamente* (Venice: Aldus, 1554), 25v; for English, see *Lorenzo de' Medici: Selected Poems and Prose*, ed. and trans. Jon Thiem (University Park: Pennsylvania State University Press, 1991), 98.

2 The Roman grammarian Maurus Servius Honoratus (b. 363 CE) first used the term *locus amoenus* in his commentary to Virgil's *Aeneid*. For a discussion of this motif in Florentine poetry and art, see Paul Watson, *The Garden of Love in Tuscan Art of the Early Renaissance* (Philadelphia: Art Alliance, 1979), 25–34, 61–90. For other discussions of literary notions of the garden of love, see Terry Comito, *The Idea of the Garden in the Renaissance* (New Brunswick, NJ: Rutgers University Press, 1978), 89–148; Lucia Battaglia Ricci, "Gardens in Italian Literature during the Thirteenth and Fourteenth Centuries," in *The Italian Garden: Art, Design and Culture*, ed. John Dixon Hunt (Cambridge: Cambridge University Press, 1996), 6–33.

3 For Claudian's description of Cyprus, see Claudian, *Panegyric on Probinus and Olybrius. Against Rufinus 1 and 2. War against Gildo. Against Eutropius 1 and 2. Fescennine Verses on the Marriage of Honorius. Epithalamium of Honorius and Maria. Panegyrics on the Third and Fourth Consulships of Honorius. Panegyric on the Consulship of Manlius. On Stilicho's Consulship 1*, trans. M. Platnauer, Loeb Classical Library 135 (Cambridge, MA: Harvard University Press, 1922), 246–49. For a discussion of Claudian's portrait of Cyprus as a *locus amoenus*, see Watson, *Garden of Love*, 25–28.

4 Filippo Villani includes Claudian's biography in his *Lives of Famous Men*, see Filippo Villani, *De origine civitatis florentie et de eiusdem famosis civibus*, ed. Giuliano Tanturli (Padua: Antenoreis, 1997), 68–73. Coluccio Salutati composed an epigram honoring Claudian in response to his portrait among the *uomini famosi* in the Palazzo Vecchio. These portraits were destroyed in one of the early reconstructions of the space. The epigram to Claudius reads, "Egipto genitum nova me florentia civem / legibus agnovit, magnis iam digna poetis. / Infernos raptus cecini pugnasque deorum, / Cesareas laudes, necnon stiliconis honores." For epigram, see Teresa Hankey, "Salutati's Epigrams for the Palazzo Vecchio at Florence," *Journal of the Warburg and Courtauld Institutes* 22 (1959): 364; Patrick Baker, *Italian Renaissance Humanism in the Mirror* (Cambridge: Cambridge University Press, 2015), 107–108.

5 Guillaume de Lorris and Jean de Meun, *The Romance of the Rose*, trans. Charles Dahlberg (Princeton, NJ: Princeton University Press, 1971), 39. For a discussion of the French medieval tradition of the garden of love as exemplified in the *Roman de la Rose*, see Watson, *Garden of Love*, 28–29.

6 *The Romance of the Rose* lists the fruit trees as "quinces, peaches, nuts, chestnuts, apples and pears, medlars, white and black plums, fresh red cherries, sorb-apples, service-berries, and hazelnuts." It also mentions "large laurels and tall pines, with olive trees and cypresses, of which there are scarcely any here. There were enormous branching elms and, along with them, hornbeams and beech trees, straight hazels, aspen and ash, maples, tall firs, and oaks." The flowers of the garden are described in less detail as "beautiful violets, fresh, young periwinkles; there were white and red flowers and wonderful yellow ones." Lorris and Meun, *The Romance of the Rose*, 49.

7 Lorris and Meun, *The Romance of the Rose*, 59.

8 In his *Amorosa visione*, Boccaccio describes a fresco depicting the land of love. "And therefore, I say that, in the examination / which I made, I saw all that part / appear green, in the form of a youthful meadow, / at once full of flowers and adorned / with many trees of unknown species, / so that to stay there seemed joyful and pleasing." ("E però dico che, nel riguardare / ch'io feci, in guisa d'un giovine prato / tutta la parte vidi verdeggiare, / similmente fiorito ed adornato / d'alberi molti e di nuove maniere, / ove'l starvi parea gioioso e grato.") Giovanni Boccaccio, *Amorosa visione*, trans. Robert Hollander, Timothy Hampton, and Margherita Frankel (Hanover, NH: University Press of New England, 1986), 62–63, canto 15, lines 7–12.

9 "Come d'Arcita Marte l'orazione / cercò, così a Venere pietosa / se n'andò sopra'l monte Citerone / quella di Palemon, dove si posa / di Citerea il tempio a la magione / fra altissimi pini alquanto ombrosa; / alla quale appressandosi, Vaghezza / la prima fu che vide in quella altezza. / Con la quale oltre andando, vide quello / ad ogni vista soave e ameno, / in guisa

d'un giardin fronzuto e bello / e di piante verdissime ripieno, / d'erbette fresche e d'ogni fior novello, / e fonti vide chiare vi surgeno, / e intra l'altre piante onde abondava, / mortine più che altro le sembiava." Giovanni Boccaccio, *Teseida*, ed. Salvatore Battaglia (Florence: G. C. Sansoni, 1938), Book 7, 197–202; for English text, see Giovanni Boccaccio, *The Book of Theseus (Teseida delle Nozze d'Emilia)*, trans. Bernadette Marie McCoy (New York: Medieval Text Association, 1974), Book 7, 176. In his commentary to *The Book of Theseus*, Boccaccio explains that he has chosen Mt. Cithaeron because it contained a famous temple to Venus (Aphrodite) frequented by the Thebans, who worshipped the goddess with "sacred rites" and "sacrifices." He also describes this location as a temperate region, which suits Venus and "venereal acts." ("Discrive adunque l'autore questo tempio di Venere esser nel monte Citerone, per due cose: l'una, perché di fatto vi fu, perciò che il monte Citerone è vicino a Tebe, e sopra quello facevano i Tebani in certi tempi dell'anno solennissima festa, e offerevano molti sacrifici ad onore di Venere; la seconda cosa si è per la qualità del luogo, la quale è molto conforme a Venere, perciò che è regione molto temperata di caldo e di freddo, … e questa temperanza negli atti venerei è molto richesta.") Boccaccio, *Teseida*, Book 7, 197; *The Book of Theseus*, Book 7, 199–200. For a discussion of Boccaccio's characterization of this Venusian landscape as a *locus amoenus*, see Watson, *Garden of Love*, 31–34.

10 Petrarch's verses read, "Giace oltra ove l'Egeo sospira e piagne / un'isoletta delicata e molle / più d'altra che'l sol scalde o che'l mar bagne; // nel mezzo è un ombroso e chiuso colle / con sì soavi odor, con sì dolci acque, / ch'ogni maschio pensier de l'alma tolle. // Questa è la terra che cotanto piacque / a Venere, e'n quel tempo a lei fu sagra / che'l ver nascoso e sconosciuto giacque; // et anco è di valor sì nuda e magra, / tanto ritien del suo primo esser vile, / che par dolce a' cattivi et a' buoni agra." Francesco Petrarca, *I trionfi*, ed. Guido Bezzola (Milan: Rizzoli, 1957), 16, part 4, lines 100–111.

11 Petrarch writes of Samson, "Poco dinanzi a lei vedi Sansone, / vie più forte che saggio, che per cìance / in grembo a la nemica il capo pone." Petrarca, *I trionfi*, 10, part 3, lines 49–51. For the popularity of the Aristotle and Phyllis vignette in illustrations of the *Triumph of Love*, see Eugenio Refini, *The Vernacular Aristotle: Translation as Reception in Medieval and Renaissance Italy* (Cambridge: Cambridge University Press, 2020), 17–21.

12 "Vagheggia Cipri un dilettoso monte, / […] / Nel giogo un verde colle alza la fronte, / sotto esso aprico un lieto pratel siede, / u' scherzando tra' fior lascive aurette / fan dolcemente tremolar l'erbette." In another passage, he writes of the flowers, "Zefiro il prato di rugiada bagna, / spargendolo di mille vaghi odori: / ovunque vola, veste la campagna / di rose, gigli, violette e fiori; / l'erba di sue belleze ha maraviglia: / bianca, cilestra, pallida e vermiglia." Angelo Poliziano, *Stanze*, trans. David Quint (University Park: Pennsylvania State University Press, 1993), 36–37, stanza 70; 40–41, stanza 77.

13 For a description of the trees within this grove, see Poliziano, *Stanze*, 42–45, stanzas 82–85.

14 "El mirto, che sua dea sempre vagheggia, / di bianchi fiori e verdi capelli orna." Poliziano, *Stanze*, 44–45, stanza 85.

15 Poliziano, *Stanze*, 62–65, stanzas 121–25.

16 Aristotle, *Minor Works (On Marvellous Things Heard)*, trans. W. S. Hett, Loeb Classical Library 307 (Cambridge, MA: Harvard University Press, 1938), 160–61, section 58.

17 Pliny, *Natural History, Volume IX: Books 33–35*, trans. H. Rackham, Loeb Classical Library 394 (Cambridge, MA: Harvard University Press, 1952), Book 34, 208–13.

18 Pliny writes, "so soothing to their feeling of fatigue is the mellow green color of the stone." ("Ita viridi lenitate lassitudinem mulcent.") Pliny, *Natural History, Volume X: Books 36–37*, trans. D. E. Eichholz, Loeb Classical Library 419 (Cambridge, MA: Harvard University Press, 1962), Book 37, 212–13. For a discussion of ancient sources on green's positive effects on vision, see Michel Pastoureau, *Green: The History of a Color*, trans. Jody Gladding (Princeton, NJ: Princeton University Press, 2014), 54–57; Bruce R. Smith, *The Key of Green. Passion and Perception in Renaissance Culture* (Chicago: University of Chicago Press, 2009), 71–72; J. W. Meadows, "Pliny on the Smaragdus," *The Classical Review* 59

(1945): 50–51; Leopoldine Prosperetti, *Landscape and Philosophy in the Art of Jan Brueghel the Elder (1568–1625)* (Aldershot: Ashgate, 2009), 157–62.

19 Hildegard of Bingen, *On Natural Philosophy and Medicine. Selections from Cause et cure*, trans. Margret Berger (Cambridge: D. S. Brewer, 1999), 107. Margret Berger discusses a manuscript found in Florence at the Biblioteca Laurenziana (MS. laur. Ashburnham 1323, fols. 1–14; ca. 1300) that seems to be copied from the single, original text, *Physica. Liber subtilitatum diversarum naturarum creaturarum*, written by Hildegard of Bingen between 1151 and 1158. See Bingen, *On Natural Philosophy and Medicine*, ix–xi.

20 "Post oraculum nobis cogitandum mandat rerum viridium naturam, quatenus virent, non solum esse vivam, sed etiam iuvenilem, humoreque prorsus salubri et vivido quodam spiritu redundantem. Quapropter odore, visu, usu, habitatione frequenti iuvenilem inde spiritum nobis influere." Marsilio Ficino, *Three Books on Life*, trans. Carol V. Kaske and John R. Clark (Tempe, AZ: Arizona Center for Medieval and Renaissance Studies, 2002), 204–205.

21 "Inter virentia vero deambulantes interim causam perquiremus, ob quam color viridis visum prae ceteris foveat salubriterque delectet. Inveniemus tandem naturam visus esse lucidam ac lucis amicam, volatilem tamen ac facile dissipabilem. Idcirco dum per lucem se dilatat, velut amicam, interdum nimio lucis excessu rapi prorsus, et vehementi dilatatione dissolvi; tenebras autem naturaliter velut inimicas fugere, ideoque radios in angustum inde retrahere ... Quamobrem color viridis maxime omnium nigrum cum candido temperans, praestat utrunque, delectans pariter atque conservans." Ficino, *Three Books on Life*, 204–205.

22 "Et molli insuper et adhuc tenera qualitate, sicut et aqua, radiis oculorum absque offensione resistit, ne abeuntes longius disperdantur. Quae enim dura sunt simul et aspera, frangunt quodammodo radios; quae vero rarissima sunt, dissolutioni aditum patefaciunt ... Quae denique praeter haec beneficia tenera quoque sunt et mollia, sicut aqua resque virides, liquidis oculorum radiis mollitia blandiuntur." Ficino, *Three Books on Life*, 204–205.

23 The first-century scholar Varro, for example, described *viridis* or "green" as being "from a certain *vis* 'power' of moisture: if this moisture has thoroughly dried out, the bush dies" ("Virgultum dicitur a viridi, id a vi quadam humoris; quae si exaruit, moritur"). Varro, *On the Latin Language, Volume I: Books 5–7*, trans. Roland G. Kent, Loeb Classical Library 333 (Cambridge, MA: Harvard University Press, 1938), Book 5, 96–97.

24 "Viridis quidem Veneri simul atque Lunae: humidus videlicet humidis atque nascentium proprius, accommodatus et matribus." Ficino, *Three Books on Life*, 344–45.

25 Bingen, *On Natural Philosophy and Medicine*, 78.

26 Bingen, *On Natural Philosophy and Medicine*, 82.

27 "Seu quia odorifera sit arbor et Venus odoribus delectatur; seu quia huius arboris odor credatur a non nullis venerea suadere; seu, ut physici dicunt, eo quod ex ea multa mulierum commoda fiant; seu quia ex bacis eius aliquod compositum fiat per quod excitatur libido ac etiam roboratur." For Latin and English text, see Giovanni Boccaccio, *Genealogy of the Pagan Gods, Volume I: Books I–V*, trans. Jon Solomon, I Tatti Renaissance Library 46 (Cambridge, MA: Harvard University Press, 2011), Book 3, 394–95.

28 "Il vino, che si fa delle bacche del mirto spremute, bollito prima alquanto, accioche non diventi aceto, bevuto per avanti non lascia imbriacare. Tanto vale in ogni cosa il vino de i mirti, quanto il lor seme. Sedendovisi dentro, giova alle precipitationi della madrice, al budello del sedere, & à i flussi delle donne. ... Mescolate con olio omphacino, overo con un poco del rosado, insieme con vino, vagliono alle ulcere serpignose, al fuoco sacro, alle infiammagioni de i testicoli." Pietro Andrea Mattioli, *I discorsi ne i sei libri della materia medicinale di pedacio Dioscoride Anazarbeo* (Sala Bolognese: Forni, 1984; reprint of Venice: Vincenzo Valgrisi, 1557), 137–38.

29 Mattioli describes the bath preparations with myrtle but also notes that this treatment can lead to lasciviousness. He writes, "la troppa cupidità di volere abbracciare ogni cosa." Mattioli, *I discorsi*, 56.

30 For the price of green earth, see the inventory of the *speziali* merchant Tomasso di Giovanni, Archivio dell'Ospedale degli Innocenti, Florence, Estranei 880, 55v. For a chart of green earth prices as found in various inventories, see Susanne Kubersky-Piredda, "The Market for Painters' Materials in Renaissance Florence," in *Trade in Artists' Materials: Markets and Commerce in Europe to 1700*, ed. Jo Kirby, Susie Nash, and Joanna Cannon (London: Archetype, 2010), 232.

31 "Alcuna volta si lavora in camera o sotto loggie, o pogiuoli che tutte / le volte non si lavora in fresco pero chel trovi per altro tempo smaltato / e vuoi lavorare, in verde per tanto togli verde terra ben macinata / e temperata con colla da ingessare non troppo forte, e danne con pennello di / setole grosso per tutto il campo due, o tre volte." The directions for drawing, dabbing with a sponge, and adding figures are included in the rest of the chapter. For Italian and English text, see Cennino Cennini, *Il libro dell'arte*, trans. Lara Broecke (London: Archetype, 2015), 245. In her footnotes, Lara Broecke describes several extant monochrome green rooms and notes that this type of décor was in fashion in the first half of the fifteenth century; see Cennini, *Il libro dell'arte*, 246.

32 For a discussion of verdure tapestries within the domestic interior, see Jacqueline Marie Musacchio, *Art, Marriage, & Family in the Florentine Renaissance Palace* (New Haven, CT: Yale University Press, 2008), 116–21.

33 Richard Stapleford, *Lorenzo de' Medici at Home: The Inventory of the Palazzo Medici in 1492* (University Park: Pennsylvania State University Press, 2013), 67, 136.

34 For examples of bedding and wall hangings fashioned from green textiles or tapestries of foliage, see Stapleford, *Lorenzo de' Medici at Home*, 66, 67, 77, 79, 88, 132, 136, 140, 144, 157, 159, 162, 165, 171, 187, 188. In the inventory, there are more green textiles than red or blue. The inventory lists a number of blue bedspreads with "Venetian embroidery"; however, there is only one blue bed curtain and no wall tapestries in blue. There are about half as many red bedcovers as green or blue, though the majority of pillows and cushions are covered with red textiles. For blue textiles, see Stapleford, *Lorenzo de' Medici at Home*, 69, 76, 78, 83, 88, 121, 158, 159, 162, 165, 179, 180, 188. For red textiles, see Stapleford, *Lorenzo de' Medici at Home*, 66, 72, 79, 82, 94, 119, 130, 132, 139, 144, 145, 174, 188.

35 Examples of scholarship on kermes red include Michel Pastoureau, *Red: The History of a Color*, trans. Jody Gladding (Princeton, NJ: Princeton University Press, 2016), 40–43, 90–93; Amy Butler Greenfield, *A Perfect Red: Empire, Espionage, and the Quest for the Color of Desire* (New York: Harper Perennial, 2006), 5–33; Luca Molà, *The Silk Industry in Renaissance Venice* (Baltimore: Johns Hopkins University Press, 2000), 107–37.

36 Florence Edler de Roover, *L'arte della seta a Firenze nei secoli XIV e XV*, ed. Sergio Tognetti (Florence: Leo S. Olschki, 1999), 44–47.

37 For information on indigo and weld, see David Coles, *Chromatopia: An Illustrated History of Colour* (New York: Thames & Hudson, 2019), 42–43, 94–95.

38 Stapleford, *Lorenzo de' Medici at Home*, 67, 93.

39 The inventory entry (no. 38) listing the painting that Shearman argues is the *Primavera* reads, "Uno quadro di lignamo apicato sopra el letucio, nel quale è depinto nove figure di donne ch'omini [B: 1⁰ quadro grande sopra il lettuccio che v'è viii fiure], estimato – l. 100–." It is located in the *camera terrena* next to Lorenzo di Pierfrancesco's *camera*. The verdure tapestries are found in the *sala grande*. The entry (no. 59) reads, "uno cortinazo di razzo a verdura minuta con seta fodrato di tella, zoè sopracielo con pendenti da tri lati e cortina da capo e drieto, estimatto – l. 360– " and "uno panno di razza a verdura minuta con seta, lungo br. 11 e largo br. 8 ½, estimato – l. 120– ." Original inventory listing: ASF, *Archivio mediceo avanti il principato*, filza CXXIX, fols. 480–528. For these entries, see the reprint found in John Shearman, "The Collections of the Younger Branch of the Medici," *Burlington Magazine* 117 (1975): 25–26. Shearman explains that the prices are in the silver currency of *lire* and *soldi* and explains that the "exchange-rate at this date is about 6 *lire* to the *fiorino*." Shearman, "The Collections of the Younger Branch of the Medici," 15.

40 Claudian, *Panegyric on Probinus and Olybrius*, 256–57.

41 Marco Antonio Altieri composed his treatise on nuptial rituals between 1506 and 1509 and made additions in 1513. With regard to Venus, myrtle, and marriage, he writes, "Imperhò diversi intenti son questi, se ben li pensarete, alli apti nuptiali: dove trovandosence per rincontro unione, benivolentia et amorevile concordia, recurrese solo allo auxilio de Venere; nè già con cose aspere, crude et rigorose, ma con mortella, inimica de ogne violentia, accompagnata poi de fiori, odori et altri irritamenti, acciò che da bene auspicata in nella copula futura sì iocunda et desiata, possase impetrarne copioso acquisto de assai melliti et amabili figlioli." Marco Antonio Altieri, *Li nuptiali*, ed. Enrico Narducci (Rome: Roma nel Rinascimento, 1995), 76.

42 For a discussion of perspectival space, see Leon Battista Alberti, *On Painting*, trans. John R. Spencer (New Haven, CT: Yale University Press, 1966), Book 1, 43–59.

43 Vannoccio Biringuccio, *Pirotechnia*, trans. Cyril Stanley Smith and Martha Teach Gnudi (New York: American Institute of Mining and Metallurgical Engineers, 1942), 53.

44 In describing the things governed by the planet Venus, Abraham Ibn-Ezra writes, "in her share is everything that is in the belly of the earth, the saffron [colored] copper." Avraham Ben Meir Ibn Ezra, *The Beginning of Wisdom (Reshith Hochma)*, trans. Meira B. Eptstein (Las Vegas: ARHAT, 1998), 100. For Venus' connection to malachite and copper, see *Picatrix: A Medieval Treatise on Astral Magic*, trans. Dan Attrell and David Porreca (University Park: Pennsylvania State University Press, 2019), 104.

45 Albertus Magnus (ca. 1200–80) describes the manufacturing of verdigris as follows: "If copper sprinkled with salt is placed over vinegar or the urine of a pure young boy, the power of the urine or vinegar will penetrate into the substance of the copper and change it to a green color. Or, again, if copper alone is placed over pressed out [grapes from the vintage], the mere vapor of wine will change it to a fine brilliant green color." Albertus Magnus, *Book of Minerals*, trans. Dorothy Wyckoff (Oxford: Clarendon Press, 1967), 225.

46 A pound of verdigris at 18 *soldi* in Tomasso di Giovanni's inventory equals, in Kubersky-Piredda's estimates, 0.9–1.0 "working days of a skilled laborer in the building industry (WDSL)." See Kubersky-Piredda, "The Market for Painters' Materials in Renaissance Florence," 234.

47 "E sse vuoi fare un verde inn erba perfettissimo ebello all occhio / manon dura ede buono." Cennini, *Il libro dell'arte*, 82.

48 For a discussion of verdigris and its problems, see Renate Woudhuysen-Keller and Paul Woudhuysen, "Thoughts on the Use of the Green Glaze Called 'Copper Resinate' and its Colour-changes," in *Looking through Paintings: The Study of Painting Techniques and Materials in Support of Art Historical Research*, ed. Erma Hermens (London: Archetype, 1998), 133–46; Hermann Kühn, "Verdigris and Copper Resinate," in *Artists' Pigments: A Handbook of Their History and Characteristics*, ed. Ashok Roy, vol. 2 (Oxford: Oxford University Press, 1993), 131–47; Daniel V. Thompson, *The Materials and Techniques of Medieval Painting* (New York: Dover Publications, 1956), 163–68; Anita Albus, *The Art of Arts: Rediscovering Painting*, trans. Michael Robertson (New York: Alfred A. Knopf, 2000), 326–37; Cole, *Chromatopia*, 50–51.

49 Pliny, *Natural History, Volume X: Books 36–37*, trans. D. E. Eichholz, Loeb Classical Library 419 (Cambridge, MA: Harvard University Press, 1962), Book 37, 256–57.

50 "Questo colore per se medesimo e grossetto e par chome sabbionino / per amor dell'azurro trialo pocho pocho cholla man leggiera pero / chesse troppo il macinasse verrebbe in colore stinto e cce / nderaccio." Cennini, *Il libro dell'arte*, 78.

51 For a discussion of malachite's properties, see Rutherford J. Gettens and Elisabeth West Fitzhugh, "Malachite and Green Verditer," in *Artists' Pigments*, vol. 2, 183–202; Rutherford J. Gettens and Elisabeth West Fitzhugh, "Malachite and Green Verditer," *Studies in Conservation* 19 (1974): 2–23; Thompson, *The Materials and Techniques of Medieval Painting*, 160–62; Cole, *Chromatopia*, 44–45.

52 Neri di Bicci, *Le ricordanze (1453–1475)*, ed. Bruno Santi (Pisa: Marlin, 1976), 366; Alessio
 Baldovinetti, *I ricordi (1470–73)*, ed. Giovanni Poggi (Florence: Liberia, 1909), 14. These
 inventories are discussed by Jo Kirby, "The Price of Quality: Factors Influencing the Cost
 of Pigments during the Renaissance," in *Revaluing Renaissance Art*, ed. Gabriele Neher and
 Rupert Shepherd (Aldershot: Ashgate, 2000), 19–42. In Kubersky-Piredda's estimates, a
 pound of malachite cost 144–168 *soldi*, which equals 7.2 to 8.4 "working days of a skilled
 laborer in the building industry (WDSL)." See Kubersky-Piredda, "The Market for
 Painters' Materials in Renaissance Florence," 235–38.

53 The following pigments are included in the *gabelle* of the Arte dei medici e speziali from
 1442: *azzurro grosso di golfo* and *azzuro vivo* (azurite), *verde terra* (green earth), and *verderame*
 (verdigris). For listings, see Giovanni Francesco Pagnini, ed., *Della decima e di varie altre
 gravezze imposte dal comune di Firenze: contenente La pratica della mercatura scritta da Giovanni di
 Antonio da Uzzano nel 1442*, vol. 2 (Lisbon and Lucca, 1765–66; reprint, Bologna: Forni,
 1967), Book 4, 17, 25, 26.

54 Kubersky-Piredda, "The Market for Painters' Materials in Renaissance Florence," 232–42.

55 Louisa C. Matthew, "'Vendecolori a Venezia': The Reconstruction of a Profession,"
 Burlington Magazine 144 (2002): 680–86.

56 In his *Il libro dell'arte*, Cennini states that *verdazzurro* is "manufactured" from azurite ("Verde
 e un colore el quale e mezo naturale et questo sifa arti / fitialmente che ssi fa dazurro
 dellamangnia e questo si chiama / verde azurro"). For Italian and English text, see Cennini,
 Il libro dell'arte, 78.

57 Biringuccio, *Pirotechnia*, 118.

58 Lara Broecke offers another theory regarding this pigment in her commentary to Cennini's
 Il libro dell'arte. She suggests that *verdazzurro* was manufactured by dyeing or tingeing azurite
 with saffron or yellow lake, a process that would produce a green-blue or *verdazzurro*
 pigment. For her theory, see Cennini, *Il libro dell'arte*, 79.

59 Cennini's chapter is titled, "The Way to Paint Trees and Grasses and Greenery in Fresco
 and in Secco." His directions are as follows: "Se vuoi adornare le dette montangnie
 diboschi darbori o / derbe metti prime il corpo dell'albero di nero puro tenperato / che
 in frescho mal si posson fare epoi fa un grado di foglie di verde / schuro pur di verde azurro
 che di verde terra nonn e buono / effa che lle lavori bene spesse poi fa un verde con
 giallorino / che ssia piu chiaretto effa delle foglie meno cominciando arri / durti a trovare
 delle cime poi toccha i chiarori delle cime pur / di giallorino e vedrai i rilievi delli arbbori e
 delle verdure ma / prima quando ai canpeggiati gli albori di negro in pie e alch / uni rami
 degli albori e buttavi su le foglie epoi i frutti e / sopra le verdure butta alchuni fiori e
 uselletti." Cennini, *Il libro dell'arte*, 122–23.

60 For a scientific report on the materials and techniques used by Botticelli for the *Primavera*'s
 vegetation, see Mauro Matteini and Arcangelo Moles, "La Primavera, Tecnica di esecu-
 zione e stato di conservazione," in *Metodo e scienza operatività e ricerca nel restauro (Firenze
 23 giugno 1982–6 gennaio 1983)*, ed. Umberto Baldini (Florence: Sansoni, 1983), 228–29. For
 the full restoration report of the *Primavera*, see Primavera: anni 1981–83, GR 8720 in the
 Archivio dell'Opificio delle Pietre Dure.

61 For the verdigris glaze, see Matteini and Moles, "La Primavera, Tecnica di esecuzione e
 stato di conservazione," 228–29.

62 For this data, see Umberto Baldini, *Primavera: The Restoration of Botticelli's Masterpiece* (New
 York: Harry N. Abrams, 1986), 101–108. For a detailed analysis of the plant species and the
 connection of various plants to the gardens of Castello, see G. Motti and C. Ricceri,
 "Piante e fiori nella 'Primavera'," in *Metodo e scienza operativita' e ricerca nel restauro*, ed.
 Baldini, 217–55. For further discussion of the painting's relationship with the gardens and
 environment of Castello, see Alessandro Cecchi, *Botticelli* (Milan: Federico Motta, 2005),
 144–61. Mirella Levi D'Ancona identified forty plants and their symbolic meaning; see
 Mirella Levi D'Ancona, *Botticelli's Primavera: A Botanical Interpretation including Astrology,
 Alchemy and the Medici* (Florence: Leo S. Olschki, 1983), 71–95. For another symbolic

interpretation of the plants, see Giovanni Reale, *Botticelli: la "Primavera" or le "Nozze di Filologia e Mercurio"? Rilettura di carattere filosofico ed ermeneutico del capolavoro di Botticelli con la prima presentazione analitica dei personaggi e di particulari simbolici* (Rimini: Idea Libri, 2001), 279–87.

63 "Dice similemente il luogo essere ombroso e pieno di fontane. Per l'ombre vuole intendere due cose: l'una per lo rinfrescamento opportuno a' troppi caldi, e per questo ancora le fonti." Boccaccio, *Teseida*, Book 7, 198; *The Book of Theseus*, Book 7, 200.

64 "Questa temperanza negli atti venerei è molto richesta; perciò che, se noi riguardiamo bene, uno uomo il quale sia di frigida natura, o sia per accidente ancora freddo, non può sanza gran difficultà a quello atto pervenire per le virtù attive dal freddo impedite. Similemente colui o che è di natura troppo caldo, o è per accidente o di soperchio vino o di fatica riscaldato, ha sì resolute le attive virtù, che esercitare non si può in cotale atto. È adunque necessaria la temperanza a cotale esercizio, per la qual cosa meritamente in temperato luogo pone l'autore il tempio di questa dea." Boccaccio, *Teseida*, Book 7, 197–98; *The Book of Theseus*, Book 7, 199.

65 Continuing in his reasoning for why Venus' place is shady, Boccaccio writes, "l'altra per la qualità del luogo che richeggiono gli effetti di Venere, i quali vogliono agio e buio: il che similemente dimostra quando disegna il luogo dove Venere dimora." Boccaccio, *Teseida*, Book 7, 198; *The Book of Theseus*, Book 7, 200.

66 For a discussion of the lance and shell, see Patricia Simons, *The Sex of Men in Premodern Europe: A Cultural History* (New York: Cambridge University Press, 2014), 112–15.

67 Charles Dempsey, *Inventing the Renaissance Putto* (Chapel Hill: University of North Carolina Press, 2001), 107–46; for quote, 137.

68 A number of scholars, including Gert Jan van der Sman, assert that the frescos commemorate Lorenzo's first marriage to Giovanna di Maso degli Albizzi; see Helen S. Ettlinger, "The Portraits in Botticelli's Villa Lemmi Frescoes," *Mitteilungen des Kunsthistorischen Institutes in Florenz* 20 (1976): 404–407; Gert Jan van der Sman, "Sandro Botticelli at Villa Tornabuoni and a Nuptial Poem by Naldo Naldi," *Mitteilungen des Kunsthistorischen Institutes in Florenz* 51 (2007): 159–86; Gert Jan van der Sman, *Lorenzo and Giovanna: Timeless Art and Fleeting Lives in Renaissance Florence*, trans. Diane Webb (Florence: Mandragora, 2010), 45–61; Patricia Simons argues more convincingly that they celebrate Lorenzo's second marriage to Ginevra Gianfigliazzi; see Patricia Simons, "Giovanna and Ginevra: Portraits for the Tornabuoni Family by Ghirlandaio and Botticelli," *I Tatti Studies in the Italian Renaissance* 14/15 (2011–12): 103–35; Maria DePrano, "Celebrating a Second Marriage: Botticelli's Frescoes for the Tornabuoni Villa," in *Art Patronage, Family, and Gender in Renaissance Florence: The Tornabuoni* (Cambridge: Cambridge University Press, 2018), 167–89. For a description of the landscape at the Tornabuoni Villa Chiasso Macieregli, see Vernon Lee, "Botticelli at the Villa Lemmi," in *Juvenilia: Being a Second Series of Essays on Sundry Aesthetical Questions* (Boston: Roberts Brothers, 1887), 79–129.

69 Using early photographs of the frescos taken between 1873 and 1882, Gert Jan van der Sman revealed that the original frescos were framed by decorative pilasters and a foreground plinth, which created an open loggia; see Sman, "Botticelli at Villa Tornabuoni," 165–67.

70 Francesco Buranelli, Jorge Mejía, and Allen Duston, eds., *The Fifteenth Century Frescoes in the Sistine Chapel* (Vatican City: Musei Vaticani, 2003), 89.

71 Mauro Matteini and Arcangelo Moles, "Indagine sui materiali e le stesure pittoriche del dipinto," *Gli Uffizi Studi e Ricerche: La Nascita di Venere e l'Annunciazione del Botticelli restaurate* 4 (1987): 78. The mixing of the yellow yolk and white (albumen) of the egg is noted in the same report (79).

72 Matteini and Moles, "Indagine sui materiali e le stesure pittoriche del dipinto," 78.

73 "Volessi lavorare alchuno albore che paresse degli / albori di paradiso togli i pezi dell oro fine in quantita secon / do il lavoro che vuoi fare o volessi scrivere." Cennini, *Il libro dell'arte*, 206.

74 Matteini and Moles, "Indagine sui materiali e le stesure pittoriche del dipinto," 79; Alfio Del Serra, "Il restauro della Nascita di Venere," *Gli Uffizi Studi e Ricerche: La Nascita di Venere e l'Annunciazione del Botticelli restaurate* 4 (1987): 52.

75 "Quello non fia universale che non ama equalmente tutte le cose che si contengono nella pittura; come se uno non li piace li paesi, esso stima quelli essere cosa di brieve e semplice investigazione, come disse il nostro Botticella, che tale studio era vano, perché col solo gittare d'una spunga piena di diversi colori in un muro, esso lasciava in esso muro una macchia, dove si vedeva un bel paese. Egli è ben vero che in tale macchia si vede varie invenzioni di ciò che l'om vole cercare in quella, cioè teste d'omini, diversi animali, battaglie, scogli, mari, nuvoli e boschi et altri simili cose; e fa com'il sono delle campane, nelle quali si pò intendere quelle dire quel ch'a te pare. Ma ancora ch'esse macchie di dieno invenzione, esse non t'insegnano finire nessuno particulare. E questo tal pittore fece tristissimi paesi." Leonardo da Vinci, *Libro di pittura. Codice Urbinate lat. 1270 nella Biblioteca Apostolica Vaticana*, ed. Carlo Pedretti, vol. 1 (Florence: Giunti, 1995), 174. For a translation and discussion of this passage, see Stefano Pierguidi, "Botticelli and Protogenes: An Anecdote from Pliny's *Naturalis Historia*," *Source* 21 (2002): 15–18.

76 Cennini, *Il libro dell'arte*, 245.

77 In a letter dated May 27, 1490 and addressed to Antonio Calderini, Ficino defends his *Three Books on Life*, writing, "Everyone who reads our books, not with a troubled mind but with sound judgement, will clearly see that I have written with equal sincerity of purpose, piety of mind, and reverence for religion. In addition, all scholars will recognize how well disposed they ought to be towards our books, as these take very good care of the life of scholars." Marsilio Ficino, *The Letters of Marsilio Ficino*, trans. Members of the Language Department of the School of Economic Science in London, vol. 9 (London: Shepheard-Walwyn, 2012), 21. For a discussion of the controversy in Rome, see Paul Oscar Kristeller, "Marsilio Ficino and the Roman Curia," *Humanistica Lovaniensia* 34 (1985): 93–95.

78 In his *Life of Fra Bartolomeo*, Vasari reports on Savonarola's preaching, writing, "Now it happened that Fra Girolamo, continuing his preaching, and crying out every day from the pulpit that lascivious pictures, music, and amorous books often lead the mind to evil, became convinced that it was not right to keep in houses where there were young girls painted figures of naked men and women." ("Avvenne che continovando Fra Ieronimo le sue predicazioni, e gridando ogni giorno in pergamo che le pitture lascive e le musiche e libri amorosi spesso inducono gli animi a cose mal fatte, fu persuaso che non era bene tenere in casa, dove son fanciulle, figure dipinte di uomini e donne ignude.") For Italian, see Giorgio Vasari, *Le vite de' più eccellenti pittori, scultori ed architettori*, ed. Gaetano Milanesi, vol. 4 (Florence: G. C. Sansoni, 1879), 178; for English, see Giorgio Vasari, *Lives of the Most Eminent Painters, Sculptors and Architects*, trans. Gaston du C. de Vere, vol. 4 (London: Macmillan, 1912), 153.

79 "Aristotile che era pagano dice nella Politica che non si debba fare dipignere figure disoneste rispetto a' fanciugli, perchè vedendole, diventano lascivi; ma che dirò io di voi, dipintori cristiani, che fate quelle figure là, spettorate, che non sta bene? Non le fate più. Voi a chi s'apartiene, doverresti fare incalcinare e guastare quelle figure che avete nelle case vostre, che sono dipinte disonestamente e faresti una opera che molto piaceria a Dio e alla Vergine Maria." Sermon is dated February 21, 1496 as the first Sunday of Lent; see Girolamo Savonarola, *Prediche Italiane ai Fiorentini, vol. 3.1, Quaresimale del 1496*, ed. Roberto Palmarocchi (Florence: La Nuova Italia, 1933), 127; for English translation, see Jill Burke, "Republican Florence and the Arts, 1494–1513," in *Florence*, ed. Francis Ames-Lewis (New York: Cambridge University Press, 2012), 255.

80 "Il Signore dice: *Vidi te conculcari in sanguine tuo*. Ecco, anima, vieni ora che io ti ho lasciato nelli peccati, chè tu hai gustato che cosa è il mondo. *Multiplicatam quasi germen agri dedi te*: io ti ho moltiplicata tutta, io ti ho messa come in un prato di fiori, io ti ho lasciato scorrere in questo prato cogliendo de' fiori e de' piaceri a tuo modo. Tu hai voluto vedere, tu giovane, tutte le fanciulle belle: tu. donna. hai voluto vedere tutti li giovani e li garzoni; tu hai avuto

piacere delli occhi quanto hai voluto, tu hai fatto dipignere li specchi nelle camera e mille figure da eccitarti a' piaceri. Io ti ho lasciato fare ogni cosa; lo occhio tuo si è pasciuto in su questo prato." Girolamo Savonarola, *Prediche sopra Ezechiele*, ed. Roberto Ridolfi, vol. 1 (Rome: Angelo Belardetti, 1955), 365.

81 "E voi, madri, che adornate le vostre figliuole con tante vanità e superfluità e cappellature, portatele tutte qua a noi per mandarle al fuoco, acciò che quando verrà l'ira di Dio, non trovi queste cose nelle case vostre e così vi comando come padre vostro, in questo caso." Girolamo Savonarola, *Prediche Italiane ai Fiorentini, vol. 1, Novembre e Dicembre del 1494*, ed. Francesco Cognasso (Perugia: La Nuova Italia, 1930), 17. For English translation, see Stefano Dall'Aglio, "Savonarola and his Dream of Reform: Art, Money and the Bonfire of Vanities," in *Money and Beauty: Bankers, Botticelli and the Bonfire of the Vanities*, ed. Ludovica Sebregondi and Tim Parks (Florence: Giunti, 2011), 94–95.

82 "Sì che dal principio della quaresima dello avento insino al carnovale fu lor dato e raccolsero eglino una moltitudine meravigliosa di così fatte figure e dipinture disoneste, e parimente capelli morti, e ornamenti di capo delle donne, pezzette di levante, belletti, acque lanse, moscadi, odori di più sorte, e simili vanità, e appresso tavolieri e scacchieri begli e di pregio, carte da giucare e dadi, arpe e liuti e cetere, e simili strumenti da sonare, l'opere del Boccaccio e Morganti, e libri di sorte, e libri magici e superstiziosi una quantità mirabile." Jacopo Nardi, *Istorie della città di Firenze*, ed. Agenore Gelli, vol. 1 (Florence: Felice Le Monnier, 1858), 92. For translation, see Dall' Aglio, "Savonarola and His Dream of Reform," in *Money and Beauty*, 96.

FIVE

EROTIC ANATOMY
Fantasy, Sex, and Disease

So, therefore, if one is wounded by the shafts of Venus, whether it be a boy with girlish limbs who launches the shaft at him, or a woman radiating love from her whole body, he tends to the source of the blow, and desires to unite and to cast the fluid from body to body; for his dumb desire presages delight.

 This is our Venus; from this also comes love's name; from this first trickled into the heart that dew drop of Venus's sweetness, and then came up freezing care. For if what you love is absent, its images are there, and the sweet name sounds in your ears. But, it is fitting to flee from images, to scare away what feeds love, to turn the mind in other directions, to cast the collected liquid into any body and not to retain it, . . . For the sore quickens and becomes inveterate by feeding, daily the madness takes on and the tribulation grows heavier . . . so in love Venus mocks lovers with images.[1]

 – Lucretius (99–55 BCE), *On the Nature of Things*

Venus governs the aroused state of mind, a neurological pathway that feeds off of images, both real and imagined. Through the sense of sight, love pierces the heart and awakens the venereal appetite.[2] In his *On the Nature of Things*, Lucretius describes the first wound of love and the nascent desire it sparks as "that dew drop of Venus's sweetness"; however, he quickly explains that "if what you love is absent, yet its images are there" and you do not flee from them, then the wound deepens, becoming chronic and incurable. Once a sweet prick, the wound becomes inflamed, triggering cognitive distortions, madness, and behaviors of a lustful, deviant, and even bestial nature. As Lucretius warns, "the body seeks that which has wounded the mind with love."[3] This neurological process, often described in poetic terms, explains the

whirlwind of passions surrounding an unattainable lover; however, it also accounts for the psychosexual power of erotic art, in which images of nude flesh, round breasts, hard nipples, plump posteriors, and erect phalluses arouse and then feed desire.

During the first half of the sixteenth century, a voluptuous tide of erotic art washed over Italy. In *Eros Visible: Art, Sexuality and Antiquity in Renaissance Italy*, James Grantham Turner investigates this "erotic-aesthetic revolution," illustrating how creativity, art, and sex intertwined in drawings, paintings, sculptures, and hardcore prints. According to Turner, this libertine culture emerged in Rome among patrons, artists, and writers connected to the Medici papal courts.[4] In 1524, Marcantonio Raimondi, for example, published his *I modi*, a series of sixteen engravings depicting heterosexual couples in various, mostly illicit, positions of copulation.[5] Though censored by a Papal Bull issued by Pope Clement VII (Giulio di Giuliano de' Medici, 1478–1534), these bawdy prints inspired other engravings, including Jacopo Caraglio's *Loves of the Gods* series (Fig. 63).[6] Soon, venereal imagery spread across Italy and France, taking on new fervor in more elaborate and expensive mediums. As a result, artists began to be praised for their subtle manipulations of sexual anatomies and their complex couplings of nude figures. Great art, according to the writers of the day, should arouse the viewer, excite the imagination, encourage fantasy, and in the end, prompt ejaculation.[7]

In this chapter, art's power to awaken sexual desire is examined within the context of sixteenth-century discussions as to whether the beauty of an object, and thus its power of attraction, is derived from its material or rather from the artist's skill. In his 1542 treatise, titled *Dialogo dove si ragiona delle bellezze*, the Venetian writer Niccolò Franco praises the artist's ability to create or *arteficiate* beauty by comparing a sculpture of Venus carved by Jacopo Sansovino to a rough block of marble, untouched by human hands. Franco explains that the beauty of Venus is not derived from the marble but rather from the sculptor's design, writing that "the artifice of the figure is its beauty."[8] Franco's comment highlights a shift – observed by Michael Baxandall in *Painting and Experience in Fifteenth-Century Italy* – in the taste of early modern patrons, for whom the artist's skill outweighed the material value of his pigments, stones, or metals.[9] In this chapter, I explore this idea in the context of erotic art produced in Florence between 1530 and 1570, arguing that the human body, rather than gold or marble, becomes the primary *materia* or material of art. In turn, the technical skill by which sixteenth-century artists manipulated the body's form and anatomy is a marker of the object's as well as its creator's value.

The chapter analyzes sensual representations of Venus by Michelangelo Buonarroti, Jacopo Pontormo, Agnolo Bronzino, Giorgio Vasari, and Michele Tosini. In ways heretofore not seen in representations of the goddess, these artists appropriated, manipulated, and referenced sexual anatomy, including

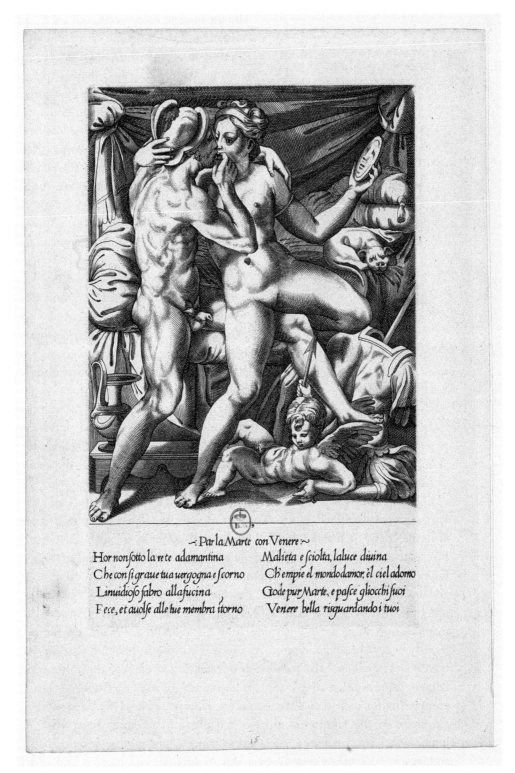

-: Par la Marte con Venere :~

Hor non sotto la re te adamantina Malieta e sciolta, la luce diuina
Che con si graue tua uergogna e scorno Ch'empie el mondo d'amor, el ciel adorno
L'inuidioso fabro alla fucina Gode pur Marte, e pasce gli occhi suoi
Fece, et auolse alle tue membra itorno Venere bella risguardando i tuoi

63 Gian Jacopo Caraglio, after drawing by Perino del Vaga, *Mars and Venus*, from the *Loves of the Gods* series, 1527, Bibliothèque nationale de France, Paris. Photo: Bibliothèque nationale de France

VIGESIMAQVINTA QVINTI LIBRI FIGVRA

64 *The Female Pelvic Anatomy*, from Andreas Vesalius' *De corporis humani fabrica*, 1543. Photo: akg-images / WHA / World History Archive

the breasts, the mons pubis, the vulva, the phallus, and the buttocks. Since antiquity, Venus had been linked to sexual anatomy and in melothesia, a branch of astrology that associated planets with specific organs and functions of the human body, the planet ruled the stomach, liver, kidneys, genitals, womb, seed, and breasts.[10] In the sixteenth century, Venus' relationship to female anatomy and the sex organs became increasingly scientific. In his *De humani corporis fabrica* of 1543, Andreas Vesalius used a sculptural fragment of Praxiteles' *Aphrodite of Knidos* to diagram the female reproductive system (Fig. 64), grafting living tissue to marble stone. And when Renaldo Colombo discovered the clitoris in 1559, he declared that "it should be called the love or sweetness of Venus."[11] The rediscovery and availability of ancient sculptural fragments of Venus, along with the publication of scientific anatomical treatises and the increasing popularity of erotic art, created an environment that encouraged the appropriation, manipulation, and reproduction of the female sexual body as the *materia* or material of art.

In their portrayals of Venus, sixteenth-century Florentine artists combined ancient torsos with the limbs of studio models, conflated male and female anatomies, and generated hybrid creatures from human and animal parts. Privileging variety, novelty, and design, they separated anatomical parts from their original sources (ancient sculptures, studio models, or anatomical treatises) and from their original materials (marble, flesh, ink-and-paper) to fashion flirtatious figures of the goddess, her son, and the lusty satyr. Through the manipulation of pose and gesture, they also explored – both openly and secretly – deviant sexual desires. As Bronzino wrote in his burlesque *capitolo*, titled "Del pennello," the paintbrush or phallus is needed to do it "from the behind, from in front, diagonally, foreshortened, or in perspective."[12] As if to compensate for their sexual transgressions, Florentine artists included sobering reminders of the emotional turmoil and physical suffering characteristic of intemperate forms of love, such as polyamory, pedophilia, hypersexuality, and incest.[13] Venus held sway over this multiplicity of amorous and sexual orientations. She also governed diseases of the sexual organs, including tumors

in the breasts and testicles and the rapidly spreading venereal disease of syphilis.[14] Thus, in contrast to the erotica produced in Rome and Venice, representations of Venus in Florence more openly explored sexual anatomy, deviant desires, and the consequences of unrestrained carnal passions.

THE PRICK OF DESIRE

Between 1532 and 1533, Michelangelo designed and Pontormo painted a *Venus and Cupid* (Fig. 65) for the private Florentine residence of the merchant banker Bartolomeo Bettini.[15] In his *Life of Pontormo*, Giorgio Vasari describes the project, stating that Michelangelo "made for his very good friend a cartoon of a nude Venus with a Cupid, who kisses her, to be executed as a painting by Pontormo and placed in the center of his [Bettini's] chamber." According to Vasari, Bettini commissioned Bronzino to fill the chamber's lunettes with portraits of "Dante, Petrarch, and Boccaccio, with the intention of having there all the other poets who have sung of love in Tuscan prose and verse."[16] Honoring both the literary and visual arts of Florence, Bettini's novel decorative program celebrated the poetics of love: the prick or rub of desire, which generates creativity alongside both pleasure and pain.[17]

When Michelangelo designed the *Venus and Cupid* cartoon (Fig. 66) in the early 1530s, erotic art was in high demand. The artist explored the genre in a

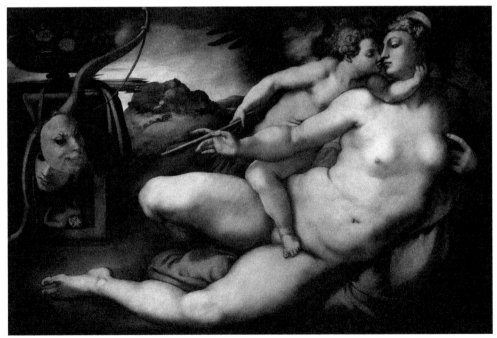

65 Jacopo Pontormo, from a cartoon by Michelangelo Buonarroti, *Venus and Cupid*, 1533, Galleria dell'Accademia, Florence, Italy. Photo: akg-images / Rabatti & Domingie

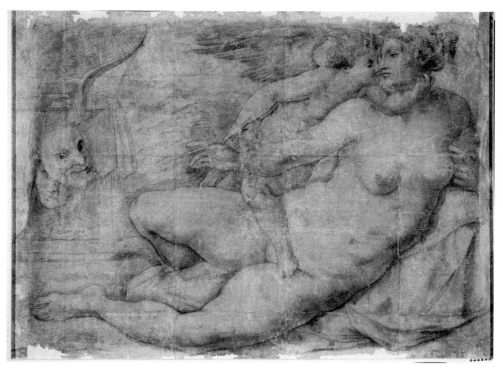

66 Attributed to Michelangelo and workshop, *Venus and Cupid*, cartoon, ca. 1550, Museo Nazionale di Capodimonte, Gabinetto Disegni e Stampe, Naples. Photo: Reproduced with the permission of Ministero per i Beni e le Attività Culturali / Raffaello Bencini / Alinari Archives, Florence

67 After Michelangelo Buonarroti, *Leda and the Swan*, after 1530, National Gallery of Art, London. Photo: Album / Alamy Stock Photo

variety of mediums. For Duke Alfonso d'Este, he painted the sexually explicit *Leda and the Swan*, the design of which can be seen in a painted copy of the cartoon (Fig. 67), now in the National Gallery of London. In the guise of a magnificent bird, Jupiter kisses and presses his body into a confident virgin princess.[18] For the Medici popes and their Florentine chapel, Michelangelo sculpted the two nude female figures of *Night* and *Dawn*.[19] A woodcut (Fig. 68) published in Sigismundo Fanti's fortune-telling game book *Triompho di Fortuna* of 1526 depicts Michelangelo carving the figure of *Dawn* in the presence of an ancient *Venus* statue.[20] Michelangelo also drew several sensual mythological subjects for Tomasso Cavalieri, the young nobleman he met and fell in love with while in Rome in 1532. These drawings include the rapturous *Ganymede* and the moralizing *Tityus*.[21] In the *Tityus* drawing, the giant – who was cast to the

68 Sigismundo Fanti, woodcut of *Michelangelo Sculpting*, from *Triompho di Fortuna*, printer: Agostino da Portese, Publisher: Giacomo Giunta, Published in Venice, January 1526, Metropolitan Museum of Art, New York. Credit Line: Gift of Paul Sachs, 1925. Photo: The Metropolitan Museum of Art, New York

underworld for attempting to rape the nymph Latona, Apollo and Diana's mother – is chained to a rock, where a rapacious vulture devours his liver over and over again. Governed by Venus, the liver was believed to be the organ responsible for the generation of semen and the management of desire and pleasure.[22] In the context of his newfound feelings for Tomasso Cavalieri, Michelangelo's drawing references the dangers of unchecked sexual desires. In the *Venus and Cupid* for Bettini, the artist visualizes aspects of both psychological and physical desire, while simultaneously offering his friend a titillating image of the god and goddess of love.

Michelangelo's design for Venus, which went as far as a charcoal cartoon (Fig. 66), features an unconventional and boldly posed nude female.[23] In a 1542 letter to Duke Guidobaldo della Rovere, recommending that he purchase copies of Michelangelo's *Leda* and *Venus and Cupid*, Pietro Aretino describes the goddess as possessing "the body of the female and the muscles of the male so that with an elegant vivacity of artifice she is moved by both masculine and feminine sentiment."[24] The artifice noted by Aretino in this letter resides in Michelangelo's convincing combination of a female torso, inspired by Roman copies of Praxiteles' *Aphrodite of Knidos* (Fig. 69), with the active and thickly

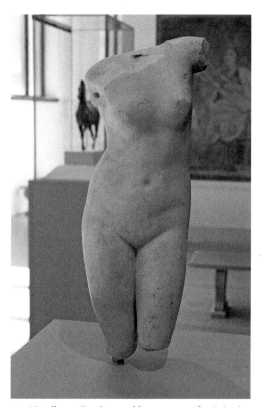

69 Headless Greek marble statue of *Aphrodite Anadyomene*, third to second century BCE, The Metropolitan Museum of Art (The Met), Upper Manhattan, New York. Photo: Melissa Jooste / Alamy Stock Photo

muscled limbs of a male.[25] By the mid-sixteenth century, ancient Venus torsos were readily available for artistic study. In his 1522 inventory of Roman antiquities, Ulisse Aldrovandi lists over fifty Venus sculptures, including one in the collection of Tomasso Cavalieri.[26] Several drawings reveal that Michelangelo studied an ancient Venus fragment between 1524 and 1532.[27] In one sketch (Fig. 70), he drew the torso from the front, using black chalk to capture the curving contours of the goddess's breasts, rib cage, waist, and hips. He then employed cross-hatchings to suggest the skeletal structure of her ribs and hips and to define the musculature of her abdomen and pelvis. Michelangelo even illustrated the subtle bend at her waist, a shift in position that occurs because Venus stands in *contrapposto*. Rather than creating a continuous contour line from this bend at the waist down to the knee, as many artists did, Michelangelo differentiated the anatomical forms into separate parts.

Bettini's painted Venus (Fig. 65) possesses the same diagonal shoulders, small breasts, mid-waist bend, and undulating hip line as the ancient sculpture. In effect, Michelangelo turned the torso on its side, elongated the upper body, and expanded the waist and hips, possibly to suggest Venus' motherhood of Cupid. In the reclining position, the left side of her torso bends more dramatically than in the original sculpture, particularly in the area of the rib cage. Michelangelo's appropriation of the ancient torso is not immediately apparent, in part because of Venus' heroic limbs and risqué pose; however, the placement of her left arm behind her body calls to mind the original sculptural fragment. By adding thick, muscular thighs and a robust, extended right arm to the torso, Michelangelo generated a reclining goddess of Herculean dimensions. The merging of male and female anatomical features in Michelangelo's Venus is outwardly hermaphroditic. One might even read the omission of the goddess's genital cleft (assuming it was absent from the original cartoon) and the placement of Cupid's foot as phallically suggestive. In his 1513 treatise titled *Li nuptiali*, Marco Antonio Altieri identified an ancient hermaphrodite statue as "the

image of Venus, who demonstrates the
bearing of one and then the other sex,
implying that with the venereal act just as
the woman, seemingly also was the man
subjugated."[28] Altieri's comment con-
nects the merged genders of the ancient
hermaphrodite statue with Venus' con-
trol over and understanding of both
masculine and feminine desires.

While no single meaning can be
ascribed to Michelangelo's Venus, her
flagrantly open thighs are sexually sug-
gestive. While male figures often reclined
with splayed legs, women did not. In a
decree to the Republic of Venice in
October 1539, which assured the city of
an audience for his new book, Andreas
Vesalius declared that he would illustrate
"how the diaphragm muscles resemble a
stripe; the thigh abductor muscles,
the guardians of chastity."[29] A similar con-
nection between a woman's thighs and
her virtuous behavior also appears in
Leonardo da Vinci's writings, when he

70 Michelangelo Buonarroti, *Antique Study (From the
Torso of an Antique Statue of Venus)*, ca. 1520, British
Museum, London. Photo: © The Trustees of the
British Museum. All rights reserved

recommends that "women should be represented with demure actions, their
legs tightly closed together, their arms held together, their heads lowered and
inclined to one side."[30] In fifteenth-century paintings, such as Paolo Schiavo's
Venus on Pillows (Fig. 31), the goddess reclines with her thighs pressed tightly
together. Oddly enough, in several anatomical treatises, such as Jacopo
Berengario da Carpi's *Anatomia Mundini* of 1521, the female pelvis and repro-
ductive organs are illustrated with a nude young woman spreading her thighs
while seated on a chair.[31] Her open legs allow the viewer to visually penetrate
her sexual anatomy.

Women *also open* their legs in erotic drawings and prints. In a drawing by
Pontormo (Fig. 71), a heroic Michelangelesque female, who is often identified
as Venus, spreads her muscular thighs and turns her body to offer a view of her
mons veneris. She wraps her fingers around the tip of an object, likely a pillow,
that is phallically suggestive. The open-legged pose also frequently appears in
the new genre of printed erotica, initiated by Romano and Raimondi's *I modi*
and followed by Rosso and Caraglio's *Loves of the Gods*. In Caraglio's engraving
of *Venus and Mars* (Fig. 63), the goddess spreads her thighs across the war god's
right leg. She is in an intermediate position with one leg bent in an athletic pose

71 Carucci Iacopo detto Pontormo, *Figure of a Reclining Female Nude (Study of Venus for the Gallerie degli Uffizi)*, ca. 1530–33, Gabinetto Disegni e Stampe, Gallerie degli Uffizi, Florence, Italy. Photo: Gabinetto Fotografico delle Gallerie degli Uffizi

on the bed and the other foot touching the floor. With the burin, Caraglio defined the triangle of her pubis and the fine line or cleft running down its center, between her open thighs. This compositional line continues through Mars's fingers, which caress Venus' mouth, to the meeting of their lips – an erotic cord of tingling energy. Pointed in the opposite direction, Cupid's arrow pricks the contour line of his mother's calf, just as the burin incised its form onto the copper plate. Here, an impending wound (between the legs) awaits the goddess of love.

The motif of phallic weapons and open thighs – a conceit that dates back to *The Romance of the Rose* – often shows up in erotic poetry and art.[32] The Florentine burlesque poet Anton Francesco Grazzini plays with this motif in a *capitolo* titled "In Praise of Nannina Zinzera, Courtesan." The poem celebrates the passion and power of a Florentine prostitute, who Grazzini claims was "made in the heavens by the hands of the gods." In describing each deity's contribution to Nannina's beauty, Grazzini explains that Venus made the thighs and the elusively lovely (*vagamente*) deep parts in between, "in which men enter often and release their seed. Well she was made by immortal hands, sweet of member, soft and gentle, the place where the arrows of Love are honed and sharpened."[33] In these verses, Grazzini uses the metaphor of honing or sharpening an arrow head to suggest the hardening of the phallus through the pressure and friction of coitus. In the *Venus and Cupid*, Michelangelo includes a comparable erotic reference with the arrow shaft running between Venus' spread fore and middle fingers, a gesture that echoes her split thighs below. The shaft rubs against her forefinger and thumb. This triangle is repeated in the split of Cupid's thumb and forefinger and the quiver's opening through which the arrow shaft also runs.

Along the contour line delineating the goddess's right thigh, another arrow tip waits – like a needle – to prick her flesh. Indeed, Venus will be wounded by Cupid's arrow, a story told in Book 10 of Ovid's *Metamorphoses*.[34]

> One day, as Cupid, son of Venus, kissed
> his mother, unaware, he scratched her breast:
> an arrow jutting from his quiver chanced
> to graze her. Though the goddess felt the prick

and pushed her son aside, the wound was far
more deep than it had seemed to her at first.
And Venus now is taken by the mortal
Adonis's beauty.[35]

In Ovid's verses, Cupid wounds Venus' breast, while in Michelangelo's design, his arrows slide toward her thigh. After being wounded by Cupid's arrow, Venus becomes the typical lover: pining over her beloved, relinquishing her home, and dispensing with her normal duties. Venus' affair with Adonis, however, ends tragically when a wild boar gores the young man to death in the groin, an ironic wound for the goddess's beloved. Ovid writes that upon seeing Adonis' bleeding corpse, Venus "tore her hair, and – much unlike a goddess – beat / her hands against her breast."[36]

In *Venus and Cupid*, the small male figure lying face up in the corner of the stone box could be a simulacrum of Adonis. Sixteenth-century representations of his death, such as Sebastiano del Piombo's *Death of Adonis* of 1511 to 1512 (Fig. 72), focus on his beautiful body lying supine and lifeless at an angle on the ground. Piombo's painting includes another episode in the myth not mentioned by Ovid: when Venus hastens to help her beloved, she steps on the thorns of a rose, tearing her foot and staining the white petals red. In the foreground of Piombo's painting, Venus sits in the pose of the ancient *Spinario*, and drops of bright red blood fall from her injured foot onto the petals of white roses. In his design, Michelangelo seems to refer to both episodes with the supine figure and the footed-bowl of roses (painted crimson by Pontormo), which are on the same vertical axis as Venus' bare foot. The composition correlates the prick of the arrow's tip with the wound of the rose's thorn; both images function as visual metaphors for the physical pain of love. Interestingly, Pontormo paints the tips of the arrows silvery black rather than bright gold, an unusual iconographic choice that may relate to a set of Cupid's arrows described in *The Romance of the Rose*. According to the tale's protagonist, the God of Love has "five arrows of another sort, as ugly as you like. The shafts and points were blacker than a devil from hell."[37] Instead of love, the arrows inspire pride, villainy, shame, despair, and new thought. The black arrows and red roses placed on the shrine-like box may commemorate Venus' tragic and painful love for Adonis.[38]

With its barren landscape, dark clouds, threatening weapons, and blood-tinged roses, Bettini's *Venus and Cupid* has an elegiac tone. How seriously, however, are we supposed to take this painting?

72 Sebastiano del Piombo, *Death of Adonis*, ca. 1512, Gallerie degli Uffizi, Florence, Italy. Photo: akg-images / Rabatti & Domingie

According to Ovid, the "shrine of Adonis, mourned by Venus" was famous in Rome; however, the ancient poet places it among the spots of love where men could easily pick up women.[39] And while the poets in Bettini's *camera* declared themselves to be besotted victims of Venus and Cupid, their constant state of desire resembled that of the satyr, whose physiognomy is sculpted into one of the masks hanging on the altar. In Renaissance art and literature, the satyr is a conventional symbol of excessive male lust – a hybrid, bisexual creature whose animalistic impulses, overwhelming sex drive, and frequent masturbation make him a priapic demon.[40] In Bettini's painting, the satyr smiles lasciviously as he looks between Venus' legs, emphasizing the erotic pleasure gained through the illicit viewing of her sexual anatomy. In sixteenth-century art and poetry, masks also symbolized the deceitful nature of dreams. Benedetto Varchi, the Florentine literary scholar and friend of Bartolommeo Bettini, established a connection between masks and dreams in a lecture presented to the Accademia Fiorentina, in which he described the false apparitions of love and lust as *larve* or masks.[41] Indeed, the masks in Michelangelo's *Venus and Cupid* may refer to the dissimulating images that haunt the lover's mind in fantasies, dreams, and hallucinations. As Lucretius warns, Venus taunts lovers with images.[42]

Above all, Michelangelo's inclusion of the satyr mask evidences the painting's erotic content and foreshadows the design's desirability among a wide range of patrons. Bartolomeo Bettini, in fact, never received the *Venus and Cupid* painting. According to Vasari, Duke Alessandro de' Medici purchased the panel from Pontormo's studio for 50 crowns and returned the cartoon to Bettini.[43] Soon after, Florentine artists began to make copies of the design, selling them alongside reproductions of Michelangelo's other female nudes. Between 1541 and 1544, Vasari painted as many as four versions of the *Venus and Cupid* and paired several of these with copies of the *Leda and the Swan*.[44] In a 1544 letter to Francesco Leoni, a humanist banker in Venice with close ties to Aretino, Vasari writes that the Venus he is sending is "still a virgin and such hot stuff that they wanted to make a brothel out of her. But her mother keeps her more or less under surveillance, so that she escaped whoredom at my hands. She is so compliant that, when she's with you, you're going to have to be careful she isn't abducted."[45] Such aggressively lurid passages together with the more-or-less mass production of Michelangelo's design suggest that the ostensibly respectable mythological credentials of the goddess provided thin cover for what was essentially an erotic visual experience.

The sex appeal of Michelangelo and Pontormo's *Venus and Cupid* was endorsed publicly by Benedetto Varchi in his *Due lezzioni*, a lecture presented to the Accademia Fiorentina in 1547. In a section analyzing the power of painting and sculpture to attract both animals and men, Varchi compared Bettini's painting to Praxiteles' *Aphrodite of Knidos*, citing the story of how a man fell in love with the statue and left a stain that "betrays this lustful act."

Varchi then declared that "the very same still happens nowadays, in the Venus that Michelangelo designed for M. Bartolomeo Bettini, colored by the hand of M. Iacopo Pontormo."[46] While Varchi's comment suggests that exposure to the *Venus and Cupid* could excite the viewer, it also playfully implicates the making of art with masturbation, drawing a thematic line between the man who stained Praxiteles' sculpture and the "hand" of Pontormo, whose paint brush ejaculated living color into the gorgeous womb of the cartoon.[47] The making and consumption of Venusian art had become a socio-sexual endeavor on a broad scale.

THE PASSIONS OF LOVE

While a number of Florentine artists produced copies of Michelangelo and Pontormo's *Venus and Cupid*, Agnolo Bronzino created several original variations of the subject. During his tenure as court artist to Cosimo I de' Medici, the Duke of Florence, Bronzino painted the *Allegory with Venus and Cupid* (Fig. 73).[48] This brilliantly colored panel was sent as a diplomatic gift to King

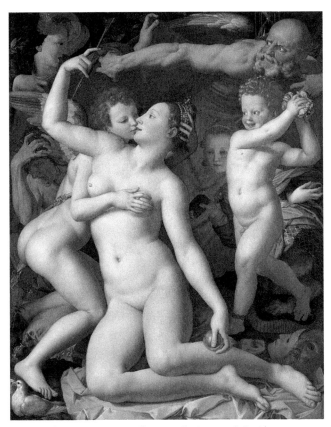

73 Agnolo Bronzino, *An Allegory with Venus and Cupid*, ca. 1544–47, National Gallery of Art, London, England. Photo: Album / Alamy Stock Photo

(a) (b)

74 Samples of (a) azurite and (b) ultramarine blue. Photo: Kip Bulwinkle / Karson Photography

Francis I between 1544 and 1547.[49] The painting's six figures interact against a curtained background, painted with the finest ultramarine blue (Fig. 74b). Bronzino's titillating imagery was to the King's taste, particularly the subject of Venus. In a 1518 letter to Duke Francesco Gonzaga, Francis I's ambassador wrote, "His Majesty tells me that he would be delighted with a painting of a nude, perhaps a Venus."[50] At Fontainebleau, the King possessed an admirable collection of Florentine erotica, including Michelangelo's *Leda and the Swan* and two paintings of *Venus* by Rosso Fiorentino, who also frescoed scenes of carnal and spiritual love on the south wall of the chateau's gallery in 1539.[51]

Bronzino created his *Allegory with Venus and Cupid* for a courtly audience that included Duke Cosimo I's cousin, the queen-to-be Catherine de' Medici. The painting resembles an *intermezzi* or *tableau vivant* with the god and goddess of love surrounded by personifications of the *passioni d'amore* or amorous passions.[52] Its content correlates with the French allegorical tradition of courtly love, as exemplified in Guillaume de Lorris and Jean de Meun's *The Romance of the Rose*.[53] The painting's satirical references and playful eroticism, however, highlight the Florentine tradition of burlesque poetry. The two traditions are foregrounded by the theatrical posturing of the figures and their hybrid anatomies to create a sensual allegory of fascinating complexity. In front of blue silk curtain, Venus takes center stage, a statuesque figure of carefully crafted beauty. The queen of love wears a sparkling crown encrusted with pearls, emeralds, diamonds, and rubies; she is the first Venus from Florence to flaunt such a regal adornment. A sizable oval emerald sits in the crown's center; a nude woman rides the stone, assuming the position of the "woman on top."[54] In her left hand, Venus holds a gold ball, whose reflective surface replicates the glittering splendor of Paris' infamous trophy, which proclaimed the goddess's unparalleled beauty but which also ignited the Trojan War's atrocities. Heraldically, this shiny sphere resembles a Medici *palla*, one of the seven orbs that make up the family's coat of arms. Is it possible that Bronzino, who was internationally known for his ability as a portraitist, intended Venus to be read as

an allegorical portrait of Catherine de' Medici, the Florentine dauphiness, who would soon become the Queen of France?[55]

Early portraits of Catherine de' Medici (Fig. 75), such as the one engraved by Frans Huys, foreground facial features that resemble those of Bronzino's Venus: curly hair pulled back tightly from the brow, wide-arched eyebrows, a prominent nose, pert lips, and a small chin. In two other well-known portraits, Bronzino portrayed rulers in the guise of mythological deities, merging their faces with the torsos of famous sculptural artefacts. He painted Duke Cosimo I de' Medici as *Orpheus* (Fig. 76) and attached his face to the *Belvedere Torso* (Fig. 77). In a portrait of Andrea Doria as *Neptune*, he connected the Genoese Admiral's features to the muscular chest of Michelangelo's *David*.[56] The portrait-plus-sculpture combination – a merging of different bodily *materia* – emphasizes the courtly rulers' heroic virility and foregrounds their sexuality under the safe cover of classical reference.[57]

Crowned with glittering jewels, holding a Medici *palla*, and a golden arrow, Bronzino's Venus may celebrate the queen-to-be, Catherine de' Medici, with a similar combination.[58] From the shoulders to the upper thighs, the goddess's body resembles the form and shape of an ancient Venus fragment (Fig. 69), such as the torso employed for illustrating *The Female Pelvic Anatomy* (Fig. 64) in Vesalius' *De humani corporis fabrica* of 1543. Bronzino, however, designs new limbs for the marble torso and places Venus in a kneeling-sitting position with her arms and legs

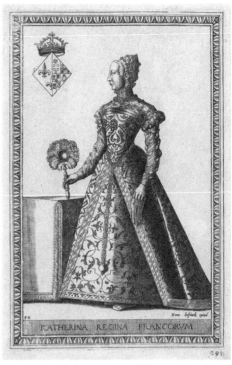

75 Frans Huys, Hans Liefrinck (I), *Portrait of Catherine de' Medici, Queen of Henri II*, ca. 1546–62. Photo: Artokoloro Quint Lox Limited / Alamy Stock Photo

76 Agnolo Bronzino, *Portrait of Cosimo I de' Medici as Orpheus*, ca. 1537–39, Philadelphia Museum of Art, Philadelphia, USA. Photo: Album / Alamy Stock Photo

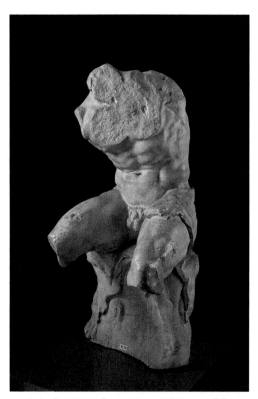

77 *Belvedere Torso*, first century BCE, over life-size statue of naked god or hero, seated on a rock covered by panther skin, the subject is controversial, signed by Apollonios of Athens, son of Nestor (the signature is written below the rock), Museo Pio-Clementino, Rome, Italy. Photo: HIP / Art Resource, NY

extended across the composition.[59] This perplexing pose appears in one of Bronzino's drawings of a male studio model and in several paintings of heroic or triumphant male figures.[60] In his fresco of *The Archangel Michael* (Fig. 78), painted shortly before the *Allegory* for the chapel of the Duchess Eleonora de Toledo, the warrior archangel perches on a cloud in this pinwheel position, brandishing a mighty sword before an emaciated, red-eyed demon with horns and webbed hands. While the genders, directions of heads, and angles of the hands and feet differ, the compositions of *The Archangel Michael* and *The Allegory of Venus and Cupid* are quite similar. Both include a winged figure, personifications of evil, and a generous use of ultramarine blue. In the *Allegory*, the combination of the Archangel Michael's triumphant pose with the ancient Venus torso creates the impression of a sovereign goddess, confidently wielding her powers of beauty and love.

In his biography of Catherine de' Medici, the French writer Pierre de Bourdeille, seigneur de Brantôme, declares that this "foreigner" was truly "a beautiful and most amiable princess."[61] He writes that her bosom was "very beautiful, white and full; her body also very white, the flesh beautiful, the skin smooth, as I have heard from several of her ladies."[62] In the *Allegory*, Bronzino's Venus displays a similarly pale and smooth complexion. Her silky skin is painted with layers of lead white and crimson lake bound in oil. The blue-toned shadows, which do not overpower the color of her flesh as they do in the Michelangelo–Pontormo painting (Fig. 65), cool rather than warm her skin. In his biography of Catherine, Brantôme describes how the young woman "made herself so beloved by the king, her father-in-law, and by King Henri, her husband [not king till the death of François I], that on remaining ten years without producing issue, . . . neither the one nor the other would consent [to repudiate her] because they loved her so much."[63] On January 19, 1544, Catherine finally gave birth to a male heir (François II de Valois), a *coup d'état* for Florence and for the Medici. Duke Cosimo I congratulated the court by sending an envoy with gifts to France.[64] If

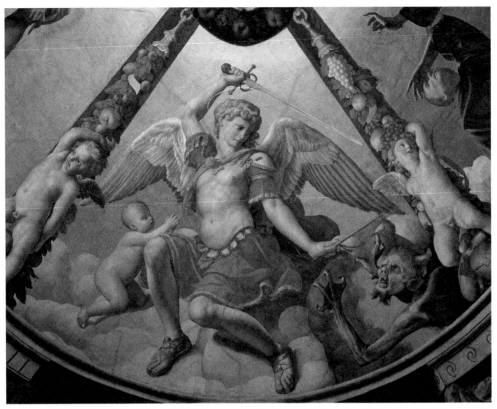

78 Agnolo Bronzino, *The Archangel Michael*, ca. 1540–65, fresco in the vault of the Chapel of Eleonora de Toledo, Palazzo Vecchio, Florence, Italy. Photo: akg-images / Rabatti & Domingie

Bronzino's Venus does refer to Catherine, then it may be understood as a visual encomium celebrating the Florentine's sculpturesque beauty, implementation of love to achieve political security, and her much-awaited success at motherhood.

Catherine herself was a child of Venus. She was born on April 13, 1519 in the zodiac house of Taurus and possessed an unusual bronze oval talisman inscribed with the planetary deity's images, signs, and inscriptions. The obverse of the disk (Fig. 79a) displays a celestial likeness of Venus, standing nude and holding an apple in her right hand and a comb in her left. This image adheres to one described in Henry Cornelius Agrippa's *Occult Magic*, published in 1533. The zodiac signs of Pisces, Taurus, and Aries appear at the bottom of the talisman.[65] As deciphered by Pierre Béhar, the names of three Venusian daemons – Hagiel, Haniel, and Asmodel – are written in uppercase Roman letters around the deity's body. Numerous other geomantic and chiromantic signs of the planet fill the bronze ground. The reverse (Fig. 79b) features another celestial image associated with Venus – a female figure with the head of a bird and the feet of an eagle, holding an arrow. According to Agrippa,

(a) (b)

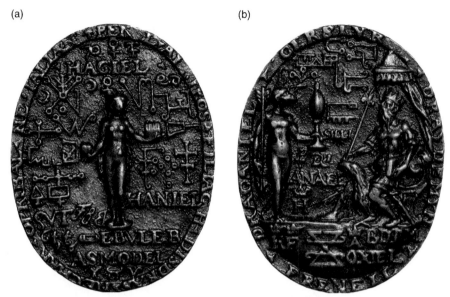

79 (a) Obverse of French manufacture, *Talisman of Catherine de' Medici*, sixteenth century, Paris, Bibliothèque nationale de France, Département des Monnaies, médailles et antiques, Médailles magiques, n. 3. Photo: Bibliothèque nationale de France. (b) Reverse of French manufacture, *Talisman of Catherine de' Medici*, sixteenth century, Paris, Bibliothèque nationale de France, Département des Monnaies, médailles et antiques, Médailles magiques, n. 3. Photo: Bibliothèque nationale de France

this figure promises grace and love. She is paired with a celestial likeness of Jove, a beneficial planet who confers the virtues of happiness, riches, and honor.[66] Though the date of this talisman's fabrication is unknown, its creation and existence establish a clear link between Catherine de' Medici and Venus. Although Bronzino's *Allegory with Venus and Cupid* is not specifically astrological, it illustrates a recognizable set of cosmologically potent Venusian materials, including roses, doves, emeralds, pearls, rubies, vervain or myrtle, honey, crimson silk, and gold embroidery.

While Bronzino's painting suggests a connection between Catherine de' Medici and Venus, we cannot ignore the goddess's forthright sexuality. Although Venus is decorous in sitting upright with her inner thighs pressed more-or-less together, she uninhibitedly displays her *mons veneris* and naked breasts for the viewer. Even more scandalous is Cupid's fondling of her breast. With his fore and middle fingers, the boy-god pinches her erect pink nipple in an overt gesture. At the same time, he embraces his mother's head, fingers her crown, and kisses her rosy lips. Their kiss suggests the all-consuming power of love as well as the power of art to arouse this flame. Several ancient and Renaissance sources recount tales of individuals so overwhelmed by Venus' beauty that they attempt to kiss her. In Lucian's *Amores* or *Affairs of the Heart*, Charicles expresses his admiration for Praxiteles' *Aphrodite of Knidos* by proclaiming his desire to be Ares or Mars (caught in Vulcan's chains).

He then eagerly rushes forward "and, stretching out his neck as far as he could, started to kiss the goddess with importunate lips."[67] A similar sentiment is expressed in an anonymous poem in praise of Michelangelo and Pontormo's *Venus and Cupid*. Here, the poet claims envy of Mars for his "happy and blessed" position as the goddess's lover. In the final stanza, he writes of how Cupid is wounded by Venus' beauty and "tries, as hard as he can, to kiss you."[68] In Bronzino's *Allegory*, the goddess of love accepts her son's kiss with an open mouth and a soft tongue.[69]

In addition to his passionate gestures, Bronzino's Cupid is also an object of sexual desire. His presentation from the backside corresponds to Florence's artistic tradition of sensualizing male posteriors, as evidenced in the works of Donatello, Michelangelo, and Rosso Fiorentino.[70] Kneeling on a pink silk pillow (a symbol of luxury), Cupid's nubile body ascends from his smooth white thighs to his round buttocks and arched back, from which spring a pair of wings, dyed blue at the tips and green at their crests. Leaning forward, the boy-god assumes a position that suggests penetration from behind. In the original design for the *Allegory with Venus and Cupid*, visible in X-radiographs taken in 1999, Cupid sits behind his mother. In the final composition, he kneels beside her with his knees spread on the pillow and his buttocks lifted into the air. The change in position required Bronzino to add a narrow strip of wood (2.7 cm) to the panel's right side. This new design was not a mere whim – it took considerable time, skill, and extra materials.[71]

Cupid's provocative pose and anatomy along with his incestuous fondling of his mother can be interpreted as lascivious, as breaking the boundaries of licit procreative intercourse. Bronzino, however, moralizes these erotic adventures with other allegorical figures and objects, which serve as reminders of the dangers involved in concupiscent desire. On the goddess's left, young *Pleasure*, "that dew drop of Venus's sweetness," rushes into the scene clutching a bouquet of saccharine pink roses.[72] The child's young body, bright curls, and naïve smile suggest the joys of innocent love. Bronzino's *Pleasure* aligns with *The Romance of the Rose*'s description of Joy, whose color was "like a new rose; and her skin was so tender that one could tear it with a tiny thorn."[73] *Deceit* hides in *Pleasure*'s shadow. This hybrid creature, with her pretty face and blushing cheeks, proffers a honey comb. Beneath her pile of brightly colored taffetas, however, winds the thick body of a snake, marked with brown and black-striped scales. This undulating form passes curved talons and a thick branch of long, sharp thorns, one of which pierces the center of *Pleasure*'s right foot, causing a red rivulet of blood to flow between the child's toes. Thrusting and retreating, the tail curves back up through *Deceit*'s fore and middle fingers. Here, it metamorphoses into an arched scorpion stinger, complete with a round vesicle of poisonous glands and a venom-injecting barb. Though beautiful, *Deceit* soon pierces, poisons, paralyzes, and then kills its prey.[74]

Another allegorical figure crouches behind Cupid, opposite *Pleasure* and *Deceit*. Painted with greenish-yellow skin, an averted gaze, and a ravaged body, this character – who may be male or female – resembles literary descriptions of Envy and Sorrow, both of which are painted on the wall protecting the desired flower in *The Romance of the Rose*. Envy, for example, has "a very ugly appearance: she looked at everything obliquely, and she had this bad habit because she could not look anything straight in the face, but closed one eye in disdain; for she burned and melted with rage when anyone at whom she looked was either wise, fair, or noble, or was loved or praised by men."[75] In the *Allegory*, Bronzino's suffering figure similarly averts his or her gaze from Venus and Cupid and clenches one eye shut. The red-tipped fingers and open mouth evidence burning and disdainful rage. The figure also displays characteristics of Sorrow, whose "color seemed to show that she had some great sorrow in her heart. She looked as though she had jaundice ... The dismay, the distress, the burdens and troubles that she suffered, day and night, had made her grow yellow and lean and pale." Sorrow exhibited scratches on her face, and her hair "was all unplaited and lay straggling down her neck."[76] In the text, Sorrow is described as the opposite of Joy. Positioned on the other side of *Pleasure* in the *Allegory*, Bronzino's figure physically manifests the anguish and anxiety of both Envy and Sorrow.

While *The Romance of the Rose* may not have been Bronzino's primary source for the *Allegory*, the text would have been familiar to the painting's courtly French audience. As J. F. Conway and Margaret Healey have argued, the other anatomical features of this allegorical figure – such as the gnarled, swollen fingers edged with burning red skin, open mouth with missing teeth, ulcerated sore on the tongue, blood-shot eyes, and long, oily unkempt hair – suggest the physical manifestations of syphilis.[77] The first known venereal disease of the Renaissance, syphilis was rampant in sixteenth-century Europe. The Florentines called it the *mal francese*, or French disease. A letter from Paris following the death of Francis I connected his demise to syphilis and the medical treatments given for it.[78] It is possible that Bronzino's agonizing figure suffers from this sexual disease, contracted through his or her chronic lust.

In his biography of Catherine de' Medici, Brantôme writes that her husband, Henri II, "was of an amorous temperament, and greatly liked to make love and to change his loves."[79] The kissing doves in the lower left of Bronzino's *Allegory* may allude to Henri's multiple lovers. In his *Genealogy of the Gods*, Boccaccio describes doves as Venus' pets and as lascivious birds, who constantly seek the embrace of new lovers.[80] This promiscuous temperament is also characteristic of the satyr, whose hypersexual bisexuality Bronzino refers to with the prominent satyr mask, located in the painting's lower-right corner. A close examination of this ruddy visage (Fig. 80) reveals a surprising feature: his nose resembles a penis! The phallus's bulbous glans and coronal ridge, complete with a urethra, form the tip of the nose, while its shaft curves

THE PASSIONS OF LOVE

upward as the bridge.[81] If the picture is flipped, the resemblance is amplified to reveal an erect phallus attached to testicles. The design is similar to the effigy of genitalia (the zucchini phallus and eggplant scrotum) found in Giovanni da Udine's vegetal decoration (Fig. 81) in the Loggia di Psiche of Agostino Chigi's Roman villa. In the *Allegory of Venus and Cupid*, Bronzino's anatomical transposition is a burlesque joke, one of the artist's specialties, which offers entertainment – in a notably Florentine fashion – to the King, the Dauphin, and his Medici wife.

At the top right of the *Allegory*, *Father Time* hovers above the tableau, as an enemy to both beauty and love.[82] Reaching out with a brawny arm, the wizened old man with his gray-white

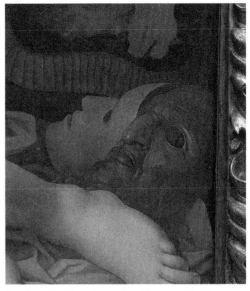

80 Agnolo Bronzino, *An Allegory with Venus and Cupid*, detail of masks, ca. 1544–47, National Gallery, London. Photo: © National Gallery, London / Art Resource, NY

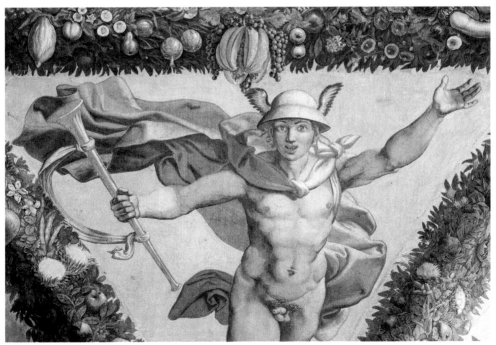

81 Giulio Romano, *Mercury*, 1518, Loggia of Cupid and Psyche, Villa Farnesina, Rome. Photo: Kim Petersen / Alamy Stock Photo

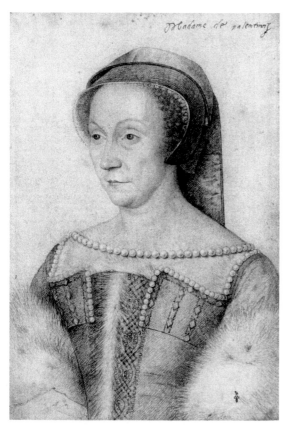

82 Workshop of François Clouet, *Diane de Poitiers, Duchess of Valentinois*, sixteenth century, Musée Condé, Chantilly, France. Photo: The Picture Art Collection / Alamy Stock Photo

feathers attempts to hide the amorous tableaux from the judgmental eyes of an older woman, whose enlarged pupils and gaping mouth reveal both shock and surprise. Stepping out from a bower of laurel, this figure may symbolize *Chastity* in the mythological guise of Diana, virginal goddess of the Moon and rival to Venus. If we read the *Allegory* as a contemporary satire of the French court, then Bronzino's figure of *Chastity* may allude to Diane de Poitiers, the mistress of Henri II and the archrival of Catherine de' Medici. Almost twenty years older than both Henri and Catherine, Diane was the Dauphin's professed chivalric lover and publicly promoted her image as Diana, wielding both the laurel plant and bow and arrow as symbols of her chaste love.[83] According to contemporary records and portraits (Fig. 82), Diane de Poitiers dressed only in black and white and wore a black snood over her hair.[84] The curly red hair and green eyes of Bronzino's figure resemble those of Diane in the portrait, and the black drapery that covers he ear and hair could be Diane's black snood. While this suggestion may seem far-fetched, it correlates with other satirical representations of the French Court's amorous rivalries, which have been analyzed by Paul Barolsky, Raymond Waddington, and Katherine Wilson-Chevalier.[85] The performative nature of Bronzino's *Allegory* fits within the erotic, theatrical, and satirical tastes of the French court and those of Catherine de' Medici, who was said to prefer comedy above all other genres.[86]

SEX AND THE SATYR

Almost a decade later, Bronzino engaged with the subject of Venus again in a panel painting of *Venus, Cupid, and the Satyr* (Fig. 83), commissioned by the Florentine patricians Alamanno and Jacopo di Alamanno Salviati.[87] The father and son exhibited the panel alongside a painted copy of Michelangelo's *Venus and Cupid* cartoon (Fig. 84) and painted versions of the sculptor's *Night* (Fig. 85) and *Dawn* (Fig. 86), rendered by Michele Tosini (a.k.a. Michele di Ridolfo del

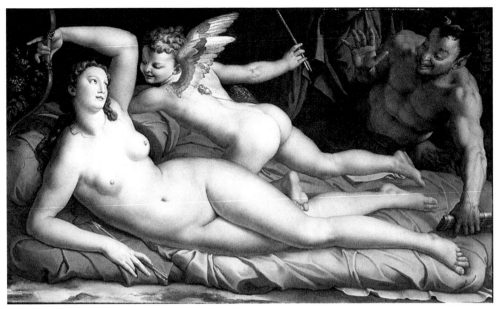

83 Agnolo Bronzino, *Venus, Cupid, and Satyr*, ca. 1553–55, Galleria Colonna, Rome. Photo: Galleria Colonna, Rome

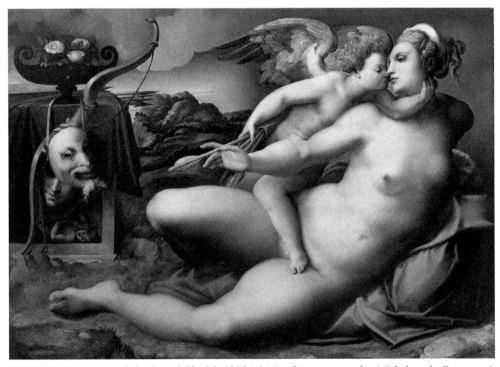

84 Michele Tosini (Michele di Ridolfo del Ghirlandaio), after a cartoon by Michelangelo Buonarroti, *Venus and Cupid*, ca. 1561–65, Galleria Colonna, Rome. Photo: Galleria Colonna, Rome

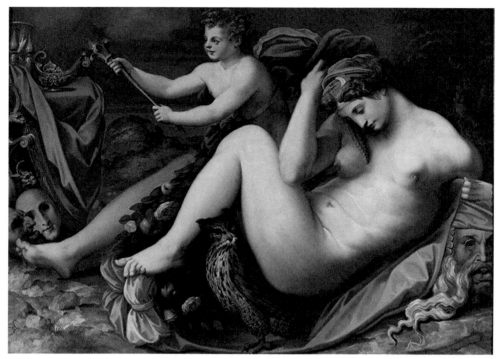

85 Michele Tosini (Michele di Ridolfo del Ghirlandaio), after a sculpture by Michelangelo Buonarroti, *Allegory of Night*, ca. 1561–65, Galleria Colonna, Rome. Photo: Heritage Images / Fine Art Images / akg-images

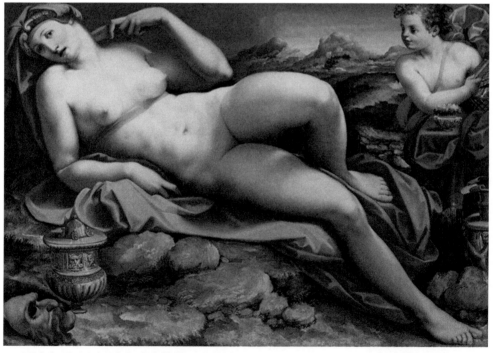

86 Michele Tosini (Michele di Ridolfo del Ghirlandaio), after a sculpture by Michelangelo Buonarroti, *Dawn*, ca. 1561–65, Galleria Colonna, Rome. Photo: XYZ PICTURES / Alamy Stock Photo

Ghirlandaio).[88] Though likely commissioned and created in two different campaigns, the four paintings form a coherent series. In each work, a nude female with porcelain skin reclines on a palette draped with shimmering silks. She is accompanied by a curly headed boy on the cusp of puberty. Leering satyrs appear as well, either as the embodied deity in Bronzino's painting or as the disembodied masks in Tosini's panels. Masks indeed are everywhere; a quick count reveals twenty-two in the four paintings – found, for example, on Cupid's quiver strap, his bow, the oil lamp, and various water vessels. Bronzino and Tosini also play with sexual anatomies: the *mons pubis*, the vulva, the buttocks, and the phallus. Some of these body parts are more hidden than others, and yet close looking reveals that many are right under the viewer's nose. Eschewing Apollonian rationality, the Salviati paintings combine Venusian love with Bacchic revelry to celebrate the joys of sex and the power of art to inflame and pleasure the viewer.

Alamanno Salviati was the youngest son of the banker Jacopo di Giovanni Salviati (1461–1533) and Lucrezia de' Medici (1470–1553), the daughter of Lorenzo the Magnificent. Though a native of Florence, Alamanno spent his childhood in Rome while his father served as a high-ranking official in the courts of the Medici Popes: Leo X (Giovanni di Lorenzo de' Medici, 1475–1521) and Clement VII.[89] As mentioned at the beginning of this chapter, the genre of erotic art began in Rome among artists and poets connected to the Medici papal courts. This group was also tied to the household of Alamanno's older brother Cardinal Giovanni Salviati (1490–1553).[90] Perino del Vaga, for example, worked for Cardinal Salviati during the same years that he produced drawings for Caraglio's *Loves of the Gods* series. Similarly, Francesco Salviati was employed by the cardinal when he drew the *Triumph of the Phallus* (Fig. 87), an explicit design that features a large phallus carried in triumph by nymphs to a tremendous pubis and vulva, whose drapery-like folds are unfurled by a retinue of putti to reveal a shadowy interior. A stream of liquid runs from a vase, nestled beside the swathed crevice.[91] The illicit eroticism explored by this circle of artists and poets close to Cardinal Giovanni Salviati likely influenced the later patronage of his younger brother Alamanno.

While three of his brothers (Giovanni, Bernardo, and Anton Maria) accepted cardinal titles, Alamanno – the youngest son of Jacopo and Lucrezia – assumed the business duties of the family. When his nephew Cosimo de' Medici became Duke of Florence in 1537, Alamanno followed his sister *and* the Medici line of power back to the city of flowers. Documents reveal that Alamanno was a confidant of both Duke Cosimo I and the Duchess Eleonora de Toledo and that he participated as a courtier in the stately affairs of their court, although he never received an official title.[92] In 1546, Alamanno purchased the Palazzo Portinari on the Via del Corso. This prestigious palace was once the home of Dante's beloved, Beatrice. Alamanno placed the property in the name of his son, Jacopo di Alamanno Salviati, who was born in 1537.[93]

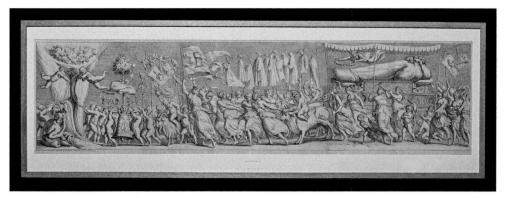

87 Monogrammist CLF, after Francesco Salviati, *The Triumph of the Phallus*, seventeenth century, British Museum, London. Photo: © The Trustees of the British Museum. All rights reserved

As distinguished patricians in Ducal Florence, Alamanno and Jacopo possessed a noble heritage and great wealth; however, they lacked official political power. Their social positions stood in stark contrast to those of their closest relatives who wielded power as cardinals, dukes, and even as a queen. While not being able to negotiate in matters of state, Alamanno and Jacopo performed on the cultural stage, acquiring art on a level equal to or above their elite blood connections. The father and son possessed one of the finest art collections in Florence, an ensemble featuring works crafted with high-quality materials by some of the most talented artists of the fifteenth and sixteenth centuries.[94] The magnificence of their collection was noted by a Venetian ambassador in 1579, who wrote, "it is possible to say that it stands up to, rivals, and possibly supersedes that of the Grand Duke."[95] Alamanno and Jacopo's inclusion of erotic art within this collection asserted a particular form of cultural power as the paintings connected the father and son to a subculture of connoisseurs, artists, and poets who delighted in liberal sexuality, bawdy humor, erudite allegory, and the classical world.

The *Venus, Cupid, and Satyr* (Fig. 83) that Bronzino painted for Alamanno and Jacopo is an original variation on Michelangelo's *Venus and Cupid* and his own *Allegory of Love*, which in 1553 was in the possession of King Henri II and Alamanno's cousin, Queen Catherine de' Medici. In the Salviati painting, Venus reclines on a soft palette laid in green and blue silks.[96] She possesses a classical feminine form, inspired by ancient Venus torsos connected to Praxiteles' *Aphrodite of Knidos*. We know that Bronzino had access to a *Venus* statuette fragment during these years, either a Roman sculpture or a modern recreation in stucco painted with ultramarine blue pigment, because he included one in his *Portrait of a Gentleman*, created between 1550 and 1555.[97] In the *Venus, Cupid, and Satyr*, Bronzino placed the torso in a reclining position and transformed sculpted marble (or ultramarine gesso) into painted flesh. His use of lead white, vermillion, and red lake for Venus' flesh along

with the ultramarine blue shadows endows the goddess with a cool, marmoreal complexion. Bronzino's Cupid possesses the same complexion; he is depicted as a young boy, on the cusp of puberty. Reaching for his bow, he stretches his body across the panel, exhibiting a smooth back and plump buttocks.

Creeping out of the woods, a satyr penetrates the mother and son's heavily draped bower. Smiling lewdly, he licks his lips with a pink tongue as he lunges forward and reaches out in anticipation of imminent sensual delights. The satyr exhibits the shaggy thighs, slanted eyes, pointed ears, curved horns, and forked beard of a goat combined with the robust torso of a fully developed man. Bronzino transforms the marble musculature of the *Belvedere Torso* (Fig. 77), which was located in the papal collection of antiquities, into the ruddy flesh of the satyr. He carefully models the semi-deity's broad pectorals, bulging shoulders, upper and lower abdomen muscles. The magnificent arm that reaches into Venus and Cupid's space replicates in reverse, vertically instead of horizontally, Time's extended arm in the *Allegory* (Fig. 73). To generate this sexual predator, Bronzino merged ancient sculpture with anatomical *materia* fashioned by his own hand.

The one body part missing from Bronzino's satyr is his phallus, which is conspicuously covered by drapery that the artist, for one reason or another, never fully painted. This lavender textile is finished above the area of the satyr's hand and then below Cupid's leg. The boy-god's pink foot, however, directs attention to the satyr's panpipe (syrinx) and its phallic cane tubes. The wrapping of the semi-deity's fingers around the pipe's hollow rods, moreover, suggests manual stimulation or masturbation. A pan flute is held in a similarly suggestive manner in Paris Bordone's *Pair of Lovers* from ca. 1555–60 (National Gallery, London), which may depict a wedded couple in the guise of Venus and Mars. In Bronzino's painting, Cupid's gold and lead arrows also enact modes of penile penetration. The gilt shaft of one arrow pierces the slit between Venus' spread fore and middle fingers, while the molten stem of the other pushes through three of Cupid's little fingers. A compositional diagonal connects these two arrows. Close by, another diagonal runs from Venus' pubis through Cupid's buttocks and straight to the satyr's open hand. These compositional conjunctions construct a series of lewd puns in which the phallic arrows penetrate the suggested closure of the female vagina and male rectum.

In Venus' sanctuary of rosy-hued fantasies, the satyr is a powerful figure, despite his deviant desires. His presence alongside the goddess of love differs dramatically, for example, from his portrayal in the bright purity of Apollo's world, where he is ridiculed and flayed by the sun god's rational harmonies. Bronzino's combination of Venusian desire with Bacchic lechery likely appealed to Jacopo di Alamanno Salviati, who was a member of the Florentine Accademia del Piano, a group of noble citizens, who engaged in ludic, carnivalesque activities, including mock ceremonies and triumphs.[98]

Like other sixteenth-century groups of this sort, the Accademia del Piano was a parodic inversion of the more serious literary academies. Members, known as *pianigiani*, adopted ancient Roman nicknames as well as titles from the Roman Republic, such as *Pontefice Massimo*, *Dittatore*, and *Senatore*. Jacopo Salviati took the name of Gaio Plutoneo and served as a *Senatore*.[99]

The Academy's motto was *dulce bibenti*, or "happy drinkers," and their *impresa* was a melon or *popone*, which – like other vegetables in the burlesque lexicon – may have alluded to the male buttocks. The tenor of the group was erudite, satirical, and somewhat sexually and politically subversive, with various members arrested for sodomy or political conspiracy.[100] In two letters to Duke Cosimo I of 1556, Lorenzo Pagni describes one of the Academy's gatherings at Bartolomeo Panciatichi's home, in which the members held a mock funeral ceremony accompanied by rustic music and vegetal effigies, constructed from turnips, carrots, and cabbages. Among the "forty-five or forty-six people" present at the gathering, Pagni singles out "Jacopo figliuolo di Messer Alamanno de' Salviati," who would have been 18- or 19-years-old at the time.[101] Duke Cosimo I responded to Pagni's letters, declaring that such activities were traditional to Florentine culture and relieved boredom. Furthermore, he declared that such a large gathering could not result in a "state conspiracy."[102]

Bronzino's *Venus, Cupid, and Satyr* correlates with the libertine interests displayed by members of the Accademia del Piano. Michele Tosini introduced similar sensual pleasures into his copies of Michelangelo's *Venus and Cupid*, *Night*, and *Dawn*.[103] It is likely that Tosini painted these panels in the 1560s, after becoming master of the Ghirlandaio workshop, where Michelangelo began his career. During these years, Tosini assisted Vasari on the completion of Duke Cosimo I's quarters in the Palazzo Ducale (Palazzo Vecchio), served as a founding member of the new Accademia del Disegno, and played a leading role in the preparations for Michelangelo's funeral.[104] Tosini may have painted up to three versions of the *Venus and Cupid* and two of the *Night*. His assistant, Francesco Brina, is credited with completing another small set of Michelangelo's Florentine female nudes, including *Venus*, *Leda*, *Night*, and *Dawn*.[105] Tosini and Brina's copies speak to the continued popularity of the older master's erotic works and possibly to Duke Cosimo I or Vasari's desire to promote the works as examples of Florentine erotica.

The hours of Venusian pleasure and Bacchic festivity – the hours when the satyr comes out to play – pass across the surface of Tosini's panels. In the *Venus and Cupid* (Fig. 84), the god and goddess of love kiss against a dusk skyline. The sun sets behind the altar, leaving soft pink streaks in the cerulean blue sky, which transforms into darkness behind the goddess. At dusk, Venus' star rises in the sky, creating a liminal moment when the bright clear light of the sun, symbol of rationality, begins to disappear. Tosini enhanced the voluptuousness of Michelangelo's heroic goddess by omitting the undulating contour lines of

her torso and thighs. He softened her quivering musculature with hazy *sfumato* shadows, painting her with ivory skin, ruby lips, and golden hair.[106]

Night (Fig. 85) sleeps against a dark sky, enameled with black and gray oil glazes. The crescent moon and star of Venus are emblazoned on her iridescent silk drapery, which winds around her downcast head. A young *spiritello* lights his torch from the oil lamp, casting a reflection on the golden eight-pointed star and setting aflame Night's dreams. Her slight smile, rosy cheeks, and curling toes suggest pleasurable visions, likely of a sexual nature. An evergreen garland interwoven with pink roses, yellow quinces, and blue nightshade flowers erupts from between Night's thighs, nestling in between and curling back towards her buttocks. At the base of the garland, Tosini incorporated two prominent bunches of drapery, which he cinched in the middle to create a decorative array of silky pink folds. This luscious bundle falls on a diagonal that runs directly to Night's actual, though hidden, genitalia and is reminiscent of this anatomical part as represented in Francesco Salviati's *Triumph of the Phallus* (Fig. 87). Following Michelangelo's example, Tosini contrasted the size and shape of Night's breasts. The one on the right is round and healthy, while the one on the left is diseased with cancerous tumors.[107] The contrast between the two nipples functions in the manner of a *momento mori*, a reminder of the vanity of desire and the ephemerality of life. The hourglass on the table asserts a similar message, as its fine grains of sand slip ever so quickly away.

Waking up from her slumber, *Dawn* (Fig. 86) lies languidly on a rocky ledge as day breaks. Tosini captured the delicate pastels of this other liminal moment, when Venus appears as the morning star, by layering a rose lake glaze and ultramarine blue on top of a lead-tin yellow ground. The colors are mirrored in Dawn's *cangiante* drapery: a blushing cochineal silk with yellow highlights and blue shadows.[108] Tosini softened the forms of Michelangelo's sculpture with the play of color across Dawn's skin and the *sfumato* shadows placed along the contours of her form. As she does in Michelangelo's original, Dawn turns her head and gazes at the viewer with parted lips; her open body and erect breasts, underlined by the ultramarine blue ribbon, address the viewer directly. In a letter of 1543, the Florentine writer Anton Francesco Doni claimed that Michelangelo's *Dawn* "makes you leave the most beautiful and divine woman you could ever see, in order to embrace and kiss" the statue itself.[109] Doni's comment follows the literary trope, dating back to Lucian and employed by Vasari and others, in which a figure of art's beauty is so great that the viewer desires to kiss it. We are also reminded of Sigismundo Fanti's illustration of Michelangelo's carving of *Dawn* in the presence of Venus (Fig. 68).

Tosini heightened the sexual intensity and erotic humor of his panels by including the satyr masks, only two of which are original to Michelangelo's designs. As with Bronzino's mask in the *Allegory* (Fig. 80), sexual anatomies emerge in the physiognomies. A profile portrait of a phallus arches across the face of the satyr mask

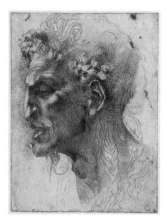

88 Michelangelo Buonarroti, *Head of a Satyr*, ca. 1522–32, pen and brown ink, INV684recto, photo: Michèle Bellot, Département des Arts graphiques, Musée du Louvre, Paris. Photo: © RMN-Grand Palais / Art Resource, NY

89 Probably Venetian, *Composite Head Formed of Phalluses*, reverse, sixteenth century. Photo: AIFA Visuals / Alamy Stock Photo

resting on the ledge below *Dawn* (Fig. 86). In the Silenus visage beneath *Night's* right arm (Fig. 85), the shaft of a penis descends down the nose, while the coronal ridge, bulbous glans, and frenulum form the tip. The nose of the other mask, which *Night* fondles with her outstretched toe, is not a phallus but takes the shape of a young man bent over, with his buttocks hanging in the air. These anatomical transpositions are fantastical and mind-bending because the erotic anatomies *seem* to appear everywhere. I use the word *seem* deliberately because once you begin to look, illusions of all sorts take shape. Are these phalli real or just cognitive distortions, imaginative fantasies that lurk in the venereal realm?

Bronzino and Tosini were not the first Florentine artists to introduce phallic forms into their satyr portraits. Michelangelo rendered suggestive phallic forms in his reworking of Antonio Mini's female head into a satyr portrait (Fig. 88), a drawing that his pupil may have carried, along with the *Leda and the Swan* painting, to France. Descending from furry round nodules, the satyr's nose resembles a penile protrusion, as does the strange shape of the god's cheek bone shooting from curly tufts of hair near his ear.[110] The drawings of Francesco Salviati are another source for these satirical *teste-di-cazzi* or "dick-heads," which also appear on a *maiolica* plate from Casteldurante and on the reverse of several medals (Fig. 89), some of which include portraits of Pietro Aretino.[111] In his most explicit drawing, Salviati renders a profile portrait composed completely of phalli, which extend, curve, and thrust their multifaceted heads in all directions.

Salviati may have created his *testa-di-cazzo* drawing in the early 1540s when he visited Venice, befriended Pietro Aretino, and drew his portrait.[112] Shortly after, Salviati worked with Bronzino in the Palazzo Vecchio during the same years that the painter completed the *Allegory with Venus and Cupid*. Alamanno could have seen a version of Francesco Salviati's phallic satyr head in Florence. When the artist first came to the city of flowers from Rome, where he had been employed by Cardinal Giovanni Salviati, Alamanno recommended him to Duke Cosimo I. The artist painted several works for both Alamanno and Jacopo during the 1540s and again in the 1560s. Of particular note is a book of drawings that Francesco Salviati gave to Jacopo,

which Vasari describes as a "beautiful book, filled with costumes of fanciful characters, comprising head-dresses and decorations of various kinds, both for men and horses, to be used in the different maskings then held."[113] The connection here to "maskings" matters, not only because it suggests the types of fantastical masks that appear throughout Tosini's panels but also because of Jacopo's interests in carnivalesque culture.

Bronzino's and Tosini's paintings of the female nude fit into a libertine burlesque culture that celebrated sexual anatomy and fleshly desires. The series asserted Alamanno and Jacopo di Alamanno Salviati's cultural authority among an elite group of patrons, including kings, dukes, and prominent patricians, who collected contemporary erotica. Each painting eschews the rational Apollonian world and proclaims instead the power of love. By including a cast relief of Apollo chasing Daphne on Cupid's quiver in the *Venus, Cupid, and Satyr* (Fig. 83), Bronzino suggested that even the highest of deities can become satyr-like when his mind is perverted by desire. The paintings broadcast sex with the depiction of the female pubis, vulva, and breasts along with the soft curves of Cupid's back and buttocks. And we should not forget the erotic allure of the satyr's hyper-masculine, beautifully cut torso and large phallus with its bulbous head. The sexual force of these paintings, possibly experienced in the dim light of oil lamps under the intoxicating influence of wine, may have eventually prompted Jacopo to make haste to his private chapel, where Alessandro Allori frescoed scenes of Mary Magdalene, whose impulsive lusts were transformed into her fervent love for Christ.

NOTES

1 "Sic igitur Veneris qui telis accipit ictus, / sive puer membris muliebribus hunc iaculatur / seu mulier toto iactans e corpore amorem, / unde feritur, eo tendit gestitque coire / et iacere umorem in corpus de corpore ductum; / namque voluptatem praesagit muta cupido. // Haec Venus est nobis; hinc autemst nomen amoris; / hinc illaec primum Veneris dulcedinis in cor / stillavit gutta, et successit frigida cura. / nam si abest quod ames, praesto simulacra tamen sunt / illius, et nomen dulce obversatur ad auris. / sed fugitare decet simulacra et pabula amoris / absterrere sibi atque alio convertere mentem / et iacere umorem conlectum in corpora quaeque, / nec retinere, semel conversum unius amore, / et servare sibi curam certumque dolorem; / ulcus enim vivescit et inveterascit alendo, / inque dies gliscit furor atque aerumna gravescit, [...] // sic in amore Venus simulacris ludit amantis." Lucretius, *On the Nature of Things*, trans. W. H. D. Rouse, rev. Martin F. Smith, Loeb Classical Library 181 (Cambridge, MA: Harvard University Press, 1924), Book 4, 358–59, lines 1052–69; Book 4, 360–61, line 1101.

2 This idea also permeates the tradition of courtly love and amorous poetry. The protagonist of *The Romance of the Rose*, for example, proclaims that the God of Love "shot at me in such a way that with great force he sent the point through the eye and into my heart." Guillaume de Lorris and Jean de Meun, *The Romance of the Rose*, trans. Charles Dahlberg (Princeton, NJ: Princeton University Press, 1971), 54.

3 "Idque petit corpus, mens unde est saucia amore." Lucretius, *On the Nature of Things*, Book 4, 356–57, line 1048.

4 James Grantham Turner, *Eros Visible: Art, Sexuality, and Antiquity in Renaissance Italy* (New Haven, CT: Yale University Press, 2017), 13–33.

5 As Bette Talvacchia has argued, Marcantonio Raimondi's *I modi* engravings breached acceptable forms of eroticism in their explicit portrayal of male and female genitalia, unnatural coital positions, and active females enjoying intercourse. Pope Clement VII banned the engravings soon after their publication and imprisoned Raimondi for his unauthorized printing of illicit material. Scandal soon followed. For information on the publication, scandal, and artistic style of *I modi*, see Lynne Lawner, *I Modi: The Sixteen Pleasures. An Erotic Album of the Italian Renaissance* (Evanston, IL: Northwestern University Press, 1988), 2–56; Bette Talvacchia, *Taking Positions: On the Erotic in Renaissance Culture* (Princeton, NJ: Princeton University Press, 1999), 3–47. See also the catalogue entries (nos. 99–100) on the nine fragments from *I modi* and the woodcuts of the *Toscanini Volume* by James Grantham Turner in *Art and Love in Renaissance Italy*, ed. Andrea Bayer (New Haven, CT: Yale University Press, 2008), 200–205. For Vasari's account of the scandal and the release of Raimondi from prison, see Giorgio Vasari, *Le vite de più eccellenti pittori, scultori ed architettori scritte*, ed. Gaetano Milanesi, vol. 5 (Florence: G. C. Sansoni, 1880), 418–19; for English text, see Giorgio Vasari, *Lives of the Most Eminent Painters, Sculptors, and Architects*, trans. Gaston du C. De Vere, vol. 6 (London: Macmillan, 1913), 104–105.

6 As Bette Talvacchia explains, the printer Il Baviera's strategy in the *Loves of the Gods* series required the "use of a mythological pretext in the presentation of the erotic scenes and the avoidance of sexual positions that approximated too closely the 'unnatural couplings' strongly and specifically *condemned* as sinful by an influential tradition within the Catholic church." Talvacchia, *Taking Positions*, 126. For a discussion of the series, see the catalogue entry (no. 101a–g) by Linda Wolk-Simon in *Art and Love in Renaissance Italy*, 205–208. James Grantham Turner offers a more contextual basis for the print series, connecting it to an earlier Roman interest in erotic portrayals of the gods, as evidenced by Baldassare Peruzzi and Polidoro da Caravaggio. While the forthright presentation of intercourse did change in Caraglio's prints, if compared with *I modi*, the theme of the loves of the gods had been prevalent in earlier erotic art, as evidenced in the decorative program of Agostino Chigi's villa in Rome. For a discussion of the series in this context, see Turner, *Eros Visible*, 159–74.

7 James Grantham Turner connects the sixteenth-century "arousal response" to ancient stories of art's power, including both Pliny and Lucian's stories of the aroused viewer of Praxiteles' *Aphrodite of Knidos*; see Turner, *Eros Visible*, 223–52.

8 "Perche vi dico, che si come la bellezza de le cose naturali deriva de le forme de la natura, cosi quella de le cose arteficiate da le forme de l'arteficio. Alche conoscere con ispeditissimo essempio, imaginiamci due marmi, rozzi ugualmente, & che ne l'uno dal Sansovino s'intagli una bellissima Venere, & ne l'altro non, conosceremo tantosto, che la Bellezza di Venere non si fa da quel marmo, vedendosi che l'altro suo pari non è si bello: ma si pare che la forma, o figura arteficiata è la sua bellezza, onde bella si fa." Niccolò Franco, *Dialogo dove si ragiona delle bellezze* (Venice: Antonium Gardane, 1542), 88r.

9 Through an analysis of fifteenth-century contracts, Baxandall illustrates the ways in which patrons diverted "funds from material to skill." Michael Baxandall, *Painting and Experience in Fifteenth-Century Italy*, 2nd ed. (Oxford: Oxford University Press, 1988), 1–27.

10 "From the internal organs, she governs the vagina, the projection of sperm, and the stomach whence emerges the ability and taste for eating and drinking." *Picatrix: A Medieval Treatise on Astral Magic*, trans. Dan Attrell and David Porreca (University Park: Pennsylvania State University Press, 2019), 134. "In her [Venus'] share of the human body is the flesh, the milk, the liver, and the semen. All moisture [in the body] belongs to her. Of her ailments are all that occur in the kidneys and the genitalia." Abraham Ibn Ezra (Avraham Ben Meir Ibn Ezra), *The Beginning of Wisdom (Reshith Hochma)*, trans. Meira B. Epstein (Las Vegas: ARHAT, 1998), 101. In *Occult Philosophy* of 1531, Cornelius Agrippa writes with regard to melothesia and Venus that "they set Venus over the kidneys, the secrets, the womb, the seed, and concupiscible power; as also the flesh, fat, belly, breast,

navel, and the venereal parts and such as serve thereto; also the *os sacrum*, the back-bone, and loins; as also the head, and the mouth, with which they give a kiss as a token of love." Henry Cornelius Agrippa, *The Three Books of Occult Philosophy or Magic*, ed. Willis F. Whitehead (New York: AMS Press, 1982), 88–89.

11 "Si nominarebus a me inventis imponere licet, amor Veneris, vel dulcedo appelletur." Realdo Colombo, *De re anatomica libri XV* (Frankfurt am Main: Johann Wechel, 1590), 447–48. For a discussion of Realdo Colombo's discovery of the clitoris, see Thomas Laqueur, *Making Sex: Body and Gender from the Greeks to Freud* (Cambridge, MA: Harvard University Press, 1990), 64–70; Thomas Laqueur, "Amor Veneris, vel Dulcedo Appeletur," in *Feminism & the Body*, ed. Londa Schiebinger (Oxford: Oxford University Press, 2000), 58–86.

12 The passage from Bronzino's "Del pennello" reads, "Chi è colui che a ragionar non goda / delle cose che fa questo cotale, / nato di pel di setola o di coda? / [...] / Io non saprei contarne de' mille uno / de' diversi atti e modi stravaganti; / sapete che il variar piace ad ognuno. / Basta, che a fargli o dirietro e davanti / a traverso, in iscorcio o in prospettiva / s'adopera il pennello a tutti quanti." For Italian and English verses, see Deborah Parker, *Bronzino: Renaissance Painter as Poet* (Cambridge: Cambridge University Press, 2000), 25.

13 The Persian Muslim astrologer Albumasar (Abu Ma'shar, 787–886 CE) links Venus with "every kind of fornication, both natural practices and those contrary to nature, performed with either sex, and both legitimate acts and illicit ones." For Albumasar's text, see Richard Kay, *Dante's Christian Astrology* (Philadelphia: University of Pennsylvania Press, 1994), 72, 306.

14 In early medicinal astrology, Venus is associated with diseases of the genitalia. In his discussion of the bodily parts and functions that the planet governs, Ibn Ezra states, "Its [Venus'] diseases include all those which arise in the loins and in the genitalia." Ibn-Ezra, *The Beginning of Wisdom*, 200.

15 For Neoplatonic interpretations of the *Venus and Cupid*, see Gaetano Milanesi, "Della Venere baciata da Cupido, dipinta dal Pontormo sul cartone di Michelangiolo Buonarroti," in his *Le opere di Giorgio Vasari*, vol. 4 (Florence: Sansone, 1881), 291–95; Henry Thode, *Michelangelo Kritische Untersuchungen über seine Werke*, vol. 2 (Berlin: G. Grote, 1908), 329–30; Charles de Tolnay, *Michelangelo: The Medici Chapel*, vol. 3 (Princeton, NJ: Princeton University Press, 1948), 109. The first thorough study of the painting's patron, cartoon, and its copies was undertaken for the exhibition *Venere e Amore* in 2002; see Franca Falletti and Jonathan Katz Nelson, eds., *Venus and Love: Michelangelo and the New Ideal of Beauty* (Florence: Giunti, 2002). For other discussions of the painting, see Philippe Costamagna, *Pontormo. Catalogue raisonné de l'oeuvre peint* (Paris: Gallimard, 1994), 217–20; Massimiliano Rossi, "'... quella naturalità e quella fiorentinità (per dir così)'. Bronzino: lingua, carne e pittura," in *Bronzino: Artist and Poet at the Court of the Medici*, ed. Carlo Falciani and Antonio Natali (Florence: Mandragora, 2010), 177–93; Rebekah Compton, "*Omnia Vincit Amor*: The Sovereignty of Love in Tuscan Poetry & Michelangelo's *Venus and Cupid*," *Mediaevalia* 33 (2012): 229–60; Grazia Badino's catalogue entry (no. IX.4) in *Pontormo and Rosso Fiorentino: Diverging Paths of Mannerism*, ed. Carlo Falciani and Antonio Natali (Florence: Mandragora, 2014), 320–21.

16 "Veggendosi, adunque, quanta stima facesse Michelagnolo del Puntormo, e con quanta diligenza esso Puntormo conducesse a perfezione e ponesse ottimamente in pittura i disegni e cartoni di Michelagnolo; fece tanto Bartolomeo Bettini, che il Buonarruoti suo amicissimo gli fece un cartone d'una Venere ignuda con un Cupido che la bacia, per farla fare di pittura al Pontormo, e metterla in mezzo a una sua camera, nelle lunette della quale aveva cominciato a fare dipignere dal Bronzino, Dante, Petrarca e Boccaccio, con animo di farvi gli altri poeti che hanno con versi e prose toscane cantato d'Amore." Vasari-Milanesi, *Le vite*, vol. 6, 277; Vasari-De Vere, *Lives*, vol. 7, 172.

17 For a discussion of Bettini's decorative program as a virtual third realm of the heavens – the planetary domain of Venus and Cupid – where poets, after transcending the mortal world, gather with one another in the divine spirit of love, see Compton, "*Omnia Vincit Amor*," 229–40.

18 For the eroticism of the *Leda and the Swan*, see Rona Goffen, *Titian's Women* (New Haven, CT: Yale University Press, 1997), 229–42; Fredrika H. Jacobs, "Aretino and Michelangelo, Dolce and Titian: *Femmina, Masculo, Grazia*," *Art Bulletin* 82 (2000): 51–67. For the painting's patronage and afterlife, see Charles Rosenberg, "Alfonso I d'Este, Michelangelo, and the Man Who Bought Pigs," in *Revaluing Renaissance Art*, ed. Gabriele Neher and Rupert Shepherd (Cambridge: Cambridge University Press, 2000), 89–99; William E. Wallace, "Michelangelo's *Leda*: The Diplomatic Context," *Renaissance Studies* 15 (2001): 473–99.

19 For the problematic aspects of *Night*'s nudity, see Jill Burke, *The Italian Renaissance Nude* (New Haven, CT: Yale University Press), 9–13.

20 Turner mentions Fanti's vignette as "the earliest depiction of the artist at work on his *Dawn*," an image where he is driven by fury rather than love, "despite the statue of Venus standing behind him." Turner, *Eros Visible*, 21.

21 For discussion of the myths of Ganymede and Tityus in relation to Michelangelo's poetry and sexuality, see James Saslow, "'A Veil of Ice between My Heart and the Fire': Michelangelo's Sexual Identity and Early Modern Constructs of Homosexuality," *Genders* 2 (1988): 77–90; James Saslow, *Ganymede in the Renaissance: Homosexuality in Art and Society* (New Haven, CT: Yale University Press, 1986), 17–62; Maria Ruvoldt, "Michelangelo's Open Secrets," in *Visual Cultures of Secrecy in Early Modern Europe*, ed. Timothy McCall, Sean Roberts, and Giancarlo Fiorenza (Kirksville, MI: Truman State University Press, 2013), 105–25.

22 According to Ptolemy, Venus governs the "liver." Ptolemy, *Tetrabiblos*, trans. F. E. Robbins, Loeb Classical Library 435 (Cambridge, MA: Harvard University Press, 1940), Book 3, 318–21. In his *The Beginning of Wisdom*, Ibn Ezra states that "In her [Venus'] share of the human body is the flesh, the milk, the liver, and the semen. All moisture [in the body] belongs to her." Ibn Ezra, *The Beginning of Wisdom*, 101. In a letter to Giovanni Nesi discussing the three powers of the soul divided according to Plato, Ficino writes, "Lastly, he has given the power of desire to the liver because its natural vigor lends itself both to the digestion of food and to the growth of bodily craving." Marsilio Ficino, *Meditations on the Soul: Selected Letters of Marsilio Ficino*, trans. Members of the Language Department of the School of Economic Science, London (Rochester, VT: Inner Traditions International, 1996), 55.

23 Vasari notes in his 1550 edition of the *Lives* that Michelangelo completed the cartoon "in charcoal in a most finished manner." A cartoon of the *Venus and Cupid* exists today at the Museo Nazionale di Capodimonte in Naples. Most scholars believe this to be a copy of the original cartoon, which likely suffered damage from the numerous copies made of it. Carmen Bambach, however, argues that the Naples cartoon is Michelangelo's original, at least in the initial sketch. She hypothesizes that Michelangelo originally only drew a sketch of the design and had an assistant complete it due to the number of commissions he was juggling during this period. Her argument is based, in part, on the provenance of the cartoon, which in 1600 belonged to Fulvio Orsini. For her argument, see Carmen Bambach, *Michelangelo: Divine Draftsman & Designer* (New Haven, CT: Yale University Press, 2018), 142–46.

24 "E perché tal dea diffonde le proprietà sue nel disiderio dei due sessi, il prudente uomo le ha fatto nel corpo di femina i muscoli de maschio, talché ella è mossa da sentimenti virili e donneschi con elegante vivacità d'artifizio." Pietro Aretino, *Lettere sull'arte*, ed. Fidenzio Pertile and Ettore Camesasca, vol. 1 (Milan: Milione, 1957), 247. For English translation, see Jacobs, "Aretino and Michelangelo, Dolce and Titian," 63.

25 Scholars in the past have attributed the "masculinity" of Michelangelo's females to his homoerotic tendencies, his misogynistic preference for men, or his lack of female models. Howard Hibbard, for example, suggested that Michelangelo's viraginous women express his overwhelming passion for and celebration of the male body; see Howard Hibbard, *Michelangelo: Painter, Sculptor, Architect* (New York: Vendome, 1978), 151. Kenneth Clark argued that Michelangelo considered the female physique inferior to the male; see Kenneth

Clark, *The Nude: A Study in Ideal Form* (New York: Doubleday, 1956), 330. Robert Liebert related Michelangelo's portrayal of females to his homoeroticism; see Robert Liebert, *Michelangelo: A Psychoanalytic Study of His Life and Images* (New Haven, CT: Yale University Press, 1983), 258. In contrast to these writers, other scholars have argued that Michelangelo endows his women with masculine characteristics in order to enhance their heroic stature and spiritual superiority; see Yael Even, "The Heroine as Hero in Michelangelo's Art," *Woman's Art Journal* 11 (1990): 29–33; Jonathan Katz Nelson, "The Florentine *Venus and Cupid*: A Heroic Female Nude and the Power of Love," in *Venus and Love*, 27–63.

26 Statues of Venus, not including single heads of the goddess, are described in the following pages of Ulisse Aldrovandi, *I nomi antichi et moderni dell'antica citta di Roma* (Venice: Segno della Speranza, 1552), 119–20, 125–26, 140, 144–45, 146, 148, 154–55, 160, 162, 172, 173, 177, 178, 182, 185, 188, 193, 202, 204, 206, 209, 214, 222, 225, 230, 232, 236, 238, 247, 252, 253, 262, 264, 276, 278, 286, 288, 290, 307, 309. One of these statues, described as "una Venere ignuda, solo coperta con un panno dal ginocchio in giu, non ha braccia, e solamente una gamba," is listed in the house of M. Tomaso Cavallieri. For this entry, see Aldrovandi, *I nomi antichi et moderni*, 225.

27 Two drawings are located in Florence at the Casa Buonarroti (Inv. 41F and Inv. 16F), and two are in London at the British Museum (1859-6-25-570 and 1859-6-25-571). For discussion of the drawings, see the catalogue entries (nos. 2–5) by Paul Joannides in *Venus and Love*, 150–51.

28 In his 1513 treatise titled *Li nuptiali*, Marco Antonio Altieri describes an ancient hermaphrodite statue, judged to be "the image of Venus, who demonstrates the bearing of one and then the other sex, implying that with the venereal act just as the woman, seemingly also was the man subjugated" ("La imagine de Venere, per la qual se demostrava tollerarse la una et poi l'altra natura; inferendose con quello acto venereo così come la donna, medesmamente ancor fussine l'homo subiugato"). Marco Antonio Altieri, *Li nuptiali*, ed. Enrico Narducci (Rome: Roma nel Rinascimento, 1995), 82.

29 For Vesalius' statement, see Henri Mondor, "A. Vésale 1514–1564," in *Anatomistes et chirurgiens*, ed. Henri Mondor (Paris: Editions Fragrance, 1949), 142; André Velter, Marie José Lamothe, and Jean Marquis, *Les outils du corps* (Milan: Ambrosiane, 1978), 135–36; Raphaël Cuir, *The Development of the Study of Anatomy from the Renaissance to Cartesianism: Da Carpi, Vesalius, Estienne, Bidloo* (Lewiston, NY: Edwin Mellen Press, 2009), 116.

30 Leonardo, *On Painting*, ed. Martin Kemp (New Haven, CT: Yale University Press, 1990), 147. For a discussion of Leonardo's comment, see Paolo Berdini, "Women under the Gaze: A Renaissance Genealogy," *Art History* 21 (1998): 567.

31 For these illustrations, see Jacopo Berengario da Carpi, *Commentaria cum amplissimis additionibus super anatomiam Mundini una cum textu ejusdem in pristinum et verum nitorem redacto* (Bologna: Hieronymum de Benedictis, 1521), 225v, 226r, 226v. For a discussion of these illustrations, see Cuir, *The Development of Anatomy from the Renaissance to Cartesianism*, 97–102.

32 *The Romance of the Rose* tells of how Venus draws her bow and sends a fiery brand into the "narrow aperature" hidden between two pillars in the tower. Sexual connotations permeate this section of the text. The lover, for example, relates, "Dame Cypris looked well upon the image which I have described, the one placed between the pillars, within the tower, right in the middle. Never yet have I seen a place where I would so gladly gaze, even go down on my knees to adore. For no archer, bow, nor brand would I have relinquished the sanctuary and its aperature and the right to enter there at my pleasure." Lorris and Meun, *The Romance of the Rose*, 340, 346.

33 "Vener le cosce e l'altre parti estreme / fe' dopo vagamente, per le quali / degli uomini entra spesso ed esce il seme. / Ben furon fatte da mani immortali / sì dolci membra, soavi e polite, / là dove affina e'ndora Amor gli strali." *Le rime burlesque edite e inedite di Antonfrancesco Grazzini detto Il Lasca*, ed. Carlo Verzone (Florence: Sansoni, 1882), 569–70, lines 22–27.

34 William Keach, "Cupid Disarmed or Venus Wounded. An Ovidian Source for Michelangelo and Bronzino," *Journal of the Warburg and Courtald Institutes* 41 (1978): 327–31. For a discussion of how this kiss relates to both lust and the act of incest, see Julia Branna Perlman, "Venus, Myrrha, Cupid and/as Adonis: Metamorphoses 10 and the Artistry of Incest," in *Metamorphosis: The Changing Face of Ovid in Medieval and Early Modern Europe*, ed. Alison Keith and Stephen Rupp (Toronto: Centre for Reformation and Renaissance Studies, 2007), 223–38; Compton, "*Omnia Vincit Amor*: The Sovereignty of Love," 245–47.

35 Ovid, *The Metamorphoses*, trans. Allen Mandelbaum (New York: Harcourt Brace, 1993), Book 10, 347–48.

36 Ovid, *Metamorphoses*, Book 10, 356.

37 Lorris and Meun, *The Romance of the Rose*, 43.

38 In a melancholy poem written from the perspective of the roses, Lorenzo de' Medici refers to the tragic ending of love: "Once Venus sorrowing raced as all forlorn / she sought Adonis, when a lurking thorn / deep on her foot impressed an impious wound. / Then prone to earth we bowed our pallid flowers, / and caught the drops divine; the purple dyes / tingeing the luster of our native hue: / nor summer gales, nor art-conducted showers / have nursed our slender forms, but lovers' sighs / have been our gales, and lovers' tears our dew." ("Ove Vener afflitta, e in pensier molti, / pel periglio d'Adon correndo in vano, / un spino acuto al nudo piè villano / sparse del divin sangue i boschi folti: / noi sommettemmo alhora il bianco fiore, / tanto ch'l divin sangue non aggiunge / à terra, ond'il color purpureo nacque. / Non aure estive, o rivi tolti à lunge / noi nutrit'hanno, ma sospir d'Amore / l'aure son sute, & pianti d'Amore l'acque.") For Italian, see Lorenzo de' Medici, *Poesie volgari, nuovamente* (Venice: Aldus, 1554), 54r; for English translation by William Roscoe, see Lorenzo de' Medici, *Selected Poems and Prose*, ed. and trans. Jon Thiem (University Park: Pennsylvania State University Press, 1991), 99. In his *Hypnerotomachia Polifili* of 1501, Francesco Colonna describes a shrine, carved with scenes of Adonis' death, where Venus and Cupid perform yearly rituals to honor her beloved. Francesco Colonna, *Hypnerotomachia Poliphili: The Strife of Love in a Dream*, trans. Joscelyn Godwin (New York: Thames & Hudson, 1999), 376.

39 Ovid, "The Art of Love," in *The Erotic Poems*, trans. Peter Green (London: Penguin Books, 1982), Book 1, 168.

40 References to the satyr's lascivious nature are numerous in the sixteenth century. The Venetian writer Lodovico Dolce, for example, declares that the goat-footed god signifies "lascivia." Dolce also includes an epigram by Pietro Bembo that playfully dissects the satyr's hybrid anatomy; see Lodovico Dolce, *Dialogo dei colori* (1565, reprint, Lanciano: Carabba, 1913), 91.

41 Varchi writes, "Che ancora con varie larve, ciò è faccie e forme, il che significa con nuovi e varii sospetti, ritorna ogni ora, più, e va sempre crescendo con maggiore inquietudine. Ed essendo anco questa parte chiara per sè, non diremo altro, se non che come sapete, LARVE in lingua latina significa, oltre quello che noi diciamo maschere, l' anime dannate de' rei, che noi volgarmente chiamiamo spiriti. Ma qui vuol dire sotto varie figure ed apparizioni, come dicono, appariscono quelle, ed è tolto dal Petrarca quando disse nel sonetto: *Fuggendo la prigione, ove Amor m'ebbe*: '. . . E poi tra via m' apparve, / quel traditor in sì mentite larve, / che più saggio di me 'ngannato arebbe'." Benedetto Varchi, *Opere di Benedetto Varchi ora per la prima volta raccolte, con un discorso di A. Racheli intorno alla filologia del secolo XVI e alla vita e agli scritti dell'autore, aggiuntevi le lettere di Gio. Battista Busini sopra l'assedio di Firenze*, vol. 2, *L'Ercolano. La Varchina/ di Jeronimo Muzio Giustinopolitano. Lezioni; Prose varie; Lettere; Sonetti* (Trieste: Sezione Letterario-Artistica del Lloyd Austriaco, 1859), 577. In Michelangelo's drawing of the *Dream*, images of various vices emerge faintly in the arch of clouds surrounding a young man, who appears to be waking up from these fantasies at the beck and call of a heavenly, winged messenger. Among vignettes of anger, avarice, and gluttony are several dream-like images of lust: an older man mounting a female, a youth

exhibiting his buttocks in front of another couple kissing, and several faintly disembodied phalluses floating around these couples. For a discussion of the masks that appear in Michelangelo's drawing of the *Dream*, see Maria Ruvoldt, "Michelangelo's Dream," *Art Bulletin* 85 (2003): 86–113; Maria Ruvoldt, *The Italian Renaissance Imagery of Inspiration: Metaphors of Sex, Sleep, and Dreams* (Cambridge: Cambridge University Press, 2004), 141–87; Turner, *Eros Visible*, 389–94.

42 "... sic in amore Venus simulacris ludit amantis." Lucretius, *On the Nature of Things*, Book 4, 360–61, line 1101.

43 Vasari relates the full story: "Avendo intanto finito Iacopo di dipignere la Venere dal cartone del Bettino, la quale riuscì cosa miracolosa; ella non fu data a esso Bettino per quel pregio che Iacopo gliele avea promessa, ma da certi furagrazie, per far male al Bettino, levata di mano a Iacopo quasi per forza e data al duca Alessandro, rendendo il suo cartone al Bettino. La qual cosa avendo intesa Michelagnolo, n'ebbe dispiacere per amor dell'amico, a cui avea fatto il cartone, e ne volle male a Iacopo; il quale se bene n'ebbe dal duca cinquanta scudi, non però si può dire che facesse fraude al Bettino, avendo dato la Venere per comandamento di chi gli era signore; ma di tutto dicono alcuni che fu in gran parte cagione, per volerne troppo, l'istesso Bettino." Vasari-Milanesi, *Le vite*, vol. 6, 278–79; Vasari-De Vere, *Lives*, vol. 7, 172.

44 The reproductions were purchased by well-educated, wealthy individuals, including Ottaviano de' Medici (a Florentine politician and formative member of Cosimo I's ducal court), Diego Hurtado de Mendoza (the Spanish Ambassador of King Charles V to Venice), Bindo Altoviti (the papal banker and once consul of Florence in Rome), and Francesco Leoni (a banker and humanist from Venice). For Vasari's copies, see Nelson, "The Florentine 'Venus and Cupid': A Heroic Female Nude and the Power of Love," *Venus and Love*, 50–56. Nelson also mentions the copies in his catalogue entries (no. 28 and no. 31) on Vasari and his circle and in his appendix listing sixteenth-century copies of Michelangelo's *Venus and Cupid*; see *Venus and Love*, 197–98, 203, 232–36.

45 For Vasari's letter, see Giorgio Vasari, *Der literarische Nachlass Giorgio Vasaris*, ed. Karl Frey, vol. 1 (Munich: Georg Müller, 1923), 132. For a discussion and translation of this correspondence, see Nelson, "The Florentine 'Venus and Cupid': A Heroic Female Nude and the Power of Love," in *Venus and Love*, 52–53.

46 "Non dice egli che gli uomini medesimi si sono innamorati delle statue di marmo, come avvenne alla Venere di Prassitele? Benché questo stesso avviene ancora oggi tutto il giorno nella Venere che disegnò Michelagnolo a M. Bartolomeo Bettini, colorita di mano di M. Iacopo Puntormo." Benedetto Varchi, "Della maggioranza e nobiltà dell'arti," in *Trattati d'Arte del Cinquecento fra Manierismo e Controriforma*, ed. Paola Barocchi, vol. 1 (Bari: G. Laterza, 1960), 47.

47 For a discussion of the human cognitive ability to use visual imagery for sexual arousal and masturbation, see Jesse Bering, *Why Is the Penis Shaped Like That?* (New York: Farrar, Straus and Giroux, 2012), 85–97.

48 Scholarship on the *Allegory* is vast and includes: Erwin Panofsky, *Studies in Iconology: Humanistic Themes in the Art of the Renaissance* (New York: Harper & Row, 1962), 86–91; Michael Levey, "Sacred and Profane Significance in Two Paintings by Bronzino," in *Studies in Renaissance and Baroque Art Presented to Anthony Blunt on His 60th Birthday* (New York: Phaidon 1967), 30–33; Graham Smith, "Bronzino's Use of Prints: Some Suggestions," *Print Collectors* 9 (1978): 110–13; Graham Smith, "Jealousy, Pleasure, and Pain in Agnolo Bronzino's 'Allegory of Venus and Cupid'," *Pantheon* 39 (1981): 250–59; Charles Hope, "Bronzino's *Allegory* in the National Gallery," *Journal of the Warburg and Courtauld Institutes* 45 (1982): 239–43; J. F. Conway, "Syphilis and Bronzino's London Allegory," *Journal of the Warburg and Courtauld Institutes* 49 (1986): 250–55; Iris Cheney, "Bronzino's London *Allegory*: Venus, Cupid, Virtue, and Time," *Source* 6 (1987): 12–18; Lynette Bosch, "Bronzino's London *Allegory*: Love Versus Time," *Source* 9 (1990): 30–35; Paul Barolsky and Andrew Ladis, "The 'Pleasurable Deceits' of Bronzino's So-Called

London *Allegory*," *Source* 10 (1991): 32–36; Robert Gaston, "Love's Sweet Poison: A New Reading of Bronzino's London *Allegory*," *I Tatti Studies* 4 (1991): 249–88; Leatrice Mendelsohn, "Saturnian Allusions in Bronzino's London *Allegory*," in *Saturn from Antiquity to the Renaissance*, ed. Massimo Ciavolella and Amilcare Iannucci (Toronto: Dovehouse, 1992), 101–50; John F. Moffitt, "A Hidden Sphinx by Agnolo Bronzino, 'Ex Tabula Cebetis Thebani'," *Renaissance Quarterly* 46 (1993): 277–307; Jaynie Anderson, "A 'Most Improper Picture': Transformations of Bronzino's Erotic Allegory," *Apollo* 139 (1994): 19–28; John F. Moffitt, "An Exemplary Humanist Hybrid: Vasari's 'Fraud' with Reference to Bronzino's 'Sphinx'," *Renaissance Quarterly* 49 (1996): 303–33; Margaret Healy, "Bronzino's London *Allegory* and the Art of Syphilis," *Oxford Art Journal* 20 (1997): 3–11; Parker, *Bronzino: Renaissance Painter as Poet*, 130–67; Simona Cohen, "The Ambivalent Scorpio in Bronzino's London *Allegory*," *Gazette des Beaux-Arts* 135 (2000): 171–88; Maurice Brock, *Bronzino*, trans. David Poole Radzinowicz and Christine Schultz-Touge (Paris: Flammarion, 2002), 214–31; Will Fisher, "Peaches and Figs: Bisexual Eroticism in the Paintings and Burlesque Poetry of Bronzino," in *Sex Acts in Early Modern Italy*, ed. Alison Levy (Burlington: Ashgate, 2010), 151–64; Patricia Lee Rubin, *Seen from Behind: Perspectives on the Male Body and Renaissance Art* (New Haven, CT: Yale University Press, 2018), 82–84.

49 Vasari describes Bronzino's *Allegory with Venus and Cupid* in the context of his decoration of Eleonora's private chapel and his designs for the *Joseph* tapestries, both intended for the Duke's residence in the Palazzo Ducale (Palazzo Vecchio). He writes, "And Bronzino painted a picture of singular beauty that was sent to King Francis I in France, wherein was a nude Venus, with a Cupid kissing her, and Pleasure on one side with Play and other Loves, and on the other side Fraud and Jealousy and other passions of love." ("Fece un quadro di singolare bellezza, che fu mandato in Francia al re Francesco; dentro al quale era una Venere ignuda con Cupido che la baciava, ed il Piacere da un lato et il Giuoco con altri Amori, e dall' altro la Fraude, la Gelosia, ed altre passioni d'amore.") Vasari-Milanesi, *Le vite*, vol. 7, 598–99; Vasari-De Vere, *Lives*, vol. 10, 7. It is likely that Bronzino created the *Allegory with Venus and Cupid* between the signing of the Treaty of Crespy in 1544 and the death of the King Francis I in 1547. Cosimo had refrained from corresponding with the French court before this date because of the Habsburg-Valois Wars, during which he was aligned with Charles V, who forbad him to send any ambassadors to France. The ban was lifted in 1544 after the Battle of Serravalle. Peaceful relations were then established between Charles V and Francis I with the signing of the Treaty of Crespy. Cosimo then initiated correspondence with Catherine de' Medici. For a discussion of the battle and relations between France, Italy, and Spain, see Robert J. Knecht, *Renaissance Warrior and Patron: The Reign of Francis I* (Cambridge: Cambridge University Press, 1994), 490–94.

50 On March 20, 1518, Luigi Gonzaga wrote to Duke Francesco Gonzaga, "Sua Maestade mi disse che volontieri haverebe una sua qualche figura nuda hover [sic] una qualche Venere." For the letter, see Clifford M. Brown and Anna Maria Lorenzoni, "Lorenzo Costa in Mantua, Five Autograph Letters," *L'Arte* 3 (1970): 102–16, for letter, 110. The Duke eventually sent Lorenzo Costa's *Venus with a Cornucopia* to Francis I; see Janet Cox-Rearick, "Sacred to Profane: Diplomatic Gifts of the Medici to Francis I," *Journal of Medieval and Renaissance Studies* 24 (1994): 241–42.

51 For Italian works of art in Francis I's collection, see Cox-Rearick, "Sacred to Profane: Diplomatic Gifts of the Medici to Francis I," 239–58; Janet Cox-Rearick, *The Collection of Francis I: Royal Treasures* (New York: Harry N. Abrams, 1996), 27–130, 191–318.

52 On March 20, 1533, Bronzino requests Vasari's help in designing theatrical settings for the Compagnia dei Negromanti's comedy; see Alessandro del Vita, ed., *Il Libro delle Ricordanze di Giorgio Vasari* (Arezzo: Tipografia Zelli, 1938), 20. In the sentence before he describes the *Allegory with Venus and Cupid*, Vasari states that Bronzino "executed in the Palace for the Carnival, two

years in succession, two scenic settings and prospect views for comedies, which were held to be very beautiful." Vasari-Milanesi, *Le vite*, vol. 7, 598; Vasari-De Vere, *Lives*, vol. 10, 7.

53 Many of Bronzino's figures have visual correspondences with the allegorical personifications of the passions of love described in *The Romance of the Rose*; see Lorris and Meun, *The Romance of the Rose*, 31–53.

54 As Paul Barolsky has pointed out, this golden figurine is actually a quotation of Bronzino's own art, an artifice of art within art; see Barolsky and Ladis, "The 'Pleasurable Deceits'," 34.

55 In a letter in the Medici Archives from Lorenzo di Andrea Pagni to Pier Francesco Riccio, dated March 20, 1544 (1545, modern year), mention is made of Catherine de' Medici requesting copies of Bronzino's portraits of Cosimo I's children, which reveals her awareness of his skill as a portraitist. The letter reads, "Il duca mio signore mi ha comandato scriva alla signoria vostra che facci ogni opera et diligentia possibile di trovare in cotesta città dua cavalli turchi che siena belli, agevoli, et habbino il portante che li vuole per la signora delfina [Caterina de' Medici] [...] Hoggi queste excellentie [Cosimo I; Eleonora di Toledo] hanno fatto una bella caccia, et amazzato molte fiere [...] Sua excellenta [Cosimo] vuole che la signoria vostra oltre a quei ritratti che io li dissi da parte sua dovesse far fare al Bronzino del signor don Francesco [I], del signor don Giovanni, et di donna Maria, ne facci fare altre tanti in tre quadri in quella migliore forma et maniera che sarà possibile perché gli vuole mandare alla signora delfina, che gli domanda." Bia, Doc ID# 2447 (ASF, MdP 1171, fol. 566 Recto).

56 For a discussion of Bronzino's *Orpheus* as a portrait of Cosimo I, see Robert B. Simon, "Cosimo I de' Medici as Orpheus," *Philadelphia Museum of Art Bulletin* 81 (1985): 16–27; Mark S. Tucker, "Discoveries Made during the Treatment of Bronzino's 'Cosimo I de' Medici as Orpheus'," *Philadelphia Museum of Art Bulletin* 81 (1985): 28–31; Deborah Parker, "The Poetry of Patronage: Bronzino and the Medici," *Renaissance Studies* 17 (2003): 135–45; Carl Brandon Strehlke's catalogue entry (no. 84) in *Leonardo da Vinci, Michelangelo, and the Renaissance in Florence*, ed. David Franklin (New Haven, CT: Yale University Press, 2005), 244–43. For discussion of Bronzino's *Portrait of Andrea Doria as Neptune*, see Brock, *Bronzino*, 49–55; Patricia Simons, "Homosociality and Erotics in Italian Renaissance Portraiture," in *Portraiture: Facing the Subject*, ed. Joanna Woodall (Manchester: Manchester University Press, 1997), 43–44; Philippe Costamagna, "Entre Raphaël, Titien et Michel-Ange: les portraits d'Andrea Doria par Sebastiano del Piombo et Bronzino," in *Les portraits du pouvoir: actes du colloque*, ed. Olivier Bonfait, Anne-Lise Desmas, and Brigitte Marin (Paris: Somogy, 2003), 29–33; Philippe Costamagna, "De la *fiorentinità* des portraits de Pontormo et de Bronzino," *Paragone* 62 (2005): 68; Philippe Costamagna's catalogue entry (no. V.5) in *Bronzino: Artist and Poet at the Court of the Medici*, 264–65; Felicia Else, *The Politics of Water in the Art and Festivals of Medici Florence: From Neptune Fountain to Naumachia* (London: Routledge, 2018), 22–32.

57 Bette Talvacchia, "Bronzino's *Corpus* between Ancient Models and Modern Masters," in *Agnolo Bronzino: Medici Court Artist in Context*, ed. Andrea M. Gáldy (New Castle: Cambridge Scholars Publishing, 2013), 58–60.

58 In 1536, when Henri II's older brother died, Catherine became the dauphiness and heir to the French throne. For a discussion of Catherine's rise to power; see Orsola Nemi and Henry Furst, *Caterina de' Medici* (Milan: Rusconi, 1980); Leonie Frieda, *Catherine de Medici: Renaissance Queen of France* (New York: Harper, 2003); Kathleen Wellman, "Catherine de Medici, King in All but Name," in *Queens and Mistresses of Renaissance France* (New Haven, CT: Yale University Press, 2013), 224–73; Marcello Simonetta, *Caterina de' Medici: Storia segreta di una faida famigliare* (Milan: Rizzoli, 2018).

59 For a discussion of how a Venus torso, belonging to the ancient crouching type, was given new limbs in a drawing by either Pontormo or Bronzino, see Leatrice Mendelsohn, "The Sum of the Parts: Recycling Antiquities in the *Maniera* Workshops of Salviati and his Colleagues," in *Francesco Salviati et la bella maniera: actes des colloques de Rome et de Paris, 1998*,

ed. Catherine Monbeig Goguel, Philippe Costamagna, and Michel Hochmann (Rome: École Française de Rome, 2001), 137–39. In 1991, Michael Levy and Paul Barolsky compared Venus' kneeling pose to that of Mary in Michelangelo's *Doni Tondo*. In turn, they discussed the *Allegory* as a playful parody, in which Bronzino replaces the Virgin of humility with the goddess of lust and transforms holy love into profane incest; see Barolsky and Ladis, "The 'Pleasurable Deceits'," 32–36.

60 The drawing of the *Seated Male Youth* is located in the Département des Arts graphiques, Musée du Louvre, Paris. Bronzino may have associated this pose with anatomical display, as he used it again for a *St. Bartholomew*, a figure that Vasari describes as having "the appearance of a true anatomical subject and of a man flayed in reality, so natural it is and imitated with such diligence from an anatomical subject." ("Fra i quali è un San Bartolomeo scorticato, che pare una vera notomia ed un uomo scorticato daddovero, così è naturale ed imitato da una notomia con diligenza.") Vasari-Milanesi, *Le vite*, vol. 7, 601; Vasari-De Vere, *Lives*, vol. 10, 8.

61 In his biography of Catherine de' Medici, Brantôme explains that she was a foreigner but that "the House of the Medici has always been allied and confederated with the crown of France, which still bears the *fleur-de-lys* that King Louis XI gave that house in sign of alliance and perpetual confederation [the *fleur de Louis*, which then became the Florentine lily]." Pierre de Bourdeille, seigneur de Brantôme, *The Book of the Ladies*, trans. Katharine Prescott Wormeley (New York: Collier, 1899), 45–48, 51.

62 Brantôme, *The Book of the Ladies*, 51.

63 Brantôme, *The Book of the Ladies*, 50.

64 On October 9, 1544, Duke Cosimo I informed his ambassador at the court of Charles V of his intention to send a Florentine envoy to congratulate Catherine de' Medici on her firstborn son; see Bia, Doc ID# 19941 (ASF, MdP 3, fol. 581). In March of that year, Cosimo I wrote a letter to Catherine de' Medici, congratulating her on the birth of her first son: "The joy that I felt over Your Excellency's giving birth was indeed greater than anything else could give me." ("La allegrezza ch'io ho preso del felice parto di Vostra Eccellenza certo è stato tanta, che altra cosa non mi poteva arrecare più allegrezza.") For entire letter, see *Négociations diplomatiques de la France avec la Toscane, 1311–1610*, ed. G. Canestrini, vol. 3 (Paris: Imprimerie Impèriale, 1865), 135–37; for translation, see Cox-Rearick, "Sacred to Profane: Diplomatic Gifts of the Medici to Francis I," 235.

65 The talisman includes an unrecognizable inscription around the oval border. According to Pierre Béhar, the signs of Taurus and Pisces indicate Venus' powers within these houses, as discussed by Henry Cornelis Agrippa. Aries is the Sun sign in Catherine's natal chart, which explains its inclusion on the talisman. For information on the talisman, see Pierre Béhar, *Les langues occultes de la Renaissance: Essai sur la crise intellectuelle de l'Europe au XVIe siècle* (Paris: Desjonquères, 1996), 63–89; Luisa Capodieci, "Caterina de' Medici e la leggenda della Regina nera. Veleni, incantesimi e negromanzia," in *Le donne Medici nel sistema europeo delle corti XVI–XVIII secolo: atti del Convegno internazionale, Firenze, San Domenico di Fiesole, 6–8 ottobre 2005*, ed. Giulia Calvi and Riccardo Spinelli, vol. 1 (Florence: Polistampa, 2008), 195–215 and Capodieci's catalogue entry (no. 9) on the medallion in *Caterina e Maria de' Medici: donne al potere. Firenze celebra il mito di due regine di Francia*, ed. Clarice Innocenti (Florence: Madragora, 2008), 66.

66 Béhar, *Les langues occultes de la Renaissance*, 72–77.

67 For Charicles' response, see Lucian, *Soloecista. Lucius or The Ass. Amores. Halcyon. Demosthenes. Podagra. Ocypus. Cyniscus. Philopatris. Charidemus. Nero*, trans. M. D. Macleod, Loeb Classical Library 432 (Cambridge, MA: Harvard University Press, 1967), 170–71. For a discussion of the varied responses in this dialogue to the Aphrodite of Knidos, see Turner, *Eros Visible*, 231–35.

68 "Deh, perché 'l bello, et il buon, com'io vorrei / non posso a pien di te spiegare in carte? / Ché la natura esser' vinta da l'Arte / a chi mai non ti vidde, mosterrei. / Se così bella in ciel Venere sei, / come si vede qui parte per parte, / ben puossi, et con ragion, felice Marte, /

anzi beato dir, fra gli altri idei. / Non han le rose, le viole, et i gigli / sì puro, acceso, vivo, almo colore, / né l'oro, né i rubin, sì dolce ardore. / Cosa mortal non è che ti simigli: / et che sia 'l ver, di te piagato il core, / si sforza, quant'ei può, baciarti Amore." The loose-sheet manuscript of the poem is located within the Casa Buonarroti (Archivio Buonarroti, XVII, c. 14 recto). It is included in Codex XVII with other "Compositions on Michelangelo Buonarroti found in the house," as labeled by Filippo Buonarroti. The Codex contains poems by friends and correspondences related to Michelangelo. The phrase "it was in the house of Bart[olome]o Bettini" appears on the lower right of the sheet (attributed by Frey to Filippo Buonarroti) and on the top of the verso. The title "On the Venus" also appears written vertically on the verso. For provenance information, see Roberto Leporatti's catalogue entry (no. 30) in *Venus and Love*, 201–202.

69 Apuleius describes Venus kissing her son with parted lips in the *Metamorphoses*. After ordering her son to wound Psyche with "a violent, flaming passion," Venus "kissed her son long and intensely with parted lips." Apuleius, *Metamorphoses (The Golden Ass), Volume I: Books 1–6*, ed. and trans. J. Arthur Hanson, Loeb Classical Library 44 (Cambridge, MA: Harvard University Press, 1996), Book 4, 198–99.

70 Patricia Rubin argues that these "gracefully described anatomies were designed to be attractive and to solicit appreciative attention. This was legitimate, but it was also potentially libidinous," considering "the city's fame, or infamy" for sodomy (an act referred to in Germany as "florenzen"). Patricia Rubin, "'Che è di questo culazzino!': Michelangelo and the Motif of the Male Buttocks in Italian Renaissance Art," *Oxford Art Journal* 32 (2009): 427–46; for quote, see 443; Rubin, *Seen from Behind: Perspectives on the Male Body and Renaissance Art*, 55–70.

71 Documentation of the original position of Cupid and the panel addition can be seen in X-radiographs taken of the painting in 1999; see Carol Plazzotta and Larry Keith, "Bronzino's 'Allegory': New Evidence of the Artist's Revisions," *Burlington Magazine* 14 (1999): 89–99.

72 "hinc illaec primum Veneris dulcedinis in cor / stillavit gutta." Lucretius, *On the Nature of Things*, Book 4, 358–59, lines 1059–60.

73 The description continues: "Her forehead, white and gleaming, was free of wrinkles, her eyebrows brown and arched, her gay eyes so joyful that they always laughed regularly before her little mouth did." Lorris and Meun, *The Romance of the Rose*, 42.

74 An allegorical figure of *Deceit* appeared in a set of ephemeral decorations designed to celebrate the Feast of San Giovanni in Florence on June 25, 1545: "the third figure [was] deceit, in this manner she carried with one hand a flower and with the other threatened death with a knife" ("La terza figura una inganno in questa maniera che ti porgeva con una mana un fiore et da l'altra minacciava la morte con un pugnale"). Giuliano de Ricci, *Cronoca (1532–1606)*, ed. Giuliana Sapori (Milan: Riccardo Riccardi, 1972), 53.

75 Lorris and Meun, *The Romance of the Rose*, 34.

76 Lorris and Meun, *The Romance of the Rose*, 34–35.

77 For a discussion of syphilis and Venus; see Conway, "Syphilis and Bronzino's London Allegory," 250–55; Healy, "Bronzino's London *Allegory* and the Art of Syphilis," 3–11. Simona Cohen examines the disease within the French court. She discusses the court's physician Jean Fernel's opinions on syphilis and a play performed in Lyon in which Dame Pox is in a triumphal procession led by Venus. The author of the play writes that "for those whose wit is taken away / by loathsome Venus, who makes them hers / usually end up as her camp-followers / prey to sickness and denied pleasure." Simona Cohen, *Animals as Disguised Symbols in Renaissance Art* (Leiden: Brill, 2008), 284–85. For a discussion of the spread of syphilis through Europe, see Anna Fox, "The New and the Old: The Spread of Syphilis (1494–1530)," in *Sex and Gender in Historical Perspective*, ed. Edward Muir and Guido Ruggiero (Baltimore: Johns Hopkins University Press, 1990), 26–45.

78 In the Medici Archives, there is a copy of a letter written from Giulio Alvarotti to Ercole II d'Este, which mentions the autopsy of King Francis I's body and connects the disease found in his throat to syphilis and its medical treatments. This section of the letter reads,

"Trovorno da un lato all'altro del corpo verso e fianchi due ulcere molto grande, le canne della gola come dire tutte abbruciate, delli quali mali si dà la colpa parte a vini gagliardi et ardenti che Sua Maestà beveva, et parte a molto più il mal franzese che hebbe già, il quale parte per non essere stato ben curato, et parte per qualche disordine di Sua Maestà haveva fatto in su detti mali nella sua persona." Bia, Doc ID# 21420 (ASF, MdP 1858, fol. 55).

79 Brantôme, *The Book of the Ladies*, 50–51.

80 Boccaccio writes of doves, "In truth, since this sort of appetite [for intercourse as a prostitute] is kindled rather than extinguished by this act, in reality the solace of having one lover is not sufficient, so, like the dove, whose most common behavior is to try out new loves, it finds its way into more embraces." For Latin and English text, see Giovanni Boccaccio, *Genealogy of the Pagan Gods, Volume I: Books I–V*, trans. Jon Solomon, I Tatti Renaissance Library 46 (Cambridge, MA: Harvard University Press, 2011), Book 3, 392–93.

81 In Greek comedy, various parts of the satyr's body, such as his bald head, were given phallic connotations. According to Carl Shaw, "the exaggerated nose on the satyrs' comic masks was certainly phallic and would invite such humorous comparisons." Carl Shaw, *Satyric Play: The Evolution of Greek Comedy and Satyr Drama* (Oxford: Oxford University Press, 2014), 73–74.

82 The idea of Time as an enemy to Love is a popular poetic motif, also described in *The Romance of the Rose*. Here, Time "destroys and devours everything; time, who changes everything, who makes all grow and nourishes all, who uses all and causes it to rot; Time, who made our fathers old, who ages kings and emperors and will age us all, unless Death cuts us off." Lorris and Meun, *The Romance of the Rose*, 35–36.

83 Henri had a medal cast with Diane's portrait on one side and on the other, the goddess Diana trampling Cupid with his bow in her hand. The inscription reads: "OMNIVM VICTOREM VICI" (I conquered him who conquered all). The medal is dated to ca. 1525 and located in the Samuel H. Kress Collection of the National Gallery of Art, Washington, DC. For description of medal, see John Graham Pollard, *Renaissance Medals. The Collections of the National Gallery of Art Systematic Catalogue*, vol. 2 (Washington, DC: National Gallery of Art, 2007), 633. The laurel is a symbol that appears in depictions of the DH monogram, symbolizing Diane and Henri. The laurel plant also appears alongside arrows, deltas, and stag antlers on a tapestry border with the DH monogram; see Edith Appleton Standen, *European Post-Medieval Tapestries and Related Hangings in The Metropolitan Museum of Art*, vol. 1 (New York: The Metropolitan Museum of Art, 1985), 249.

84 Brantôme writes, "Aucunes conduisoient des limiers et petits levriers, espaigneuls et autres chiens, en laisse avec des cordons de soye blanche et noire, couleurs du Roy pour l'amour d'une dame du nom de Diane qu'il aimoit: les autres accompagnoient et faisoient courre les chiens courants qui faisoient grand bruit. Les autres portoient de petits dards de bresil, le fer doré avec de petites et gentilles houppes pendantes, de soye blanche et noire, les cornets et trompes mornées d'or et d'argent pendantes en escharpes à cordons de fil d'argent et soye noire." Pierre de Bourdeille Brantôme, *Vies des dames galantes* (Paris: Garnier Frères, 1872), 192.

85 For a discussion of erotic satire in the art of Francis I, see Paul Barolsky, *Infinite Jest: Wit and Humor in Italian Renaissance Art* (Columbia: University of Missouri Press, 1978), 113–15; Raymond B. Waddington, "The Bisexual Portrait of Francis I: Fontainebleau, Castiglione, and the Tone of Courtly Mythology," in *Playing with Gender: A Renaissance Pursuit*, ed. Jean R. Brink, Maryanne C. Horowitz, and Allison P. Coudert (Chicago: University of Illinois Press, 1991), 108–14; Kathleen Wilson-Chevalier, "Women on Top at Fontainebleau," *Oxford Art Journal* 16 (1993): 34–48; Stephen J. Campbell's catalogue entry (no. 10) on the *Venus and Mars* engraving based on Rosso's drawing in Stephen J. Campbell and Sandra Seekins, *The Body UnVeiled: Boundaries of the Figure in Early Modern Europe* (Ann Arbor: Goetzcraft Printers, 1997), 34–35.

86 Brantôme wrote that Catherine "listened readily to comedies and tragi-comedies, and even those of 'Zani' and 'Pantaloon,' taking great pleasure in them, and laughing with all her heart like any other; for she liked laughter, and her natural self was jovial, loving a witty word and ready with it." Brantôme, *The Book of the Ladies*, 53–54.

87 In his *Life of Bronzino*, Vasari writes that "Bronzino then painted for Signor Alamanno Salviati a Venus with a Satyr beside her, so beautiful as to appear in truth Venus Goddess of Beauty" ("Fece poi Bronzino al signor Alamanno Salviati una Venere con un satiro appresso, tanto bella, che par Venere veramente Dea della bellezza"). Vasari-Milanesi, *Le vite*, vol. 7, 600; Vasari-De Vere, *Lives*, vol. 10, 8. Based on Vasari's description of the *Venus, Cupid, and Satyr* after Bronzino's *Resurrection* of 1552 and before his departure for Pisa in 1554, it has been dated to 1553. Raffaello Borghini also describes the painting in his *Il Riposo* of 1584, stating that "in the house of Jacopo Salviati [the son of Alamanno] is a beautiful painting by Bronzino of Venus with a satyr" ("In casa Jacopo Salviati è in un quadro fatto da lui Venere con un satiro, pittura bellissima"). Raffaello Borghini, *Il riposo*, ed. Mario Rosci, vol. 2 (Milan: Labor, 1967), 537.

88 In the 1583 inventory of the Palazzo Salviati, these four paintings are listed in the *camera su la sala dipinta*. All four are attributed to Bronzino, which acknowledges their stylistic similarities. Scholars, however, attribute the *Night*, *Dawn*, and *Venus and Cupid* to Michele Tosini. The entries read, "Tre simili tocchi d'oro dentrovi la Notte… [*sic*] e l'Aurora di mano del Bronzino Vecchio" and "Un quadro grande simile e tre sopradetti con adornamento tocco d'oro, dentrovi una Venere di mano del detto." The 1583 inventory is reprinted in Antonio Fazzini, "Collezionismo privato nella Firenze del Cinquecento. L' 'appartamento nuovo' di Jacopo di Alamanno Salviati," *Annali della Scuola Normale Superiore di Pisa. Classe di lettere e filosofia* 3 (1993): 204.

89 In 1514, Leo X granted Jacopo di Giovanni Salviati the title of "Pontifical administrator, the general commissioner of salt for the State of the Church and the director of the treasury of Romagna." During the rule of Pope Leo X, Jacopo was consulted in the contract and arrangements for Catherine de' Medici's marriage to Henri II. After his death, Jacopo maintained his elevated position by becoming the secretary of Pope Clement VII. For information on Jacopo Salviati in Rome, see Pierre Hurtubise, *Une famille-témoin. Les Salviati* (Vatican City: Biblioteca Apostolica Vaticana, 1985), 59, 137–67; Ewa Karwacka Codini and Milletta Sbrilli, *Archivio Salviati. Documenti sui beni immobiliari dei Salviati: palazzi, ville, feudi. Piante del territorio* (Pisa: Scuola Normale Superiore, 1987), 11–27.

90 Mythological art featuring explicit sexual imagery decorated Agostino Chigi's villa in Rome, Cardinal Bibbiena's steam-heated bathing chamber, and the Loggia of Leo X. For a discussion of these spaces, see Turner, *Eros Visible*, 74–79, 109–33. Cardinal Giovanni Salviati's circle included Giulio Romano, Perino del Vaga, Francesco Salviati, and Pietro Aretino. For information on this group, see Hurtubise, *Une famille-témoin. Les Salviati*, 283–88; Philippe Costamagna, "Le mécénat et la politique culturelle du Cardinal Giovanni Salviati," in *Francesco Salviati et la bella maniera*, 217–52.

91 For a discussion of the erudition, sexual promiscuity, and homosexuality of the circle of Cardinal Giovanni Salviati, see Catherine Monbeig Goguel, "Francesco Salviati et la *bella maniera*: quelques points à revoir: interprétation, chronologie, attributions," in *Francesco Salviati et la bella maniera*, 24–34. Salviati's *Triumph of the Phallus* was likely commissioned in Rome by the Papal official Giovanni Gaddi. It was later seen by Montesquieu in the Gaddi collection in Florence. For Salviati's *Triumph of the Phallus*, see the catalogue entry (no. 102) by Linda Wolk-Simon in *Art and Love in Renaissance Italy*, 209–10; Turner, *Eros Visible*, 57–60.

92 A sense of Alamanno's relationship with Duke Cosimo I and the Duchess Eleonora de Toledo can be gleaned from documents in the Medici Archives. In his *ricordi*, for example, the secretary Pier Francesco Riccio mentioned that Alamanno gambled with the Duchess Eleonora, Pedro de Toledo, and Don Giovanni; see Bia, Doc ID# 6721 (ASF, MdP 600,

fol. 5). In a letter of 1546 from Vincenzo Ferrini to Riccio, Alamanno is listed as one of the people in Florence who was to receive a portion of meat as a gift from the Duke, who had just killed ten wild boar; see Bia, Doc ID# 7661 (ASF, MdP 1172, fol. 453 recto).

93 The family archives include a letter of 1540 from Cardinal Giovanni to Alamanno, in which he encourages his brother to purchase a proper palazzo for the family in Florence, one with a "beautiful façade, worthy of the Salviati name." The letter from Cardinal Giovanni was sent to Alamanno Salviati from Ferrara on March 25, 1540. For letter, see BAV, Barb., Salv, Augogr. ½, fasc. 5. The letter is also discussed by Hurtubise, *Une famille-témoin. Les Salviati*, 273–74. The sale of the Palazzo Portinari was carried out by the Spedale di Santa Maria Nuova; see Codini and Sbrilli, *Archivio Salviati*, 27.

94 Alamanno and Jacopo's collection included works by Agnolo Bronzino, Andrea del Sarto, Francesco Salviati, Michele Tosini, Baccio Bandinelli, Giambologna, and Alessandro Allori. Although few documents exist with regard to specific commissions, the 1583 and 1609 inventories list over 100 ancient objects, 1,290 medals, and 85 works by fifteenth- and sixteenth-century Florentine artists. For inventories, see Fazzini, "Collezionismo privato nella Firenze," 202–24.

95 For the ambassador's letter, see Fazzini, "Collezionismo privato nella Firenze," 193.

96 For scholarship on Bronzino's *Venus, Cupid, and Satyr*, which usually occurs in the context of writing on his *Allegory*, see the catalogue entry (no. 32) in *Catalogo sommario della Galleria Colonna in Roma*, ed. Eduard A. Safarik and Gabriello Milantoni (Busto Arsizio: Bramante, 1981), 41–42; the catalogue entry (no. 34) by Janet Cox-Rearick in *Venus and Love*, 208–10; Brock, *Bronzino*, 234–35; Fisher, "Peaches and Figs: Bisexual Eroticism," 151–64; the catalogue entry (no. II.1) by Andrea Baldinotti in *Bronzino: Artist and Poet at the Court of the Medici*, 212–13; Rubin, *Seen from Behind: Perspectives on the Male Body and Renaissance Art*, 82.

97 A portrait of Alamanno Salviati by Bronzino is listed in the 1609 inventory of the Palazzo Salviati. It is possible that the Ottawa painting is this portrait. For inventory entry (no. 1228), see Fazzini, "Collezionismo privato nella Firenze," 220. There are two Venus sculptures (no. 1039 and no. 1040) described in the 1609 inventory of the Palazzo Salviati. They are listed as, "una venerina di Marmo di tondo rilievo di Altezza di br. 1 o/4 incirca anticha risarcita" and "una Altra venere di marmo di tondo rilievo di br. 2 incirca anticha risarcita." Fazzini, "Collezionismo privato nella Firenze," 213. For other attributions regarding the identity of the sitter in the Ottawa portrait, see Janet Cox-Rearick and Mary Westerman Bulgarella, "Public and Private Portraits of Cosimo de' Medici and Eleonora di Toledo: Bronzino's Paintings of his Ducal Patrons in Ottawa and Turin," *Artibus et Historiae* 25 (2004): 101–59; Catherine Johnston's catalogue entry (no. 85) in *Leonardo da Vinci, Michelangelo, and the Renaissance in Florence*, 244–47. Leatrice Mendelsohn discusses Bronzino's inclusion of the Venus torso in the *Portrait of a Gentleman*; however, she argues that its blue hue suggests "not bronze but a painted or waxed gesso" statue; see Mendelsohn, "The Sum of the Parts," in *Francesco Salviati et la bella maniera*, 119–21.

98 In two letters to Duke Cosimo I describing a gathering of the Accademia del Piano, Lorenzo Pagni mentions the following Florentines by name: Pandolfo Pucci, Luca Torrigiani, Jacopino Pitti, the son of Ottaviano de' Medici, Agnolo di Girolamo Guicciardini, Bernardo Cambi, Baccio Barbadori, and Jacopo, the son of Alamanno Salviati. For the letters, see Michele Maylender, *Storia delle Accademie d'Italia*, vol. 4 (Bologna: Licinio Cappelli, 1929), 280–84.

99 Maylender, *Storia delle Accademie d'Italia*, vol. 4, 278. For a roster of *pianigiani* names, see the following manuscripts: BNCF, MS. Magl. VII, 345, f. 254v ("Nomi delli Accademici del Piano"); BNCF, MS. Magl. VIII, 47, ff. 211v–215v ("Dicera nell'Accademia del Piano"); BNCF, MS. Magl. IX, 18, f. 1r ("Nota de' nomi proprii in lingua Pianigiana"); BNCF, MS.II.III.427 (formerly Magl. IX, 126), F.12r ("Nomi e soprannomi dell'Accademia del Piano"). For a discussion of these sources, see Salvino Salvini, *Fasti consolari dell'Accademia Fiorentina* (Florence: Accademia Fiorentina, 1717), 198; Domenico Zanrè, "Ritual and Parody in Mid-Cinquecento Florence: Cosimo de' Medici and the Accademia del

Piano," in *The Cultural Politics of Duke Cosimo I de' Medici*, ed. Konrad Eisenbichler (Burlington: Ashgate, 2001), 189–204.

100 Giovanni Cavalcanti (Gneo Scaracchio), for example, wrote a satire titled *Il processo di Gajo Tibero Stanchini della Colonia Sillana*, conserved in the Biblioteca Nazionale (MSS. N. 924). For a discussion of the satirical tone of the group, see Maylender, *Storia delle Accademie*, vol. 4, 280. For a discussion of the members arrested for sodomy or holding questionable political views, see Zanrè, "Ritual and Parody," 189–204.

101 "Non lassando di dirgli che l'huomo del Bargiello m'ha riferito che le persone che erano congregate in quella casa, le quali nell'uscire furono numerate da lui, erano quarantacinque o vero quarantasei, et con loro era stato Jacopo figliuolo di Messer Alamanno de' Salviati." For letter, see Maylender, *Storia delle Accademie*, vol. 4, 282.

102 For Cosimo's response to Pagni, see Maylender, *Storia delle Accademie*, vol. 4, 282–84.

103 For scholarship on these paintings, see the catalogue entries (nos. 115–17) in *Catalogo sommario della Galleria Colonna in Roma*, 88–91 and Jonathan Katz Nelson's catalogue entries (no. 13 and no. 28) in *Venus and Love*, 166–67, 197–98.

104 The literature on Michele Tosini's career is limited. For a discussion of his connections with the Ghirlandaio workshop, his partnership with Vasari in the Palazzo Vecchio, and his work for major Florentine clients, see David Franklin, "Ridolfo Ghirlandaio and the Retrospective Tradition in Florentine Painting," in *Italian Renaissance Masters*, ed. Annemarie Sawkins, David Franklin, and Louis Alexander Waldman (Milwaukee: Haggerty Museum of Art, 2001), 17–23; David Franklin, "Towards a New Chronology for Ridolfo Ghirlandaio and Michele Tosini," *Burlington Magazine* 140 (1998): 445–55; David Franklin, "Ridolfo Ghirlandaio's Altarpieces for Leonardo Buonafé and the Hospital of S. Maria Nuova in Florence," *Burlington Magazine* 135 (1993): 4–16; Heidi J. Hornik, "The Strozzi Chapel by Michele Tosini: A Visual Interpretation of Redemptive Epiphany," *Artibus et Historiae* 23 (2002): 97–118; Heidi J. Hornik, *Michele Tosini and the Ghirlandaio Workshop in Cinquecento Florence* (Portland, OR: Sussex Academic Press, 2009), 34–53.

105 For Tosini and Brina's copies, see Jonathan Katz Nelson's catalogue entries (no. 13 and no. 28) and his appendix listing copies of Michelangelo's *Venus and Cupid* in *Venus and Love*, 166–67, 197–98, 232–36.

106 For the restoration report of Tosini's *Venus and Cupid*, see Angela Negro, "Le indagini diagnostiche e il restauro," in *Venere e Amore di Michele di Ridolfo del Ghirlandaio: Il mito di una Venere di Michelangelo fra copie, repliche e pudiche vestizioni* (Rome: Campisano, 2001), 35–45.

107 James J. Stark and Jonathan Katz Nelson, "The Breasts of 'Night': Michelangelo as Oncologist," *New England Journal of Medicine* 343 (2000): 1577–78. For a rebuttal of the interpretation of *Night*'s breast as cancerous, see John Landor, "The Question of Breast Cancer in Michelangelo's 'Night'," *Source: Notes in the History of Art* 25 (2006): 27–29.

108 For a discussion of the *cangianti* manner of painting as it begins with Michelangelo and continues into the art of Mannerist painters, such as Michele Tosini, see Marcia B. Hall, "From Modeling Techniques to Color Modes," in *Color and Technique in Renaissance Painting: Italy and the North*, ed. Marcia B. Hall (Locust Valley, NY: J. J. Augustin, 1987), 14–22.

109 For Doni's letter, see *Il carteggio di Michelangelo*, ed. Paola Barocchi, vol. 4 (Florence: Sansoni, 1979), 161. For a discussion of the erotic appeal of the Medici Chapel statues and sensuous drawings of *Dawn* by Francesco Salviati and others, see Turner, *Eros Visible*, 384–89.

110 Discussions of this drawing do not mention the phallic imagery suggested in the facial features of the satyr; see Michael Hirst, *Michelangelo and His Drawings* (New Haven, CT: Yale University Press, 1988), 23, 74; John Paoletti, "Michelangelo's Masks," *Art Bulletin* 74 (1992): 423–40. Michelangelo's reworking of Mini's drawing in a manner that holds erotic suggestions is not the first of these interactions between the master and his student, as seen

in the corner of a sheet of the 1520s in the Ashmolean Museum. Here, Michelangelo drew a man lying down and lifting his legs to reveal his genitals; Mini responded with a suggestive phallic-fist. For analyses of the drawing dialogue between Michelangelo and Antonio Mini, see William Wallace, "Instruction and Originality in Michelangelo's Drawings," in *The Craft of Art: Originality and Industry in the Italian Renaissance and Baroque Workshop*, ed. Andrew Ladis, Carolyn Wood, and William Eiland (Athens, GA: University of Georgia Press, 1995), 115–18; Turner, *Eros Visible*, 48–49.

111 For information on the *maiolica* plate, see Timothy Wilson, "Un 'intricamento' tra Leonardo ed Acrimboldo," *Ceramica Antica* 15 (2005): 10–44; Linda Wolk-Simon's catalogue entry (no. 11) in *Art and Love in Renaissance Italy*, 217–19. For Aretino's medals, see Raymond Waddington, "A Satirist 'impresa': The Medals for Pietro Aretino," *Renaissance Quarterly* 42 (1985): 655–81; Raymond Waddington, *Aretino's Satyr: Sexuality, Satire, and Self-Projection in Sixteenth-Century Literature and Art* (Toronto: University of Toronto Press, 2004), 109–24; Turner, *Eros Visible*, 55–57.

112 For a discussion of Francesco Salviati's phallic portraits, see Goguel, "Francesco Salviati et la *bella maniera*," in *Francesco Salviati et la bella maniera*, 34–39.

113 For the paintings Francesco Salviati produced for Alamanno and Jacopo, see Vasari-Milanesi, *Le vite*, vol. 7, 21–22, 38; Vasari-De Vere, *Lives*, vol. 8, 173–74, 187. The book of masks is listed in the 1609 inventory entry (no. 1276) of the Palazzo Salviati as "Un libro di Abiti di Maschere di mano di cecchino salviati." See the inventory in Fazzini, "Collezionismo privato nella Firenze," 222.

SIX

MARITIME TREASURES

Venus' Gifts from the Sea

Hearing the tale, the Nereids, too, came mounted on various beasts ... Cymothoë presents a girdle, Galatea a precious necklace, Psamathe a diadem heavily encrusted with pearls gathered by herself from the depths of the Red Sea. Doto suddenly dives to gather coral, a plant so long as it is beneath the water, a jewel once it is brought forth from the waves. The nude crowd of Nereids throng around Venus, following her and singing her praises after this manner: "We beg thee, Venus, our queen, to bear these our gifts, these adornments, to queen Maria ... Let the daughter of Stilicho hereby realize the devotion of the sea and know that Ocean is her slave.[1]

— Claudius (10 BCE–54 CE), *Epithalamium for Honorius and Maria*

Among the four elements, water belongs to Venus. The "wide stretches of ocean laugh" and become "full laden with ships," Lucretius writes, when Venus ascends in the spring.[2] The goddess possessed legitimate maritime credentials due to her birth within the salty womb of the sea. The ancient painter Apelles (370–306 BCE) illustrated her liquid nativity in his *Aphrodite Anadyomene*, a work so beautiful that Alexander the Great (356–323 BCE) surrendered his own mistress, Campaspe, to the artist (Fig. 90).[3] She had captured the heart of Apelles while modeling nude for the figure of Aphrodite. Years later, the Emperor Augustus (63 BCE–14 CE) purchased Apelles' painting from the island of Kos and exhibited it within the temple of his adopted father, the deified Julius Caesar.[4] Epithets to Aphrodite and later to Venus also pay homage to her aquatic origins. Aphrodite Euploia is the goddess of good sailing, while Venus Pelagia is mistress of the sea. Ancient tourists could catch a glimpse of Praxiteles'

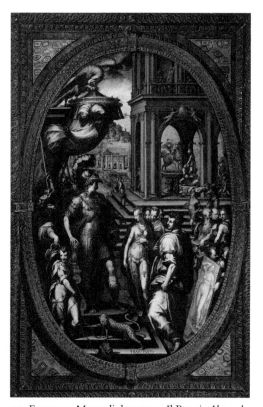

90 Francesco Morandi, known as Il Poppi, *Alexander the Great Giving Campaspe to Apelles*, ca. 1570–72, Studiolo of Francesco I, Palazzo Vecchio, Florence, Italy. Photo: akg-images / De Agostini Picture Lib. / G. Nimatallah

nude *Aphrodite* while docked in one of Knidos' two harbors. According to Pliny the Elder (23–79 CE), mollusks were worshipped at this sanctuary because their spiraling calcine shells and vulva-like apertures could resist a storm's fury, bring a ship to a halt, stop miscarriages, and keep a fetus within the womb.[5]

Other materials culled from the depths of the sea belonged to Venus: the iridescent pearl, vermillion coral, Tyrian purple, and fragrant ambergris. Ancient rulers sought these rare and mysterious treasures to woo lovers, claim wealth, or pledge favor. Many even displayed them as *spoglie* or trophies to mark their conquests of distant lands and seas. In 46 BCE, for example, Julius Caesar dedicated a cuirass of ivory pearls to *Venus Genetrix* to honor his crossing of the English Channel and victory over the Isle of Britain.[6] In the quote from Claudian's fourth-century epithalamium included at the beginning of this chapter, the pearl-encrusted diadem and bright coral gems presented by the Nereids to Venus for the bride Maria symbolize the ocean's submission to her husband Honorius, the Emperor of the Western Roman Empire, and her father Stilicho, the general of the Roman army.

When Cosimo I de' Medici became the Duke of Florence in 1537, he too employed Venus as a potent symbol of political power. Initially, he drew upon her floral fecundity, commissioning Agnolo Bronzino to design a *Primavera* tapestry illustrating the goddess riding Aries' ram while scattering chaste lilies and blushing roses across the verdant valley of Tuscany.[7] This fertile imagery symbolized the return of a Golden Age to Florence after the devastation wrought by war, plague, and famine during the early 1530s. As the Duke's political interests turned from the *terra firma* towards the Mediterranean, however, prosperous seas replaced springtime gardens. Cosimo I's maritime achievements were considerable and include the development of ports and fortresses at Livorno, Pisa, and Elba, the control of the Maremma beaches down to Orbetello, and the purchase of the Isola del Giglio in the Tuscan Archipelago.[8] He also built a small but powerful naval fleet and founded the

Order of the Knights of San Stefano, a military organization charged with protecting the Tyrrhenian Sea from Turkish raids and from the French and Spanish navies.[9] In 1564, Cosimo I even became the governor of the Venetian-ruled island of Cyprus, the beloved homeland of Venus.[10] Such an expansion of Florence's territory and wealth along the Ligurian and Tyrrhenian coastlines was an extraordinary feat for the ruler of a landlocked city whose only native waterfronts were along the Arno River.

With so much attention directed towards the sea, it is not surprising that Cosimo commissioned Bartolomeo Ammannati's *Neptune* fountain (Fig. 91) for the Piazza della Signoria, a symbol of maritime might that vied with the Republican *virtù* of Michelangelo's *David*.[11] As this chapter argues, Venus embodied a similar, though distinctively different, aquatic ascendency for Cosimo I. First, the goddess of the sea appeared in semi-public rather than public places, where the Duke entertained high-powered dignitaries, diplomats, and patricians. At the Villa of Castello and in the Duke's Hall of State, Venus and her maritime gifts charmed visitors and proclaimed the liquid fertility of Tuscany. Second, her governance over calm waters ensured successful trade and promoted peaceful diplomacy. This chapter examines portrayals of Venus, particularly *Venus Anadyomene*, by Niccolò Tribolo, Zanobi Lastricati, Giorgio Vasari, and Jean Boulogne (Giambologna). It also investigates aquatic materials infused with Venus' virtues and with Imperial Rome's history. Florence's artists

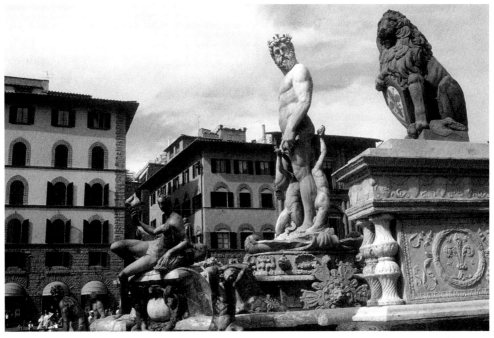

91 Bartolomeo Ammanati, *Neptune Fountain*, completed 1575, Piazza della Signoria, Florence, Italy. Photo: Cosmo Condina Western Europe / Alamy Stock Photo

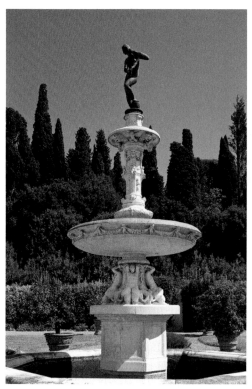

92 Niccolò Tribolo and Giambologna, *Fountain of Anadyomene Called Fiorenza*, eighteenth-century copy of original sixteenth-century fountain, Villa Medicea della Petraia, Sesto Fiorentino, Italy. Photo: REDA & Co srl / Alamy Stock Photo

transformed these raw materials into luxurious works of art. While the ducal perfumer, Ciano (Bastiano di Francesco di Jacopo, 1503–66), converted a waxy ball of ambergris into an alluring, powdery perfume, the goldsmith Benvenuto Cellini wove pearls into luminescent adornments for the Duke's new bride. Such gifts of the goddess secured bonds of both friendship and love.

THE VILLA OF CASTELLO

The first *Venus Anadyomene*, in the guise of *Fiorenza*, which Duke Cosimo I commissioned, stood atop a white marble candelabra fountain (Fig. 92) nestled inside an arboreal labyrinth at the Villa of Castello. According to Giorgio Vasari, Botticelli's paintings of the *Birth of Venus* and the *Primavera* also hung at Castello.[12] Purchased in 1477 by Giovanni and Lorenzo di Pierfrancesco de' Medici, the villa was inherited by Cosimo I from his father Giovanni delle Bande Nere.[13] Located 3.5 miles northwest of Florence, Castello (Fig. 93) stands at the base of Monte Morello, the tallest peak in the Arno valley. The villa's name derives from an ancient reservoir, *castellum* in Latin, which collected water from the nearby springs to mark the beginning of a Roman aqueduct constructed to bring water from Valdimarina to Florence.[14] It was believed that Augustus built this water conduit when the city was founded; it was one of only three ancient edifices still standing in sixteenth-century Florence. The historical value of Castello's location and its connection to water likely influenced Cosimo's decision to develop a full-scale decorative program here.[15]

The Duke initiated reconstruction and redecoration of the Villa of Castello following his defeat of the *fuorusciti* (the exiled Florentines who opposed Medici rule) at Montemurlo on July 31, 1537. This military triumph firmly secured Cosimo's position as head of the Florentine state and ensured a period of peace and stability for the city. The Duke and many of his contemporaries considered both his election and his victory at Montemurlo to have been divinely ordained. "As a sign of the imperium, which would be attained," Mario Matasilani wrote

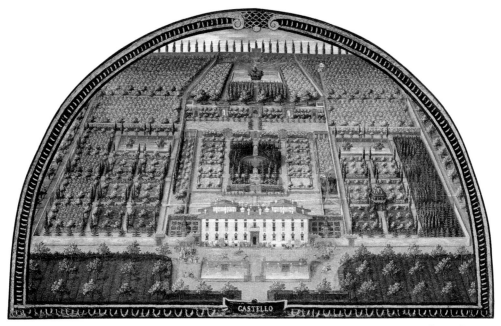

93 Giusto Utens, *View of the Villa Medicea di Castello from the Bird's Eye View*, 1599/1602, Villa Medicea La Petraia, Florence, Italy. Photo: akg / Edition Lidiarte / S. Mocka

in 1572 that "his garden at the villa of Castello, the only one among all the others, in the month of January, blossomed all over in a miraculous abundance of every sort of flower, when the plants of the farms nearby seemed to be all completely blighted by the continual cold."[16] Cosimo was born under a highly favorable natal horoscope with Saturn as lord of the ascendant in the domicile of Capricorn, a birth sign that signaled his proclivity towards *imperium* or rulership and *felicitas* or good fortune.[17] Moreover, the Duke shared this auspicious horoscope with the ancient Roman Emperor Augustus and the current Holy Roman Emperor Charles V.[18] The Capricorn established a strong link between Cosimo I and Augustus, a link that was further solidified by the fateful coincidence that the Duke achieved victory at Montemurlo on the same day that Augustus defeated Marc Antony at Actium.[19]

During his imperial reign, Augustus honored Venus as a state goddess. This act bolstered his connection to Julius Caesar, who claimed divine ancestry from her. Having conceived Aeneas, Venus was the de facto mother of Rome (Mars was the city's father through his generation of Romulus), and the goddess guaranteed fertility and prosperity to her child.[20] Augustus issued coins of Venus holding the arms of Mars and erected statues of her accompanied by the war god in various temples.[21] He also purchased Apelles' *Aphrodite Anadyomene* and displayed it in the Temple of Julius Caesar. It is possible that Duke Cosimo I chose to embody the city of Florence with the figure of *Venus*

Anadyomene in order to emphasize his connections to Augustus, who was the proclaimed founder of the Tuscan city.

Cosimo I began work on the Villa of Castello by commissioning Jacopo Pontormo to fresco the main house's entrance loggia with his fortuitous natal horoscope.[22] Soon after, he hired Niccolò Tribolo to design the gardens, fountains, and sculptures. In the spring of 1538, Tribolo began transforming the agricultural estate into a *villa della mostra* that would proclaim Cosimo's magnificence to official visiting dignitaries, while also providing pleasure and entertainment for the Duke, his children, and his court. Water was central to Tribolo's designs. His constructed landscape (Fig. 93) followed the topographic flow of Tuscany's rivers. Beginning in the Apennine Mountains, which were embodied as a hoary giant located in the upper gardens, water descended to the Mugnone and Arno rivers, both of which were represented as reclining river gods. It then flowed down into a grotto, an interior space decorated with two marble tubs carved with aquatic creatures, niches filled with sculptures of exotic animals in multicolored stones, and walls covered with *spugne* and shells. From here, the water streamed into the principle garden and to the *Fiorenza* fountain. Tribolo's hydraulics carried the water up the fountain through a central pipe and then released it through the bronze statue of *Fiorenza* as *Venus Anadyomene*, who appeared to squeeze it from her long, curly tresses.[23] The liquid then descended into a series of white marble basins carved with terrestrial and aquatic imagery. At the summit of another marble fountain located at the front of the gardens, Hercules protected Cosimo I's Tuscan domain by crushing the tyrannical spirit of Antaeus.[24]

For Castello's principle garden (Fig. 94), where the *Venus Anadyomene* as *Fiorenza* fountain was erected, Tribolo chose a precise, circular planting of cypress, laurel, and myrtle trees that resembled descriptions of Venus' shrines at Cyprus and Cythera.[25] In a 1543 letter, the Florentine writer Niccolò Martelli declared that the garden surpassed those seen at the Venusian cult sites of "Paphos, Knidos, and Cyprus," while the French naturalist Pierre Belon described how these trees, arrayed in the shape of a crown, were "always green" and diffused "a sweet perfume."[26] Wielding the shovel instead of the brush, Tribolo transformed Venus' painted gardens into a living landscape. Here, moist herbal scents intertwined with the heady perfume of roses and the sweet aroma of citrus trees. Such a verdant and fragrant landscape was intended to restore as well as delight the spirit.[27] For Cosimo, Eleonora, and their children, the villa's gardens provided an escape from the dense urban fabric of Florence. Numerous documents refer to the family walking in the gardens of Castello and enjoying dinners, comedic performances, and fireworks.[28] In October and November 1544, Cosimo recuperated from an illness here, and he and his wife found refuge at the villa after the death of their son Pietro in

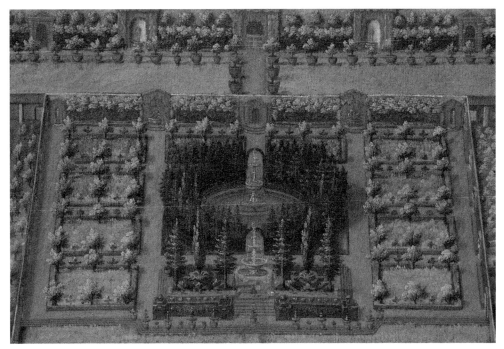

94 Giusto Utens, *View of the Villa Medicea di Castello from the Bird's Eye View*, detail, 1599/1602, Villa Medicea La Petraia, Florence, Italy. Photo: akg-images / Rabatti & Dominigie

1547. The sweet air at Castello provided salubrious and pleasurable benefits to Cosimo and the people he held dear.

Niccolò Martelli's letter confirms that Tribolo had conceived of the *Fiorenza* fountain by 1543, and in Vasari's painting of *Cosimo Surrounded by the Artists of His Time* (Fig. 95), the sculptor presents a model of the fountain to the Duke. Although multi-tiered freestanding candelabra fountains were common in drawings, prints, and reliefs, the construction of one with lively figural groups and a hierarchical succession of basins was rare in mid-sixteenth-century Florence.[29] Tribolo and his workshop carved nine different marble sections, which were threaded with hydraulics and mounted between 1545 and 1550, the year of the sculptor's death.[30] The high and low relief sculptures on the fountain merge maritime and pastoral imagery, illustrating the Duke's desire to control the *terra firma*, rivers, coasts, and sea of Tuscany. On the base (Fig. 92), satyr couples in the form of caryatids ride pairs of dolphins – Venus' maritime companions and symbols of fair weather.[31] Processing around the second basin, small putti carry garlands of mollusk shells, shrimp, and crayfish interspersed with foliage, fruit, and flowers. On the socles and underneath the upper basin of the fountain, winged *amorini* perch – armed and ready to wound all who enter the goddess's garden of love.

95 Giorgio Vasari, *Cosimo Surrounded by the Artists of His Time*, 1560, Sala del Duca Cosimo I, Palazzo Vecchio, Florence, Italy. Photo: akg-images / Rabatti & Domingie

In his conception of the fountain's crowning figure, Tribolo broke with convention and depicted Florence as *Venus Anadyomene* or Venus rising from the sea, an iconography made famous by Apelles' painting of the subject (Fig. 90). Although destroyed, this painting was well known during the sixteenth century from several epigrams in the *Greek Anthology*, which Lorenzo de' Medici commissioned to be translated into Latin. The text was published in 1531. One of the epigrams by Antipater of Sidon offers a vivid image of *Anadyomene*: "Look on the works of Apelles' pencil: Cypris, just rising from the sea, her mother; how, grasping her dripping hair with her hand, she wrings the foam from the wet locks."[32] Other epigrams in the collection describe Apelles' figure as "not painted but alive. With beautiful grace doth she wring out her hair with her finger-tips, beautifully doth calm love flash from her eyes, and her paps, the heralds of her prime, are firm as quinces."[33] Another poet warns the viewer to "back quickly from the picture" in order to avoid "being wetted by the foam that drips from her tresses as she wrings them."[34]

In his hydraulic designs, Tribolo incorporated Venus' gesture of wringing her hair into the mechanical dynamics of the fountain, planning for a pipe to be inserted into the sculpture's weight-bearing leg. This pipe ran up to Venus'

shoulder and then down through her hair, so that a stream of water flowed from her tresses. Tribolo also literalized the ancient poets' fear of becoming soaked by Apelles' painted water by hiding tiny jets around the fountain that drenched visitors admiring the goddess.[35] Niccolò Martelli describes this "beautiful trickery" as consisting of "a thousand little jets of clear fresh water, with amazing crossing sprays, so that it is impossible for the unknowing person to escape without getting wet, a thing which gives much laughter to others: and all of this has been designed and invented by Tribolo."[36] The sculptor's innovative use of water as a material in this work of art inspired both laughter and delight – two of Venus' gifts – in those who visited this garden at Castello.

In 1550, Tribolo died and left many of the works at Castello incomplete, including the bronze *Venus Anadyomene* as *Fiorenza* sculpture. Antonia Boström has convincingly argued that Zanobi Lastricati (1508–90) cast the fountain's bronze statue of *Venus Anadyomene* (Figs. 96 and 97) on the basis of Tribolo's design in the early 1550s. Lastricati's *Venus Anadyomene* is crowned with a sovereign's diadem that displays the Medici *palle* and the Florentine lily. Today, the sculpture stands atop another fountain (Fig. 96) in the Jardin de la Isla in Aranjuez, Spain. Don Garzía, the brother of Duchess Eleonora, sent the sculpture along with an ensemble of marble and jasper to Spain in August 1571, the same year that Giambologna's *Venus Anadyomene Called Fiorenza* (Fig. 104) was installed atop the fountain.[37]

In mid-sixteenth-century Florence, Zanobi Lastricati was a distinguished sculptor, who ran a successful forge. He received commissions from Duke Cosimo I and other prominent patricians, such as Lorenzo Ridolfi. He cast Pierino da Vinci's clay models of four children for the Villa of Castello and bronze door knockers for the Sala degli Elementi in the Palazzo Ducale (Palazzo

96 *Fountain of Venus*, with *Venus Anadyomene* by Zanobi Lastricati, sixteenth century, Jardín de la Isla, Aranjuez, Madrid province, Spain. Photo: Maria Galan / Alamy Stock Photo

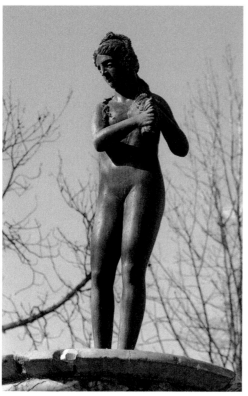

97 Zanobi Lastricati, *Venus Anadyomene*, ca. 1550–58, Jardín de la Isla, Aranjuez, Madrid province, Spain. Photo: © PATRIMONIO NACIONAL

Vecchio).[38] Lastricati was also a founding member of the Accademia del Disegno and *provveditore* for Michelangelo's funeral. His sculptures are not as well known today, in part because he worked in a period of Florentine artistic activity when bronze was at its height, and sculptors such as Benvenuto Cellini, Bartolommeo Ammannati, Giambologna, and Vincenzo Danti were producing mannerist masterpieces. In comparison to their works, Lastricati's sculptures, including his *Venus Anadyomene* (Fig. 97), are static rather than fluid, standing in classical *contrapposto* positions rather than the more complex *serpentinata* poses. Lastricati was, however, appreciated by these artists for his ability to successfully convert their designs into bronze sculptures. Furthermore, his *Venus Anadyomene* as *Fiorenza* appears to be the first life-size, nude sculpture of the goddess in Florence to be cast in bronze.

In a letter dated May 15, 1546, Niccolò Martelli describes another maritime Venus designed by Zanobi Lastricati for the courtyard of the ducal perfumer, Bastiano di Francesco di Jacopo, who went by the nickname of Ciano.[39] Lastricati and Ciano, sculptor and perfumer, appear to have been close friends and collaborators. Between 1549 and 1551, for example, the pair completed a bronze *Mercury* for the courtyard of the Palazzo Tornabuoni, which was being restored by Cardinal Ridolfi and his brother, Lorenzo di Piero Ridolfi.[40] For Ciano's courtyard, the two created a varied ensemble of mythological deities. Martelli describes this sculptural decoration in a humorous letter that softly critiques the perfumer's acceptance into the Accademia Fiorentina, the city's official literary academy.[41] In the letter, Martelli tells of a *Cupid* carved in *pietra serena* and a fountain ornamented with a sculpture of *Bacchus*. He goes on to recount that "Lastricato's incredible hand of ingenuity, seems to have worked in stucco and ultramarine color, above a niche, beautiful Venus, Neptune with a trident, sea horses and the wet curls of Galatea, Thetis, Melite, and other marine nymphs, playing lasciviously on the shore," which gives "the eye an infinite pleasure."[42] Martelli notes that the courtyard also included "the Ducal arms of his most Illustrious Cosimo with the laurel and the Arno of our Accademia."[43]

Venus' presence in Ciano's decorative program correlates with her planetary governance over perfumers, the art of distillation, and sweet-smelling fragrances.[44] Accordingly, we might expect her to have appeared with myrtle, roses, or orange blossoms rather than with Neptune and the Nereids.[45] Venus as goddess of the sea, however, held sway over another natural material central to the art of perfumery: ambergris (Fig. 98). In his letter to Ciano, Martelli mentions this odiferous substance as one of the precious materials handled by the perfumer.[46] In sixteenth-century Florence, the origins of ambergris were somewhat mysterious. Giovanni Battista Tedaldi wrote a scientific

98 Ambergris, amber gris, ambergrease, or grey amber, isolated on white background, November 26, 2019. Photo: Tetiana Kovalenko / Alamy Stock Photo

analysis on ambergris and dedicated it to Duke Cosimo I in 1564. His treatise outlines four hypotheses on the origins of ambergris: (1) a material born in the foam of lake water and washed out to sea, (2) a species of mushroom growing on top or beneath the sea, (3) a fake mixture of other materials, or (4) a coagulation of whale sperm.[47] Tedaldi then puts forth his own theory, arguing that ambergris consists of a whale's excrement and/or purgation, which becomes fragrant from the herbs that the whale ingests on the ocean's floor. He contends that the beaks and claws found in lumps of ambergris are not those of parrots – because parrots are not found on the high seas – but rather those of octopi, which are ingested by the whales on the ocean's floor.[48]

Tedaldi's hypothesis regarding the origins of ambergris is correct, to a certain point. According to twenty-first-century theories, this fragrant material is a secretion from the bile duct of a sperm whale, whose intestines have been scratched by the beak of a giant squid. The substance – which may include the beak – exits the whale's body as excrement or vomit and then floats on the sea, sometimes for years, until it washes up on the shores of certain beaches. Today, as in the sixteenth century, ambergris is a highly desirable and expensive material.[49] Documents in the Medici archives reveal that Duke Cosimo I and the Duchess Eleonora eagerly sought to procure this rare material, which was used in perfumery, medicine, and magic. In 1553, Eleonora requested ambergris and musk from a Medici associate traveling to Egypt, and in a 1559 letter, inquiry was made as to whether a ship from England was carrying either substance.[50] When a ship from Alexandria arrived in the port of Livorno in 1566, Medici agents were directed to look for ambergris, musk, and civet.[51]

The Medici court consumed ambergris in several different ways. In the art of perfumery, animal oils – such as ambergris, musk, and civet – provided a stable and long-lasting fixative for volatile floral essences, which dissipated quickly. Documents reveal that ambergris was a key ingredient in room perfumes and the scenting of adornments.[52] Ciano, for example, applied the resilient fragrance to leather gloves, several pairs of which were sent as diplomatic gifts to foreign dignitaries, including Pope Julius III (Giovanni Maria Ciocchi del

Monte, 1487–1555).[53] Ciano also infused ambergris into the colored pastes that were inserted – like jewels – into Cosimo's and Eleonora's belt buckles and pendants.[54] These sweet and sultry fragrances, wafting from the Duke and Duchess, announced their presence and engraved their aura upon the viewer's mind, like a perfumed love letter.

Ambergris was also a pharmacological substance. In 1544, Cosimo I treated his heart with a heart-shaped poultice sewn with crimson taffeta, ornamented with heart-shaped drawings, and scented with musk and ambergris.[55] Physicians, including Andrea Mattioli, listed ambergris as a remedy for infertility because it strengthened the phallus, opened and dilated the uterus, provoked menstrual cycles, and stimulated coitus.[56] Balls of ambergris were placed in pomanders – perforated gold or silver filigree containers – that were worn on the body to protect individuals from viruses, infections, and diseases. The name pomander comes from the *pomum ambrae* or "apples of amber," which the circular containers held.[57] Giovanni de' Medici, the youngest son of Cosimo and Eleonora, wears a pomander in Agnolo Bronzino's *Portrait of Giovanni de' Medici* (Fig. 99), created for the Duke and Duchess around 1545. The fragrant material was also used in magic, and in his *Occult Philosophy* published in 1533, Henry Cornelius Agrippa describes a suffumigation (the burning of materials during a magical ritual) to channel Venus, which includes "musk, ambergris, lignum aloes, red roses and red coral, made up with the brain of sparrows and the blood of pigeons."[58]

99 Agnolo Bronzino, *Portrait of Giovanni de' Medici as a Child*, 1545, Gallerie degli Uffizi, Florence, Italy. Photo: akg-images / Rabatti & Domingie

Venus' association with ambergris and the centrality of this ingredient to Ciano's profession may explain why the perfumer located the goddess in an aquatic rather than a floral setting in his courtyard's decorative program. A maritime Venus surrounded by Tritons and Nereids debuted more publicly in the Palazzo Ducale (Palazzo Vecchio), which Duke Cosimo I took over as his personal residence in 1540. The Duke commissioned Vasari and a team of assistants to decorate his official suite of apartments. The *Birth of Venus* fresco (Figs. 2 and 100) adorns one wall of the Sala degli Elementi or Room of the Elements (completed between 1551 and 1566), which Cosimo I used as a Hall of State. The decorative

program revolves around the four elements of nature: Air is represented on the ceiling with a scene of Saturn castrating Uranus; Water on the north wall with the birth of Venus; Fire on the west wall with Vulcan's forge; and Earth on the south wall with Saturn's agricultural domain.[59]

Venus, who is depicted on two of the walls and whose nativity is referenced in the ceiling fresco, is the only female to hold a prominent position within the room. In the *Birth of Venus* fresco on the north wall (Fig. 100), the goddess stands with her back to the Arno River. Blue water covers more than two-thirds of the fresco. Vasari and his workshop painted this broad liquid expanse with even brushstrokes – nearly straight lines – to represent how Father Ocean, who rises out of the waves slowly in the foreground, calmed the seas for Venus' birth. In a 1558 treatise titled *Ragionamenti*, Vasari explains to the Duke's son Francesco that this scene refers to his father's calming "the troubled waters of this sea of government" and "stilling the spirits of the populace, made so agitated by the winds of passion in their hearts."[60] In addition to a state of peace, the topographical placement of Venus in the Sala degli Elementi fresco connects the goddess to the fluvial resources of the Arno valley. The gifts presented to her by Nereids and Tritons acknowledge the fertility of Cosimo's maritime pursuits and the devotion of the sea to Florence. The iconography resembles Claudian's *Epithalamium for Honorius and Maria* with the intended recipient of the gifts being Florence and more specifically, Cosimo and Eleonora.[61] As will be illustrated in the following pages, the Duke and the Duchess eagerly desired these maritime materials, which possessed economic, medicinal, apotropaic, and aesthetic value. Of particular interest to this chapter are two Venusian treasures: pearls and coral.

In Vasari's fresco of the *Birth of Venus*, several of the Tritons and Nereids offer gifts to the goddess. On the viewer's left, Proteus presents a collection of pearls in a giant clam shell. Palaemon, another Triton who presses against Proteus, carries a lobster and a shell filled with round stones (either pearls or ambergris). Behind the Tritons, Galatea rides a fantastical sea beast in reverse. Modeling an intricate branch of coral in her coiffure, she extends a string of pearls in a small scallop shell to Venus. On the viewer's right, the Triton Glaucus hefts a dolphin over his shoulder, while Amphitrite and her companion offer a mollusk snail and "snail shells of mother of pearl," according to Vasari.[62] The three Graces await the goddess on the myrtle-girthed shores of Cyprus, holding a garment dyed Tyrian purple, the dye procured from the bodies of murex snails, a marine gastropod mollusk.

In Book 37 of his *Natural History*, Pliny writes that pearls are considered the most valuable material found in the sea.[63] This gem's associations with the womb of bivalve shells, royal adornments, and incandescent skin made it an obvious attribute of Venus, whose sacred, pearlescent body was also birthed

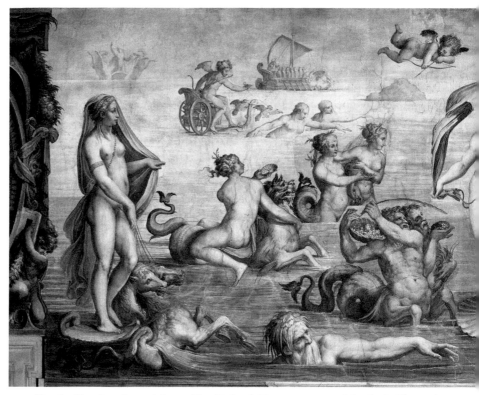

100 Giorgio Vasari and workshop, *The Birth of Venus*, 1555–57, Sala degli Elementi, Quartiere degli Elementi, Palazzo Vecchio, Florence, Italy. Photo: Heritage Image Partnership Ltd / Alamy Stock Photo

from a scallop shell.[64] Because of their rarity, pearls represented the height of luxury, and their procurement by rulers often held potent political connotations. As mentioned in the opening of the chapter, Julius Caesar dedicated a cuirass of pearls in the temple of *Venus Genetrix* after crossing the English Channel and conquering Britain. Similarly, the Emperor Augustus took an illustrious pearl belonging to Cleopatra, split it, and fashioned pearl earrings for a statue of Venus in the Pantheon.[65] In both examples, the dedication of these iridescent, light reflective gems to Venus signified Rome's maritime might and the ability of the Empire to expand across oceans.[66]

Like most men of power in sixteenth-century Europe, Duke Cosimo I sought out and purchased pearls. Of particular note are the 200 pearls that he gave to Eleonora de Toledo as part of her counter-dowry. On the advice of his mother Maria Salviati, Cosimo sent fifty pearls as a betrothal gift; after the wedding, he presented his new wife with the remaining 150 pearls.[67] Eyewitness accounts note that Eleonora arrived at the port of Pisa wearing a pearl necklace, likely made with the fifty pearls she received from Cosimo I.

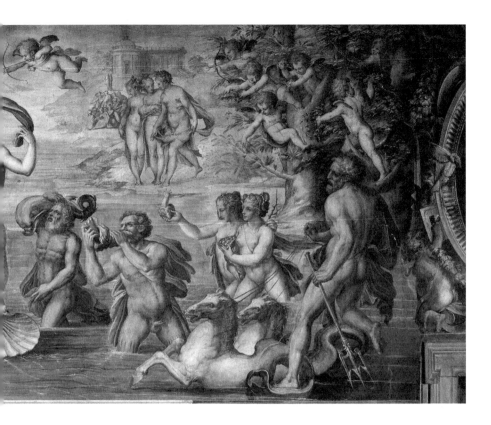

Florentine goldsmiths, such as Benvenuto Cellini, affixed the other 150 pearls to charming adornments.[68] Some, if not all, of these pearls appear in Agnolo Bronzino's portrait of *Eleonora of Toledo and Her Son Giovanni de' Medici* (Fig. 101), painted around 1544. The duchess wears a long necklace of grape-sized pearls, a pearl choker, pearl earrings, a gold-and-pearl snood, and a gold shoulder net ornamented with pearls. Finally, strands of tiny pearls dangle, like a tassel, from her emerald, diamond, and ruby girdle.

Eleonora de Toledo's connections to Spain may have aided in the court's procurement of pearls, which were among the prized treasures discovered in the New World. In a 1543 letter, Bernardo

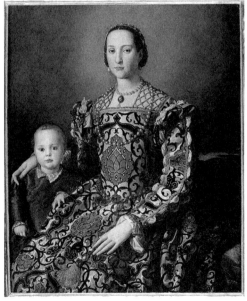

101 Agnolo Bronzino, *Eleonora of Toledo and Her Son Giovanni de' Medici*, 1544, Gallerie degli Uffizi, Florence, Italy. Photo: akg-images / Rabatti & Domingie

Alberti informs Eleonora of the arrival in Livorno of two ships from Cadiz, Spain that are carrying pearls and pearl powder.[69] In May 1548, the Duchess requests that pearls and gold thread be sent to Antonio Bacchiacca for the embroidery of some pillows.[70] Eleonora's desire to possess these rare and luxurious gems is acknowledged in an anecdote found in Benvenuto Cellini's *Biography*, in which the Duchess begs the goldsmith to convince Cosimo to purchase a string of pearls for her. Cellini resists her pleas at first, arguing that the pearls are defective, describing them as "not jewels" but rather "fishes' bones" that "suffer with time."[71] To keep the graces of the Duchess, however, Cellini speaks to Cosimo, who also perceives their flaws and refuses to purchase them. In the midst of the conversation, the Duke makes a telling statement, declaring that he does, in fact, "need such things, not so much for the Duchess as in connection with my arrangements for my sons and daughters."[72] In this passage, Cosimo likely refers to the wedding arrangements of his children, which required pearls and other gems for dowries and counterdowries. Letters within the Medici archives document Cosimo I's pursuit of pearls, his careful selection of them, and his borrowing of money for their purchase.[73] Reports include news of false pearls coming from Spain to Livorno, the discovery of a river in Peru suitable for pearl fishing, and the mention of an engineer who invented a machine that could be used for pearl fishing.[74]

The other great gem of the sea that the Nereids and Tritons offer Venus in Vasari's Sala degli Elementi fresco (Fig. 100) is coral. In the sixteenth century, red coral (*Corallium rubrum*) was harvested along the coasts of Tunisia, Naples, Sardinia, and the Tuscan Archipelago.[75] Prior to the eighteenth century (when the animal nature of coral was discovered), the marine organism's status wavered between a plant and a stone. In Marsilio Ficino's *Three Books on Life* and in the *Picatrix*, coral is listed as a Venusian material alongside other minerals and gemstones, such as carnelian, sapphire, lapis lazuli, and malachite.[76] Coral possessed several Venusian virtues. According to Camillo Leonardo's *Speculum lapidum*, printed in Venice in 1502, coral is beneficial for the heart and stomach as well as for the pain of kidney stones.[77] Pliny writes that it restores vision and heals scars of the flesh.[78] In his popular eleventh-century lapidary, Marbode Bishop of Rennes connects coral to fertility, explaining that it is hung in vineyards and olive trees or crushed and spread throughout fields to ensure fertility and multiply fruit. He also praises the apotropaic powers of this mineral, which repels evil spirits, demonic fantasies, tempests, and typhoons.[79]

Throughout his tenure as Duke, Cosimo I displayed an avid interest in coral. The earliest letters describe his encounters with the Genoese Admiral Andrea Doria over coral supplies and taxation.[80] From May to September 1550, Cosimo hatched a plan with a merchant named Giovanni Gallego to procure

a Florentine license to collect coral from Tabarka, Tunisia in order to replace the Genoese stronghold in this area.[81] Tabarka, which is still famous today for its red coral, held some of the largest reserves of coral in the Mediterranean during the sixteenth century. In a letter of June 16, 1550, Luigi Arnoldi provided Cosimo with a summary of the contractual obligations established between the Genoese merchants and King Charles V with regard to coral trade.[82] Florentine merchants were then directed to go to Milan and meet with Ferrante I Gonzaga to procure licenses for coral fishing. Following the meeting, steps were made in September 1550 to defend the island of Tabarka.[83] Documents reveal that by 1552, Cosimo had developed a fleet of coral fishing ships, and in 1564 ships from Tabarka arrived carrying 200 boxes of coral.[84] Duke Cosimo developed further connections with the coral fishing industry when he took control of the Sienese Maremma coast, which was rich in coral, tuna, and seashells.[85] Cosimo's dealings with coral continued into the 1570s. After purchasing the Isola del Giglio, the Duke reserved the right to collect coral in the waters surrounding the island.[86] In October 1571, he "authorized" payments to coral workers, who cleaned and worked the material in Pisa.[87] Another letter in the Medici archives even reveals his desire to manufacture coral and marble with alchemy.[88]

During the sixteenth and seventeenth centuries, coral was a luxury item, particularly in Northern Europe, where merchants paid high prices for boxes of Italian coral.[89] Large branches (Fig. 102) were among the most desirable forms of the aquatic organism because they could be mounted and displayed as sculptures. Small branches could be alloyed with gold or silver connectors and then hung as talismans from chains or beaded necklaces. In Bronzino's *Portrait*

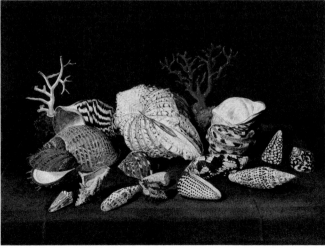

102 Jacques Linard, *Still Life with Shells and Corals*, 1630s, Fondation Custodia. Photo: Album / Alamy Stock Photo

of Giovanni de' Medici (Fig. 99), the son of Cosimo and Eleonora wears a gold chain ornamented with a branch of red coral. As a natural wonder, coral also featured prominently in cabinets of curiosities. A number of branches appear in an inventory of June 1574 describing the contents of the *studiolo* of Francesco de' Medici, Cosimo's son and heir. It is likely that some of these coral branches are displayed today in the Museo degli Argenti of the Palazzo Pitti, Florence. In addition to branches, Francesco's collection included smaller coral pieces as well as coral carved into a "crucifix and other figures."[90] Letters reveal that the material was also collected for display in garden fountains, which merged nature and artifice in highly original ways.[91]

In Francesco I's *studiolo* of the four elements in the Palazzo Ducale (Palazzo Vecchio), Venus' gifts from the sea are presented in the paintings that line the wall dedicated to water. Alessandro Allori's *Pearl Fishing* (Fig. 103) shows divers jumping off cliffs to hunt for pearls, while a beautiful nude female – possibly Venus – collects the iridescent gems and a variety of mollusk shells in the painting's foreground. In a letter to Vasari, Raffaello Borghini instructs that this scene should include "marine nymphs and Tritons" similar to those in the Sala degli Elementi, "which should be very playful and sensuous."[92] In addition to *Pearl Fishing*, Allori painted the tale of Cleopatra dissolving a prized pearl in vinegar to prove to Marc Antony that she could throw the most expensive banquet in history.[93] A third painting in this triad is Francesco del Coscia's depiction of Juno taking the magical cestus from Venus in order to charm the wandering eyes of Jupiter. Other works on the water wall include the acquisition of ambergris from a whale, the discovery of Tyrian dye from the murex snail, the myth of coral's origin from the blood of Medusa's severed head, and Alexander the Great awarding his mistress Campaspe to Apelles (Fig. 90).[94] Finally, a bronze sculpture of *Venus Anadyomene*, rising from the sea and wringing sea foam from her tresses, was installed above these paintings, which celebrate the origins of her aquatic treasures. Vincenzo Danti's small bronze sculpture differs from the earlier, more static *Venus Anadyomene* of Zanobi Lastricati and relates more closely to the new sculpture of *Venus Anadyomene Called Fiorenza*, designed and cast by Giambologna between 1571 and 1572 for the marble candelabra fountain at Castello.[95]

It was likely due to Giambologna's position as the foremost sculptor in Florence during the 1570s that he was asked to design and cast a new *Venus Anadyomene* (Fig. 104) to replace the older one by Lastricati. The art of bronze casting in Florence had advanced since 1550 (when Lastricati completed his work), and Giambologna's new sculpture reveals these achievements. The proliferation of bronze statues and statuettes in Florence during the second half of the sixteenth century may be due, in part, to Duke Cosimo I's success at procuring copper. Letters in the Medici archives reveal that the Duke actively pursued and oversaw copper extraction from mines in Pietrasanta, Carrara,

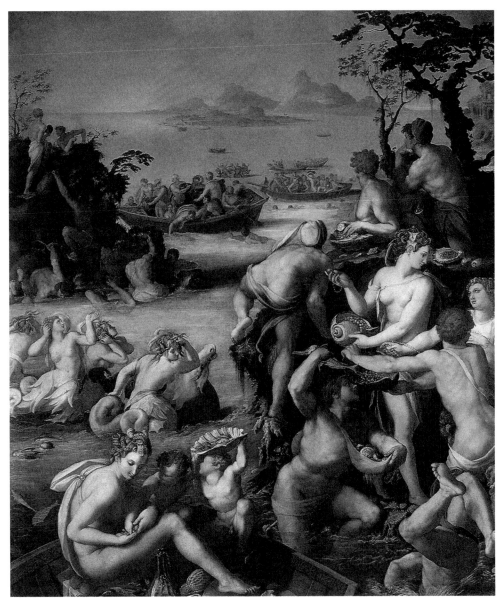

103 Alessandro Allori, *Pearl Fishing*, 1573, Studiolo of Francesco I, Palazzo Vecchio, Florence, Italy. Photo: Universal Images Group North America LLC / Alamy Stock Photo

Montecatini, and as far south as Campiglia Marittima.[96] Cosimo I's acquisition of copper from Florentine territories could have contributed to the increase in commissions for bronze sculptures.

The use of bronze rather than marble for the *Venus Anadyomene* depends, in part, on the sculpture's function in the fountain's waterworks. Its material also correlates with Venus' astrological governance of copper, the primary metal in bronze alloys. In the glosses appended to his *Book of Theseus*, Giovanni

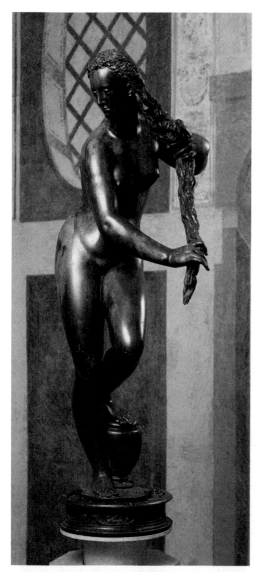

104 Giambologna, *Venus Anadyomene Called Fiorenza*, frontal view, ca. 1570–72, originally from the Villa Castello, now at the Villa La Petraia, Sesto Fiorentino, Italy. Photo: Scala / Ministero per i Beni e le Attività culturali / Art Resource, NY

Boccaccio explains that copper is "born of the planet Venus" and shares three properties related to her "effects." The first is its shiny appearance. The second is its very sweet sound. The third is that copper "solders and joins and binds every other metal." According to Boccaccio, this property is among the effects of Venus because "it is through her influence that all conjunctions happen to be made, and especially when conjunction is needed for procreation."[97] The ability of copper to join easily with other metals explains its use in bronze alloys. In one of his notebooks, Leonardo da Vinci jotted down a recipe for a mold or bronze patina that includes copper as one of its primary ingredients. He identifies the metals in the recipe by their ruling planetary deities rather than by their common names: Venus = copper; Jupiter = tin; Saturn = lead; Mercury = mercury. The entry reads,

> The mold (or patina) may be of Venus, or of Jupiter and Saturn and placed frequently in the fire. And it should be worked with fine emery and the mold (or patina) should be of Venus and Jupiter impasted over Venus. But first you will test Venus and Mercury mixed with Jove and take means to cause Mercury to disperse; and then fold them well together so that Venus or Jupiter be connected as thinly as possible.[98]

Leonardo's recipe illustrates the artistic association between Venus and copper as well as the prevalence of the metal in the forging of bronze materials.

The cosmological correlations between Venus and copper may have inspired Tribolo or Lastricati to cast the Villa of Castello's *Venus Anadyomene Called Fiorenza* in bronze. Tribolo established a similar relationship between material

and subject matter in his sculpture of the *Allegory of Fiesole* (Fig. 105), also for the Villa of Castello. Personified as Diana holding a crescent moon, *Fiesole* is carved out of *pietra serena* or sandstone, the native stone of Florence's neighboring city. In the fifteenth-century *cassone* panel depicting Boccaccio's *Nymph of Fiesole* (Fig. 19), Diana sits within one of the sandstone or *pietra serena* caves that defines Fiesole's landscape. In the *Venus Anadyomene Called Fiorenza*, Venus' body is cast from bronze, a shinier and more expensive material than *pietra serena*. The change in materials may suggest Florence's dominance over Fiesole; it may also reference the wider geographical span of Tuscany. With exposure to air and water, the copper component in *Fiorenza*'s bronze body changes from a chocolate brown to a grassy green. This color conversion literalizes the trans-

105 Niccolò Tribolo, *Allegory of Fiesole*, ca. 1540s, originally from the Villa Castello, now at the Museo Nazionale del Bargello, Florence, Italy. Photo: Alinari / Art Resource, NY

formation of the Tuscan landscape in the spring, when its rolling hills become verdant. Cast in costly bronze, Giambologna's statue of *Venus Anadyomene Called Fiorenza* (Fig. 104) – washed by the waters of the Arno and Mugnone rivers – epitomizes the fertility of the Tuscan countryside and the city of Florence, both of which flourished under Duke Cosimo I's rule.

Perched atop the white marble candelabra fountain (Fig. 92), Giambologna's *Venus Anadyomene Called Fiorenza* stands in an elegant *contrapposto* with her left foot placed on a vase, an attribute that may refer to the villa's location near the ancient reservoir that collected water from the springs nearby. As Venus reaches across her body to wring water from these springs, she initiates a graceful spiral – a true *serpentinata* pose translated into a three-dimensional space. For the figure not only rises vertically in an S-shaped undulation but also laterally: as the bent right knee projects forward, the hips move backward, and the torso, neck, and head curve forward. This curvature of the body along with the opposing position of the arms leaves no part of sculpture on the same plane. Giambologna denies a central frontal view and encourages the viewer to move around the figure, following the circular shape of the basin and the enclosing labyrinth of fragrant evergreens (Fig. 94).

As the viewer circles the sculpture, the views change, most significantly in relation to *Venus*' face and gaze. From the front, the graceful contours of her

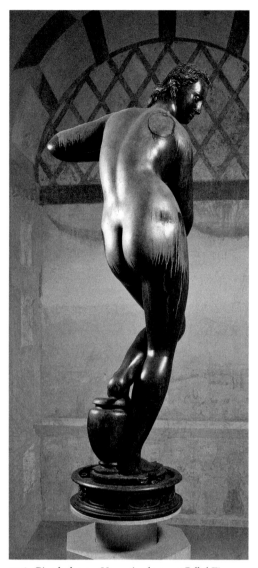

106 Giambologna, *Venus Anadyomene Called Fiorenza*, back view, ca. 1570–72, originally from the Villa Castello, now at the Villa Medicea della Petraia, Sesto Fiorentino, Italy. Photo: Gabinetto Fotografico delle Gallerie degli Uffizi

pudenda and breasts are visible. Moving around to the left and following the direction of her arms, the S-shaped curve of her body is most prominent. From this angle, Giambologna produces a melodic symmetry with the female's long flowing hair echoing the elegant bend of her torso and upper thigh. From behind (Fig. 106), her long curving back comes into view and then, almost suddenly, her face as she looks over her right shoulder. All at once, the viewer is "caught" gazing upon her body. The delineated oval visible on the back of the sculpture relates to the fountain's hydraulics and denotes the position of the original pipe, which ran down Venus' extended right arm and allowed water to flow from her long tresses. In the garden of the labyrinth, the nude body of *Venus Anadyomene Called Fiorenza* could be seen from all sides, as in the famous circular temple of the goddess on Knidos.[99] Standing above a fountain filled with aquatic imagery, the goddess emerges from the sea; the fluid form of her nude body washed by the waters of the Arno and Mugnone epitomizes the purity and fertility of Florence's geography.

During his tenure as the Duke of Florence and the Grand Duke of Tuscany, Cosimo I worked assiduously to discover and acquire the natural resources of his growing empire on both land and water. The figure of *Venus Anadyomene* triumphantly proclaimed his maritime might and Florence's liquid fertility in the semi-public spaces of the Villa of Castello and Palazzo Ducale (Palazzo Vecchio). The goddess also established important visual and political connections with Imperial Rome, specifically Julius Caesar and Augustus. Duke Cosimo I appealed to the goddess for her sway over the sea and its treasures – including ambergris, coral, and pearls – more than for her dominance over the verdant Tuscan valley and the city's rich silk industry, which had been foregrounded in

Botticelli's mythologies. The political implications of this *Venus Anadyomene* took precedence over some of the goddess's more sensual powers, particularly as they related to deviant sexual desires. Cosimo I's enjoyment of sexuality flourished within the confines of an affectionate and fruitful marriage, which produced eleven children before his beloved Eleonora tragically and unexpectedly died of malaria in Pisa in 1562. Eventually remarrying, Cosimo continued to pursue the most fundamental of Venusian devotions with the same zeal that he brought to his quest for coral. A letter written in January 1573, a little more than one year before his death, reveals that the ailing Duke and his new wife Camilla Martelli, who were residing at the Villa Castello, were not abstaining from "Venere," much to the dismay of his medical advisors.[100]

NOTES

1 "Cingula Cymothoë, rarum Galatea monile / et gravibus Psamathe bacis diadema ferebat / intextum, Rubro quas legerat ipsa profundo. / mergit se subito vellitque corallia Doto: / vimen erat dum stagna subit; processerat undis: / gemma fuit. // Nudae Venerem cinxere catervae / plaudentesque simul tali cum voce sequuntur: / 'hos Mariae cultus, haec munera nostra precamur / reginae regina feras [. . .] / devotum sentiat aequor, / agnoscat famulum virgo Stilichonia pontum'." Claudian, *Panegyric on Probinus and Olybrius. Against Rufinus 1 and 2. War against Gildo. Against Eutropius 1 and 2. Fescennine Verses on the Marriage of Honorius. Epithalamium of Honorius and Maria. Panegyrics on the Third and Fourth Consulships of Honorius. Panegyric on the Consulship of Manlius. On Stilicho's Consulship 1*, trans. M. Platnauer, Loeb Classical Library 135 (Cambridge, MA: Harvard University Press, 1922), 254–55, lines 166–77.

2 "Aeneadum genetrix, hominum divomque voluptas, / alma Venus, caeli subter labentia signa / quae mare navigerum, [. . .] / tibi suavis daedala tellus / summittit flores, tibi rident aequora ponti / placatumque nitet diffuso lumine caelum." Lucretius, *De rerum natura*, trans. W. H. D. Rouse, Loeb Classical Library 181 (Cambridge, MA: Harvard University Press, 1875), Book 1, 2–3, lines 1–3, 7–9.

3 "And yet Alexander conferred honor on him [Apelles] in a most conspicuous instance; he had such an admiration for the beauty of his favorite mistress, named Pancaspe, that he gave orders that she should be painted in the nude by Apelles, and then discovering that the artist while executing the commission had fallen in love with the woman, he presented her to him … Some persons believe that she was the model from which the Aphrodite Anadyomene (Rising from the Sea) was painted." Pliny, *Natural History, Volume IX: Books 33–35*, trans. H. Rackham, Loeb Classical Library 394 (Cambridge, MA: Harvard University Press, 1952), Book 35, 324–25.

4 "His [Apelles'] Aphrodite emerging from the Sea was dedicated by his late lamented Majesty Augustus in the Shrine of his father Caesar; it is known as the Anadyomene; this like other works is eclipsed yet made famous by the Greek verses which sing its praises." Pliny, *Natural History, Volume IX: Books 33–35*, Book 35, 328–29. Strabo writes, "And Aphrodite Anadyomene used to be there, but it is now dedicated to the deified Caesar in Rome, Augustus thus having dedicated to his father the female founder of his family. It is said that the Coans got a remission of one hundred talents of the appointed tribute in return for the painting." Strabo, *Geography, Volume VI: Books 13–14*, trans. Horace Leonard Jones, Loeb Classical Library 223 (Cambridge, MA: Harvard University Press, 1929), Book 14, 286–89.

5 In Pliny's entry on the mollusk, he writes, "within our memory the fish stayed the ship of the Emperor Gaius as he was sailing back from Astura to Antium … I do not doubt all this

kind of fish have the same power, since there is a famous and even divinely sanctioned example in the temple of the Cnidian Venus, where snails too, we are forced to believe, have the same potency. Of the Roman authorities some have given this fish the Latin name of *mora*, and a marvel is told by some Greeks, who have related, as I have said, that worn as an amulet it arrests miscarriage, and by reducing procidence of the uterus allows the foetus to reach maturity; others say that preserved in salt and worn as an amulet it delivers pregnant women; this being the reason why another name, *odinolytes*, is given to it." Pliny, *Natural History, Volume VIII: Books 28–32*, trans. W. H. S. Jones, Loeb Classical Library 418 (Cambridge, MA: Harvard University Press, 1963), Book 32, 466–69.

6 "It is established that small pearls of poor color grow in Britain, since the late lamented Julius desired it to be known that the breastplate which he dedicated to Venus Genetrix in her temple was made of British pearls." Pliny, *Natural History, Volume III: Books 8–11*, trans. H. Rackham, Loeb Classical Library 353 (Cambridge, MA: Harvard University Press, 1940), Book 9, 242–43. Marleen B. Flory argues that Caesar's dedication of this gift of a pearl breastplate in the temple of Venus was intended to vie with Pompey's famous display of pearls in his triumph of 61 BCE after his conquests in the East, which included thirty-three pearl crowns and a portrait of himself fashioned from pearls. Pompey also built a temple to Venus Victrix; see Marleen B. Flory, "Pearls for Venus," *Historia: Zeitschrift für Alte Geschichte* 37 (1988): 498–500.

7 Bronzino created the *Primavera* cartoon between 1544 and 1545, and the tapestry was woven in Cosimo I's new tapestry atelier run by the Flemish master Jan Rost. The *Primavera* was delivered on May 15, 1546. For a discussion of the tapestry's iconography, see Janet Cox-Rearick, "Themes of Time and Rule at Poggio a Caiano: The Portico Frieze of Lorenzo il Magnifico," *Mitteilungen des Kunsthistorischen Institutes in Florenz* 26 (1982): 167–210; Lynette M. F. Bosch, "Time, Truth, and Destiny: Some Iconographical Themes in Bronzino's *Primavera* and *Giustizia*," *Zeitschrift für Kunstgeschichte* 73 (1983): 73–82. The tapestry is also discussed in Lucia Meoni's catalogue entry (no. 8) in *The Myth of Venus*, ed. Maria Sframeli (Milan: Silvana, 2003), 84–85. For Cosimo's introduction of tapestry weaving into Florence, see Lucia Meoni, *Gli arazzi nei musei fiorentini. La collezione medicea* (Livorno: Sillabe, 1998), 35–61; Thomas P. Campbell, *Tapestry in the Renaissance: Art and Magnificence* (New Haven, CT: Yale University Press, 2002), 493–504.

8 Cosimo I's maritime interests are well documented in the Medici Archives. The following documents record specific developments in this area. A letter dated July 7, 1543 communicates that Chiarissimo de' Medici has secured the Fortress of Livorno in the name of the duke: "Chiarissimo [de' Medici] per la volta di Livorno a pigliare il possesso di quella Fortezza et consegnarla poi a nostro nome al Cap.no Giovanni di Lodron, quale habbiamo deputato per castellano di essa, et non s'è mancato di [inviare] conveniente merzede a Giovanni Pasquier et una paga per li soldati suoi." Bia, Doc ID# 3905 (ASF, MdP 5, fol. 217). A letter of August 9, 1543 mentions work needing to be carried out on the Porta al Mare in Pisa: "Sì come per l'altra s'è scritto del Baloardo [Baluardo] Stampace [Cittadella Vecchia], et alla Porta alle Spiagge [Porta Mare], di nuovo dico ch'è necessario repararli gagliardamente, de' ripari puoi che per adesso non si può con il murare. Et di questo se spetta la commissione che non è mai venuta." Bia, Doc ID# 2158 (ASF, MdP 362, fol. 94). A letter of May 4, 1548 reports on construction progress at the fortress of Portoferraio on Elba: "Il forte dell'Elba [Portoferraio], secondo l'ultimi avisi, era tanto innanzi che fra X giorni sarà in termine di guardarsi alla barba di genovesi, e quali si sono non solo raffredati di quella lor furia et caldezza, ma ancora agghiacciati di maniera che non si moveranno a far pazzie." Bia, Doc ID# 6369 (ASF, MdP 1170a, fol. 718). A letter of October 4, 1552 indicates Cosimo I's plans to fortify Port'Ercole, Grosseto, and Orbetello: "Parmi sia risoluto di fortificare Port'Hercole et Grosseto. La spesa di Port'Hercole sarà un 3 mila scudi e si fara prima di quella di Grosseto per essere maggiore ... A Orbatello hanno pensato di fare un forte in su quella striscia di terra presso al castello nel luogo che è chiamato il pozo ... Stasera è arrivato qui parte de le celate che vengano da Parma, quale si pensa anderanno in Maremma." Bia,

Doc ID# 8416 (ASF, MdP 1851, fol. 114). Another document, dated October 1, 1558, witnesses the sale of the Isola del Giglio to Eleonora de Toledo: "A requisitione et instantia del S.or Amb.re [Bongianni Gianfigliazzi] dell'Ecc.a del S.or Duca di Fiorenza [Cosimo I] qui in Roma, noi Don Indico Piccolomini d'Aragonia, marchese di Capestrano, facciamo fede come essendosi tra noi trattata la vendita del Giglio et Castiglione della Pescaia, terre della S.ra Marchesa mia consorte [Silvia di Pietro Francesco Piccolomini] a l'Ecc.a della S.ra Duchessa di Fiorenza [Eleonora de Toledo] siamo finalmente rimasti d'accordo del prezzo." Bia, Doc ID#8853 (ASF, MdP 2009, fol. 5).

9 A letter of March 11, 1561 reports that Cosimo I will be invested as Grand Master of the Order of the Knights of San Stefano: "Questa domenica S. Ex.za [Cosimo I] piglierà l'habito dei cavalieri di s.to Stephano, et così il dono della berretta et spada mandatogli da S. S.tà [Pius IV] per il S.r Giannotto Castiglioni. Et perché v'è indulgentia plenaria e chi si confesserà et comunicherà, credo che hoggi si farà ciò publicare, o in altro modo sparglierne la notitia. Il S.or Giannotto è ito stamani col S.r Nuntio a Livorno a vedere quelle galere di S. S.tà et tornerà stasera." Bia, Doc ID# 4191 (ASF, MdP 1212a, fol. 45).

10 In a letter of January 15, 1564, Jacopo Malatesta writes of Cosimo I's appointment as Governor to the Kingdom of Cyprus by the Venetian state: "Havendomi questi signori miei patroni eletto per Governator Generale del Regno di Cipro, et occorrendomi partir in breve con ottocento fanti, mi è parso mio debito con questa mia visitar V. Ecc.za Ill.ma [Cosimo I] et baciarle la mano." Bia, Doc ID# 3497 (ASF, MdP 503, fol. 154). In 1567, Cosimo sends instructions with regard to fortifications on Cyprus; see Bia, Doc ID# 17454 (ASF, MdP 225, fol. 126).

11 For information on the *Neptune* fountain, see Henk Th. van Veen, *Cosimo I de' Medici and His Self-Representation in Florentine Art and Culture*, trans. Andrew P. McCormick (New York: Cambridge University Press, 2006), 103–16; Felicia Else, "'La Maggior Porcheria Del Mondo': Documents for Ammannati's Neptune Fountain," *Burlington Magazine* 147 (2005): 487–91; Felicia Else, "Bartolomeo Ammannati: Moving Stones, Managing Waterways, and Building an Empire for Duke Cosimo I de' Medici," *Sixteenth Century Journal* 42 (2011): 393–425; Felicia Else, *The Politics of Water in the Art and Festivals of Medici Florence: From Neptune Fountain to Naumachia* (London: Routledge, 2018), 13–112. Cosimo I also used Neptune imagery for the *Entrata* planned for his son Francesco I's marriage to Giovanna of Austria; see Randolph Starn and Loren Partridge, *Arts of Power: Three Halls of State in Italy, 1300–1600* (Berkeley: University of California Press, 1992), 179–80, 277–78.

12 Vasari describes Botticelli's two painting at Castello, writing, "For various houses throughout the city he painted round pictures, and many female nudes, of which there are still two at Castello, a villa of Duke Cosimo's; one representing the birth of Venus, with those Winds and Zephyrs that bring her to the earth, with the Cupids; and likewise another Venus, whom the Graces are covering with flowers, as a symbol of spring; and all this he is seen to have expressed very gracefully." ("Per la città, in diverse case fece tondi di sua mano, e femmine ignude assai; delle quali oggi ancora a Castello, villa del Duca Cosimo, sono due quadri figurati, l'uno, Venere che nasce, e quelle aure e venti che la fanno venire in terra con gli Amori; e così un'altra Venere, che le Grazie la fioriscono, dinotando la primavera; le quali da lui con grazia si veggono espresse.") Giorgio Vasari, *Le vite de più eccellenti pittori scultori ed architettori scritte*, ed. Gaetano Milanesi, vol. 3 (Florence: G. C. Sansoni, 1878), 312; for English text, see Giorgio Vasari, *Lives of the Most Eminent Painters, Sculptors, and Architects*, trans. Gaston du C. de Vere (London: Macmillan, 1912), 248.

13 Upon the death of Andrea di Lotteringo della Stufa in 1477, Lorenzo and Giovanni di Pierfrancesco de' Medici, the nephews of Cosimo il Vecchio, acquired the Villa at Castello. In 1510, Giovanni delle Bande Nere (the only son of Giovanni di Pierfrancesco and his wife Caterina Sforza) inherited the property, which was then passed on to his son Cosimo, the future Duke of Florence. For a history of Castello, see David Roy Wright, "The Medici

Villa at Olmo a Castello: Its History and Iconography" (PhD diss., Princeton University, 1976), 13–15.

14 Vasari describes the aqueduct at Castello: "che viene da uno acquidotto antico fatto da'Romani per condurre acque da Valdimarina a Firenze." Vasari-Milanesi, *Le vite*, vol. 6, 73; Vasari-De Vere, *Lives*, vol. 7, 16.

15 In his fourteenth-century biography of Florence, Giovanni Villani celebrates the aqueduct as one of the three monuments erected by the Romans at the time of the city's foundation. The other two are the Baptistery, believed to be a temple to Mars, and an amphitheater. For Villani's discussion of the aqueduct, see Janet Ross, *Florentine Villas* (New York: Dutton, 1901), 67; Claudia Lazzaro, *The Italian Renaissance Garden* (New Haven, CT: Yale University Press, 1990), 167–68. Vasari depicted the aqueduct's construction, which includes portraits of Augustus, Marc Antony, and Lepidus, in his painting of *The Foundation of Florence* for the Sala Grande of the Palazzo Vecchio. For Vasari's painting, see Nicolai Rubinstein, "Vasari's Painting of *The Foundation of Florence* in the Palazzo Vecchio," in *Essays in the History of Architecture Presented to Rudolf Wittkower*, ed. Douglas Fraser, Howard Hibbard, and Milton J. Lewine, vol. 1 (London: Phaidon, 1967), 64–73.

16 In 1572, Mario Matasilani mentions the miraculous blooming at Castello in his biography of the Duke: "Per segno dell'imperio, che dovea conseguire, il suo Giardino nella villa di Castello, solo fra tutti gl'altri, essendo del Mese di Gennaio, era tutto fiorito con miracolosa abbondanza d'ogni sorte fiori, quando le piante de i poderi vicini pareva, che fossero ancora tutte intirizzate d'un continovato freddo." Mario Matasilani, *La felicità del serenissimo Cosimo Medici granduca di Toscana* (Florence: Giorgio Marescotti, 1572), 28. In his *Storia Fiorentina* written between 1527 and 1530, Benedetto Varchi also recounts the spring-like weather in Florence, noting that supporters for and opponents against Cosimo interpreted it in different ways. He states that "all over there was beautiful spring-like weather, of the manner in which the fields flower as in spring; an occasion which allowed the *fuorusciti* to say that the heaven and earth were in celebration over the death of Alessandro, and to the others, this was a most happy sign of fortune that the earth and sky gave for the election of Signor Cosimo." ("In tutta quella vernata andarono tempi bellissimi, di maniera che i prati fiorirono come quasi di primavera; il che diede occasione di dire a' fuorusciti, che ciò avveniva per la molta festa che faceva il cielo e la terra della morte d'Alessandro, ed agli altri, questi esser felicissimi segni ed augurii che ne dava la terra e'l cielo per la creazione del signor Cosimo.") Benedetto Varchi, *Storia Fiorentina*, ed. Gaetano Milanesi, vol. 3 (Florence: Felice Le Monnier, 1888), 222.

17 The fourth-century astrologer Firmicus Maternus notes that "whoever has the ascendant in the first degree of Capricorn will be a king or emperor." Firmicus Maternus, *Matheseos Libri VIII*, trans. Jean Rhys Bram (Park Ridge: Noyes Press, 1975), 294. Piero Valeriano (1477–1558) wrote that the Capricorn portended *felicitas*, saying, "The sign of Capricorn, which we see on many medals of Caesar Augustus, portends (as the Astrologers say) the highest happiness [good fortune] to those, who are born under it." ("Il segno di Capricorno, il qual vediamo in molte medaglie di Cesare Augusto, augurando [come dicono gl'Astronomi] somma felicita a quegli, che son nati sotto di lui.") Piero Valeriano, *Hieroglyphica* (Basel: Per Thomam Guarinum, 1567), 798.

18 Aldo Mannucci, a biographer of the Duke, wrote in 1586, "Cosimo esteemed highly the prediction of the stars observed by the mathematician Don Basilio, who had demonstrated to him his future rule on the Capricorn, which he had in the ascendant with a fortunate aspect of the other planets just as Augustus had had, and more recently Charles V." ("Ma più certo stimava il presagio delle stelle, osservate dal Matematico D. Basilio, il quale gli aveva la futura grandezza mostrata pel Capricorno, ch'egli aveva nell'ascendente con felicissimo aspetto guardato da' pianeti, come aveva avuto già Augusto, e novellamente Carlo Quinto.") Aldo Mannucci, *Vita di Cosimo de' Medici Gran Duca di Toscana* (Pisa: presso Niccolò Capurro co'caratteri di F. Didot, 1823), 50–51.

19 In his *Dialogo del imprese*, Paolo Giovio notes the triumvirate use of the Capricorn as well as the fateful coincidence that Cosimo achieved victory at Montemurlo on the same day that Augustus defeated Marc Antony at Actium; see Paolo Giovio, *Dialogo del imprese militari et amorose* (Lyon: Guglielmo Rouillio, 1574), 32–33. In his biography of the Duke, Matasilani constructs an extended metaphor comparing Cosimo to Augustus, concluding that "the signs and successes (as I have related of Grand Cosimo) are equal with those of Octavian Augustus . . . and the people of Tuscany enjoy that peace and security that was provided to all the world under the Empire of Octavian." ("Si come per i segni, & successi (com'hò detto del Gran Cosimo) che sono eguali con quelli di Ottaviano Augusto, . . . & i popoli di Toscana d'havere à goder quella pace, & sicurezza, che fu concessa à tutto il mondo sotto l'Imperio di Ottaviano.") Matasilani also compares Cosimo's victory at Montemurlo to Augustus' defeat of Marc Antony; see Matasilani, *La felicità del serenissimo Cosimo Medici*, 2–14, for quote, 14.

20 In the *Fasti*, Ovid discusses Venus' role as the sovereign of April, connecting her position specifically to Caesar's claim of divine ancestry from the goddess and the notion of Venus as the mother of Rome via her generation of Aeneas. He also explains her position in relation to the etymology of April, which signifies the opening of all things in spring; see Ovid, *Fasti*, trans. James G. Frazer, rev. G. P. Goold, Loeb Classical Library 253 (Cambridge, MA: Harvard University Press, 1931), Book 4, 188–97.

21 For Augustus' use of Venus, see Paul Zanker, *The Power of Images in the Age of Augustus* (Ann Arbor: University of Michigan Press, 1990), 35–98; Richard Ulrich, "The Temple of Venus Genetrix in the Forum of Caesar in Rome: The Topography, History, Architecture, and Sculptural Program of the Monument" (PhD diss., Yale University, 1984); Eve D'Ambra, "The Calculus of Venus," in *Sexuality in Ancient Art: Near East, Egypt, Greece, and Italy* (Cambridge: Cambridge University Press, 1996), 219–26.

22 Pontormo's frescos are no longer extant. For the program, see Janet Cox-Rearick, *Dynasty and Destiny in Medici Art: Pontormo, Leo X and the Two Cosimos* (Princeton, NJ: Princeton University Press, 1984), 258–69.

23 Vasari describes the statue: "Upon that shaft it was the intention of Tribolo to place a bronze statue three *braccia* high, representing Florence, in order to signify that from the above-named Mounts Asinaio and Falterona the waters of the Arno and Mugnone come to Florence, of which figure he had made a most beautiful model which, pressing the hair with the hands, caused water to pour forth." ("Sopra il quale piede era d'animo il Tribolo che si ponesse una statua di bronzo alta tre braccia, figurata per una Fiorenza, a dimostrare che dai detti monti Asinaio e Falterona vengono l'acque d'Arno e Mugnone a Fiorenza: della quale figura aveva fatto un bellissimo modello, che spremendosi con le mani i capelli ne faceva uscir acqua.") Vasari-Milanesi, *Le vite*, vol. 6, 79; Vasari-De Vere, *Lives*, vol. 7, 22. In a letter of 1543, the Florentine writer Niccolò Martelli also wrote of this fountain, "in the middle resides a Florence above a fountain of the whitest marble . . . and these rivers meet in the middle of the labyrinth, where the beautiful Florence is, dividing her waters with amazing majesty." ("Nel mezzo del quale risiede una Fiorenza sopra una fonte di bianchissimo marmo sì pulito e terso, . . . et questi due fiumi, versando i vasi delle lor vene principali, mettano in mezzo il laberinto, dove è la bella Fiorenza, compartendo l'acque loro con mirabil magistero.") Niccolò Martelli, *Lettere*, ed. Cartesio Marconcini (Lanciano: R. Carabba, 1916), 22–23.

24 For scholarship on the garden's decorative program, see Claudia Conforti, "Il giardino di Castello come immagine del territorio," in *La città effimera e l'universo artificiale del giardino: la Firenze dei Medici e l'Italia del'500*, ed. Marcello Fagiolo (Rome: Officina, 1980), 152–61; Claudia Conforti, "L'invenzione delle allegorie territoriali e dinastiche del giardino di Castello a Firenze," in *Il giardino come labirinto della storia* (Palermo: Centro studi di storia e arte dei giardini, 1984), 190–97; Claudia Conforti, "Acque, condotti, fontane e fronde: le provisioni per la delizia nella villa medicea di Castello," in *Teatro delle acque*, ed. Attilio Petruccioli and Dalu Jones (Rome: Elefante, 1992), 76–89; Claudia Conforti, "Il Castello

verde: il giardino di Castello, gli spazi del manierismo," *FMR* 12 (1993): 59–78; Cristina
Acidini Luchinat and Giorgio Galletti, *Le ville e i giardini di Castello e Petraia a Firenze*
(Ospedaletto: Pacini, 1992), 42–92; Giorgio Galletti, "Tribolo maestro delle acque dei
giardini," in *Niccolò detto il Tribolo tra arte, architettura e paesaggio*, ed. Elisabetta Pieri and Luigi
Zangheri (Poggio a Caiano: Comune di Poggio a Caiano, 2001), 151–60.

25 A vivid "eye-witness" account of the garden surrounding the shrine of Aphrodite's temple
at Knidos appears in Lucian's *Amores*: "And immediately, it seemed, there breathed upon us
from the sacred precinct itself breezes fraught with love. For the uncovered court was not
for the most part paved with smooth slabs of stone to form an unproductive area but, as was
to be expected in Aphrodite's temple, was all of it prolific with garden fruits. These trees,
luxuriant far and wide with fresh green leaves, roofed in the air around them. But more
than all others flourished the berry-laden myrtle growing luxuriantly beside its mistress and
all the other trees that are endowed with beauty. Though they were old in years they were
not withered or faded but, still in their youthful prime, swelled with fresh sprays.
Intermingled with these were trees that were unproductive except for having beauty of
their fruit – cypresses and planes that towered to the heavens and with them Daphne, who
deserted from Aphrodite and fled from that goddess long ago. But around every tree crept
and twined the ivy, devotee of love." Lucian, *Soloecista. Lucius or The Ass. Amores. Halcyon.
Demosthenes. Podagra. Ocypus. Cyniscus. Philopatris. Charidemus. Nero*, trans. M. D. Macleod,
Loeb Classical Library 432 (Cambridge, MA: Harvard University Press, 1967), 166–69.
Angelo Poliziano mentions myrtle, laurel, and cypress trees as growing on Cyprus; see
Angelo Poliziano, *The Stanze*, trans. David Quint (University Park: Pennsylvania State
University Press, 1993), 42–45, stanzas 81–85. Francesco Colonna describes Venus' shrine
on Cythera: "But first I admired on the bare banks beside the shore the tall, uniform
cypresses with their astringent, pitted cones, rising firmly to their heavy tops ... This
regular order continued round in a circle and was followed along the entire periphery of
the island. Then came a circle of pleasant flowering myrtle, lover of the babbling banks,
forever vowed and dedicated to the divine mother of amorous fires ... In the first section,
the grove was Daphnic, or laureated with many laurels." Francesco Colonna,
Hypnerotomachia Poliphili: The Strife of Love in a Dream, trans. Joscelyn Godwin (New
York: Thames & Hudson, 1999), 293–94.

26 Martelli writes, "E passando drento a detto palazzo vedrà poi dove si spazia un giardino
che Pafo, Gnido e Cipri e Delo non lo vidder tale, con up prato di fresca verzura."
Martelli, *Lettere*, 22. Pierre Belon describes this garden as follows: "Inizia una superficie
piana fatta a cerchio, piena di Cipressi e circondata da una siepe di Bosso simile a una
corona: frammisti ai Cipressi vi sono molti alberi piantati secondo un preciso ordine, come
Corbezzoli, Mirti, Allori, che, sempre Verdi, diffondono suoavi profumi e aggiungono
molta bellezza al luogo. Al centro di questa spianata circolare si trova una fonte artificiale
che schizza acqua da molti sottili fori e si prende gioco delle persone che non se
l'aspettano." Pierre Belon, *De neglecta stirpium cultura, atque earum cognitione libellus*, in
Exoticorum libri decem, ed. Charles de l'Écluse (Leiden: Officina Plantiniana, 1605), 242.
On Belon's trip to Florence, see Marie Boas, *Il Rinascimento scientifico 1450–1630* (Milan:
Feltrinelli, 1973), 47–48.

27 Giorgio Vasari notes that the trees of the labyrinth were laid out in a circle "so even and
grown with such beautiful order that they have the appearance of a painting done with the
brush" ("È nel mezzo di questo giardino un salvatico d'altissimi e folti cipressi, lauri e
mortelle, i quali girando in tondo fanno la forma d'un laberinto circondato di bossoli alti
due braccia e mezzo, e tanto pari e con bell'ordine condotti, che paiono fatti col pen-
nello"). Vasari-Milanesi, *Le vite*, vol. 6, 74; Vasari-DeVere, *Lives*, vol. 7, 17. In a letter to
Pier Francesco Riccio of October 24, 1544, Lorenzo Pagni mentions that Cosimo "was in
the garden for about an hour having rose bushes planted around the labyrinth" ("Questa
sera è stata [Cosimo I] nel giardino circa d'una hora a far piantar de' rosai intorno al
laberynto"). Bia, Doc ID# 7007 (ASF, MdP 1171, fol. 516).

28 The following letters in the Medici Archives reveal the activities of Cosimo I and his court at Castello. A letter of August 8, 1544 notes that Cosimo will dine that evening in the garden at Castello; see Bia, Doc ID# 2439 (ASF, MdP 1171, ins. 2, fol. 88). The Duke recovers from a "quartana" fever at Castello. He writes on October 9, 1544 that his recovery is due in part because he is at Castello and able to enjoy the sweet air of the garden, which has been adorned beautifully by Tribolo. ("Noi ci troviamo con queste benedette quartane [le quali] ci hanno levato il gusto et ci tengano [assai] fiacco et fastidiato, et ci stiamo a Castello dove habbiamo commodità di godere questa aria [proposed reading: molto] dolce et amena et [anco] questo giardino [che di già si trova] adornato [cancelled: hora mai] assai bene per le mani del Tribolo [Niccolò de' Pericoli].") Bia, Doc ID # 19941 (ASF, MdP 3, fol. 581). On this same day, Cosimo orders a firework show for Castello. Lorenzo di Andrea Pagni is to "shoot fireworks from his tower at Petraia towards Castello," and Tribolo is ordered to oversee the display; see Bia, Doc ID# 2441 (ASF, MdP 1171, fol. 259 Recto). In November of 1544, Cosimo is still at Castello recovering. It is noted in this letter that he spent more than an hour in the garden of the labyrinth watching the dwarf catch birds with his son Francesco and daughter Maria. ("Il duca ... questa sera è stato nel giardino più d'un'hora, dove il Nano, avendo teso i panioni a quelli bossi del laberinto [labirinto] di fuora, et havendo messoli appresso la sua civetta ha preso sei or otto uccellini con gran piacere di sua excellentia, ma molto maggiore delli signori don Francesco et donna Maria.") Bia, Doc ID# 6562 (ASF, MdP 1171, fol. 283 Recto). For a discussion of Cosimo and Eleonora's children growing up at Castello, see Caroline P. Murphy, *Murder of a Medici Princess* (Oxford: Oxford University Press, 2008), 19–33.

29 According to Bertha Wiles, the earliest extant example of the candelabrum type was made in 1506 by a group of Genoese sculptors, working under the direction of Agostino Salario, for the château of the Cardinal d'Amboise at Gaillon; see Bertha Wiles, *The Fountains of Florentine Sculptors and their Followers from Donatello to Bernini* (New York: Hacker Art Books, 1975), 23.

30 For documents pertaining to the mounting of the fountain's marble parts, see Cristina Acidini Luchinat, "La fontana di *Fiorenza* appunti di lettura iconografica e formale," in *Fiorenza in Villa*, ed. Cristina Acidini Luchinat (Florence: Alinari, 1987), 25–27.

31 During restoration of the fountain, a ring of marble was found between the caryatid base and festooned basin with the inscription on one side: NICOLO ALIAS TRIBOLO FIORENTINO and on the other: MDXXXXV, signifying that this section of the fountain was completed by Tribolo in 1545. A letter from Lorenzo Pagni to Pier Francesco Riccio supports this date, stating that "the foot and the basin of the fountain of the labyrinth are set up, and it looks good; its shaft will be carried out in order to give perfection to the said fountain" (ASF, MdP 376, fol. 129); transcribed by C. O. Tosi, "Cosimo I e la R. Villa di Castello," *L'Illustratore Fiorentino* 5 (1907): 33–46.

32 *The Greek Anthology, Volume V: Book 13: Epigrams in Various Metres. Book 14: Arithmetical Problems, Riddles, Oracles. Book 15: Miscellanea. Book 16: Epigrams of the Planudean Anthology Not in the Palatine Manuscript*, trans. W. R. Paton, Loeb Classical Library 86 (Cambridge, MA: Harvard University Press, 1918), Book 16, 262–63.

33 This poem is by Leonidas of Tarentum; see *The Greek Anthology*, vol. 5, Book 16, 264–65, poem 182.

34 This poem is by Julianus, prefect of Egypt; see *The Greek Anthology*, vol. 5, Book 16, 264–65, poem 181.

35 Vasari writes, "After which, taking the waters from the Arno and the Mugnone, and bringing them together under the level of the labyrinth by means of certain bronze pipes that were distributed in beautiful order throughout the whole space, he filled that whole pavement with very fine jets, in such a manner that it was possible by turning a key to drench all those who came near to see the fountain. Nor is one able to escape either quickly or with ease, because Tribolo made round the fountain and the pavement, in which are the

jets, a seat of grey-stone supported by lion's paws, between which are sea monsters in low relief." ("Poi prese l'acque d'Arno e Mugnone, e ragunatele insieme sotto il piano del laberinto con certe canne di bronzo che erano sparse per quel piano con bell'ordine, empiè tutto quel pavimento di sottilissimi zampilli, di maniera che, volgendosi una chiave, si bagnano tutti coloro che s'accostano per vedere la fonte; e non si può agevolmente nè così tosto fuggire, perchè fece il Tribolo intorno alla fonte ed al lastricato, nel quale sono i zampilli, un sedere di pietra bigia sostenuto da branche di leone tramezzate da mostri marini di basso rilievo.") Vasari-Milanesi, *Le vite*, vol. 6, 78–79; Vasari-De Vere, *Lives*, vol. 7, 21.

36 Niccolò Martelli describes the water jets in the labyrinth as "beautiful trickery," which "gives much laughter to others" ("Con bello inganno, si vede in un tratto, senza saper donde, gittar mille zampilli di acqua chiara e viva, con bei compartimenti intraversata, che, senza bagnarsi, non è possibile, chi non ha avuto prima le novelle, liberarsene, che non dia da ridere altrui: et tutto è stato ingegno e invenzion del Tribolo"). Martelli, *Lettere*, 22.

37 In August 1571, Don Garzía exported an entire fountain, which included a bronze figure, forty blocks of marble, jasper for the two circular *tazze*, the octagonal basins, and the shafts. The ensemble was shipped from Florence to Alicante and then taken to the royal summer palace at Aranjuez near Madrid. For analysis and documents, see Antonia Boström, "A New Addition to Zanobi Lastricati: Fiorenza or the Venus Anadyomene: The Fluidity of Iconography," *The Sculpture Journal* 1 (1997): 1–6; J. J. Martín González, "El Palacio de Aranjuez en el siglo XVI," *Archivo Español de Arte* 35 (1962): 251.

38 For documents related to Lastricati's life and career, see Giuseppe Palagi, *Di Zanobi Lastricati, scultore e fonditore fiorentino del secolo XVI. Ricordi e documenti* (Florence: Le Monnier, 1871), 6–22; Gino Corti, "Il testamento di Zanobi Lastricati, scultore fiorentino del cinquecento," *Mitteilungen des Kunsthistorischen Institutes in Florenz* 32 (1988): 580–81; Antonia Boström, "Zanobi Lastricati: A Newly Discovered Document," *Burlington Magazine* 136 (1994): 835–36. Evidence supports Lastricati's involvement at Castello. In his *Life of Pierino da Vinci*, Vasari writes that clay models of four children, made by Pierino da Vinci and designated for Castello, "were afterwards cast in bronze by Zanobi Lastricati, a sculptor and a man very experienced in matters of casting; and they were placed not long since around the fountain, where they make a most beautiful effect" ("Il Vinci per commessione del Tribolo gli fece di terra: i quali furono poi gettati di bronzo da Zanobi Lastricati, scultore e molto pratico nelle cose di getto, e furono posti non è molto tempo intorno alla fonte, che sono cosa bellissima a vedere"). Vasari-Milanesi, *Le vite*, vol. 6, 124; Vasari-De Vere, *Lives*, vol. 7, 45.

39 Bastiano di Francesco di Jacopo is listed in the Medici accounts as Ciano "profumiere." He is included in a list with other artisans in a letter regarding the salary of Benvenuto Cellini. The document reads, "Benvenuto Cellini domanda che la sua provisione cominci il primo d'agosto [rescript: Il primo di settembre]. Vorrebbe gli fussero pagate alla giornata quantità di verghe di ferro, ferro, legno terra opere di manovali et d'altra [rescript: A che conto è rescritta a conto suo]. Ciano profumiere de' soi conti [rescript: si vegghino]. … Niccolò Fonditore e il compagnio. El controbasso. Baiaccha [Antonio Verdi, Bachiacca] ricamatore chiede scudi 8 il mese [rescript: faccisi] … Baiacca [Francesco Verdi, Bachiacca] pictore per i disegni della sala scudi 8 al mese … Maestro Janni [Jan Rost] tappezziere. Il fregio d'un altra portiera con altra storia. … La colubrine. … Selle per le chinee di Francia. … decto Palline scafaiuolo nostro da Livorno a Signa 24 pezzi di marmi sino nel 42 et non è stato pagato di suo nolo. Servirono per Castello, Il Tribolo fa fede che così sta la cosa." Bia, Doc ID# 17948 (ASF, MdP 613, ins. 1, fol. 28). For a discussion of Ciano's life and work, see Alessandro Nesi, *Ciano profumiere: un personaggio stravagante della corte di Cosimo de' Medici* (Florence: Maniera, 2015), 1–29.

40 The base of the Ridolfi *Mercury* sculpture is inscribed, "Florentine friends Zanobi Lastricati and Ciano Compagni made the figure in order to learn." For a discussion of the *Mercury*, see Marco Spallanzani, "The Courtyard of the Palazzo Tornabuoni-Ridolfi and Zanobi

Lastricati's Bronze Mercury," *The Journal of the Walters Art Gallery* 37 (1978): 6–21; Nesi, *Ciano profumiere*, 18–19.

41 For an analysis of Martelli's comments, see Nesi, *Ciano profumiere*, 6–16.

42 "Ma la volta della loggetta mi può comandare dove, con mirabil mano dell'ingegnoso lastricato, appariscon a lavoro di stucco et di colori oltramarini, sopra un nicchio, Venere bella, Nettuno col tridente, i cavalli spinosi e'l crine umido, Galatea, Theti, Melite, et altre ninfe assai, marine, scherzar lascivamente a proda, che arrecano all'occhio un piacer infinito." Martelli, *Lettere*, 73.

43 "Non vi mancando però l'arme Ducale di sua Eccellenza Illust. con il lauro et l'Arno della nostra Accademia." Martelli, *Lettere*, 73.

44 In the *Tetrabiblos*, Ptolemy writes, "If Venus rules action, she makes her subjects persons whose activities lie among the perfumes of flowers or of unguents, in wine, colors, dyes, spices, or adornments, as, for example sellers of unguents, weavers of chaplets, innkeepers, wine-merchants, druggists, weavers, dealers in spices, painters, dyers, sellers of clothing." Ptolemy, *Tetrabiblos*, trans. F. E. Robbins, Loeb Classical Library 435 (Cambridge, MA: Harvard University Press, 1940), Book 4, 384–85.

45 Several letters reveal the use of floral oils in Duke Cosimo I's court. In a 1549 letter, Duchess Eleonora orders almond oil, rose oil, and rose honey. "La signora duchessa [Eleonora de Toledo] vuole che la signoria vostra [Pier Francesco Riccio] mandi qui domattina avanti che elle si lievi uno fiaschetto d'acqua di chiocciole, che con questa sarà il fiaschetto, et dell'olio rosato, anzi melrosato, . . . et dell'olio di mandrolle dolcie, che tutto sia qui domattina di buon'hora avanti che la si lievi." Bia, Doc ID# 12991 (ASF, MdP 1175, fol. 151 Recto). Six weeks later, she orders carnation oil from Ciano. "Mia signora [Eleonora de Toledo] vuol che vostra signoria [Pier Francesco Riccio] li mandi el primo che qui si spaccia del olio di gherophani qual dice harete di Ciano profumiere." Bia Doc ID# 13159 (ASF, MdP 1175, fol. 372).

46 Martelli writes of Ciano's work, "et dèttevi un mestiero conveniente al bello spirito che avete, perchè è ben ragionevole ch' uno animo bello si pasca et si notrisca d' odori soavi et preziosi, et che sempre le mani della sua spoglia maneggino ambra, muschi, zibetti, olij delicati, polvere odorifere, acque d' angeli et d' arcangeli, e che, componendoli insieme, profumiate un quartieri non che le genti, che di continuo vanno alla Nunziata, di modo che quando si vuol lodare uno che sappia ben di buono, se li dice: 'tu sai di Ciano'." Martelli, *Lettere*, 71.

47 For Tedaldi's summary of opinions on the origins of ambergris, see Giovanni Battista Tedaldi, *Discorso sopra la pianta dell'aspalato, il musco e l'ambracane*, in *Notizie dei secoli XV. e XVI. sull'Italia Polonia e Russia*, ed. Sebastiano Ciampi (Florence: Leopoldo Allegrini e Giov. Mazzoni, 1833), 119–21.

48 "Ritrovarsi ne' pezzi dell' Ambra alcune piccole unghie, e becci, i quali si assomigliano bene a quelli de' pappagalli, ma con verità sono, et gli ho riscontrati e fatti riconoscere a molti altri essere quelli de pesci polpi, de' quali ho poi inteso ritrovarsene gran moltitudine in quei mari, i quali polpi dovendosi per avventura anch' essi cibare di quelle herbe che piacciono alle balene, dcono essere da quelle insieme con l'herbe inghiottiti, e poscia vengono ad essere mandate fuora nello escremento, quando le balene si purgano, l'unghie et le bocche di tali polpi." Tedaldi, *Discorso sopra la pianta dell'aspalato, il musco e l'ambracane*, 122.

49 For details on the sperm whale's production of ambergris, see Christopher Kemp, *Floating Gold: A Natural (and Unnatural) History of Ambergris* (Chicago: University of Chicago Press, 2012), 8–16.

50 In 1542, Pier Francesco Riccio paid Carlo Lenzoni 81 ½ gold *scudi* for 9 ounces of ambergris. From the *ricordi* of Pier Francesco Riccio: "Feci una poliza a Carlo Lenzoni che pagasse per la Duchessa n.ra [Eleonora di Toledo] scudi 81 ½ d'oro italiani per once 9 denari 3 d'ambra a scudi 9 d'oro oncia." Bia, Doc ID #6786 (ASF, MdP 600, fol. 12). In a note of December 30, 1553, Tommaso de' Medici authorizes the purchase of musk for

Eleonora from Paolo Baccegli who is traveling to Alexandria. "Io Tomaso d'Jacopo de' Medici sotto maiordomo di sua excellentia illustrissima [Cosimo I] commetto a voi Pagolo di Romolo Baccegli che in questo vostro viaggio d'Alexandria d'Egitto voi chomperiate per la illustrissima signora duchessa [Eleonora de Toledo] del muscho et dell'ambra [ma non] sia il muscho in vesciche e per lo illustrissimo signor Ducha uno lione maschio." Bia, Doc ID# 3333 (ASF, MdP 5922b, fol. 17). In another letter of June 6, 1559, Cosimo asks Bastiano Campana to see if musk or ambergris are on a ship that has just arrived from England. "Quanto alla [nave] venuta d'Inghilterra, vedrete se vi sono robbe fine e avisatecene insieme con li pregi, et che musco et ambra vi si trovi." Bia, Doc ID# 1302 (ASF, MdP 211, fol. 4).

51 The letter, dated May 27, 1566, from Bernardo di Bartolomeo Baroncelli to Francesco I de' Medici, reads, "Arrivò la nave di Jacopo di Niccolò; la portata sua sarà con questa. Domandai del muschio e de l'ambra, zibetto, e belzui." Bia, Doc ID# 9834 (ASF, MdP 521a, fol. 773).

52 On October 18, 1549, Eleonora requested from Ciano "some perfumed resin for scenting her bedroom." The request from Tommaso di Jacopo de' Medici to Pier Francesco Riccio reads, "La signora Sulisse mi ha fatto intendere per parte della signora duchessa che io mandi a Ciano perchè mandi qui domattina avanti che la signora duchessa si lievi della storace per fare le pasticche per profumare la camera come è solito mandare." Bia, Doc ID# 12996 (ASF, MdP 1175, fol. 165 Recto).

53 On August 9, 1539, Cosimo I received gloves scented with ambergris from Spain. The acknowledgement of receipt reads, "Li guanti sono stati al proposito, come speriamo sarà anche la ambra." Bia, Doc ID# 20011 (ASF, MdP 2, fol. 261). On January 17, 1550, Eleonora sent perfumed gloves to Pope Julius III. The entry, which is found in a summary of letters to Cosimo I, reads, "che saria ben che la Duchessa [Eleonora de Toledo de' Medici] inanzi carnovale mandasse qualche cosa a S. S.tà [Julius III] [Rescript: che la Duchessa non manchera et almeno manderà guanti profumate]." Bia, Doc ID# 6803 (ASF, MdP 401, fol. 235).

54 The 1566 inventory of jewels in the Medici household includes the following entries: "n. 290 una cinta da cignere col pendaglio d'oro lavorata di straforo a giorno ripiena tutta di pasta odorifera di masco [proposed reading, musco] et ambra, composta di cinquanta bottoni d'oro come è detto piccoletti et di cinquantatre bottoni simili ma dua tanto maggiori in circa, et da piede una gran pera a fogliami d'oro trasparenti a giorno, ripiena tutta della medesima pasta, et in fondo tre festoncini d'oro smaltati per finimento." Bia, Doc ID# 25325 (ASF, MdP 643, fol. 21) and "n. 291 una maniglia de medesimi bottoni che la cinta di numero 290 composta di sette de detti bottoni della minore sorte, et di altri sette bottoni della sorte maggiore, tutti ripieni di pasta odorifera di musco et ambra, come la cinta." Bia, Doc ID# 25326 (ASF, MdP 643, fol. 22).

55 The ducal physician Andrea Pasquali gives directions for this heart-shaped poultice, which read, "Questa sarà perché voria un sacchettino per tenere in sul core a sua excellentia [Cosimo I] quando ha certe ventosità come ha hauto stasera, e così lo ordinerete a Labino spetiale. E qui lo manderete secondo la riceputa in questa. . . . Sua excellentia à questa sera cenato pocho e così andato in letto ben caldo che si era a ttavola mezo rafreddo s'è adormentato. E così dorme. Oggi è tirato qui tramontano e a tuti è parso freddo . . . El vescovo di Forlì [Bernardo de' Medici] à le gotte in le ginochia e arpresso la febre e tocca del terzo giorno domani, nè altro . . . Se avessi 4 tartufi sarebono a proposito . . . R. Speziale . . . o.1 musco, ambra . . . Misce per fare un sacchetin in taffetà di grana come la figura al rimpetto. E bisognando più spetie, multiplicate secondo la ricepta tanto che basti . . . [Inside, heart-shaped drawing of poultice: Fatelo più presto mezo dito maggiore che minare [minore]." Bia, Doc ID# 6539 (ASF, MdP 1171, fol. 232).

56 Mattioli writes, "È l'ambra calida, & secca. Corrobora, nell'odorarla, il cuore, & il cervello. Conferisce molto à vecchi, & frigidi di natura: & imperò à costoro si possono realmente concedere i guanti, che sieno ben profumati con essa. Conforta le membra indebilite, &

parimente i nervi: aumenta l'intelletto, conferisce à i malinconici, conforta lo stomacho, & apre le oppilationi della madrice: provoca i mestrui, mitiga i dolori colici, irrita al coito, giova al mal caduco, à i paralitici, & allo spasimo. L'ambra infusa nel vino, fa eccessivamente inebbriare." Pietro Andrea Mattioli, *I discorsi ne i sei libri della materia medicinale di Pedacio Dioscoride Anazarbeo* (Sala Bolognese: Forni, 1984), 46.

57 John M. Riddle, "Pomum ambrae: Amber and Ambergris in Plague Remedies," *Sudhoff's Archiv für Geschichte der Medizin und der Naturwissenschaften* 48 (1964): 111–22.

58 Henry Cornelius Agrippa, *The Three Books of Occult Philosophy or Magic*, ed. Willis F. Whitehead (New York: AMS Press, 1982), 136.

59 For information on Vasari's Sala degli Elementi, see Ugo Muccini and Alessandro Cecchi, *The Apartments of Cosimo in Palazzo Vecchio* (Florence: Le Lettere, 1991); Claudia Rousseau, "Cosimo I de' Medici and Astrology: The Symbolism of Prophecy" (PhD diss., Columbia University, 1983), 322–57; Charles Davis, "The Pitfalls of Iconology, or How It Was That Saturn Gelt His Father," *Studies in Iconology* 4 (1978): 79–94; Else, *The Politics of Water in the Art and Festivals of Medici Florence*, 46–48.

60 "Tutto questo tessuto dell' elemento dell' acqua, Signor Principe mio, è accaduto al Duca Signore nostro, il quale aspettato dal Cielo in questo mare del governo delle torbide onde, le ha rendute tranquille e quiete, e fermato gli animi di questi popoli tanto volubili per li venti delle passioni degli animi loro, i quali sono dagli interessi proprj oppressi." Giorgio Vasari, *Ragionamenti sopra le invenzioni da lui dipinte in Firenze nel Palazzo vecchio con d. Francesco Medici allora principe di Firenze* (Pisa: N. Capurro, 1823), 22; for English, see J. L. Draper, "Vasari's Decoration in the Palazzo Vecchio: The Ragionamenti Translated with an Introduction and Notes" (PhD diss., University of North Carolina, 1973), 110. For a critical study of Vasari's *Ragionamenti*, see Paola Tinagli, "Claiming a Place in History: Giorgio Vasari's *Ragionamenti* and the Primacy of the Medici," in *The Cultural Politics of Duke Cosimo I de' Medici*, ed. Konrad Eisenbichler (Aldershot: Ashgate, 2001), 63–76.

61 Vasari's *Birth of Venus* may have also been inspired by the marine triumph of Venus in Apuleius' *Metamorphoses*, especially the Triton blowing the conch shell and the silken drapery that the goddess holds above her head. The passage reads, "What she [Venus] began to desire happened at once, as if she had given orders in advance: the instant obeisance of the seas. Nereus' daughters came singing a choral song, and shaggy Portunus with his sea-green beard, and Salacia with her womb teeming with fish, and Palaemon the little dolphin-charioteer. Now troops of Tritons bounded helter-skelter through the sea-water: one blew gently on a tuneful conch shell; another shielded her from the hostile sun's blaze with a silken awning; another carried a mirror before his mistress's eyes; others swam along yoked in pairs to the chariot. Such was the army escorting Venus as she moved out toward Ocean." Apuleius, *Metamorphoses (The Golden Ass), Volume I: Books 1–6*, ed. and trans. J. Arthur Hanson, Loeb Classical Library 44 (Cambridge, MA: Harvard University Press, 1996), Book 4, 200–201.

62 For Vasari's description of the sea gods and goddesses as well as the gifts that they present to Venus, see Vasari, *Ragionamenti*, 20–22; Draper, *Vasari's Decoration in the Palazzo Vecchio: The Ragionamenti*, 107–108.

63 Pliny writes, "The first place therefore and the topmost rank among all things of price is held by pearls. These are sent chiefly by the Indian Ocean, among the huge and curious animals that we have described as coming across all those seas over that wide expanse of lands from those burning heats of the sun. And to procure them from the Indians as well, men go to the islands – and those quite few in number: the most productive is Ceylon, and also Stoidis, as we said in our circuit of the world, and also the Indian promontory of Perimula; but those round Arabia on the Persian Gulf of the Red Sea are especially praised." Pliny, *Natural History, Volume III*, Book 9, 234–35.

64 Discussing the luxuries desired by Roman women and provided by the love of men, Propertius mentions the pearls (referred to as *concha*) of Venus. He writes, "et venit e Rubro

concha Erycina salo." Propertius, *Elegies*, trans. G. P. Goold, Loeb Classical Library 18 (Cambridge, MA: Harvard University Press, 1990), Book 3, 266–67. For a discussion of Propertius and pearls, referred to as *concha* in poetry, see Flory, "Pearls for Venus," 500–501. The *Picatrix* also dedicates pearls to Venus: "From the stones, she governs pearls." *Picatrix: A Medieval Treatise on Astral Magic*, trans. Dan Attrell and David Porreca (University Park: Pennsylvania State University Press, 2019), 134.

65 For Pliny's discussion of these offerings, see Pliny, *Natural History, Volume III*, Book 9, 242–47.

66 Flory, "Pearls for Venus," 498–504; Monroe E. Deutsch, "Caesar and the Pearls of Britain," *The Classical Journal* 19 (1924): 503–505.

67 The pearls for Eleonora de Toledo are discussed between Maria Salviati and her son Cosimo I in three letters dated March 6–8, 1538 (1539 modern year). The report on the sending of the pearls to Eleonora reads, "Hiersera a hore tre di notte in circa comparse il Selvastrella et ne presentò lo scatolino con le perle et pendente ... Delle perle si seguirà l'ordine datoci delle cinquanta, et l'altre si manderanno a Napoli come è detto ... Ho piacere havere inteso la bella caccia, et che V. Ex. ne habbi preso contento assai. Duolmi bene che li tempi non corrispondino al suo desiderio." Bia, Doc ID# 3601 (ASF, MdP 5926, fol. 10).

68 Roberta Orsi Landini and Bruna Niccoli, *Moda a Firenze, 1540–1580: Lo stile di Eleonora di Toledo e la sua influenza* (Florence: Pagliai Polistampa, 2005), 48.

69 The letter dated June 1543 provides a list of items on the two ships from Cadiz: "Questo giorno sono adrivati in questo porto due nave grosse una la characcha Santa Maria di Rodi padrone frate Francesco Giron, laltra la nave Trinita d'Antonio Preve chariche tutte in Chalix [presumably Cadiz] di grossa somma di lane, pepi, zucheri, chuoia d'India, perle e polvere di perle, fardelli di grana e [proposed reading parmecha] cordohani, chase di conserve e guardamazzili, e più altre mercie per a merchanti spagniuoli e fiorentini e lucchesi et perché è nostro solito darne adviso dello adrivo loro non vogliamo manchare." Bia, Doc ID# 26659 (ASF, MdP 653, ins. 13, fol. 360).

70 The letter to Eleonora de Toledo reads, "Antonio di Ubertino Verdi decto el Bachiacha richamatore di vostra Excellentia [Eleonora di Toledo] fa intendere a quella come ha fornito di richamare e [proposed reading: i] guanciali et per lui non manca che non sia omgni cosa in sua perfectione. Hora per non gli essere mai stato dato perle et oro tirato non può mostrare quanto e' desidera di mandare ad effecto quello che gli è imposto per conto di vostra excellentia, si che degnisi quella dare adviso et ordinne si che el decto oro et perle gli sia consegnato." Bia, Doc ID# 3308 (ASF, MdP 5922a, fol. 142). Another letter describes the embroidery project as overseen by Pier Francesco Riccio and Cassandra Nerli de' Bardi; see Bia, Doc ID# 6375 (ASF, MdP 1170a, fol. 722 Recto).

71 Benvenuto Cellini, *Autobiography*, trans. George Bull (London: Penguin Books, 1998), 357.

72 Cellini, *Autobiography*, 358.

73 Numerous documents in the Medici archives attest to Cosimo I's dealings in pearls. Some of these include: (1) payment to Tommaso Lapi for pearls in 1542, see Bia, Doc ID# 6812 (ASF, MdP 600, fol. 17); (2) payment to Antonio Landi for pearls on January 6, 1545 (1546 modern year), see Bia, Doc ID# 17990 (ASF, MdP 613, ins. 3, fol. 7); (3) inquiry for the price of some pearls being sold by Bartolomeo Panciatichi in 1546, see Bia, Doc ID# 5584 (ASF, MdP 1170a, fol. 156 Recto); (4) a reminder dated February 11, 1546 (1547 modern year) to Cosimo I to repay the Pinadori family, who lent money to Hieronimo Serra to purchase pearls for the Duke, see Bia, Doc ID# 17975 (ASF, MdP 613, ins. 2, fol. 55); (5) a letter of March 21, 1562 (1563 modern year) discussing the possibility of buying pearls from Giambattista Dei, see Bia, Doc ID# 16218 (ASF, MdP 219, fol. 76); (6) a letter of January 9, 1564 (1565 modern year) discussing the purchase of pearls from the galley "Regina," once owned by Baccio Martelli, see Bia, Doc ID# 26518 (ASF, MdP 1687, fol. 56); (7) a letter of September 1, 1565 informing Giovanbattista Borghini that Cosimo I is interested in purchasing the two pearls he has for sale, see Bia, Doc ID# 13552 (ASF, MdP 221, fol. 4).

74 Cardinal Innocenzo Cibo informs Cosimo I of a report that some pearls that have arrived on a ship at Livorno are believed to be fake. He writes, "Il ditto Andrea, subito che fu giunto a Livorno, non solo fu quello che scoperse la fraude che era stata fatta in ditta nave di quelle perle che vi erano, appartenenti a Gregorio e Luigi Polanco, mercanti spagnuoli, ma che ha sodisfatto alli detti mercanti per la sua rata la valuta di dette perle, sia contenta perdonargli il ditto errore." Bia, Doc ID# 23661 (ASF, MdP 3718). In a letter of December 13, 1560, Bernardetto Minerbetti writes to Cosimo I about the discovery of pearls in a river in Peru: "Io credo che mi sono scordato dirle che nel Perù li spagnoli hanno non so in che parte trovato un fiume d'acqua dolce et senza alcuno reflusso nel quale si pesca quantità di buone perle." Bia, Doc ID# 27411 (ASF, MdP 5040, fol. 24 Recto). Antonio de' Nobili writes to Cosimo I on July 17, 1570 about an engineer who has developed an underwater machine for pearl fishing. The letter reads, "qui è stato x mesi sono un ingegnere stato nelle Indie che fece un modello di un instrumento capace per quattro persone da mettere in cento passi d'aqqua, et pescar perle et quanto si volea; suonava trombe, et camminava sott'aqqua molte braccia; e tanto che portando seco fuoco lavorato havea un ingegno, che mettendosi sotto a una nave o una galera gliene ficcava nel corpo a uso di succhiello, et dava al fuoco quel termine, che li tornava commodo per far balzar in aria, et abbruciar qualsivoglia vassello. Fece costui il disegno, qual'io non vidi; ma chi lo vide dicea esser bellissimo et riuscibile, et che nell'Indie ven'era assai per pescare a le perle ma qui come non son vaghi di novità, non li prestorno orecchi." Bia, Doc ID# 16332 (ASF, MdP 4902, ins. 1, fol. 251).

75 For general historical discussion of coral in the Mediterranean, see Caterina Ascione, "L'arte del corallo: mito, storia e lavorazione dall'antichità ai giorni nostri," in *Il corallo rosso in Mediterraneo: arte, storia e scienza*, ed. Fabio Cicogna and Riccardo Cattaneo Vietti (Rome: Ministero delle risorse agricole alimentari e forestali, 1993), 11–36; Cristina del Mare, "Corallo in Sicilia dall'XI al XVII secolo: mercanti, tradizione e maestranze ebraiche," in *Mirabilia coralii: capolavori barocchi in corallo tra maestranze ebraiche e trapanesi*, ed. Cristina del Mare and Maria Concetta di Natale (Naples: Arte'm, 2009), 10–53.

76 "One obtains things from Venus through her animals which we have mentioned and through carnelian, sapphire, lapis lazuli, bras (yellow or red), coral, and all pretty, multicolored or green colors and flowers, musical harmony and pleasant odors and tastes." Marsilio Ficino, *Three Books on Life*, trans. Carol V. Kaske and John R. Clark (Tempe, AZ: Arizona Center for Medieval and Renaissance Studies, 2002), 250–51. The *Picatrix* reads, "Out of the metals, Venus governs red bronze and has a part in silver and glass. Out of the stones, she governs azure, coral, and malachite, and partly over beryl and magnesium." *Picatrix*, 104. The *Picatrix* also includes directions for a talisman of Venus on coral: "From the figures of Venus, inscribe on a stone of coral the figures of two male cats and one mouse (in the hour of Venus with her ascending). No mouse will remain where you place the figure." *Picatrix*, 111.

77 "Their virtues, but chiefly of the red, is to stop every flux of blood . . . It gives relief in pains of the stomach and heart. Being hung down upon the stomach or taken internally, it helps the weakness thereof . . . The shavings or scrapings of it, drank with wine, are good against the gravel." Camillo Leonardi, *The mirror of stones: in which the nature, generation, virtues and various species of more than 200 different jewels, precious and rare stones are distinctly described* (London: J. Freeman, 1750), 83–84.

78 Pliny, *Natural History, Volume VIII*, Book 32, 478–79.

79 "Ipsius est, ut ait Zoroastres, mira potestas; / et sicut scribit Metrodorus optimus auctor, / fulmina, typhonas, tempestatesque repellit. / A rate vel tecto, vel agro, quocunque geratur. / Ast in vinetis aspersus, et inter olivas, / aut a ruricolis cum semine iactus in agris, / grandinis avertit calamis contraria tela, / multiplicans fructus, ut fertilitate redundent. / Umbras demonicas, et Thessala monstra repellit." Marbode, Bishop of Rennes, *Lapidari: la magia delle pietre preziose*, ed. Bruno Basile (Rome: Carocci, 2006), 62.

80 In a letter dated April 30, 1548, Cosimo instructs Antonio de Aldana to lift the "dogana" or customs for the ships of Andrea Doria, which are carrying coral. "Et a voi Proveditore che lassiate a ciascun [levare] della Dogana [et d'altrove] le sua merchantie et robbe per

condurle dove saranno destinate secondo il solito. Et particolarmente permetterete a quello ch'è venuto con le galee del S.or Principe [Andrea Doria] che possa [levare della Dogana et] caricare le casse de' coralli per portarle a Genova." Bia, Doc ID# 6978 (ASF, MdP 11, fol. 90). In another letter of May 5, 1548, Cosimo I writes that the Genoese have suddenly removed coral and silk from the port of Livorno, which he sees as evidence of their contentious position towards the Florentines. The notice reads, "Et accioché V. S. sia certo del malo animo loro, sappi che in quelli tumulti subito mandorno certi mercanti a levare da Livorno tra sete et coralli per la somma di cento milia ducati, li quali n'erono stati meglio che un anno per non pagare gabella in Genova, si che questo denota non volevono far altro che venire alle armi, le quali robbe non lasciai trarre insiemi con molte altre che tutte in sieme ascendevono a 150mila scudi con li quali pensano fare loro assai male et da più bande." Bia, Doc ID# 7074 (ASF, MdP 11, fol. 122).

81 For letters concerning Giovanni Gallego and his plan for Florence to replace the Genoese in the business of coral fishing on the island of Tabarka, see the following documents: (1) Letter of May 17, 1550 discussing Gallego's plan and the Genoese presence in the industry, see Bia, Doc ID# 19370 (ASF, MdP 397a, fol. 626); (2) Letter of June 2, 1550 informing Cosimo I of Luigi Arnoldi's discussions with Gallego for a contract, see Bia, Doc ID# 6403 (ASF, MdP 397a, fol. 771); (3) Letter of June 8, 1550 in which Luigi Arnoldi asks Cosimo I for instructions on following through with the coral contract, see Bia, Doc ID# 6404 (ASF, MdP 397a, fol. 803); (4) Letter of June 26, 1550 that informs Cosimo I that Giovanni Gallego intends to come to Florence and discuss the enterprise in person with Cosimo I, see Bia, Doc ID# 21031 (ASF, MdP 1852, fol. 449).

82 According to Luigi Arnoldi, the Genoese were required to give a fifth of their coral harvest to King Charles V and were responsible for the expenses involved in defending the island. In a letter of June 16, 1550, he writes, "Et in questo modo: di quanto peschassino ne havessero adare la quinta parte a Sua Maestà [Karl V], che li mercanti havessino a tenere guardato l'Isola, et pagare li cinquanta soldati spanioli che vi sogliono stare et l'arteglierie e tutte altre cose necesarie di munitioni per defendersi bisognando." Bia, Doc ID# 17099 (ASF, MdP 397a, fol. 895).

83 For the meeting with Ferrante I Gonzaga in Milan regarding the coral fishing license, see the following documents: (1) Bia, Doc ID# 12082 (ASF, MdP 3102, fol. 108); (2) Bia, Doc ID# 17331 (ASF, MdP 3102, fol. 109); (3) Bia, Doc ID# 17334 (ASF, MdP 3102, fol. 117). Discussions of the negotiations and defense of the island for coral fishing appear in a letter of September 5, 1550 from Francesco di Paolo to Cosimo I, which reads, "Nel negozio de coralli, mentre dicevo a S.S. Ill.ma [Ferrante I Gonzaga di Guastalla], che el Gualterotto veniva mi soggiunse quelche le diro appresso che li Genovesi, non potendo condurne di nuovo l'appalto eran' resoluti se van li suoi instrumenti artiglieria monitione e homini che hanno alla Tabarcha di modo che seguendo li Turchi la occuperebbeno, e mai più se potrebbe recuperare, onde è stato necessario compiacerli di questo anno proximo che possino continuar' in la pescaggione, con questa conditione non dimeno che finito il 1551 sieno obligati relassare nella Tabarcha tutte l'artiglierie monitioni ferramenti e altre cose che vi tengano per uso e S.M. [Karl V] habbia a pagarli loro per pregio conveniente ne habbino da poi commodita alcuna per smaltimento del suo corallo, ma s'intenda subito che subintiera in la nuova condotta del 1552 potere peschare liberamente senza riservo, et considerato che li Genovesi potevano impedire per la convenzione vecchia [cancelled: impedire] la pescagione del 51 non pare se tolga tempo al [Bartolomeo] Gualterotto o alli altri mercanti Fiorentine ne che vorranno nel 52 entrar' nel' appalto, come di tutto ne farà dare particolare raguaglio e V. E. da Gian Galego il quale il dì otto partirà di qua con il Marchese di Marignano [Giangiacomo de' Medici di Marignano] per essere a Siena ad eseguir' l'ordine venuto nuovamente da S.M. de fabricare la fortezza." Bia, Doc ID# 17364 (ASF, MdP 3102, fol. 125).

84 A letter of March 18, 1563 documents the arrival of a galley from Tabarka carrying coral: "Un galeone grosso di quelli Lomellini, che viene da Tabarche dalla pescheria dei coralli,

padroneggiato da Bartolomeo Pariscosso, con dugento homini in corpo, che si mutono da quelle peschiere, carico di corami e di dugento casse di coralli." Bia, Doc ID# 3310 (ASF, MdP 503a, fol. 1163).

85 In a letter of July 24, 1557, Conte Massaini writes to Cosimo of the treasures found in his new territory: "dove ancora sono in la Maremma pascoli et bandite di molta importanza, con porti come V. Ecc.za [Cosimo I] informato n'è, neli quali sono la pesca del corallo et de la tonnara, dela qual tonnara se ne cavaria otto o x mila scudi l'anno, tanta abbundanzia se ne trova, con due isole in le quali sono tanti conigli che è cosa meravigliosa." Bia, Doc ID# 8652 (ASF, MdP 1864, fol. 60).

86 "Vi diciamo che non vogliamo concedere la pesca del corallo in cotesto luogo a persona, perché la vogliamo per noi." Letter from Cosimo I to Gaspare (di Billiena) Nuti on August 8, 1571, see Bia Doc ID# 16882 (ASF, MdP 238, fol. 6).

87 "Habbiamo inteso del corallo ricevuto e pagato per conto di Ms. Giuseppe Bono e del venduto in su la fiera di Pisa che bisogna i denari ritratti di detti coralli venduti questa fiera di Pisa e di quelli venduti in su la fiera di Pontremoli gli paghiate a' Salviati del banco di qui per nostro conto ... E quando quelli maestri che lavorano et puliscano il corallo non haranno faccenda sopra quelli di Ms. Giuseppe [Bono] perché non si stieno, darete loro a lavorare della nostra decima parte et la spesa pagherete de nostri denari et pr nostro conto proprio." Bia, Doc ID# 279 (ASF, MdP 238, fol. 25).

88 "Habiamo inteso per la lettera vostra per la informatione che ci havete mandata le cose grandi et rare che dice saper fare quel cavaliero amico vostro che si truova di presente in Roma delle quali ci è piacciuto grademente haver notitia et così per publica commodita come per vostra participazione quando fussimo per riuscire volentieri ci metteremmo a darle il modo di demostrare quella sua virtù di fondere il marmo et il corallo massimamente ma ci piacerebbe prima che venisse qua vederne qualche prova. Ditele adunque che faccia un poco di fonditione di corallo et cela mandi per che se noi vedremo che si riesca di fonder quello crederemo facilmente il resto et ci disporremo a darli la commodità che desidera per far di quelle opere che si promette di saper fare." Bia, Doc ID# 7739 (ASF, MdP 195, fol. 182).

89 For a discussion of the desire for coral in cities like Antwerp in the sixteenth and seventeenth centuries, see Marlise Rijks, "'Unusual Excrescences of Nature': Collected Coral and the Study of Petrified Luxury in Early Modern Antwerp," *Dutch Crossing: Journal of Low Countries Studies* 10 (2017): 1–29.

90 The coral is found in "armario numero 11" of the inventory; see Lindsay Alberts, "The *studiolo* of Francesco I de' Medici: A Recently-Found Inventory," *ARTHS 2.0* 1 (2015): 9, 19.

91 A three-letter exchange between June 3–6 of 1559 refers to the delivery of coral to Florence for use in certain fountains, possibly for the grotto at Castello. See the following documents: (1) Bia Doc ID# 9567 (ASF, MdP 479, fol. 173); (2) Bia Doc ID# 9432 (ASF, MdP 606, fol. 6); (3) Bia, Doc ID# 1302 (ASF, MdP 211, fol. 4). A letter of June 6, 1573 to Francesco I's wife, Giovanna, describes a shortage of fountain ornaments, including shells and coral. The letter reads, "Ho cerco secondo ch l'Alt.a V [Johanna von Habsburg-de' Medici] si degnò farmi comandare di trovare alcune cose per onamento di una fontana, come nicchi, chiocciole, coralli, et altro. Ma perché sovente ne sono richieste per mandarle a Roma, et poco avanti [fu] fatto diligente procaccio, trovai non esserci niente; pure in questi pochi giorni ho raccolto quel che è capitato, et se bene non sono a mio giudicio cose degne di esser mandate, non ho voluto mancare, come mi fu ordinato, di mandarle, sì per ubedir l'Alt.a V., come anco per sapere che in simil edificio si accomodano varie et diverse cose a gusto del artefice, secondo i luoghi." Bia, Doc ID# 3727 (ASF, MdP 5952, fol. 70). In another letter of September 15, 1582, Francesco I de' Medici thanks Antonio Lencio for a gift of coral to use for fountain decoration: "Ogni commodo et piacere che farete a Pompeo di Serandino raccomandatovi da me, mi sarà molto grato; et gratissimi mi sono stati li coralli, che mi havete inviati per ornamento di fontane." Bia, Doc ID# 14004 (ASF, MdP 257, fol. 37).

92 "Sotto l'acque ha essere una pesca di perle et di coralli fatta da Ninfe marine, et Tritoni simile e quella che facesti nella sala degli elementi: et sarà molto piacevole et vaga." Borghini's correspondence regarding the studiolo is reprinted in Marco Dezzi Bardeschi et al., *Lo Stanzino del Principe in Palazzo Vecchio: I concetti, le immagini, il desiderio* (Florence: Le Lettere, 1980), 35.

93 Borghini also gives instructions for the Cleopatra painting: "Alle perle farei (io dico questo per un esempio et per un modo di discernere) la cena di Cleopatra con Marc'Antonio, che con una perla sola mise tutte le delizie e la spesa di Marcantonio." Bardeschi, *Lo Stanzino*, 55. For an analysis of this anecdote, see Berthold L. Ullman, "Cleopatra's Pearls," *The Classical Journal* 52 (1957): 193–201.

94 While the subject of the "large fish" scene in the *studiolo* is not perfectly clear, there is a note from Borghini describing two paintings by Giovanni Battista Naldini that connects one of them to ambergris. The note reads, "di sua mano [Naldini] sono nella scrittoio del duca Francesco, fatti a concorrenza con molti altri pittori, due quadri a olio, l'uno de quali è di lastra di pietra in cui apparisce il modo che si tiene a far l'ambracane." Bardeschi, *Lo Stanzino*, 64. Vasari offers a description of the coral painting: "Perseo che sciogliendo Andromeda nuda allo scoglio marino et avendo posato in terra la testa della Medusa, che uscendo sangue dal collo tagliota e imbrattnado l'acqua del mare, ne nasceva i coralli." Bardeschi, *Lo Stanzino*, 51.

95 The first reference to Giambologna's authorship appears in Filippo Baldinucci's *Notizie dei professori del disegno* of 1688, in which he states that the sculptor "cast in Florence a woman in the act of combing her hair for the above-mentioned Villa of Castello" ("Gettò dipoi a Firenze una femmina in atto di pettinarsi le chiome, per l'altre volte nominata villa di Castello de' serenissimi"). Filippo Baldinucci, *Notizie dei professori del disegno da Cimabue in qua per le quali si domostra come, e per chi le belle arti di pittura, scultura e architettura, lasciata la rozzezza delle maniere greca e gotica, si siano in questi secoli ridotte all'antica loro perfezione*, ed. Ferdinando Ranalli, vol. 2 (Florence: V. Batelli e Compagni, 1846), 568. More substantial proof for the Giambologna attribution resides in a portrait of the artist created by Hans von Aachen in 1572. In the painting, Giambologna sits in front of his workshop at the Palazzo Pitti with the stucco model of *Oceanus* as well as the statue of *Fiorenza* visible in the background. The *Oceanus* was finished between 1571 and 1572 and removed from the workshop in October of 1572. Thus, the *Fiorenza* must have been completed by 1571 or 1572 and mounted shortly thereafter. Elizabeth Dhanens brought the portrait to the attention of scholars; see Herbert Keutner, "Recensione di E. Dhanens 1956," *Kunstchronik* 11 (1958): 326.

96 In a letter to Eleonora de Toledo of 1543, Ridolfo Carnesecchi asks for more workers to help at Pietrasanta's copper mine; see Bia, Doc ID# 23455 (ASF, MdP 362, fol. 436). In March of 1544, Cosimo I received two samples of copper from the Carrara mines. The copper is praised for its high quality; see Bia, Doc ID# 23633 (ASF, MdP 3717). On May 16, 1545, Cosimo I recruited experts from Pietrasanta's copper mines to accompany him on a visit to the copper mine of Montecatini; see Bia, Doc ID# 2427 (ASF, MdP 1171, fol. 750 Recto). Another letter dated July 18, 1559 reports the finding of copper at the mines near Campiglia Marittima; see Bia, Doc ID# 9578 (ASF, MdP 479, fol. 562).

97 Giovanni Boccaccio, *The Book of Theseus (Teseida delle Nozze d'Emilia)*, trans. Bernadette Marie McCoy (New York: Medieval Text Association, 1974), Book 7, 202.

98 "La sagoma sia di venere overo di giove o saturno è spesso rigittata in grembo alla madre sua; E sia adoperata con sottile, e'l sagomato sia venere e giove inpastato sopra venere; Ma prima proverai venere e mercurio misto con giove e tieni modo che mercurio se ne fugga poi in volgili bene in modo che venere o giove sinnectuti vi sottilissimamente quanto sia possibile." Leonardo da Vinci, *The Literary Works of Leonardo da Vinci*, ed. Jean Paul Richter (London: Low, 1883), 323.

99 Tommaso Mozzati, "Il tempio di Cnido. Il nudo e il suo linguaggio nell'età di Giambologna," in *Giambologna. Gli dei, gli eroi. Genesi e fortuna di uno stile europeo nella*

scultura. Catalogo della mostra (Firenze, 2 Marzo–15 giugno 2006), ed. Dimitrios Zikos and Beatrice Paolozzi Strozzi (Florence: Giunti, 2006), 66–87.

100 In a letter of January 24, 1572 (1573 modern date), Antonio Serguidi reports to Pietro di Francesco Usimbardi that Cosimo is endangering his health by refusing to abstain from sexual relations with Camilla. He writes, "Non voglio lassare di darle conto della salute di S. Alt.za [Cosimo I] per contento del Carl.le n.ro s.re [Ferdinando de' Medici], et certo andrebbe augumentando giornalmento se non gli desse spesso occasione di ricaduta, come intervenne duoi giorni fà che, havendo fatto con la moglie [Camilla Martelli] quello che non doverrebbe, ritornò quasi nel medesimo accidente del altro giorno. Pure certe pillore et un servitiale l'hanno evaquato et lassato assai scarico. Ma se non s'astiene da Venere torneremo presto alle medesime, che a Dio non piaccia." Bia, Doc ID# 4221 (ASF, MdP 1212, ins. 1, fol. 103).

CONCLUSION

Attendant Pleasures

*V*ENUS AND THE ARTS OF LOVE HAS EXAMINED VENUS IN RENAISSANCE
Florence, focusing on the goddess's portrayal in paintings, sculptures, and
the decorative arts between 1300 and 1600. Venus first entered Tuscan litera-
ture and art as an astrological deity, attracting lovers and patrons alike with her
scintillating splendor. From the heavens, she descended to earth. *Au naturel* or
fashionably dressed, she entered the spaces where men and women dressed,
undressed, bathed, and engaged in procreative intercourse. Her clear complex-
ion, rosy cheeks, and pink lips encouraged women to cultivate and care for
their skin, while simultaneously reinforcing their duty to join their flesh with
that of another to produce new flesh. Draped in white and red silks and girded
with her magical *cestus,* the goddess also modeled Florence's fashionable silks,
reminding her devotees of the enchanting power of clothing and adornment
and challenging artists to render them in vibrant colors. Indeed, the corres-
pondences between Venus' celestial likeness and her earthly materials stimu-
lated painterly innovations in media and technique. Her be-flowered and
fruitful gardens, which reveal developments in naturalism, introduced ver-
dancy into the domestic interior. Green places were not only amorous but also
therapeutic, since the color could soothe the eyes and transfer a salubrious
spirit, via the sense of sight, to the body, mind, and spirit.

Venus' demands could stimulate a great many things, including excessive
economic expenditures. Florentine citizens were known to spend small for-
tunes on wedding festivities, including crimson velvets, sparkling jewels,

verdure tapestries, and painted furnishings for their bedroom suites. Between 1494 and 1498, Girolamo Savonarola critiqued these Venusian vanities in an effort to turn the eyes of the Florentine citizens back to God; however, his attempt to control desires of the heart eventually backfired, as his own heart was reduced to smoldering ashes in the middle of the Piazza della Signoria on May 23, 1498. Meanwhile, Venus, like many of the Florentine artists, had taken refuge in Rome. When she returned to the city of flowers in 1532, she was a bolder and more sexually assertive goddess, kissing boys, stealing arrows, and even falling in love with a mortal. She soon became the darling of the art world, and artists began to be praised, not for their portrayal of her rosy-hued flesh or shimmering raiments, but for their manipulation of her sexual anatomies, which aroused viewers and encouraged erotic fantasies. Savonarola's sermons still echoed, however, in Florentine portrayals of the goddess with their somber references to the chronic emotional, psychological, and physical stress of venereal excess. In the political art of Duke Cosimo I de' Medici, Venus escaped disease and defied moral indictments, clearing her name and reentering her natural habitat as a dignified goddess. Appearing in semi-public places and different mediums, she symbolized Florence's newfound maritime interests and the extension of the city into the Grand Duchy of Tuscany. Her luxurious marine gifts, including coral, pearls, seashells, and ambergris, visually established the fecundity of the sea in the heart of the Arno River Valley.

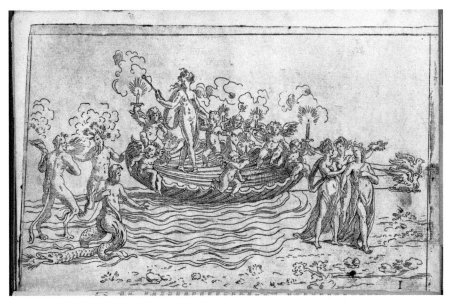

107 Etching from *Feste nelle nozze de don Francesco Medici gran duca di Toscana*, written by Raffaello Gualterotti, printed by Stamperia Giunti, Florence, 1579. Credit Line: Harris Brisbane Dick Fund, 1931. Photo: The Metropolitan Museum of Art, New York

Following the resignation of Duke Cosimo I, Venus' arts of love continued to flourish in the lavish spaces of the Medici court, particularly under the rule of Duke Francesco I. As we have seen, *Venus Anadyomene* was honored in his Palazzo Vecchio *studiolo*, and many of Venus' alluring materials were collected and stored in the cabinets lining the study walls. The private nature of this commission and its connections to science, alchemy, and magic speak to the natural and scientific interests of its owner. Venus' presence in one of the theatrical performances celebrating Francesco I's second marriage to Bianca Cappello also speaks to the developing arts of theater, music, stage-set, and costume-design, which were quickly becoming fashionable in late sixteenth-century Florence.

Francesco I's marriage to Bianca Cappello followed a highly public and illicit affair of fourteen years, carried out while the duke was still married to the Duchess Giovanna of Austria. The Florentine populace did not approve of the affair nor of the marriage, and various poets and writers accused Bianca of love magic, calling her a syphilitic whore. The celebrations honoring Francesco I's contested second marriage were scheduled only two months after the Duchess Giovanna's death.[1] During a theatrical performance on the first day of the nuptials, Venus arrived on a float drawn by swans and beasts of the sea. A drawing of this scene (Fig. 107) is included in the published festivities,

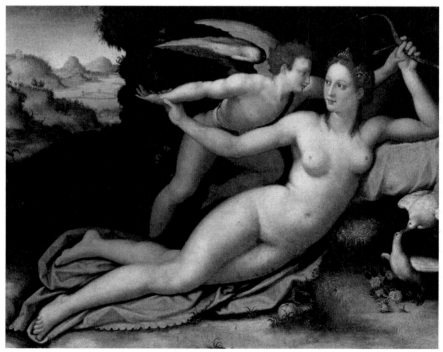

108 Alessandro Allori, *Venus and Amor*, after 1570, Gallerie degli Uffizi, Florence, Italy.
Photo: Heritage Image Partnership Ltd / Alamy Stock Photo

titled *Feste nelle nozze de don Francesco Medici gran duca di Toscana* from 1579. According to the script, Venus proclaimed that she "had called the fair Bianca from the shores of the Adriatic and how upon her arrival on Arno's banks, the winged boy Cupid had hidden himself in her eyes and thence wounded the prince with his arrows."[2] Venus then handed a golden apple, symbol of her unparalleled beauty, to an *amoretto* or little love, who presented it to Bianca. As if by magic, the apple opened and metamorphosed into a jeweled crown, marking the Venetian citizen's ascent to the position of Grand Duchess of Tuscany.[3] In Alessandro Allori's *Venus and Amor* (Fig. 108), which Francesco commissioned for Bianca in the 1570s, the nude goddess – now modeling the same red hair as the Duke's lover – reclines in a verdant landscape on a luxurious silk textile. Two white doves kiss on a bed of roses. Venus' golden apple, the bright shiny round orb of sovereign beauty, sits in the foreground.[4]

In 1587, Ferdinando I de' Medici became Duke of Florence, following the mysterious deaths (from arsenic or malaria) of Francesco and Bianca at the Villa Petraia.[5] Once Duke, Ferdinando married Christina of Lorraine and expanded his interests in theater and music, hiring artists to build stages, install special effects, and design costumes. He also hired musicians, singers, and writers. Through his merging of the arts, Duke Ferdinando I patronized some of the earliest operas. In 1575, he purchased the famous *Medici Venus*, now in the Uffizi. Ferdinando I also commissioned Giusto Utens' series of villa paintings, including his *View of the Villa Medicea di Castello* of 1599.

In the following century, Venus makes a few appearances in the panel paintings of Florentine Baroque artists. Giovanni da San Giovanni features the goddess and her son in his allegory of *Painting* (Fig. 109) from ca. 1612–36. The poised and disciplined female figure appears simultaneously as a studio model and a painter. She can be read as Venus, and yet, the softly colored female that she paints, alighting on a bank of fluffy white clouds, may also be the celestial goddess

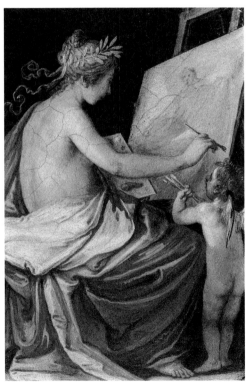

109 Giovanni da San Giovanni, *Painting*, ca. 1612–36, the Palatine Gallery, Pitti Palace, Florence, Italy. Photo: Reproduced with the permission of Ministero per i Beni e le Attività Culturali / Finsiel / Alinari Archives

of love. Sitting on a stool, this allegorical figure is nude from the waist down with a golden silk draped across her lap and over her left shoulder. The shimmering textile forms a lovely arc that frames her porcelain, rosy-hued skin. Her blonde hair is crowned with myrtle or laurel, and tiny curls kiss the nape of her neck. As she reaches to paint on the surface of her canvas, she decorously covers her breast. Young Cupid stands at her knees, clutching a set of wooden arrows tipped with white feathers; these weapons simultaneously read as paint brushes – both of which arouse desire. The toddler sports a small pair of delicate blue wings and gazes up in veneration at the artist's creation. San Giovanni's decision to portray Cupid from the back adheres to the Florentine tradition of depicting beautiful bottoms; however, the boy-god's young body does not read as erotic. Cupid simultaneously represents the love that inspires the artist and the love that the artist bestows upon his or her creation, a love that generates art's children. San Giovanni's *Painting* renders the charm and attraction of beauty, which through the sense of sight, pierces the heart to inspire love and its attendant pleasures.

NOTES

1 For details on Francesco and Bianca's affair and marriage, see Mary Steegman, *Bianca Cappello* (London: Constable and Company, 1913), 74–217; Jacqueline Marie Musacchio, "Wives, Lovers, and Art in Italian Renaissance Courts," in *Art and Love in Renaissance Italy*, ed. Andrea Bayer (New York: Metropolitan Museum of Art, 2008), 35–39.

2 For quote, see Steegman, *Bianca Cappello*, 206–207.

3 In addition to her first appearance in the theatrical performance celebrating Francesco and Bianca's wedding, Venus appeared a second time as *Venus Anadyomene*, arriving in triumph on a cart in the shape of a golden shell, drawn by two doves, and preceded by a procession of Tritons. For a description of Venus' appearances in the festivities celebrating Francesco and Bianca's marriage, see A. M. Nagler, *Theatre Festivals of the Medici, 1539–1637* (New Haven, CT: Yale University Press, 1964), 54–56.

4 Simona Lecchini Giovannoni, *Alessandro Allori* (Turin: Allemandi, 1991), 225–26; Philippe Costamagna's catalogue entry (no. 43) in *Venus and Love: Michelangelo and the New Ideal of Beauty*, ed. Franca Falletti and Jonathan Katz Nelson (Florence: Giunti, 2002), 226; Giovanna Giusti Galardi's catalogue entry (no. 4) in *The Myth of Venus*, ed. Maria Sframeli (Milan: Silvana, 2003), 74–75.

5 Anna Maria Testaverde, "Spectacle, Theatre, and Propaganda at the Court of the Medici," in *The Medici, Michelangelo, and the Art of Late Renaissance Florence*, ed. Cristina Acidini Luchinat (New Haven: Yale University Press, 2002), 123–31.

BIBLIOGRAPHY

PRIMARY SOURCES

Agrippa, Henry Cornelius. *The Three Books of Occult Philosophy or Magic*. Edited by Willis F. Whitehead. New York: AMS Press, 1982.

Alberti, Leon Battista. *Opere volgari*. Edited by Anicio Bonucci. Vol. 5. Florence: Galileiana, 1849.

———. *Della pittura*. Edited by Luigi Malle. Florence: Sansoni, 1950.

———. *On Painting*. Translated by John R. Spencer. New Haven, CT: Yale University Press, 1966.

———. *The Family in Renaissance Florence*. Translated by Renée Neu Watkins. Columbia: University of South Carolina Press, 1969.

———. *On the Art of Building in Ten Books*. Translated by Joseph Rykwert, et al. Cambridge, MA: MIT Press, 1988.

Aldrovandi, Ulisse. *I nomi antichi et moderni dell'antica citta di Roma*. Venice: Segno della Speranza, 1552.

Alighieri, Dante. *The Divine Comedy*. Translated by Allen Mandelbaum. 3 Vols. Berkeley: University of California Press, 1980–82.

———. *Convivio. A Dual-Language Critical Edition*. Edited and translated by Andrew Frisardi. Cambridge: Cambridge University Press, 2018.

Altieri, Marco Antonio. *Li nuptiali*. Edited by Enrico Narducci. Rome: Roma nel Rinascimento, 1995.

Apuleius. *Metamorphoses (The Golden Ass), Volume I: Books 1–6*. Edited and translated by J. Arthur Hanson. Loeb Classical Library 44. Cambridge, MA: Harvard University Press, 1996.

Aretino, Pietro. *Lettere sull'arte*. Edited by Fidenzio Pertile and Ettore Camesasca. Vol. 1. Milan: Milione, 1957.

———. *The Letters of Pietro Aretino*. Translated by Thomas Caldecot Chubb. New Haven, CT: Yale University Press, 1967.

———. *Lettere*. Edited by Francesco Erspamer. Vol. 1. Parma: U. Guanda, 1995.

Aristotle. *Minor Works (On Marvellous Things Heard)*. Translated by W. S. Hett. Loeb Classical Library 307. Cambridge, MA: Harvard University Press, 1938.

Baldinucci, Filippo. *Notizie dei professori del disegno da Cimabue in qua per le quali si domostra come, e per chi le belle arti di pittura, scultura e architettura, lasciata la rozzezza delle maniere greca e gotica, si siano in questi secoli ridotte all'antica loro perfezione*. Edited by Ferdinando Ranalli. Vol. 2. Florence: V. Batelli e Compagni, 1846.

Baldovinetti, Alessio. *I ricordi (1470–73)*. Edited by Giovanni Poggi. Florence: Liberia, 1909.

Barberino, Francesco da. *I documenti d'amore*. Edited by Marco Albertazzi. Lavis: La Finestra, 2008.

Belon, Pierre. "De neglecta stirpium cultura, atque earum cognitione libellus." In *Exoticorum libri decem*. Edited by Charles de l'Ècluse. Leiden: Officina Plantiniana, 1605.

Berengario da Carpi, Jacopo. *Commentaria cum amplissimis additionibus super anatomiam Mundini una cum textu ejusdem in pristinum et verum nitorem redacto*. Bologna: Hieronymum de Benedictis, 1521.

Bicci, Neri di. *Le ricordanze (1453–1475)*. Edited by Bruno Santi. Pisa: Marlin, 1976.

Biringuccio, Vannoccio. *Pirotechnia*. Translated by Cyril Stanley Smith and Martha Teach Gnudi. New York: American Institute of Mining and Metallurgical Engineers, 1942.

Boccaccio, Giovanni. *Geneologia de gli dei: i qvin deci libri*. Translated by Giuseppe Betussi. Venice: Comino da Trino di Monferrato, 1547.

 Teseida. Edited by Salvatore Battaglia. Florence: G. C. Sansoni, 1938.

 The Nymph of Fiesole. Translated by Daniel J. Donno. New York: Columbia University Press, 1960.

 The Book of Theseus (Teseida delle Nozze d'Emilia). Translated by Bernadette Marie McCoy. New York: Medieval Text Association, 1974.

 Tutte le opere. Edited by Vittore Branca. Vol. 3, *Amorosa vision – Ninfale fiesolano – Trattatello in laude di Dante*. Milan: Mondadori, 1974.

 Amorosa visione. Translated by Robert Hollander, Timothy Hampton, and Margherita Frankel. Hanover, NH: University Press of New England, 1986.

 Filostrato. Edited by Vincenzo Pernicone. Translated by Robert P. apRoberts and Anna Bruni Seldis. New York: Garland, 1986.

 The Elegy of Lady Fiammetta. Translated by Mariangela Causa-Steindler and Thomas Mauch. Chicago: University of Chicago Press, 1990.

 Genealogy of the Pagan Gods, Volume I: Books I–V. Translated by Jon Solomon. I Tatti Renaissance Library 46. Cambridge, MA: Harvard University Press, 2011.

Borghini, Raffaello. *Il riposo*. Edited by Mario Rosci. Vol. 2. Milan: Labor, 1967.

Brantôme, Pierre de Bourdeille. *Vies des dames galantes*. Paris: Garnier Frères, 1872.

 The Book of the Ladies. Translated by Katharine Prescott Wormeley. New York: P.F. Collier & Son, 1899.

Capellanus, Andreas. *The Art of Courtly Love*. Translated by John Jay Parry. New York: Frederick Ungar Publishing, 1959.

Cartari, Vincenzo. *Le imagini de i dei de gli antichi*. Lyon: Stefano Michele, 1581.

Cellini, Benvenuto. *Autobiography*. Translated by George Bull. London: Penguin Books, 1998.

Cennini, Cennino. *Il libro dell'arte*. Translated by Lara Broecke. London: Archetype, 2015.

Claudian. *Panegyric on Probinus and Olybrius. Against Rufinus 1 and 2. War against Gildo. Against Eutropius 1 and 2. Fescennine Verses on the Marriage of Honorius. Epithalamium of Honorius and Maria. Panegyrics on the Third and Fourth Consulships of Honorius. Panegyric on the Consulship of Manlius. On Stilicho's Consulship 1*. Translated by M. Platnauer. Loeb Classical Library 135. Cambridge, MA: Harvard University Press, 1922.

Clement of Alexandria. "Exhortation to the Heathen." In *Fathers of the Second Century: Hermes, Tatian, Athenagoras, Theophilus, and Clement of Alexandria (Entire)*. Edited by Philip Schaff. London: Aeterna Press, 2016.

Cocles, Bartolommeo della Rocca. *Chyromantie ac physionomie anastasis cum approbatione Magistri Alexandri de Achillinis*. Bologna: Joannem Antonium Platonidem Benedictorum, 1504.

Colombo, Realdo. *De re anatomica libri XV*. Frankfurt am Main: Johann Wechel, 1590.

Correggio, Niccolò da. *Opere: Cefalo, Psiche, Silva, Rime*. Edited by Antonia Tissoni Benvenuti. Bari: Laterza, 1969.

Dolce, Lodovico. *Dialogo dei colori*. Lanciano: Carabba, 1913.

Ficino, Marsilio. *Commentary on Plato's Symposium on Love*. Translated by Sears Reynolds Jayne. Dallas: Spring Publications, 2000.

 The Philebus Commentary. Translated by Michael Allen. Tempe: Arizona Center for Medieval and Renaissance Studies, 2000.

 Three Books on Life. Translated by Carol V. Kaske and John R. Clark. Tempe: Arizona Center for Medieval and Renaissance Studies, 2002.

 Platonic Theology. Edited by James Hankins with William Bowen. Translated by Michael J. B. Allen and John Warden. Vol. 4. I Tatti

Renaissance Library 23. Cambridge, MA: Harvard University Press, 2004.

The Letters of Marsilio Ficino. Translated by Members of the Language Department of the School of Economic Science. Vol. 9. London: Shepheard-Walwyn, 2012.

Filarete (Antonio Averlino). *Filarete's Treatise on Architecture; Being the Treatise by Antonio di Piero Averlino, Known as Filarete*. Edited and translated by John R. Spencer. New Haven, CT: Yale University Press, 1965.

Firenzuola, Angolo. *On the Beauty of Women*. Translated by Konrad Eisenbichler and Jacqueline Murray. Philadelphia: University of Pennsylvania Press, 1971.

Franco, Niccolò. *Dialogo dove si ragiona delle Bellezze*. Venice: Antonium Gardane, 1542.

Ghiberti, Lorenzo. *I commentari*. Edited by Ottavio Morisani. Naples: Ricciardi, 1947.

Giovio, Paolo. *Dialogo dell'imprese militari et amorose*. Lyon: Guglielmo Rouillio, 1574.

Grazzini, Antonfrancesco. *Tutti i trionfi, carri, mascherate, o canti carnascialeschi andati per Firenze dal tempo del Lorenzo de' Medici*. Florence: Lorenzo Torrentino 1559.

Tutti i trionfi, carri, mascherate, o canti carnascialeschi andati per Firenze dal tempo del Lorenzo de' Medici fino all'anno 1559. Lucca: Pel Benedini, 1750.

Le rime burlesque edite e inedite di Antonfrancesco Grazzini detto Il Lasca. Edited by Carlo Verzone. Florence: Sansoni, 1882.

The Greek Anthology, Volume V: Book 13: Epigrams in Various Metres. Book 14: Arithmetical Problems, Riddles, Oracles. Book 15: Miscellanea. Book 16: Epigrams of the Planudean Anthology Not in the Palatine Manuscript. Translated by W. R. Paton. Loeb Classical Library 86. Cambridge, MA: Harvard University Press, 1918.

Greek Mathematical Works, Volume I: Thales to Euclid. Translated by Ivor Thomas. Loeb Classical Library 335. Cambridge, MA: Harvard University Press, 1939.

Hildegard of Bingen. *On Natural Philosophy and Medicine. Selections from Cause et cure*. Translated by Margret Berger. Cambridge: D. S. Brewer, 1999.

Holy Bible. Douay–Rheims Version. Edited by Bishop Richard Challoner. London: Baronius Press, 2007.

Homeric Hymns. Homeric Apocrypha. Lives of Homer. Translated by Martin L. West. Loeb Classical Library 496. Cambridge, MA: Harvard University Press, 2003.

Ibn Ezra, Avraham Ben Meir. *The Beginning of Wisdom (Reshith Hochma)*. Translated by Meira B. Eptstein. Las Vegas: ARHAT, 1998.

Isidore of Seville. *The Etymologies*. Edited and translated by Stephen A. Barney, W. J. Lewis, J. A. Beach, and Oliver Berghof. Cambridge: Cambridge University Press, 2006.

Leonardi, Camillo. *Speculum lapidum, cui accessit Sympathia septem metallorum ac septem selectorum lapidum ad planetas. Petri Arlensis de Scudalupis*. Paris: Sevestri et Gillius, 1610.

The mirror of stones: in which the nature, generation, properties, virtues and various species of more than 200 different jewels, precious and rare stones, are distinctly described. London: J. Freeman, 1750.

Leonardo da Vinci. *The Literary Works of Leonardo da Vinci*. Edited by Jean Paul Richter. London: Low, 1883.

On Painting. Edited by Martin Kemp. New Haven, CT: Yale University Press, 1990.

Libro di pittura: edizione in facsimile del Codice Urbinate lat. 1270 nella Biblioteca Apostolica Vaticana. Edited by Carlo Pedretti. Vol. 1. Florence: Giunti, 1995.

Lirici toscani del Quattrocento. Edited by Antonio Lanza. 2 vols. Rome: Bulzoni, 1973–75.

Lorris, Guillaume de, and Jean de Meun. *The Romance of the Rose*. Translated by Charles Dahlberg. Princeton, NJ: Princeton University Press, 1971.

Lucian. *Soloecista. Lucius or The Ass. Amores. Halcyon. Demosthenes. Podagra. Ocypus. Cyniscus. Philopatris. Charidemus. Nero*. Translated by M. D. Macleod. Loeb Classical Library 432. Cambridge, MA: Harvard University Press, 1967.

Lucretius. *On the Nature of Things*. Translated by W. H. D. Rouse. Revised by Martin F.

Smith. Loeb Classical Library 181. Cambridge, MA: Harvard University Press, 1924.

Machiavelli, Niccolò. *Florentine Histories.* Translated by Laura F. Banfield and Harvey C. Mansfield, Jr. Princeton, NJ: Princeton University Press, 1988.

Macrobius. *Saturnalia.* Translated by Percival Vaughan Davies. New York: Columbia University Press, 1969.

Magnus, Albertus. *Book of Minerals.* Translated by Dorothy Wyckoff. Oxford: Clarendon Press, 1967.

Mannucci, Aldo. *Vita di Cosimo I. de' Medici granduca di Toscana.* Pisa: Niccolò Capurro, 1823.

Marbode, Bishop of Rennes. *Lapidari: la magia delle pietre preziose.* Edited by Bruno Basile. Rome: Carocci, 2006.

Marcotti, Giuseppe. *Un mercante fiorentino e la sua famiglia nel secolo XV.* Florence: G. Barbèra, 1881.

Martelli, Niccolò. *Lettere.* Edited by Cartesio Marconcini. Lanciano: R. Carabba, 1916.

Matasilani, Mario. *La felicità del serenissimo Cosimo Medici granduca di Toscana.* Florence: Giorgio Marescotti, 1572.

Maternus, Firmicus. *Matheseos Libri VIII.* Translated by Jean Rhys Bram. Park Ridge, NJ: Noyes Press, 1975.

Mattioli, Pietro Andrea. *I discorsi ne i sei libri della materia medicinale di pedacio Dioscoride Anazarbeo.* Sala Bolognese: Forni, 1984.

Medici, Lorenzo de'. *Poesie volgari, nuovamente.* Venice: Aldus, 1554.

———. *Selected Poems and Prose.* Edited and translated by Jon Thiem. University Park, PA: Pennsylvania State University Press, 1991.

———. *The Autobiography of Lorenzo de' Medici the Magnificent: A Commentary on My Sonnets.* Translated by James Wyatt Cook. Binghamton, NY: Medieval & Renaissance Texts & Studies, 1995.

Mercanti scrittori. Ricordi nella Firenze tra medioevo e rinascimento. Edited by Vittore Branca. Milan: Rusconi, 1986.

Nardi, Jacopo. *Istorie della città di Firenze.* Edited by Agenore Gelli. Vol. 1. Florence: Felice Le Monnier, 1858.

Négociations diplomatiques de la France avec la Toscane (1311–1610). Edited by G. Canestrini. Vol. 3. Paris: Imprimerie Impèriale, 1865.

Ovid. *Heroides. Amores.* Translated by Grant Showerman. Revised by G. P. Goold. Loeb Classical Library 41. Cambridge, MA: Harvard University Press, 1914.

———. *Fasti.* Translated by James G. Frazer. Revised by G. P. Goold. Loeb Classical Library 253. Cambridge, MA: Harvard University Press, 1931.

———. *The Erotic Poems.* Translated by Peter Green. London: Penguin Books, 1982.

———. *The Metamorphoses.* Translated by Allen Mandelbaum. New York: Harcourt Brace, 1993.

Pagnini, Giovanni Francesco, ed. *Della decima e di varie altre gravezze imposte dal comune di Firenze.* 2 vols. Lisbon and Lucca, 1765–66. Reprint. Bologna: Forni, 1967.

Palmieri, Matteo. *Della vita civile.* Milan: Giovanni Silvestri, 1825.

Parenti, Piero di Marco. *Delle nozze di Lorenzo de' Medici con Clarice Orsini nel 1469.* Edited by Gaetano Milanesi. Florence: Bencini, 1870.

Petrarch. *I trionfi.* Edited by Guido Bezzola. Milan: Rizzoli, 1957.

———. *The Canzoniere or Rerum vulgarium fragmenta.* Translated by Mark Musa. Bloomington: Indiana University Press, 1996.

Philostratus the Elder, Philostratus the Younger, and Callistratus. *Philostratus the Elder, Imagines. Philostratus the Younger, Imagines. Callistratus, Descriptions.* Translated by Arthur Fairbanks. Loeb Classical Library 256. Cambridge, MA: Harvard University Press, 1931.

Picatrix: A Medieval Treatise on Astral Magic. Translated by Dan Attrell and David Porreca. University Park, PA: Pennsylvania State University Press, 2019.

Pizan, Christine de. *Christine de Pizan's Letter of Othea to Hector.* Translated by Jane Chance. Cambridge: D. S. Brewer, 1997.

Pizan, Christine de et al. *Debate of the Romance of the Rose.* Edited and translated by David F.

Hult. Chicago: University of Chicago Press, 2010.

Plato. *Timaeus. Critias. Cleitophon. Menexenus. Epistles.* Translated by R. G. Bury. Loeb Classical Library 234. Cambridge, MA: Harvard University Press, 1929.

Plautus. *The Little Carthaginian. Pseudolous. The Rope.* Edited and translated by Wolfgang de Melo. Loeb Classical Library 260. Cambridge, MA: Harvard University Press, 2012.

Pliny. *Natural History, Volume III: Books 8–11.* Translated by H. Rackham. Loeb Classical Library 353. Cambridge, MA: Harvard University Press, 1940.

Natural History, Volume IX: Books 33–35. Translated by H. Rackham. Loeb Classical Library 394. Cambridge, MA: Harvard University Press, 1952.

Natural History, Volume X: Books 36–37. Translated by D. E. Eichholz. Loeb Classical Library 419. Cambridge, MA: Harvard University Press, 1962.

Natural History, Volume VIII: Books 28–32. Translated by W. H. S. Jones. Loeb Classical Library 418. Cambridge, MA: Harvard University Press, 1963.

Poliziano, Angelo. *The Stanze.* Translated by David Quint. University Park, PA: Pennsylvania State University Press, 1993.

Propertius. *Elegies.* Translated by G. P. Goold. Loeb Classical Library 18. Cambridge, MA: Harvard University Press, 1990.

Ptolemy. *Tetrabiblos.* Translated by F. E. Robbins. Loeb Classical Library 435. Cambridge, MA: Harvard University Press, 1940.

Ricci, Giuliano de. *Cronoca (1532–1606).* Edited by Giuliana Sapori. Milan: Riccardo Riccardi, 1972.

Ruscelli, Girolamo. *De secreti del reverendo donno Alessio Piemontese.* Lyon: Theobaldo Pagano, 1558.

Sacchetti, Franco. *Il Trecentonovelle.* Edited by Emilio Faccioli. Turin: Einaudi, 1970.

Savonarola, Girolamo. *Sermoni e prediche di F. Giroloamo Savonarola.* Prato: R. Guasti, 1846.

Prediche Italiane ai Fiorentini, vol. 1, Novembre e Dicembre del 1494. Edited by Francesco Cognasso. Perugia: La Nuova Italia, 1930.

Prediche Italiane ai Fiorentini, vol. 3.1, Quaresimale del 1496. Edited by Roberto Palmarocchi. Florence: La Nuova Italia, 1933.

Prediche sopra Ezechiele. Edited by Roberto Ridolfi. Vol. 1. Rome: Angelo Belardetti, 1955.

Selected Writings: Religion and Politics, 1490–1498. Edited by Anne Borelli and Maria C. Pastore Passaro. New Haven, CT: Yale University Press, 2005.

Savonarola, Michele. *Il trattato ginecologico-pediatrico in volgare.* Edited by Luigi Belloni. Milan: Società Italiana di Ostetricia e Ginecologia, 1952.

Scritti d'arte del Cinquecento. Edited by Paola Barocchi. 9 vols. Turin: G. Einaudi, 1977–79.

Strabo. *Geography, Volume VI: Books 13–14.* Translated by Horace Leonard Jones. Loeb Classical Library 223. Cambridge, MA: Harvard University Press, 1929.

Strozzi, Alessandra Macinghi. *Lettere di una gentildonna fiorentina del secolo XV ai figliuoli esuli.* Edited by Cesare Guasti. Florence: Sansoni, 1877.

Tempo di affetti e di mercanti: lettere ai figli esuli. Milan: Garzanti, 1987.

Selected Letters. Translated by Heather Gregory. Berkeley: University of California Press, 1997.

Tedaldi, Giovanni Battista. "Discorso sopra la pianta dell'aspalato, il musco e l'ambra-cane." In *Notizie dei secoli XV. e XVI. sull'Italia Polonia e Russia.* Edited by Sebastiano Ciampi. Florence: Leopoldo Allegrini e Giov. Mazzoni, 1833.

Tertullian. "On the Apparel of Women." In *Fathers of the Third Century: Tertullian, Part Fourth; Minucius Felix; Commodian; Origen, Parts First and Second.* Edited by Alexander Roberts and James Donaldson. Ante-Nicene Fathers. Vol. 4. Grand Rapids, MI: Eerdmans, 1972.

Theophrastus. *Enquiry into Plants, Volume II: Books 6–9. On Odours. Weather Signs.*

Translated by Arthur F. Hort. Loeb Classical Library 79. Cambridge, MA: Harvard University Press, 1916.

Trattati d'arte del Cinquecento fra manierismo e Controriforma. Edited by Paola Barocchi. Vol. 1. Bari: G. Laterza, 1960.

The Trotula. A Medieval Compendium of Women's Medicine. Translated by Monica H. Green. Philadelphia: University of Pennsylvania Press, 2001.

Valeriano, Piero. *Hieroglyphica*. Basel: Thomam Guarinum, 1567.

Varchi, Benedetto. *Opere di Benedetto Varchi ora per la prima volta raccolte, con un discorso di A. Racheli intorno alla filologia del secolo XVI e alla vita e agli scritti dell'autore, aggiuntevi le Lettere di Gio. Battista Busini sopra l'assedio di Firenze*. 2 vols. Trieste: Sezione Letterario-Artistica del Lloyd Austriaco, 1858–59.

Storia Fiorentina. Edited by Gaetano Milanesi. Vol. 3. Florence: Felice Le Monnier, 1888.

Varro. *On the Latin Language, Volume I: Books 5–7*. Translated by Roland G. Kent. Loeb Classical Library 333. Cambridge, MA: Harvard University Press, 1938.

Vasari, Giorgio. *Le vite de più eccellenti pittori scultori ed architettori*. Edited by Gaetano Milanesi. 9 vols. Florence: G. C. Sansoni, 1878–85.

Lives of the Most Eminent Painters, Sculptors, and Architects. Translated by Gaston du C. de Vere. 10 vols. London: Macmillan, 1912–15.

Der literarische Nachlass Giorgio Vasaris. Edited by Karl Frey. Vol. 1. Munich: Georg Müller, 1923.

Il libro delle ricordanze di Giorgio Vasari. Il carteggio di Giorgio Vasari dal 1563 al 1565. Edited by Alessandro del Vita. Rome: Reale Istituto d'Archeologia e Storia dell'Arte, 1938.

Ragionamenti sopra le invenzioni da lui dipinte in Firenze nel Palazzo vecchio con d. Francesco Medici allora principe di Firenze. Pisa: N. Capurro, 1823.

Villani, Filippo. *De origine civitatis florentie et de eiusdem famosis civibus*. Edited by Giuliano Tanturli. Padua: Antenoreis, 1997.

Women's Secrets: A Translation of Pseudo-Albertus Magnus's De Secretis Mulierum with Commentaries. Edited by Helen Rodnite Lemay. Albany, NY: State University of New York Press, 1992.

SECONDARY SOURCES

Ajmar-Wollheim, Marta, and Flora Dennis, eds. *At Home in Renaissance Italy*. London: Victoria and Albert Museum, 2006.

Alberts, Lindsay. "The *studiolo* of Francesco I de' Medici: A Recently-Found Inventory." *ARTHS* 2.0 1 (2015): 3–24.

Albus, Anita. *The Art of Arts: Rediscovering Painting*. Translated by Michael Robertson. New York: Alfred A. Knopf, 2000.

Alfano, Marina. "L'armonia di Schifanoia: Allegoria musicale nel Rinascimento." In *Lo Zodiaco del principe: i decani di Schifanoia di Maurizio Bonora*. Edited by Elena Bonatti, 71–80. Ferrara: Maurizio Tosi, 1992.

Anderson, Christy, Anne Dunlop, and Pamela Smith, eds. *The Matter of Art: Materials, Practices, Cultural Logics, c. 1250–1750*. Manchester: Manchester University Press, 2015.

Anderson, Jaynie. "A 'Most Improper Picture': Transformations of Bronzino's Erotic Allegory." *Apollo* 139 (1994): 19–28.

Andrews, Lew. "Botticelli's 'Primavera', Angelo Poliziano, and Ovid's 'Fasti'." *Artibus et Historiae* 32 (2011): 73–84.

Arasse, Daniel, Pierluigi de Vecchi, and Jonathan Katz Nelson, eds. *Botticelli e Filippino: l'inquietudine e la grazia nella pittura fiorentina del Quattrocento*. Milan: Skira, 2004.

Arscott, Caroline, and Katie Scott, eds. *Manifestation of Venus: Art and Sexuality*. Manchester: Manchester University Press, 2001.

Ascione, Caterina. "L'arte del corallo: mito, storia e lavorazione dall'antichità ai giorni nostri." In *Il corallo rosso in Mediterraneo: arte, storia e scienza*. Edited by Fabio Cicogna and Riccardo Cattaneo Vietti, 11–36. Rome:

Ministero delle risorse agricole alimentari e forestali, 1993.

Austin, Herbert D. "Dante Notes: III from Matter to Spirit." *Modern Language Notes* 38 (1923): 140–48.

Babcock, Robert G. "Astrology and Pagan Gods in Carolingian 'Vitae' of St. Lambert." *Traditio* 42 (1986): 95–113.

Bachmann, Hans-Gert. *The Lure of Gold: An Artistic and Cultural History*. Translated by Steven Lindberg. New York: Abbeville Press, 2006.

Baker, Patrick. *Italian Renaissance Humanism in the Mirror*. Cambridge: Cambridge University Press, 2015.

Baldini, Umberto, *Primavera: The Restoration of Botticelli's Masterpiece*. New York: Harry N. Abrams, 1986.

Bambach, Carmen. *Drawing and Painting in the Italian Renaissance Workshop: Theory and Practice, 1300–1600*. Cambridge: Cambridge University Press, 1999.

Michelangelo: Divine Draftsman & Designer. New York: Metropolitan Museum of Art, 2018.

Bambach, Carmen, Janet Cox-Rearick, and George R. Goldner, eds. *The Drawings of Bronzino*. New Haven, CT: Yale University Press, 2010.

Barasch, Moshe. *Light and Color in the Italian Renaissance Theory of Art*. New York: New York University Press, 1978.

Bardeschi, Marco Dezzi et al. *Lo Stanzino del Principe in Palazzo Vecchio: I concetti, le immagini, il desiderio*. Florence: Le Lettere, 1980.

Barolsky, Paul. *Infinite Jest: Wit and Humor in Italian Renaissance Art*. Columbia, MO: University of Missouri Press, 1978.

"Botticelli's 'Primavera' and the Poetic Imagination of Italian Renaissance Art." *Arion: A Journal of Humanities and the Classics* 8 (2000): 5–35.

Barolsky, Paul, and Andrew Ladis. "The 'Pleasurable Deceits' of Bronzino's So-Called London *Allegory*." *Source* 10 (1991): 32–36.

Barriault, Anne B. *Spalliera Paintings of Renaissance Tuscany. Fables of Poets for Patrician Homes*. University Park, PA: Pennsylvania State University Press, 1994.

Baskins, Cristelle L. *Cassone Painting, Humanism, and Gender in Early Modern Italy*. New York: Cambridge University Press, 1997.

Bass, Marisa. *Jan Gossart and the Invention of Netherlandish Antiquity*. Princeton, NJ: Princeton University Press, 2016.

Baxandall, Michael. "Bartholomaus Facius on Painting: A Fifteenth-Century Manuscript of *De Viris Illustribus*." *Journal of the Warburg and Courtauld Institutes* 27 (1964): 90–107.

The Limewood Sculptors of Renaissance Germany. New Haven, CT: Yale University Press, 1980.

Painting and Experience in Fifteenth-Century Italy. 2nd ed. Oxford: Oxford University Press, 1988.

Bayer, Andrea, ed. *Art and Love in Renaissance Italy*. New Haven, CT: Yale University Press, 2008.

Béhar, Pierre. *Les langues occultes de la Renaissance: E ssai sur la crise intellectuelle de l'Europe au XVIe siècle*. Paris: Desjonquères, 1996.

Bellini, Luigi. *Gallery Bellini. Museo Bellini dal 1756*. Florence: Nerbini, 2009.

Bellosi, Luciano. "Il Maestro della Crocifessione Griggs: Giovanni Toscani." *Paragone* 17 (1966): 44–58.

Beltrami, Luca. "L'annullamento del contratto di matrimonio fra Galeazzo M. Sforza e Dorotea Gonzaga (1463)." *Archivio Storico Lombardo* 6 (1889): 126–32.

Berdini, Paolo. "Women under the gaze: A Renaissance Genealogy." *Art History* 21 (1998): 565–90.

Bering, Jesse. *Why Is the Penis Shaped Like That?* New York: Farrar, Straus and Giroux, 2012.

Bertozzi, Marco. "Schifanoia: Il salone dei dipinti perduti. Con una appendice su Aby Warburg: lo 'stile' del paganesimo antico." In *Lo Zodiaco del principe: i decani di Schifanoia di Maurizio Bonora*. Edited by Elena Bonatti, 23–33. Ferrara: Maurizio Tosi, 1992.

Bestor, Jane Fair. "Marriage Transactions in Renaissance Italy and Mauss's Essay on the Gift." *Past and Present* 164 (1999): 6–46.

Birbari, Elizabeth. *Dress in Italian Painting, 1460–1500.* London: John Murray, 1975.

Blazekovic, Zdravko. "Music in Medieval and Renaissance Astrological Imagery." PhD diss., City University of New York, 1997.

Blume, Dieter. *Regenten des Himmels: Astrologische Bilder in Mittelalter und Renaissance.* Berlin: Akademie, 2000.

"Michael Scot, Giotto, and the Construction of New Images of the Planets." In *Images of the Pagan Gods: Papers of a Conference in Memory of Jean Seznec.* Edited by Rembrandt Duits and François Quiviger. Warburg Institute Colloquia 14, 129–50. London: Aragno, 2009.

"Picturing the Stars: Astrological Imagery in the Latin West, 1100–1550." In *A Companion to Astrology in the Renaissance.* Edited by Brendan Dooley, 333–98. Leiden: Brill, 2014.

Boas, Marie. *Il Rinascimento scientifico 1450–1630.* Milan: Feltrinelli, 1973.

Bomford, David, Jill Dunkerton, Dillian Gordon, Ashok Roy, and Jo Kirby. *Art in the Making. Italian Painting before 1400.* London: National Gallery Publications, 1989.

Borris, Kenneth, and George Rousseau, eds. *The Sciences of Homosexuality in Early Modern Europe.* London: Routledge, 2008.

Bosch, Lynette. "Time, Truth, and Destiny: Some Iconographical Themes in Bronzino's *Primavera* and *Giustizia.*" *Zeitschrift für Kunstgeschichte* 73 (1983): 73–82.

"Bronzino's London *Allegory*: Love Versus Time." *Source* 9 (1990): 30–35.

Boskovits, Miklós. "Il Maestro di Incisa Scapaccino e alcuni problemi di pittura tardogotica in Italia." *Paragone* 501 (1991): 35–53.

Boström, Antonia. "Zanobi Lastricati: A Newly Discovered Document." *Burlington Magazine* 136 (1994): 835–36.

"A New Addition to Zanobi Lastricati: Fiorenza or the Venus Anadyomene: The Fluidity of Iconography." *The Sculpture Journal* 1 (1997): 1–6.

Bradburne, James M., ed., *Bronzino Revealed. The Hidden Secrets of Three Masterpieces.* Florence: Alias, 2010.

Branca, Daniela Delcorno. "Un discepolo del Poliziano: Michele Acciari." *Lettere italiane* 28 (1976): 464–81.

Brendel, Otto. "Origin and Meaning of the Mandorla." *Gazette des beaux-arts* 25 (1944): 5–24.

Brizza, Maria Teresa Balboni, ed. *Botticelli e il ricamo del Museo Poldi Pezzoli. Storia di un restauro.* Milan: Museo Poldi Pezzoli, 1990.

Brock, Maurice. *Bronzino.* Translated by David Poole Radzinowicz and Christine Schultz-Touge. Paris: Flammarion, 2002.

Brody, Lisa R. et al. "A 'Cassone' Painted in the Workshop of Paulo Uccello and Possibly Carved in the Workshop of Domenico del Tasso." *Yale University Art Gallery Bulletin* (2010): 114–17.

Brooks, Jeanice. "Music as Erotic Magic in Renaissance Romance." *Renaissance Quarterly* 69 (2007): 1207–56.

Brown, Clifford, and Anna Maria Lorenzoni. "Lorenzo Costa in Mantua, Five Autograph Letters." *L'Arte* 3 (1970): 102–16.

Brownmiller, Susan. *Against Our Will: Men, Women, and Rape.* Toronto: University of Toronto Press, 1981.

Bucklow, Spike. *The Alchemy of Paint: Art, Science, and Secrets from the Middle Ages.* London: Marion Boyars, 2009.

"Lead White's Mysteries." In *The Matter of Art: Materials, Practices, Cultural Logics, c. 1250–1750.* Edited by Christy Anderson, Anne Dunlop, and Pamela H. Smith, 141–59. Manchester: Manchester University Press, 2015.

Red: The Art and Science of a Colour. London: Reaktion Books, 2016.

Buhler, Stephen M. "Marsilio Ficino's De stella magorum and Renaissance Views of the Magi." *Renaissance Quarterly* 43 (1990): 348–71.

Buranelli, Francesco, Jorge Mejía, and Allen Duston, eds. *The Fifteenth Century Frescoes in the Sistine Chapel*. Vatican City: Musei Vaticani, 2003.

Burke, Jill. *Changing Patrons: Social Identity and the Visual Arts in Renaissance Florence*. University Park, PA: Pennsylvania State University Press, 2004.

"Republican Florence and the Arts, 1494–1513." In *Florence*. Edited by Francis Ames-Lewis, 252–89. Cambridge: Cambridge University Press, 2012.

The Italian Renaissance Nude. New Haven, CT: Yale University Press, 2018.

Calamandrei, Egidia Polidori. *Le vesti delle donne fiorentine nel Quattrocento*. Rome: Multigrafica, 1973.

Callmann, Ellen. *Apollonio di Giovanni*. Oxford: Clarendon Press, 1974.

"An Apollonio di Giovanni for an Historic Marriage." *Burlington Magazine* 119 (1977): 174–81.

"Masolino da Panicale and Florentine Cassone Painting." *Apollo* 150 (1999): 42–49.

"A 'Cassone' Painted in the Workshop of Paolo Uccello and Possibly Carved in the Workshop of Domenico del Tasso." *Yale University Art Gallery Bulletin* (2010): 114–17.

Camille, Michael. *The Medieval Art of Love: Objects and Subjects of Desire*. London: Abrams, 1998.

Campbell, Stephen J. *The Cabinet of Eros: Renaissance Mythological Painting and the Studiolo of Isabella d'Este*. New Haven, CT: Yale University Press, 2004.

The Endless Periphery: Toward a Geopolitics of Art in Lorenzo Lotto's Italy. Chicago: University of Chicago Press, 2019.

Campbell, Stephen J., and Sandra Seekins, eds. *The Body UnVeiled: Boundaries of the Figure in Early Modern Europe*. Ann Arbor, MI: Goetzcraft Printers, 1997.

Campbell, Thomas P. *Tapestry in the Renaissance: Art and Magnificence*. New Haven, CT: Yale University Press, 2002.

Cantelupe, Eugene B. "The Anonymous *Triumph of Venus* in the Louvre: An Early Renaissance Example of Mythological Disguise." *Art Bulletin* 44 (1962): 238–42.

Capodieci, Luisa. "Caterina de' Medici e la leggenda della Regina nera. Veleni, incantesimi e negromanzia." In *Le donne Medici nel sistema europeo delle corti XVI–XVIII secolo: atti del Convegno internazionale, Firenze, San Domenico di Fiesole, 6–8 ottobre 2005*. Edited by Giulia Calvi and Riccardo Spinelli. Vol. 1, 195–215. Florence: Polistampa, 2008.

Carli, Cecilia de. *I deschi da parto e la pittura del primo Rinascimento toscano*. Turin: Umberto Allemandi, 1997.

Cecchi, Alessandro. *Botticelli*. Milan: Federico Motta, 2005.

Cecchi, Alessandro, and Antonio Natali, eds. *L'officina della maniera: Varietà e fierezza nell'arte fiorentina del Cinquecento fra le due repubbliche 1494–1530*. Florence: Giunta, 1996.

Chastel, André. *Art et humanisme à Florence au temps de Laurent le Magnifique*. Paris: Presses universitaires de France, 1959.

Cheney, Iris. "Bronzino's London *Allegory*: Venus, Cupid, Virtue, and Time." *Source* 6 (1987): 12–18.

Cheney, Liana. *Botticelli's Neoplatonic Images*. Potomac, MA: Scripta Humanistica, 1993.

Christopoulos, John. "By 'Your Own Careful Attention and the Care of Doctors and Astrologers': Marsilio Ficino's Medical Astrology and Its Thomist Context." *Bruniana & Campanelliana* 16 (2010): 389–404.

Clark, Charles W. "A Christian Defense of Astrology in the Twelfth Century: The 'Liber Cursuum Planetarum' of Raymond of Marseilles." *International Social Science Review* 70 (1995): 93–102.

Clark, David Lang. "The Louvre 'Triumph of Venus' Panel: A Satire of Misogynists." *Aurora* 10 (2009): 1–12.

Clark, Kenneth. *The Nude: A Study in Ideal Form*. New York: Doubleday, 1956.

Codini, Ewa Karwacka, and Milletta Sbrilli. *Archivio Salviati. Documenti sui beni immobiliari dei Salviati: palazzi, ville, feudi. Piante del*

territorio. Pisa: Scuola Normale Superiore, 1987.

Cohen, Simona. "The Ambivalent Scorpio in Bronzino's London *Allegory*." *Gazette des beaux-arts* 135 (2000): 171–88.

Animals as Disguised Symbols in Renaissance Art. Leiden: Brill, 2008.

Colantuono, Anthony. *Titian, Colonna and the Renaissance Science of Procreation: Equicola's Seasons of Desire*. Burlington, VT: Ashgate, 2010.

Cole, Bruce. "Three New Works by Cenni di Francesco." *Burlington Magazine* 111 (1969): 81–83.

Cole, Michael W. *Cellini and the Principles of Sculpture*. New York: Cambridge University Press, 2002.

Coles, David. *Chromatopia: An Illustrated History of Colour*. New York: Thames & Hudson, 2019.

Comito, Terry. *The Idea of the Garden in the Renaissance*. New Brunswick, NJ: Rutgers University Press, 1978.

Compagni, Vittoria Perrone. "La magia ceremoniale del 'Picatrix' nel Rinascimento." *Atti dell'Accademia di Scienze Morali e Politiche* 88 (1977): 279–330.

Compton, Rebekah. "*Omnia Vincit Amor*: The Sovereignty of Love in Tuscan Poetry & Michelangelo's *Venus and Cupid*." *Mediaevalia* 33 (2012): 229–60.

Conforti, Claudia. "Il giardino di Castello come immagine del territorio." In *La città effimera e l'universo artificiale del giardino: la Firenze dei Medici e l'Italia del '500*. Edited by Marcello Fagiolo, 152–61. Rome: Officina, 1980.

"L'invenzione delle allegorie territoriali e dinastiche del giardino di Castello a Firenze." In *Il giardino come labirinto della storia*, 190–97. Palermo: Centro studi di storia e arte dei Giardini, 1984.

"Acque, condotti, fontane e fronde: le provisioni per la delizia nella villa medicea di Castello." In *Teatro delle acque*. Edited by Attilio Petruccioli and Dalu Jones, 76–89. Rome: Elefante, 1992.

"Il Castello verde: il giardino di Castello, gli spazi del manierismo." *FMR* 12 (1993): 59–78.

Connor, Steven. *The Book of Skin*. Ithaca, NY: Cornell University Press, 2004.

Conway, J. F. "Syphilis and Bronzino's London Allegory." *Journal of the Warburg and Courtauld Institutes* 49 (1986): 250–55.

Cooper, Charlotte E. "Learning to Read Christine de Pizan's *Epistre Othea*." *Pecia. Le livre et l'écrit* 17 (2014): 41–63.

Copenhaver, Brian. "Scholastic Philosophy and Renaissance Magic in the *De vita* of Marsilio Ficino." *Renaissance Quarterly* 37 (1984): 523–54.

Corli, Gino. "Il testamento di Zanobi Lastricati, scultore fiorentino del Cinquecento." *Mitteilungen des Kunsthistorischen Institutes in Florenz* 32 (1988): 580–81.

Costamagna, Philippe. *Pontormo. Catalogue raisonné de l'oeuvre peint*. Paris: Gallimard, 1994.

"Entre Raphaël, Titien et Michel-Ange: les portraits d'Andrea Doria par Sebastiano del Piombo et Bronzino." In *Les portraits du pouvoir: actes du colloque*. Edited by Olivier Bonfait, Anne-Lise Desmas, and Brigitte Marin, 25–33. Paris: Somogy, 2003.

"De la *fiorentinità* des portraits de Pontormo et de Bronzino." *Paragone* 62 (2005): 50–75.

Cox-Rearick, Janet. "Themes of Time and Rule at Poggio a Caiano: The Portico Frieze of Lorenzo il Magnifico." *Mitteilungen des Kunsthistorischen Institutes in Florenz* 26 (1982): 167–210.

Dynasty and Destiny in Medici Art: Pontormo, Leo X and the Two Cosimos. Princeton, NJ: Princeton University Press, 1984.

"Sacred to Profane: Diplomatic Gifts of the Medici to Francis I." *Journal of Medieval and Renaissance Studies* 24 (1994): 239–58.

The Collection of Francis I: Royal Treasures. New York: Harry N. Abrams, 1996.

Cox-Rearick, Janet, and Mary Westerman Bulgarella. "Public and Private Portraits of Cosimo de' Medici and Eleonora di Toledo: Bronzino's Paintings of His Ducal Patrons in Ottawa and Turin." *Artibus et Historiae* 25 (2004): 101–59.

Cranston, Jodi. *The Muddied Mirror: Materiality and Figuration in Titian's Later Paintings.* University Park, PA: Pennsylvania State University Press, 2010.

Crawford, Katherine. *The Sexual Culture of the French Renaissance.* Cambridge: Cambridge University Press, 2010.

Cropper, Elizabeth. "On Beautiful Women, Parmigianino, Petrarchismo, and the Vernacular Style." *Art Bulletin* 58 (1976): 374–94.

Cuir, Raphaël. *The Development of the Study of Anatomy from the Renaissance to Cartesianism: Da Carpi, Vesalius, Estienne, Bidloo.* Lewiston, NY: Edwin Mellen Press, 2009.

D'Ambra, Eve. "The Calculus of Venus: Nude Portraits of Roman Matrons." In *Sexuality in Ancient Art: Near East, Egypt, Greece, and Italy.* Edited by Natalie Boymel Kampen, 219–32. Cambridge: Cambridge University Press, 1996.

Damisch, Hubert. *The Judgment of Paris.* Translated by John Goodman. Chicago: University of Chicago Press, 1996.

Däubler-Hauschke, Claudia. *Geburt und Memoria. Zum italienischen Bildtyp der deschi da parto.* Berlin: Deutscher Kunstverlag, 2003.

Davis, Charles. "The Pitfalls of Iconology, or How It Was That Saturn Gelt His Father." *Studies in Iconology* 4 (1978): 79–94.

Debenedetti, Santorre. "Per la fortuna della *Teseida* e del *Ninfale Fiesolano* nel secolo XIV." *Giornale storico della letteratura italiana* 40 (1912): 259–64.

Degenhart, Bernhard and Annegrit Schmitt. *Corpus der italienischen Zeichnungen, 1300–1450.* Berlin: Mann, 1968.

Del Mare, Cristina. "Corallo in Sicilia dall'XI al XVII secolo: mercanti, tradizione e maestranze ebraiche." In *Mirabilia coralii: capolavori barocchi in corallo tra maestranze ebraiche e trapanesi.* Edited by Cristina del Mare and Maria Concetta di Natale, 10–53. Naples: Arte'm, 2009.

Del Serra, Alfio. "Il restauro della Nascita di Venere." *Gli Uffizi Studi e Ricerche: La Nascita di Venere e l'Annunciazione del Botticelli restaurate* 4 (1987): 49–57.

Dempsey, Charles. "Mercurius Ver: The Sources of Botticelli's *Primavera.*" *Journal of the Warburg and Courtauld Institutes* 31 (1968): 251–73.

——. *The Portrayal of Love: Botticelli's Primavera and Humanist Culture at the Time of Lorenzo the Magnificent.* Princeton, NJ: Princeton University Press, 1992.

——. *Inventing the Renaissance Putto.* Chapel Hill: University of North Carolina Press, 2001.

——. *The Early Renaissance and Vernacular Culture.* Cambridge, MA: Harvard University Press, 2012.

DePrano, Maria. *Art Patronage, Family, and Gender in Renaissance Florence: The Tornabuoni.* Cambridge: Cambridge University Press, 2018.

Deutsch, Monroe E. "Caesar and the Pearls of Britain." *The Classical Journal* 19 (1924): 503–05.

Draper, J. L. "Vasari's Decoration in the Palazzo Vecchio: The Ragionamenti Translated with an Introduction and Notes." PhD diss., University of North Carolina, 1973.

Duits, Rembrandt. *Gold Brocade and Renaissance Painting: A Study in Material Culture.* London: Pindar, 2008.

Edler de Roover, Florence. "Andrea Banchi, Florentine Silk Manufacturer and Merchant in the Fifteenth Century." In *Studies in Medieval and Renaissance History.* Edited by William M. Bowsky. Vol. 3, 223–85. Lincoln: University of Nebraska Press, 1966.

——. *L'arte della seta a Firenze nei secoli XIV e XV.* Edited by Sergio Tognetti. Florence: Leo S. Olschki, 1999.

Else, Felicia. "'La Maggior Porcheria Del Mondo': Documents for Ammannati's Neptune Fountain." *Burlington Magazine* 147 (2005): 487–91.

——. "Bartolomeo Ammannati: Moving Stones, Managing Waterways, and Building an Empire for Duke Cosimo I de' Medici." *Sixteenth Century Journal* 42 (2011): 393–425.

The Politics of Water in the Art and Festivals of Medici Florence: From Neptune Fountain to Naumachia. London: Routledge, 2018.

Ettlinger, Helen S. "The Portraits in Botticelli's Villa Lemmi Frescoes." *Mitteilungen des Kunsthistorischen Institutes in Florenz* 20 (1976): 404–407.

Evans, Mark, and Stefan Weppelmann, eds. *Botticelli Reimagined.* London: V&A Publishing, 2016.

Even, Yael. "The Heroine as Hero in Michelangelo's Art." *Woman's Art Journal* 11 (1990): 29–33.

Fahy, Everett. "Florence and Naples: A Cassone Panel in the Metropolitan Museum of Art." In *Hommage à Michel Laclotte. Études sur la peinture du Moyen Age et de la Renaissance.* Edited by Pierre Rosenberg, Cécile Scailliérez, and Dominique Thiébaut, 231–43. Milan: Electa, 1994.

Falciani, Carlo, and Antonio Natali, eds. *Bronzino: Artist and Poet at the Court of the Medici.* Florence: Mandragora, 2010.

Pontormo and Rosso Fiorentino: Diverging Paths of Mannerism. Florence: Mandragora, 2014.

Falletti, Franca, and Jonathan Katz Nelson, eds. *Venus and Love: Michelangelo and the New Ideal of Beauty.* Florence: Giunti, 2002.

Fazzini, Antonio. "Collezionismo privato nella Firenze del Cinquecento. L' 'appartamento nuovo' di Jacopo di Alamanno Salviati." *Annali della Scuola Normale Superiore di Pisa. Classe di lettere e filosofia* 3 (1993): 192–224.

Ferguson, Gary. *Queer (Re) Readings in the French Renaissance: Homosexuality, Gender, Culture.* Aldershot: Ashgate, 2008.

Ferruolo, Arnolfo B. "Botticelli's Mythologies, Ficino's *De Amore*, Poliziano's *Stanze per la Giostra*: Their Circle of Love." *Art Bulletin* 37 (1955): 17–25.

Field, Arthur. *The Origins of the Platonic Academy of Florence.* Princeton, NJ: Princeton University Press, 1988.

Fisher, Will. "Peaches and Figs: Bisexual Eroticism in the Paintings and Burlesque Poetry of Bronzino." In *Sex Acts in Early Modern Italy: Practice, Performance, Perversion, Punishment.* Edited by Allison Levy, 151–64. Farnham: Ashgate, 2010.

Flory, Marleen B. "Pearls for Venus." *Historia: Zeitschrift für Alte Geschichte* 37 (1988): 498–500.

Focillon, Henri. *The Life of Forms in Art.* New York: Zone Books, 1989.

Fowler, Caroline. "Technical Art History as Method." *Art Bulletin* 101 (2019): 9–17.

Fox, Anna. "The New and the Old: The Spread of Syphilis (1494–1530)." In *Sex and Gender in Historical Perspective.* Edited by Edward Muir and Guido Ruggiero, 26–45. Baltimore: Johns Hopkins University Press, 1990.

Franklin, David. "Ridolfo Ghirlandaio's altarpieces for Leonardo Buonafé and the Hospital of S. Maria Nuova in Florence." *Burlington Magazine* 135 (1993): 4–16.

"Towards a New Chronology for Ridolfo Ghirlandaio and Michele Tosini." *Burlington Magazine* 140 (1998): 445–55.

"Ridolfo Ghirlandaio and the Retrospective Tradition in Florentine Painting." In *Italian Renaissance Masters.* Edited by Annemarie Sawkins, David Franklin, and Louis Alexander Waldman, 17–21. Milwaukee, WI: Haggerty Museum of Art, 2001.

Freedman, Luba. *The Revival of the Olympian Gods in Renaissance Art.* Cambridge: Cambridge University Press, 2003.

Classical Myths in Italian Renaissance Painting. Cambridge: Cambridge University Press, 2011.

Freud, Sigmund. *Civilization and Its Discontents.* Translated and edited by James Strachey. New York: W. W. Norton & Company, 1961.

Frick, Carole Collier. *Dressing Renaissance Florence. Families, Fortunes, & Fine Clothing.* Baltimore: Johns Hopkins University Press, 2002.

Frieda, Leonie. *Catherine de Medici: Renaissance Queen of France.* New York: Harper, 2003.

Galinsky, Karl. *Ovid's Metamorphoses: An Introduction to Its Basic Aspects.* Oxford: Blackwell, 1975.

Galletti, Giorgio. "Tribolo maestro delle acque dei giardini." In *Niccolò detto il Tribolo tra arte, architettura e paesaggio*. Edited by Elisabetta Pieri and Luigi Zangheri, 151–60. Poggio a Caiano: Comune di Poggio a Caiano, 2001.

Garin, Eugenio. *Astrology in the Renaissance: Zodiac of Life*. Translated by Carolyn Jackson, June Allen, and Clare Robertson. London: Arkana, 1990.

Garrard, Mary. *Brunelleschi's Egg: Nature, Art, and Gender in Renaissance Italy*. Berkeley: University of California Press, 2010.

Garzelli, Annarosa. *Il ricamo nella attività artistica di Pollaiolo, Botticelli, Bartolomeo di Giovanni*. Florence: Edam, 1973.

Gaston, Robert. "Love's Sweet Poison: A New Reading of Bronzino's London 'Allegory'." *I Tatti Studies in the Italian Renaissance* 4 (1991): 249–88.

Gell, Alfred. "The Technology and the Enchantment of Technology." In *Anthropology, Art, and Aesthetics*. Edited by Jeremy Coote and Anthony Shelton, 40–63. Oxford: Clarendon Press, 1992.

——— *Art and Agency: An Anthropological Theory*. Oxford: Oxford University Press, 1998.

Gettens, Rutherford J., and Elisabeth West Fitzhugh. "Malachite and Green Verditer." *Studies in Conservation* 19 (1974): 2–23.

Gilbert, Creighton E. "The Archbishop on the Painters of Florence, 1450." *Art Bulletin* 41 (1959): 75–87.

——— "Ghiberti on the Destruction of Art." *I Tatti Studies in the Italian Renaissance* 6 (1995): 135–44.

Gill, Meredith. *Angels and the Order of Heaven in Medieval and Renaissance Italy*. Cambridge: Cambridge University Press, 2014.

Gillies, Jean. "The Central Figure in Botticelli's 'Primavera'." *Woman's Art Journal* 2 (1981): 12–16.

Gilson, Simon A. *Medieval Optics and Theories of Light in the Works of Dante*. Lewiston, NY: Edwin Mellen Press, 2000.

Gnignera, Elisabetta. *I soperchi ornamenti: copricapi e acconciature femminili nell'Italia del Quattrocento*. Siena: Protagon, 2010.

Godman, Peter. *From Poliziano to Machiavelli: Florentine Humanism in the High Renaissance*. Princeton, NJ: Princeton University Press, 1998.

Goffen, Rona. *Titian's Women*. New Haven, CT: Yale University Press, 1997.

Goldthwaite, Richard A. "An Entrepreneurial Silk Weaver in Renaissance Florence." *I Tatti Studies in the Italian Renaissance* 10 (2005): 69–126.

Gombrich, E. H. "Botticelli's Mythologies: A Study in the Neoplatonic Symbolism of His Circle." *Journal of the Warburg and Courtauld Institutes* 8 (1945): 7–60.

——— "Apollonio di Giovanni: A Florentine *Cassone* Workshop Seen through the Eyes of a Humanist Poet." *Journal of the Warburg and Courtauld Institutes* 18 (1955): 16–34.

González, J. J. Martín. "El Palacio de Aranjuez en el siglo XVI." *Archivo Español de Arte* 35 (1962): 237–52.

Greenfield, Amy Butler. *A Perfect Red: Empire, Espionage, and the Quest for the Color of Desire*. New York: Harper Perennial, 2006.

Gregory, Heather. "Daughters, Dowries and the Family in Fifteenth Century Florence." *Rinascimento* 27 (1987): 215–37.

Hagstrom, Aurelie A. "The Symbol of the Mandorla in Christian Art: Recovery of a Feminine Archetype." *ARTS* 10 (1998): 25–29.

Hale, J. R. *Florence and the Medici: The Pattern of Control*. London: Thames and Hudson, 1977.

Hall, Marcia B. *Color and Meaning: Practice and Theory in Renaissance Painting*. Cambridge: Cambridge University Press, 1992.

Hall, Marcia B., ed. *Color and Technique in Renaissance Painting: Italy and the North*. Locust Valley, NY: J. J. Augustin, 1987.

Hankey, Teresa. "Salutati's Epigrams for the Palazzo Vecchio at Florence." *Journal of the Warburg and Courtauld Institutes* 22 (1959): 363–65.

Hatfield, Rab. "The Compagnia de' Magi." *Journal of the Warburg and Courtauld Institutes* 33 (1970): 107–61.

Botticelli's Uffizi "Adoration": A Study in Pictorial Content. Princeton, NJ: Princeton University Press, 1976.

Herald, Jacqueline. *Renaissance Dress in Italy 1400–1500*. London: Bell & Hyman, 1981.

Herman, Eleanor. *The Royal Art of Poison: Filthy Palaces, Fatal Cosmetics, Deadly Medicine, and Murder Most Foul*. New York: St. Martin's Press, 2018.

Hibbard, Howard. *Michelangelo: Painter, Sculptor, Architect*. New York: Vendome, 1978.

Hills, Paul. *The Light of Early Italian Painting*. New Haven, CT: Yale University Press, 1987.

Veiled Presence: Body and Drapery from Giotto to Titian. New Haven, CT: Yale University Press, 2018.

Hindman, Sandra L. *Christine de Pizan's Epistre Othéa: Painting and Politics at the Court of Charles VI. Studies and Texts 77*. Toronto: Pontifical Institute of Mediaeval Studies, 1986.

Hirst, Michael. *Michelangelo and His Drawings*. New Haven, CT: Yale University Press, 1988.

Hope, Charles. "Bronzino's *Allegory* in the National Gallery." *Journal of the Warburg and Courtauld Institutes* 45 (1982): 239–43.

Horne, Herbert P. *Alessandro Filipepi, Commonly Called Sandro Botticelli, Painter of Florence*. Vol. 1. London: G. Bell & Sons, 1908.

Hornik, Heidi J. "The Strozzi Chapel by Michele Tosini: A Visual Interpretation of Redemptive Epiphany." *Artibus et Historiae* 23 (2002): 97–118.

Michele Tosini and the Ghirlandaio Workshop in Cinquecento Florence. Portland, OR: Sussex Academic Press, 2009.

Hughes, Graham. *Renaissance Cassoni: Masterpieces of Early Italian Art: Painted Marriage Chests 1400–1500*. London: Art Books International, 1997.

Hurlbut, Holly S. *Daughter of Venice: Caterina Corner, Queen of Cyprus and Woman of the Renaissance*. New Haven, CT: Yale University Press, 2015.

Hurtubise, Pierre. *Une famille-témoin. Les Salviati*. Vatican City: Biblioteca Apostolica Vaticana, 1985.

Innocenti, Clarice, ed. *Caterina e Maria de' Medici: donne al potere. Firenze celebra il mito di due regine di Francia*. Florence: Madragora, 2008.

Jacobs, Fredrika H. "Aretino and Michelangelo, Dolce and Titian: *Femmina, Masculo, Grazia*." *Art Bulletin* 82 (2000): 51–67.

James, Liz. *Light and Colour in Byzantine Art*. Oxford: Clarendon Press, 1996.

Janes, Dominic. *God and Gold in Late Antiquity*. Cambridge: Cambridge University Press, 1998.

Joannides, Paul. *Masaccio and Masolino: A Complete Catalogue*. London: Harry N. Abrams, 1993.

Johnson, Marguerite. *Ovid on Cosmetics: Medicamina Faciei Femineae and Related Texts*. London: Bloomsbury, 2016.

Jurdjevic, Mark. "Politicians and Prophets: Marsilio Ficino, Savonarola, and the Valori Family." *Past and Present* 183 (2004): 41–77.

Kanter, Laurence B. "The 'cose piccole' of Paolo Uccello." *Apollo* 52 (2000): 11–20.

Kanter, Laurence B., and Pia Palladino, et al. *Fra Angelico*. New Haven, CT: Yale University Press, 2005.

Kay, Richard. *Dante's Christian Astrology*. Philadelphia: University of Pennsylvania Press, 1994.

Keach, William. "Cupid Disarmed or Venus Wounded? An Ovidian Source for Michelangelo and Bronzino." *Journal of the Warburg and Courtauld Institutes* 41 (1978): 327–31.

Kemp, Christopher. *Floating Gold: A Natural (and Unnatural) History of Ambergris*. Chicago: University of Chicago Press, 2012.

Kirby, Jo. "The Price of Quality: Factors Influencing the Cost of Pigments during the Renaissance." In *Revaluing Renaissance Art*. Edited by Gabriele Neher and Rupert Shepherd, 19–42. Aldershot: Ashgate, 2000.

Kirby, Jo, Maarten van Bommel, and André Verhecken, eds. *Natural Colorants for Dyeing and Lake Pigments. Practical Recipes and Their Historical Sources*. London: Archetype, 2014.

Klapisch-Zuber, Christiane. *Women, Family, and Ritual in Renaissance Italy*. Translated by Lydia Cochrane. Chicago: University of Chicago Press, 1985.

Kleinbub, Christian. *Vision and the Visionary in Raphael*. University Park, PA: Pennsylvania State University Press, 2011.

Kline, Katy, ed. *Beauty & Duty: The Art and Business of Renaissance Marriage*. Brunswick: Bowdoin College Museum of Art, 2008.

Knecht, Robert J. *Renaissance Warrior and Patron: The Reign of Francis I*. Cambridge: Cambridge University Press, 1994.

Körner, Hans. "'Più femmine gnude bellissime'. Entkontextualisierung als künstlerische und ökonomische Strategie im Werk von Sandro Botticelli." In *Sandro Botticelli (1445–1510): Artist and Entrepreneur in Renaissance Florence. Proceedings of the International Conference Held at the Dutch University Institute for Art History, Florence, 20–21 June 2014*. Edited by Gert Jan van der Sman and Irene Mariani, 75–99. Florence: Centro Di, 2015.

Kren, Thomas, with Jill Burke and Stephen J. Campbell, eds. *The Renaissance Nude*. Los Angeles: J. Paul Getty Museum, 2018.

Kreytenberg, Gert. "Andrea Pisano's Earliest Works in Marble." *Burlington Magazine* 122 (1980): 3–7, 9.

Andrea Pisano und die toskanishce Skulptur des 14. Jahrhunderts. Munich: Bruckmann, 1984.

Kristeller, Paul Oscar. "The Platonic Academy of Florence." *Renaissance News* 14 (1961): 147–59.

Renaissance Thought and Its Sources. Edited by Michael Mooney. New York: Columbia University Press, 1979.

"Marsilio Ficino and the Roman Curia." *Humanistica Lovaniensia* 34 (1985): 83–98.

Kubersky-Piredda, Susanne. "The Market for Painters' Materials in Renaissance Florence." In *Trade in Artists' Materials: Markets and Commerce in Europe to 1700*. Edited by Jo Kirby, Susie Nash, and Joanna Cannon, 223–43. London: Archetype, 2010.

La Malfa, Claudia. "Firenze e l'allegoria dell'eloquenza: una nuova interpretazione della *Primavera* di Botticelli." *Storia dell'Arte* 97 (1999): 249–93.

Lacan, Jacques. *The Four Fundamental Concepts of Psychoanalysis*. Edited by Jacques-Alain Miller. Translated by Alan Sheridan. London: Kainac, 2004.

Landini, Roberta Orsi, and Bruna Niccoli. *Moda a Firenze, 1540–1580: Lo stile di Eleonora di Toledo e la sua influenza*. Florence: Pagliai Polistampa, 2005.

Landor, John. "The Question of Breast Cancer in Michelangelo's 'Night'." *Source: Notes in the History of Art* 25 (2006): 27–29.

Laqueur, Thomas. *Making Sex: Body and Gender from the Greeks to Freud*. Cambridge, MA: Harvard University Press, 1990.

"Amor Veneris, vel Dulcedo Appeletur." In *Feminism & the Body*. Edited by Londa Schiebinger, 58–86. Oxford: Oxford University Press, 2000.

Lawner, Lynne. *I Modi: The Sixteen Pleasures. An Erotic Album of the Italian Renaissance*. Evanston, IL: Northwestern University Press, 1988.

Lazzaro, Claudia. *The Italian Renaissance Garden*. New Haven, CT: Yale University Press, 1990.

Leach, Eleanor Winsor. "Plautus' Rudens: Venus Born from a Shell." *Texas Studies in Literature and Language* 15 (1974): 915–31.

Lecchini Giovannoni, Simona. *Alessandro Allori*. Turin: Allemandi, 1991.

Lee, Vernon. *Juvenilia: Being a Second Series of Essays on Sundry Aesthetical Questions*. Boston: Roberts Brothers, 1887.

Lehmann, Sophie. "Fleshing Out the Body: The 'Colours of the Naked' in Workshop Practice and Art Theory, 1400–1600." *Nederlands Kunsthistorisch Jaarboek* 58 (2007–2008): 87–109.

"How Materials Make Meaning." *Nederlands Kunsthistorisch Jaarboek (NKJ/ Netherlands Yearbook for History of Art* 62 (2012): 6–27.

Levey, Michael. "Sacred and Profane Significance in Two Paintings by Bronzino." In *Studies in Renaissance and*

Baroque Art Presented to Anthony Blunt on His Sixtieth Birthday, 30–33. London: Phaidon, 1967.

Levi D'Ancona, Mirella. *The Garden of the Renaissance: Botanical Symbolism in Italian Painting*. Florence: Leo S. Olschki, 1977.

Botticelli's Primavera: A Botanical Interpretation Including Astrology, Alchemy and the Medici. Florence: Leo S. Olschki, 1983.

Liebert, Robert. *Michelangelo: A Psychoanalytic Study of His Life and Images*. New Haven, CT: Yale University Press, 1983.

Lindquist, Sherry C. M., ed. *The Meanings of Nudity in Medieval Art*. Farnham: Ashgate, 2012.

Long, Jane C. "Botticelli's 'Birth of Venus' as Wedding Painting." *Aurora: The Journal of the History of Art* 9 (2008): 1–27.

"The Survival and Reception of the Classical Nude: Venus in the Middle Ages." In *The Meanings of Nudity in Medieval Art*. Edited by Sherry C. M. Lindquist, 47–64. Farnham: Ashgate, 2012.

Luchinat, Cristina Acidini, ed. *Fiorenza in Villa*. Florence: Alinari, 1987.

Luchinat, Cristina Acidini, and Giorgio Galletti. *Le ville e i giardini di Castello e Petraia a Firenze*. Ospedaletto: Pacini, 1992.

Maclagan, Eric, and Margaret H. Longhurst. *Catalogue of Italian Sculpture. Text*. London: Victoria and Albert Museum, 1932.

Mahnke, Dietrich. *Unendliche Sphäre und Allmittelpunkt. Beitrage zur Genealogie der mathematischen Mystik*. Halle an der Saale: M. Neimeyer, 1937.

Marchi, Piero. *I blasoni delle famiglie toscane conservati nella raccolta Ceramelli-Papiani*. Rome: Athena, 1992.

Markale, Jean. *Courtly Love: The Path of Sexual Initiation*. Translated by Jon Graham. Rochester, VT: Inner Traditions, 2000.

Markey, Lia. *Imagining the Americas in Medici Florence*. University Park, PA: Pennsylvania State University Press, 2016.

Marle, Raimond van. *Iconographie de l'art profane au Moyen-Age et à la Renaissance et la décoration des demeures*. Vol. 2. Hague: Nijhoff, 1932.

Mather, Frank J. "A Quattrocento Toilet Box in the Louvre." *Art in America* 11 (1922): 45–51.

Matteini, Mauro, and Archangelo Moles. "La Primavera, Tecnica di esecuzione e stato di conservazione." In *Metodo e scienza operatività e ricerca nel restauro (Firenze 23 giugno 1982–6 gennaio 1983)*. Edited by Umberto Baldini, 226–33. Florence: Sansoni, 1983.

"Indagine sui materiali e le stesure pittoriche del dipinto." *Gli Uffizi Studi e Ricerche: La Nascita di Venere e l'Annunciazione del Botticelli restaurate* 4 (1987): 75–82.

Matthew, Louisa C. "'Vendecolori a Venezia': The Reconstruction of a Profession." *Burlington Magazine* 144 (2002): 680–86.

Matthews-Grieco, Sara F., and Sabina Brevaglieri, eds. *Monaca Moglie Serva Cortigiana: Vita e immagine delle donne tra Rinascimento e Controriforma*. Florence: Morgana Edizioni, 2001.

Maylender, Michele. *Storia delle Accademie d'Italia*. Vol. 4. Bologna: Licinio Cappelli, 1929.

Mazzi, Curzio. *Due provvisioni suntuarie fiorentine (29 novembre 1464, 29 febbraio 1471 [1472])*. Florence: C. Mazzi, 1908.

McCall, Timothy. "Brilliant Bodies: Material Culture and the Adornment of Men in North Italy's Quattrocento Courts." *I Tatti Studies in the Italian Renaissance* 16 (2013): 445–90.

McCall, Timothy, Sean Roberts, and Giancarlo Fiorenza, eds. *Visual Cultures of Secrecy in Early Modern Europe*. Kirksville, MI: Truman State University Press, 2013.

McHam, Sarah Blake. *Pliny and the Artistic Culture of the Italian Renaissance: The Legacy of the "Natural History"*. New Haven, CT: Yale University Press, 2013.

Meadows, J. W. "Pliny on the Smaragdus." *The Classical Review* 59 (1945): 50–51.

Meiss, Millard. "The Earliest Work of Giovanni di Paolo." *Art in America* 24 (1936): 137–43.

French Painting in the Time of Jean de Berry. The Limbourgs and Their Contemporaries. London: Thames and Hudson, 1974.

Melchior-Bonnet, Sabine. *The Mirror: A History.* Translated by Katharine H. Jewett. New York: Routledge, 2001.

Mendelsohn, Leatrice. "Saturnian Allusions in Bronzino's London *Allegory.*" In *Saturn from Antiquity to the Renaissance.* Edited by Massimo Ciavolella and Amilcare Iannucci, 101–50. Toronto: Dovehouse, 1992.

"The Sum of the Parts: Recycling Antiquities in the *Maniera* Workshops of Salviati and His Colleagues." In *Francesco Salviati et la bella maniera: actes des colloques de Rome et de Paris, 1998.* Edited by Catherine Monbeig Goguel, Philippe Costamagna, and Michel Hochmann, 107–48. Rome: École Française de Rome, 2001.

Mensger, Ariane, ed. *Weibsbilder: Eros, Macht, Moral und Tod um 1500.* Berlin: Deutscher Kunstverlag, 2017.

Meoni, Lucia. *Gli arazzi nei musei fiorentini. La collezione medicea.* Livorno: Sillabe, 1998.

Meoni, Lucia, ed. *The Myth of Venus.* Milan: Silvana, 2003.

Merrifield, Mary P. *Original Treatises on the Arts of Painting.* Vol. 2. New York: Dover, 1967.

Milanesi, Gaetano. "Della Venere baciata da Cupido, dipinta dal Pontormo sul cartone di Michelangiolo Buonarroti." In *Le opere di Giorgio Vasari.* Vol. 4, 291–95. Florence: Sansone, 1881.

Miziolek, Jerzy. "The Awakening of Paris and the Beauty of the Goddesses: Two *Cassoni* from the Lanckoronski Collection." *Mitteilungen des Kunsthistorischen Institutes in Florenz* 51 (2007): 299–336.

Moffitt, John F. "A Hidden Sphinx by Agnolo Bronzino, 'Ex Tabula Cebetis Thebani'." *Renaissance Quarterly* 46 (1993): 277–307.

"An Exemplary Humanist Hybrid: Vasari's 'Fraud' with Reference to Bronzino's 'Sphinx'." *Renaissance Quarterly* 49 (1996): 303–33.

Molà, Luca. *The Silk Industry of Renaissance Venice.* Baltimore: Johns Hopkins University Press, 2000.

Mondor, Henri. *Anatomistes et chirurgiens.* Edited by Henri Mondor. Paris: Editions Fragrance, 1949.

Monson, Don A. *Andreas Capellanus, Scholasticism, & the Courtly Tradition.* Washington, DC: The Catholic University of America Press, 2005.

Moskowitz, Anita Fiderer. *The Sculpture of Andrea and Nino Pisano.* Cambridge: Cambridge University Press, 1986.

Motti, G., and C. Ricceri. "Piante e fiori nella 'Primavera'." In *Metodo e scienza operativita' e ricerca nel restauro (Firenze 23 giugno 1982–6 gennaio 1983).* Edited by Umberto Baldini, 217–55. Florence: Sansoni, 1983.

Mozzati, Tommaso. "Il tempio di Cnido. Il nudo e il suo linguaggio nell'età di Giambologna." In *Giambologna. Gli dei, gli eroi. Genesi e fortuna di uno stile europeo nella scultura. Catalogo della mostra (Firenze, 2 Marzo–15 giugno 2006).* Edited by Dimitrios Zikos and Beatrice Paolozzi Strozzi, 66–87. Florence: Giunti, 2006.

Muccini, Ugo, and Alessandro Cecchi. *The Apartments of Cosimo in Palazzo Vecchio.* Florence: Le Lettere, 1991.

Munro, John H. "The Medieval Scarlet and the Economics of Sartorial Splendour." In *Cloth and Clothing in Medieval Europe.* Edited by E. M. Carus-Wilson, Kenneth G. Ponting, and N. B. Harte, 13–70. London: Heinemann, 1983.

Müntz, Eugène. *Les collections des Médicis au XVe siècle.* Paris: Jules Rouam, 1888.

Murphy, Caroline P. *Murder of a Medici Princess.* Oxford: Oxford University Press, 2008.

Musacchio, Jacqueline Marie. "Imaginative Conceptions in Renaissance Italy." In *Picturing Women in Renaissance and Baroque Italy.* Edited by Geraldine A. Johnson and Sara F. Matthews Grieco, 42–60. Cambridge: Cambridge University Press, 1997.

The Art and Ritual of Childbirth in Renaissance Italy. New Haven, CT: Yale University Press, 1999.

Art, Marriage, & Family in the Florentine Renaissance Palace. New Haven, CT: Yale University Press, 2008.

Nagel, Alexander. "Gifts for Michelangelo and Vittoria Colonna." *Art Bulletin* 79 (1997): 647–68.

Nagler, A. M. *Theatre Festivals of the Medici, 1539–1637.* New Haven, CT: Yale University Press, 1964.

Nauert, Charles G. *Humanism and the Culture of Renaissance Europe.* Cambridge: Cambridge University Press, 2006.

Negro, Angela. *Venere e Amore di Michele di Ridolfo del Ghirlandaio: Il mito di una Venere di Michelangelo fra copie, repliche e pudiche vestizioni.* Rome: Campisano, 2001.

Nelson, Jonathan Katz. "Putting Botticelli and Filippino in Their Place: The Intended Height of *Spalliera* Paintings and *Tondi*." In *Invisibile agli occhi. Atti della giornata di studi in ricordo di Lisa Venturini, Firenze, Fondazione Roberto Longhi, 15 dicembre 2005.* Edited by Nicoletta Baldini, 53–63. Florence: Fondazione di studi di storia dell'arte Roberto Longhi, 2007.

Neri, Enrica Lusanna. "Un ciclo di affreschi dominicano e l'attività tarda di Pietro di Miniato." *Arte Cristiana* 710 (1985): 301–14.

Nesi, Alessandro. *Ciano profumiere: un personaggio stravagante della corte di Cosimo de' Medici.* Florence: Maniera, 2015.

Nethersole, Scott. *Art and Violence in Early Renaissance Florence.* New Haven, CT: Yale University Press, 2018.

— *Art of Renaissance Florence: A City and Its Legacy.* London: Laurence King Publishing, 2019.

Norman, Diana, ed. *Siena, Florence and Padua: Art, Society and Religion 1280–1400.* Vol. 1. New Haven, CT: Yale University Press, 1995.

Nuttall, Paula. *From Flanders to Florence: The Impact of Netherlandish Painting, 1400–1500.* New Haven, CT: Yale University Press, 2004.

Palagi, Giuseppe. *Di Zanobi Lastricati, scultore e fonditore fiorentino del secolo XVI. Ricordi e documenti.* Florence: Le Monnier, 1871.

Panofsky, Dora, and Erwin Panofsky. "The Iconography of the Galerie François Ier at Fontainebleau." *Gazette des Beaux-Arts* 1 (1958): 114–90.

Panofsky, Erwin. *Studies in Iconology: Humanistic Themes in the Art of the Renaissance.* New York: Harper & Row, 1962.

Panofsky, Erwin, and Fritz Saxl. "Classical Mythology in Mediaeval Art." *Metropolitan Museum Studies* 4 (1933): 228–80.

Paoletti, John. "Michelangelo's Masks." *Art Bulletin* 74 (1992): 423–40.

Paolini, Claudio, Daniela Parenti, and Ludovica Sebregondi, eds. *Virtù d'amore. Pittura nuziale nel Quattrocento fiorentino.* Florence: Giunti, 2010.

Parker, Deborah. *Bronzino: Renaissance Painter as Poet.* Cambridge: Cambridge University Press, 2000.

— "The Poetry of Patronage: Bronzino and the Medici." *Renaissance Studies* 17 (2003): 135–45.

Pastoureau, Michel. *Green: The History of a Color.* Translated by Jody Gladding. Princeton, NJ: Princeton University Press, 2014.

— *Red: The History of a Color.* Translated by Jody Gladding. Princeton, NJ: Princeton University Press, 2016.

Pendergrast, Mark. *Mirror, Mirror: A History of the Human Love Affair with Reflection.* New York: Basic Books, 2003.

Perlman, Julia Branna. "Venus, Myrrha, Cupid and/as Adonis: Metamorphoses 10 and the Artistry of Incest." In *Metamorphosis: The Changing Face of Ovid in Medieval and Early Modern Europe.* Edited by Alison Keith and Stephen Rupp, 223–38. Toronto: Centre for Reformation and Renaissance Studies, 2007.

Pierguidi, Stefano. "Botticelli and Protogenes: An Anecdote from Pliny's *Naturalis Historia*." *Source* 21 (2002): 15–18.

Pisetzky, Rosita Levi. *Storia del costume in Italia.* Vol. 2. Milan: Istituto Editoriale Italiano, 1964.

Plazzotta, Carol, and Larry Keith. "Bronzino's 'Allegory': New Evidence of the Artist's Revisions." *Burlington Magazine* 14 (1999): 89–99.

Pollard, John Graham. *Renaissance Medals. The Collections of the National Gallery of Art Systematic Catalogue.* Vol. 2. Washington, DC: National Gallery of Art, 2007.

Poncet, Christopher. *La scelta di Lorenzo: La Primavera di Botticelli tra poesia e filosofia.* Pisa: Fabrizio Serra, 2012.

"Ficino's Little Academy of Careggi." *Bruniana & Campanelliana* 19 (2013): 67–76.

Pope-Hennessy, John. *Giovanni di Paolo, 1403–1483.* New York: Oxford University Press, 1938.

Catalogue of Italian Sculpture in the Victoria and Albert Museum. Volume I: Text. Eighth to Fifteenth Century. London: Her Majesty's Stationery Office, 1964.

Previtali, Giovanni. *Gotico a Siena: miniature, pitture oreficerie, oggetti d'arte.* Florence: Centro Di, 1982.

Prizer, William. "Games of Venus: Secular Vocal Music in the Late Quattrocento and Early Cinquecento." *Journal of Musicology* 9 (1991): 3–56.

Prosperetti, Leopoldine. *Landscape and Philosophy in the Art of Jan Brueghel the Elder (1568–1625).* Aldershot: Ashgate, 2009.

Quinlan-McGrath, Mary. *Influences: Art, Optics, and Astrology in the Italian Renaissance.* Chicago: University of Chicago Press, 2013.

Randolph, Adrian W. B. *Engaging Symbols: Gender, Politics, and Public Art in Fifteenth-Century Florence.* New Haven, CT: Yale University Press, 2002.

"Gendering the Period Eye: Deschi da Parto and Renaissance Visual Culture." *Art History* 27 (2004): 538–62.

Touching Objects: Intimate Experiences of Italian Fifteenth-Century Art. New Haven, CT: Yale University Press, 2014.

Rasmussen, Ann Marie. "Hybrid Creatures: Moving Beyond Sexuality in the Medieval Sexual Badges." In *From Beasts to Souls: Gender and Embodiment in Medieval Europe.* Edited by Jane E. Burns and Peggy McCracken, 221–47. Notre Dame, IN: University of Notre Dame Press, 2013.

Reale, Giovanni. *Botticelli. La "Primavera" o le "Nozze di Filologia e Mercurio"? Rilettura di carattere filosofico ed ermeneutico del capolavoro di Botticelli con la prima presentazione analitica dei personaggi e di particolari simbolici.* Rimini: Idea Libri, 2001.

Refini, Eugenio. *The Vernacular Aristotle: Translation as Reception in Medieval and Renaissance Italy.* Cambridge: Cambridge University Press, 2020.

Ribeiro, Aileen. *Facing Beauty: Painted Women & Cosmetic Art.* New Haven, CT: Yale University Press, 2011.

Ricci, Lucia Battaglia. "Gardens in Italian Literature during the Thirteenth and Fourteenth Centuries." In *The Italian Garden: Art, Design and Culture.* Edited by John Dixon Hunt, 6–33. Cambridge: Cambridge University Press, 1996.

Riddle, John M. "Pomum ambrae: Amber and Ambergris in Plague Remedies." *Sudhoff's Archiv für Geschichte der Medizin und der Naturwissenschaften* 48 (1964): 111–22.

Rigobello, Maria Beatrice, and Francesco Autizi. *Palazzo della Ragione di Padova: Simbologie degli astri e rappresentazioni del governo.* Padua: Il Poligrafo, 2008.

Rijks, Marlise. "'Unusual Excrescences of Nature': Collected Coral and the Study of Petrified Luxury in Early Modern Antwerp." *Dutch Crossing: Journal of Low Countries Studies* 10 (2017): 1–29.

Riordan, Teresa. *Inventing Beauty: A History of the Innovations that Have Made Us Beautiful.* New York: Broadway Books, 2004.

Rocke, Michael. *Forbidden Friendships: Homosexuality and Male Culture in Renaissance Florence.* Oxford: Oxford University Press, 1996.

Rogers, Mary, and Paolo Tinagli, eds. *Women in Italy, 1350–1650. Ideals and Realities.* Manchester: Manchester University Press, 2005.

Roscoe, William. *The Life of Lorenzo de' Medici: called the Magnificent.* 8th ed. London: Henry G. Bohn, 1865.

Rosenberg, Charles. "Alfonso I d'Este, Michelangelo and the Man Who Bought Pigs." In *Revaluing Renaissance Art.* Edited by Gabriele Neher and Rupert Shepherd, 89–99. Cambridge: Cambridge University Press, 2000.

Ross, Janet. *Florentine Villas.* New York: Dutton, 1901.

Rostislava, Todorova Georgieva. "The Migrating Symbol: *Vesica Piscis* from the Pythagoreans to Christianity." In *Harmony of Nature and Spirituality in Stone*, 217–28. Belgrade, Serbia: Stone Studio Association, 2011.

——. "Visualizing the Divine Mandorla as a Vision of God in Byzantine Iconography." *Ikon* 6 (2013): 287–96.

Rousseau, Claudia. "Cosimo I de' Medici and Astrology: The Symbolism of Prophecy." PhD diss., Columbia University, 1983.

Roy, Ashok, ed. *Artists' Pigments: A Handbook of Their History and Characteristics*. Vol. 2. Oxford: Oxford University Press, 1993.

Rubin, Patricia Lee. "'Che è di questo culazzino!': Michelangelo and the Motif of the Male Buttocks in Italian Renaissance Art." *Oxford Art Journal* 32 (2009): 427–46.

——. *Seen from Behind: Perspectives on the Male Body and Renaissance Art*. New Haven, CT: Yale University Press, 2018.

Rubin, Patricia Lee, and Alison Wright. *Renaissance Florence: The Art of the 1470s*. London: National Gallery Publications Ltd, 1999.

Rubinstein, Nicolai. "Vasari's Painting of *The Foundation of Florence* in the Palazzo Vecchio." In *Essays in the History of Architecture Presented to Rudolf Wittkower*. Edited by Douglas Fraser, Howard Hibbard, and Milton J. Lewine. Vol. 1, 64–73. London: Phaidon, 1967.

Ruvoldt, Maria. "Michelangelo's Dream." *Art Bulletin* 85 (2003): 86–113.

——. *The Italian Renaissance Imagery of Inspiration: Metaphors of Sex, Sleep, and Dreams*. Cambridge: Cambridge University Press, 2004.

Safarik, Eduard A., and Gabriello Milantoni, eds. *Catalogo sommario della Galleria Colonna in Roma: dipinti*. Busto Arsizio: Bramante, 1981.

Saslow, James. *Ganymede in the Renaissance: Homosexuality in Art and Society*. New Haven, CT: Yale University Press, 1986.

——. "'A Veil of Ice between My Heart and the Fire': Michelangelo's Sexual Identity and Early Modern Constructs of Homosexuality." *Genders* 2 (1988): 77–90.

Saunders, David, Marika Spring, and Andrew Meek, eds. *The Renaissance Workshop*. London: Archetype, 2013.

Schabacker, Peter, and Elizabeth Jones. "Jan van Eyck's 'Woman at Her Toilet': Proposals concerning Its Subject and Context." *Annual Report (Fogg Art Museum)* 1974/ 1976 (1974–76): 56–78.

Schubring, Paul. *Cassoni: Truhen und Truhenbilder der italienischen Frührenaissance*. Leipzig: K. W. Hiersemann, 1915.

Schultz, James A. *Courtly Love, the Love of Courtliness, and the History of Sexuality*. Chicago: University of Chicago Press, 2006.

Schumacher, Andreas, ed. *Botticelli: Likeness, Myth, Devotion*. Frankfurt: Städel Museum, 2010.

Schutte, Anne Jacobson. "'Trionfo delle donne': Tematiche di rovesciamento dei ruoli nella Firenze rinascimentale." *Quaderni storici* 44 (1980): 474–96.

Sebregondi, Ludovica, and Tim Parks, eds. *Money and Beauty: Bankers, Botticelli and the Bonfire of the Vanities*. Florence: Giunti, 2011.

Seznec, Jean. *The Survival of the Pagan Gods: The Mythological Tradition and Its Place in Renaissance Humanism and Art*. Princeton, NJ: Princeton University Press, 1972.

Shaw, Carl. *Satyric Play: The Evolution of Greek Comedy and Satyr Drama*. Oxford: Oxford University Press, 2014.

Shaw, James, and Evelyn Welch. *Making and Marketing Medicine in Renaissance Florence*. New York: Rodopi, 2011.

Shearman, John. "The Collections of the Younger Branch of the Medici." *Burlington Magazine* 117 (1975): 12, 14–27.

Silver, Nathaniel. "'Among the Most Beautiful Works He Made.' Botticelli's *Spalliera* Paintings." In *Botticelli Heroines + Heroes*. Edited by Nathaniel Silver, 32–55. London: Paul Holberton Publishing, 2019.

Simon, Robert B. "Cosimo I de' Medici as Orpheus." *Philadelphia Museum of Art Bulletin* 81 (1985): 16–27.

Simonetta, Marcello. *Caterina de' Medici: Storia segreta di una faida famigliare*. Milan: Rizzoli, 2018.

Simons, Patricia. "Homosociality and Erotics in Italian Renaissance Portraiture." In *Portraiture: Facing the Subject*. Edited by Joanna Woodall, 29–51. Manchester: Manchester University Press, 1997.

"Anatomical Secrets: *Pudenda* and the *Pudica* Gesture." In *Das Geheimnis am Beginn der Moderne*. Edited by Gisela Engel, Brita Range, Klaus Reichert, and Heide Wunder, 302–27. Frankfurt: Vittorio Klostermann, 2002.

"Giovanna and Ginevra: Portraits for the Tornabuoni Family by Ghirlandaio and Botticelli." *I Tatti Studies in the Italian Renaissance* 14/15 (2011–12): 103–35.

The Sex of Men in Premodern Europe: A Cultural History. New York: Cambridge University Press, 2014.

Smith, Bruce R. *The Key of Green. Passion and Perception in Renaissance Culture*. Chicago: University of Chicago Press, 2009.

Smith, Graham. "Bronzino's Use of Prints: Some Suggestions." *Print Collectors* 9 (1978): 110–13.

"Jealousy, Pleasure, and Pain in Agnolo Bronzino's 'Allegory of Venus and Cupid'." *Pantheon* 39 (1981): 250–59.

Smith, Joanne. *The Primavera of Sandro Botticelli*. New York: Peter Lang, 1993.

Smith, Webster. "On the Original Location of the *Primavera*." *Art Bulletin* 57 (1975): 31–40.

Spallanzani, Marco. "The Courtyard of the Palazzo Tornabuoni-Ridolfi and Zanobi Lastricati's Bronze Mercury." *The Journal of the Walters Art Gallery* 37 (1978): 6–21.

Spallanzani, Marco, and Giovanna Gaeta Bertelà. *Libro d'inventario dei beni di Lorenzo il Magnifico*. Florence: Associazione Amici del Bargello, 1992.

Spike, John T., and Alessandro Cecchi. *Botticelli and the Search for the Divine: Florentine Painting between the Medici and the Bonfires of the Vanities*. Williamsburg, VA: Muscarelle Museum of Art, 2017.

Standen, Edith Appleton. *European Post-Medieval Tapestries and Related Hangings in The Metropolitan Museum of Art*. Vol. 1. New York: The Metropolitan Museum of Art, 1985.

Stapleford, Richard. *Lorenzo de' Medici at Home. The Inventory of the Palazzo Medici in 1492*. University Park, PA: Pennsylvania State University Press, 2013.

Stark, James J., and Jonathan Katz Nelson. "The Breasts of 'Night': Michelangelo as Oncologist." *New England Journal of Medicine* 343 (2000): 1577–78.

Starn, Randolph, and Loren Partridge. *Arts of Power: Three Halls of State in Italy, 1300–1600*. Berkeley: University of California Press, 1992.

Steegman, Mary. *Bianca Cappello*. London: Constable and Company, 1913.

Strathern, Paul. *The Medici: Power, Money, and Ambition in the Italian Renaissance*. London: Pegasus, 2017.

Talvacchia, Bette. *Taking Positions: On the Erotic in Renaissance Culture*. Princeton, NJ: Princeton University Press, 1999.

"Bronzino's *Corpus* between Ancient Models and Modern Masters." In *Agnolo Bronzino: Medici Court Artist in Context*. Edited by Andrea M. Gáldy, 51–66. Newcastle: Cambridge Scholars Publishing, 2013.

Tambling, Jeremy. "'Nostro peccato fu ermafrodito': Dante and the Moderns." *Exemplaria* 6 (1994): 405–27.

Thode, Henry. *Michelangelo Kritische Untersuchungen über seine Werke*. Vol. 2. Berlin: G. Grote, 1908.

Thompson, Daniel V. *The Materials and Techniques of Medieval Painting*. New York: Dover Publications, 1956.

Tinagli, Paola. "Claiming a Place in History: Giorgio Vasari's *Ragionamenti* and the Primacy of the Medici." In *The Cultural Politics of Duke Cosimo I de' Medici*. Edited by Konrad Eisenbichler, 63–76. Aldershot: Ashgate, 2001.

Tolnay, Charles de. *Michelangelo, Volume 3: The Medici Chapel*. Princeton, NJ: Princeton University Press, 1948.

Tosi, C. O. "Cosimo I e la R. Villa di Castello." *L'Illustratore Fiorentino* 5 (1907): 33–46.

Trachtenberg, Marvin. *The Campanile of Florence Cathedral: "Giotto's Tower".* New York: New York University Press, 1971.

Testaverde, Anna Maria. "Spectacle, Theatre, and Propaganda at the Court of the Medici." In *The Medici, Michelangelo, and the Art of Late Renaissance Florence.* Edited by Cristina Acidini Luchinat, 123–31. New Haven, CT: Yale University Press, 2002.

Trinkaus, Charles. *The Poet as Philosopher: Petrarch and the Formation of Renaissance Consciousness.* New Haven, CT: Yale University Press, 1979.

Trottein, Gwendolyn. *Les enfants de Vénus: art et astrologie à la renaissance.* Paris: Lagune, 1993.

Tucker, Mark S. "Discoveries Made during the Treatment of Bronzino's 'Cosimo I de' Medici as Orpheus'." *Philadelphia Museum of Art Bulletin* 81 (1985): 28–31.

Turner, James Grantham. *Eros Visible: Art, Sexuality and Antiquity in Renaissance Italy.* New Haven, CT: Yale University Press, 2017.

Turner, James Grantham, ed. *Sexuality and Gender in Early Modern Europe: Institutions, Texts, Images.* Cambridge: Cambridge University Press, 1993.

Ullman, Berthold L. "Cleopatra's Pearls." *The Classical Journal* 52 (1957): 193–201.

Ulrich, Richard. "The Temple of Venus Genetrix in the Forum of Caesar in Rome: The Topography, History, Architecture, and Sculptural Program of the Monument." PhD diss., Yale University, 1984.

Van der Sman, Gert Jan. "Sandro Botticelli at Villa Tornabuoni and a Nuptial Poem by Naldo Naldi." *Mitteilungen des Kunsthistorischen Institutes in Florenz* 51 (2007): 159–86.

Lorenzo and Giovanna: Timeless Art and Fleeting Lives in Renaissance Florence. Translated by Diane Webb. Florence: Mandragora, 2010.

Veen, Henk Th. van. *Cosimo I de' Medici and His Self-Representation in Florentine Art and Culture.* Translated by Andrew P. McCormick. New York: Cambridge University Press, 2006.

Velter, André, Marie José Lamothe, and Jean Marquis. *Les outils du corps.* Milan: Ambrosiana, 1978.

Vidas, Marina. "The Copenhagen Cassoni. Construction Narrative Images for Quattrocento Audiences." *Analecta Romana* 29 (2003): 55–65.

Waddington, Raymond B. "A Satirist 'Impresa': The Medals for Pietro Aretino." *Renaissance Quarterly* 42 (1985): 655–81.

"The Bisexual Portrait of Francis I: Fontainebleau, Castiglione, and the Tone of Courtly Mythology." In *Playing with Gender: A Renaissance Pursuit.* Edited by Jean R. Brink, Maryanne C. Horowitz, and Allison P. Coudert, 99–132. Chicago: University of Illinois Press, 1991.

Aretino's Satyr: Sexuality, Satire, and Self-Projection in Sixteenth-Century Literature and Art. Toronto: University of Toronto Press, 2004.

Waldman, Louis A. "Botticelli and His Patrons: The Arte del Cambio, the Vespucci, and the Compagnia dello Spirito Santo in Montelupo." In *Sandro Botticelli and Herbert Horne: New Research.* Edited by Rab Hatfield, 105–35. Florence: S.E.I. srl, 2009.

Wallace, William E. "Instruction and Originality in Michelangelo's Drawings." In *The Craft of Art: Originality and Industry in the Italian Renaissance and Baroque Workshop.* Edited by Andrew Ladis, Carolyn Wood, and William Eiland, 113–33. Athens, GA: University of Georgia Press, 1995.

"Michelangelo's *Leda*: The Diplomatic Context." *Renaissance Studies* 15 (2001): 473–99.

Warburg, Aby. "Sandro Botticelli's *Birth of Venus* and *Spring*: An Examination of Concepts of Antiquity in the Italian Early Renaissance (1893)." In *The Renewal of Pagan Antiquity: Contributions to the Cultural History of the European Renaissance.* Translated by David Britt, 88–156. Los Angeles: Getty Research Institute, 1999.

Watson, Paul. "Boccaccio's *Ninfale Fiesolano* in Early Florentine Cassone Painting." *Journal*

of the Warburg and Courtauld Institutes 34 (1971): 331–33.

———. *The Garden of Love in Tuscan Art of the Early Renaissance*. Philadelphia: Art Alliance Press, 1979.

Welch, Evelyn. "Art on the Edge: Hair and Hands in Renaissance Italy." *Renaissance Studies* 23 (2009): 241–68.

Wellman, Kathleen. *Queens and Mistresses of Renaissance France*. New Haven, CT: Yale University Press, 2013.

Wheeler, Jo. *Renaissance Secrets: Recipes and Formulas*. London: Victoria and Albert Museum, 2009.

Wiles, Bertha. *The Fountains of Florentine Sculptors and Their Followers from Donatello to Bernini*. New York: Hacker Art Books, 1975.

Wilkins, David. "Maso di Banco and Cenni di Francesco: A Case of Late Trecento Revival." *Burlington Magazine* 111 (1969): 83–85.

Wilson, Bronwen. "Bedroom Politics: The Vexed Spaces of Late Medieval Public Making." *History Compass* 10 (2012): 608–21.

Wilson, Timothy. "Un 'intricamento' tra Leonardo ed Acrimboldo." *Ceramica Antica* 15 (2005): 10–44.

Wilson-Chevalier, Kathleen. "Women on Top at Fontainebleau." *Oxford Art Journal* 16 (1993): 34–48.

Witt, Ronald G. *"In the Footsteps of the Ancients": Origins of Humanism from Lovato to Bruni*. Leiden: Brill, 2000.

Witthoft, Brucia. "Marriage Rituals and Marriage Chests in Quattrocento Florence." *Artibus et Historiae* 3 (1982): 43–59.

Wolfthal, Diane. "'A Hue and A Cry': Medieval Rape Imagery and Its Transformation." *Art Bulletin* 75 (1993): 39–64.

———. *In and Out of the Marital Bed: Seeing Sex in Renaissance Europe*. New Haven, CT: Yale University Press, 2010.

Woudhuysen-Keller, Renate, and Paul Woudhuysen. "Thoughts on the Use of the Green Glaze Called 'Copper Resinate' and Its Colour-changes." In *Looking through Paintings: The Study of Painting Techniques and Materials in Support of Art Historical Research*. Edited by Erma Hermens, 133–46. London: Archetype, 1998.

Wrapson, Lucy, ed. *In Artists' Footsteps: The Reconstruction of Pigments and Paintings. Studies in Honour of Renate Woudhuysen-Keller*. London: Archetype, 2012.

Wright, David Roy. "The Medici Villa at Olmo a Castello: Its History and Iconography." PhD diss., Princeton University, 1976.

Zanker, Paul. *The Power of Images in the Age of Augustus*. Ann Arbor: University of Michigan Press, 1990.

Zanrè, Domenico. "Ritual and Parody in Mid-Cinquecento Florence: Cosimo de' Medici and the Accademia del Piano." In *The Cultural Politics of Duke Cosimo I de' Medici*. Edited by Konrad Eisenbichler, 189–204. Aldershot: Ashgate, 2001.

Zirpolo, Lilian. "Botticelli's 'Primavera': A Lesson for the Bride." *Women's Art Journal* 12 (1991): 24–28.

Zorach, Rebecca. *Blood, Milk, Ink, Gold: Abundance and Excess in the French Renaissance*. Chicago: University of Chicago, 2006.

———. "Love, Truth, Orthodoxy, Reticence; or, What Edgar Wind Didn't See in Botticelli's *Primavera*." *Critical Inquiry* 34 (2007): 190–220.

INDEX